David V. Erdman, Professor of English at the State University of New York at Stony Brook and Editor of Publications at the New York Public Library, is editor of *The Poetry and Prose of William Blake,* of the Cornell University Press *Concordance of the Works of Blake,* and of two volumes in the forthcoming Bollingen *The Collected Works of Samuel Taylor Coleridge.*

BLAKE: Prophet against Empire

How I did secretly Rage! I also spoke my Mind.

BLAKE

Prophet against Empire

A POET'S INTERPRETATION OF THE

HISTORY OF HIS OWN TIMES

BY DAVID V. ERDMAN

REVISED EDITION

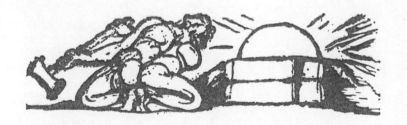

ANCHOR BOOKS

DOUBLEDAY & COMPANY, INC.

GARDEN CITY, NEW YORK

1969

TO
VIRGINIA
&
HEIDI & WENDY
&
TORY & LISSALOTTE

Preface

SINCE 1954 the study of Blake's life, works, sources, and associations—and of the intellectual and social history of his times—has altered and enlarged the intellectual context of this book. The temptation to revise entirely has at times been strong; in a paragraph or footnote here and there this edition is responsive to the urge to make a new assessment. But on the whole I have (with the encouragement of friends and critics) kept the main structure and in fact the text of this volume very much as they were. New biographical and bibliographical information relevant to Blake's interpretation of history has been incorporated as unobtrusively as possible. Quotations of Blake's writings have been corrected in the few places necessary and also brought closer to the original spelling and punctuation.

A few important and several minor readjustments have been necessitated by revised dating. We now know that the Blakes moved from 27 Broad Street in 1785, little more than a year after the partnership of Parker & Blake was formed; that they moved to Lambeth not in 1793 but in 1791—thanks to the rate-book investigations of Paul Miner. Details in the style of Blake's lettering support other evidence that *A Divine Image* is an early, not a late, trial Song of Experience; that the "Argument" of *The Marriage of Heaven and Hell* is an original part of the work, not an addition. And the work of G. E. Bentley, Jr., and my own investigations have taught me that the stages and chronology of the manuscript of *The Four Zoas* are less definable than I had supposed.

To accommodate these and other revisions, some paragraphs have been moved forward or backward; some have been left standing, with notes of explanation. New material has generally been added in the notes, though occasionally by incorporation into the main narrative. Stanbury Thompson's discovery and publication of the *Journal* of John Stedman must be credited for the most fascinating new information, both about Blake's re-

lations with author and publisher and printer and about his London, Stedman being a sort of Ginger Man. G. E. Bentley's notes have been useful for details here and there, particularly for the missing documentary link in the tale of Cromek's serpentine behavior. Many revisions and amplifications of historical particulars derive from the publications and conversation of E. P. Thompson and Lucyle Werkmeister. Martha England and Nancy Bogen have assisted in the revision of chapters dealing with *An Island in the Moon;* Mrs. Bogen and Mary S. Hall have communicated important discoveries about the sources and meanings of *Tiriel.* I have drawn afresh upon an ancient correspondence with Palmer Brown, and received much clarification from exchanges with S. Foster Damon and W. H. Stevenson. At the last minute Stanley Gardner's "Literature in Perspective" *Blake* has added some vivid London details.

Too late for more than hasty perusal of its splendid and numerous illustrations came Kathleen Raine's *Blake and Tradition.*

For continuing help and encouragement I am grateful to Sir Geoffrey Keynes, Northrop Frye, George Goyder, and F. W. Bateson; for criticism and particular advice, to Robert F. Gleckner and Edward J. Rose. For a variety of helpful suggestions and particular services I am indebted to Morton Paley and Ruthven Todd; also to Morchard Bishop, Harold Bloom, J. T. Boulton, Martin Butlin, Patrick J. Callahan, Kenneth Neill Cameron, Anne Freedgood, John E. Grant, William F. Halloran, Sally Hyde, Robert Kolker, Anne T. Kostelanetz, Lewis Patton, Vivian de Sola Pinto, Charles E. Robinson, Eric Robinson, Irene Tayler, and Michael Tolley. For indulgence as well as assistance I must also thank William L. Coakley, Marilan Lund, and Eugenia McGrath of the New York Public Library, and Cecelia Grimm and Lillian Silkworth of the State University of New York; and, beyond definition, the five persons of my dedication.

D.V.E.

Crane Neck Point
June 1969

Preface to the First Edition

WITH the growth of interest in Blake as a poet of social vision the need has grown for a methodical study of his thought and art in relation to the history of his own times. Recent studies have related Blake's work to the Enlightenment and to the general context of the French Revolution and the Industrial Revolution. But "General Knowledge is Remote Knowledge," as Blake was wont to insist, and we miss much of the vitality if not the sublimity of his "Sublime Allegory . . . addressed to the Intellectual powers" as long as we remain only remotely acquainted with the "acts" of his age which he considered it his poetic duty "to record and eternize."

Today it is not uncommon to find Blake regarded as the greatest of the Romantic poets or as the poet who means most for the modern world because of his awareness of the implications of history in the industrial epoch. Yet many of his shrewdest observations upon modern life are misconstrued, his pointed prophecies are treated as intentionally nonprophetic, his ironies and caricatures are taken for sober absurdities, and his unmistakably topical allusions are interpreted so carelessly that we have one decade mistaken for another, a counterrevolution for a revolution, a cabinet change for a riot, an orphan asylum for a madhouse, a recruiting officer for an agriculturist, and—most fundamentally—an indictment of war for an indictment of industry.

Like his contemporaries Goya and Beethoven, Blake saw the age of the spinning jenny and the balloon and the citizen army not primarily as an age of rising industry but as one of increasingly prodigious war and uncertain peace. He felt the cannonfire and the mud of Valmy almost more acutely than did Goethe, who was on the scene. "Industrial Revolution" is a concept produced by the rational intellect in a later generation to describe a single component of the changes in Blake's lifetime (1757–1827). It misleads twentieth-century readers such as the one who mistakes the poet's wry observation on the economics of cavalry supply— "the horse is of more value than the man"—for a lament about

horsepower. War and Peace is the pattern Blake saw as he watched "the New Age" with mingled delight and terror. For him the human question was framed not in terms of improved production but as a choice or an issue between the peaceful Looms of Jerusalem, weaving clothing and a symbolically lucent atmosphere, and the Mills of Satan, casting steel cannonbarrels and filling the sky with the smoke of battles and of burning towns. Factory smoke was not a major ingredient of the cloud over London.

In order to get close to the eye-level at which Blake witnessed the drama of his own times—the level at which history is "nothing else but improbabilities and impossibilities, what we should say was impossible if we did not see it always before our eyes"—I have read the newspapers and looked at the prints and paintings and sampled the debates and pamphlets of Blake's time. As Blake would say, I have "walked up & down" in the history of that time. And I have learned to read the idiom of current allusion with sufficient familiarity to detect its presence even in Blake's obscurer pages, where workshops are dens of Babylon and royal dragoons are punishing demons and the House of Commons is a windy cave. I have become familiar, too, with Blake's use of sources in the ironic manner which historians of painting call witty quotation. Burke having said of Marie Antoinette, "surely never lighted on this orb, which she hardly seemed to touch, a more delightful vision," Blake exclaims: "The Queen of France just touched this Globe And the Pestilence darted from her robe." Or Blake pivots a prophecy of Armageddon on an allusion to Milton which requires our recognizing a cosmic jest which reverses the predicament of Nature in Milton's Nativity *Hymn*. Sometimes the mere homeliness of Blake's method of reading white for black has baffled us, as in his elaboration of an emblem of *The Gates of Paradise* from a satiric political print, or as in his choice of the name Los (loss) for his visionary *prophet* in a world of Paradise *Lost*.

Blake thought of himself as a prophetic bard with a harp that could prostrate tyranny and overthrow armies—or, more simply, as an honest man uttering his opinion of public matters. And although he often veiled his opinion or elaborated it into a complex symbolic fabric having little to do with public matters on many of its levels of meaning, it has been possible to trace through nearly all of his work a more or less clearly discernible thread of historical

reference. Many of the proposed identifications of Blake's Minute Particulars are, I trust, firmly established as to source and context and evident meaning, though sometimes extensive documentation has been necessary in separate articles or in footnotes; some of the identifications derive their probability chiefly from their consistency with the rest; some of those made quickly in the opening chapters must be judged in the light of evidence cumulatively supplied in the sequel.

What I have attempted is a bold survey of the history of Blake's time as it swirls about and enters into the texture of his emblematic painting and poetry. Part One is concerned with the impact of the American Revolution and of London Patriotism on Blake as a youth; Part Two with his drift into cynical and then devotional social attitudes during the commercial decade that followed. Part Three deals with his exuberant response to the French Revolution; Part Four with his prophetic editorials, pictorial and poetic, against the English Crusade and the Pitt Terror. Parts Five, Six, and Seven follow Blake as he "follows the wars" of 1793–1802 and 1803–1815 and is wrenched from his prophetic course by the brief interval of peace between these wars. The final years of Blake's life, devoted chiefly to painting and engraving, are touched only briefly in an Epilogue.

My large indebtedness to the work of previous scholars, especially the commentaries of S. Foster Damon and of D. J. Sloss and J. P. R. Wallis and the studies of Jacob Bronowski, Mark Schorer, Northrop Frye, and Geoffrey Keynes, is not at all adequately acknowledged in the notes, I am afraid.

For patient and critical reading of various drafts of my manuscript, I am deeply indebted to Howard O. Brogan and Northrop Frye. I wish to thank Geoffrey Keynes for many services and for permission to quote from his letters; Howard Wandrei and Paul La Porte for drawings; Max Gartenberg for the suggestion of the Blake-Barlow relationship; Palmer Brown for a valuable correspondence and for his transcript of *An Island in the Moon,* also the Fitzwilliam Museum for permission to quote from this transcript of the MS in their possession; Lord Abinger and the Duke University Library for permission to quote from the unpublished diary of William Godwin, and especially Lewis Patton for use of his transcript of the diary.

For critical advice, particular services, and general encouragement I am grateful to Joseph Warren Beach, Charles G. Osgood, Mark Schorer, H. M. Margoliouth, Ruthven Todd, Samuel H. Monk, William P. Dunn, Huntington Brown, Theodore Hornberger, William Riley Parker, Ernest Tuveson, Herman Ramras, Miss Grace Marie Graham, Miss Marjorie White, Miss Josephine Miles, Leslie L. Hanawalt, Miss Margaret Ruth Lowery, Henry Nash Smith, William Van O'Connor, Mrs. Mary Bess Cameron and Kenneth N. Cameron, Barthold Fles, Fred Marsh, Donald Erdman, Miss Elizabeth Atkins, Miss Ruth Reavey, Miss Elizabeth Nitchie, Miss Elisabeth Schneider, Sigmund Diamond, Edwin Wolf 2nd, Miss Elizabeth Mongan, and Karl Kiralis.

To my graduate students I am grateful for their challenging discussion and for their reading of manuscript chapters: Miss Ming Chu Chang, Miss Nancy Belle Swan, Donald Bateman, Richard Gollin, Charles Knickrehm, Peirce R. Ressler, Stanley Hirsch, Stanley Frieberg, James Boness, Bill Elbrecht, Joseph Burgess, John McBride, Ordell Paulson, Kingsley Widmer, Donald Gray, and especially Martin Nurmi and Julian Markels, who assisted in research. For assistance in typing I wish to thank Mrs. Barbara McNally and Mrs. Roberta Markels.

For generous grants in aid I wish to thank Henry Allen Moe and the Trustees of the Guggenheim Memorial Foundation, and Theodore C. Blegen and the Graduate School of the University of Minnesota. I have had the additional advantage of a light teaching schedule during my year at Duke University. I am indebted to the librarians of the University of Minnesota, especially Mrs. Vera Clausen, Miss Virginia Doneghy, Mrs. Yvonne Van Der Boom, Mrs. Edna Rodabaugh, and Mrs. Evelyn B. Thompson; of the Detroit Public Library, especially Miss Gamel; of the Pierpont Morgan Library; of the Yale University Library, especially Miss Barbara D. Simison; of the Harvard College Library, especially Miss Carolyn E. Jakeman, Miss Mabel A. E. Steele, and Mr. Philip Hofer; and of Duke University Library, especially Emerson Ford. For permission to reproduce pictures I am indebted to the National Gallery of Art, the Pierpont Morgan Library, the Boston Museum of Fine Arts, the Harvard College Library, the Trustees of the Tate Gallery, and the Duke of Hamilton. For permission to make use of material in published articles I must thank the respective editors of the journals listed.

I am indebted to James Sisson and Bruce Teets for help in proofreading, and to Mrs. Victoria S. Bohan for assistance in preparing the index; and to Benjamin F. Houston of Princeton University Press for his patient and sympathetic editorial guidance. And most of all, for critical advice at every stage and for such miracles of self-denial "as both astonish & comfort me," I am indebted to my wife.

D.V.E.

Durham, North Carolina
March 1953

Explanation of Notes

1. The following abbreviations are employed for Blake's works:

A. *America*

D.C. *A Descriptive Catalogue*

E. *Europe*

F.R. *The French Revolution*

F.Z. *The Four Zoas* (earlier title, *Vala*)

I.M. *An Island in the Moon*

J. *Jerusalem* (plate numbers of variant Chapter 3 given in brackets [])

M. *Milton*

M.H.H. *The Marriage of Heaven and Hell*

Marg. The Marginalia

N. *Notebook* (the Rossetti MS)

P.A. *Public Address* (in *N.*)

P.S. *Poetical Sketches*

T. *Tiriel*

T.S.B. *Then She Bore Pale Desire*

V.D.A. *Visions of the Daughters of Albion*

V.L.J. *Vision of the Last Judgment* (in *N.*)

2. Roman numerals indicate chapter or scene or "night" divisions marked or implied by Blake.

3. Arabic numerals indicate plate or page and line numbers, thus: *A*.5:2 means *America*, plate 5, line 2. But numerals with *F.R.* refer simply to lines. For Blake's marginalia to Lavater and to Swedenborg they indicate numbered paragraphs or sections.

4. When useful, reference is given to pages in *The Poetry and Prose of William Blake*, ed. David V. Erdman, commentary by Harold Bloom, Garden City, 1965; third printing, 1968, indicated by the letter "E"—followed by reference to pages in *The Complete Writings of William Blake*, ed. Geoffrey Keynes, London, 1966; fourth printing, 1968, indicated by "K"; but the text quoted is, in its particulars, the former. (This Keynes pagination is also that of the Nonesuch edition, first set in 1957.)

ABBREVIATIONS FOR MOST FREQUENTLY
CITED REFERENCES

Antal	Frederick Antal, *Fuseli Studies,* London, 1956
Barnes	Joshua Barnes, *History of Edward III,* London, 1688
B. Bibliog.	G. E. Bentley, Jr., and Martin K. Nurmi, *A Blake Bibliography,* Minneapolis, 1964
Bisset	Robert Bisset, *History of the Reign of George III,* 2 vols., London, 1816 (1803)
Blackstone	Bernard Blackstone, *English Blake,* London, 1949
Blunt	Anthony Blunt, *The Art of William Blake,* New York, 1959
B.M. Satires	Mary Dorothy George, *Catalogue of Political and Personal Satires . . . in the British Museum,* 8 vols., London, 1935–1947
BNYPL	*Bulletin of The New York Public Library*
Bronowski	Jacob Bronowski, *William Blake: A Man Without a Mask,* London, 1944; reprinted as *William Blake and the Age of Revolution,* New York, 1965, for which page nos. are added in brackets
Damon	S. Foster Damon, *William Blake: His Philosophy and Symbols,* New York, 1924
Damon's *Dictionary*	S. Foster Damon, *A Blake Dictionary: The Ideas and Symbols of William Blake,* Providence, 1965
Elliot	*Life and Letters of Sir Gilbert Elliot First Earl of Minto,* ed. The Countess of Minto, 3 vols., London, 1874
Frye	Northrop Frye, *Fearful Symmetry: A Study of William Blake,* Princeton, 1947
Gardner	Stanley Gardner, *Blake* (Literature in Perspective), London, 1968
Gilchrist	Alexander Gilchrist, *Life of William Blake,* revised by Ruthven Todd, London, 1945

Lowery	Margaret Ruth Lowery, *Windows of the Morning*, New Haven, 1940
Paine	*Thomas Paine, Complete Writings*, ed. Philip S. Foner, 2 vols., New York, 1945
Rapin	Rapin de Thoyras, *The History of England*, tr. with addl. notes by N. Tindal, 3rd edn., 5 vols., London, 1743
Schorer	Mark Schorer, *William Blake, The Politics of Vision*, New York, 1946
Sloss and Wallis	D. J. Sloss and J. P. R. Wallis, *William Blake's Prophetic Writings*, 2 vols., Oxford, 1926
Symons	Arthur Symons, *William Blake*, London, 1907
Thompson	E. P. Thompson, *The Making of the English Working Class*, New York, 1964
Werkmeister	Lucyle Werkmeister, *A Newspaper History of England, 1792–1793*, Lincoln, 1968
Whitley, *Art*	William T. Whitley, *Art in England: 1800–1830*, Cambridge, 1928
Whitley, *Artists*	William T. Whitley, *Artists and Their Friends in England: 1700–1799*, 2 vols., London, 1928
Wright	Thomas Wright, *Life of William Blake*, 2 vols., Olney, 1929

Contents

List of Illustrations

(following p. 192)

Plate

(following p. 336)

Figures in the Text

Part One

THE AMERICAN WAR

. . . a mighty & awful change threatened the Earth.
The American War began. All its dark horrors passed
 before my face . . .

<div align="right">— to Flaxman, September 1800</div>

1. War Unchained

WILLIAM BLAKE (1757–1827) lived through sixty-nine years of wars and revolutions, political, industrial, and intellectual. But the first big fact about his life is that he grew up in a time of peace and never lost the feeling that England was a green and pleasant land, potentially the mart of peaceful nations; that London's towers were a fit dwelling place for the Lamb of God. Without regular occupation until the age of ten when he entered drawing school, "sweet [he] roamed from field to field"; saw angels in a sunlit tree at Dulwich and among haymakers at dawn; bathed in the ponds near Willan's farm and in the Thames; haunted the printshops and the few accessible art collections; read the poets and prophets from Isaiah to Milton; recorded his joy in songs of laughter; and stored up impressions for the later building of Jerusalem. Blake's vision of paradise is no lost traveler's dream but the sunny side of eighteenth-century London life as experienced by a boy given to roaming the adjacent fields and living in an indulgent family in a Broad Street on a square named Golden.

All the biographers rightly emphasize Blake's happy boyhood; yet in their discussion of his youthful "visions" they tend to isolate themselves from Blake by treating him as quaint or mystic. They generally fail to take into account the graphic artist's professional interest in "seeing through the eye" or to recognize that the community of London artists which was Blake's only college was a milieu that encouraged visionaries—not those who had "ineffable" but those who had vivid and distinct revelations. Hogarth, scarcely a mystic, saw visions; and many other artists, including Cosway, who taught at Pars's Drawing School and was intimate with Blake for many years, boasted of ghostly visitors who sat for their portraits.[1] Blake came to insist, however, that his paintings were

[1] Richard Cosway (1740–1821) became a teacher in Pars's school some time after 1760; Blake attended from 1768 to 1772. I am not certain that their time there overlapped. For their later relations see below.

Blake spoke to Crabb Robinson of having the faculty of vision "from early infancy," but the only anecdotes we have of early visions "savor of too much telling," as Miss Lowery observes, p. 1.

drawn from *intellectual* visions, not corporeal hallucinations. But a greater failing of the biographers, the archetype of whom is the Carlylean Alexander Gilchrist, is that they have no eye at all for the wider framework around the national peace which England enjoyed between Blake's fifth and seventeenth years. Yet the story of Blake's early intellectual growth is in part the story of his learning to see the larger web of commerce and war within which "peace" was often mere hallucination.

Britannia with trident in hand was the emblematic image (soon to go out of fashion in the iconology of political engraving) of the peace attained in 1762 after The Great War for the Empire, as scholars now call it. British naval power had driven France out of America and the richer plunder depots of India, and had hastened the Spanish Empire toward its ruin. It was a peace, as the slightly older poet Chatterton sardonically observed in 1770, "modelled in gingerbread, and ready to fall in pieces at the slightest touch."[2] And the statue's base was the triangle of commerce in slaves, sugar, rum. But surely Blake's attention as a boy was not focused on the foundations of his paradise.[2a]

[2] Item signed "Decimus" in the *Middlesex Journal*, May 26.

[2a] This is not to say he was unaware of what Stanley Gardner calls "the commonplace misery and arrogance that hung in the air he breathed." Gardner's chapter on "Blake's Westminster" (pp. 18–28) supplies details of his neighborhood. "Round the corner from Blake's house was Carnaby Market . . . includ[ing] a slaughter-house, with women among its butchers, and the voice of the cattle . . . stayed with Blake all his life. . . . In the Pawlett's Garden burial ground [nearby] was the St. James's Workhouse, 'capable of containing 300 poor people. When . . . sick, they are removed to the infirmary . . . near Broad Street.' . . . The [workhouse] inmates were strictly controlled . . . put to tasks of weaving, spinning. . . . In 1782 . . . hardly a hundred yards west of Blake's home . . . a School of Industry for older children from the workhouse. . . . after strict training and regular religious discipline the boys were sent to sea or apprenticed, and the girls 'placed out in service'." On the other hand, when Blake "came out of his front door and walked a few yards south down Marshall Street he came to Golden Square, 'which is very small, but neat, and is adorned on the inside with grass plats and gravel walks, and is surrounded with handsome iron rails'. In the middle was a statue, claimed to be of George [II] a different world . . . a cosmopolitan gentry At times the foreign legations moved into Golden Square. . . . Some streets were 'much inhabited by the French', who had places of worship, as did Anabaptists, Presbyterians, and Independents. Dominating all this was royalty and the church Opposite the parish church of St. James, Piccadilly, the young and extravagant Lord Melbourne had built his mansion, now called Albany. . . ."

A sudden altering and sharpening of focus did come, however, with the second big fact in Blake's life, the American Revolution and the American War, which made the golden sunlight on the Thames a cheat and shook to ruin Jerusalem's arches over Primrose Hill and Marybone (*J.*27). Blake reached maturity during the American War; as soon as the war was over he printed poems and exhibited paintings full of the war's "dark horrors," and ten years later he drew upon one of these paintings for the frontispiece and title page of his epic prophecy *America,* in which he told the story not so much of the American Revolution as of its impact on London in those war years. Yet this mountainous fact which Blake said "passed before" his face and signified "a mighty & awful change" (to Flaxman, September 1800) has been utterly ignored or misunderstood.

The difficulty comes at least as much from a failure to enter imaginatively into Blake's times as it does from a failure to enter Blake's imagination. Thus an assumption as to "the sterility" of Blake's environment can lead even an acute observer of Blake to abandon a valuable hypothesis about the irony in his early dramatization of England's commercial warriors.[3] As for Gilchrist, once he has established Blake as an engraver for the antiquaries he ignores the larger world in which they all lived and accepts as comprehensive the statement that after his twentieth year Blake's energies were "wholly directed to the attainment of excellence in his profession."[4] When Gilchrist says, "These were *not* favourable days for designing, or even quiet engraving," he is merely referring to one June week which he treats in anecdotal isolation; yet the week in question epitomizes, as we shall see, the intimate and enduring relationship of the prophetic journeyman engraver to the citizens of London who sympathized with America in the days of "Wilkes and Liberty."

We tend to think of English opposition to the American War as a matter of a few bold speeches by Chatham, Burke, Fox, and Wilkes, without considering that these politicians, though outnumbered in a Parliament dominated by "King's friends," were voicing the sentiment of a majority who looked upon the King's

[3] See Frye, p. 180.

[4] Gilchrist, p. 31, quoting the *P.S.* advertisement. See Deborah Dorfman, "Blake in 1863 and 1880: The Gilchrist *Life,*" BNYPL, LXXI (1967), 216–244, for a critique of the strengths and weaknesses of the original and the revised Gilchrist.

attempt to suppress the American trade as a display of arbitrary power. In English trading centers the war was never popular. Even during the middle years, when many merchants were enjoying large war contracts, the London Common Council persistently voted against recruiting volunteers to fight for the King. All the London members in the House of Commons between 1774 and 1784 consistently opposed the war policy and said they were speaking for their constituents.[5] The modern historian discovers with some surprise that most of the satiric prints which served as the graphic editorials of the day were pro-American, representing America as the land of liberty and virtue, England as that of corruption and slavery, and King George as a cruel and obstinate tyrant.[6] We should not be surprised to find that Blake shared the common view nor to find in some of his earliest work the germs of his later republicanism.

Hardly a sterile environment for such ideas was the London whose printshops featured such "comic history painting" as *The State Blacksmiths forging fetters for the Americans* (1776), *Poor Old England endeavouring [with a scourge] to reclaim her Wicked American Children* (1777), and *The Horse America, throwing his Master* (1779). Critics, however, with rare exception have assumed that the poetry, and most of the history painting, produced by Blake during the American Revolution express chiefly a simple romantic nationalism and a youthful enthusiasm for kingly war, although some passages are recognized as strongly anti-war. This topsy-turvy interpretation is due in part to Blake's somewhat indirect way of expressing his sympathy with the American "Patriots," but also in large part to neglect of the historical context. Failure to recognize the element of London radicalism in his early work has sent readers of Blake off to a bad start and has also distorted the general picture of eighteenth-century British culture, through omission of Blake's important contribution to the democratic side.[7]

[5] David S. Reid, "An Analysis of British Parliamentary Opinion on American Affairs . . ." *Journal of Modern History,* xviii (1946), 202–221.

[6] *B.M. Satires,* v, xviii–xxii. Prints next mentioned are nos. 5328, 5397, 5549. For "an almost incredibly violent attack on the king, the Ministry, and the conduct of the war" see no. 5470.

[7] An omission being rectified by E. P. Thompson, who argues: "Against the background of London Dissent, with its fringe of deists and earnest

The history of Blake's famous picture *Glad Day,* more properly called *The Dance of Albion* or *Albion rose* (Plate I), will furnish a startling example of how Blake's "sublime allegory" can be missed and misread. In 1780 in the fifth year of the war, when Blake was twenty-two and free both from his apprenticeship which had ended the year before and from "Matrimony's golden cage" which he would enter two years later, he drew a bold picture transforming a textbook diagram of the proportions of the human figure[8] into a terrific social utterance. Along came his Victorian biographer eighty years later; decided to call it "Glad Day," though one would think the facial expression in this picture rather sober than glad; and saw no connection with those June days which he elsewhere remarked as unfit for quiet engraving. Blake himself, however, had recorded the connection between this drawing and the American Revolution and the Gordon Riots of 1780.

In *America* Blake describes the spirit of rebellion as crossing the Atlantic to Great Britain and inspiring, particularly in London and Bristol, open demonstrations against the war, which temporarily deranged the guardians of the status quo and hastened the coming of peace. Amid "fires of hell" and "burning winds driven by flames" of Revolution,

> The millions sent up a howl of anguish and threw off their
> hammerd mail,
> And cast their swords & spears to earth, & stood a naked
> multitude. (*A.*15:4–5)

Historians have come to realize that an important ingredient of the June riots was wrath against "the unfortunate management of the War against the American Rebellion."[9] For several days the

mystics, William Blake seems no longer the cranky untutored genius that he must seem to those who know only the genteel culture of the time. On the contrary, he is the original yet authentic voice of a long popular tradition." Thompson, p. 52.

[8] In Vincenzo Scamozzi, *Idea dell' Architettura Universale,* Roma, 1615, II, 40. Noted by Anthony Blunt in *Journal of the Warburg Institute,* II (1938), 65.

[9] J. Paul De Castro, *The Gordon Riots,* London, 1926, p. vii, considers this "a greater influence in stimulating the Riots than has been recognized." Cf. *B.M. Satires,* v, xxiii.

multitudes were in control of the streets of London, and there were uprisings in Bristol and other towns. Wearing the blue cockade of Wilkes and Liberty, crowds sacked and burned "Papist" chapels and the houses of ministers, magistrates, bishops, lawyers; they burst open jails and released the prisoners. As for the "howl of anguish," the *Annual Register* describing the flames ascending from the prisons, from the hated ha'penny toll-houses on Blackfriars Bridge, from alcohol blazing in a demolished distillery, mentions "the tremendous roar of the authors of these horrible scenes," continuing all the night (the fifth day).

The mixture of motives in the rioters' minds remains obscure. "Government and the Rioters," observed a contemporary, "seemed to have felt an equal disposition, by drawing a veil over the extent of the calamity, to bury it in profound darkness";[10] and they succeeded. "No Popery!" was the cry, and it seemed somewhat out of date. But there was a link to government efforts to win Catholic support and Catholic troops for the armies in America. It was Lord Gordon's view that recent Catholic relief bills had been devised "for the diabolical purpose of arming the Papists against the Protestant Colonies in America."[11] There was also an urge among "lower classes" to imitate the Reform agitation of "respectable gentlemen" who had been meeting and speaking all spring.

" 'The Rights of the People'—'The Majesty of the People,' were then the fashionable expressions, and several gentlemen went so far as to say, that Ireland had only obtained her independence by the force of 60,000 bayonets, and that if Parliament did not comply with their Petitions, it would be necessary to take the same

[10] Sir N. W. Wraxall, *Historical and Political Memoirs, 1772–90*, London, 1884, I, 335.

[11] George Lord Gordon, *Innocence Vindicated*, London, 1783. The Catholic relief (for Canada) in the Quebec Act of 1774 was viewed as a carrot to draw Catholic Canadians to the Tory side, accompanying the club of coercive acts against Massachusetts. In 1778 a British Catholic relief bill was passed, the repeal of which was the rallying demand of the 1780 demonstrations. R. W. Postgate, *That Devil Wilkes*, London, 1929, p. 229, summarizes the popular fears: "Had not the Quebec act legalized Roman Catholicism as part of an attack on the Americans? Were not Catholic armies being raised in Canada, Scotland, and Ireland? Was it not well known that Catholics . . . had inserted themselves as the chief agents of tyranny in many of the highest places?"

means to enforce them. Such was the temper of these Meetings. . . ."12

And it was at this time that the Society for Constitutional Information was formed, of which we shall hear more later.

Alarmed conservatives—the blue-stocking Mrs. Montagu for one —thought the riot was intended to force capitulation to "the conditions of peace with America on the terms offered by the Congress, the French and Spaniards." Horace Walpole pondered the rumor that "Some Americans, perhaps, taught by the lessons we have given them of burning towns," had "joined in the opportunity," but he was more impressed by the force of "a thousand discontents."13

Gilchrist, who states that "Blake long remembered" his having been in "the front rank" of the crowd that burned and opened the gates of the great fortress and prison of Newgate on June 6th, is careful to qualify Blake's participation as "involuntary," just as later he is careful (and patently incorrect) to absolve Blake of sympathy with the French Revolution after 1792. Jacob Bronowski's observation is probably nearer the truth, that "Blake did not grow afraid of the crowd, then or later."14 We may let "involuntary" stand, for any physical participation, but it seems clear that Blake shared the sentiments of Gilchrist's "triumphant black-guardism" insofar as "the mob" believed that freeing their fellows from Newgate was a step toward freeing Albion from an oppressive war.

Thomas Wright makes the pregnant observation that "these terrific scenes—the flaming houses and chapels and the occurrences at the jail—affected [Blake] extraordinarily, and gave him ideas for many a startling print in *Europe, America* and the other

12 Such was the recollection of Thomas Walker, in the *Courier* of July 12, 1794—an interesting confirmation of the recollection of Blake, finishing *America* in the previous summer.

13 De Castro, pp. 231–232, 241.

14 Bronowski, p. 36 [62]. It may be noted that Blake was in the streets during the fifth day and at the center of the action; the day when, according to Thompson in a discussion of recent studies of the Gordon Riots (pp. 71–72), "some of the 'better sort of tradesmen' faded away, while journeymen, apprentices, and servants—and some criminals—thronged the streets."

Prophetic Books."[15] But for Wright too the "striking" 1780 draw-
ing is only "Glad Day" or "Jocund Day." Blake did not, indeed,
find any quiet time to engrave *that* picture for many years. When
he did he identified it with the inscription "WB inv[enit] [i.e.
made the original drawing] 1780." The picture has attained
wide popularity, but its topical significance has never been ob-
served. On a mountain top, arms in a gesture of tremendous
energy and confidence, stands the "naked multitude" portrayed
as a single giant in keeping with Blake's theory that "Multitudes
of Men in Harmony" appear "as One Man."[16] The hair is
twisted into flame-like points.

Gilchrist saw a personification of sunrise, Wright the exhilara-
tion of youth aglow—making nothing of the lines Blake engraved
under the picture some time in 1800 or later:[17]

Albion rose from where he labourd at the Mill with Slaves
Giving himself for the Nations he danc'd the dance of
 Eternal Death. (E660/K160)

The symbolism of this inscription derives from Blake's paraphrase
of the Declaration of Independence in *America,* though it is a later
symbolism than that of *America,* for Albion is here more than a
place name: he is "Albion the ancient Man" of *The Four Zoas,*
that is, the eternal Englishman or, more broadly, the people. Blake
is saying that in 1780 the people of England rose up in a demon-
stration of independence, dancing the dance of insurrection (apoc-
alyptic self-sacrifice) to save the Nations (Blake's term in *America*
for the Colonies). Albion's facial expression must be read as that of
one offering himself a living sacrifice.

[15] Wright, 1, 8. One might note *A.* pl. 10; *E.* pl. 18. "That Blake,
who detested the government, ever regretted the experience is unlikely."
Wright's neglected volumes are full of these undigested apperçus.

[16] *V.L.J.*76: E546/K607. This is Blake's later language, but he could have
formed the concept in 1780. A handbill called *The Scourge,* quoted
in Holcroft's *Narrative of the Late Riots,* London, 1780, urges "the necessity
of . . . persevering and being united as One Man, against the infernal
designs of the Ministry." —I cite this not as a source but as evidence
of currency of the idea.

[17] See my note, "The Dating of William Blake's Engravings," *Philological
Quarterly,* xxxi (1952), 337–343, and *Blake Newsletter,* June 1969. On E804
I wavered to an earlier date, from a hasty dating of the script and forgetting
the lateness of the "Albion" symbol.

Albion's dance comes from, and serves as a characteristic Blakean reversal of, the following passage in Burke's 1796 *Letter to a Noble Lord*. Recollecting "the portentous crisis from 1780 to 1782" precipitated by the Gordon riots, Burke shudders at the thought of how close England came to revolution at a time when "wild and savage insurrection quitted the woods and prowled about our streets in the name of Reform." Had the horrid "comet of the Rights of Man . . . crossed upon us in that internal state of England," or had the changes called for by the Reformers "taken place, not France, but England would have had the honor of leading up the death-dance of democratic revolution." We begin to see the kind of London Blake's ideas developed in.[18]

2

Blake's testimony in 1800 as to his intellectual life preceding the American War is brief but suggestive. "Now my lot in the Heavens is this, Milton lov'd me in childhood & shew'd me his face. Ezra came with Isaiah the Prophet, but Shakespeare in riper years gave me his hand; Paracelsus & Behmen appear'd to me, terrors appear'd in the Heavens above And in Hell beneath, & a mighty & awful change threatened the Earth. The American War began. All its dark horrors . . . ," and so on. The change was mighty and perhaps sudden but not unexpected. In the Heavens it was presaged by Paracelsus & Boehme.[19] One gathers that Blake's reading in

[18] Even *Albion rose* can be seen in Establishment terms, however; Anthony Blunt, who reads Blake's *Nelson* painting as not ironic, suggests that the 1780 drawing "probably" illustrates *King Edward the Third* iii.1–5, ". . . the bright morn Smiles on our army. . . ." (Blunt, p. 5, n. 13.)

[19] The dates of publication of *The Works of Jacob Behmen the Teutonic Theosopher,* London, 1764–1781, do overlap the beginning of the American War (vols. 1 & 11, 1764; vol. 111, 1772; vol. 1v, 1781). Blake was evidently attracted by the striking symbolic "figures" designed by Dionysius Freher but first engraved for this edition. Blake told Crabb Robinson that "Michael Angelo could not have surpassed them" (Symons, p. 290). Unsigned, but in the general style of line engraving practised by Basire, they are sufficiently complicated to have been talked of in the trade—e.g. the plate of ten layers which unfold from the zodiac, to man in Eden, to the Logos.

Possible evidence of an interest in theosophical writings is the fact that in 1779 the name "Mr. William Blake" (if our Blake's then suitably

these murky seers corresponded to a growing awareness of social conflict "in Hell beneath" (for his language in this letter is adapted to the views of a "dear friend" who wished to purge him of his Jacobinism). The large place assigned by Boehme to evil in the cosmos as necessary to the manifestation of God's goodness; the emphasis of Paracelsus on reversal and change, on the interaction of the opposites forming the alchemical unity of generation: Blake would not incorporate these things into his own world-view until much later, but even now they must have lent a larger and at times fearful significance to his formal studies of "the exact rules of proportion" and the "Most Exact grounds and Rules of SYM-METRY."[20]

So, too, the mounting tension between peaceful citizens and a tyrant king must have entered his awareness with considerable force even before the war, for his response to its outbreak assumes at once the language of extreme contrasts, as we shall see. In *America*, a fully organized account written in the light of the French Revolution, Blake anticipates the modern historian in the belief that the American Revolution took place in the minds of men in the decades preceding the war.[21] He may not have recognized what was happening at the time, but it will repay us to consider what evidences of threatened change must have appeared on at least the fringes of Blake's consciousness as he entered the "riper years" of his teens. Further on we will have to examine more closely the

humble beside "William Sharp, Esq.," "Jacob Bryant, Esq.," et al.), appears in a list of subscribers to *Discourses on Various Subjects* by Jacob Duché, a preacher who had come to London from Philadelphia in 1777 (having lost hope in the patriot cause), who had long been interested in "the mysticism of Jacob Behmen and William Law" (as may appear in the *Discourses*), and who was to become "interested in the visions of Swedenborg" in the early '80s. Sharp, who engraved the frontispieces and "also apparently took care of the publishing details" (*B. Bibliog.*, p. 305), moved on to Swedenborg. So did Blake, but perhaps not until 1787 or 1788; see below.

[20] Here and in the next paragraph I quote from the title pages of two drawing-school texts we may suppose Blake to have used: Alexander Browne's *Whole Art of Drawing*, 1660, and his frequently reprinted *Ars Pictoria*, 1675. For Blake's copying of figures from the latter see Collins Baker, *Huntington Library Quarterly*, IV (1940–1941), 359 ff.

[21] See analysis below of the Preludium of *America;* cf. Arthur Schlesinger, *New Viewpoints in American History*, New York, 1922, p. 162.

questions that occupied his mind as an "Ingenious Practitioner in the Art of Symmetry."

The American War climaxed a decade during which the trades-men and householders of London, such as Blake's father, a hosier, and Blake's master, an engraver—though we have no knowledge of their sentiments in particular—had become more than usually aroused in defense of their chartered rights and had exercised their voting strength to control local institutions and elect "Wilkites" to Parliament through the exceptionally democratic franchise sys-tems of the cities of London and Westminster and the county of Middlesex. From Blake's tenth to his twenty-second year this Lon-don area was the central rallying-ground, outside the American colonies, of resistance to the court. George III, who had come to the throne in 1760, liked to call himself "the sovereign of a free people," but he had moved steadily toward personal rule, and his apparent ambition to crush the spirit of independence wherever it might appear caused grave alarm. Two revolutions had taught kings of England to respect the people, and George III did not at-tempt to ignore their Parliamentary representatives. He simply bought them. Taking over the Whig machinery of bribery and electoral manipulation, he effectually disintegrated the Whigs and surrounded himself with "friends." During this process an odious general warrant was issued in 1763 to destroy the gadfly opposition of John Wilkes's editorials in the *North Briton*. The dragnet ap-plication of the warrant wounded the dignity of some forty-eight compositors and printers and other shopmen, and when Wilkes declared that his resistance to the court was testing the liberty of "all the middling and inferior set of people," London agreed and its juries demanded stiff fines of the law officers who had conducted the arrests. As for Wilkes himself, "accident made him a patriot," as he said. And while there lingers some doubt as to how thorough a patriot she made him, the fact is that in the following years "Wilkes and Liberty" came to mean civic and Parliamentary reform, freedom of the press, freedom from the press gangs, a larger loaf, and solidarity with the "Liberty Boys" of Boston and Philadelphia. The shopmen of London chose John Wilkes for sheriff and alder-man and mayor, and he checked abuses in law-court, meat-market, and debtors' prison. When they elected him to Parliament, in 1768, they shut up shop and took over the streets for two days, a genial and triumphant crowd, covering the city with liberty em-

blems. Benjamin Franklin, a witness of this demonstration, opined that if the King had had a bad character and Wilkes a good one, George would have been dethroned.[22]

There had been similar rejoicing in 1766 when the American Stamp Act had been repealed—bells ringing from dawn to midnight, flags flying from every ship in the Thames, candles in every window. Both rejoicings misgauged the royal stubbornness. George in turn misgauged that of his subjects and proceeded with further steps to school them in obedience. The new member of Parliament for Middlesex went to jail, and when crowds assembled in protest, fighting broke out and royal troops fired among the people, slaying seven. "His Majesty highly approves," an officer announced, and angry murmurs spread. Word went round that this "Massacre of St. George's Fields" had been premeditated. Again and again the voters named Wilkes their representative but were overruled with doubtful constitutionality by the King's majority in the House of Commons. As the conflict between King and City deepened it also widened, and Patriots began to organize in other English towns and in the colonies across the Atlantic. "The fate of Wilkes and America must stand or fall together," wrote an ardent correspondent from Boston.

Then in Blake's twelfth year came the "Boston Massacre" of 1770, in which three citizens were slain by royal musketmen. In London the Patriot press carried graphic illustrations of the fatal scene,[23] and both cities grew increasingly defiant of royal tyranny. Lord Mayor Beckford momentously *replied*, politely but audibly, to the King's rejection of a City petition. In the following year a Wilkite mayor countered royal efforts to increase the standing army with press-gang methods by prosecuting officers of the crown for using press-warrants in the city. Among the throngs who cried "Wilkes and Liberty" some were beginning to add "and no King." In the fall of 1774 Wilkes and twelve patriot "Apostles" were

[22] For many of the details on Wilkes and Wilkism I am indebted to Postgate, *That Devil Wilkes,* and Dora Mae Clark, *British Opinion and the American Revolution,* New Haven, 1930.

[23] See engraving in *Freeholder's Magazine* for May 1770. Three 1770 London issues of Paul Revere's engraving *The Fruits of Arbitrary Power: or The Bloody Massacre* are recorded in W. L. Andrews, *An Essay on the Portraiture of the American Revolutionary War,* New York, 1896. Couplets and Bible verses appended to some copies strike a note similar to that of Blake's John and Edward Prologues (see below).

elected to Parliament on a platform of electoral reform and NO
WAR! Popular celebration exceeded previous street demonstrations
and no officials risked firing upon the crowd this time. When open
war did come it was commonly referred to in London as "the civil
war," with the implication that geography did not make the cause
remote. Commenting on the King's address to Parliament in Febru-
ary 1775, Wilkes exclaimed: "It draws the sword unjustly against
America!"

When news of Lexington and Concord reached London late in
May, it was the patriot version, signed by Arthur Lee, that first
filled the papers: that Major Pitcairne had fired the first shot to
force unwilling English troops to shed fraternal blood. The
Gazette urged the public to suspend belief, and an official version
was circulated that rebel Sons of Liberty had fired first, from
behind a wall. But it was the English shot that was heard round
the world; Blake would never forget that it was "Satan" who
"first the black bow bent" (*J*.52:17). Affidavits were sent from
America and circulated widely to support the patriot account;
George Washington's covering letter with one set of these expressed
a sentiment common on both sides of the Atlantic:

"Unhappy it is . . . to reflect that a Brother's Sword has been
sheathed in a Brother's breast, and that the once happy and
peaceful plains of America are either to be drenched with blood or
Inhabited by Slaves. Sad alternative. But can a virtuous Man
hesitate in his Choice?"[24]

Indignant pamphlets on the bookstalls used the same high rhet-
oric, frequently drawing upon the strongest phrases from the Old
Testament and Shakespeare.[25] Blake wielded the current idiom in
his own way when he composed the following indictment of an
English king for launching an unjust war in the name of justice.
No London patriot could have missed its modern ring even though
Blake designed it ostensibly as a "Prologue" for an unwritten play
about civil war in the days of King John:

"Justice hath heaved a sword to plunge in Albion's breast; for
Albion's sins are crimson dy'd, and the red scourge follows her

24 Washington to G. W. Fairfax in London, May 31, 1775.
25 See for example *A Second Appeal to the Justice and Interests of the
People on the measures respecting America*, London, 1775, p. 51.

desolate sons! Then Patriot rose; full oft did Patriot rise, when Tyranny hath stain'd fair Albion's breast with her own children's gore. . . . The stars of heaven tremble: the roaring voice of war, the trumpet, calls to battle! Brother in brother's blood must bathe, rivers of death! O land, most hapless! O beauteous island, how forsaken! . . . The aged senators their ancient swords assume![26] The trembling sinews of old age must work the work of death against their progeny; for Tyranny hath stretch'd his purple arm, and 'blood,' he cries;—Beware, O Proud! thou shalt be humbled; . . . O yet may Albion smile again, and stretch her peaceful arms . . . !" (E430/K11).

Blake wrote this and several other *Poetical Sketches* in the same vein, justifying the insurrection of Patriots against Tyranny and warning certain unnamed "Kings and Nobles of the Land" to look out for the wrath of God and the people. Though addressed to conflicts of the past, the words throb with living emotion and the poet breaks in time and again to exhort a royal audience—as if he were writing an open letter to King George—and to pray for sufficient eloquence to "dispel Envy and Hate, that thirst for human gore" (*Imitation of Spenser*).

The speaker of the *Prologue to King John* can seldom pull himself away from the present tense. The speaker of the *Prologue, intended for a dramatic piece of King Edward the Fourth* is almost unhinged with prophetic wrath against the "Kings and Nobles" who have caused a sinful war and must "answer at the throne of God." His desire for prophetic power is explicit:

> O for a voice like thunder, and a tongue
> To drown the throat of war!

Gwin, King of Norway opens directly with a call to "Kings" to "listen to my song," and the message is a bloody one, full of intense sympathy for husbandman and merchant, shepherd and workman who must take up arms to resist Gwin's "cruel sceptre" (E409/K11).

Blake's later account, in *America,* tells the same story of popular opposition. Tyranny having consulted his Privy Council or "call'd the stars round his feet," "George the third" calls upon "his Lords &

[26] On February 2, 1775, the House of Commons voted an Address to the King promising support with their own lives and fortunes against America.

Commons" to vote for war. When Parliament does so (in the session of 1774–1775) "its shining pillars split in twain," signalizing not simply the divided vote but the fact that Parliament has abrogated its function as a representative body. The pillars split and the roofs crack because "the valley mov'd beneath." Here "valley" signifies "the people": they have moved in one direction while their "dismal" representatives have moved in another. Blake dwells on the ominous silence of the people out of doors in response to the official drum-beating and flag-waving. "Arm'd clouds arise terrific round the northern drum" in pursuance of the vote for an army increase, but "the world is silent at the flapping of the folding banners." The whole valley of the Thames is darkened by "clouds of smoke from the Atlantic" betokening the increase of "American" patriotism in England. According to Blake the Colonies also refused "the loud alarm" until the King sent over his "punishing Demons."[27]

How immediate Blake's response was we do not know; the *Poetical Sketches* were not printed until 1783, the year of the peace treaties, and we know only that some were written before and some during the war. We should hardly expect a chronological order in the lyrics and fragments of blank verse and cadenced prose that fill the volume, for they seem to be loosely arranged according to these respective types; nevertheless the sequence from laughing songs, one of which we are told was "written before the age of fourteen,"[28] to grim prophecies, such as the *Prologue to King John*, is as marked as the change from peace to war during the time Blake was writing; and manifestly the anti-war pieces reflect the launching

[27] *A*.b and 10:4: E57, 54/K204, 200. "Valley" as a symbol for "people" is found earlier, in *F.R.*: "the voice of the people arising from valley and hill," "the voice of vallies, the voice of meek cities," "the valleys of France shall cry to the soldier, 'Throw down thy sword and musket. . . .'"

For evidence that in 1776 various reformers were considering a plan to replace Parliament with a national Association representing all Englishmen, see H. Butterfield, *George III, Lord North and the People, 1779–80*, London, 1949, p. 263.

[28] From the testimony of Benjamin Heath Malkin in 1806 and the anonymous Advertisement in *Poetical Sketches* we may date the poems between 1770 and 1779, when Blake's apprenticeship ended in August. The prose sketches at the end may be of relatively early composition; the opening group of season songs may have been prepared late, as an archway into the collection.

and first years of the war rather than the patriots' victories that ended it.

The progression of the volume is then a kind of weather chart of Blake's ripening years. Most of the first sixteen poems are idyls of the untroubled life; their author loves to "strike the silver wire" or sound his "fresh pipe" in songs of mirth and peace: "I love the jocund dance, The softly breathing song . . . the laughing vale . . . the pleasant cot . . . our neighbours all, [and] Kitty." Sorrow, even in the Gothic ballad *Fair Elenor,* is personal and romantic; the only tyrant exhorted is Winter. Nearly all the remaining sketches, from *Gwin* to *Samson,* depict or reflect a state of war and deal with the tyrants that oppress nations. Possibly some of the more pensive selections were written before the war: *Contemplation, Blind-Man's Buff,* and *An Imitation of Spenser* touch on bloodshed and misery but without the social urgency of the prologues or *Samson.* Two others must be put aside for the moment as enigmas: the fragmentary drama, *King Edward the Third,* and *A War Song to Englishmen.* The rest express an intense, even propagandistic abhorrence of war-making kings. These sketches, indeed, corroborate Blake's later assertion that he responded to the "dark horrors" of the war with "nervous fear." According to *King Edward the Fourth* "the senses are shaken, and the soul is driven to madness" at contemplation of the fury and slaughter unleashed by kings and nobles. According to *King John* "each heart does tremble, and each knee grows slack" at the prospect of civil war. And in *Samson,* a prose poem full of bitter words against the oppression and slaughter of nations, the poet prays to the white-robed Angel of Truth to "guide my timorous hand to write as on a lofty rock with iron pens the words of truth, that all who pass may read."

The contrast between iron pens and timorous hand is to be noted, for it epitomizes the conflict between bardic duty and personal caution that will emerge later as an important symptom of Blake's frustration as a prophet without an audience. The *Poetical Sketches* were never published except among friends, perhaps as an early result of the nervous fear that often inhibited Blake's utterance. In the *Sketches* the prophet speaks plainly enough for "all who pass" and can well have expected—and even feared[29]—that

[29] Wilkes's associate John Horne (later Horne Tooke) was charged with seditious libel for uttering what all the papers had published—the American version of the killings at Lexington and Concord. Howell's *State Trials,* xx, 723.

his contemporaries would grasp the historical parallels. It is instructive to note that on at least one later occasion he did quietly call attention to the prophetic timeliness of the *Prologue for Edward the Fourth*.[30]

Surely Gilchrist was right when he said that Blake was "a fervent propagandist" of the idea of "the supreme despicableness of war . . . in days when war was tyrannously in the ascendant" (p. 47), but he was speaking only of Blake's two paintings exhibited in the spring of 1784. The poems he dismissed as "a boy's poems."[31] And he did not notice that the paintings recorded not only the war's end, *A Breach in a City the Morning after the Battle,* but its beginning: *War unchained by an Angel—Fire, Pestilence, and Famine following.*

[30] In one variant of his engraved print *Our End is Come,* 1793, denouncing in effect the King and Ministers then attacking France, Blake used for a caption a line and a half from this earlier denunciation of the King and Nobles attacking America, with page reference to the *Sketches* for anyone who possessed a copy. See below, Plate IV. For the variant captions, see E660.

[31] Many readers have recognized the anti-war sentiment of some of the *Sketches* but have found jingoism in some and thought it to be Blake's. Bronowski is unique in asserting that Blake "always held" a strong feeling against war "in the whole context made by the American war and the England of his time" (p. 32 [58]), and Bronowski is the only critic who calls attention to the Wilkite radicalism of Blake's England; but he says nothing at all about any of the *Sketches* except *Gwin.*

2. The Fierce Americans

"Pull down the tyrant to the dust,
 "Let Gwin be humblèd,"
They cry; "and let ten thousand lives
 "Pay for the tyrant's head."

AMONG the *Poetical Sketches* the ballad *Gwin, King of Norway*, addressed in a precautionary plural to "Kings" who are to "listen to my song," is of considerable interest as Blake's earliest and plainest account of a revolution and as evidence of how far he entered imaginatively into the drama of civil conflict. The geography is sufficiently obscure so that the "nations of the North" oppressed by King Gwin may easily be compared to the nations of North America oppressed by King George.[1] Their economic plight is represented as driving them to desperation; the Nobles feed upon the hungry Poor:

> The land is desolate; our wives
> And children cry for bread;
> Arise, and pull the tyrant down;
> Let Gwin be humblèd.

The people's cry rouses the sleeping giant Gordred, a kind of unchained Prometheus, whose shaking of the hills immediately produces a "num'rous" armed multitude, rushing along under "troubl'd banners." Wives and children follow, "weeping loud," yet willing to sacrifice ten thousand lives for "the tyrant's head." That would not be an unusual price, according to the history books. The Scots who resisted Edward III at Halidon Hill, for example, were said to have lost 30,000 in the process of slaying only fifteen of the King's men. But kings who listen to Blake's song are to understand

[1] In imagery and phrasing Blake's *Gwin* (E409–412/K11–14) owes something to Chatterton's *Godred Crovan*, ballad of a Norse tyrant's invasion of the Isle of Man. See Lowery, ch. vii. But there is no popular uprising in Chatterton, while in Blake the king is not the invader but the oppressor of certain "nations" which he rules.

that an armed and roused populace are not deterred by long odds: the women and children become "furious as wolves," the men "Like lions' whelps, roaring abroad, Seeking their nightly food."

Led by their giant champion the nations roll up to the palace. Gwin is not directly said to tremble (as "the King of England looking westward trembles" at a similar vision in *America*). But "his palace shakes," his chiefs "stand around the King" like "reared stones around a grave," and seize their spears. The consistency of Blake's view of history is indicated in his use of this same scene for similar moments in *The French Revolution* and *Our End is Come* (Plate IV).

The people's army is made up of minutemen: the husbandman from the plow, the merchant from "the trading shore," the workman exchanging his hammer for "the bloody bill." In a similar passage in *Samson* (E436/K40) "the shepherd bears a sword; the ox goad is turned into a spear! O when shall our Deliverer come?" In *Gwin* the rising up of the oppressed behind the "troubled banners" of their Deliverer "Gordred the giant" parallels the hope that some American champion would prove the Samson of the New World. After a brief declaration of war by King Gwin and a declaration of insurrection by Gordred, who is a kind of George Washington and Tom Paine in one, the "raging armies" rush at each other to produce a sea of blood, hills of slain, "famine and death," and "cries of women and of babes" surpassing any horrors to be found in Chatterton or Macpherson. The King, nevertheless, is kept in the limelight so that all the actual slaying seems to be done by him: "beneath his arm like sheep they die." And the prophet cries out:

> O what have Kings to answer for
> Before that awful throne!

Ghosts of the thousands Gwin has slain "glut the throat of hell" and groan "for vengeance."[2]

The revolutionary act of justice that follows is relatively surgical. The giant Deliverer severs the King's head with "the first blow." The tyrant's remaining armies flee the land. The poet's message to kings is unmistakable.

[2] For a comparably violent analogue see *The Closet*, a satiric print of Jan. 28, 1778, which charges the King and his ministers with tyranny and with responsibility for savage atrocities in America. *B.M. Satires*, no. 5470.

2

Gwin as a prophecy promises the destruction of both the king and his armies. The fact that King George survived the conflict moved Blake in 1793 to write a full account of it in *America, A Prophecy*[3] to point to the spiritual continuity of the American and French Revolutions and to suggest that the ruin of kings was coming ever closer to the home of tyrant George. *America* is colored by that purpose and by the maturing of Blake's thought in the light of historical developments. Yet despite a luxuriant elaboration of symbolism, to which we must attend later on, *America,* like *Gwin,* tells essentially the story of a simple struggle between rulers and "oppressed." A comparison of the two will demonstrate how largely *Gwin* is an imaginative interpretation of the American Revolution, will illustrate the continuity and development of Blake's revolutionary sympathies, and will serve to give proper emphasis to the central importance in his life and works of the events of the 1770's.

The story in *America* (E51/K197) opens with tyrant and patriots facing each other across the Atlantic on the world stage:

The Guardian Prince of Albion burns in his nightly tent,
Sullen fires across the Atlantic glow to America's shore:
Piercing the souls of warlike men, who rise in silent night.

As in *Gwin,* responsibility for open war is put squarely upon the King, whose ambition is indicated by the "sullen fires"—an echo perhaps of Paine's epithet in *Common Sense:* "the sullen-tempered Pharaoh of England." As desperation forces the oppressed in *Gwin* to become "sons of blood," in *America* the threat of "blood from Albions fiery Prince" pierces the souls of "Washington, Franklin, Paine & Warren, Gates, Hancock & Green," forcing them to rise and meet as "warlike men."

Washington points to the threat of war ("a bended bow") and to the shackling legislation from England intended to turn the people of the Colonies into the whip-driven slaves of a modern Pharaoh.

[3] "1793" is the date on the title page, but *America* had undergone considerable revision—as witness the surviving plates of an earlier draft—and may have been several years in preparation.

. . . Friends of America[!] look . . . a heavy iron chain
Descends link by link from Albions cliffs across the sea to bind
Brothers & sons of America, till our faces pale and yellow;
Heads deprest, voices weak, eyes downcast, hands work-bruis'd,
Feet bleeding on the sultry sands, and the furrows of the whip
Descend to generations that in future times forget.

$$(A.3:6-12)$$

Blake derives this speech (unlike anything the silent general ever uttered) from a poetic fiction by Joel Barlow in which Washington addresses the patriot armies as he assumes command near the smoldering ruins of Charlestown after the battle of Bunker Hill;[4] but Blake includes Warren, who died in that battle, among the warlike men with Washington and seems to fuse this scene into Barlow's picture of the first patriot Congress a year earlier. Thus the war has begun spiritually but not yet corporeally.[5]

Hearing Washington's "strong voice" from America, the wrathful Prince of Albion assumes "a dragon form" (pictured on plate 4: see Fig. 1) and clashes his scales. At this point an early draft of

Fig. 1

4 Max Gartenberg has called my attention to Blake's use of Barlow's *Vision of Columbus: A Poem in Nine Books,* Hartford and London, 1787. In Book V, while "banner'd hosts around him roll," Washington calls on patriot chiefs and daring bands to resist the invaders lest "following millions" as the "endless years descend" be forced to "Bend the weak knee, in servile chains consign'd, And sloth and slavery overwhelm mankind." See my note, "William Blake's Debt to Joel Barlow," *American Literature,* XXVI (1954), 94-98.

Washington's speech in *America* may also owe something to Washington's letter of 1775 quoted above.

5 Blake's transformation of the narrative symmetry of chronology into scenic or thematic symmetry is a subject outside the scope of the present volume. The present purpose is to extract and bring into focus the imbedded narrative matter.

the poem shifts to the meeting of Parliament which split in voting for war—a passage we have already discussed. The "Prince of Albion" (Barlow's term) undergoes a Hyde-Jekyll transformation, dropping his scales, glowing eyes, and other features that "Reveal the dragon thro' the human" before entering the House as "George the third."[6] Meanwhile (to return to the final version of the poem) a tremendous event is taking place in America. The theory of freedom is emerging into practice. With vast birth pangs a new "Wonder" arises, naked, gigantic, and "Intense!" Surrounded by "cloudy terrors" and dark banners similar to the "troubl'd banners" around Gordred—a similarity that reveals the continuity of Blake's visions—this new spirit of revolution is "a Human fire fierce glowing."

The physically gigantic Deliverer has grown into the gigantic moral power of the glowing spirit of humanity. Yet this spirit supplies "heat but not light" to the "fierce Americans" (A.4:11; 15:12) and appears to the trembling "King of England" as a "Spectre . . . horrid" who proceeds to recite the Declaration of Independence in the form of a sequence of images or what Blake will come to call "Visionary forms dramatic" (J.98). Such language is proper to emancipated humanity, but its beauty is wasted on the jaundiced King.

It is important for us to recognize this passage (*America,* plate 6) as Blake's poetic paraphrase of the Declaration of Independence because he frequently alludes to it by repeating one or two of its central images, as we have seen him do in the engraved inscription

[6] In the final draft King George is not named. His "dragon form," especially as pictured (Fig. 1), suggests the grinning dragons on the banners of the Men of Kent and other British regiments, from which the name Dragoon Guards is derived. See below, p. 74, n. 35.

Patrick J. Callahan has found a likely (but more bulldoggish) dragon, confronting a segmented serpent ("JOIN OR DIE") across the top of a Colonial newspaper.

Kathleen Raine calls attention to a "dragon of the moon" in Agrippa (not very like) and an "emblem of matter" in Thomas Vaughan's *Lumen de Lumine* (1651) which does resemble Blake's dragon in head, wings, scales, and arrow-pointed tail (though *not,* as she carelessly says, in "paws"—for Vaughan's are vulture's claws and Blake's human hands). Attending more to alchemical symbols than to Blake's, she gets Urizen and Orc mixed but does ask the useful question whether this dragon is a basilisk. (*Blake and Tradition,* Princeton, 1969, I, 115, 117, figs. 50, 52, 53.) The fitting and Blakean irony is that the dragon form of the King is that of a basilisk or king-killer; his assumption of it symbolizes his own destruction.

to *Albion rose*. The page is illuminated with a picture of a naked young (resurrected) man sitting on the grave of his dead past and gazing confidently into the heavens. The passage is too long to quote in full, but Blake's method can be indicated if we place his nuclear images beside the corresponding phrases of the Declaration. That document holds that all men are endowed with "certain inalienable rights," including:

life—"The morning comes . . . The grave is burst."
liberty—"Let the slave grinding at the mill run out into the field"; "Let the inchained soul . . . look out"; "let his wife and children return from the opressors scourge."
and the pursuit of happiness—"Let him look up into the heavens & laugh . . . Whose face has never seen a smile in thirty weary years"; the reunited family "look behind at every step & believe it is a dream. Singing. The Sun has left his blackness, & has found a fresher morning."
. . . it is their right, it is their duty, to throw off such Government. . . . having in direct object the establishment of an absolute Tyranny—"For Empire is no more, and now the Lion & Wolf shall cease."

The King, burning "wrathful," replies with what today would be called "red-baiting":

. . . Art thou not Orc . . . serpent-form'd . . .
Blasphemous Demon, Antichrist, hater of Dignities;
Lover of wild rebellion, and transgresser of Gods Law;
Why dost thou come to Angels eyes in this terrific form?
(*A*.7:3–7)

—an outburst that seems based on the royal proclamation of August 23, 1775, denouncing "Rebellion . . . Treasons and Traitorous Conspiracies . . . against Us, Our Crown and Dignity."

Only after another declaration by the fierce-glowing Spirit of Rebellion, who accepts the name Orc,[7] and further blowing of the

[7] ". . . the word *orca* . . . is applied to any monster or creature of the imagination [and] occurs in Milton," we are told in Hoole's *Orlando Furioso*, 1783, for which Blake made an engraving. Noted by Palmer Brown.

Orc is a common name for a whale, either the grampus or the killer, and the name suggests Orcus, Hell's inexorable reaper (of kings). Blake makes a classical allusion in *Tiriel* iv.76 to "vacant Orcus," and it is notable that Carlyle refers to the September 1792 slaying of royalist suspects as a bursting

war trumpet by Albion's Prince or Angel, does the Angel of Boston finally throw off allegiance to monarchy (robe and scepter), setting an example which the other twelve Angels follow.[8] The action moves across Blake's stage on several levels and transcends chronology, so that this exchange of challenges seems to precede the mustering of British troops; yet the first scene is filled with the smoke of British naval bombardment even though the command to fire is not heard till plate 14.[8a] Blake is experimenting with the process of dramatic rearrangement of detail begun in his major source, Barlow's epic *Vision of Columbus* (1787), in which all the bombardments and burnings of colonial towns throughout the war are portrayed as a simultaneous action preceding the battle of Bunker Hill. Blake distributes the lurid images of Barlow's vision of bombardment through several passages of *America*.[9]

forth of "Night and Orcus . . . as was long prophesied." Orc is born in or above the Atlantic deeps, and in the Preludium he speaks of his ability to appear in many forms, "sometimes a whale . . . anon a serpent." On pl. 4 there is something like a whale (Wilkism perhaps?) lying beside the King on Albion's shore: and that is what the pictured King is looking at, although the text has him "looking westward . . . at the vision." The revolution is too close for comfort.

The Biblical Leviathan is also both whale and sea serpent, but Blake always paints him as sea serpent, "War by Sea," a separate thing from the Orc symbol. In the social body, Orc is not the heart (*cor*) as some have thought, but the genitals (ὄρχεις), as Blake makes pretty clear.

[8] *A*.11–12. If Blake is following Barlow at this point, Boston's Angel is Samuel Adams, concluding a speech in the First Congress (1774) with a thundering appeal for "INDEPENDENCE."

[8a] And even as Boston's Angel speaks, the American Angels, "indignant burning with the fires of Orc," are flying "thro' the dark night" (pl. 11)— and beneath these words a naked youth rides a soaring pen swan, suggesting a combination of Paul Revere, Adams, and Tom Paine, "the scribe of Pennsylvania" who, on pl. 14, "casts his pen upon the earth" only to use it as a weapon.

[9] Comparison to Barlow makes clear that the "Demon red, who burnt towards America" when Boston's Angel took his stand with Washington, was not Orc but one of Albion's "punishing Demons" or redcoats (or the King in his dragon form) guiding the navy which, in Barlow's synoptic vision, cast a shadow on the American shore from the St. Lawrence to Georgia, pointed black batteries to the peopled shore, and then poured "bursting flames," "stormy thunders," and "shells o'er-arching" into American ports until flames mounted "from realm to realm" in "smoky volumes" and "heavy wreaths," to kindle heaven. Compare Blake: "the Demon red . . . burnt towards America [while] in black smoke [the] thunders and loud winds rejoic[ed] in its [the Demon's] terror, Breaking in smoky wreaths

Another early page at this point describes the arming of Albion's Angel in London:

. . . silent stood the King breathing damp mists:
And on his aged limbs they clasp'd the armour of terrible gold.

(*A*.c:5–6)

The age is as figurative as the armor. George was only 37 in 1775, but tyranny was old.

Rebellion "gath'ring thick In flames as of a furnace on the land from North to South," a fire kindled by British guns but in effect a furnace of resistance, soon routs "the thirteen Governors that England sent." They rush out of Governor Bernard's house, "Shaking their mental chains," to grovel at the feet of Washington.[10] And while they lie writhing, all is not well with the King's troops. "My punishing Demons," he has complained, "cannot smite the wheat, nor quench the fatness of the earth. They cannot smite with sorrows, nor subdue the plow and spade. . . . For terrible men stand on the shores, & in their robes I see Children take shelter from the lightnings."[11] Now, giving up the conflict, all

The British soldiers thro' the thirteen states sent up a howl
Of anguish: threw their swords & muskets to the earth & ran
From their encampments. . . . (*A*.13:6–8)

Thus briefly does Blake summarize the military story, emphasizing the British surrenders (chiefly at Saratoga, 1777, and Yorktown,

from the wild deep [here is naval cannonfire] & gath'ring thick In flames as of a furnace [here are the burning towns] on the land from North to South" (*A*.12:9–12). Yet even these flames, since they terrify the British governors but not Boston and Washington, become metamorphosed into the flames of rebellion. The addition of *plague* fires (there are none in Barlow) completes the transformation: but that is matter for a later chapter. I have written a more elaborate analysis of the choreography and dynamics of *America* in "*America*: New Expanses," *Blake's Visionary Forms Dramatic,* ed. D. V. Erdman and J. E. Grant; Princeton, 1970.

[10] *A*.12:12; 13:1–5. Here Blake reaches back to the fall of Francis Bernard, who was sent to govern Massachusetts in 1760 but had to be recalled to England in 1769. His "fatal deficiency in political tact and insight undoubtedly assisted to hasten the war" (D.N.B.), and Blake has chosen his "house" as a fitting residence for all the governors who continued his fatal policy.

[11] *A*.9:3–10. Barlow's Washington sheds light here: the covetous invaders "see your fields to lordly manors turn'd, Your children butcher'd, and your villas burn'd." The "lightnings" from which Washington protects the children must be "the long lightnings" which burn from British "musquets."

1781). He then develops the political history from the Boston tea party ("mariners of Boston . . . unlade") to the collapse of royal authority in London, a matter for later discussion.

It is evident that there are important differences between *Gwin* and *America*, but none that imply any basic shift of sympathy. *Gwin*, written in anger before the victory of the rebelling "nations" was in sight, prophesies the downfall of royalty but pictures no relief for the blood-drenched and "overwhelm'd" land. *America*, written after the formation of republics in America and France, exults both in the failure of royal efforts to smite the wheat and overwhelm the people and in the solidarity of the farmers and citizens who "all rush together in the night in wrath" (*A*.14:19).

In *Gwin* the insurrectionary acts of the people are subordinated to the heroic deeds of their Deliverer, a champion in the Biblical tradition.[12] In *America* the champions are Washington, Paine, Franklin; scribe, builder, mariner—"terrible men" in the eyes of a tyrant, but not supermen. Their strength is in their united rising and in the force of the human fire that inspires them. It is notable that the British surrenders are pictured as a kind of mass desertion by the common soldiers, "seeking where to hide From . . . the visions of Orc," and that their generals are not mentioned, although in the illustrations there is a revolutionary trial of the King by warlike patriots, comparable to Gordred's beheading of Gwin.[13]

[12] Perhaps a reflection of the primitive character of Wilkism as a somewhat amorphous rallying of masses behind a champion.

[13] *A*.5, discussed below.

A poetic response to the American War that presents several analogies to Blake's is that of Thomas Day, 1748–1789. His *Ode for the New Year 1776* predicts ruin to follow from Albion's drinking "her Children's gore." Conquest claps her wings over the patriots, but justice will smite the guilty. Compare Blake's Prologues. Then in *The Devoted Legions*, March 1776, he predicts doom to the campaign against the Carolinas. In this poem he calls Britain "Rome" and uses the framework of Gray's *Bard* to prophesy the terrors that await aggressive rulers; he, as bard, will die. The scene presented in *The Desolation of America*, December 1777, is comparable to the desolation pictured in *Gwin* and *Samson*. Day's group of three Americans fleeing the invaders, an aged father, a mother, and a daughter, is like the group frequently drawn by Blake.

It is possible that Blake knew, certain that he admired, Day. Irene Tayler has noted that in 1796 Blake gave him memorial honors by inscribing "Thomas Day" on a metaphoric gravestone in the design for the fourth page of Night Nine of Edward Young's *Night Thoughts*.

In both prophecies Blake warns kings, nobles, and bishops: If you go on binding the nations, oppressing the poor, and ravaging the countryside with war, the result must be revolt. The people will overthrow war, pull down the temples of tyranny, and bring you to judgment. The means of judgment differ somewhat. In *America* the patriots themselves hold the fiery sword and the balances (plate 5) and their resistance to the code of kings is itself a judgment of kings. In the inconsistent theology of the *Poetical Sketches* there is a "god of war" who takes part in the battle and drinks blood, and the armies of Gwin and Gordred are said to be "like balances held in th' Almighty's hand." But at the same time the "stench of blood makes sick the Heav'ns," and kings will have to answer for the bloodshed "Before that awful throne." In the *Prologue for King Edward the Fourth* we are told first that the nations are driven into war by God's "frowns"—but then that kings, nobles, and ministers of God have "caused" the war and that the poet hopes for their sake that God will "hear it not." This contradiction will never be entirely resolved, but in *America* Blake sharply distinguishes the god of war, Urizen, and his Satanic Angel the Prince of Albion, from the Christ-like god, Orc, who is divine yet human and whose sword promotes peace.

Before we go on to *King Edward the Third*, the maturest of the *Sketches* and the one most intricately and surprisingly related to *America*, but also the most enigmatic, it is time to return to the valley of the Thames in the years when it was "dark with clouds of smoke from the Atlantic" (*A*.b), for we should now be ready to re-examine the supposedly cloistral isolation of Blake's apprentice years to see at how many windows the noise of London Patriotism must have entered his world.

3. Republican Art

Renew the Arts on Britains Shore . . .
And War shall sink beneath thy feet.[1]

"REPUBLICAN ART" is a phrase that flows casually from Blake's pen in the last year of his life, summarizing the aims of that life in a letter to his republican friend, the artist George Cumberland. In a broad general sense we may use the phrase to characterize the new interest in national and popular art which accompanied the widespread enthusiasm for peaceful progress just before and during the American Revolution, an interest which Wilkes himself responded to with considerable vigor, and an interest which must be reckoned as a central one in Blake's formative years. Yet our information about these years is so meager that to the important question of how soon Blake found out that "an Angel" at his birth had, as he declared in 1810, commanded him to renew the arts in an essentially republican fashion, we must reply with a chapter of inferences and associations that say more about Blake's world than about Blake himself.

Shortly before his thirteenth birthday—at the commencement of his third year of attendance at Pars's Drawing School if we may trust his own usually careful dating—Blake set out to cultivate "the two Arts, Painting & Engraving," and thereafter "during a Period of Forty Years never suspended his Labours on Copper for a single day."[2] This choice of vocation was novel but forward looking, and James Blake was doing well enough in his hosiery shop to be able to encourage his headstrong son. English painting, long neglected, had begun to come into its own, and in this same year a Royal Academy of Art was being formed. The Society for the Encouragement of Arts, Commerce, and Manufactures was offering prizes to young painters; and exhibitions of contemporary

[1] N.79: E471/K557 (ca. 1810). "War" first read "Armies."
[2] N.117: E557/K587; cf. E560. I take it that Blake refers to the autumn of 1770.

English art, a very new thing, were attracting the public. A new and rapidly expanding domestic and continental trade in engraved prints promised much to the youth who could both draw and engrave. Two years later, in August 1772, Blake began his seven-year apprenticeship to James Basire, engraver to the London Society of Antiquaries and to the new Royal Academy, and within a year he was able to etch and engrave an entire plate himself, after a fashion.[3] In 1774 he was assigned by his master to copy, for the Antiquaries, the monuments of ancient British dynasts.

Blake's association with the Antiquaries has been taken to connote something conservative and even rather desiccated in his early environment, but the Society itself was young,[4] and some of its members were exploring the sources of culture and history in the spirit of a national renaissance. They constituted the inevitable special audience for whom the scrivener's apprentice Thomas Chatterton prepared his Bristowe "antiquities," and their somewhat democratically biased interest in the relics of British history stands in a similar incubative relationship to the historical paintings and poems of the engraver's apprentice Blake.

There were, of course, dull fellows among the Antiquaries. There was Thomas Astle, for example, who read old documents not for the meanings of the words but for the shapes of the letters, who pored over pictures of the "monuments of the Etruscans" to make out "the Pelasgian language and characters,"[5] and who appears, possibly, in Blake's caricature "Etruscan Column the Antiquarian," a pedant overflowing with "an abundance of Enquiries to no purpose" and engrossed in the contemplation of "his eternal fame."[6]

[3] The *Joseph of Arimathea* "Engraved by W. Blake 1773" and until recently taken as evidence of precocious skill proves to have been crude enough in its first state. See Geoffrey Keynes, *Blake Studies*, London, 1949, pp. 45–46 and pl. 14; also my note in *Philological Quarterly*, XXXI (1952), 337–353.

[4] Incorporated 1751. There had been an earlier Society, but this was a new beginning.

Basire was also engraver to the Royal Society of London. For a list of the simple illustrations made for its *Philosophical Transactions* during Blake's apprenticeship, see William S. Doxey, *BNYPL*, LXXII (1968), 252–260.

[5] Astle, *Origin and Progress of Writing*, London, 1803 [1784], p. 230. The illustrations were engraved in Basire's shop.

[6] *I.M.*i: E440/K44. The identification of Blake's "Antiquarian" as Astle remains conjectural. George M. Harper has suggested the Rev. John Brand, a friend of Flaxman's but not otherwise associated with Blake (Harper,

A more human and visual interest in historical remains was displayed by the antiquarian Sir Joseph Ayloffe, who arranged in the summer of 1775 to have some tapestries removed in Westminster Abbey so that Blake could copy the hidden Gothic portraits of King Sebert and Henry III. Ayloffe too was full of pedantry, but his objects were sometimes sensational. In May 1774 he obtained permission to open the tomb of Edward I and remove the cerecloth and the crimson facecloth (which felt like cobwebs) to see whether the extant busts of Edward were *like*. Sir Joseph concluded that they were very like, if one assumed that the nose had shrunken from the size shown in the portraits. And while Basire's apprentice made some sketches, Ayloffe examined the body, discovered that the king's old nickname "Edward Longshanks" had had no physical basis, and ordered the coffin top and stone slab replaced.[7]

Blake's biographers have assumed that he glowed with "a reverent good faith" toward the kings and queens whose relics he copied, but it is possible that his feelings were more akin to those of the republican Shelley when he considered the "wrinkled lip, and sneer of cold command" which an antique and presumably republican sculptor had recorded in the stone effigy of Ozymandias, once king of kings.

Other Antiquaries, busy recovering neglected folksong and "antique" poetry, brought live coals of inspiration to Blake. His first and later poems owe much to the antiquarian Bishop Percy's *Reliques of Ancient English Poetry*, an anthology begun in 1765 and augmented in 1775 with express indebtedness to the rich

Neoplatonism of William Blake, Chapel Hill, 1961, p. 40). Damon (*Dictionary*, p. 130) adds details about Brand; but the antiquities he was interested in were popular superstitions, not Etruscan art. More likely to talk about Pliny, Giotto, and Etruscan remains were George Romney and P. F. H. d'Hancarville; see Robert Rosenblum, *Transformations in Late Eighteenth Century Art*, Princeton, 1967, pp. 156, 163.

[7] Ayloffe's account appears in *Archaeologia*, III, 1775. Blake's drawings and engravings of the Sebert and Henry III are extant. Two simple drawings of the mummy of Edward I remain in the Antiquaries' library. At the time, or later, Blake made for himself "two or three noble sketches" of Edward (according to Flaxman in a letter of Aug. 12, 1805). See Paul Miner, "The Apprentice of Great Queen Street," *BNYPL*, LXVII (1963), 639–642.

Apparently Blake worked mainly in Basire's shop until 1774, when two more apprentices were added and he was given the outside assignments. Symons, p. 313.

library of the Antiquary Society. In Blake's elevated conception of bardic power we can see the influence of Percy's thesis, hotly debated in the society, that Saxon minstrels and other ancient poets enjoyed tremendous political and moral eminence.[8]

A very different influence, drawing Blake toward the related but almost contradictory concept of *esoteric* cultural power, came from the antiquarian Jacob Bryant, in whose *New System or Analysis of Ancient Mythology,* published in 1774–1776 with plates engraved in Basire's shop, scholars are now finding both Blakean pictorial motifs and some clues to Blake's own system of mythology.[9] Bryant applied to Egyptian, Grecian, and other myths the fruitful principle that "there was always a covert meaning," and he could prove, for example, that Noah and Dionysius and Prometheus were one and the same patriarch. Whereas to "Etruscan Column" Chatterton's fictitious "Rowley" poems were "paltry, flimsy stuff" (*I.M.*i), Bryant could recognize their power—and "antiquity"—at once.

Blake, we know, accepted the antiquity or "eternal" worth of *both* Rowley and Chatterton—and of Macpherson's Ossianic fragments, which were another sensation among the Antiquaries. Blake would come to boast of his own writings as "poems of the highest antiquity" or true "British Antiquities"—and to draw on Bryant for hints of their "mythological and recondite meaning."[10] The idea in Blake's *America* that a portion of the infinite would have been lost if America had been "o'erwhelm'd by the Atlantic" recalls Bryant's interest in relics of the antique nations lost in the Deluge and also suggests Bryant's reading of Acts 17:26 as a text against the desire of kings to overrun other nations. One of Blake's apprentice engravings illustrates Bryant's allegorical interpretation of the flood.[11] More generally the influence of all these "Antique

[8] See Dr. Pegge's retraction of his objections to Percy's introduction, *Archaeologia,* III. For Blake's debt to Percy's *Reliques,* see Lowery, pp. 160 f.

[9] See Ruthven Todd, *Tracks in the Snow,* London, 1946, pp. 29–60, and Keynes, *Blake Studies,* pp. 42–49 and pls. 10–12. But the greater importance of Edward Davies' *Celtic Researches,* London, 1804, is noted by Frye, p. 173, and by Todd. On Davies and Blake see also Edward B. Hungerford, *Shores of Darkness,* New York, 1941. For Bryant's and possibly Blake's interest in a modern student of Boehme, see above, p. 11, n. 19.

[10] *D.C.*v, ii: E533, 522/K578, 566. Lowery, p. 235, makes the curious mistake of supposing Blake to refer to the possession of some Chatterton originals; but Blake expressly declares that *he* has written these antique poems as an inhabitant of Eden.

[11] Todd, *Tracks,* pl. 12.

Borers"[12] was to impress Blake with a sense of the rich contemporaneousness and spiritual homogeneity of the art and lore of all ages and nations. "The antiquities of every Nation under Heaven," he would argue, "are the same thing, as Jacob Bryant and all antiquaries have proved" (*D.C.*v).

Finally there was the directly republican antiquarianism of Thomas Hollis, "a gentleman of ample fortune and . . . virtuous morals" who chaired the exhibition committee of the Society of Arts and was, according to Walpole, "the most bigoted of all republicans to a degree of being unwilling to converse with men of other principles."[13] Hollis was a collector of portraits and records of Milton and of "liberty-coins" and other relics of resistance to tyranny. He edited a number of American pamphlets, corresponded frequently with "the colonists, those faithful friends to liberty," and as early as 1765 sympathized with American dreams of independence. He looked upon Wilkes, in spite of "irregularities" which he dismissed "as spots in the sun," as the champion of true Britons—"a great, and yet free, though a sunken, falling people" if their weak king and his knavish advisor were allowed to pursue the path of ruin.[14]

Hollis died in 1774, and during the next six years his *Memoirs*, full of Milton portraits engraved by Cipriani and copies of coins and documents engraved by Basire's apprentices, were prepared for the press by a committee of Antiquaries. Blake must have seen some of these materials and heard a good deal about Hollis; he is said to have engraved some of the plates in the *Memoirs*. Hollis idolized Milton as the "assertor of British liberty." "Milton lov'd me in childhood & shew'd me his face," said Blake, whose sympathies, a friend recalled, were "not with Milton as to his puritanism" but as to his "love of a grand, ideal scheme of republicanism."[15] Once Crabb Robinson asked the man who had seen Milton's face "which of the three or four portraits in Hollis' *Memoirs* is the most like. He answered, 'They are all like, at different ages. I have seen him as a youth and as an old man with a long flowing

[12] To Cumberland, Dec. 6, 1795—possibly a punning allusion to old-fashioned *engravers*.

[13] Whitley, *Artists*, II, 117–119.

[14] [Francis Blackburne and others], *Memoirs of Thomas Hollis*, London, 1780, I, 110, 275, 289.

[15] *ibid.*, I, 112; Blake to Flaxman, 1800; Gilchrist, p. 327, quoting Blake's friend John Linnell apparently.

beard.' "[16] We are not told which face Milton showed to Blake in childhood, but we may be sure that the Milton he encountered in the vortex of Thomas Hollis was Milton the republican, anticipator of Wilkes and Liberty.

In that vortex were the cousins John and Timothy Hollis and a Fellow of the Society whose activities were more republican than antiquarian—Thomas Brand, an early sponsor of Basire,[17] who became Thomas Brand Hollis on inheriting the Hollis estate. He was an associate of Tooke, an admirer of Paine, and an organizer of London reform societies. In the '80s and '90s we find several of Blake's friends in close association with all the Hollises.[18]

Closer socially at least to the apprentice Blake were his fellow craftsmen, but their lives and thoughts are even more lost in obscurity than Blake's. Inevitably he became more or less intimate with various painters, engravers, and patrons of the arts "from their Intimacy with Basire, my Master." Years later he could recall the names and styles of famous and obscure engravers and remember which journeyman had etched this or that plate for a master who cunningly reaped the glory and the profits. He had grown to hate or at least to rant against the "Ignorant Journeymen" who were employed in preference to himself; he appears from the first to have despised the "Trading Dealers" who exploited them (P.A.51). Anonymous apprentice work was a different matter, and Blake never seems to have rebelled against Basire, though he refused "to take part with his master against fellow apprentices" who did.[19] Presumably the etchers and engravers who, like Blake, never attained the status of wealthy masters, and even some of the latter, constituted one element in the artisan radicalism of London. But we know little about these men, and our list of the engravers known to Blake is limited chiefly to the few he disliked.

We do know that the engraver William Sharp was, in the 1790's, a leading member of the London Society for Constitutional

[16] Symons, p. 295. (Symons' *Blake* contains a handy compilation of the early notices of Blake by B. H. Malkin, H. C. Robinson, J. T. Smith, and others.)

[17] Basire as a student in Rome had copied Raphael pictures under the eyes of Stuart, Reynolds, and Brand, who appear to have promoted his appointment as engraver to the Society of Antiquaries around 1760. See J. Nichols, *Literary Anecdotes,* London, 1815, III, 717.

[18] See n. 31 below.

[19] Symons, p. 313.

Information, a Reform club which links Wilkism with later English Jacobinism. And we know that in 1780, when that society was first formed, Sharp painted and engraved a political picture of George Washington with liberty cap and don't-tread-on-me rattlesnake. By 1787 Sharp had joined the Society of London Swedenborgians, with whom Blake also associated for a while in 1789;[20] and Sharp and Blake were fairly intimate later when Sharp had turned again from fading hopes of reform to the radical or at least plebeian mysticism of Richard Brothers and Joanna Southcott, though Sharp was unable "to make a convert of Blake" to the cause of Joanna. They may frequently have walked the same path; yet we have little to link their names in the 'eighties except such facts as that Sharp was one of the chief engravers of the work of Mortimer, intensely admired by Blake, that Sharp was a friend of Blake's friend Flaxman, and that Sharp and Blake in 1780–1786 both engraved many pictures after Thomas Stothard, with whom we know Blake was intimate. Stothard evidently shared Sharp's interest in Reform, for in 1782 he designed and Sharp engraved "an enormous plate" which could hardly have escaped Blake's notice, "thickly strewn with inscriptions, emblems, etc., sets for 'The Declaration of Rights,'" inscribed: "To the Society for Constitutional Information."[21] And one summer while England was at war with France (1779–1782) a curious mistake linked Stothard and Blake and another painter, Ogleby, as suspected spies "surveying for purposes inimical to the safety of Old England." On a sketching excursion up the Medway they were put under arrest in an improvised tent of sails and oars (sketched by Stothard, who depicts Blake as the camp cook) until cleared by a message from "certain members of the Royal Academy."[22]

Rather more can be made of Blake's collecting habits and his interest in, if not intimacy with, Mortimer and other contemporary painters. His father allowed him enough pocket money to collect prints, and Blake frequented bookstalls, printshops, and auction

[20] Just possibly as early as 1787; see below.
[21] W. S. Baker, *William Sharp*, Philadelphia, 1875, pp. 18, 20, 68, 73, 86; Wright, I, 156. Sharp was very active in the S.C.I. from March 1792 to the trials of 1794, and during that time he became intimate with Tooke and Holcroft and Godwin; his name appears frequently in Godwin's manuscript diary until the record of his death in 1824. See below, Ch. 7.
[22] Wright, I, 8–9, and pl. 3. Morchard Bishop thinks Blake is more probably the reclining figure in a three-cornered hat.

rooms where works of art, genuine and spurious, could be seen as they passed from one private collection to another. The auctioneer Langford came to regard him as "his little connoisseur; and often knocked down to him a cheap lot."[23] Blake is said from the first to have been interested exclusively in pictures "of the historic class," especially the symbolic and heroic paintings of Raphael, Michelangelo, Dürer, and Hemskerk. "I cannot say that Rafael Ever was from my Earliest Childhood hidden from Me. I saw & I Knew immediately the difference between Rafael & Rubens"—a difference one gathers that had to do with grandeur and ideality of style as well as firm and determinate "outlines."[24] Among contemporary artists he was interested chiefly in Barry, Mortimer, and Fuseli (all born 1741), painters who could invent a sublime allegory or treat history with poetic vigor. Benjamin West was the most prolific history painter of the day, but Blake "lookd upon him with contempt" as he "hesitated & equivocated with me" in an argument about drawing.[25] And Blake probably shared Barry's scorn of West for using historical subjects to flatter the reigning monarch.[26]

John Hamilton Mortimer, who lived for a time above Langford's auction rooms, was a forceful eccentric who dressed in scarlet and

[23] Symons, p. 313.

[24] Marg. to Reynolds, xiv–xv: E627/K447.

[25] *P.A.*53: E562/K593. Here again Sharp, West's engraver, hovers in the background. West, however, came to think highly of Blake's art. See Joseph Farington's *Diary*, London, n.d., I, 141, Feb. 19, 1796.

[26] A word must be said of Edgar Wind's conjectures about "the very puzzling relation which connects Burke with Barry and thereby indirectly with Blake," in "The Revolution of History Painting," *Journal of the Warburg Institute*, II (1938), 116–127. Their political allegiances are indeed "wrought with contradictions," as Wind says, if West is to be taken for "a loyal democrat" because he was an American and if Barry is to be thought of as an opponent of "West's mitigated realism and its democratic appeal." The latter idea rests on the legend that Barry painted a *Death of Wolfe* with all the figures nude, in protest against the realism of West's *Wolfe*, so that Blake's *Nelson* appears to be in the same tradition. Actually Barry's *Wolfe* is more realistic than West's (and in that sense more "democratic") and its figures are not nude. It has recently been rediscovered and reproduced by J. Clarence Webster in "Pictures of the Death of Wolfe," *Journal of the Society of Army Historical Research*, VI (1927), 35. See Barry, *Works*, London, 1809, I, 230. The legend seems to have been erected by West's inventive biographer John Galt upon an error in Edward Edwards, *Anecdotes of Painters*, London, 1808. See note 38 below.

gold, made a show of "waiting for the inspirations of Genius,"[27] and died in the last year of Blake's apprenticeship at the close of a brief career that illustrated Blake's defensive assertion: "Painters are noted for being Dissipated & Wild."[28] In theme and manner Blake's early paintings owe much to Mortimer's heroic and ethical treatment of British history in such work as *King John Signing Magna Charta* and *St. Paul Preaching to the Britons*. Mortimer's monsters also "foreran the monsters of Blake," as Geoffrey Grigson observes, and his fresh and raw interpretation of Shakespearean metaphor was a new kind of literal translation pointing toward Blake's way of designing literally out of Shakespeare and Milton.[29] Mortimer's "comic history painting" also influenced the development of pictorial satire away from the static emblem to the flexible caricature of Gillray and Rowlandson, a development of which Blake was doubtless well aware.[30]

James Barry, "the really Industrious, Virtuous & Independent Barry" as Blake called him when he aired the bitter Irishman's grievances as if they were his own (*P.A.*60), was originally a protégé of Edmund Burke, though somewhat to the left of Burke in philosophy and politics. Barry championed the republicans not only of America but of Ireland and was a democrat on such questions as African slavery and the rights of women, though often arrogant in tone. He knew Wilkes, was associated in an eating club with Price and Priestley, dined frequently with Holcroft, was a close friend of the republican Hollises, particularly Timothy, and became one of Godwin's intimates as early as 1783.[31] In his own profession

[27] See Marg. to Reynolds, 47: E635/K457.

[28] *ibid.*, 15: E633/K454.

[29] "Painters of the Abyss," *Architectural Review*, cviii (1950), 215–220. See also W. Moelwyn's illustrated survey of "Blake's Shakespeare," *Apollo*, lxxix (1964), 318–325.

[30] *B.M. Satires*, v, p. xii. For Blake's debt to Gillray, see below; for Blake on Rowlandson, see letters to Dr. Trusler and to Geo. Cumberland, Aug. 23, 26, 1799.

[31] Barry, *Works*, I, 49, 327; II, 533 n., and passim; Whitley, *Artists and Art*, passim. A dated list of first acquaintances, in Godwin's unpublished diary, includes John Hollis in 1782, Tim Hollis and Barry in '83, and Brand Hollis in '84. From 1788, when Godwin began to make daily entries, until 1805 there are over a hundred references to Barry. In 1791–1792 Godwin and Barry got together to "talk of aristocracy," "talk of counter revolution," "talk of Paine, read on truth"; Godwin went to Barry's lecture of Feb. 18, 1793; and Barry was the most faithful caller in the days when Mary Wollstonecraft was dying, in September 1797. Among those with whom Godwin

Barry was one of the more articulate champions of "the true sublime style of historical art," constantly searching for the means "of extricating historical painting out of the confused mass of meaner arts with which it is indiscriminately jumbled."[32]

Blake came to think of himself as a direct continuer of the ethical and historical tradition of Mortimer and Barry, and he has a good deal to say about Barry in his Reynolds marginalia, but we

Fig. 2. James Barry

do not know how soon the two became friends. There exists a copy of Barry's 1783 *Account* of his murals for the Society of Arts containing a "wonderfully vivid and vigorous" portrait of Barry by Blake (Fig. 2) "which, from internal evidence, seems to be a sketch from life in pencil, slightly fortified with India-ink when he got home from the exhibition."[33] Since Blake's sketch is not

occasionally encountered Barry are the Hollises, the Opies, Henry Richter, William Sharp, Joseph Ritson, Sir Francis Burdett, John Thelwall, and Arthur O'Connor. But Godwin and Barry usually saw each other alone or with Holcroft.

[32] *An Inquiry*, etc., London, 1774, pp. 132–144. Full title below, p. 43.
[33] H. Buxton Forman, in Gilchrist, p. 370.

drawn in the book but only tipped in, it is only a guess that Blake owned this copy of the *Account* or that he knew Barry at the time of the exhibition. Yet the guess is strengthened by the probability that one of the songs in Blake's *Island in the Moon* (1784) owes its inspiration to Barry's grumbling at the meager exhibition receipts. Much earlier Blake must have known Barry's paintings and could hardly have escaped hearing of the man who wanted Parliament to vote, as Walpole put it, that he "should decorate Westminster Hall with giants." That ambition, at any rate, became Blake's own.

In the early 1770's Barry's allegorical *Mercury inventing the Lyre* and *Adam and Eve* were criticized for insufficiency of drapery but were "much admired by the imaginative,"[34] among whom we must include Blake—for we learn what happened to Barry's *Pandora,* painted for Burke and exhibited in 1775 with a challenge of comparison to Raphael, from Blake's marginalia in which he repeats without question Barry's evaluation of his own work: "Barry Painted a Picture for Burke equal to Rafael or Mich Ang or any of the Italians. Burke used to shew this Picture to his Friends & to say I gave Twenty Guineas for this horrible Dawb. . . ."[35] (An example of Barry's grand manner is given in Fig. 3.)

Barry's first academic lecture as professor of painting (March 1784) discloses antiquarian interests similar to, and perhaps influential upon, Blake's. Even the ancients' "wildest productions of imagination" contain concealed truths "not unworthy of the patient investigation of artists and philosophers," and Barry has his own theories about the Titanic antediluvian Atlantides, whose art was superior to that of succeeding nations but whose land was overwhelmed by the Atlantic ocean.[36]

In 1776 Barry produced two paintings dealing with the recent imperial war in Canada and the current war with the Colonies.

[34] Whitley, *Artists,* 1, 284, 294. Blake's notebook couplet,
> Ghiottos Circle or Apelles Line
> Were not the Work of Sketchers drunk with Wine,
>
> (E504/K542)

may have been influenced by a newspaper couplet of 1778 shortly afterwards said to have been written by Barry of and to himself (*Artists,* 1, 339–340):

> Homer revives in Milton's mighty line,
> And great Apelles lives again in thine.

[35] Whitley, *Artists,* 1, 310–311; Marg. to Reynolds, cxx: E631/K541.
[36] *Works,* 1, 308–309, 352–354 n.

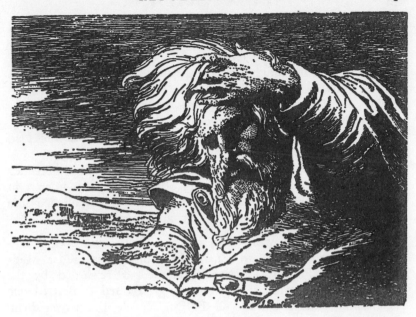

Fig. 3. Barry, *King Lear*

One, now lost, was issued as an engraved print with the title, *The Rise of America, with the Decline of Europe,* described by an unsympathetic editor as "an allegorical design he etched at the heat of the American War, when those who espoused the cause of the colonists suffered their imaginations to run riot in the sunshine that was to bless America, and to lament the eternal gloom that was spreading on this side of the Atlantic" (*Works,* I, 318). The other, *The Death of General Wolfe,* was one of several treatments of the same theme, of which the most famous was West's. Barry's is relatively simple and realistic compared to West's operatic set crowded with dignitaries who had not been on the field but could purchase a place on the canvas. At the end of the American War, when Ireland was celebrating the British concession of a separate Irish Parliament, Barry, completing his murals consecrated to "the *melioration, liberties,* and *reform* of mankind," chose the legislative "remedy for the disorders in Ireland" for "the business of my principal group of Legislators in Elysium" (II, 574).

Even West, by birth an American, had a certain romantic pride in his native land, though divorced from politics and somewhat second hand. The figure of a handsome Indian in his and Barry's

Wolfe paintings has been traced to a Niagara Falls scene by Fuseli,[37] though Barry probably painted several Indians in his lost *Rise of America,* if it represented "a combat of naked men."[38] The red skin of the Indians in these pictures is a symbolic equivalent of the almost vermilion flesh of the "warlike naked Britons" in Blake's lost fresco, *The Ancient Britons,* which Blake explains as "the flush of health in flesh, exposed to the open air"—a dramatic contrast to the flesh of "modern Man" who, "stripped from his load of cloathing . . . is like a dead corpse."[39]

This fresco belongs to a later decade but a decade in which Blake looked back on his youth and observed that his interest in Mortimer and Barry, and subsequently Fuseli, had aligned him with the underdog and rebel in the art community:

"While Sr Joshua was rolling in Riches Barry was Poor & Unemployd except by his own Energy; Mortimer was calld a Madman & only Portrait Painting applauded & rewarded by the Rich & Great. Reynolds & Gainsborough Blotted & Blurred one against the other & Divided all the English World between them. Fuseli, Indignant, almost hid himself. I am hid."[40]

Henry Fuseli, a Swiss painter of the macabre-sublime who "had a considerable share in furnishing" Blake's mind, had been a radical humanist in his youth in Zurich, from which he had fled after a "bold attack on corruption and oppression in high places." In London in the 1760's he had published a pamphlet in defense of Rousseau, but his subsequent career was largely a-political, though

[37] Webster, *loc.cit.*

[38] Edwards refers to a Barry picture of 1776 as representing an American battle as "a combat of naked men." I take this to be the *Rise of America,* but Whitley, *Artists,* I, 376, assumes it to be Barry's *Wolfe,* a picture neither of combat nor of naked men. See above, note 26. Edwards himself seems to have misread his notes, for when he writes of the *Wolfe* (p. 298) he says in error that Barry "chose to paint the figures as nudities" and supposes he did so "with a view of demonstrating his knowledge of the human form." This hypothetical demonstration has become, with Galt and later critics, Barry's campaign against West's democratic realism!

[39] *D.C.*v: E536/K581. Crabb Robinson at the time described Blake's naked Ancient Britons as "almost crimson" and later remembered their color as "very like that of the Red Indians." Mona Wilson, *William Blake,* London, 1948, pp. 220–224.

[40] Marg. to Reynolds: E624/K445. Though in the early 1770's Barry was rising to Academic fame, collectors fought shy of his subject paintings and he was "desperately in need of commissions." Whitley, *Artists,* I, 294.

"his look [was] lightning, his word a thunderstorm."[41] Returning in 1779 from a long sojourn in Italy, Fuseli in the next decade became intimate with Blake, who relished his exuberant combination of high-flying fancy and mordant profanity and appropriated many of his ideas on the theory and history of art. Fuseli's paintings were poetical if not historical, and his work formed a prominent part of the print-dealer John Boydell's Shakespeare Gallery. But these and his Milton paintings were "almost hid" because of the lack of any truly public or permanent exhibition hall.

To sum up the implication of Blake's early interests, we may say that they propelled him along what would prove to be a path of poverty and neglect, for without public patronage Republican art could not flourish: "We want a Fair Price . . . & a General Demand for Art."[42] The general availability of art was an item in the social program of the Enlightenment, put forward in the *Encyclopedia,* and in France its realization was to be one of the early fruits of the revolution.[43] The angel at Blake's birth, foreseeing as much, told him ruefully that if England should refuse the arts and "scorn the immortal Muse," France would save Blake and his works "from the Ungrateful shore."

The pessimism of the angel's statement, written down some fifty years after Blake's birth, must be considered apocryphal. And even when Blake was "hid," he did not pack up and go to Paris.[44] As late as 1800 Blake and Cumberland were full of hope that Parliament would carry forward the artists' comprehensive "plan for a National Gallery."[45] They were probably even more hopeful in the days when the proposal was being agitated by Barry, in the Academy and in such pamphlets as his *Inquiry into the Real and*

[41] Eudo C. Mason, *The Mind of Henry Fuseli,* London, 1951, p. 18, quoting Lavater in 1773. For Fuseli's *Remarks on the Writings and Conduct of J. J. Rousseau,* London, 1767, see excerpts below (see Index). This is now available in an extensively annotated reprint, with German translation, and introduction by Eudo C. Mason: *Schweizerisches Institut für Kunstwissenschaft, Kleine Schriften Nr. 4,* Zürich, 1962.

Before August 1779, i.e. while his address was still Basire's, "Lincolns Inn," Blake owned a copy of Fuseli's translation of Winckelmann. See Keynes, *Blake Studies,* pp. 47–48.

[42] Marg. to Reynolds, ii: E626/K446.

[43] Joseph Billiet, "The French Revolution and the Fine Arts," in *Essays on the French Revolution,* ed. T. A. Jackson, London, 1945, pp. 197–208.

[44] "Now Art has lost its mental Charms" *N.*79: E471/K557.

[45] To Cumberland, July 2, 1800.

Imaginary Obstructions to the Acquisition of the Arts in England,
1774, and by Wilkes, in Parliament.

It was perhaps but an accident of Wilkes's chequered career
that he should have been president of the committee responsible,
in 1760, for the first exhibition of contemporary art in England.
And few artists may have participated in the exhibition held by
the obscure "Polite Artists of Great Britain" in 1768, featuring
a painting of Wilkes for the edification of "every lover of liberty."[46]
But Wilkes's speech in Parliament in 1777, proposing the collec-
tion of a national gallery and the development of the twenty-year-
old British Museum into a great free public library, was an integral
part of the radical bourgeois movement for which he spoke. Wilkes
made the point that the promotion of painting would stimulate the
profitable commercial arts of engraving and publishing and might
even lead to the introduction of the art of tapestry weaving. And
he dramatized his campaign for public viewings by protesting a cur-
rent example of monarchic indifference. The original Raphael car-
toons for tapestries for the Sistine Chapel had long been on public
display in Hampton Court Palace—a rare exception to the general
inaccessibility of art—until George III ordered them locked away
in private rooms in Buckingham House.[47] "They are entirely se-
cluded from the public eye," protested London's champion, "yet,
Sir, they were purchased with public money before the accession of
the Brunswick line." They should properly be regarded "as an in-
valuable national treasure, as a common blessing, not as private
property," Wilkes argued.[48]

In the same speech he suggested that public patronage begin
with the employment of a half dozen British painters to adorn the
bare interior of St. Paul's. This project had been proposed in 1773
by Barry and supported by Burke and later by West. But the
Bishop of London of those years had vetoed the project as "savour-
ing of Popery," and despite Wilkes's hope that the new bishop
would be more receptive to the idea, the opposition of clergy and
"King's friends" defeated all the Patriot's proposals. At this the
impatient Barry, "Unemployd except by his own Energy," un-
dertook single handed his vast mural project in the hall of the

[46] Whitley, *Artists,* I, 165–167, 192–193.
[47] In 1763; they were moved again in 1787 to Windsor Castle.
[48] Whitley, *Artists,* I, 325–327; cf. F.Z.v.64:15–18:E337/K310: "O
did I close my treasuries . . . And darken all my Palace walls . . . [and]
hide . . . holy workmanship!"

Society of Arts, on the promise of reimbursement from future receipts. To complete this work he had to live on "Bread & Apples," as he told Blake; cease to exhibit at the Academy; and decline, in 1782 before the murals were finished, an invitation from the American Congress "to paint the actions of General Washington."[49] By this time Blake had passed the zenith of his own first phase of historical painting, to which we must now give some attention.

2

Blake's early history paintings belong to a time around the close of his apprenticeship in 1779, but he did not begin adding explanatory symbolic inscriptions to his engravings until late in the 1790's, and he did not have occasion to write out his theories about art until he was preparing a catalogue for his own exhibition in 1809. Yet at that time it was Blake's belief that his artistic opinions were "exactly Similar" to those he had held "when very Young."[50] And for a check on his early artistic interpretation of history we have the *Poetical Sketches* and the early prose fragment on the passions, *Then She Bore Pale Desire,* a work highly relevant to the psychological ironies of the paintings.

From first to last Blake sets the republic of art above the empire of the sword and pits Joy against the Pride of Kings. Always for him historic art must be heroic, rich in prophetic or allegoric meaning, displaying "the historical fact in its poetical vigour so as it always happens" (*D.C.*v). For instance it must portray a wicked man's death as both a public ornament and a warning to other wicked men: "an Ornament & an Example."[51] *The Death of Earl Goodwin,* Blake's first work exhibited at the

[49] *ibid.*, I, 375.

[50] Marg. to Reynolds, 244; late insertion: E650/K476. Blake's early notes are lost.

[51] *P.A.*17: E567/K598. The meaning of "so as it always happens" is not that history repeats itself but, on the contrary, that actual happenings are always so surprising, so full of "miracle" and "improbabilities and impossibilities" that the only way we can believe in the reality of history is to "see it always before our eyes." That is why the poet or true historian must give us the facts in full "poetical vigour" and not try to rationalize them into a dull consistency.

Royal Academy (May 1780), is a warning example of the sudden death that overtakes the strong wicked hypocrite. Like Gwin, Goodwin is condemned before the throne of God by the ghosts of his victims. "I pray God that this morsel I am going to eat may choak me at this moment, if I had any hand in the death of that Prince," the eleventh-century earl is reported to have said; whereupon the morsel "stuck in his throat and choaked him immediately, to the great astonishment of the Standers-by."[52]

For less headstrong tyrants, we learn from the *Prologue to King John,* "lingering Fate is slow" but nevertheless certain as soon as the "iron heart is smitten." Two of the early paintings show us historical moments when tyrants' hearts are being smitten by divine and popular judgment in favor of their victims. These are *The Ordeal of Queen Emma* and *The Penance of Jane Shore,* the former a direct sequel to Mortimer's *Edward the Confessor seizing the Treasures of his Mother* (i.e. of Queen Emma).

The story of Edward, "to whom is given the glorious titles of Saint and Confessor," as the historian Rapin sarcastically observes, is one of violence and rapacity. When he came to the throne he stripped his mother of all her treasures (the theme of Mortimer's picture), and then to cover his own crime he accused her of adultery (the theme of Blake's). He "caused her to be accused of Incontinence with Alwin, Bishop of Winchester" and then "was so hardhearted as to make her undergo the Ordeal trial . . . to walk barefoot and hoodwink'd over nine red-hot Plough-shares."[53] Blake pictures Emma, hoodwinked, coming across the hot ploughshares nicely—to the amazement of King Edward and the Archbishop her accuser, and a numerous court. Mortimer's influence,

[52] Rapin, I, 134. My reasons for using Rapin's *History* as a gloss are given below. Here note that Blake and Rapin agree in the spelling *Goodwin* as against Chatterton's *Goddwyn* or the usual *Godwin*. Blake's sketch for this painting is reproduced in Kerrison Preston, ed., *The Blake Collection of W. Graham Robertson,* London, 1952, pl. 55.

[53] Rapin, I, 131. For clarity I have modified Rapin's punctuation here and elsewhere. *The Ordeal* is reproduced in Wright, I, pl. 5, and in Blunt, pl. 4b.

The "reasoning historian" David Hume dismissed this and similar anecdotes as "the inventions of the monkish historians . . . propagated and believed from the silly wonder of posterity" (*Works,* I, 134). Blake's preference was like that of William Morris—for "uncritical or traditional histories" (*Collected Works,* XXII, XIV). Cf. p. 67, n. 23.

it will be noted, extends beyond manner to the suggestion of a congenial political subject.

The story of Jane Shore is a chapter in the ruthless career of the Duke of Gloucester who, on his way through plots and assassinations to the throne, found it expedient to accuse of sorcery the one-time mistress of Edward IV in order to implicate other enemies. Because "he could alledge nothing in proof of these accusations," he changed the indictment to adultery, which nobody could deny "since the whole Court was witness she had been kept by the late King, and afterwards by the Lord Hastings. Whereupon she was delivered over to the Bishop of London, and condemned by the Ecclesiastical Court to do open penance in St. Paul's Church in a white Sheet, with a Wax-Taper in her hand, before all the people" (1, 635).

"In all this Action," we are told—and this is the theme of Blake's painting—"she behaved with so much modesty and decency, that such as respected her Beauty more than her fault, never were in greater admiration of her, than now." Blake's Jane, modestly robed in her sheet, is triumphant over her accusers, the discomfited bishop and duke and duchess.[54]

In neither Emma nor Jane is Blake picturing injured innocence any more than in his later picture of *The Woman taken in Adultery* and befriended by Christ. His theme rather is the exposure of royal and episcopal hypocrites who cry whore to cover their own greedy political whoredoms. These paintings and Blake's later curious definition of kings as "accusers of adultery" (as in the inscription of *Our End is Come* or *The Accusers*) serve to explain each other. The code of sin is a political fraud used by ambitious tyrants; in 1793 King George will go to war with France to defend the honor of Marie Antoinette.

Another kind of blow at the hard heart of a tyrant is delivered in Blake's interpretation of *The Bard, a "Pindaric Ode"* by *Thomas Gray,* exhibited in 1784 and again, with commentary, in 1809. Here a tyrant and his armies are smitten directly by

[54] *The Penance* is described and reproduced in Preston, pp. 74–76, pl. 20. Preston overlooks the hunched back of the "old man, leaning upon a staff," who must be Gloucester. See also Blunt, pl. 42 and p. 9, where my interpretation of Blake's intent is "confirmed" yet generalized into "hypocrisy in sexual matters."

the artist as prophet. Indeed the picture and comment epitomize Blake's desire for the power to drown the throat of war. The story concerns Edward I, conqueror of Wales, who ordered the execution of all the Welsh bards to prevent their keeping alive the spirit of popular resistance. According to the legend as elaborated by Gray (in 1757), one bard escapes the slaughter and later accosts King Edward and his army from an inaccessible rock. Defiantly striking his harp, and supported in "dreadful harmony" by the ghosts of his slain companions, the bard prophesies the doom of Edward and his entire line:

> On a rock, whose haughty brow
> Frown'd o'er old Conway's foaming flood,
> Robed in the sable garb of woe,
> With haggard eyes the Poet stood;
> Loose his beard, and hoary hair
> Stream'd like a meteor to the troubled air.
>
> Weave the warp, and weave the woof,
> The winding sheet of Edward's race.[55]

The effect of the bard's words, as Blake portrays it, is like the effect achieved by Tom Paine, that "worker of miracles" whom Blake admired for being able "to overthrow all the armies of Europe with a small pamphlet," i.e. *Common Sense*.[56] It is presumably the sort of effect Blake wanted when he prayed, in *Samson*, for power "to write as on a lofty rock with iron pens":

"King Edward and his Queen Elenor [explains Blake] are prostrated, with their horses, at the foot of a rock on which the Bard stands; prostrated by the terrors of his harp on the margin of the river Conway, whose waves bear up a corse of a slaughtered bard at the foot of the rock. The armies of Edward are seen winding among the mountains. . . . Mortimer and Gloucester [Edward's chief warriors] lie spell bound behind their king" (*D.C.*iv).

The living bard dominates the scene, literally weaving a great twist of sheeting on his harp; we remember it was Edward's winding sheet that the Antiquaries partially removed in 1774.

Essentially what the history painter of Barry's or Blake's sort

[55] *The Bard,* ii, iv. From Gray's "dreadful harmony" to Blake's "fearful symmetry" is only a step, but a rather tremendous one.

[56] Marg. to Watson, 12–13: E606/K391.

does is to assert the moral and social power of the inspired bard, a power to overwhelm evil rulers and summon together patriots. He also soars beyond the representational school of West and Copley who, in Blake's eyes, simply apply the blotting and blurring of Reynolds and Gainsborough to historical subjects. "Weaving the winding sheet of Edward's race by means of sounds of spiritual music and . . . articulate speech is a bold, and daring, and most masterly conception," declares Blake. And since "the public have embraced and approved" such conceptions in poetry, "shall painting be confined to the sordid drudgery of fac-simile representations?" The repeated exhibition of *The Bard* is a characteristically devious announcement of Blake's dedication of his powers to the weaving of tyranny's shroud. In poetry he uses the same image— in 1792 to describe the harlot's curse which "weaves around the marriage hearse" (*N.*109) and later to prophesy that licensed corruption, concentrated in the harlot's cry, will "weave Old England's winding Sheet" (*Auguries of Innocence*). These London harlots are descendants of Jane Shore, testifying to the tyrannous hypocrisy of a whole society.

Shelley in 1819 will use Gray's image to taunt the *Men of England* with a prophecy that if they do not stand against tyranny they will weave their own "winding-sheet, till fair England be [their] sepulchre." Both Blake and Shelley give Gray's theme a more revolutionary twist than Gray intended. For while his bard unsparingly indicts the Edwardian dynasty, he hails the coming Tudors of Welsh ancestry as a virtual return of King Arthur, and leaps into the river Conway confident that there will always be a King of England.

Blake sees no Arthurian strain in the present monarchy but adapts the Welsh prophecy of the return of Arthur to his own hope for a golden future. In his notes on *The Ancient Britons,* a painting which also featured the swan-song of a patriotic bard "singing to his harp" in defiance of armed invaders, Blake describes the return of "the Sun of Britain" as a thing yet to come, presumably through a Last Judgment or its political equivalent (*D.C.*v). In this use of Celtic traditions of resistance to English tyranny, Blake had precedents in the popular movement, as Bronowski has pointed out. Welsh counties supporting Wilkes in 1771 compared themselves to "Ancient Britons" who did not bow to kings. Many of "those who fought George III's court. . . . Freemasons, the Ancient Family of Leeches, the small men who made Wilkes &

Liberty a symbol for their discontent, took the Ancient Britons for forefathers of their brotherhoods" (p. 3 [23]).

3

Now day arose, the Golden Sun his mighty Race began, Refreshing the Cold earth with beaming Joy. But Pride awoke nor knew that Joy was born . . . forth Came Ambition Crawling like a toad. . . . Then Nineveh & Babylon & Costly tyre. . . .[57]

Blake's study of moral indictment as a political stratagem, by the accusers of Queen Emma and Jane Shore, suggests that even in his early twenties he had gone some distance in his analysis of the behavior of oppressors, and this impression is confirmed by the prose fragment which begins, "then She [Fear] bore Pale desire."[58] This rather cryptic manuscript is interesting in this connection for two reasons. As an allegorical genealogy of Pride and Shame and Policy and "the Kingdoms of the World & all their Glory," it shows Blake revolving the problem of man's fate in terms that link imperial pride and individual frustration. As a document of response to the American Revolution it reveals Blake as one of those whose imaginations did, to quote Barry's editor, "run riot on the sunshine that was to bless America" and at the same time "lament the eternal gloom that was spreading on this [European] side of the Atlantic." To bring out these contemporary implications—but not in any sense to suggest a "source"—I shall compare this document with Paine's *Common Sense*.

Both Paine and Blake, living in a culture that still discussed politics in moralistic and Biblical terms inherited from the English Civil War, viewed the American Revolution as a sort of mass resurrection or secular apocalypse that would overthrow poverty and cruelty and establish a new Eden in which the arts flourished and habitations were illuminated, to use Blake's language, not by destructive fires but by the joys of the noonday sun.[59] According

[57] *T.S.B.*: E766, 437/K40–41, the first sentence a deletion.

[58] Usually dated ca. 1777 from its closeness in language to *P.S.*

[59] Jack Lindsay, *Perspective for Poetry*, London, 1944, p. 26, speaks of Blake as building "his basic myth forms around the Christian world-view, restoring integrity to that world-view by his revolutionary identification of

to Paine the doctrines of original sin and hereditary succession were two sides of the same coin. Before the days of kings there had been no wars: "it is the pride of kings which throws mankind into confusion." King-making and idolatry were in the first instance disaffection from the King of Heaven. The resultant government by kings "is the badge of lost innocence; the palaces of kings are built upon the ruins of the bowers of paradise. For were the impulses of conscience clear . . . and irresistibly obeyed, Man would need no other law-giver." A survey of the history of monarchic England shows it filled with civil wars and rebellions; a survey of the globe shows Freedom driven out of Asia, Africa, and most of Europe and compelled to seek refuge in America to "prepare in time an asylum for mankind."[60]

Blake, surveying the spiritual history of humanity, sees Innocence driven out by the Pride of Kingdoms, the earth overrun with the numerous progeny of Pride and Shame and Fear, and Conscience and the light of Reason fouled:

"Pride bears [Ambition] in her Bosom, and the Gods all bow to it. So Great its Power that Pride inspird by it Prophetic Saw the Kingdoms of the World & all their Glory . . . built with Murder. Then Babel . . . with thousand tongues. Confusion it was calld. . . . Conscience came from heaven. But O who listens to his Voice. . . . Conscience was sent a Guard to Reason, Reason once fairer than the light, till fould in Knowledges dark Prison house. For knowledge drove sweet Innocence away. . . . Pride against her father [the King of Heaven?] Warrd & Overcame . . . bound him, then usurpd oer all the Gods."

The force cutting through this long reign of Power and Murder and Confusion is the sunshine of Joy, now appearing in the west. Thus far in history Joy's periods of influence have been extremely

himself with the crucified masses." For Blake's sources (somewhat sketchily reconstructed) in the antinomian and revolutionary tradition "tenaciously held by the descendants of the small tradesmen and artisans who had formed the extreme left of the Commonwealthsmen," see A. L. Morton, *The Everlasting Gospel,* London, 1958. See Thompson, especially Part I, for a documented reconstruction of the radicalism in Paine's and Blake's England. An extended study of Blake's antinomianism is to be published by Thompson in 1970.

[60] Paine, I, 4–10.

brief. He first refreshed the cold earth in the day of the rising of the Golden Sun, presumably in the Eden of eternity. But Pride and her progeny arose and overran the earth. Joy's second appearance is an interlude in the chronology of Kingdoms built with Murder. He comes not as a sun but as a cloud overshadowing for a moment the Empire of Rome, "Emblem of Pride." Viewed historically, the life of Christ is but a brief threat to tyranny, and Rome swiftly consolidates the power of empire, now "Miterd and crown'd with triple crown."[61]

Joy's third appearance signifies the new freedom and pursuit of happiness in America preceding tyranny's latest attack. The Sun of Joy is seen rising in the direction of "the Setting Sun" and shedding a "Sweet Influence oer the Earth" which threatens the reign of Pride "here" in "her City." Here Rome and London, interchangeable symbols of empire, seem to merge as in Blake's later symbolic writings. "Pride feared for her City, but not long, for looking Stedfastly, She saw that Pride Reignd here." In the sequel of this passage, which weaves most bewilderingly away from these general historical terms to personal analysis and *perhaps* back again, Blake indicates that the primary source of the Envy and Hate that breed in his city, in London during the darkness of war against the American sunshine, is Pride's fear of losing dominion—a fear that will become obsessive in Blake's later imperialist, Urizen.

It is from this fear that "Satire, foul Contagion," is engendered, and while Blake writes as if his own satiric impulse were inspired chiefly by envy of others who "in Contentments downy Nest do sleep," it can hardly be far from the truth to add that among these "others" are the kings, nobles, and ministers who cause war and oppress the poor. It is particularly the "Envy and Hate, that thirst for human gore" that Blake wants to destroy "with potent spell," according to *An Imitation of Spenser*. And when he cries, in the manuscript, "could I at Envy Shake my hands, my notes Should Rise to meet the New born Day," he may be taken to mean, in full context, that if he could attain sufficient independence to afford to shake his fists at "Sr Joshua & his Gang of Cunning Hired Knaves," under whose "Opression" he later said he had

[61] This theme is developed in *Europe;* see especially the figure of State Religion in pl. 6.

spent "the Vigour of [his] Youth & Genius,"[62] he should declare
his republican zeal as boldly as any. This is sheer extrapolation,
resting partly on a late reminiscence. But two things seem in-
contestable: that Blake felt the inspiration of a new dawn many
years before the French Revolution, and that he wished for but
did not find the boldness to express his dangerous hopes.

We can now push a little further the question of how Blake felt
about proud kings of England when he copied their brazen effigies
for the Antiquaries. The drawings that he made in warm months
in Westminster Abbey and engraved in Basire's shop in winter re-
main essentially enigmatic as they lie before us in the large black
prints of the Antiquary Society's *Vetvsta Monvmenta* and Gough's
Sepulchral Monuments in Great Britain. The faces are manifestly
full of power and vigor, however, in contrast to the vacuity in
those engraved earlier by Vertue and Gravelot for Rapin's *History*.
Blake undoubtedly took the regal forms of Eleanor and Philippa
and Edward III in the chapel of Edward the Confessor to be as
real and powerful exemplars of "the historical fact" as George III
and Queen Charlotte. And he may indeed have labored with such
absorption among the royal tombs that he became "himself almost
a Gothic monument."[63] But we need not assume with Gilchrist
(p. 15) that Blake saw in the bard-cursed Edwards and their
queens and councilors only "noble grandeur," "austere sweet-
ness," and "gracious stateliness." It is more likely that he could
not view them "unalarmed."[64]

We come closer to Blake's actual feelings when we study the
residual effects in later art and poetry of his early intimacy with
the extinct dynasts in their canopied tombs. In the description in
America of the joint assembly of the Houses of Parliament to
listen to the King's speech, for instance, three levels of association
are blended—the historical reality of 1774–1775, the conclave of

[62] Marg. to Reynolds: E625/K445.

[63] Malkin, in Symons, p. 315. The original drawings and the copper
plates have survived. For photographic comparison of the drawings with
the monuments (of Edward III, Philippa, Elinor, and Richard II) see Miner
in *BNYPL*, LXVII (1963), 639–643.

[64] Blake told Crabb Robinson he was made sick by Wordsworth's writing
of passing "unalarmed" the thrones of Jehovah and his shouting Angels.
Symons, p. 258. See Blake's notes on Wordsworth's Preface to *The Excursion*,
E656/K784.

fallen angels in *Paradise Lost* ("th' Angelic seats"), and the familiar Gothic statuary of Westminster Abbey ("forms art-bound"):

. . . George the third holds council, & his Lords & Commons meet:
. . . dismal visions mope around the house.

On chairs of iron, canopied with mystic ornaments
Of life by magic power condens'd; infernal forms art-bound
The council sat; all rose. . . . the dark house was rent,
The valley mov'd beneath; its shining pillars split in twain,
And its roofs crack across down falling on th'Angelic seats.[65]

If Blake had imagined the statues of Plantagenets and Tudors in the Abbey coming to life in response, at last, to the stone angels who hold moldering trumpets of judgment above their heads, he might have described them thus. The dwarfish statuettes such as the small bustos of Edward I and Edward III, on the marble canopies, are indeed life "condens'd" into mystic ornaments by the magic power of art. And the effigies too are infernal forms art-bound. Yet Blake is not describing the Abbey but the nearby House of Lords, which he must have known was actually barren of statuary. The living rulers are the "dismal visions" and "infernal forms" alluded to in this passage.

It is not simply that Blake sees the present in images of the antique. It is rather that he seems to be saying to king, lords, and commons: You war-makers are not living in the spirit of the present. You are reenacting the oppressions and aggressions of ancient times. You are the ghosts of warriors long since relegated to inferno or bound down in miracles of art by the sculptor and the bard. I must bind down your infernal forms once more, for I too can prostrate tyrants with my art.[66] You, George the Third, however young you may seem, are really a snowy bearded old man; your "eyes Reveal the dragon thro' the human"; you are an apparition out of the feudal past, in your hard heart another ambitious Edward.

The lofty rock on which Blake took his bardic stand was located at once in the middle ages and in eighteenth-century London. His

[65] *A*.b:9–24: E57/K204.
[66] Malkin said of Blake's interest in the Abbey tombs that "all the ornaments appeared as miracles of art, to his Gothicised imagination." Symons, p. 314. For Blake's assertion that he could work miracles like those of Christ and Tom Paine, see Marg. to Watson, 12–13: E606/K391.

own account of what happened when George held council and blew the loud war trumpet is that the conflict finally reached a revolutionary crisis not in America but right in his own city— in the riots of 1780, which melted the bolts and hinges of Blake's soul as we have seen, and in a whole cluster of apocalyptic phenomena which he pictures in *America* as bringing the war to an end if not liberating the citizens of London. From the quiet connotations of the paintings and the faded and meager relics of biographic record, let us turn once more to the vivid, teeming pages of the poems.

4. The Enormous Plagues

ANOTHER reading of *America,* this time with attention to the *consequences* of war unchained, will lead us to the tragic precedent in English history upon which Blake bases both the cosmic dialectics and the imaginal pattern of his vision of the American War as a Last Judgment upon England. That precedent in brief is the supposed relation between English aggressions during the Hundred Years' War and the appalling visitation of the Great Pestilence in 1348. Blake first read about this Judgment when he was gathering material for his unfinished play *King Edward the Third,* as we shall see. That play and another Poetical Sketch and one or two early paintings prove to be fragments of a first halting attempt to record with iron pens a vast political Truth which kings of England should heed. To understand the potential fusion of those fragments it will serve us well to work backward from *America,* where we can see the work completed and the panoramic movement of the Great Plague presented in a swift, compacted symbolism which must be the result of its having lain for more than a dozen years in what John Livingston Lowes might call Blake's mind's volcanic cauldron.

Some contemporary analogues will introduce the theme on the level of mere metaphor. In the mirthful postwar *Criticisms on the Rolliad,* a Whig satire written by the antiquary George Ellis and others, one of King George's ministers, Dundas, is said to have schemed during the war to reduce the Americans by "Starvation": "He like some Angel, sent to scourge mankind, Shall deal forth plagues," not "to produce an actual famine in America" but "to prevent the Americans from eating . . . thereby insuring their reduction without bloodshed."[1] In the more bitter wartime caricature print, *The Closet,* cited above, another of the King's ministers, Lord George Germain, is shown giving instructions to kill and kill "Tho Nature's Germins tumble all together, Evn till Destruction Sicken."

[1] *The Rolliad,* Dublin, 1796, p. 23. These satires were begun in 1784; a complete text was first published in 1791.

Blake too pictures the attack upon America as a dispatch of British angels "arm'd with diseases of the earth" in an attempt to smite the wheat and quench the fatness of the land. And this may be understood, like the bacteriological warfare conducted by Jehovah, as both fact and symbol. The American patriots "heard the voice of Albions Angel give the thunderous command: His plagues obedient to his voice flew forth out of their clouds Falling upon America, as a storm to cut them off" ($A.14:3-5$). The attack was literally an effort to destroy the Colonial economy and figuratively an inciting of "domestic insurrections amongst us," of which the framers of the Declaration of Independence complained. The metaphor of disease blends easily with the metaphor of fire, especially if one is drawing as Blake and his contemporaries did upon the Biblical and medieval confusion of fire and pestilence. On the simple political level Blake's metaphor is the jargon of the day. The town-burning naval fire is symbolic of political incitement, though this point does not happen to be made by Barlow; the American disease becomes the French disease; "Republicanism," writes an American in Paris in the spring of 1789, "is absolutely a moral Influenza from which neither Titles, Places, nor even the Diadem [the crown] can guard their possessor . . . the Lord preserve us from a hot summer."[2]

It is the reversal of the scourge upon the scourger till Destruction itself sicken that interests the ingenious practitioner of the art of symmetry. In this sense the pattern of *America* is simple but dialectical. The King seeks with divisive diseases ("Fury! rage! madness!") to infect the Americans, but his hurled flames produce an opposing flame in "the fierce rushing of th'inhabitants together." If the plague of disunity had overcome the "citizens of New-York . . . mariners of Boston . . . scribe of Pensylvania . . . [and] builder of Virginia," "Then had America been lost." "But all rush together in the night in wrath and raging fire," and America is saved.[3] And now the whole process reverses. The King's attempt to quench the "Human fire" of revolt "as a sea o'erwhelms a land in the day of an earthquake" begins to overwhelm England.

[2] Gouvernour Morris, *A Diary of the French Revolution,* Boston, 1939, I, xli.

[3] $A.14:10-19$: E55/K201. Here with symbolic economy, Paine (the scribe), Jefferson (the builder), and Boston Sons of Liberty (the mariners) are employed as types of humanity.

His punishing Demons are themselves punished. And the rulers who sowed the wind reap the whirlwind when the divisive plagues "recoil" and roll back "with fury On Albions Angels" to produce a bloody epidemic of civil disaffection that sweeps throughout the British Isles:

> . . . then the Pestilence began in streaks of red
> Across the limbs of Albions Guardian, the spotted plague
> smote Bristols
> And the Leprosy Londons Spirit, sickening all their bands:
> The millions sent up a howl of anguish . . .
> The plagues creep on the burning winds driven by flames
> of Orc,
> And by the fierce Americans rushing together in the night
> Driven o'er the Guardians of Ireland and Scotland and
> Wales
> They spotted with plagues forsook the frontiers. . . .

The "naked multitude" refuse to fight; the King and his Guardians lie "Sick'ning" (*A.*15).

There are no hints in Barlow for this development, nor for Blake's rain of blood and other apocalyptic manifestations. These go back, ultimately, to the book of Revelation. But Blake's immediate source is Joshua Barnes's *History of Edward III* (1688). Blake is concentrating the dispersed images of Barnes's leisurely but panoramic account of the movement of the Black Death through the Continent and over the British Isles into a visionary synopsis (with some blend from Barlow) of the spread of disaffection through the Isles in 1780–1782.

Compare this sequence of phenomena in Barnes's *History:* a "Dreadful Comet . . . a Pillar of fires . . . frequent and terrible Earthquakes"; "It rained Blood in Germany, and Comets, Meteors, fiery Beams"; the plague originated in Asia in "a certain Igneous Vapor, or Sulphurous Fire, horribly breaking forth from the Earth; or . . . descending from Heaven . . . rowling along in smoaky globes of horrid Stink and Pestilential Fire . . . whereby the Air became so infected, that there fell down Millions of young Serpents, and other venemous Insects"; "black Nodes, or Spots . . . over all the Body" were symptoms; in England the disease "began in the Sea-port Towns . . . ran up to Bristow . . . about the first of November it reached London"; "in Wales [it] raged

extreamly . . . and among English in Ireland"; "the Scots . . .
made a warlike Rendezvous . . . to invade the North-Borders"
but suddenly were infected and fled (pp. 428–440)—to the following sequence of phenomena in *America:* "red meteors round
the land of Albion"; "red clouds & raging fires" belching from
the deeps; "Red rose the clouds . . . in vast wheels of blood";
"the terror like a comet" "with beams of blood" "in black smoke
thunders and loud winds . . . breaking in smoky wreaths from
the wild deep, & gath'ring thick in flames"; "diseases . . . forty
millions, must'ring in the eastern sky"; "plagues flew forth out
of their clouds, Falling . . . as a storm . . . as a plague wind
fill'd with insects . . . as a sea . . . in the day of an earthquake";
"the plagues . . . rolld"; "the spotted plague Smote Bristols . . .
Londons Spirit"; "plagues creep on the burning winds . . . Driven
o'er the Guardians of Ireland and Scotland and Wales. They
spotted with plagues forsook the frontiers" (*A*.3:16–15:14).

The political moral is explicit in the source. Barnes calls the
Black Death a judgment on England for the aggressive wars of
Edward III. Blake treats disease in the eighteenth-century body
politic as a similar judgment upon the England of George III.
Blake's *King Edward the Third* makes a beginning at the same
moral. But we must not leave *America* until we have observed
the minuteness with which Blake selects those elements which serve
as receptacles of contemporary detail: we shall then see whether
the same way of rewriting medieval history does not operate, at
least crudely, in *Edward* as well.

2

A single inaccuracy in one law, may shake the frame of
the whole community.
 — *Annual Register,* 1781

When the pestilential fires of Orc reach Britain they have a
threefold effect—upon the multitude, whom they cause to howl
and throw off their hammered mail and stand naked; upon the
rulers including king, bishops, poet laureate, and priests, whom
they cause to lie writhing or to hide in caves as self-evident
reptiles; and upon the female spirits, whom they release from the
fetters of religion in renewed youth.

We have seen how the naked multitude howled and danced the dance of revolution. Literally the throwing down of arms by all the "bands" (*troops* is the modern word) suggests the mass desertion of Britain's fighting men, a matter of record. The appalling rate of desertions "at different periods of the war" and especially at its end almost brings tears to the army's historian, Sir John Fortescue. Blake must frequently have seen in London streets the "hapless" soldiers he writes of in *London,* human molecules of the complete disintegration of the army that occurred in 1783 as the peace was signed. Following the "instant and simultaneous flight of almost every man who was intitled to his discharge," says Fortescue, it was impossible *for the next ten years* to recruit troops enough to back up Pitt's occasional "firm attitude" towards France or Spain or Russia. Recruits secured by fair means or foul soon deserted; a decree of death to deserters had no effect; the Empire had to rely for its belligerency on 12,000 subsidized Hessians available on demand.[4] As for Ireland and Scotland, in these nations with longstanding grievances ("their banners seard With fires of hell [which] deform their ancient heavens with shame & woe") serious mutinies occurred as early as 1778. By 1782 rebellion in Ireland reached the proportions of a revolution, and in Scotland a "contagion" of debate over Reform "reached the north like the influenza which accompanied it," as Burns's publisher remembered.[5]

The particular mention of Bristol and London is appropriate, not only for the riots but because these two merchant cities were most deeply involved in the American trade and remained in sullen opposition throughout the war. The *Remonstrance* of the mayor and council of London in 1781, declaring to King George "our Abhorrence of the Continuation of this unnatural and unfortunate War," may be cited in evidence of the leprosy of London's spirit a year after the riots. And for Bristol a battle of flags which accompanied a bye-election early that year appears symptomatic. In over two months of polling, the "Liberty" candidate, whose position was accurately represented by the display of "the American colours on some of our churches," was narrowly de-

[4] *History of the British Army,* New York, 1899, III, 498–521. Many bands were literally sick. Scurvy reduced the garrisons of Minorca and Gibraltar to handfuls of wasted men. Thousands died in Jamaica.

[5] William Creech, *Edinburgh Fugitive Pieces,* Edinburgh, 1815.

feated by Treasury support of his Tory rival but was shortly afterward elected mayor.[6]

Of the plight of "the ancient Guardians Fainting upon the elements, smitten with their own plagues,"[7] Blake supplies many examples. The King, "Albions Guardian," goes out of his mind, "Pale quivring toward the brain his glimmering eyes, teeth chattering . . . convuls'd" (A.15:7–8). George III did suffer a mild mental depression at the end of the American War, which Blake writing ten years later could have known about, though his first prolonged illness came in 1788; and in his fits of madness the King was obsessed with anxiety over loss of "my American colonies."[8] The bishops lie sickening, "Londons Guardian, and the ancient miter'd York, Their heads on snowy hills, their ensigns sick'ning in the sky" (9–10). As a matter of fact not long after the news of Cornwallis' surrender both Bishop Lowth of London and Bishop Newton of Bristol did sicken and die, though York did not. The laureate "Bard of Albion" also feels "the enormous plagues," and a cowl of flesh grows over his head "& scales on his back & ribs" (16–17). He does not die but is exposed. The actual laureate, since the year of Blake's birth, was William Whitehead, who regularly supplied the newspapers with odes on the

[6] See London Chronicle of March 3, 1781. Whether the American flags were a form of baiting is not clear, but they did not make "Cruger and Liberty" less popular with the multitude, who on one occasion demanded that a British victory flag hoisted by the Tory candidate's supporters on a harbor vessel "be struck" and were answered by fire from a swivel-gun that killed two and wounded eleven men and three children. The war was not remote.

Cruger's popularity rested on vigorous pro-American speeches in Parliament. Standard political histories are simply not reliable in these matters. They assume that the loss of the 1780 election by Cruger and Burke meant a change of sentiment in Bristol; yet we know from the papers of John Robinson, Treasury secretary, that the election was purchased. Only in a recent special study has the point been made that the election upset "had little or no connection with any change in local feeling on national issues." Reid, Journal of Modern History, xviii (1946), 204.

Now (1968) it appears that Cruger in 1779, and possibly earlier, had been secretly receiving a government subsidy. Can he have somehow thrown the election? See Lewis Namier and John Brooke, The House of Commons, 1754–1790, Oxford, 1964, ii, 280.

[7] A.16:17–18, at the end of the poem, where the fainting is looked back on from the perspective of 1793 by "France Spain & Italy."

[8] See Manfred C. Guttmacher, America's Last King, New York, 1943.

King's birthday and on New Year's. This allusion should be kept in mind for *Edward the Third*.

The priests also "Rush into reptile coverts, hiding from the fires of Orc," because "The doors of marriage are open . . . Leaving the females naked and glowing with the lusts of youth" (19–22). And actually in 1781 there was a crisis in the marriage law which not only disconcerted the priesthood but, according to the *Annual Register,* shook "the frame of the whole community." By a ruling in the Court of King's Bench the wording of the Marriage Act of 1751 was interpreted as making void all marriages performed in chapels erected since passage of the act. As Lord Beauchamp exclaimed in Commons the next week, the ruling made thousands of children bastards and denied parish relief settlement to "illegitimate" families throughout the land. All London was agog. Neighborhood gossips had a thirty-year crop of "adulterous" unions to speculate upon. Here was accusation of adultery on a mass scale.

It might be argued that the reference to the opening of the doors of marriage is a purely philosophical assertion that one result of revolution is the overthrow of a perverted moral code fettering individual freedom. Orc's announced purpose is to stamp to dust the "stony law" of the ten commandments, "to renew the fiery joy, and burst the stony roof, That pale religious letchery, seeking Virginity, May find it in a harlot, and in coarse-clad honesty . . . for every thing that lives is holy" (8:5–13). But we must not underestimate Blake's acquaintance with historical detail. Even his description of the priests "in rustling scales" (note the modulation from rustling robes)[9] rushing to hide from the fires may owe something to the speech of the Whig leader Charles Fox, reported thus in the newspapers:

"He observed that by the newly discovered blot in that law [he called the whole Marriage Act 'tyrannical and absurd'] most of the clergy in the kingdom had been ignorantly guilty of felony by the celebration of marriages in the new chapels; so that (as he laughably continued) we might expect to see most of our prelates, either transported to America, or sent in their lawn sleeves to work on board the ballest lighters [floating prisons on the Thames]."

[9] The bard and priests appear in reptile form because the legendary plague winds were filled with reptiles and "other insects."

Lord Beauchamp quickly brought in a bill to mend the breach, and Fox, in an effort at drastic, Orc-like reform, introduced a bill to reduce legal marriage requirements to the simple formality of civil registration. Fox's bill was actually passed by the House, though subsequently thrown out by the Lords. A crack had appeared in the stony law which a prophetic bard did not forget.[10]

The total effect of the raging of the "red flames fierce" over "the hills, the vales, the cities" of Great Britain was that for a time "The Heavens melted from north to south." Yet ultimately the revolt did not succeed as it had in America; the human fire was damped down "with clouds & cold mists"; and "Angels & weak men" were once more able to "govern o'er the strong" (16:1–14). In a disconnected fragment Blake wrote: "So The British Colonies beneath the woful Princes fade. And so the Princes fade from earth"; but they had not faded from England.

3

Yet death is terrible, tho' borne on angels' wings!
— *King Edward the Third*

Blake often painted pictures of the Great Plague in gruesome detail, whether in an Egyptian or medieval setting or in that of the London of 1665—which doubtless had for him a political association with the Restoration.[11] The key to the unfinished *King Edward the Third* is the great Death which lies in wait for the warriors of Edward's ill-starred invasion of France, a "successful" and proud invasion followed by retreat and then by the Black Death over Britain and then by a conflict so perpetual that it came to be called the Hundred Years' War. But since Blake wrote only six short scenes of this drama, the key lies buried in other

[10] The emancipated "females naked and glowing with the lusts of youth" who "run from their fetters reddening" seem to be some kin to the women in the old ballad whose nakedness shows through the magic mantle of chastity and who run "Fast, with a red rudd," to escape the laughing males. One version of this ballad, "The Boy and the Mantle," appears in Percy's *Reliques*, which we know Blake read.

[11] See especially *E.* pl. 14 and the water colors *Pestilence, Plague,* and *Death of the Firstborn*. In Blake's list of subjects in *N.*116, probably for his lost "History of England, a small book of Engravings," we find this sequence: "18 Ch I beheaded. 19 The Plague. 20 The fire of London."

fragments of the story, which we shall come to in due course, and in his sources and their later use in *America,* which we have observed.

The enigma of the *Edward* fragment is further enhanced by the fact that it lacks the sort of editorial prologue written for King John and King Edward IV in which the poet announces his moral and hints at modern parallels. There are many indications of Blake's general prophetic intent in these scenes; yet if we forget to ask what historical climax they point toward we may be quite puzzled that Blake's Edward and his brave and battle-ready warriors appear to be undertaking their invasion of the vineyards of France under favorable auspices, to be marching with jingoistic complacency toward a great slaughter of enemy troops, and to be getting by with what they represent to each other as glorious and fully justifiable murder. They are Englishmen with a God-given "right to France" as well as a "right" to be "sovreigns of the sea." They rejoice at an opportunity to worship the English goddess, Liberty, by slaughtering enemies who, not being English, are "in chains."

The reader who accepts the *Poetical Sketches* as the advertised product of "untutored youth," or even the reader who views them as the serious work of riper years—for there is a good deal of Shakespeare in *Edward,* and Blake says that Shakespeare only "in riper years gave me his hand"—can easily mistake these scenes for the author's personal expression of a "boylike" delight in "the picturesqueness of war."[12] Even one reader who discovers that in the fourth scene the author does not share the warriors' ambition but for the moment at least sees through their chatter about rights and liberty, has been inclined to jump to the conclusion that Blake's suddenly revealed cynicism is the result of a "flash of revelation" which is unrelated to the rest of the work and must have come "as swift and momentary to Blake as it comes to his readers now."[13]

Revelation was available to Blake, however, both in the terrors of his own times and in his historical sources. He did not have to

[12] Lowery, p. 127. Cf. Mark Schorer's difficulty with the "confused and contradictory" sentiments he reads in the poems (Schorer, pp. 188–192). And cf. Frye, pp. 179–180.

[13] Article signed "A.K.C." in *Poetry Review,* 1916: "suddenly we are aware that this Victory is a painted hag, Liberty cross-eyed, and the rest of our good company not so reputable as they seemed."

wait for the pamphlets of Thelwall[14] and Wollstonecraft and
Paine in the 1790's to find Edward III cited as the archetype of
aggressive, frustrated "ambition." According to Gray's *Bard,* of
which we hear verbal and thematic echoes in Blake's play, this
Edward's particular share in the general curse upon his whole
dynasty was to serve as "the scourge of Heaven" against France,
then to be surrounded by "terrors" of Flight and Sorrow and
Solitude, and finally to lie unpitied on his "funeral couch," a
mighty conqueror at whose passing no one shed a tear.[15] Ac-
cording to the pseudo-Shakespearean *Raigne of King Edward the
Third* Edward's dubious purpose in France was "to hack and
hew poor men."[16] For details Blake had to go to prose histories
of Edward's reign, and even the most favorable of these showed
it filled with aggressive wars, cruel executions, and hypocritical
manifestos.

Barnes, for example, though often laudatory, itemizes the "many
Rapes, Murders and Robberies" of Edward's armies; makes plain
that his generals were little better than brigands; and describes the
sacking of towns as the main achievement of the campaign in
France. In the "march" alluded to at the end of Blake's first
scene, Barnes's Edward simply "overran the Country far and
near . . . Burning and Spoiling whatever he met with" and putting
inhabitants to the sword without mercy (pp. 346–351). Some-
times the invaders won, "and sometimes they lost, as the Course of
War is; but the Country always suffer'd" (p. 401). We might
ascribe to some hypothetical author the naïve "patriotism" that
could transform these rapes and sackings into a pretty tale adorned
with the platitudes of the author of *Rule, Britannia!* about "Kings

14 Cf. John Thelwall in "Pretences for entering into the present War,"
The Tribune, Apr. 11, 1795: "Edward III claimed the Crown of France.
But though England was depopulated, though France was converted into
one scene of slaughter and desolation, what lasting triumphs did we obtain?
Let the distractions which followed those mad projects of ambition dictate
to us a more wise and prudent conduct for the future. Instead of preventing
civil discord all our attempts at conquest have produced that discord."

15 *The Bard.* Blake's echoes are discussed below. See his illustration of
Gray, ca. 1797, in which Edward III soars, whip in hand, above the fields
of France pursuing villagers who represent Amazement, Flight, Sorrow, and
Solitude (see Plate II).

16 *The Raigne,* 1596, was published by E. Capell in his *Prolusions,* London,
1760. It is Froissart versified and chronologically scrambled. See Lowery,
p. 110.

supported by almighty Love." But such naïveté is not conceivable in the author of *Samson, King John,* and *Gwin,* an author who deeply and strongly sympathizes with oppressed and harried villagers against "bands of enemies" laying waste their land and rioting on their flocks. Any idea that Blake is "indulging" in youthful jingoism in his portrayal of Edward's pillagers is far wide of the mark.[17] Rather, since the American War as a civil war suggested parallels in the reigns of John and Edward IV, we might suppose that as a war with France, which it became in 1778, it suggested to Blake—as it did to his contemporaries—the wars of Edward III. The "historical fact" of Edward's effigy he knew in Westminster Abbey. The story of Edward's career he probably first encountered in the painters' history book, Rapin, before he went for more detail to Barnes.[18]

The *History of England* translated in 1723–1731 by Nicholas Tindal from the French of Rapin de Thoyras, a Huguenot who had served under William III, sounded a critical note toward kings that suited well the rising spirit of bourgeois democracy in Blake's England. As one reviewer observed, Rapin showed "that the people have their rights as well as kings their prerogatives" and furnished "the people of England with the best material against the two most evils under the sun, i.e. superstition and tyranny." The work of Rapin "should be in the hands of every Englishman, and engraven on his heart."[19] It soon was. Sold in illustrated weekly numbers, with engravings by Basire's predecessors Vertue and Gravelot, Rapin's *History* was an enormous popular success. It promoted a widespread interest in national antiquity, inspired a school of English history painters from Kauffmann to Blake, and opened the era of English commercial engraving.[20]

[17] Such is the interpretation of Margaret L. Plunkett, "The Political Philosophy of William Blake," *South Atlantic Quarterly,* xxx (1931), 27–39.

[18] Blake follows Rapin in spelling, emphasis, and general pattern; but he needed Barnes for some details. His knowledge of Barnes is also evident in *The Couch of Death* and *America.* It should be noted that the ultimate source, Froissart, has nothing at all about the Pestilence.

[19] *London Magazine,* 1732, cited in John Pye, *Patronage of British Art,* London, 1845, p. 52. On his title page the author of the *History* is plain "Mr. Rapin de Thoyras," and so I have kept him though he appears in catalogues as "de Rapin-Thoyras, Paul."

[20] Pye ascribes the opening of "a field for engraving in England" in the first instance to the success of Vertue's Rapin. It pointed the way for Hogarth and Boydell.

Painters liked Rapin for his full visual detail and his practice of enriching his narrative with set pieces or dramatic scenes. Angelica Kauffmann cited volume and page of Rapin under the titles of her history paintings exhibited in 1776.[21] Blake's early history paintings can nearly all be traced to corresponding passages in Rapin, and the Antiquaries were following leads suggested by Rapin when they sent Blake to Westminster Abbey and other graveyards to draw the effigies of kings and queens such as Edward III and Philippa.[22] Some of the Antiquaries liked Rapin for his democratic bias. For example, one of the compilers of Hollis' *Memoirs* contrasted historians who write "for the use of kings, or rather tyrants"—among whom he included Hume, Echard, and Smollett—with Rapin and others who write "for the use of the people."[23]

After the American Revolution Benjamin West painted at the King's command the scenes of Edward's glorious victories, for these in the short run at least had been more gratifying than the "victories" of Burgoyne and Cornwallis. We cannot ascribe to Blake, however, any similar interest in glorifying the founder of the Order of the Garter. Toward the end of his life when he was obliging the astrologer John Varley with pictures of the spirits that visited his inward eye, Blake, according to report, questioned the spirit of Edward III about "the butcheries of which he was guilty in the flesh," and Edward's "detestable" reply was that what Blake and his friends called carnage was "a trifle unworthy of notice"; that "destroying five thousand men" was "merely re-

[21] Kauffmann lived in Golden Square from 1769 to 1781, when she moved to Rome. Her two paintings from Rapin in 1776 were *Lady Elizabeth Gray imploring of Edward IV the restitution of her deceased husband's lands,* a subject akin to Blake's *Queen Emma* and *Jane Shore,* and *The tender Eleanora sucking the venom out of the wound which Edward I, her royal consort, received with a poisoned dagger from an assassin in Palestine,* a subject which Blake too painted in his *King Edward and Queen Elenor,* ca. 1779, though the only extant version is an engraving dated 1793. Part of the pathos is the subsequent early death of Eleanora after her unworthy husband's assassination of the bards. Blake possibly considered this an ironic prelude to the Welsh episode.

[22] Ayloffe cites Rapin concerning the body of Edward I. *Archaeologia,* III (1775), 377.

[23] I, 210. Blake in 1809 (*D.C.*v) scolds without discrimination Hume, Gibbon, Voltaire, Echard [Eckhart], Rapin, Plutarch, and Herodotus as "reasoning historians."

moving them from one state of existence to another."[24] Blake had never any doubt there really was such a king, indifferent to the slaughter of thousands, but we must not read Edward's indifference as Blake's.

Edward the Third has been said to reflect the manner of Shakespeare's plays but to have none of their dramatic quality.[25] If we recognize that Blake was setting up his heroes in order to knock them down later or let them be knocked down by the fury of God's judgment, we can see why he could draw heavily on Shakespeare for the blustering talk of warriors before battle yet show no interest at all, here or in any later writing, in the elements of dramatic action.[26] Intending a vast moral pageant rather than a drama of conflicting human wills, Blake neglects action for insight and for the preparation of a prophetic contrast between the glorious anticipation and the appalling results of armed conquest. The title of Blake's 1784 painting, *War unchained by an Angel: Fire, Famine, and Pestilence following,* may be taken as a panoramic outline of his general theme. The Angel which seems to serve God in employing Edward as the scourge of France will reveal the full measure of God's judgment when the wind changes and the fire kindled in France redounds upon Bristol and London. The historical "victory" of Crécy will be followed by the Black Death, the melting away of Edward's power, and, in the ensuing reign, "Cruel and Unnatural Civil War" (Barnes).

Thus if we take it to be Blake's general intention to make the most of the historical ironies pointed out in his sources, we can understand that his effort in the opening scenes is to present a reasonable facsimile of boastful princes and generals and gullible infantry preparing to "reap rich harvest in the fields of Cressy," as his king expresses it. King Edward, addressing his army just landed on the coast of Brittany, prays to God to "let Liberty blaze in each countenance, and fire the battle" in which "cries of blood"

[24] Reports quoted in Wright, II, 96–97 and Lowery, p. 226.

[25] Richard Garnett cited in Lowery, pp. 121, 130, who notes many Shakespearean echoes.

[26] And Blake is interested less in the "official" than in the unofficial sentiments of *Henry V*, for example. He is the sort of reader of Shakespeare who sees in that play some of the "underlying irony" discussed by D. A. Traversi, *The Importance of Scrutiny,* New York, 1948, pp. 120–140, and by Allan Gilbert, "Patriotism and Satire in *Henry V,*" *Studies in Shakespeare,* Miami, 1952, pp. 40–64.

will "tear horror from heav'n." He boasts of "English courage" and congratulates his generals on being "conquerors everywhere" and having "such an army of heroes" as never before "shouted to the Heav'ns, nor shook the field." Edward's son, the Black Prince, a Hotspur without brains, chatters that "It is my sin to love the noise of war" and day-dreams happily about the "thousand deaths" soon to be heaping "this fatal field of Cressy." Sir Thomas Dagworth, one of Edward's generals, makes a great show of wanting a real battle, and when he is satisfied that the King will order one his "heart dances" and he feels like "the young bridegroom going to be married." Finally a minstrel inspires the troops with a bloodthirsty song pronouncing it their destiny to found an "empire of the sea" on "gore" and on a perpetual use of sword and spear.[27]

These are plausible imitations. They are not the real thing—partly because Blake is not entering into his warriors' feelings with any delight but is attempting to represent the awful voice of war which, as we know from his other *Sketches,* he wishes to silence. Again and again the impulse to *expose* the sentiments of his dramatis personae interferes with the imperfect effort to give them verisimilitude. Blake abandons his characters as human beings in order to plant ironies in their speeches—a tendency that will get so completely out of control in later prophecies that his warriors will become "mountains" too gigantic for any human stage and will express their delight in the pursuit of war in language that approaches the "fi-fo-fum" variety. The irony of vision is not the irony of satire. Satire would exclaim: These are human beings acting like beasts of prey. Vision insists: These really are beasts! Our problem in reading *Edward* is not simply to account for the characters' expression of delight in bloodshed but to account for the fact that much of the hidden irony which underlies that expression remains hidden.

Edward's opening lines, for example, contain a buried indictment of war's horror similar in phrase and image to Blake's Edward IV Prologue which charges kings with causing and drawing upon themselves "the whirlwind of fury" "from the Throne of God." Edward III, having prayed to the God "to whose fury the nations are But as dust," assumes that his prayer is answered and that God's

²⁷ *King Edward* iii:137; i:11–12, 7; iii:71–76, 232, 222–223, 144–145; vi:11, 42: E415–429/K17–32.

fury will operate only against the French. We know that his troops will vanquish the French, yet that in the end his own career will demonstrate the truth of his announcement that without divine aid the implements of war prove but "idle trophies of the vanquisher." His boasts—that English Liberty will carry his warriors safely through the ruin and confusion of battle and that conquest supported by God is not hollow—constitute an ironic inversion of the Welsh bard's prophecy that the conquests of the Edwards will prove hollow and that even their virtues will not save them from ruin and confusion.[28] With the play unfinished, the vulnerability of these boasts remains unexploited—as does also, in the third scene, the vulnerability of Edward's inadvertent admission that the Englishmen's "right to France" rests only upon their boldness as conquerors; of the Prince's self-condemnation as one whose "vast Ambition" overflows all bounds of moderation; and of his mentor Chandos' promise of a life untroubled by "the voice of Conscience" to the soldier who makes a good adjustment to his bloody occupation.

More self-evident perhaps is the Machiavellianism of Chandos' recipe for transforming defensive patriotism into aggressive militarism: "Teach man to think he's a free agent," let him "build himself a hut and hedge a spot of ground," and he will defend them as "his by right of nature." Once "thus set in action," the same home-lover can be inspired to fight for "glory" and even to invade France if under the impression that he does so "to enlarge his castle." In the summer of 1778 the Bard of Albion was urging British troops to fight in France to "guard their sacred homes."[29]

The irony in the fourth scene is explicit and has not gone un-

[28] *King Edward* i: 1–20. Gray's bard declares to Edward I that helm and hauberk's twisted mail and royal banners will prove idle "Though fanned by conquest's crimson wing." Blake's Edward admits that twisted mail, forged helm, and brazen shield are, without divine aid, "idle trophies of the vanquisher." Gray's bard calls for ruin and confusion to seize the ruthless Edward I; says that his son will die mid shrieks of death as his wife tears his bowels and bears Edward III, and that the latter will scourge France only to find that "terrors round him wait!" Blake's Edward III, undertaking to scourge France, anticipates confusion, cries of blood that tear horror from heaven, and yelling death.

[29] See William Whitehead's *Ode* of June 4, 1778.

noticed. General Dagworth accuses his man William—who talks like Blake[30] stepping onto his own stage—of being "an endless moralist" and "a natural philosopher" who knows "truth by instinct, while reason runs aground." The general seems to feel called upon to defend the French campaign before this "moralist" —but he cannot. His bombast before the troops, his talking about Liberty to give them "noble hopes," collapses into an evasive opportunism. Honest William refuses to view in a romantic light the antics of armed men mouthing "right" and "Liberty." To him their war games are foolish: "When we were in England at the tournament at Windsor and the Earl of Warwick was tumbled over, you ask'd me if he did not look very well when he fell? and I said, No, he look'd very foolish." And their wars are sinful:

William. Then, Sir, I should be glad to know if it was not ambition that brought over our King to France to fight for his right?
Dagworth. [It was.]
William. Then if ambition is a sin, we are all guilty in coming with him, and in fighting for him.
Dagworth. Now, William, thou dost thrust the question home.[31]

The question thrust home is the condemnation of aggression implicit throughout the play. It *is* a sin to love war. The King of England's right to France is supported not by divine aid but by Ambition, defined by Dagworth as "the desire or passion that one man has to get before another in any pursuit after glory." In Blake's "Pale desire" MS he traces all the evil "Glory" of the kingdoms of the world to the same source:

". . . forth Came Ambition, Crawling like a toad. Pride Bears it in her Bosom, and the Gods all bow to it. So Great its Power that Pride inspird by it Prophetic Saw the Kingdoms of the World. . . ." (E437/K41)

Here Ambition is a crawling thing. In the play William asks if it is "a little creeping root that grows in ditches?" The image suggests that Blake has in mind a letter of 1340, quoted in his sources,

[30] And like "Williams" in Shakespeare's *Henry V,* whose function is to call attention to war's wickedness. Cf. Gilbert, *loc.cit.*
[31] Scene iv: E425–426/K28–29.

from Pope Benedict to Edward III, berating him for ambitiously asserting a right to France:

"Those that hear as much are amaz'd, ascribing it not to discretion, but rather to Simplicity and Vanity. Finally We judge it ought to be more strictly consider'd, that such a Title, wanting both Reality and Advantage . . . is feared to Be a Poysonous Root, which will probably . . . bring forth Fruits of Bitterness and Sorrow."[32]

The climax of all the talk about Liberty as a glorious lure to "lead them on to battle" comes with the introduction of two suitably bloody chants by a hired "minstrel." This court poet, announced in scene four by a sort of Shakespearean clown named Peter Blunt, is a corrupt descendant of the ancient bards.

Peter. Yonder's a musician going to play before the King; It's a new song about the French and English, and the Prince has made the minstrel a 'squire, and given him I don't know what [a pension, according to Barnes], and I can't tell whether he don't mention us all one by one; and he is to write another about all us that are to die, that we may be remembered in Old England, for all [that] our blood and bones are in France . . . and I came to tell your honour, because you love to hear war-songs.

The minstrel is Blake's bridge back to the eighteenth century, for his "song about the French and English," which fills the sixth scene, is at least as appropriate to the modern as to the medieval theme of conquest, while his other song, "about all us that are to die," is Blake's parody of the battle songs of modern Britain. This second song is printed not in the text of the play but three pages further on as a separate *War Song to Englishmen*—a typographical mischance which has encouraged the mistaken impression that not only General Dagworth but Blake himself loved "to hear war-songs," although the reference to both songs as the minstrel's is plain enough in Peter's speech.

In the real thing, King George's laureate urges Britons to be "Proud of Edward's victories," to emulate his attacking armies and "navies powerful," and to "Waste no zeal in idle breath" but

[32] Barnes, p. 161. Yet there may also be an echo of Gibbon's *Decline and Fall,* ch. 69: "Ambition is a weed of quick and early vegetation in the vineyard of Christ."

"rouse to deeds of death!"[33] Blake's minstrel chants more sadistically: "Prepare your hearts for Death's cold hand!" The one cries, prepare to kill; the other, prepare to be killed—and wish you had "three lives" to give all at once.

The minstrel's other song, printed as the sixth scene of the play, is an inflammatory potion issued on the dawn of battle to the "Warriors met at the King's Tent." They are exhorted to go out and work as fierce slaughter upon the French as did their own Trojan ancestors upon the early giants of Albion. These were "savage monsters," according to the minstrel, "wild men, Naked and roaring like lions"—an outrageous idea as we know from Percy and other Antiquarians, who taught Blake that the ancient Britons were "naked *civilized* men, learned, studious, abstruse in thought and contemplation . . . overwhelmed by brutal arms" (*D.C.*v.). Be as brutal as your invading ancestors, urges the minstrel, through whom Blake is saying: You ARE as brutal as your ancestors, "Heated with war, fill'd with the blood of Greeks,"

> O sons of Trojan Brutus, cloath'd in war,
> Whose voices are the thunder of the field,
> Rolling dark clouds o'er France, muffling the sun
> In sickly darkness like a dim eclipse,
> Threatening as the red brow of storms, as fire
> Burning up nations in your wrath and fury!

It is *in this context* that the glory of British maritime power is celebrated, the beauty of "Liberty" based on the armed might of Albion's sons and daughters who "shall rule the empire of the sea" like "eagles [of] prey":

> Our sons shall rise from thrones in joy,
> Each one buckling on his armour; Morning
> Shall be prevented by their swords gleaming,
> And Evening hear their song of victory!
> Their towers shall be built upon the rocks,
> Their daughters shall sing, surrounded with shining spears!

> Liberty shall stand upon the cliffs of Albion,
> Casting her blue eyes over the green ocean;

33 Whitehead, "Verses to the People of England," in *Odes,* 1774.

Or, tow'ring, stand upon the roaring waves,
Stretching her mighty spear o'er distant lands. . . .[34]

To sing surrounded by spears. To have each morning sun antici-
pated or outshone by swords. If the picture of Liberty stretching her
mighty spear o'er distant lands appears fine, the minstrel's own
parallel words negate it: "Burning up nations in your wrath and
fury!"

To grasp the full ironic contrast, however, we should have the
unwritten sequel to these opening scenes—first the furious war un-
chained[35] at "Cressy," and then the "Fire, Pestilence and Famine
following"—a sequel indicated not only in *America* but in the nar-
ratives of Barnes and Rapin, in the titles of Blake's war paintings,
and in *The Couch of Death,* one of the *Poetical Sketches.*

4

After the "total defeat" of French forces at Crécy, Edward con-
ducted a ten-month siege of Calais during which British soldiers
died by the tens of thousands, "chiefly by the rage of the Bloody
Flux," ominous of future pestilence. At the conclusion of the siege
Edward's tyranny was displayed—and driven by defiant mockery
into a "Conqueror's Rage"—in a moving scene chosen by Blake as
the subject for an early drawing, *The Keys of Calais.*[36] "Six
illustrious Burghers" in their manner of yielding the city's keys to
their conqueror risked "the Sacrifice of their Lives," according to
Rapin, appearing "bare-footed, in their Shirts, with Halters about
their Necks," symbolic of the harsh terms of surrender. Edward
was "so highly incensed" that he commanded the defiant burghers

[34] Cf. Whitehead's "New Year Ode for 1759":
 Already Albion's lifted spear,
 And rolling thunders of the main,
 Which justice' sacred laws maintain,
 Have taught the haughty Gaul to fear.
[35] At their royal tents before battle, the King of France erected his
banner of *Oriflambe,* signifying no mercy except to king and prince, and
King Edward "caused also his *Burning-Dragon* to be raised up, which signi-
fied as little Mercy to be shew'd to the *Frenchmen*" (Barnes, p. 356). With
the same significance before the American War, Albion's Prince "burns in
his nightly tent" and arises in "dragon form" (*A.*3:1–15).
[36] Barnes, pp. 389, 399.

to be beheaded, and though he finally called off the execution at the behest of his son and tearful queen, he suffered no real change of heart. "A few days after *Edward* had made his Entry into *Calais,* he turned out all the Inhabitants . . . to people it with English."[37]

Blake also deals with a siege such as that of Calais in his painting, *A Breach in a City the Morning after the Battle,* exhibited in 1784 with *War unchained.* In the breach in the city wall lie dead and dying warriors, wept over by wives and parents. Later use of the same figures and wall in the title page and frontispiece of *America* reinforces the impression that Blake had the American War in mind in the first place. In *America* the breach is occupied by the gigantic form of a naked angel (Orc) who will prevent an utter sacking of the city but is manacled (compare the haltered burghers of Calais) because in the old world tyranny still reigns.[38]

The title of the companion painting, *War unchained . . . Fire, Pestilence and Famine following,* suggests that the climax of the Crécy-Calais war was the apocalyptic Black Death which swept England in the following year; and this is the cadence of the histories and of *America.* Barnes (p. 416) sends up the curtain on this act with a suitably prophetic flourish:

"Now doth King *Edward* the Third seem to stand in the full Zenith both of his Age and Glories: He had but just past the 35 Year of his Life, and yet was crown'd at Home in his Family with

[37] Rapin, II, 426. Blake's water color, described in Preston, *The Blake Collection of W. Graham Robertson,* p. 174, and now in the Beinecke Library, Yale, emphasizes the tension between the irate king, clad in garish red mantle and golden mail, and the arm-entwined burghers and the pleading queen and prince. (But the halters are already off the necks of Blake's independent burghers: human unity against the king is to triumph.)

[38] An early version of *A Breach,* perhaps that of 1784, has now turned up, in the collection of Charles J. Rosenbloom (pl. 93 in Frederick Cummings and Allen Staley, eds., *Romantic Art in Britain, 1769–1860,* Philadelphia, 1968; also in Erdman and Grant, eds., *Blake's Visionary Forms Dramatic,* 1970). One can see that the version hitherto considered early (Preston, pl. 56; Blunt, pl. 8b) must be of the 1790's.

A still later version inscribed "inv WB 1805" and sold to Butts under the title *War,* Blake has added the Orc figure to the heap of bodies in the breach; he is reduced in stature and wingless but otherwise the same naked curly-headed youth. Reproduced in Schorer, opp. p. 254.

a Lovely Row of Hopeful Children, and a Vertuous and Beautiful Consort; in his Kingdoms with Peace and full Prosperity: And abroad he was renowned above all the Kings of the Earth for his Noble Victories by Sea and by Land, in *Scotland, France* and *Bretagne;* for set battles, or taking of Towns; for Kings slain, Kings routed, and Kings taken captive. . . .

"For now . . . it seem'd as if the Golden Age was reduced to *England;* and a New Sun began to shine in our Horizon: So great Riches and Plenty, the usual Attendants of Conquest, being generally diffused over the face of the whole Land. For there was scarce a Lady, or Gentlewoman of any Account, which had not in her possession some precious Household-stuff, as rich Gowns, Beds, Counterpains, Hangings, Linen, Silks, Furs, Cups of Gold and Silver, Porcelain and Chrystal, Bracelets, Chains and Necklaces, brought from *Caen, Calais,* or other Cities beyond the Sea. And yet as the Roman Historians complain, that they were overcome by the Luxury and Fashions of the Nations they conquer'd: So from this time the Native Candour and simplicity of the *English* Nation did visibly empair; and Pride, Superfluity and Vanity began to lift up their hatefull Heads; till they provok'd the Author of the World to visit this Land also with his awakening Judgments."

Blake had a sufficiently broad hint here for his last act. Here was the "plenty" which in his minstrel's prophecy was to be the fruit of imperial conquest, and here was God's judgment following. To shift to a less prolix historian, Rapin (1, 426–427):

"God permitted not these Disorders to go long unpunished. A terrible Plague, after raging in *Asia,* and part of Europe, spread itself into *France,* and from thence into *England,* where it made such Desolation, that one half of the Nation was swept away. *London* especially felt the Effects of its Fury, where, it is observed, in one Year above fifty thousand Persons were buried in a Church-yard belonging to the Cistercians."

Neglect of crops and cattle led to widespread famine, and fires raged unchecked through the stricken villages. The fiery sequel to aggressive war, itemized in Blake's early painting and in the text of *America,* reappears frequently with similar prophetic significance, as in the final plate of *Europe* where the result of British war against France is indicated as a general conflagration. Likewise in periods of renewed war (1794, 1805) Blake painted realistically horrible illustrations of *Plague.*

But the literal Plague had not, after all, pulled down or even humbled the Proud, and Blake's first literary treatment of it, in the *Poetical Sketches,* emphasizes moral rather than political aspects. "When the Wars were again renewed between England and France," says Barnes, "King Edward seem'd nothing the weaker for all the great loss of his People in this Plague: For the Common Sort of France was as much exhausted hereby as England, and in a manner all King Edward's expert Barons and Captains remained still alive to be another Plague to that Nation" (p. 440). Yet if the Plague had failed to revolutionize society, it had, according to the historian, effected a revolution or reformation in moral and psychological values; and it is this aspect that we find in *The Couch of Death,* a delicate sketch in cadenced prose.[39]

This lyric meditation, blending images from Milton, Barnes, Chatterton, and the Bible,[40] is written in a melancholy mood induced apparently by Blake's habit, in his monument-copying for the Antiquaries, of walking "through dreary places . . . and in church-yards; and . . . sitting by Sorrow on a tomb-stone," to quote an adjacent Sketch.[41] As he returns from a day's walk, perhaps to one of the outlying churchyards, the poet's imagination is stirred by the English twilight: "The veiled Evening walked solitary down the western hills, and Silence reposed in the valley; the birds of day were heard in their nests, rustling in brakes and thickets; and the owl and bat flew round the darkening trees."[42] His mind turns to Barnes's description of the year after Calais when the Black Death "proceeded to decimate all Mankind, or rather to destroy Nine of Ten thro the whole World."[43] Blake evidently recalls the historian's observation that "as the Scripture says of the Pestilence that it walketh in Darkness or invisibly . . . this Plague also walked, or rather flew. . . ." He imagines a sickbed scene: "In former times, on such an evening, when . . .

[39] E432–433/K35–36.

[40] For the Chattertonian and Biblical influences, see Lowery.

[41] *Contemplation,* which rejects the temptation to escape from Misery and Discontent by fleeing to the countryside. The "clamour" that "brawls along the streets" and the "destruction" that "hovers in the city's smoak" are the London poet's birthright; his genius compels him to roam "on lofty rocks," the rocks of truth. Compare *London.*

[42] Compare Milton's garden of Eden: "Now came still Evening on . . . Silence accompanied, while beast and bird . . . to thir nest" etc. *Paradise Lost* iv. Blake's youth "laments through the still evening."

[43] Barnes, pp. 432–435.

our ancestors, who now sleep in their graves, walked on the stedfast globe, the remains of a family of the tribes of Earth,[44] a mother and a sister were gathered to the sick bed of a youth; Sorrow linked them together . . . they stood by the bed like reeds bending over a lake, when the evening drops trickle down." Like Shelley's west wind, the plague served both as destroyer and preserver of relationships, breaking asunder human ties that were corroded, linking together those based on enduring values. Blake must have read how the plague was "so contagious, that [some] Parents forsook their Children, and Wives their Husbands [while others] being awaken'd to the quick by so dreadfull an appearance of Death at their Elbow, are said to have piously set themselves to bewail their sins [and] even [to have] rejoyced as they were dying."

He imagines a family linked together not only by Sorrow but by a common fate. "Beneath me burns eternal fire! O for a hand to pluck me forth!" wails the plague-stricken youth, and his mother assures him that she too is "infected": "The youth lay silent—his mother's arm was under his head; he was like a cloud tossed by the winds, till the sun shine[s], and the drops of rain glisten, the yellow harvest breathes, and the thankful eyes of the villagers are turned up in smiles."

The ideal of a peaceful life beyond the reach of plague and famine and tyranny hovers on the margin of this vision. Though our attention is focused on the individual and the family we are aware of the larger society of villagers thankful for a "yellow harvest." The recovery of individual innocence, paradise regained, is the same theme as the Final Judgment of all souls, taken singly. Barnes reports that "Innocent children being at the point of Death, did for the most part joyfully set forth the Praises of God: And . . . Sinners themselves . . . even willingly waited for Death."

Blake's elegy continues: "Such smiles were seen upon the face of the youth; a visionary hand wiped away his tears, and a ray of light beamed around his head! All was still. . . . The sorrowful pair lift up their heads, hovering Angels are around them, voices of comfort are heard over the Couch of Death, and the youth breathes out his soul with joy into eternity."

Both historian and poet interpret the Black Death as due to the

[44] This allusion to the decimation of mankind is so unobtrusive that some readers doubt the connection.

sins of its victims; yet if these sins originated in the sinful war policy of the King and the sinful Luxury of the nobility, why do king and nobility escape death, and for what sin do the masses die, "Nine of ten through the whole World"? Barnes does not say. Blake has put the argument in *Edward the Third:* "if ambition is a sin, we are all guilty in coming with [the King], and in fighting for him." In *The Couch of Death* those infected by the disease, both son and mother, take the guilt upon themselves ("My ways are sinful," "the arrows of sin stick in my flesh"); yet there is a suggestion in the image of arrows that some outside force has drawn the bow. Sin-and-repentance is here only the husk of an old formula; what bring joy and courage to the youth and mother are their rushing together and the replacement of a vision of hellfire by a vision of a new world of peace and golden harvests. Already, as in his paintings of Queen Emma and Jane Shore, Blake is moving toward his mature conviction that the whole doctrine of sin is a social and political fraud.[45]

5

Lord Bishop, what was rash in me, is wise
In you; I dare not own the plan. 'Tis not
Mine. Yet will I, if you please,
Quickly to the Lord Mayor, and work him onward
To this most glorious voyage. . . .
　　　　　—Lord Percy in *King Edward the Third,* scene two

In the year after Crécy and during the siege of Calais the Regent, Prince Lionel of Clarence, called a Parliament "for the Common Peace and Wealth of this Kingdom" and then directed it not toward peace but toward war, with a sensational revelation of French plans to invade England.[46] Blake's second scene, ostensibly

[45] The Couch of Death is a frequent symbol in Blake's drawings: the human body lying lifeless as a copper-gilt effigy, pillowed, supine, the bedclothes like fluted marble—suggesting also the meekness of those who, purged of all aggressive "ambition," are ready to inherit a new earth. Or, in the case of the "strong wicked man" who dies not in resignation but in terrified convulsions, a loss of all power to terrorize others, a ripeness for eternal fires that will burn away the not human.

[46] Barnes, pp. 387, 398.

dealing with this occasion, is a nice example of his modification of fourteenth-century matter to suit eighteenth-century issues. The specific modern parallel is the government's announcement, in the spring Parliament of 1778, of a secret French-American treaty. Blake replaces the early court's need of financial assistance from the merchants with the modern government's need to persuade merchants that a war which interfered with commerce was really good for commerce.[47] And he moves the royal convocation to a time before Crécy to relate it causally to the attack upon France.

Blake's Prince, the Duke of Clarence, opens his court with the pious declaration, not borne out by his subsequent martial announcement, of a royal wish to promote the peaceful arts of agriculture and commerce while the King "toils in his wars" on the other side of the channel. The "glory" of the King's victories will "not be dimm'd with clouds of care," says the Regent, if Edward, looking homeward,

> . . . sees commerce fly round
> With his white wings, and sees his golden London,
> And her silver Thames, throng'd with shining spires
> And corded ships; her merchants buzzing round
> Like summer bees, and all the golden cities
> In his land, overflowing with honey. . . . (ii:9–14)

When he gets down "to business," however, Clarence acknowledges that there are clouds on the horizon, that the French with "small ships of war . . . Infest our English seas, devouring all Our burden'd vessels" (compare the raids of American and French ships in English coastal waters in 1779), and that "The merchants do complain, and beg our aid." The court's problem is to persuade the merchants to arm and "bestir themselves" against the enemy, to do battle for the recently asserted right of Britons to be "sovereigns of the sea."[48]

Blake's interpretation of the relationship between court and city is clearly modern. By the time France and Spain had been drawn directly into the American war, the Wilkites had quarreled among themselves and lost the mayoralty (in 1778) to a wealthy contractor, and the anti-war coalition of merchants and artisans had suffered the defection of several merchants influenced by war

[47] See Clark, *British Opinion,* p. 224.
[48] ii:66–69, 76–79: E418/K20.

profits and royal graft. The buzzing of London's merchants was more like that of wasps than that of "summer bees"; the sudden prosperity of a few only intensified the bitterness of others who were forced into or close to bankruptcy.[49] Beside Clarence's words of innocence about "golden cities" and wartime commerce free of "care" we must read the words of experience in Blake's contemporary manuscript on Pride and Strife:

"Strife, Shapeless, Sitteth under thrones of kings, like Smouldring fire, or in the Buzz of Cities flies abroad. Care . . . Covet . . . Strife . . . Revenge . . . Policy . . . Guile & fraud . . . live in the Smoke of Cities, on Dusky wing breathing forth Clamour & Destruction. Alas, in cities wheres the man whose face is not a mask unto his heart?"[50]

In the 1790's when Blake wrote of the Thames as "dirty," he was returning to this theme, not discovering it for the first time.[51] Under the shadow of war, the Thames is not silver but dirty, the wings of commerce are dusky, not white, and the city is more smoky than golden. Blake's picture of London as a golden hive has been traced to Thomson's *Liberty* and *Summer,* in which "generous commerce" is hailed as a pursuit "for Britons, chief . . . reserved," but the implicit irony has gone unnoticed.[52]

Blake's Queen and lords spiritual and temporal preparing in court to lead the merchants into war are as cheerily rhetorical as are the King and his generals and minstrel preparing on the battlefield to "Let war stain the blue heavens with bloody banners." In each situation a youthful prince—Edward at Crécy, Clarence at court—"plays with danger, as the innocent child, Unthinking, plays

[49] Clark, chs. iv, viii.
[50] *T.S.B.* conclusion: E438–439/K42.
[51] "Dirty Thames" in the first draft of *London* was changed to "charter'd Thames" in the etched version.
[52] Lowery, pp. 141–155, makes out Blake's verbal and imaginal debt to Thomson. She observes that "Blake reflected nothing of the philosophy of nature Thomson set forth" and "none of Thomson's moralizing" yet assumes that Blake accepted Thomson's views on war and commerce without question.

Recently Robert F. Gleckner, in "Blake's Seasons," *Studies in English Literature,* v (1965), 533–551, has shown that in *Poetical Sketches* Blake's superficial debt to the eighteenth-century poetical milieu ("least of all to Thomson") is eclipsed by "his characteristic and exciting adaptation, *reversal,* modification, and even perversion of the traditions of poetry *and thought* which he inherited" (my italics).

upon the viper's den" (as Prince Edward says of himself) so that
we see the wisdom of William's observation that the ambitious
"may do a great deal of harm without knowing it." In contrast Sir
John Chandos and the Bishop, the advisers of these gullible and
thoughtless youths, are revealed as men of cunning (vipers).

We are explicitly warned in an aside that the "unfleg'd"
Clarence is being "imposed on by the closer sort!"[53] His notion
that commercial England can dwell in peace while the King toils
in his wars is not only contrary to Blake's iterated thesis, in
Gwin and *King John* and *Samson,* that war compels workmen to
abandon their tools and merchants to "leave the trading shore."[54]
It is also contrary to the manifest intent of his advisers. The
Bishop[55] utters for the Regent's benefit a comfortable homily on
the filial relationship of Commerce to Agriculture and assures the
"Sweet Prince" that "the arts of peace are . . . no less glorious
than those of war, Perhaps more glorious to the philosophic mind."
"O my good Lord," gushes Clarence, quite taken in, "true wisdom
drops like honey From your tongue, as from a worship'd oak!"[56]
But when the talk gets around to war, the Bishop quickly adjusts
"the philosophic mind" to the sentiments of *Rule, Britannia!* and
proposes to arm merchant vessels. Chandos' transition from defense

[53] And the Queen scorns as "giddiness" the Prince's wistful preference
for natural behavior: "I have been used so much To dignity, that I'm sick
on't." E417–418/K21–22.

[54] Those who read the play as an expression of jingoism on Blake's part
are equating the author with the most naïve of his characters, the "glittering
youth of courts" to use the phrase in *King John.* Yet in *I.M.,* only a year
after the printing of *P.S.,* see how deeply Blake mines beneath such naïve
characters as Little Scopprell.

The entry under "King Edward the Third" in Damon's *Dictionary,*
has it both ways: a paragraph accepting my reading of Blake's "moral
shrewdness" and "irony throughout the play"—and then a paragraph revert-
ing to the notion (even while taking it as Blake's response to the 1778
war) that the play expresses "uncritical patriotism"!

[55] Evidently the Archbishop of Canterbury, who was on Edward's naval
defense committee and whom Barnes (p. 119) credits with having caused
it to be "the Common Talk in England, that the King of England had
a Right to the Crown of France, which he intended to claim and pursue."

[56] William confused the oak and the creeping root of Ambition. Here is
further indication that the Druid oak is already for Blake a symbol of error
and evil. Damon's *Dictionary,* under "Oak," manages to have it that "the
Oak appears first in Blake as the protector of innocence"—but only by
ignoring the present passage.

of the cottage to extension of the castle is matched in the logic of the Bishop: from his first argument that agriculture is fostered by the promotion of trade it is but a step to his conclusion that trade is fostered by a war for sovereignty of the sea.

In 1778 authorized privateering and licensed monopolies were the persuasion used with ship owners, although in the House of Lords the Bishop of London wrapped in ethical sanctions his assertion that England had resources "enough to build a fleet large enough to protect this nation" by attacking France.[57] Blake's Bishop, anxious to persuade the merchants to arm and "help themselves," suggests the sanctions of national pride and of Britain's divine and natural right to rule the waves,

> . . . our right, that Heaven gave
> To England, when at the birth of nature
> She was seated in the deep, the Ocean ceas'd
> His mighty roar; and, fawning, play'd around
> Her snowy feet, and own'd his awful Queen.[58]

Here Blake parodies such imperial fantasies as those of James Thomson and William Mason.[59]

At this point the blunter parasite, Lord Percy, who has seemed opposed to putting pressure on the merchants, drops his mask to reveal that he is eager to share in what takes shape as no mere defensive armament but a glorious privateering campaign on which he will venture his "whole estate."

6

Had Blake managed to complete this broadly conceived history play, its unity with the simpler and more directly fervent sketches must have been self-evident. Even as it stands the work yields to

[57] *Parliamentary History*, March 17, 1778. Bishops and other ministers of Heaven figured so prominently in the war talk that they were accused in Commons of being "clothed in blood."

[58] ii: 79–83: E418/K20–21. In the first edition I followed Keynes in the reading "lawful Queen," but the original text of *P.S.* and recent editions of Keynes read "awful" (i.e. awe-inspiring). There are printer's errors in *P.S.*, but "awful" suits the context and Blake's general usage.

[59] See *Rule, Britannia!* ("When Britain first, at Heaven's command, Arose from out the azure main") and Mason's *Caractacus*, Act II.

analysis a consistent pattern of variations on the theme of a contrast between words of peace and deeds of war. The simple ideal expressed in *Prologue to King John*—of a golden haired Albion *not* stretching her spear o'er distant lands but "stretch[ing] her peaceful arms," "her citizens" thronging about the gates, her sons joying "as in the morning," her daughters singing "as to the rising year," and "her mariners" singing upon the sea: all exulting in peace without tyranny[60]—is mirrored in illusory forms in *King Edward the Third:* in the minstrel's perverse vision of an armed *pax Britannica*, the sons "in joy" buckling on armor, the daughters singing "surrounded with shining spears"; in General Dagworth's hollow promise of peace through war and his irresponsible declaration that the blood of those who "spend their sweet lives" in France will irrigate English prosperity; and in the honeyed thesis that London can be a peaceful hive even while English armies are sowing "the fiery whirlwind of swift war" in other lands.[61]

Blake significantly omits merchants from his list of war makers (kings, nobles, and ministers of God); but he is already cynical about their buzzing. He will seldom be found to condemn cities and commerce in themselves or without qualification, but when they are dusked with war clouds he will not say they are sunny and golden. Unless commerce is peaceful, he implies, it is not beautiful. Merchants do not rush into war. But kings and councilors, spurred by a love of combat and an ambition to rule the ocean and the nations, bring about a state of war. Bloodshed and plunder are sanctioned and glorified by corrupt ministers and minstrels. Mayor and merchants are then drawn into the business, and all share the profits of "rich harvest" and "glorious voyage."[62]

By the time *Poetical Sketches* was printed, in 1783, the wars were over, Tyranny had been shaken but not humbled,[63] the buzz of cities had begun to increase, and Blake himself had entered commerce and had got married. Before the end of the next year he

[60] E431/K34.

[61] v:49–54; v:56; i:48.

[62] iii:137; ii:95.

[63] For the slow effect of the American Revolution implied in the last plate of *America*—the icing over of fires, the twelve years of weak rule—see the last chapters of Vincent T. Harlow, *The Founding of the Second British Empire, 1763–1793*, Vol. II: New Continents and Changing Values, London, 1965.

wrote a complexly ironic satire, now called *An Island in the Moon*, upon the notions and ambitions of citizens of the busy hive—a satire which we may take both as an index of Blake's postwar experiences and as an answer to any lingering doubt as to his subtlety of mind or his awareness of the strife that sitteth under thrones of kings or flies abroad in corded ships.

Part Two

THE PEACEFUL 'EIGHTIES

Honour & Genius is all I ask
And I ask the Gods no more.
　—*An Island in the Moon*

5. English Genius and the Main Chance

IN MARCH 1782 a vote to discontinue the American War upset the cabinet of Lord North, and vital changes were expected by the patriots. Bills for political and economic reforms swept through Parliament in May and June with little opposition. Blake recapitulated the situation twelve years later in *Europe* by saying the air was "filld with immortal demons of futurity" who came in a cloud from America and bore "hard upon the council house, down rushing on the heads of Albions Angels." Twice King George actually drafted a message of abdication. Twice in two years Opposition ministries were forced upon him. "One hour" the King's Friends, "smitten Angels," lay "buried beneath the ruins of that hall" (*E*.9). But then they rallied under angelic young William Pitt; a cold and leprous tyranny (Urizen) was able to damp down the fires of revolt, "Hiding the Demon red with clouds & cold mists from the earth" and permitting "Angels & weak men" to govern once more "o'er the strong" (*A*.16). There was peace, and the treaties of 1783 were made, not of gingerbread this time, but of good wheaten bread. But it remained a question whether the people were any nearer to a fair slice of it.

Trade recovered rapidly from the first shock of peace and by the middle of 1784 had attained the vigor of "returning prosperity." Free America and Britain's distant possessions "flocked in quest of British wares" and afforded "a very large vent for the productions and acquisitions of British industry and skill." Of course as the flow of money increased, the uncertainty of its flow and the injustices in its distribution became increasingly apparent. Some who ventured their capital found they had "glutted the market and lost their former profits, and from the misjudging eagerness of avarice completely defeated their own purposes and become bankrupts." Yet "skilful and able traders continued to realize fortunes," and for a time the ambition of kings and ministers was obscured by the

multitudinous ambition of every citizen with a project or a little stock in trade to seek his fortune as one of the "skilful and able."[1]

In the autumn of 1784, having come into a small inheritance on the death of his father in July,[2] Blake took a step upward from the economic status of journeyman engraver by entering into partnership with James Parker, a somewhat older Basire apprentice, and venturing upon the manufacture and sale of engraved prints. Fortunes were being made on single issues—for printseller if not for artist or engraver. An engraving of Fuseli's *Night Mare* in 1783 brought the publisher £500. A mediocre engraver, Boydell, having gone shares with the engravers Ryland and Woollett on the latter's engraving of West's *Death of General Wolfe,* was able to finance a print-selling business that was expanding into a firm employing seven journeymen. The decently erotic and discreetly naked Floras and Venuses designed by Stothard and engraved by Blake, for Parker & Blake and later for himself, may not have missed the turn of fortune's wheel by very much.[3]

When James Parker and William and Catherine Blake opened their new print shop in comfortable quarters at 27 Broad Street, next door to the family hosiery shop, James a specialist in mezzotint, William in line engraving, and Catherine a grocer's daughter who had become Blake's wife in 1782 and was learning to color the prints and operate an engraver's press, doubtless they hoped to have fortune if not fame within their grasp.[4] We are able to gather the spirit of Blake's robust self-confidence at the time from the rollicking *Island in the Moon,* written during the first months of Parker & Blake and expressive both of a desire to make hundreds

[1] Bisset, II, 28. I draw upon Bisset's *History* (London, 1803) for its closeness to the newspapers of the day.

[2] Conjecture supported by the underscoring and double exclamation mark applied by Blake to Lavater's 157th aphorism: "Say not you know another entirely, till you have divided an inheritance with him." E576/K70.

[3] Only two extant prints have the "Parker & Blake" inscription: *Zephyrus and Flora* and *Calisto,* stipple engravings by Blake after Stothard, both pub'd Dec^r. 17, 1784. Apparently they meant also to stock the prints of others, and perhaps copies of prints they had made for book and magazine illustrations, of which several are extant.

[4] Catherine Butcher, or Boucher, was illiterate at marriage. We know that in 1803 Blake considered her an expert at plate printing, "& being under my own eye the prints are as fine as the French prints & please everyone." To James Blake, Jan. 30, 1803.

of thousands of pounds and of an intention to find time for writing and painting as well as engraving, the three being mentioned in that order.[5] After a year or so the firm was dissolved, having secured for its members neither wealth nor leisure; and in later years Blake and his wife would look back on the venture as a false step in the dark, Blake declaring that "exactly" at this time the light he had enjoyed in youth had been "closed from me as by a door and window-shutters" and that he had become "a slave bound in a mill among beasts and devils" with "my feet and my wife's feet" in fetters.[6] It is not clear whether the beasts and devils were fellow engravers and shopkeepers dehumanized in the mill of competition or potential customers insensitive to the values of Blake's art. Recalling the torment of this period he would write:

"We remember when a Print shop was a rare bird in London & I myself remember when I thought my pursuits of Art a kind of Criminal Dissipation & neglect of the main chance which I hid my face for not being able to abandon as a Passion which is forbidden by Law & Religion. . . ."[7]

Later he would name the cage, or the prison treadmill that he had walked into, Commerce.

The bitterness of these late reminiscences must not be antedated, however. It belongs to a time when other artists and other print dealers had succeeded while Blake was "hid" and could find little comfort in the thought that the work of rivals was somehow better "Suited to the Purposes of Commerce" (P.A.57). In 1783–1784 Blake at 26 was riding the crest of the wave. One admirer was trying to raise a subscription to send him to study in Italy. The famous Romney was telling people that Blake's "historical drawings rank with those of Michael Angelo." And he was not without employ-

[5] The MS of *An Island* is sometimes assigned a date of ca. 1784–1787, but there is every indication that it was written in the last months of 1784. (In sum, the indicators are an abundance of allusions to events and fashions of 1784, including the death of Johnson in December—this, possibly, anticipated in fancy—, the lack of allusions to topics of 1785, and a reference to the exhibition of "next year"—not appropriate in January–May.)

[6] Blake's "exactly" refers back twenty years from Oct. 23, 1804. Letter to Hayley: E703/K952.

[7] To Cumberland, July 2, 1800: E679/K798.

ment as an engraver, although even then "his encouragement," according to his friend John Flaxman, was "not extraordinary."[8] Blake of Parker & Blake was not above catering to the tastes of print collectors who wanted pretty, sentimental drawing that was mildly erotic and that mirrored current illusions without disturbing them. The only prison mentioned in *An Island in the Moon* is "Matrimony's Golden cage"—for if a young artist has only himself to care for he can make his competitors "look foolish," we are told —and it would seem that he chooses "to make game of Matrimony" largely from an excess of high spirits.[9]

Probing questions are laughed aside, and out of the sly ironist and angry prophet of the *Poetical Sketches* emerges the self-professed Cynic of *An Island*. "William" who laughed at the antics of the mounted nobility and questioned the ambition of the King has become Quid the Cynic who makes game of everyone's ambitions, including his own, and mingles laughter at the pursuers of the main chance with laughter at the pursuers of Art. If we detect a sour note even here, a hint now and then that the merriment is but another mask, then we have discovered that the author himself is acutely aware that cynicism is close to opportunism. This closeness and the author's variously ironic revelation of it provide both the mirth and the intellectual tension of Blake's 1784 satire.

2

"In the Moon [Blake's satire begins] is a certain Island near by a mighty continent, which small island seems to have some affinity to England, & what is more extraordinary the people are so much alike & their language so much the same that you would think you was among your friends."[10]

The invitation to see the real England and hear the voices of real people known to the author is unmistakable, and it used to be said that *An Island in the Moon*[11] represented Blake's angry turning away from the bluestocking salon of a certain Mrs. Mathew.

[8] *The Letters of William Blake*, ed. Archibald G. B. Russell, London, 1906, p. 52.
[9] *I.M.*viii, ix: E447, 451/K53, 57.
[10] *I.M.*i: E440/K44.
[11] The title is not Blake's but comes from the opening words.

Guesswork has managed to populate Mrs. Mathew's drawing-room but not with suitable originals for Blake's caricatures—nor is the satire really upon bluestockings.[12] A more recent hypothesis, that Blake is satirizing the members of a London off-shoot of the Birmingham Lunar Society which met at Slaughter's Coffee House, is merely an exaggeration of the highly conjectural proposition that "inflammable Gass the Wind finder" is Joseph Priestley of the Birmingham Society. But to look for a men's club in place of a bluestocking salon is to move even further from the text.[13] [13a]

[12] Gilchrist and Wilson and others have built so fictionally upon the meager account by J. T. Smith (Symons, pp. 358–360) that one is tempted to throw aside the whole "Mathew legend." Palmer Brown, however, and later G. E. Bentley, Jr. (*BNYPL*, LXVII [1963], 443–454) have found record of an actual Mathew family—or rather several acquainted but only partly related families. We may take Smith's word that Blake knew some of them, but we must approach *I.M.* without the bias of the legend.

Flaxman's aunt Jane Matthews, not one of Smith's Mathew family, with her husband John, sold books and prints in the Strand (e.g. selling prints for Bartolozzi in January 1784), and Bentley surmises that it may have been she and/or her husband—not the Rev. A. S. Mathew indicated by Smith—who, with Flaxman, in 1783 took care of the printing of Blake's *Poetical Sketches*.

[13] I have but recently come to doubt the identification of Blake's Windfinder as Priestley. The objections raised by Nancy Bogen in *Satire Newsletter*, v (1968), 110–116, and more extensively in a forthcoming study, are in the main valid; the slight link to Blake, my conjecture that the "Basire" engravings of Priestley's apparatus may have been drawn by Blake, vanishes with proof that Priestley made his own drawings for the engravers; it has not been possible to house the historical Mr. and Mrs. Priestley in London for the Flammables' entertainment of the Islanders; the few slight indications I noted of Blake's acquaintance with writings of Priestley's might enter his caricature of any contemporary chemist-philosopher. There is also Martha Winburn England's broad and suggestive reconstruction (in "Apprenticeship in the Haymarket," *BNYPL*, LXXIII [1969]) of the topical London matinee theatre of Samuel Foote and his imitators as the probable genre and source for Blake's "piece" (as Blake calls *I.M.*). "Blake used Foote's own formulaic jokes, and used them as Foote used them on stage. . . . any audience Blake had in mind would recognize . . . the cat, the Antiquarian Society, the College of Surgeons, the Robin Hood discussion group, the lecture based on microscope slides—these were jokes of ancient and reverend ancestry." The genre includes the mocking of contemporaries the audience recognizes; Blake's friends will know that Steelyard is Flaxman, Tearguts is Jack Hunter, who the Philosophers are, and the Flammables, but without the precise clues given for Steelyard, Tearguts, Jacko, Quid and Suction, we may easily guess wrong.

In 1951 Palmer Brown urged the identification of Inflammable Gass as

These legends, especially the one presenting Blake as a simple youth singing his woodnotes wild among the cognoscenti, have diverted us from Blake's essential canniness which smouldered in the ambiguities of *Edward the Third* and now bursts forth in

Gustavus Katterfelto, conjuror and empiric, and my resistance to the idea was perhaps unduly influenced by the fact that I had already written this chapter. Brown sent me copies of newspaper announcements of 1783 from the *Morning Post* (Jan. 1 and June 27), *Morning Herald* (Apr. 22 and 28), and *Gazetteer* (May 28) of Katterfelto's "Lectures in Natural Experimental Philosophy and Mathematics" morning, noon, and evening in Piccadilly, assisted in his "experiments" by his wife; among his stage properties was a "new-improved Solar Microscope" by which he demonstrated "that a man is a lump of corruption; for every thing he eats, and every thing he drinks, abounds with insects" (carriers of plague, as we know: see above), also "an air pump so capable of refining the quality of air, as to kill with its salubrity" (I quote the June *Morning Post*). In 1784 he added, to keep his audiences, some pseudo balloon ascensions, perhaps making the most of the excitement of inflammable gas; "Let us fly up to de Sun Mr Katerfelto" is the caption on a print of Jan. 1, 1784, *Montgolfier and Katterfelto Taking an Airing in Balloons* (B.M. Satires, no. 6705). As Brown argued, though Blake may have had Priestley in mind, there are certain burlesqued traits of Inflammable Gass—the barker-like "Here, ladies & gentlemen, I'll shew you a louse &c &c" evocative of the sideshow; the maid tripping in with the paraphernalia, the magic-pictures, the lethal air pump— which any Londoner who read his daily newspaper in 1782–1784 would instantly associate with the Piccadilly conjuror. Even the behavior of Blake's youthful Islanders, smearing the glass, breaking the air pump—and the wind-finder's outraged reaction (he "turnd short round & threw down the table & Glasses & Pictures" etc.)—echo the described behavior of youths and lecturer at Piccadilly: "Here the drunken bucks, or frothy fools, unwilling to improve, and unable to amend, kick up a dust . . . and madly break, or meanly pilfer, some of the apparatus . . . till the philosopher, forgetting the first principle of his profession, a command of temper, breaks into a paroxysm of rage, vented in half English, half German, puts on the terrific death's head Hussar cap worn by his grand father the General, till the champion of confusion . . . discamping, he resumes his lectures" (*M. Post*, June 27, 1783).

Nevertheless, Inflammable Gass is not presented *as* Katterfelto; the setting is domestic; the experiments are shown to a few friends and relatives (Mrs. Inflammable being Miss Gittipin's "cousin").

[13a] Stanley Gardner (pp. 63, 65) has suggested Dr. George Fordyce, chemist and physician who supplied the hydrogen ("inflammable gas") to lift Lunardi's balloon on its Sept. 15 London ascent—or Henry Cavendish (1731–1810), discoverer of the constitution of water and atmospheric air, "who was working on arsenic in 1784 at 13 Great Marlborough Street, near [Blake at] Broad Street, and was a greater authority on 'inflammable gas' than Priestley."

caricatures at once ingenious and outlandish of Jack Hunter, the print-collecting surgeon, of John Flaxman, the saintly impecunious sculptor, and of a dozen other friends and acquaintances of the first months of Parker & Blake. Author, antiquary, bookseller, inventor-preacher, attached and unattached females; they constitute if anything a Blake set.

Far from turning away from the people he caricatures (including himself as Quid the Cynic) Blake appears to delight in drawing out, as if he were a Jane Austen tapping a Kitty Bennet's flow, the conversation of even his most worldly friend, Miss Gittipin. If we listen with him to the chatter of this woman who is so eager to *get up in* the world of fashion, we may observe that Blake as printseller has properly filled his mind with a knowledge of the latest ephemera. Her particular envy is the wealthy Miss Filligreework, who can afford to live up to the moment: "she goes out in her coaches & her footman & her maids & Stormonts & Balloon hats & a pair of Gloves every day & the Sorrows of Werter & Robinsons & the Queen of Frances Puss colour & my Cousin Gibble Gabble says that I am like nobody else. I might as well be in a nunnery" (viii).

London engravers, whose swift etching of fashion plates was challenging Parisian work even in the export market, were perforce acquainted with balloon hats, "Robinson" hats and gowns, and Marie Antionette's puce (flea) color. The balloon bonnet, a bulky linen case stuffed with hair *à la Montgolfier* or *à la Lunardi,* was in vogue for a few months around the time of Lunardi's balloon ascent from the London artillery ground in September 1784. The fall *Lady's Magazine,* a publication for which Blake is said to have engraved some plates, discussed it as an "absurd style" except for women "in affluent circumstances"; the same journal had previously dealt from time to time with various splendid apparel introduced by Mrs. Mary "Perdita" Robinson, the actress and poetess who had been mistress to the Prince of Wales and was now, on pension, leading the *ton*.[14] At least seven painters, including

[14] Even Miss Filligreework's "Sorrows of Werter" was a hat, not the book itself. A "Robinson gown" is noted in the April 1783 *Lady's,* a "Robinson hat for Ranelagh . . . introduced by Mrs. Robinson" in May, a variant "Robinson hat" in December. The "air baloon hat" is featured in *Town and Country Magazine* for May 1784.

According to historians of the matter, hat styles changed seventeen times "in the course of two years, from 1784 to 1786." Miss Anne Buck of the Gallery of English Costume, Manchester, advised Palmer Brown in

Romney, Reynolds, and Cosway, supplied the engravers with por-
traits of Mrs. Robinson before her fashionable career was termi-
nated, at the end of 1784, by a crippling accident.

Richard Cosway, a mushroom-rich miniature painter and a
fabulous dandy, is probably the original of Miss Gittipin's other
idol, "Mr. Jacko." Jacko was an "astonishing monkey from the
fair of St. Germain's Paris" that performed at Astley's Amphi-
theatre during the summer of 1784:[15] Cosway was laughed at for
his monkey face and called "little Jack-a-Dang." His mulberry
silk coats scandalized the sober, but his charming Maria attracted
the aristocracy of wit and fashion to her concerts and assemblies.
Miss Gittipin says of Jacko: "He knows what riding is & his wife
is the most agreeable woman you hardly know she has a tongue in
her head and he is the funniest fellow . . . & they have black
servants lodge at their house. I never saw such a place in my life he
says he has Six & twenty rooms in his house, and I believe it & he is
not such a liar as Quid thinks he is."

In 1784 the Cosways were entertaining in Berkeley Street, where
they "kept a black servant, who published an octavo work upon
Slavery." Later, despite the envy of many artists, they moved to
quarters even more lavish, with roof garden and greenhouse.[16] The

1952 that "the *Balloon* cap and the *Robinson* had . . . vogue from late
1783 to the last months of 1784 when they were both referred to as
going out. The *Werter* is the latest in point of time, and was in vogue from
late 1784 to mid-summer of 1785." Miss Gittipin speaks when the latter
two hats were in competition (as a newspaper item of Dec. 16 indicates);
by Jan. 13, 1785, the forces of the *Werter* had prevailed.

"An Excursion to the Moon" by "Humgruffier" and "De Gull" is the
subject of an anonymous engraving issued by J. Basire, Feb. 20, 1784, one
of numerous satiric prints on balloon ascents. *B.M. Satires,* VI, no. 6707.
(This is the only Basire satire in the British Museum collection.)

[15] See *B.M. Satires,* VI, no. 6715, by S. Collings, several of whose drawings
Blake was engraving for the *Wit's Magazine* at this period.

[16] George C. Williamson, *Richard Cosway,* London, 1905, p. 32; and, for
envious attacks on Cosway, Whitley, *Artists,* II, 35–49, 113–119. Cosway
"had worked his way through drawing school by fetching and carrying";
at Pars's he "had done shameless miniatures for snuff-box lids to suit the
taste of the dandies. By 1771 the ragged boy had become a full Academician.
Ten years later he married the Italian daughter of an Irishman who ran
an inn at Leghorn, and, being socially alert, kept her in seclusion till she
had learnt to speak and behave as the English—which accounts for Miss
Gittipin's remark about her quietness" (Gardner, p. 64).

Gardner (p. 65) points to a nuance that had escaped me in Miss

material rewards of the fashionable painter, held up for envy by Miss Gittipin, are thus held up for ridicule by the satirist—yet he too is touched by envy. Of Quid-Blake the speaker adds, in a line subsequently crossed out: "but he is always Envying."

The persons of Blake's satire gather chiefly in "the Philosophers house," where Quid and Suction live and Obtuse Angle has his study, and in minor eddies in "the house of Steelyard the Lawgiver" and "the house of Inflammable Gass." The central stage is Quid's parlor, where three Philosophers sit "together thinking of nothing," "Suction, the Epicurean, Quid the Cynic, & Sipsop, the Pythagorean," enjoying a special camaraderie and some private mirth at the expense of the others. As the story opens these three are greeting guests absently, "the Cynic smiling the Epicurean seeming studying the flame of the candle & the Pythagorean playing with the cat." They listen "with open mouths to the edifying discourses," but talk rather seriously when the guests are gone. Sipsop, who is a medical student, confides his misgivings about the cruelties of surgery, and at length departs.[17] Quid and Suction, left alone, ex-

Gittipin's "I do believe he'll go in partnership with his master": "Cosway . . . is said to have earned £10,000 a year from the Prince of Wales who (no less) is the 'master' Miss Gittipin mentions. . . . so close was Jacko to the throne that he had a private way from his house to Carlton Palace Gardens." Carleton Palace was the Prince's residence.

In the 1790's we find Cosway praising Blake's designs and turning employment his way; after 1809 when Blake was venting his frustrations upon former "friends," Cosway is one who feared "to associate with Blake" (N.37). By this time Cosway was a Swedenborgian and a believer in Mesmerism.

[17] A likely Sipsop appears in the "Dr. Mathew" whom J. T. Smith in 1828 calls "my worthy friend" and "the late John Hunter's favourite pupil" (A Book for a Rainy Day, London, 1845, p. 96; Nollekens and His Times, London, 1828, II, 435). This was William Henry Mathew, fifteen in 1784 (when Smith was eighteen), the Mathews' son. Mrs. Bogen, in the article cited above in note 13, was confident that Sipsop was, "in reality, the son of the famous Mrs. Mathew"; in 1951 Brown and I had been almost confident. Currently Mrs. Bogen inclines to an impression of Sipsop as nearer the end than the beginning of surgical apprenticeship— and thus more probably Dr. John Abernethy, who was 20 or 21 in 1784 and whom Blake in 1826 (in a letter to Linnell) remembered with pleasure.

Even accepting the identification of Sipsop as Mathew, we still have no Mathew circle in I.M. Sipsop refers to his father (not present) but not to his mother, and none of the action takes place at his house. As a highly conjectural identification Mrs. Bogen suggests Mrs. Sigtagatist as a

change private boasts of their literary and artistic ambitions, and "so . . . to bed."

This is no bluestocking salon but the home of the central figure, Quid, who has always been recognized as an extravagant self-portrait of Blake himself. Obtuse Angle, who has a study in the house but does not seem to live there, may just conceivably be Blake's partner James Parker. He is called "the Mathematician" perhaps in the same metaphorical spirit in which another artist is called "the Lawgiver." Parker was a solid citizen seven years Blake's senior, a commercial engraver "not very distinguished as an artist, but greatly respected for his amiable disposition, integrity, and good sense."[18]

There is rather more to support the conjecture that mirthful, impatient Suction, who sleeps in Quid's house and shares his most intimate thoughts, is Blake's favorite brother Robert, whom he had been teaching to draw since 1777, who in 1784 was 22, the age at which William had first exhibited at the Royal Academy, and who "made one in the family" at 27 Broad Street, according to Gilchrist. Robert, who died in February 1787, never attained exhibition status, but doubtless wished to do so. If we take the following midnight dialogue as a demonstration of the intimacy and interlocking ambitions of William and Robert Blake in 1784, we can match it in the juxtaposition of their drawings in a 1777–1778 sketch-book and of the poems of William and the drawings of both brothers in the famous notebook which William continued to

caricature of Mrs. Mathew, whose learning or pretensions to it may be assumed to be respected by the company since no one challenges her taking Mrs. Nannicantipot to task for being "an ignorant jade." (But none of the action occurs at her house either.) This hypothesis, combined with the hypothesis of Mrs. Nann as Mrs. Blake the unlettered, ties a knot of fancy on Mark Schorer's hypothesis that Blake's break with the Mathew clan resulted from his wife's unsophistication. If we must repopulate the legend by guesswork, we may as well let Smith himself be that "skipping flea," Little Scopprell, if only for a vague character resemblance.)

[18] *Memoirs of Abraham Raimbach, Engraver,* London, 1843, p. 36. Yet there seems more to Obtuse than to Parker; as Mrs. Bogen observes, "his tool is not a burin, but a *quadrant,* and his work is performed in a *study.* . . . More than likely, the man . . . was some sort of tutor or schoolmaster"; both of his songs have to do with education; he is a pedant; "his relationship with Aradobo, Tilly Lally, and Little Scopprell . . . bears a striking resemblance to that of a teacher with his students." Unhappily we know of no one whose study was located in Blake's house.

use for intimate thoughts and songs of experience after Robert's death.[19] Quid expresses his poetic ambition with outrageous self-confidence: "Then said Quid I think that Homer is bombast & Shakespeare is too wild & Milton has no feelings they might be easily outdone. Chatterton never writ those poems" (vii). He will outdo Shakespeare and Milton by dismissing them as wild and unfeeling, Chatterton by finding out that he never wrote. His companion expresses the ambition of the painter, though it was William and not Robert who sent four water colors to the Academy for the next May exhibition, his last for many years: "If I dont knock them all up next year in the Exhibition Ill be hangd said Suction. hang Philosophy I would not give a farthing for it do all by your feelings and never think at all about it. Im hangd if I dont get up tomorrow by four oclock & work Sir Joshua—"[20] Suction has evidently been stirred by Reynolds' admonition to ambitious students to "go to work, willing or unwilling, morning, noon and night."

"—Before ten years are at an end said Quid [Blake's thoughts now jumping to the challenge of his rivals in engraving, 'lumps of Cunning & Ignorance' such as Woollett and Strange, who 'etch'd very bad' but won fame and fortune] how I will work these poor milk sop devils, an ignorant pack of wretches.

"So they went to bed."

Poetry to outdo Homer and Shakespeare, painting to knock them all up at the Academy, and cunning to escape being bound in a mill among ignorant devils. Behind Blake's confidence lies the vision of a man who has his own mill and who begins to see a way to replace the division of labor with the harmony of One Man, to renew and join together the arts of poetry and painting without going outside his own shop and his own head. Blake might scoff at the experi-

[19] See Keynes, *Blake Studies*, p. 7 and pl. 2, for the folio sketch-book inscribed "Robert Blake's Book 1777," now at the Huntington Library.

[20] The four paintings sent to the Academy may reflect some of the artist's feelings of self-justification: *The Bard, Joseph making himself known to his Brethren, Joseph ordering Simeon to be bound,* and *Joseph's Brethren bowing before him.* If Blake's more worldly brethren had known they had a Joseph in their midst they might have bowed before him instead of inquiring into his monthly profits. For William's relations to James, the businessman of the family, see letter of 1803.

ments of anatomy and chemistry, but he would not hesitate to apply "Mr. Birch's Electrical Magic" to his wife's "rheumatism."[21] Our Cynic shares the enthusiasm of his age for projects and inventions. "Honour & Genius is all I ask," professes Quid, but the junior partner of Parker & Blake has noticed George Cumberland's announcement in October of a New Method of Printing which will eliminate the setting of type.[22] To a somewhat inattentive auditor, apparently Miss Gittipin,[22a] Quid explains that he will "have all the writing Engraved instead of Printed & at every other leaf a high finishd print." He will be able to "Print off two thousand" copies of his own work, and in "three Volumes folio" (note that hyperbole has crept in) he will "sell them a hundred pounds a piece." The dream of grossing two hundred thousand pounds is fantastic, but his giddy auditor exclaims innocently: "whoever will not have them will be ignorant fools & will not deserve to live" (xi: E456/K62).

Cumberland's scheme saved the cost of composition but required the still more costly labor of a writing engraver who could do hand lettering in reverse. Blake ultimately worked out a simple transfer method for getting around this difficulty, some crucial secret of the process being revealed to him by Robert Blake in a dream after Robert's death in 1787. The first small publications (three tiny sets of aphorisms) were ready in 1788. By 1793, however, he would have an inventory comprising six various "Illuminated Books . . . Printed in Colours . . . on the most beautiful wove paper that could be procured," and he would announce that he had "invented a method of Printing both Letter-press and Engraving in a style more ornamental, uniform, and grand, than any before discovered, while it produces works at less than one fourth of the expense."[23] "Even Milton and Shakespeare" had not been able to "publish their own works." Though preparing to outdo them first in the realm of commerce, Blake felt that by combining

[21] To Hayley, Oct. 23 and Dec. 18, 1804.

[22] In Maty's *New Review;* but Quid's following description of the process is much closer to the language of a private letter of Cumberland early in 1784 to his brother Richard (". . . you may print 4 editions, 2000 and then sell the Plates . . .") quoted in Geoffrey Keynes, *Blake: Poet, Printer, Prophet,* New York, 1964, p. 13, and may have come directly from Cumberland, already a friend though it is hard to think who he might be in *I.M.*

[22a] Or Mrs. Nannicantipot, on Mrs. Bogen's conjecture. But I hesitate to suppose that Blake had changed Kate into Nan.

[23] Prospectus, Oct. 10, 1793: E670/K208.

"the Painter and the Poet" he was pursuing the main chance without neglecting art. Not reckoning his own time closely, he felt "sure of his reward."

With such grand and extravagant projects revolving in his head, Quid could afford to smile enigmatically at his friends as he imbibed "rum & water" and roared:

> Honour & Genius is all I ask
> And I ask the Gods no more
> No more No more ⎱ the three Philosophers
> No more No more ⎰ bear Chorus

(iii)

Yet the satire pierces Quid's protestations of honorable ambition, reducing them to egoism and envy. In an earlier monologue, Blake had written:

"My Cup is fill'd with Envy's Rankest Draught; a miracle No less can set me Right."

"Envy hath a Serpents head . . . her poisnous breath breeds Satire . . . from which none are free. . . . while others in Contentments downy Nest do sleep, it is the Cursed thorn wounding my breast that makes me sing. However sweet, 'tis Envy that inspires my Song. Prickt by the fame of others how I mourn, and my complaints are Sweeter than their Joys. . . ."[24]

In 1784 the kind of envy that breeds satire is that of the artist and artisan who is anticipating the taste of success and is especially perceptive of the element of opportunism in himself and in all his associates.

The surgeon (at first given the actual name of the famous Jack Hunter but then metamorphosed into "Jack Tearguts") is indifferent to the crying of charity patients "that have it done for nothing." The surgeon's apprentice, Quid's intimate Sipsop, called a Pythagorean because he has the squeamishness of a vegetarian, is more conscientious but admits that mutual envy prevents one professional from trusting another: "Ah," says he to the poet and the painter, "you think we are rascals & we think you are rascals."[25]

24 *T.S.B.:* E437–438/K41.
25 *I.M.*vi. The blunt and impatient Jack Hunter (Tearguts) was an anatomist, a print collector, and a friend of Blake's rival, Woollett. The Hunters lived not far from Blake at No. 28 Leicester Square, with their

Aradobo, "Dean of Morocco" (bookworm, perhaps, rather than bookseller, considering his youth), seems indifferent to the aesthetic and cultural components of artistic genius; even of "the God of Physic, Painting Perspective Geometry . . . Mythology Astrology Osteology . . ." he must ask "if he understood Engraving."[26] The Enlightened philosopher continues "to go to church" to hold down "a place of profit" (iv). And

> Theres Doctor Clash
> And Signior Falalasole
> O they sweep in the cash
> Into their purse hole
> Fa me la sol La me fa Sol.[27]

Wretched musicians sweep in the cash while Youth and Genius starve. And consider Chatterton. Not only did he eat very little and so die, despite his genius: now his reputation is being slain at the

Hunterian Museum; next door was the widow of Hogarth; across the square Reynolds. For Blake's later use of Hunter's embryology, see Carmen S. Kreiter, "Evolution and William Blake," *Studies in Romanticism*, IV (1965), 110–118.

The notion that Sipsop is Thomas Taylor the future Neoplatonist does not hold water and is properly rejected in Harper's *Neoplatonism of Blake*, p. 40. Harper wants Taylor in Blake's circle, however, and decides that "a much more plausible role is that of Obtuse Angle." None of Blake's mirth at the obtuseness of Obtuse Angle is admitted into Harper's book, though; indeed a quite different book would be required to picture Taylor in this "role" in relation to Quid-Blake.

[26] *I.M.*iii. Here the satire touches Blake's ambition: the list is based on the text-book requirements for "history-painting." According to Jonathan Richardson's *Theory of Painting*, London, 1715 *et seq.*, a history painter must be "a good historian," "a good poet" and "absolutely" must "understand anatomy, osteology, geometry, perspective, architecture and many other sciences. . . ."

[27] *I.M.*xi. This burlesque of the 1784 Handel festival probably reflects the special pleading of James Barry, the unrequited muralist. In 1783 the first exhibition of his murals was attended by 6,541 persons. Only 3,511 attended in 1784 when a greater attraction was the jubilee of Handel's music. Barry complained "that £1,800 had been squandered that year upon a 'Jubilee of hackneyed German music . . . an empty hubbub of fiddles and drums which was dissipated in the air as soon as performed,' while his pictures were neglected." Wright, I, 15. Cf. Blake's concluding stanza.

Martha England, as cited, points to Doctor Catgut (pillorying the respectable Dr. Thomas Arne) in Foote's *The Commisary* (1765, produced at Covent Garden in 1782) as the model for Blake's gentler Doctor Clash.

hands of the smug Antiquary, Etruscan Column, who calls Chatterton's poetry "wretched paltry flimsy Stuff" while he expects his own dull volume to bring him "eternal fame" (i), and by the bookseller's pragmatic obituary: "Chatterton was clever at Fissic Follogy, Pistinology . . . Hogamy, Hatomy, & hall that but in the first place he eat very little wickly that is he slept very little which he brought into a consumsion, & what was that that he took Fissic or somethink & so died" (v). Chatterton may have been as great as Phebus, Giotto as great as Pindar, but in the end their reputations are cut up or ignored by some "nasty ignorant puppy" like Plutarch or Aradobo (vi).

"English genius forever here I go," is Quid's cry, but the opportunism of the purse hole and the contrast between aims and results—in the arts, and in chemistry, surgery, politics, and marriage—elicit sardonic mirth throughout *An Island in the Moon*.[28] And beneath the appearance of social intercourse, everyone's face is a mask unto his *lack* of heart. Mrs. Gimblet "seemd to listen with great attention while the Antiquarian seemd to be talking of virtuous cats,[29] but it was not so"; and each Philosopher was "endeavouring to conceal his laughter, (not at them but) at his own imaginations" (i). The contrast between appearance and reality in the realm of communication lies at the center of Blake's satiric method, but it relates to more than method. It touches the contradiction between individual enterprise and social vacuum, and we come to suspect the common humanity of the Islanders. As one says to another, "they hate people who are of higher abilities than their nasty filthy Selves" (xi) and at times they appear to be a collection of animals and insects.

"I think your face . . . is like that noble beast the Tyger," says Quid to the woman whom he has already induced, in the antic manner of Hamlet with Polonius, to agree that his own is "Very like a Goats face."[30] As a satirist Quid can enjoy the contrast

28 *The Downfall of Taste & Genius or The World as it Goes* is the title of the Collings print cited above for "Jacko."

29 Vivian de Sola Pinto, in his *William Blake*, New York, 1965, p. 181, suggests that the Antiquarian may have been talking about "virtuoso casts" —but Mrs. England points out that one of Foote's routine parodies was a meeting of the Society of Antiquaries discussing Whittington's cat, eminent for feline virtue.

30 Damon, p. 266, notes the allusion to *Hamlet*. Yet here again we may observe artists at play. William Sharp, for instance, "had some eccentric

between his own ironic alertness and his auditor's innocence or ignorance. A later Blake will address his *Jerusalem* to the public as "Sheep" and "Goats." But this view reveals such gaps between mind and mind as may be too wide for wit to leap. Can a tiger understand a goat? Or in any meaningful way can a goat envy a monkey (a Jacko)?[31] One cannot communicate with an insect, and the stupidest Islander, Little Scopprell, provokes Quid himself to incoherence: "What you skipping flea how dare ye? I'll dash you through your chair says the Cynic. This Quid (cries out Miss Gittipin) allways spoils good company in this manner & its a shame" (ix).

These lines are crossed out. The mirror was being held too close for good mockery; besides, as Blake once said of "Caricature Prints, which ought not to abound so much," "Fun I love but too much Fun is . . . loathsom."[32] But the breakdown of communication and the substitution of violence for intellectual persuasion is the limit which Blake's fun constantly explores—to the ruin of good company. In chapter i Etruscan Column, worsted in argument, prepares to give "a formal answer" with his fists. In chapter iv Mrs. Sigtagatist describes how her preacher "would kick the bottom of the Pulpit out" and "cry & stamp & kick & sweat and all for the good of their souls."[33] Whereupon even the sensible Mrs. Nannicantipot advises passionately knocking down the "passionate wretch." And at the end Quid proposes to his friend a duet of bellowing and stamping to "frighten all the People there & show them what truth is."

All this fun is a demonstration of "what truth is" in Babel. And

notions on the subject of physiognomy . . . that every man's countenance had depicted on it the appearance of some bird or beast. . . . Thus in those whose dispositions were generous and courageous, he fancied he could discover the likeness of a lion; in those who were fierce, he saw that of tigers or eagles," etc. W. S. Baker, *Sharp*, p. 25. But it is not clear whether Sharp held these notions before 1789 when he and Blake were engraving plates for Lavater's *Essay on Physiognomy*.

[31] Compare the animal "Proverbs" in *M.H.H.* and Oothoon's questions in *V.D.A.*

[32] To Trusler, Aug. 23, 1799: E676/K793.

[33] The enthusiastic Mr. Huffcap, whose theatrical preaching she enacts, would have been taken for the "mighty Whitefield" (similarly parodied in Foote's "Squintum"), field-preaching from portable pulpit, "In his wooden palace jumping/Tearing, sweating, bawling, thumping" (Chatterton, *Journal* 6th), as both Palmer Brown and Martha England testify.

this fellow Quid is akin to Dagworth's man William, who knows truth "by instinct, while reason runs aground," and to many a Shakespearean "fool" including Hamlet. The author of *An Island* is the author of *Edward the Third* enjoying his rum and water. But in its merrier aspects the role of Quid is one he will seldom play. In later life Blake will have to content himself with porter's ale; he will become more than jestingly convinced that the insights of one's "own imaginations" are incommunicable; and his inclination to believe that others are nastily envious of his abilities, and to be "always envying," will be carried to the verge of paranoia.

3

Prosperous and peaceful as the times were, there were moments when one felt anxiety, fancied "storms arising, which already 'no bigger than a man's hand,' will by and by overspread and blacken the whole face of heaven." So William Wilberforce expressed himself in a letter of 1785. It was not "the confusion of parties" that alarmed one but "the universal corruption and profligacy of the times, which taking its rise amongst the rich and luxurious has now extended its baneful influence and spread its destructive poison through the whole body of the people. When the mass of blood is corrupt, there is no remedy but amputation."[34]

In Blake's satire when the goatish Cynic and his intimates join the more sheeplike Islanders, "lowring darkness" is said to hover "oer th assembly" (v)—a curious burlesque anticipation of a symbol which, in Blake's later prophecies, always presages war or other disaster. In the chapter of *An Island in the Moon* in which the merry company visit Inflammable Gass and his wife Gibble Gabble,[35] the careless Islanders are pictured as going out of their way to bring upon their world a visitation of the plague:

"Thus these happy Islanders spent their time but felicity does not last long, for being met at the house of Inflammable Gass the windfinder, the following affairs happend.

[34] *Life of Wilberforce*, by his sons, London, 1839, I, 84.
[35] One difficulty with my previous acceptance of these as caricatures of the Priestleys was lack of evidence that Mrs. Priestley was with her husband or that he or they had any domestic establishment during his three or four weeks in London in April and May 1784.

"Come Flammable said Gibble Gabble & lets enjoy ourselves. bring the Puppets.

"Hay Hay, said he, you sho, why ya ya, how can you be so foolish. —Ha Ha Ha she calls the experiments puppets. Then he went up stairs & loaded the maid, with glasses, & brass tubes, & magic pictures." (x)

Calling the experiments puppets would remind Londoners of Samuel Foote's satiric use of puppets, real and imaginary. The whole scene would remind them of Foote's microscopic slide lecture satirizing Sir William Browne, President of the College of Surgeons, as Dr. Hellebore.[36] The "magic pictures" were in truth more for amusement than for experiment. Blake's broad caricature of the absent-minded preacher-chemist may be inspired by contempt for science, as Damon suggests, but the nature of that contempt is complex. Blake is dealing in contrasts when he shuffles together two different kinds of apparatus in the action that follows, a table microscope with "sliders" of insects to amuse, and a delicate blown-glass air-pump for experiments with that dangerous plague-bearing element, Phlogiston. It may have been the sight under Katterfelto's shilling-a-look Solar Microscope of "those insects which were the cause of the Influenza last Spring"[37] that inspired Blake's later vision of the *Ghost of a Flea;* but the microscope even in such hands as Priestley's was put to little scientific use; the serious business, in Priestley's, was the "pumping at the air-pump."

"Here ladies & gentlemen said he Ill shew you a louse or a flea or a

[36] "Dr. Hellebore shows under the microscope the yellow insects which cause jaundice, and the spiders which cure it by eating the flies." Martha England, as cited. Here, or in this kind of demonstration (for Katterfelto did the same thing), we can see a source of the "Memorable Fancy" in *M.H.H.*17–20 where Blake is shown his eternal lot as "between the black & white spiders"; indeed the Angel who shows him the sun, the deep, and the air as full of "animals sprung from corruption" and apparently "composed of them" proves to be a combination Swedenborg-Hellebore-Huffcap-Katterfelto. See next note.

[37] *Morning Herald,* Apr. 22, 1783. In this puff Katterfelto declares that "neither he nor his Black Cat bear any resemblance to Devils, as they are represented in the Print-Shops." (And for Katterfelto caricature prints, see *B.M. Satires* passim.) Can this (iterated) part of the conjuror's "spiel" be echoed in *M.H.H.*18 where we are told that the spiders and other "terrific shapes of animals sprung from corruption . . . are Devils, and are called Powers of the air"?

butterfly or a cock chafer the blade bone of a tittle back no no heres a bottle of wind. . . ."

Behind the puppet-show stands danger. In the climax Blake leaves realism ("Smack went the glass") for symbolism and the prophetic note:

"Inflammable Gass turnd short round & threw down the table & Glasses & Pictures, & broke the bottles of wind. . . . He saw the Pestilence fly out of the bottle & cried out . . . come out come out we are putrified, we are corrupted, our lungs are destroyd with the Flogiston this will spread a plague all thro' the Island he was down stairs the very first on the back of him came all the others in a heap.

"So they need not bidding go."

Considering Blake's interest in the prophetic and symbolic aspects of plague winds, we may surmise that the joke is not entirely on the scientist. Blake seems to distinguish the ridiculous from the malign, the magic lanthorn aspect of science from the cataclysmal, though neither escapes his satire. The real Priestley was engaged in portentous experiments with the "several kinds of air" he was discovering. Mysterious and unexpected things happened, as he recorded in his *Experiments*, when a bottle of wind broke.

The invention of quick new methods of producing "inflammable air" for filling balloons, which engaged Priestley's attention in the fall of 1784, was plausibly regarded, by layman and scientist alike, as threatening the felicity of peaceful citizens. Horace Walpole looked on the balloons as potential floating batteries for a new kind of warfare. William Cowper had a dream in which he drove himself "through the upper regions in a balloon and pair, with the greatest ease." He conjectured that the modern philosopher might swallow enough inflammable air to soar about with "a pasteboard rudder, attached to his posteriors." But looking at the question soberly, whether navigation of the air would "in its consequences prove a mercy, or a judgment?" he concluded: "I think, a judgment." Even Priestley thought it was not simply a gas that he had discovered, but the "principle" of fire, still widely considered the bearer of pestilence. At the height of the balloon-flying, Cowper heard reports from a neighboring county of an epidemic "nearly as fatal as the plague." And when one balloon burst into flames in

the air, he supposed that a Calvinist would prognosticate from this omen "the most bloody war that was ever waged in Europe."[38]

Blake links philosophical and experimental radicalism when he causes Flammable to blurt out, after a discussion of Voltaire: "He was the Glory of France—I have got a bottle of air that would spread a Plague."[39] The context reveals that Blake was familiar with Voltaire's *Le Philosophe Ignorant*[40] and was well aware that Voltaire and Priestley were playing with the kind of fire he would describe, in *America,* as borne on phlogistic winds and striking terror to monarchs. Probably his thought already coincided with Priestley's recent application of a favorite Voltairean irony: "It was ill policy in Leo the Tenth to patronise polite literature. He was cherishing an enemy in disguise. And the English hierarchy . . . has equal reason to tremble even at an air-pump or an electrical machine."[41] Quid does not commit himself when Flammable and the Antiquarian are "only quarreling about Voltaire," but everywhere it is evident that postwar cynicism has modified the faith of the poet who expected kings to receive justice at the throne of God. Quid is ready to curse both God and Emperor ("Phebus" and "Pharoh"): "Hang them both" (iv).

Priestley's religious radicalism is given similar two-edged treatment. Quid's contempt for Phebus raises the question of public worship. The hypocrite Mrs. Sinagain (go to church and sin again) violently defends church-going and pulpit-stamping. The anticanting Mrs. Nannicantipot thinks "a person may be as good at home." Whereupon Flammable, as Blake's puppet, is made to express not the reasonable Humanitarianism of Priestley's *History of the Corruptions of Christianity* (1782) concerning superstitious reverence of the outward forms of worship, but a reductio ad absurdum of that position:

[38] Cowper, *Correspondence,* ed. T. Wright, London, 1905, II, 105–106, 125, 134–135.

[39] *I.M.*i. A perversion of Priestley's actual view that Voltaire was "exceedingly partial to the power and glory of France." *Lectures on History,* p. 12 (delivered in 1770's; published 1788).

[40] The chapter is filled with echoes of this essay. See below. A bust of Voltaire figures in *The Temple of Mirth,* drawn by Stothard and engraved by Blake for the *Wit's Magazine* of Feb. 1, 1784.

[41] Priestley, *Experiments,* 1774, I. The policy of Pope Leo is cited in Voltaire's *Moeurs des Nations* in a passage which Blake twice refers to in Marg. to Reynolds, once quoting it in French.

"If I had not a place of profit that forces me to go to church[42] said Inflammable Gass, Id see the parsons all hangd a parcel of lying————

"O said Mrs Sigtagatist [Sinagain] if it was not for churches & chapels I should not have livd so long."

Blake knows that the caricature is outrageous:[43] "Then Mr Inflammable Gass ran & shovd his head into the fire & set his hair all in a flame & ran about the room—No No he did not I was only making a fool of you."

The apocalyptic theme reappears, in more subjective form, in the lamentations of the struggling artist who is disguised, again to make a fool of the reader, under the name of "Steelyard the Lawgiver." The "Lawgiver" proves to be an important friend of Blake's, and this early caricature will help us to get their relationship clear. In spite of his title, Steelyard is no member of Parliament, alderman, or lawyer. He holds a wretched parish job so lowly that he fears he cannot escape constable duty. A tax collector of some sort, he must "stand & bear every fools insult" and cope with any "brat" who comes to the door, however much he may wish to "wring off their noses." He reads graveyard literature—and his rivals are artists, Double Elephant (named from the largest size of Whatman paper) and Filligreework. If he had only himself to care for, he would soon make these fellows "look foolish" (viii).

"What a disguise!" as Steelyard himself says in reference to "the parish business." But this is precisely the disguise of the sculptor John Flaxman in 1784. He had entered matrimony's golden cage two or three years earlier and taken a very small house near the Blakes; in his art he favored simple classic lines the opposite of filigreework; he might well envy the users of double elephant paper, because he found himself confined to cameo work, although

[42] As Mrs. Bogen points out, it is hard to apply this to Priestley, a Dissenter; it suggests rather a person holding a sinecure requiring observance of the Corporation and Test Acts, and it seems a private allusion like that to Steelyard's parish job (see below).

[43] If it is a caricature of Priestley, that is, whose actual view was that church-going has a certain value as social participation. The same view was argued by Mrs. Anna Laetitia Barbauld (Mrs. Nannicantipot's original, I conjectured but now rather doubt) in her *Thoughts on the Devotional Taste*, 1775. Blake's point is that if the histrionics of Huffcap and Sinagain are "not religion," neither are the "expediency and propriety" of Mrs. Anna.

Blake was "gratuitously" helping him design his first monuments;[44] and he eked out his small income by serving as a parish rate collector.[45]

Two years older than Blake, Flaxman was a man "of even temperament and of great purity and simplicity of character" but also of an unresponsive and prudish disposition, a man who had invariable rules (the "weight & measure" of a steelyard or butcher's scales) as to whom he should shun or cultivate.[46] He had been a precocious exhibitor and prizewinner in his teens, developing into "a most supreme Coxcomb" (as Josiah Wedgwood put it) until failure to win a Royal Academy medal sobered him. From 1775 to 1787 his chief employment was designing and making wax models for the cameo wares of Wedgwood and Bentley. The "Genius of Sculpture" Wedgwood called him; but when Flaxman raised his terms, the potter restricted his commissions. Fame and fortune from carving tombs would come in another decade, but in 1784 it was still necessary for Ann Flaxman to be "the most frugal of house-keepers." During their residence in Wardour Street between 1782 and 1787, before they went to Italy for seven years, John Flaxman was a collector of the watch-rate for the Parish of St. Anne's, often seen "with an ink-bottle in his button-hole, collecting the rate."[47]

In Blake's satire Steelyard's house stands out as the place where the Islanders are least merry, where no rum is served, and where the nearest approach to improper behavior is the innocent game of "forfeits." In contrast to the Philosophers' ready profanity, Steelyard's only oath is "Poo Poo!" Beset by disorder, he displays, like Flaxman, a righteous forbearance, acting "more like a Saint than a Lawgiver." The portrait is not unsympathetic, but Steelyard's saintly effort to divert the company from vulgar street cries and

[44] *P.A.*53: E561/K592.

[45] J. T. Smith, *Nollekens*, II, 436–437; *Rainy Day*, pp. 126–127; and Sidney and Beatrice Webb, *English Local Government: the Parish and the County*, London, 1906, pp. 16–28.

[46] Harold Bruce, *William Blake in This World*, New York, 1925, p. 61.

[47] Smith, *Nollekens, loc.cit.* G. E. Bentley, Jr., who in "Blake's Engravings and his Friendship with Flaxman," *Studies in Bibliography*, XII (1959), 165, quoted Flaxman's sister-in-law, Maria Denman, as having "never heard" of his rate-collecting and as knowing "that he scrupulously avoided all parish business throughout his life" (we can see why), has subsequently located the rate-book evidence that confirms the identification.

scatological anthems to a prettified ballad of "Violets that smell so sweet" is roughly pushed aside by Tilly Lally's "Hang your Violets heres your Rum & water" and burlesqued by his anecdote of one-eyed Joe "in the Sugar house" dipping "his hand up to the shoulder in treacle. here lick lick lick."[48]

Blake once rated Flaxman's friendship so highly that we have been inclined to overlook the cool steel in the man whom he at times accepted as his lawgiver and at times rejected violently. In a grateful moment in 1800 Blake would thank the "father of Heaven & Earth, that ever I saw Flaxman's face" and believe that "I could not subsist on the Earth, But by my conjunction with Flaxman, who knows to forgive Nervous Fear." Again in a less grateful moment in 1812 he would call him blockhead and hangman ("Jack Hemp"). The caricature of Flaxman as Steelyard suggests that Blake always suspected the potential hangman in the saintly lawgiver. The poet's long rebellion against law and prudence and the steel compasses of Urizen evidently contained a strong element of resistance to the "Dear Sculptor of Eternity" and to the necessity of leaning on such a friend in Nervous Fear.[49]

Yet a more attractive side of Flaxman was his interest in meditative and apocalyptic literature, an interest that would lead him, more uncritically than Blake, to Swedenborgianism.[50] Here too there is authenticity in the portrait of Steelyard "sitting at his table taking extracts from Herveys Meditations among the tombs & Youngs Night thoughts" (viii). His own economic insecurity puts him in the mood for a literature that both dwells on and defies

[48] Other students of Flaxman's personality have also found it prim and sweet—"faultlessly kind, upright, and generous, and in conversation sweetness itself," says Colvin in D.N.B. Bruce notes his slight response "to Blake's demonstrative affection, or to his high esteem." Lowery, pp. 45–47, stresses his friendship and underplays his opportunism and Blake's latent resistance. Bentley, while recognizing that "Flaxman's mind was pious and conventional," documents his life-long faithfulness to Blake's interests and the unevenness of their relations.

[49] To Flaxman, Sept. 12 and 21, 1800. For Jack Hemp see E495/K537.

[50] There is a theory that Flaxman introduced Blake to the New Church; he did not, literally, since he was in Italy when the Blakes attended a Swedenborgian conference in 1789—yet he writes as a Swedenborgian believer in his letters from Italy and in all probability had begun to read in this direction as early as February 1784, when he asked Hayley in a letter, "Pray when you have a favourable opportunity let me have Swedenborg." Morchard Bishop, *Blake's Hayley*, London, 1951, p. 78.

Fig. 4. Flaxman, self-portrait, 1782

mutability. His previous absorption in a certain act of Parliament, of which he "said that it was a shameful thing that acts of parliament should be in a free state," suggests anxiety about legislation under discussion in 1784 which would have wiped out the office of parish watch-rate collector.[51] Now he is worried that his patron may hurt him by "making me Constable or taking away the parish business. Hah!" And he adduces suitable quotations:

> "O what a scene is here what a disguise [*del.*]
> My crop of corn is but a field of tares[!]

Says Jerome happiness is not for us poor crawling reptiles of the earth. Talk of happiness & happiness its no such thing—every person has something. . . ."[52]

Or perhaps every person but poor Steelyard:

[51] Webb, *op.cit.,* pp. 574–578.

[52] Keynes's punctuation and capitalization make Steelyard seem to attribute "My crop of Corn" (from a seventeenth-century death-cell ballad) to Jerome.

"If I had only myself to care for I'd soon make Double Elephant look foolish, & Filligree work I hope shall live to see—

 The wreck of matter and the crush of worlds
as Younge says."

In his lugubrious anticipation of the ruin of his rivals in a universal doom, Steelyard misquotes Addison as Young and is not sure whether he is reading Hervey's *Meditations Among the Tombs* or his *Theron and Aspasio.* "Oh no . . . it was the meditations." "Obtuse Angle took up the book & read till the other was quite tir'd out." And Blake himself would read these books, if he had not begun to do so already. Indeed although Quid laughs at passionate preachers, it would be wrong to conclude that Blake disliked passionate preaching. It has been said that he liked the "electrifying eloquence and earnestness" of Augustus Toplady in his youth.[53] He did not fail to read Hervey, a popular dealer in "Mercy and Wrath" who extracted the most sensational matter to be found in the Old and New Testaments and served it up with the sermon rhetoric of a hell-fire preacher. "Violent Passions Emit the Real Good & Perfect Tones," Blake once declared, and he found the emotional meditations of Young and Hervey full of subjects for prophetic painting.[54] The sermons in *Theron and Aspasio* (1775) indicate the sort of Judgment Day imagery Blake must have come across on his friend's bookshelf. In paraphrasing Jehovah's peroration to Job, Hervey gives full organ-power to the manifest violence of the Lord and lingers eloquently on the fearfulness of the Monsters of the Deep. If the Leviathan and the voracious Shark evoke such Dread that none dare provoke them to combat, "how greatly is the CREATOR himself to be feared! who can turn the most harmless Inhabitant of the Ocean, into a ravenous Alligator, or a horrid Crocodile! Who can arm every Reptile of the Ground, with all the Force and Rage of a Lion!"[55] Here are ingredients for Blake's vision of the demonic Urizen whose menaces

[53] Wright, I, 7, with no indication of source.

[54] Marg. to Reynolds, 209. Blake painted a water color of Hervey's *Meditations,* ca. 1810. Hervey strides down a Gothic aisle toward a vision of history from Adam to the Apocalypse. In the Heavens, on either side of God's throne, are the contraries Mercy and Wrath. Plate 11, with key, in Damon's *Dictionary,* 1965.

[55] *Theron,* III, 159–160; cf. Job 41.

turn the peaceful inhabitants of America into a fiery Orc rising above the Deep, and for the "Tyger" question which Blake will ask in 1792.

Already the menaces intruded upon the mirth. Air that would spread a Plague, meditations upon the crush of worlds and upon Strength not to be resisted; such images crowded on the periphery of Blake's consciousness during these cynical years of "peace." The more hopefully one ventured upon the ocean of business, the more one dreamed of crocodiles. Behind anxieties about the plague of balloon warfare lay the inflammable condition of the truce with France, Spain, Holland, and America. And behind all other uncertainties of this glittering decade lay the certainty that the more prosperous Britain became, the nearer it moved toward conflict with its rivals.

Temporarily George III and Pitt held to a policy of good neighborliness, wanting several years of peace and commercial expansion in which to build up the strength and prestige of the empire. But it was understood that they looked forward to a time when British power could play once more "a shewy part in the transactions of Europe," as the King put it,[56] especially in a new attempt to crush France. By October 1787 Burke, seeing all the nations of Europe "going to war," would observe that the British "nation" (by which he meant the men of substance, not the multitude) were "well satisfied" and "willing to go to war with or without a pretence, with or without a policy."[57] Soon enough the French Revolution would provide both pretense and policy. In the aftermath of the American Revolution the premonition of renewed European war naturally blended with a premonition of a renewed stirring of the sleeping nations that would cause the mighty to tremble upon their thrones. Meanwhile one need not bidding go. After Lexington, the author of *Common Sense* announced, "I rejected the hardened, sullen-tempered Pharaoh of England for ever." Blake's Pythagorean philosopher declares: "Pho nonsense hang Pharoh & all his host . . . sing away Quid" (iii).

[56] Quoted in D. G. Barnes, *George III & William Pitt*, Stanford, 1939, p. 142.

[57] Elliot, I, 169. As for balloons, the French would use them effectively for observation in the battles of Liège and Fleurus and the sieges of Mainz and Coblenz, in 1794. J. A. Farrer, *The War for Monarchy*, London, 1920, p. 35.

6. We Who Are Philosophers

Blow boisterous Wind, stern Winter frown,
Innocence is a Winter's gown;
So clad, we'll abide life's pelting storm
That makes our limbs quake, if our hearts be warm.[1]

AN ALTERNATIVE to cynicism is the state of mind Blake thought of as organized innocence.[2] His twenty-three *Songs of Innocence,* published in Illuminated Printing over the date 1789, cannot be understood if we suppose that the author himself is innocent or oblivious of "life's pelting storm." "Innocence dwells with Wisdom," Blake wrote later, "but never with Ignorance."[3] The stanza quoted above, which makes substantially the same point, belongs to a very early Song.[4] The parallel *Songs of Experience* were not published until 1793–1794. But Blake, like Samson, had had experience long before that.[5] And it is misleading to reason that when he etched the *Songs of Innocence* there was "no contrary . . . in his mind."[6] Only a person aware of much amiss and seeking a cloak against ill winds could have made Blake's conscious creative effort to organize a place of shelter for Wisdom and Innocence, lion and lamb, to dwell in together.

It is of course significant that a poet who had written many bitter as well as many sweet songs should choose, in 1789, to publish the sweet ones by themselves. Although the contradictions exposed by the postwar cynicism of *An Island* did not vanish,

[1] *Song by an Old Shepherd,* written in a copy of *P.S.:* E457/K64.
[2] "Unorganizd Innocence, An Impossibility." Note written on the back of F.Z.viib, p. 93: E763/K380.
[3] *loc.cit.*
[4] This *Song* is based on *Blind-Man's Buff, P.S.* It did not get into *Songs of Innocence* because it is a song not *of* but *about* innocence.
[5] "Samson yhad experience" is the caption of a picture Blake engraved for Bell's *Chaucer,* May 1783.
[6] Bronowski, p. 113 [156].

Blake had, as we shall learn, a strong tendency to suppress prophetic alarm whenever the people were being ruled by covert guile and not open war. Both public and private matters may have encouraged the suppression of Quid the Cynic in favor of the Piper of "happy songs." Wilkism and Reform were asleep; the sharp dramatic conflict of Patriot and Tyrant had subsided. "Tranquillity was diffused" even "over British India," and while the government was taking all the credit for "prosperity," the leaders of the opposition were occupied chiefly in "efforts to amuse and entertain."[7]

In such times it was natural to seek the cause and the cure of what was amiss, not in the ambition of tyrants, but in the cold heart of every man, which must be sheltered from wintry weather and warmed from within. The outer world supplied no glowing flames of revolt nor warm rushing together of inhabitants. Blake, coming upon Lavater's observation that "He, who reforms himself, has done more toward reforming the public than a crowd of noisy, impotent patriots," could write "Excellent."[8]

It had not always been his view of patriots, nor would it be. But Blake probably saw more wisdom in Pitt's commercial treaty with France than in the noisy opposition of "Patriots" like Fox who in this period "maintained, that France was the inveterate and unalterable enemy of Great Britain."[9] "Peace," declared Blake as bard of innocence, is "the human dress."[10]

As for private matters, the death of his beloved brother Robert in 1787 produced a kind of sorrow more adequately surmounted by the cultivation of inner warmth than by cynicism, which had required a certain irreverence. The abandonment of the print shop, a year or so earlier,[11] may or may not indicate commercial failure; it may mean that the Blakes had accumulated enough reserve or at least enough confidence to venture independently upon the ocean of business. For their new home, 28 Poland Street, was still a shop. On the one hand the Blakes seem rather plainly not to have come

[7] Bisset, II, 48.
[8] Marg. to Lavater, 521: E584/K81.
[9] Bisset, II, 78.
[10] *The Divine Image:* E12/K117.
[11] Paul Miner finds rate-book evidence ("William Blake's London Residences," *BNYPL,* LXII [1958], 541) that by Christmas 1785, rather than in 1787 as previously supposed, the Blakes had moved to 28 Poland Street, leaving Parker in 27 Broad Street (where he continued until 1794). Presumably the partnership ceased at once, though possibly it did not.

upon halcyon days; on the other hand they must have been warm-
ing their hearts with considerable hope as they began to publish
works from "Blake's Original Stereotype."[12]

Blakean innocence is more than a cultivated state of inner
warmth, however, for the cultivation of innocence is itself a form
of social criticism. Blake might have said of his *Songs* what he
wrote, at the time of their publication, beside Lavater's 633d
aphorism: "Those who are offended with any thing in this book
would be offended with the innocence of a child & for the same
reason, because it reproaches [them] with the errors of acquired
folly." Quid curses and laughs: the happy Piper reproaches. Both

Fig. 5. Organized Innocence?

express a consciousness of the errors and ironics of a society in
which every man's face is a mask. Northrop Frye is exceptional
among critics in recognizing that the *Songs of Innocence* "satirize
the state of experience" and expose its hypocrisies by contrast.[13] He
observes that the "glint in the eye of the poet" who wrote *An
Island* never faded out, and that the occurrence of "three of the
most delicate and fragile of the *Songs of Innocence*" embedded in
the "Gargantuan nightmare" of *An Island* is an indication that
Blake's juxtaposition of innocence and experience was "in origin
an idea connected with satire."

Before touching the *Songs of Innocence* as published in 1789,

<hr>

[12] Colophon of *Ghost of Abel:* E270/K781, in which the date 1788 is
given.

[13] Frye, pp. 237, 192. Schorer, pp. 230–234, also notes that the innocence
is consciously organized, with "overtones of tragedy." He speaks of "the
irony of Blake's forms."

let us make use of the excellent opportunity provided by the growth of these fragile songs in a satiric matrix to explore the process whereby organized Innocence *springs out* of Experience. All of the twenty-one poems or parts of poems in *An Island,* sung by nine of the characters, are satiric at least by location. And the subtle matching of song to singer provides a satiric analysis of singer and subject. Three of the songs, sung by Obtuse Angle, Mrs. Nannicantipot, and Quid, are to emerge as *Songs of Innocence.* Two others, "When old corruption" and "Hail Matrimony," sung by Quid, might have become *Songs of Experience* except that they are not sufficiently *songs.* Seven or eight are versions of popular ballads or street cries, such as Miss Gittipin's "This frog he would awooing ride" and Steelyard's "As I walkd forth one may morning." Several of these contain a strong element of parody. "To be or not to be" and "This city & this country" are parodies which also contain ironies not fully apparent to Obtuse Angle and Steelyard, who recite them. Perhaps "Theres Dr Clash," recited by Scopprell, comes into the same group. "A crowned king," recited by the Pythagorean Sipsop, is presumably more consciously satiric. The rest are mainly ribaldry, doggerel, and nonsense verse.[14]

The problem of detecting the degrees of irony in the songs is related to the problem of detecting the degrees of lack of insight in the characters, ranging from the utter fatuity of Scopprell to the overweening suspiciousness of Quid, with the kindly nearsightedness of Obtuse Angle standing as the critical case (which we shall return to in a moment) because it is just the wrong side of being a right angle. This is not to say that the simplest songs are sung by the simplest persons. There are layers of innuendo that reveal themselves only under careful and repeated examination, and the degree of tension between the surface meaning and the satiric implications depends much on the intellectual distance between the singer and the real author, Blake. For example, the satire in Quid's own songs, on Surgery and Matrimony, is direct and of Hogarthian breadth; the meaning cannot be mistaken even by the simple-minded, but

[14] Martha England's placing of *An Island* in the tradition of Samuel Foote's "Tea at the Haymarket," a parodistic, quick-change, musical miming of the legitimate theatre and of London topics and personalities, greatly increases our intimacy with the "piece" and with its author-composer as a connoisseur of London vanities and anti-theatre. See "Apprenticeship in the Haymarket?" in *BNYPL,* LXXIII (1969) and in *Blake's Visionary Forms Dramatic.*

only rejected. "Go & be hanged" is Scopprell's response. Nor are there any two meanings—or even one—in Sipsop's "Italian" song:

> Fa ra so bo ro
> Fa ra bo ra
> Sa ba ra ra ba rare roro, etc.

At the other extreme are the songs of Scopprell and Gittipin. Her "Leave O Leave [me] to my sorrows" is not funny to her, though Frye (p. 193) is correct in saying that it has a satiric tone midway between *Ah! Sun-flower,* a later Song of Experience, and some of Blake's more ribald epigrams. Her garbled rendition of the frog and cock ballad strikes Scopprell as "truly elegant" though we, along with Blake, are oppositely impressed. Scopprell's song reducing the Handel Jubilee to a matter of fingers and cash is a statement, at his mind-level, that the Handel concert was elegant and successful. Indirectly it informs us that the young fellow has been impressed by "an empty hubbub," but Scopprell himself is not the satirist.

Between these extremes lie the truly ambiguous songs of Steelyard and Obtuse Angle, reflecting the ambiguous wise blindness or blind wisdom of these friends who are not lumps of ignorance nor yet men of goatish or philosophical vision. Steelyard's song about the good old days of a dateless past when "Good English hospitality . . . did not fail" and when "the Mayor & Aldermen Were fit to give law to the city" is appropriately nostalgic for a man who is worried about reforms that may abolish his parish job. The singer himself does not seem to see anything wrong with a perpetuation of "the hungry poor" as long as they are hospitably invited in to "eat good beef & ale" after the city fathers are through eating "as much as ten." Yet the particulars are as loaded with social comment as are those of Hogarth's picture of *The industrious 'Prentice grown rich, and sheriff of London,* devouring good beef and ale among fat aldermen while the gaunt poor await their leavings.[15]

The songs of Obtuse Angle reflect his character as an amiable pedant who must "empty his pockets of a vast number of papers,"

[15] I fear that Damon, p. 265, arguing that "Blake was not sarcastic, and used the phrase (Old English hospitality, noted by Smollett as 'very much used . . . out of the island . . . by way of irony and sarcasm') in good faith," has been taken in by both Blake and Smollett.

close his eyes, and scratch his head before entering the conversation. Both his songs stem from the pedant's kindliness—one lauding a charity school founder, the other blessing the multitudes of charity children in London town. But both also reveal his habit of "shutting his eyes" to the unpleasant and less mathematical aspects of charity. A deleted line indicates that Obtuse Angle is supplying "a Mathematical Song" when he transposes "To be or not to be"[16] into a rimed essay on pragmatism. His hero is Richard Sutton, founder of the Charterhouse or Sutton's Hospital, described in Fuller's *Worthies of England* as "the Master-piece of Protestant English Charity."[17] By worldly standards (see Boswell)[18] the Charterhouse in 1784 was a respectable pensioners' home and school for boys. But Blake, as a self-educated person who thanked God he "never was sent to school," saw only social and intellectual stultification in Hospitals (boarding schools) and apparently always considered them "nets & gins & traps to catch the joys of Eternity."[19] If recited by Quid doubtless the hymn to Sutton would have been as cynical as Quid's songs on Surgery and Matrimony. As it is, the cynicism is that of omission.

Our purblind (obtuse) pragmatist concentrates on the building rather than the schooling, on the "great capacity" evident in Sutton's "money in a box" which "he drew out of the Stocks," and on the fervor with which he employed bricklayer and carpenter. According to Fuller, Sutton in his day was charged "with purblindness in his soul, looking too close on earth"; he had accumulated his money by shady and miserly—yet not grasping—practices. Obtuse Angle gives no thought to where the money came from or what may go on behind the "walls of brick & stone." Like Sutton he looks close on earth and is impressed by the "sinks & gutters" and the pavement made "to hinder pestilence."[20]

The practical man, confident of his capacity to hinder pestilence with pavingstones, supposes that the children's happiness

[16] E450, 451/K56, 57.

[17] For the other worthies, Doctor South and Sherlock, see William King's *Works*, London, 1776, I, 221–222; also John Pomfret's *Reason*, noted by Brown.

[18] *Private Papers*, 1933, XVII, 3.

[19] N.42: E502/K550; *Song of Los* 4:2: E66/K246.

[20] Charterhouse stands on the Black Death burial site mentioned above, p. 75; chapel first endowed by Sir Walter Manny, who figures in Blake's *Edward*.

follows automatically. But Blake's Schoolboy, in *Songs,* asks "How can the bird that is born for joy Sit in a cage and sing?" Obtuse Angle in his other song, which turns out to be the "innocent" version of *Holy Thursday,* accepts the annual regimented singing of London charity-school children as evidence that the flogged and uniformed boys and girls are angelically happy:

Upon a holy thursday their innocent faces clean
The children walking two & two in grey & blue & green
Grey headed beadles walkd before with wands as white as snow
Till into the high dome of Pauls they like thames waters flow

O what a multitude they seemd, these flowers of London town
Seated in companies they sit with radiance all their own
The hum of multitudes were there but multitudes of lambs
Thousands of little girls & boys raising their innocent hands

Then like a mighty wind they raise to heavn the voice of song
Or like harmonious thunderings the seats of heavn among
Beneath them sit the revrend men the guardians of the poor
Then cherish pity lest you drive an angel from your door

After this recital the Islanders sit "silent for a quarter of an hour"—not, as some will have it, in admiration of Blake's verse, for it is Obtuse's, drawn from him by Miss Gittipin in a desperate effort to enliven a dull evening at the house of Steelyard.

We can find the story in the newspapers. Every Holy Thursday (Ascension Day) some six thousand uniformed children from all the charity schools of the metropolis would march to St. Paul's to hear a sermon and to sing before their patrons; "though they might not be in perfect musical concord of voice, their little hearts panted with harmony of sentiment, and they felt more than they could express." Sometimes a disturbance was caused by parents or other "improper company" attempting to have a look at the children, some of whom had been benevolently "removed from their wicked parents" and thus "snatched from perdition" to be trained to useful servitude.[21]

Like Obtuse, who thinks only of the pious singing, the scrubbed

[21] *The Times,* June 6, 1788, Jan. 13 and Apr. 24, 1789. On the latter date a special thanksgiving service for the King's recovery was held, in addition to the annual assembly in June. See also Hannah More, *Memoirs,* New York, 1836, I, 310–311.

faces, and the grey-headed beadles, the reporter feels sure that these new services "must raise the mind to sympathy and to brotherly love."[22] He too is uplifted:

". . . the glorious sight of 6000 children, reared up under the humane direction of the worthy Patrons, and supported by the public contributions of well disposed persons . . . aiding to the nurture of a future generation to fight his [majesty's] battles —carry forward the commerce and manufactories of Great Britain, and assist in maturing infant arts, to the honour and prosperity of the country.

"The scene was the most pleasant to be conceived to every friend of Orphan innocence, in seeing so many adopted children of public benevolence brought together, and skreend from the rude hand of misery and shame."

This obtuse, roseate view is refuted point by point when Blake returns to Holy Thursday in the *Songs of Experience:*

Is this a holy thing to see
In a rich and fruitful land,
Babes reducd to misery,
Fed with cold and usurous hand?

Only the sentimental can call "that trembling cry a song" or be complacent about the "thousands of little girls & boys" in uniform who are "so many children poor." In a land of true honor and prosperity, babes would "never hunger": "It is a land of poverty!" To deny the latent satire in the first song it is necessary to forget about Quid the Cynic and accept Obtuse Angle as the self-portrait of Blake in 1784.[23]

[22] June 6, 1788. The services had been held in St. Paul's only since 1782.

[23] Concern over charity-school abuses rose early in the 1780's. By 1786 a social reformer could refer to the "well known" fact "that an apprentice for labour of either sex, seldom turns out well, whether bound by the parish or a charity school." M. Dorothy George, *London Life in the 18th Century,* New York, 1925, p. 254.

M. G. Jones, *The Charity School Movement,* Cambridge, 1938, quotes Blake's first *Holy Thursday* for the "pride and compassion aroused on these occasions" (p. 62) and then quotes his second poem as a justifiable comment on the conditions in some schools, especially the hospitals (boarding schools) where children were flogged and half starved by masters and mistresses who "lined their pockets with money saved from the children's

2

Following Obtuse Angle's recital and the quarter hour of silence, Mrs. Nannicantipot says, "It puts me in Mind of my mothers song," and proceeds to recite the pastoral stanzas that appear later as *The Nurse's Song* in *Songs of Innocence,* beginning:

> When the tongues of children are heard on the green
> And laughing is heard on the hill
> My heart is at rest within my breast
> And every thing else is still.[24]

Mrs. Nannicantipot, whoever in Blake's circle she may be, sings as if in gentle parody of—or at least derives phrasing, images, and mood from—the second and fifth *Hymns in Prose for Children* (1781) of Anna Barbauld.[25]

rations" (p. 103). As for the plight of those children wearing "grey" uniforms, we learn from the Minutes of the Grey Coat Hospital cited, "Girls, as well as boys, were so cruelly flogged . . . that the matron was arrested, and was allowed out on bail with difficulty. In the same schools boys deliberately smashed the windows to ensure an enquiry from the governors, and, on another occasion, the girls, for the same end, set fire to the woodwork. When the governors made enquiry into the 'rebellion' they were answered that the children were so 'utterly wretched' from constant flogging and semi-starvation, that they could endure it no longer."

Even where the hand that fed was less "cold and usurous" the regimen was designed "to *condition* the children for their primary duty in life as hewers of wood and drawers of water," and the grey or blue or green uniforms were "of the COARSEST KIND and of the plainest form" lest the flowers of London town "possibly be tempted to take pleasure in their rayment," as Isaac Watts and the Bishop of Oxford specified (pp. 5, 75).

Finally there is the evidence of Blake's synopsis of the evils of forced education in the concluding lines of *Tiriel.* When the scourged infant reaches school age, he "walks . . . in sorrow compelld to number footsteps"— i.e. to walk two and two. *T*.viii:19: E282/K110:32.

[24] *I.M*.xi: E453/K59. Before drawing psychological conclusions about this shift from mother to nurse, as does Bronowski, p. 114 [157], we must note that before writing "my mothers" Blake had written "my grand mothers song," while his first thought had been to have Mrs. Sigtagatist sing.

[25] The conjectured identification of Mrs. Nannicantipot as Mrs. Barbauld rested partly on the identification of Inflammable as Priestley, since the Barbaulds and Priestleys were social intimates, partly on the name, and partly on the aptness of the songs—all very slight grounds.

Nancy Bogen's suggestion, on equally impressionistic and "admittedly

Mrs. Barbauld's two hymns picture the happy play of children and animals in the fields, and then the stillness when the "loud bleating is no more heard among the hills." In her second hymn children sporting on the green with lambs and goslings are glad to be alive to "thank him with our tongues." In the fifth the sun is set, night dews fall, sheep and little birds rest, there is no sound "of voices, or of children at play," and the child sleeps upon its mother's breast until morning. Blake's song interweaves these themes. The little ones playing on the green are called home when the dews of night arise, but because the sheep and little birds are still at play they are allowed to leap and shout till the light fades away, when they must rest till morning; day and night the mother's heart is at rest within her breast.

These and other *Hymns in Prose* are echoed in several of Blake's *Songs*.[26] Especially curious is his use of Barbauld's description of Heaven (Hymn 12) in *both* Holy Thursday poems. First, as Obtuse

slim" evidence (*Satire Newsletter*, v [1968], 114–115), is worth serious consideration: Blake's wife Catherine, who, because Blake himself stopped going to church sometime during the 1780's, might well have been charged, as Mrs. Nan is, with hindering her husband from going to church; who could in 1784 be described as an "ignorant jade" (and might socially be aspersed with that remark, since she was not only illiterate at marriage but "appears to have worked as a maidservant prior to that event" [the evidence is from Fuseli, via Farington]); and who can fairly well, if with some shock, be imagined in the role of Quid's wife as one reads through *I.M.*, especially the final passage, where Quid's remarks can best be understood as exchanged with a wife ("when we are at Mr Femality's" etc.). As for her "vindictive declaration concerning Preacher Huffcap," we may remember Catherine Blake's declaration cited in Schofield's deposition (see below, p. 406).

As for their social calendar, I shan't venture a guess about Mr. Femality, but there is an artist whose name can be heard in "Sicknakers" (for that is, I think on looking again at the manuscript, a better transcription than my earlier "Sicknakens"); he is the sculptor Thomas Scheemakers (1740–1808), who exhibited sixty-two works at the Free Society of Artists and the Royal Academy between 1765 and 1804; I don't know where he lived in 1784.

[26] Branching from the root imagery of Hymns 2 and 5 are Blake's *Night, The Echoing Green,* and *Laughing Song.* Similarly related to other Hymns are *The Shepherd* (compare "Behold the shepherd of the flock," Hymn 3) and *The Lamb* (compare "He made . . . I am but a little child," Hymn 1). And there are many Blakean echoes of these questions of Hymn 12: "Canst thou measure infinity with a line? canst thou grasp the circle of infinite space?"

Angle, Blake draws upon it in good faith, so to speak, comparing the charity children to Barbauld's hymning angels.[27] Later, as bard of Experience, Blake contrasts the actual "eternal winter" of the children's existence with the promissory "eternal spring" of Barbauld's rosy vision, and contradicts her "tree of life" and "flowers that never fade" with his picture of fading and dead "flowers of London town" beneath a leafless tree.[28]

The manuscript of *An Island* (xi) shows that Blake's first intention was to follow Mrs. Nannicantipot immediately with Tilly Lally's rough and ready rime about natural children at play—barefoot Bill who "has given me a black eye," Joe who bowls the ball into filth and cleans it "with my handkercher," and the boy telling the story who has "a good mind to go And leave you all." Blake's second thought was to insert between the sentimental and the realistic versions of child-play a note of tragedy, by Quid, who sings of what can happen to a child who is allowed, as in Mrs. Nan's song, to stay out after the night dews fall.

> O father father where are you going
> O do not walk so fast
> O speak father speak to your little boy
> Or else I shall be lost
>
> The night it was dark & no father was there
> And the child was wet with dew

[27] See E453, 767/K59. Under the spell of "Myriads of happy spirits are there," he writes, ungrammatically, "The hum of multitudes were there." Surrounding "the throne of God" Barbauld's "angels with their golden harps sing praises continually" with "the cherubims." Obtuse compares the "multitude of innocents" to "angels on the throne of heavn raising their voice of praise." Then crossing this out and discarding the angels for the cherubim he writes "Let Cherubim & Seraphim now raise their voices high." The concluding moral, "Then cherish pity lest you drive an angel from your door," echoes Mrs. Barbauld's "Respect in the infant the future man. Destroy not in the man the rudiments of an angel." (Quoted in Grace A. Oliver, *Life of Mrs. Barbauld*, Boston, 1874, p. 98, from a text of the *Hymns* which I have not seen.) Of course the ultimate source is Hebrews 13:2.

[28] Barbauld: "There is a land where roses are without thorns, where the flowers are not mixed with brambles. In that land there is eternal spring, and light without any clouds." Blake: "It is a land of poverty! And their sun does never shine . . . And their ways are fill'd with thorns. It is eternal winter there." And in *The Little Black Boy* heaven is a place where "I from black and he from white cloud" will be "free."

> The mire was deep & the child did weep
> And away the vapour flew

This is the "lost" half of what will become *The Little Boy Lost* and *The Little Boy Found* in *Songs of Innocence*. The "found" part, written later, implies that the will-o'-the-wisp[29] that has misled the boy is an impersonal God, for only a god in human form—or only a human father—can kiss and save the child.[30]

Quid's song, as a response to Obtuse Angle's, implies that the "holy" atmosphere investing the charity-school beadles does not make up for the children's separation from their real fathers. This dismal ballad sinks the company's spirits for fair, and nobody can sing any longer until Tilly plucks up a spirit and repeats his racy doggerel, after which "a laugh" begins and Miss Gittipin sings two stanzas beginning

> Leave O leave [me] to my sorrows
> Here Ill sit & fade away
> Till Im nothing but a spirit . . .

Her sentimentality carries the will-o'-the-wisp theme to the point of burlesque. It also mocks Barbauld's Hymn 6 in which the "Child of reason" fails to recognize the voice of God in a forest breeze.

Here, then, is the environment in which Blake's "happy songs" of innocence were born. Innocence and Experience as "two contrary states of the human soul" are already present in the songs of Obtuse Angle and Nannicantipot on the one hand and of Tilly Lally and Quid on the other. In context the innocent songs are at least ironic. Yet the same songs, removed from this matrix, illuminated with pictures of carefree babes and birds and put beside *A Cradle Song, The Divine Image,* and *Night* in a collection of *Songs of Innocence* announced as "songs of pleasant glee" from the "rural pen" of a Piper piping "with merry chear," are plainly not presented as satire. Their social purpose is larger—to construct one of the foundations of an imaginatively organized and truly

[29] A phenomenon in which Priestley was greatly interested.

[30] After Lavater's aphorism 552, "He who adores an impersonal God, has none," Blake wrote: "Most superlatively beautiful & Most affectionatly Holy & pure would to God that all men would consider it." E586/K82. Cf. Hymn 6.

happy prosperity. Their author rises a step and sometimes two steps above the Fun of the ignorant philosophers, according to the scale indicated by Blake's "Mirth is better than Fun & Happiness is better than Mirth—I feel that a Man may be happy in This World."[31]

Perhaps he knew this all along, or it may be that having set out to present the obtuse view as something he could see beyond, he discovered by looking through his own mockery that he could see much *through* the shut eyes of "the Good" who "Think not for themselves."[32] As long as his country was at peace he could write without much cynicism:

> . . . Mercy has a human heart
> Pity, a human face:
> And Love, the human form divine,
> And Peace, the human dress.
> (*The Divine Image*)

In this spirit he was prone to believe, as he wrote in the margins of John Casper Lavater's *Aphorisms on Man:* "that which [in man] is capable of good is not also capable of evil, but that which is capable of evil is also capable of good" (489). He did not publish his *Songs of Experience* until Britain had once more gone to war and her commercial prosperity had plummeted.

The notes on Lavater, made while Blake was preparing the pages of *Songs of Innocence* for publication, are the nearest thing we have to a commentary on the Songs themselves and are invaluable in that connection. They reveal Blake in a mood in which he loves the obtuse. He will have nothing said against superstition, which is "ignorant honesty . . . beloved of god & man," and he pronounces "heavenly" Lavater's preference for "heroes with infantine simplicity." In Lavater's characterization of the purest religion as "the most refined Epicurism," Blake sees "True Christian philosophy," and he is willing to go much further than La-

[31] To Trusler, Aug. 23, 1799. In his revision of *Holy Thursday* for *Songs of Innocence* Blake brightened the charity school uniforms from "grey & blue & green" to "red & blue & green."

[32] A satiric Notebook "Motto" which Blake did not use (*N.*101: E490/ K183); in it innocence is mocked as obtuse: *thought* and *experience* reveal that what we believed was charity is hypocrisy and those we called guardians of the poor are usurous knaves.

vater in favor of loving and laughing. "ALL LIFE IS HOLY," Blake declares. He will not accept Lavater's condemnation of *exuberance,* and his strongest disagreement with "Lavater & his cotemporaries, is, They suppose that Womans Love is Sin; in consequence all the Loves & Graces with them are Sin." Blake emphasizes the Humanitarian theology, noting that "true worship" is the love of God in men, for "human nature is the image of God."[33]

All these themes, except Woman's Love, appear in *Songs of Innocence.* Humanitarian Christianity is expressed categorically in *The Divine Image.* Since the "virtues of delight" are God, and God is Man, "Then every man . . . That prays in his distress, Prays to the human form divine":

> And all must love the human form,
> In heathen, turk or jew.
> Where Mercy, Love & Pity dwell
> There God is dwelling too.

Addressed to children, the songs assert the joys of sport and laughter and lamb-like behavior and preach the omnipresence of God and guardian angels. Fathers and mothers can "never never" be indifferent to infant groans and infant fear, and therefore our maker can never, never "Hear the woes that infants bear" without joining in the grief and destroying it with his joy.

There is woe in this world. The robin sobs, the little boy and the emmet get lost, the little black boy is not loved by the "little English boy," the chimney sweeper has been sold to hard labor, and the charity children are poor. And all that the happy Piper can provide for comfort is the inner warmth of faith. The lost are found through the merciful order of God's universe. Angels try to protect the sheep. If the wolves and tygers "rush dreadful," however, the mild spirits of their prey will be transported to a land where the lion's wrath is changed to pity. The black child will receive the white child's love—in heaven. The poor remain poor, the sweeps have to rise in the dark to work in the soot, but though the morning is cold their cloak of innocence keeps them "happy & warm."

Why do children *weep* "with joy to hear" these songs? Because the message transcends the realities of their condition without

[33] Marg. to Lavater, 342, 343, 366, 309, 532, 640 f., 554.

changing them. The poet is organizing innocence; weaving a winter's garment of True Christian philosophy. Inadvertently—for it is a lone exception—the admonition, "Then cherish pity," in *Holy Thursday,* remains as a word to adults (the enslaved child's word) rather than to children; otherwise adults are reproached only indirectly.

In *The School Boy* Blake is concerned not simply about the constraint of the classroom in summer weather but about the moral defeatism forced upon "the little ones" who are compelled to "spend the day In sighing and dismay." And in the poem that follows, Blake's Bard has a contrary educational program:

> Youth of delight come hither:
> And see the opening morn,
> Image of truth new born.

No use to "stumble all night over bones of the dead" (an anticipation of one of the *Proverbs of Hell*).[34]

In Blake's Lavater notes there are also important themes that belong to the *Songs of Experience,* a further indication that Blake had both contraries in mind all along. The idea that poverty and hunger "appall" the mind of the charity children is elucidated by a note (640 f.) in which Blake speaks of "the omissions of intellect springing from poverty." In modern terms this would amount to an observation that juvenile delinquency is caused by malnutrition and substandard living conditions, for Blake is talking about what is mistakenly "call'd Vice." He accused Lavater and others of confusing energy, exuberance, and "all the Loves & Graces"[35]—in short "all Act"—with "contrary" behavior such as murder, theft, and backbiting, which is really "the omission of act in self & the hindering of act in another: This is Vice, but all Act is Virtue." "It does not signify what the laws of Kings & Priests have call'd

[34] It may be that *The Voice of the Ancient Bard* (E31–32/K126) was not written until 1790; its style of lettering seems to put it later than the rest of the *S.I.* It was ultimately moved over to *S.E.*—as were, sooner, *The School Boy, The Little Girl Lost* (looking to prophetic "futurity"), and *The Little Girl Found.*

[35] Something of Rousseau enters here, possibly via Fuseli's *Remarks on . . . Rousseau,* London, 1767, pp. 7–8: Rousseau demonstrated "that the arts, the graces of our life, if prudently managed, are become the manacles of the weak, and the ulcers of society."

Vice; we who are philosophers ought not to call the Staminal Virtues of Humanity by the same name that we call the omissions of intellect springing from poverty."

In *Songs of Experience* Blake will apply this thesis to the harlots and vagabonds of London. But the *Songs of Innocence* are already permeated with the distinction between virtue as act, and vice as omission of act (or accident). For children they bear the message: laugh and love and play and do your duty, and you will never *feel* harm; you are not vicious for being poor—or for having a black skin, whether by accident of being a Negro or of having been sold apprentice to a sweep. For adults: don't be smug about poverty. Things being what they are, cherish pity, mercy, love, and peace. But do not confuse the accidental features of poverty with the staminal virtues of man's genius.[36]

3

. . . all eyes as blind as Tiriels to your woes

Tiriel v

We have been approaching the watershed of history marked by the storming of the Bastille in July 1789, beyond which streams of thought and action run in new channels. Blake's *French Revolution,* printed in 1791, is alive with the sense of a new and revolutionary break with the past and a great hopeful movement of the people. In contrast, the works Blake wrote or published (i.e. etched or dated) in 1789 all bear the pre-revolutionary emphasis on the plight or energy of the individual. The postwar cynicism of Quid has been submerged, but the ardor of Orc has not yet arisen. The etching of *Songs of Innocence* and *Thel* fulfills Blake's early ambition to shake his fist at Envy and let his notes

[36] Rousseau, according to Fuseli (*Remarks,* p. 8), found that nations confined to nature kept "with ignorance and poverty their innocence of manners."

A graphic source of fresh inspiration in the late 1780's is called to our attention by Jean Hagstrum (*William Blake: Poet and Painter,* Chicago, 1964, pp. 31–33). James Edwards, a wealthy bookseller and a friend of Johnson, invited scholars, students, and persons of taste to examine his books, manuscripts, and missals. "It is not a wild conjecture that young William Blake was one of those invited. If so, he saw the splendid Book of Hours," the Bedford Hours illuminated by French or Flemish artists between 1430 and 1450, in the pages of which Hagstrum finds several impressive sources of design, detail, and color in Blake's Illuminated Printing.

"Rise to meet the New born Day."[37] But these are not yet the music of that Day. *Tiriel* too, though depicting the collapse of a tyrant, deals not with insurrection but with inner changes and family quarreling; it draws upon Rousseau for his theories not of society but of education; it belongs to the winter preceding the great springtime.[38]

London during that winter was only placidly aware of something stirring across the Channel. The minds of the French people were said to be more violently agitated than at any time "since the last civil wars," and great legislative reforms were expected from a national assembly King Louis had been forced to call.[39] But the bankruptcy of the French King and all the growing crises of which it was a symptom were overshadowed in British minds by the first prolonged mental illness of King George, which lasted from the spring of 1788 to the spring of 1789 with a middle period of considerable violence.

The madness of George III may have seemed a delayed Judgment upon him for earlier tyranny and ambition; it did not evoke any rising of patriots but rather focused attention upon a battle of physicians and upon unfathomed processes in the royal mind. In France the people in motion were compelling the King to relax his grasp of the scepter. In England the royal grasp had suddenly failed, but there seemed nothing for the people to do but wait and see, while politicians struggled to name the next king or drive their rivals from the bedside of the ailing one. When the King's recovery

[37] *T.S.B.* 43–44: E438/K42.

Between the etching of *Songs of Innocence* (except *The Voice of the . . . Bard*) and the etching of *Thel* Blake learned how to get his words onto copper without writing them backward. Both the *Songs* and *Thel* are dated "1789," but all extant copies of *Thel* have a final page and a "Motto" plate that were etched not earlier than 1791 and constitute a sort of "Experience" climax and commentary attached to what may in 1789 have been more purely a poem of "Innocence."

[38] I am more inclined now (1969) to think that the winter of *Tiriel* reflects not the pre-revolutionary darkness in France but the continuing unrevolutionary weather in England—and that the poem may have been written in 1790. I had supposed that it must predate *Thel,* since some of its lines (deletions on p. 8) were polished and appropriated to *Thel.* But the borrowing is limited to "Thel's Motto" and plate 6, i.e. to the late additions to *Thel.* Other evidence for a date of 1790 for *Tiriel* is the occurrence of variants of *Tiriel* 8:9 in the 1790 portion of *M.H.H.* (pl. 24) and in *V.D.A.* (pl. 7).

[39] *London Chronicle,* Dec. 31, 1788; Feb. 14, 1789.

was celebrated, a bit prematurely, in March 1789, "happiness" was again official.

Popular movements did exist, but except for the almost subterranean strike of London blacksmiths for a shorter workday they were largely humanitarian or pious in orientation and in no immediate sense revolutionary or broadly directed. In 1788 philanthropists secured a piece of protective legislation for the "climbing boys" which provided that a boy should not be apprenticed before he was eight, should be thoroughly washed once a week, and should not be compelled to go up an ignited chimney. Blake's *The Chimney Sweeper* deals with the first two points: "I was very young," "father sold me while yet my tongue Could scarcely cry ''weep!'" In dreamland "thousands of sweepers" "wash in a river" and rise "naked & white." This was possibly written during agitation for passage of the bill, which would be "a bright key" like the one in the poem, opening the black coffins in which the boys were "lock'd up."[40] Another Song of Innocence, *The Little Black Boy,* assists the philanthropic agitation of the Society for Effecting the Abolition of the Slave Trade, which was formed in 1787 and began soliciting subscriptions in November 1788.

A good deal of this sort of pre-revolutionary humanitarianism is contained in the longer symbolic poems, *Tiriel* and *The Book of Thel.* In *Thel,* a sort of mystery play for adolescents, a world of equalitarian harmony is presented in which the cloud feeds the

[40] The Experience version of this song followed after several years in which the act remained virtually a dead letter.

Kathleen Raine, *Blake and Tradition,* 1, 25–26, cites Swedenborg's *Concerning the Earths in our Solar System,* London, 1787, section 79, making report of "Spirits amongst those from the Earth Jupiter, whom they call Sweepers of Chimnies, because they appear in like Garments, and likewise with sooty Faces." The "inconceivable Quickness" with which they cast off their dark raiment when called upon by Angels, to be "clothed with new shining Raiment, and become Angels," leads Swedenborg to associate them with "the seminal Vessels" and their "burning Desire" to ejaculate. Miss Raine does not quote the physical details of the passage, but the symbolic parallels she points to are striking—between Swedenborg's and Blake's chimney sweepers when "prepared for Heaven" or "set . . . all free" and Urizen's image of Orc in *F.Z.viia* (E347/K321)—and she rightly observes "There is nothing improbable in the suggestion that the figure of Orc-Eros has its beginning—or one of its beginnings—in this strange and uncouth fable of the erotic figure of the sweeper of chimneys." (Section 79 follows very shortly the section 73 that Blake himself cites in his notes on Swedenborg's *Heaven and Hell:* E591/K939.)

tender flowers and the clod of clay comforts the "helpless and naked" worm. Thel, a lovely maiden full of lamentation, interrogates lily and cloud and clod, who answer her in a series of Barbauldian moral hymns the burden of which is that "Every thing that lives, Lives not alone, nor for itself." The individual who shrinks in virgin fear as Thel does from the self-sacrifice of cooperation may think to remain forever in Eden. But when (in the final page) she takes flight from experience because it looks like her grave, she is actually fleeing life itself.

The evils of inequality and the fallacy of attempting to live for oneself alone are elaborately demonstrated in *Tiriel,* a murky parable of the decline and fall of a tyrant prince who learns to his sorrow that one law for "the lion and the patient Ox" is oppression, and under whose visionless dictatorship the arts of life, Poetry and Painting as represented in the idle sports of his parents Har and Heva, have not flourished.[40a] The diagnosis of Tiriel's bad upbringing and of his internal collapse through selfishness owes much to the moral psychology of Rousseau and Swedenborg; the forests and palaces in Blake's illustrations and the names and garments of Tiriel's "lawless race" derive, as Mary Hall and Nancy Bogen have recently discovered, from reconstructions of the pyramid-building dynasties of shepherd kings of Africa (Titans, Amazons, Cuthites—all one, according to Bryant and other antiquarians);[41] yet the pattern of Tiriel's "madness and deep dis-

[40a] But their "many sports" are perhaps less idle than sinister. Nancy Bogen (see next note) suggests that Har, Heva, and their apparent mother, Mnetha, may be Tiriel's gods—their names suggest Cuthite deities—or priests worshiped in their stead, and that their singing in a great cage where they feed singing birds and sleep on fleeces may be related to the "fact" in Bryant that Arkite priests first raised birds and animals in the temple for display in religious processions and later (cf. *M.H.H.*11) usurped the roles of the gods and were themselves worshiped with bird and animal sacrifices.

[41] See Mary S. Hall, *"Tiriel:* Blake's Visionary Form Pedantic," and Nancy Bogen, "A New Look at Blake's *Tiriel," BNYPL,* LXXIII (1969). Tiriel's wife Myratana, "Queen of the western plains," is traced to Jacob Bryant's account of Myrina, Queen of the Amazons of Mauretania, "in the most western Parts of Africa," and in Blake's drawings this association is confirmed by the Amazonian dress, with right breast bared, of Hela and Mnetha—though not of Myratana herself. Har is traced to Bryant's conflation of the Amazonian deities Ares and Harmon (or Harmonia) with Harmonia the wife of Cadmus, of Egyptian origin and founder of the place at Athens called Academia, "a place of exercise and science."

may" parallels that of King George's and his agony anticipates that of Albion's Prince.

Tiriel exemplifies a kind of satiric drama we might call the histrionic grotesque. Taken straight, it is "a crude failure"; read as its frantic, gesture-cued language requires, it is as funny as— and in a direct Blakean line between—*An Island in the Moon* and *The Book of Urizen*. Only with the publication in 1967 of a facsimile edition, by Gerald Bentley, has the further dimension of contrast been accessible in Blake's drawings for (but not with) the poem—of improbably stately royal figures and austere, if oak-groved, geometrical architecture. "The failure of these empty, pseudo-antique figures to convey Blake's vision of the cursing father and his rebellious sons" can be defined as "Blake's exhaustion of the 'heroic' mode."[42] But the exhaustion should be recognized as a Quiddian reduction to absurdity.

The action of *Tiriel* is mostly a pacing of the stage; Bentley has diagramed Tiriel's movement from his palace to Har's tent and back, and back again. The plot consists chiefly in a chain reaction of cursing and dissembling. The blind aged King, standing before his "beautiful palace," curses his already accursed sons and calls upon them to observe their mother's death. They bury her but declare they have rebelled against their father's tyranny, and Tiriel wanders off through the mountains. In the "pleasant gardens of Har" he comes upon Har and Heva as senile infants, whose imbecility illustrates the fate of those who shrink from experience—and, allegorically, the stultification of poetry and art. Tiriel is invited to help catch singing birds and hear Har "sing in the great cage"[43] but must wander on "because of madness & dismay." His terrible brother Ijim seizes Tiriel and carries him

[42] Anne T. Kostelanetz, "The Human Form Divine in the Poetry and Art of William Blake," diss. Columbia, 1967, p. 65.

[43] *T*.iii:21: E276/K102:23. Here Blake treats the activities of Har as allegorical of subservient poetry and art; possibly Har's lament, "My sons have left me" (iii:16), is meant to indicate a general flight from art in tyrannous times. "To catch birds & gather them ripe cherries" signifies triviality and saccharinity of subject matter; to "sing in the great cage," rigidity of form. Schorer, p. 228, suggests that the latter is a reference to the heroic couplet. But Tiriel is both blind and deaf (to his children); if Har and Heva are the presiding earth deities of Academia (see note 41), we may suspect Blake of a side glance at the Royal Academy and artists of whom he would say "I found them blind" (E500/K543).

back to the palace as an impostor, only to find that both father and sons are "dissemblers." With new curses Tiriel calls down thunder and Pestilence upon his children and finally even blights with madness his daughter Hela, his healing sense of touch, or vision, whose assistance he needs to guide him back to the pleasant valley. Tiriel is mocked and pelted with dirt and stones as he and Hela pass the caves of Zazel, another brother. The tyrant expires at his journey's end while explaining, like a stage villain, how his mind has been warped and how "Thy laws O Har & Tiriels wisdom end together in a curse" (*T*.viii).

It may be that the tyrant in Blake's parable is a king simply because, as Frye observes, "a king is the only man who gets a real chance to be a tyrant" (p. 243). But Tiriel's wandering in the desert "like the King of Babylon in hell who in Isaiah represents the collapse of that empire" is a preliminary study of the symbolic portrait of the ruler of the British Empire appearing in later prophecies. Blake was not here writing directly about British history as in *America* and *Europe,* but he knew that the monarch who represented the father principle of law and civil authority was currently insane. And many details suggest that he was drawing upon the living example of King George—as well as the literary example of King Lear—when he composed this story of a king and father gone amok, pulling down the temple like a blind Samson (but no deliverer), cursing sons and daughters, and storming about the wilderness bemoaning his loss of a western empire.

Loss of "my American colonies" was a major theme in King George's delirium, and he sometimes imagined he was still ruler of them.[44] Tiriel boasts, when he is no longer in command of anything: "I am Tiriel King of the west" (viii:4). His wife is described as "once the Queen of all the western plains."[45] And

[44] Gouveneur Morris (*Diary,* i, xxxvi) sent to George Washington the gossip that "the defender of the Faith, in one of his Capricios, conceived himself to be no less a personage than George Washington at the Head of the American Army. This shews that you have done something or other which sticks most terribly in his stomach."

[45] America is not western Africa, but neither is Academia; Bryant did not supply Blake with even an imaginary historical action or locale but with correspondences and conflations; he selected and developed his own. Mrs. Hall notes that Tiriel's crowned son Heuxos has a name derived from the royal shepherds of Egypt; Blake could have made the connection with

the eldest son speaks in the manner of an American rebel: "Were
we not slaves till we rebeld[?] Who cares for Tiriel's curse[?]
His blessing was a cruel curse. His curse may be a blessing" (*T.*i).
Again the reversal described in *America,* the hurling back upon
himself of the madness with which the King sought to plague the
nations, is suggested in the return upon his own head of the curse
with which Tiriel had "enslavd the sons of Zazel." Tiriel's mad-
ness is less emphasized than his blindness, but his behavior as a
blind man is much like that of mad King Lear. King George did
not go blind during his 1788 illness, but at times his eyes were, as
the Queen said, "nothing but black currant jelly," and he nearly
burnt her with his candle.[46]

Tiriel's queen dies. Queen Charlotte did not, but during his
madness George rejected her, insisting that all marriages had been
annulled (probably recollecting the breakdown of the Marriage
Act in 1781), and professing a violent attachment for the Lady of
the Queen's Bedchamber. The loud eroticism of the mad King
was indeed the curse returned upon the curser, for not only had
George recently signed a Royal Proclamation against Vice and Im-
morality but the immediate cause of his illness was the fact that
three of his sons had joined in flagrant rebellion against the moral
code, making public demonstrations of inebriety, flaunting their
association with court prostitutes, and opening their own gambling
club. Tiriel's sons rebel against their father's cruel law and bring
"tears & cares" to their mother, and the king curses them as

King George's notorious interest in farming—but there seem to be no
allusions in *Tiriel* either to Shepherd Kings or to "Farmer George."

Gardner (p. 81) conjectures that "the geographical location suggesting
the vale and gardens of Har was surely Vauxhall Gardens, in the Vale of
Lambeth on the road to Battersea. The fashionable walks at Vauxhall
were 'well planted with lofty trees that form a delightful shade, with
woodbines and underwoods, which furnish a safe asylum for the birds';
though Sir Roger de Coverley remarked that he would have liked the gar-
dens better 'if there were more nightingales and fewer strumpets.' "

[46] Details here and below are from Guttmacher, *America's Last King,*
but see Lucyle Werkmeister, pp. 141, 175, 297, for an indication of the
extent of gossip and anonymous pamphleteering. By March 12 at least one
newspaper had been warned that it was "Treason to assert, either orally
or in print, that the King's mind is deranged, or that he is not in a capacity
to act as Sovereign of the British Empire." Blake would scarcely have un-
dertaken an undisguised dramatization of the royal "father of a lawless
race."

"Serpents not sons."[47] He calls himself "poor blind Tiriel," but his curses issue from a "hypocrite that sometimes roars a dreadful lion," and his eroticism is evident in his cursing all his five daughters or senses except the "youngest daughter" Hela, the symbol of what Swedenborg calls scortatory love, and thereby falling into his own hell.[48] His subsequent quarrel with Hela, because she recognizes that he wants her not for mutual affection but "for thy self thou cruel man," "O leagued with evil spirits thou accursed man of sin," leads him to curse her too as one who "Laughs at affection glories in rebellion, scoffs at Love" (v), a female or Amazonian Orc, whose hair the King's curse makes literally "serpent formd" —as we see in drawing 10; when he dies (drawing 12) her hair returns to normal.

King George was hysterical in the presence of his daughters, screamed when he saw but could not reach them, and was calm only with "his beloved youngest child, Amelia, then only five." On his return to Windsor Castle after a levee, which the King held despite his illness, "he saw his four youngest daughters waiting to receive him, and was so overcome that he had an hysteric fit. His children, and his attendants were all struck with the alteration in his looks; and he said to . . . one of the equerries . . . 'I return to you a poor old man, weak in body and mind.' "[49] On the return of "poor blind Tiriel," "The cry was great in Tiriels palace his five daughters ran And caught him by the garments weeping with cries of bitter woe" (v).

A different sort of indication that Blake wrote with the condition of the British Empire in mind is his choice of the name Tiriel. In Cornelius Agrippa's *Occult Philosophy* Tiriel is the name for the Intelligency of the planet Mercury, both God of commerce and the cause of the contraries of plenty and poverty. In a "fortunate" phase, this planet "bringeth gain, and prevents poverty," but "an

[47] *T*.i: E273/K99. In *America* Albion's Angel sees rebellion as "serpent-formed."

[48] *T*.iv–v: E278–279/K105–106. The logic is ironic: *because* he thinks sexual desire is sin, his own obsession with it is hell. If he could recognize love as a staminal virtue, he would effect a marriage of heaven and hell and escape the dull round of corporeal desire. A further irony may be intended in the favorite's name. Hela in Scandinavian myth is Death, daughter of Satan, according to Mallet. See Coleridge, *Watchman* No. 3, p. 68.

[49] Fanny Burney, levee of Oct. 25, 1788. Guttmacher, p. 196.

unfortunate *Mercury* doth all things contrary to these."[50] Here we see how Blake used the dialectics of the occultists and mystics. His fallen sovereign is Mercury in an unfortunate phase. Once "chearful as a prince" and "king of all the west," now Tiriel "is the king of rotten wood & of the bones of death"; his "paradise is falln" and become "a drear sandy plain" (iii, ii, viii).

Commerce did, actually, respond to the fluctuating reports of the King's health. Stocks fell ten points in a few hours when the King's physician happened to sell some personal securities. Tiriel's collapse and his inability to cope with rebellion suggest the breakdown of a whole set of codes and curses. Even though the focus is on individual and family behavior, the individual and family are royal, and the poem ends with a prophetic note when Tiriel, who has brought "Thunder & fire & pestilence" (war and war's sequel), says with his dying breath that his "voice is past."[50a]

4

If it were not for the Poetic or Prophetic character the Philosophic & Experimental would soon be at the ratio of all things, & stand still . . .

 —*There is No Natural Religion,* 1

[50] Damon, p. 306.

[50a] Nancy Bogen (*BNYPL,* LXXIII, 1969) suggests that two of Tiriel's "sons" may be, from their behavior during the Regency crisis of 1788–1789, Charles Fox (Zazel) and William Pitt (Ijim), but there are few striking parallels. Rather more of a case is made for the idea that Har's "great cage" burlesques a church or cathedral, his singing in it the celebration of a mass, and his feeding cherries to the caged birds (minds shackled by law and custom) a priest's indoctrination or preaching (compare the poisoning of "all around him" by black berries in Tiriel's last speech). "The scene ends in true burlesque fashion with Tiriel's forgoing the invitation [to pray and humble his immortal spirit]: he will accept the benediction and the sacrament, but that is all." (Earlier he knelt for Har's and Heva's blessings; his partaking of "milk & fruits" with them is "perhaps a saccharine reference to the Eucharist.")

"Tiriel's denunciation of Har and himself at the end of the poem," concludes Mrs. Bogen, "is indeed instructive on this level. Blake seems to be saying: all of England's ills, from factionalism to the King's poor health, are owing to the moral laws promulgated by the Church Establishment and sanctioned by the King, its head. . . ."

Blake's marginalia of the pre-revolutionary period show his thought reaching out impatiently beyond the laws of monarchic society and caged art. The new humanism of Lavater and Swedenborg and Rousseau reached him in certain specific texts apparently just a few months before the revolution in France, although he seems to have had inklings of it for some time. Lavater's *Aphorisms on Man,* translated by Henry Fuseli, came out early in 1789;[51] Swedenborg's *Divine Love and Divine Wisdom* was published a few months before that; and Rousseau's *Émile, or Education,* while possibly long known to Blake, seems to make its first impact on his poetry in the patched and emended concluding lines of *Tiriel.* When he speaks of Lavater and "all his cotemporaries" he indicates that he has already done some fairly wide reading or at least talking. But any effort to trace sources would have to take into account the rapidity with which a mind like Blake's, even while assimilating a new text, can discover that it already has a superior formulation of the Good Things it is finding and that "a strong objection to Lavater's [or anybody's] principles" must be made if "we who are philosophers" are to speak with accuracy. Blake's own aphorisms, in the three tiny booklets declaring that *There is No Natural Religion* and yet that *All Religions Are One,* issued perhaps in 1788 as his first experiment in Illuminated Printing, establish the principles and terminology from which he corrects Lavater and Swedenborg; yet they may or may not have been formulated before he read these sages.[52]

The development in Blake's thinking which takes place in the two or three years before 1789 can be approached biographically

[51] Dated 1788 but published "in the beginning of the year (1789)" according to John Knowles, *Life and Writings of Henry Fuseli,* London, 1831, I, 159. The dedication to Fuseli is signed 1787. Fuseli's radical theological interests were fertile ground for radical politics—which Fuseli himself did not cultivate.

[52] Blake may have been reading in Swedenborg as early as 1787, the date of the pamphlet he cites as "Worlds in Universe" (*Earths in the Universe*) in his meager and apparently early notes on *Heaven and Hell* (E591/K939). Until Blake's copy of Swedenborg's *Heaven and Hell* turned up at Harvard recently, I had supposed it would be the 1789 edition. It is the 1784, advertised in London, July 8, but the citing of the 1787 work puts the date of Blake's notes at least that late.

through the little we know of his changing circumstances and associations in this period. In the breadwinning labor of every day, Blake is still engaged in engraving satiric pictures that continue the spirit of Quid and Suction—from the production for the 1784 *Wit's Magazine* of such prints as Collings' *Tythe in Kind; or The Sow's Revenge* and *May-Day in London*[53] to the engraving in 1788 of Hogarth's *Beggars Opera* and Morland's Hogarthian *Industrious Cottager* and *Idle Laundress*. By 1788 he is engraving portraits of Democritus and Spalding for Lavater's *Essays on Physiognomy* and an emblematic frontispiece, after Fuseli, for the *Aphorisms*.

All these prints, as well as the sentimental-erotic *Venus dissuades Adonis from Hunting*, after Cosway (Nov[r] 21st 1787), were published by others; not so *Timon and Alcibiades*, after Fuseli, "Published by W. Blake, Poland St. July, 28: 1790"—indicating a combination of new friendship and old commercial determination (but the print is exceedingly rare).[54] In the idiom of *An Island in the Moon*, if we accept the identification of Steelyard as Flaxman and Quid and Suction as William and Robert Blake, the year 1787 marks a dispersal of the happy company who made merry at the Philosophers' house. In February death took Robert, the exuberant Epicurean. And the reader of Jerome and Hervey relinquished his parish job and went, with the sweet Anne he had managed to care for, to study in the galleries of Rome for seven years. Sipsop (if Mathew) left Jack Tearguts and went to Cambridge.

What happened next was that Robert in a dream inspired his brother to proceed with his great project of Illuminated Printing. And the saintly Lawgiver was replaced in Blake's affections by a jovial son of the Enlightenment who had been in London for many years but not apparently in Blake's circle: "When Flaxman was taken to Italy, Fuseli was given to me for a season." The season would run its course in about a decade, to be repeated more mildly in a later time.[55]

Henry Fuseli, in his independence and capacity for jest, has

[53] See below.

[54] See Geoffrey Keynes, *Engravings by William Blake: The Separate Plates: A Catalogue Raisonné*, Dublin, 1956.

[55] To Flaxman, Sept. 1800. See Mason, *The Mind of Fuseli*, pp. 41–57.

affinities with Blake's Quiddian spirit. And some of the anecdotes of their relationship belong in another *Island*. But his coming to Blake as a spiritual comforter after the death of Robert and the departure of Flaxman implies a more sober sympathy between the two men, such as may have been established by Fuseli's interest in Rousseau and Lavater. His influence on Blake's art, that new "emancipated anatomy" which seems uniquely characteristic of each of them, comes somewhat more slowly. "There is still very little trace of it in the [illustrations of] *Songs of Innocence*," Eudo Mason observes (p. 52), though it is fully assimilated by the time of *America* and *Europe* (1793–1794). What absorbed Fuseli and interested Blake during the first years of their intimacy was the translation and publication of the essays of Lavater, physiognomical and *unphysiognomische*, i.e. the *Essays* and the *Aphorisms*—the latter Fuseli's own "extremely free English rendering" published by Joseph Johnson.[56] Thus while Blake's annotation of a printed copy of the *Aphorisms* may have been the latest of the intellectual documents we are discussing, the earliest impact of the new philosophy or psychology upon Quid was probably that of Lavater via Fuseli. In the emblematic frontispiece which Blake engraved, the attention of a contemplative philosopher at his reading desk is engaged by an (innocent) child who points to the Greek motto "Know thyself," meaning in this context "Discover thy genius." Meditations upon the tombs have been replaced, or supplemented, by meditations upon the staminal virtues visible in the faces and actions of men.

Fuseli seems to have had nothing to do, however, with the climactic influence of this period, Blake's introduction to the visionary "theosophy" of Emmanuel Swedenborg, a Swedish mineralogist of the early part of the century who had been inducted by angels into the spiritual arcana of the Old and New Testaments. Swedenborg's voluminous Latin works were slowly being translated into English, and in London in April 1789 people who were beginning to be called Swedenborgians held their first General Conference, some of them having recently founded a small New Jerusalem

[56] Mason, p. 137. See Antal, ch. iv, for Fuseli's liberal-conservative position in London intellectual circles and his evolution from a "fiery follower of Rousseau" (though always more a theological than a political radical) into "an adorer of elegance" (p. 83). On Lavater see Antal passim.

Church. Blake and his wife or sister or mother ("W. Blake" and "C. Blake") attended the Conference, and Blake at about this time obtained a copy of the 1788 translation of *The Wisdom of Angels Concerning Divine Love and Divine Wisdom.*

The legend that Blake was born into a family of Swedenborgians[57] is a back formation from the fact that he did delve into Swedenborgianism in 1789. The five-day Conference of some eighty people, including no known acquaintance of Blake, was largely taken up with the reading aloud of passages from the Master and the discussion of resolutions embodying doctrinal points. Blake's marginal comments on the *Divine Love* disclose an interest in it as something fresh and new though confirmatory of the human creed he has already begun to formulate in different terms. He finds that the printed message differs in some points from what "was asserted in the society," but he assumes that "The Whole of the New Church is in the Active Life & not in Ceremonies at all." He finds some passages "False" but is generally inclined to give the Swedish sage the benefit of the doubt as against many who "perversely understand him" in a materialistic sense "because themselves are mercenary & worldly."[58] Blake, always a scorner of sectaries, quite evidently did not join those ceremonially inclined who were endeavoring to establish the New Church as a sect with an ordained priesthood. In 1790 when the sequel volume *Concerning Divine Providence* came out, Blake discovered the more conservative side of Swedenborg and concluded that he was, after all, "a Spiritual Predestinarian" supported by "Lies & Priestcraft."[59] By this time his own thinking had been drawn by the French Revolution away from the wisdom of angels. He acquired

[57] "The Problem of Blake's Early Religion" is discussed by Nancy Bogen in a recent issue of *The Personalist*. That it may have been Anglican or Anglican-Moravian is considered more likely than the common assumption that it was Dissenting. The impression of Blake's spiritual kinship with the seventeenth-century antinomians and their descendants—E. P. Thompson is particularly struck by affinities in Muggletonian thought and hymnody— is another matter.

[58] Marg. to *Divine Love*, 414, 49, 220, 257: E593–598/K91–96 (but K cites by pages instead of sections). In "Blake's Early Swedenborgianism: A Twentieth-Century Legend," *Comparative Literature*, v (1953), 247–257, I made perhaps too little of the probability of some two or three years' interest before 1789—and too little of Blake's positive indebtedness.

[59] Marg. to *Divine Providence*, 277.2 and xvii: E600 and 599/K133 and 131.

a copy of the 1791 *Apocalypse Revealed* but read it for laughs—or so his parodies of it in his *Marriage of Heaven and Hell* seem to indicate.

What most attracted Blake in the new psychology and the new religion were their positive benevolism, their invitation to mine beneath the codified meanings with which kings and priests had restrained and perverted Life, and their promise that the infinite vital power of the genius in every man could be released through Love. What drew his criticism, even at the beginning, was a tendency to describe rather than to perform that release.

The humanitarian side of the New Church doctrine loomed large both in the *Divine Love* and in the passages read during the Conference. The warmest part of the new reading of the Scriptures was a simple worship of Christ as "One God in One Divine Humanity" and a belief that "Love is the Life of Man." Blake's comments mark his relish of passages stressing the primacy of the Affections over the Understanding. He sides with Swedenborg and "the common People" against those who "pronounce God to be invisible" and supports his case with the imagery of *Songs of Innocence*.[60] But he must translate Swedenborg's too abstract theology. "Spiritual idea" he reads as "Poetic idea." The "Negation" in society that "constitutes Hell" is not "the Negation of the Lord's Divinity" but rather "the Negation of the Poetic Genius": for "the Poetic Genius . . . is the Lord."[61]

That is, what must not be negated by rod and rule is the divinity of the creative individual. Blake has been learning from the physiognomists what an amazing variety of creatures men are, and he finds Lavater and Swedenborg in agreement that outward form is an index of inward genius. In Rousseau he has read of the tyrannous parents who bind their infants' bodies and try to shape their heads. See the dying confession of Tiriel, whose whole life has been a compounded misdirection of his own and other people's geniuses from the moment "the child springs from the womb."[62] The important thing, Blake declares in his own aphorisms, is that all men are "alike" with "infinite variety," both in outward form and "in the Poetic Genius." And it is the poetic genius in every man that can see both these aspects of every other man, for it requires a kind

[60] See Marg. to *Divine Love*, 11, 12: E593/K90.
[61] *ibid.*, 7, 13, 10.
[62] Compare *T*.viii and *Émile*, Everyman edn., pp. 10, 13, 16, 55, 55 n.

of fourfold vision to see the outward likeness and variety and the inward likeness and variety.

To accept the psychology of Locke is to see only the likenesses. The whole Newtonian universe, conceived in such dull terms, would be, though vast, just "the same dull round . . . a mill with complicated wheels."[63] To see only the varieties, however, is to be the Cynic who sees men as goats and tigers and fleas. The poet or prophet must restore a vision of men's common humanity as well as their infinite variety, so that cynicism and rationalism can be reclaimed by love or the mutual adoration of each other's variety of form and genius.

Blake had already thought about these matters. His current reading may have been a kind of refresher course in the wisdom of Paracelsus and Boehme which had "appeared" to him in his youth.[64] There is a full and entire heaven in every man, according to these sages, which yet corresponds to each man's "specificity." And what each man specifically has is a flow of energy which must not be inhibited, for the life of the body is fire.[65]

Nevertheless energy *is* restrained or not nurtured. Tiriel does rule, though his efforts to measure creatures as various as "the lion & the patient Ox" according to "one law" are more oppressive than successful, and although time after time he destroys his own paradise by "Consuming all, both flowers & fruits." Blake's diagnosis of tyranny probably owes something to a reading of Swedenborg on "the essence of diabolic love," the true nature of which "is hatred; for . . . in its inmost nature it desires to rule over all, and to possess the property of all, and at last to be worshipped as a

[63] In *There is No Natural Religion,* first series, Blake exposes the lifeless mechanism of Locke's principles as he has found them listed in Voltaire's *Ignorant Philosopher.* This is partly the work of Quid.

[64] In 1790 Blake declares that any mechanical mind could have produced Swedenborg's writings "from the writings of Paracelsus or Jacob Behmen." *M.H.H.*21. And see above.

[65] See Paracelsus, *Selected Writings,* ed. J. Jacobi, New York, 1951, pp. 112–119. "Boehme is undoubtedly the source for Blake's general conception of the contraries, though Blake's use of this conception is his own"; he drew upon Boehme "for support of the very doctrines that constitute the chief points of difference between the ideas of the two men." Martin K. Nurmi, *Blake's* Marriage of Heaven and Hell: *A Critical Study,* Kent, 1957, p. 34. See also the "Behmen" and "Paracelsus" entries in Damon's *Dictionary.*

god."[66] To the tyrant who wants that sort of obedience, the varieties of men's forms and geniuses are an intolerable menace. Some men, says Tiriel, are "nostrild wide breathing out blood. Some close shut up In silent deceit . . . With daggers hid beneath their lips . . . Or eyed with little sparks of Hell or with infernal brands Flinging flames of discontent . . ." (*T*.viii: E736/K109).

Such flames smoldered even in the genius of William Blake when he suspected that Tiriel was not the only slavish tyrant who had been educated in "Hypocrisy the idiots wisdom & the wise mans folly." With all the wisdom of the "spiritual sense of the Bible" newly available, Blake was ready for some action, not ceremonies and pieties. When the author of the *Divine Love and Wisdom* writes of elevating one's mind above Time and Space so that one "shakes off the Darkness of natural Light, and removes its Fallacies from the Center to the Circumference," Blake insists that the "fallacies of darkness," even when hurled to the circumference, still "cast a bound about the infinite."[67] No spiritual legerdemain, he implies, can remove from the infinite world such "fallacies" as slavery or prostitution unless *action* removes them from the "natural" world. No matter how far Blake seems to go along with a mysticism that treats "the Natural Earth & Atmosphere" as "a Phantasy," he remains concerned with the essence of human history and is not seeking "spiritual" escape from it. "Active Evil is better than Passive Good," he exclaims to Lavater. And he insists to Swedenborg that Love "was not created impure & is not naturally so."[68]

[66] Swedenborg, *True Christian Religion,* par. 45. Cited by Frye, p. 243. Blake had some acquaintance with this work, available in English in two volumes by 1784; he parodies par. 74 in *M.H.H.*18; he can hardly have read even its first chapter before then, or he would not have been surprised at the views of Omniscience &c. to which he reacted with shock in his marginalia to the 1790 *Divine Providence.*

[67] Marg. to *Divine Love,* 69. Twenty years later, still defending the specificity of his own genius as a thing not easily dismissed, Blake will "Cry looking quite from Skumference to Center [of his Umbrella] No one can finish so high as the original Inventor" (*N*.65: E496/K555).

[68] Marg. to Lavater, 409; Marg. to *Divine Love,* 419. Blake's attack on accusers of adultery strikes at the center of Swedenborg's ethical code. "Adulteries are the complex of all [evils]," the sage was informed by an angel, "and unless you shun them you cannot approach the Lord." *Conjugal Love,* par. 356.

When Swedenborg talks of "hereditary evil," Blake is constrained to explain that "Heaven & Hell are born together" and that Swedenborg is quite confused about "Good & Evil."[69] In a few years Blake will be greeting the revival of "the Eternal Hell" in France and indulging in some Quiddian laughter, in his own *Marriage of Heaven and Hell*, at a spiritual system that had been so inept as to put the date of a New Heaven *in the past*.[70]

[69] Marg. to *Divine Love*, 68, 432.

[70] In the 1780's Blake may also have read Charles Wilkins' translation of *The Bhagavad-gita* issued by the East India Company (London, 1785); see Blake's description of his 1809 painting, now lost, of "Mr. Wilkin[s] translating the Geeta; an ideal design, suggested by the first publication of that part of the Hindoo Scriptures, translated by Mr. Wilkin[s]" (*D.C.*ix). John Adlard, in *English Studies*, XLV (1964), 460–462, notes traces of the "Geeta" in *M.H.H.*—not in the form of directly borrowed concepts but in that of "a fairly vigorous contradiction." If Blake echoes Wilkins' terms—desire, restrain, reason, govern, passive—it is to overturn "Geeta" ideals, e.g. of "strength . . . free from lust and anger" and "desire regulated by moral fitness." In the "Geeta" desire is the "inveterate foe" and Kreeshna the "comforter": in *M.H.H.* "the comforter" *is* Desire. If the "Geeta" directs man to find happiness by closing up "all the doors of his faculties," Blake announces that man must cleanse "the doors of perception" and reverse the process whereby he has "closed himslf up."

Part Three

THE FRENCH REVOLUTION

Then the French Revolution commenc'd in thick clouds.
— To Flaxman, September 1800

7. First Voice of the Morning

> From my window I see the old mountains of France, like
> aged men, fading away.
> —The King of France (*F.R.*9)[1]

IN THE SPRING OF 1789, while the British were celebrating the re-
covered sanity of King George, the French were bringing their
grievances to King Louis. Looking out his window any day for the
past two years the King of France could have seen, with his
spiritual eye, his villagers and peasants and citizens rising against
his provincial governors, against his tax-collectors, against his new
plenary courts, and even against his troops, although these some-
times threw down their swords and fraternized with the people.
Londoners reading of these events were told, on the one hand,
that a severe grain shortage was spreading disorder and anarchy
throughout France, and, on the other, that the French nation was
engaged in a struggle to obtain the blessings of an English Parlia-
ment.[1] Meteorological omens were reported such as the devastat-
ing hailstorm and tempest of midsummer 1788 marked by "a
dreadful and almost total darkness" over the face of the earth.
And there were political omens such as the rain of tiles from
the roofs of Grenoble that routed a royal garrison or the descent
of the mountain people of Pau to support a rebellious local
parliament of nobles. As Blake read the news, the people of France
inspired by the new energy of America were awaking to pursue
life, liberty, and happiness with all the fury of a spiritual existence,
and the King of France would have to wake from his feudal
"slumbers of five thousand years" or cease to exist.

The events of 1789 were on the whole auspicious. Yielding to
the rebellion against taxation without representation, begun by
the nobles but taken away from them by the more zealous bour-
geoisie, the bankrupt King had agreed to summon a representative
assembly of the three estates of nobles, clergy, and commons to

[1] See the *Annual Register* for 1788 and 1789.

meet in May. As step by step the King acceded to the pressure of the commons or Third Estate it looked from abroad as though the French were to have a proper constitutional monarchy. Almost universal male suffrage was assumed as villagers and citizens assembled to elect delegates, and it was agreed that the commons were to match in number the nobles and clergy together.

Naturally the struggle was more than parliamentary. The countryside was swept by bread riots as well as elections, and the voting citizens supplied their delegates with long lists of grievances, *cahiers de doléances.* At times the lines of a class war seemed sharply drawn between the nobility and upper clergy on the one hand, and on the other the bourgeoisie, prodded forward by peasants and artisans and many lesser clergy. The commons accepted the Whiggish leadership of the royal Duke of Orleans and the noble Marquis de La Fayette, won the battle of the estates, and assumed the title of National Assembly. Yet fears of an aristocratic coup d'état inspired the citizens of Paris to seek arms and seize the Bastille in July, and the peasants, now determined to make their revolt against feudal dues and oppressive taxes irreversible, began burning the archives of extortion.[2]

The autumn harvest was plentiful, however, and the rest of the year was filled with auguries of peace and unity. In August the aristocrats yielded to the inevitable with a good grace and took the lead in legislation to abolish their ancient privileges, while the clergy relinquished their sacred but no longer practicable right to collect tithes. The Assembly agreed to reimburse them for these concessions and proceeded in high spirits to draft into a Declaration of the Rights of Man and Citizen the principles of Voltaire, Rousseau, Paine, and Jefferson: that "Men are born and remain free and equal in rights," that "Liberty consists in the ability to do whatever does not harm another," and that "No hindrance should be put in the way of anything not prohibited by law," when law is "the expression of the general will."[3]

Blake had recently expressed a similar belief in "the Staminal Virtues of Humanity" and in the beauty and purity of any exercise of liberty that does not "hinder another."[4] Fresh from

[2] For a judicious account see Georges Lefebvre, *The Coming of the French Revolution,* tr. R. Palmer, Princeton, 1948.

[3] Articles I, IV, V, VI, as translated in Lefebvre.

[4] Marg. to Lavater, 640 f.: E590/K88.

his exploration of the innocence of childhood and the love and wisdom of angels, he greeted with enthusiasm the sight of an entire nation discarding ceremonies for the Active Life and giving concrete recognition to the Human Form Divine. If to some the French people seemed rather to be following the wisdom of devils, then Blake was for the devil's party. "The man who never alters his opinion is like standing water, & breeds reptiles of the mind."[5] Obviously, arbitrary monarchy, shaken by the American Revolution, was being drained of all power by the French one, and even the personifications of tyranny were dying. In *Tiriel* Blake had traced the internal disintegration of despotism in the story of the "king of the west" whose children gloried in rebellion and whose visitations of "fire & pestilence" hastened his own collapse. Louis of France was now fallen into the condition of another "sick, sick" king, shivering at the rebellion of his meek valleys while the aching cold of change ran "from his shoulder down the bone" and "into the scepter, too heavy for mortal grasp. No more To be swayed by visible hand, nor in cruelty bruise the mild flourishing mountains."[6] In the Duke of Orleans' embracing of equality Blake saw a confirmation of his own belief that a man capable of evil is also capable of good. In the new National Guard of the merchants of Paris, commanded by Jefferson's friend La Fayette, Blake saw a reappearance of the civic patriotism that had defended the children and grain of America. He saw assisting the revolutionists the spirits of Voltaire and Rousseau, driving out priestcraft. And at the same time he witnessed, and in his writing joined, a renascence of popular enthusiasm in England such as had not existed even in the days of Wilkes and Liberty.

Dr. Richard Price, pointing to the French Revolution in his famous address of November 4, 1789, before the Society for the Commemoration of the Revolution (of 1688) in Great Britain, exclaimed: "Be encouraged, all ye friends of freedom, and writers in its defence! The times are auspicious." A year later Edmund Burke's *Reflections,* attacking the revolutionary spirit in France and in England, set in motion the pens of a hundred writers in its

[5] *M.H.H.*19: E41/K156.
[6] *F.R.*2-5. In a London handbill of July 11, 1791, calling for a demonstration on Bastille Day, Englishmen were exhorted to think of "The Crown of a certain great personage becoming every day too weighty for the head that wears it! too heavy for the people who gave it!"

defense, Blake's among them. In *The Marriage of Heaven and Hell* (1790–1792) he somewhat cryptically announced his allegiance to "the Devil's party."[7] In *The French Revolution* (1791), "A Poem in Seven Books," he undertook to deal rather simply and directly with the glorious events in France. Abandoning Illuminated Printing, perhaps from zealous haste or perhaps because he had found a regular publisher, he had "Book the First" set in type by Joseph Johnson and hoped no doubt soon to have the whole seven volumes on the bookstalls among the prophetic works of Mackintosh, Barlow, Paine, Wollstonecraft, and other writers in freedom's defense.

For some reason Blake's work was not published, however.[8] Perhaps it was not even continued, for only the first volume is extant. In February 1791 Johnson printed Paine's first volume of *The Rights of Man* and then decided not to publish it because a Tory hue and cry was rising.[9] Paine found another publisher, but Blake did not.[10] In the privacy of his notebook he continued to write plainly and sympathetically of revolutionary developments in France. In subsequent illuminated prophecies, *A Song of Liberty*, *America*, and *Europe*, he continued to write of revolution sympa-

[7] The date of *M.H.H.* is variously given, because in both composition and etching it ranges from 1790 to 1792–1793. I have given up the idea that the "Argument" is a late part of the work; in style of lettering it is early, as are plates 3 (containing allusion to Blake's 33rd birthday, i.e. Nov. 28, 1790, alongside which Blake wrote "1790" in one copy), 5–6, 11–13, and 21–24. The later plates include a parody of the 1791 *Apocalypse Revealed* (par. 484, in pls. 17–20). The "Song of Liberty" (pls. 25–27) refers to events of late autumn 1792 and perhaps later.

[8] The only extant text, a set of page proofs, bears the date 1791. It was probably written after the breakup of the religious houses in February 1790. See line 275.

[9] Antal, pp. 78, 105, says that Johnson was advised against publishing by John Bonnycastle, one of Fuseli's intimates (and a mathematician who is one possibility for Blake's Obtuse Angle in *I.M.*).

[10] Cf. Paine, 1, 243. Within the year booksellers were jailed for selling Paine. Johnson *could* have decided against Blake's work for its title. Bronowski, pp. 47–51 [74–79], and Schorer, pp. 162–166, both reason that *F.R.* was abandoned for fear of prosecution. Yet a year later Johnson published Barlow's radical *Advice* and his fairly violent *Conspiracy of Kings*. And even in August 1791 he was willing to publish an abridged *Rights of Man*. See *Trial of Horne Tooke*, 1795, 1, 156. Nor does Blake's work contain any direct reflection on English politics. It would be consistent with his other conduct for *Blake himself* to have withdrawn it.

thetically, but not plainly. The final text of *America,* for example, eliminates all direct naming of George III and his Parliament.

Failure to publish *The French Revolution* was a decisive failure for Blake. In this work, imaginatively high-flown as it is, he came closer than he ever would again to making his interpretation of history comprehensible to the English public of his own day. Withdrawal of this work was to mean Blake's withdrawal from any audience beyond a few uncritical or even uncomprehending friends, his withdrawal from the essential experience of communication, without which even the most richly significant and creative art cannot attain full stature and true proportions. Failure to communicate with the fraternity of citizens for whom and of whom he wrote encouraged Blake to pursue the involuted symbolism and obscure manner he had already made use of in *Tiriel* and *The Marriage.* (Yet today, as Blake's audience grows, we comprehend that the "failure" was but for a season.)

His isolation also gave free rein to his nervous fear of censorship, which was related to the political realities of his time only in an exaggerated form that interpreted the possibility of jail as a probability of hanging. Blake appears to have been deeply impressed by the persecution of Priestley and Paine, by the government's "every ban," and by the harsh trials in 1793 of the British Reformers who convened in Edinburgh and were sentenced to transportation as early "Victims to Justice" (*J*.38). He was temperamentally inclined to "shrink at the little blasts of fear" blown into his ear by potential informers (*N*.113). Without the salutary corrective of public appearance in print, he assumed that his own republican thoughts would be considered deeply subversive and bring him to the scaffold. Yet in his bardic self he remained bold. *The Marriage of Heaven and Hell, The French Revolution, America,* and the *Songs of Innocence and of Experience* reverberate with hope and energy, and defiance of repressive terrors. If these works did not reach the awakening citizens who were reading Paine and rushing together in republican societies, they did nevertheless reflect the stir and tumult of that awakening. Possibly these were Blake's least solitary years, but the record, once again, is too meager for biography.

That Blake was among politically sympathetic friends when he wrote his revolutionary prophecies of 1790–1795 seems fairly evident. There are indications that he inducted some people into the

political meanings of even his more obscure symbols.[11] And the relationship of Blake's *America* to the earlier and later versions of Joel Barlow's American epic is a two-way relationship indicating that they were acquainted with each other's work.[12] But beyond that we do not know whether any of the English Jacobins were aware of Blake except as a minor engraver occasionally employed by Johnson. We have no indication that Priestley or Paine or Mary Wollstonecraft or Godwin or Holcroft ever saw a line of his poetry. We need not question Gilchrist's report that Blake in his old age spoke of having known Paine and having "always avowed himself a 'Liberty Boy,' a faithful 'Son of Liberty,' " but we must suspect most of the circumstantial details in the anecdotes of Blake's association with "the Paine set" and the Johnson "coterie."[13]

Gilchrist and his anecdotal informants in the 1850's were working up recollected or orally reported material that had already attained a thirty years' polish in the conversation of Catherine and William Blake when they recited it in the 1820's. How much can we accept of the story that Blake saved Paine's life in September 1792 by warning him, after his report at Johnson's of a fiery speech he had delivered before the Friends of Liberty (the title of no known organization),[14] to flee at once to Paris ("whither he was

[11] See George Cumberland's glosses in the British Museum copy of *E.;* reference to *P.S.* in the second inscription of *Our End is Come;* and the conversion of an "angel" into a friend in *M.H.H.*

[12] For Blake's use of the 1787 *Vision of Columbus,* see above. Barlow, in the revision finished in 1804, *The Columbiad,* added a giant figure of War bearing Famine and Pestilence precisely at the point where Blake describes a Demon bearing Pestilence. In *America* the speech of Boston's Angel (paralleling the speech of Barlow's Adams) is followed by the appearance of a "Demon red" who threatens America and rejoices in the "terror" of naval bombardment and urban conflagration. In *The Columbiad* Barlow adds to the naval bombardment at this point a "demon Form" who stalks the Atlantic and is accompanied by meteors and other phenomena, all possibly suggested by Blake. Compare *Columbiad* v.471–472 and *A.*4:2–3; *C.*473–476 and *A.*3:13–16; *C.*477–478 and *A.*3:16–4:10; *C.*479–480 and *A.*4:5–7; *C.*481–486 and *A.*5:1–6, 15:7.

[13] Gilchrist, pp. 80, 174, 79.

[14] There *was* an ad hoc society of "Friends of Universal Peace and Liberty," however, which tried to meet Aug. 4, 1791 (and did meet Aug. 20) on the anniversary of the end of feudalism. *Trial of Tooke,* I, 151–155. But suppose it to have met the following year: then Blake warned Paine a month or so before he left!

now in any case bound," as Gilchrist admits)? The story grows from three inaccurate sentences in Tatham, where Paine is inadvertently sent fleeing to America, to a florid paragraph in Gilchrist, to a modern account in which Blake's "figure really emerges, leaps out clear, as it were," to a fully dramatized scene in a recent biography of Paine.[15] It is not out of character for Blake to have feared for Paine's life. But Paine left England to attend the opening of the French Convention, not to avoid arrest. He was already under indictment for seditious utterance, but the government was less eager than he to try the temper of a London jury.[16]

Some anecdotes seem designed to represent Blake as both a colorful revolutionary and a harmless one. (In Sharp's biography we find the same thing.) First he must have a revolutionary costume, a red cap and a white cockade, and be "the only one of the set" with courage enough to wear it. Then when the French republicans humiliate their English "sympathizers" with a "defiance of kings and of humanity," Blake must tear off "his white cockade" indignantly.[17] But the white cockade happens to have been a royalist symbol, not a republican. Again one wonders in what sense Blake may have "rebuked the profanity of Paine"[18] at a time when his own motto was, "Damn braces: Bless relaxes."[19] Yet the legend of Blake's association with a "remarkable coterie" of English Jacobins at Joseph Johnson's weekly dinners is not such a will-o'-the-wisp as the legend of the earlier Mathew set.

[15] Tatham in Russell, *Letters of Blake,* p. 40; Gilchrist, pp. 81–82; Schorer, p. 163; and W. E. Woodward, *Tom Paine: America's Godfather,* New York, 1945, p. 231. Of Paine biographers only Frank Smith, *Thomas Paine, Liberator,* Philadelphia, 1938, and of Blake biographers only Bruce, *Blake in This World,* have been able to resist this legend. Wright, 1, 47, has Blake attend the "Friends of Liberty" and also "often" the gatherings of the Revolution Society—which were *annual.* See also note 31 below.

[16] An instructive analogue to the Blake-Paine story appears in Ada Earland, *John Opie and His Circle,* London, 1911, p. 97. In 1795 two painters, Opie and Blake's friend Ozias Humphry, played a practical joke on the satirist Wolcot. Having learned that Wolcot had attended a meeting of the Friends of the People, they convinced him that spies were after him, advised him to "Get into the country as fast as you can," and regaled the Academicians with an account of Wolcot's hiding in obscure lodgings for a fortnight.

[17] Gilchrist, p. 81.

[18] *ibid.,* p. 303, a letter from Palmer in 1855.

[19] *M.H.H.*9: E37/K152; cf. Bruce, p. 66.

Johnson did entertain his authors, and we know from letters and diaries that among his more or less frequent guests were Priestley (from the 1770's to 1793), Fuseli (from 1779 to 1809), Mrs. Barbauld (in 1784 and occasionally later), Mary Wollstonecraft (in the early '90s), William Godwin (once in 1791, once in 1796, regularly after January 1797), and (at intervals between the spring of 1791 and the fall of 1792) Joel Barlow and Tom Paine. Johnson's printing of *The French Revolution* in 1791 virtually raised Blake to the status of author. And we have a letter of that July from Johnson to Erasmus Darwin in which Blake as a competent engraver is referred to familiarly as known and trusted by both.[20] It is fairly safe to assume that Blake sometimes attended Johnson's conversational Tuesday dinners in the early '90s. We know that he was intimate with Fuseli in this period, and Antal reminds us that Fuseli, besides possessing a "formidable library of antique authors" presumably available to Blake, was "one of the chief contributors to Johnson's literary magazine, the *Analytical Review*."[21] We have noted the possibility of Blake's acquaintance with Priestley and Mrs. Barbauld and Barlow. In his Notebook there is a portrait-like drawing of a face like Paine's, and in the "Well done Paine" of his 1798 marginalia there may be a note of personal rapport.[22] He seems to have read Wollstonecraft's two Vindications of the Rights *of Men* and *of Woman,* as we shall see, and in 1791 he was employed by Johnson in designing and engraving a number of illustrations for her *Original Stories* and *Elements of Morality*. We may suppose that author and artist met and further that Blake was aware of much in the private lives of Fuseli's friends—as when Mary Wollstonecraft, Johnson, and the Fuselis made plans to visit France in the summer of 1792 and had Barlow engage rooms for them in Paris—though we need not go on to suppose that Wollstonecraft is the subject of a poem which Blake entitled *Mary* when he wrote it, or wrote

[20] Keynes, *Blake Studies,* pp. 68–69.

[21] Antal, pp. 105–106; for a still neglected source of potential influences on and by Blake, see the list of Fuseli's contributions to the *Analytical,* 1788–1798, in Mason, pp. 356–358. There is also a slight link of influence (see below) between Blake's Thames poem of ca. 1792–1793 and a book on America by Gilbert Imlay, lover of Mary Wollstonecraft and associate of Paine, Barlow, and Thomas Christie, editor of the *Analytical.*

[22] N.74, top center; Marg. Watson, 109: E608/K395.

it down, a decade or so later.[23] Nevertheless the direct records of Blake's dining with Johnson are few, and rather late.

In John Stedman's recently discovered *Journal* the notes of his frequent social intercourse with Blake include a dinner party in June 1794 with Johnson, two of his engravers (Blake and Bartolozzi), the portrait-painter Rigaud, and a former planter.[24] William Godwin's diary for April 4, 1797, records his dining at Johnson's with Fuseli, Blake, Grignion (an engraver) and others.[25] It means little that this is the first such entry, since Godwin, contrary to Gilchrist's assumption, had not joined the circle of John-

[23] Nor does *Mary* fit the case of Mary Wollstonecraft. There is foundation, however, for Knowles's story that she was in love with Fuseli in 1792. See Ralph M. Wardle, *Mary Wollstonecraft*, Lawrence, Kansas, 1951, pp. 171–182, 347, 350.

[24] *The Journal of John Gabriel Stedman, 1744–1797*, ed. Stanbury Thompson, London, 1962, p. 382. Stedman was rarely in London; when there he called on Johnson and Blake, moved to Blake's for two or three days at a time when his inn was too "full of whores and rascals" (dragoons) (e.g. August 1795, pp. 389–390), and came to trust Blake more than Johnson—even in the matter of seeing to it that Luke Hansard, Johnson's printer, printed Stedman's book properly. Blake's availability and his ability to serve as expediter between Stedman and Johnson and Hansard are impressive tokens of his standing as well as activity:

Late June, 1795: "A hot quarrel with Johnson." *Ca. 3 Aug.:* "Dined Johnson's twice lately. . . . I kick the landlady of the *Saracen's Head* [his inn, in Holborn] . . . I visit Mr. Blake for 3 days, who undertakes to do business for me when I am not in London. I leave him all my papers [presumably concerning the printing and subscription list for the *Narrative*]. . . . D–mn Bartolozzi. . . . Johnson uncivil all along. . . . Two days at Blake's. Quiberon expedition fail'd."

In September, confined to bed, he "saw Johnson" at least once and heard of Blake's being robbed, perhaps from Blake himself.

Dec. 18: "Being come home [to Tiverton] on the 18th, I calmly arrange all my matters. . . . Send a goose to Johnson, and one to Blake." Between January and May, 1796, Stedman corresponded busily with Johnson, Hansard, and, most heavily, Blake (e.g. *May:* "I wrote lately to Hansard . . . 12 letters to Blake . . . to Johnson, 2, and damn him in them. . . ." (pp. 386–395).

[25] Others present were Dr. John Anderson and Arthur Aikin, a nephew of Mrs. Barbauld. For all references to the unpublished diary of William Godwin I am indebted to Lord Abinger, to the Duke University Library, and to Lewis Patton, who is preparing an annotated edition. Godwin kept an apparently exhaustive record of his daily reading and association from 1788 to 1836.

son's regular diners until this year and had not even met Fuseli until recently. But the triweekly presence of Fuseli's name in the diary for the next twelve years and the entire absence of Blake's are eloquent of the latter's retirement.[26]

A possibility of early contact (strengthened if we assume that it was our "William Blake esq." of London who subscribed in 1788 to Gordon's *History of the Rise of the United States*) is that the poet's interest in America was revived before or during Barlow's first London visit, in 1788, perhaps by William Hayley. Barlow had sent ahead a copy of *The Vision of Columbus* to Hayley, with whom he visited and corresponded again in 1792.[27] It was during the visit of February 1792, as we shall see, that Hayley's attention was called (by Barlow or his companion John Warner) to the fact that his projected life of Milton for Boydell would compete with Johnson's plan to publish Fuseli's Milton Gallery with a text by Cowper and engravings by Blake and William Sharp and others.[28] Yet we do not know that Blake and Hayley were in communication, though Hayley had been introduced to Blake's poems in 1783 and the acquaintance of the two men is now recognized as having begun long before 1800.[29]

It is also possible that Blake's intimacy with William Frend[30] began not long after that radical Unitarian, expelled from Cambridge for the "sedition and defamation of the Church" in his

[26] Godwin first dined at Johnson's Nov. 13, 1791, when he met Paine (whom he saw again only twice) and Wollstonecraft (whom he saw twice more, then not again till Jan. 8, 1796); he next dined there Aug. 7, 1796, when he met Fuseli; beginning Jan. 31, 1797, he dined once every three weeks, with few lapses, until Johnson's death in December 1809.

[27] William Gordon's *History* plus Barlow's *Vision* could just about supply the American history (as distinct from the London history) in Blake's *America*. Yet the subscriber may have been, say, the William Blake of Aldersgate Street who was a contributing member of the Society for the Encouragement of Arts between 1783 and 1803; see annual *Transactions*. For Hayley's interest in Barlow ("though I am *not yet a Republican*, I have read with great pleasure") see M. Ray Adams, *Studies in the Literary Backgrounds of English Radicalism*, Lancaster, Pa., 1947, pp. 28, 34, and Bishop, *Blake's Hayley*, p. 144.

[28] In 1791 Blake was among the subscribers to Cowper's translation of *The Iliad and Odyssey of Homer*, according to G. E. Bentley, Jr., *Notes & Queries*, XII (1965), 172.

[29] Bishop, p. 197.

[30] Wright, II, 95–96. Frend was just six days older than Blake. Wright supposes them to have been introduced by Linnell, i.e. not earlier than 1818.

Peace and Union recommended to the Associated Bodies of Republicans and Anti-Republicans (1793), came to London to associate with such republicans as Holcroft and Brand Hollis.

Much more certainly Blake could not have failed to have some acquaintance with the famous Society for Constitutional Information, which was revived early in 1791 by Tooke and Hollis and Richard Sharp, chiefly in connection with the promotion of Paine's *Rights of Man*.[31] In March 1792 the Society resumed regular weekly meetings, which were attended occasionally by Paine and Barlow and John Richter, whose brother Henry was an engraver who knew Blake,[32] and quite regularly by Holcroft, whose name is slightly associated with Blake's through the *Wit's Magazine* of 1784, and by William Sharp, whose name is frequently associated with Blake's through engraving projects both in *Wit's Magazine* days and around 1790.[33] Sharp, who later "endeavoured to make a convert of Blake" to the sect of Joanna Southcott[34] and as a Swedenborgian in the 1780's may have stimulated Blake's interest

[31] The S.C.I. is usually said to have been revived in March 1792, but meetings of March 23, Apr. 1, and July 22, 1791, are recorded in minutes read in the Tooke and Hardy trials. See *Trial of Tooke*, I, 145–148. In the trials there is some confusion of Richard and William Sharp (both spelled either Sharp or Sharpe).

[32] See below. John Richter, one of the indicted leaders, was a London Corresponding Society delegate. His brother and father, both named Henry, were engravers. The brothers associated with Godwin, often together, and it is probable that Henry shared John's republicanism. In Godwin's diary for June 12, 1796, we find the Blakean constellation of Barry, Sharp, and H. Richter at Holcroft's. The younger Henry Richter, who in 1788 at 16 was exhibiting at the Academy, was probably known to Blake by then, for he had received his "early tuition in art from Stothard" (D.N.B.) in the period of the latter's close association with Blake. Farington (*Diary*, III, 226), saw "old Mr. Richter" bring Robert Fulton to see West's *Nelson* on May 11, 1806; not long afterward Fulton subscribed for two copies of Blake's Blair. Todd, in Gilchrist, index, confuses the Richters.

[33] For example, both Blake and Sharp engraved plates for the first volume of Lavater's *Physiognomy*, 1789, under Fuseli's careful supervision, and both undertook some engraving for Johnson's Milton. See Mason, p. 137, and Knowles, *Fuseli*, I, 171–173. Behind the business of Blake's warning Paine in 1792 may lie the fact that Sharp was on a committee of the S.C.I. which was directed on May 18 "to enquire into the rumour of [government] prosecution of Paine" and which reported on June 22 that an information had been filed against him. *Trial of Tooke*, I, 129–133. For Holcroft and Blake, see Schorer, p. 158.

[34] H. Crabb Robinson's diary, Jan. 30, 1815.

in the New Church, *may* in this period have encouraged his interest in Paine and Barlow. We know that Blake did not attend S.C.I. meetings, however, for their minutes were put on record in the sedition trials of 1794; yet doubtless he knew of Sharp's activity long before "the celebrated engraver" appeared as a key witness whose examination by the Crown contributed to the acquittal of the Society leaders.[85]

The published trials link the names of Holcroft and Sharp and Blake—but the latter was an Arthur Blake, who seems to have been an acquaintance of William Godwin.[86] He is of no known relation to William Blake—except that they had mutual acquaintances, were both interested in republicanism and art, and are thus vexingly intertwined in Godwin's diary, the entries of which need careful interpretation lest we jump to the conclusion that most of them refer to William Blake.[87] Yet he must have followed the trials (but we have no attendance records) and rejoiced with "all of London" at the acquittals, November 5, 1794. The names of Blake's friends—and friends' friends—are frequent in the public

[85] In two and a half years Sharp attended 38 of the 48 meetings recorded in the trial proceedings; in correspondence he was "Citizen Sharp"; for his prominence as witness see especially *Trial of Tooke*, II, 192–193: "Consider who Mr. Sharpe is: he is a member of the Constitutional Society . . . he was a member of the Committee of Conference . . . he was a member of the Committee of Cooperation." Godwin encountered him frequently among those who talked "of ideas and revolution" at Tooke's and elsewhere, with Holcroft, Thelwall, and other radicals. On Oct. 20, 1792, Godwin went in the rain to Sharp's to see "Romney's Paine, Fuseli's Devil, and Trumbul's Gibraltar," paintings which Sharp was engraving.

[86] *Trial of Hardy* (in Howell's *State Trials*), II, 104–119, III, 35. Arthur Blake attended the S.C.I. in February, March, and April 1794, always with Sharp; he and Sharp were stewards at the anniversary dinner May 2, 1794. Both were questioned before the Privy Council in June. See next note.

[87] The single encounter at Johnson's *may* have supplied all the grounds there were for Gilchrist's report (p. 79) that Blake "got on ill" with Godwin. In Godwin's diary the name Blake appears thirteen times (not counting references to Admiral Blake) in 1794–1823, at first evidently in reference to the radical Arthur Blake "of Devonshire-street, Portland-place." An entry of Apr. 16, 1796, *could* refer to William Blake ("Sa. . . . tea Miss Hayes, w. Hamilton, Blake, Christal, Mrs. Gregory and Dr. Crauford") but is followed by "A Blake" references. The only convincing William Blake entry is that for Apr. 4, 1797, cited above: "Dine at Johnson's, w. Fuseli, Grignion, Blake, Dr. Anderson and A Aikin." (For the other entries, see my long note in the first edition, pp. 145–146.)

notices.[38] One, in the *Telegraph* of October 27, 1796, announcing "a Meeting of the Friends of Freedom, at the Crown & Anchor," on the second anniversary of "that propitious Day," lists among the stewards of the banquet Thomas Brand (who, with Sharp, went bail for John Frost in December 1793), Godwin's friends Arthur Blake and William Bosville, Earl (Citizen) Stanhope, and Benjamin Heath Malkin—the man whose *Memoirs* a decade later would include a sympathetic presentation of *The Tyger* and other Songs with an authentic sketch of Blake's early career—but no indication of the recency of their acquaintance.[38a]

One rare anecdote affords us a glimpse of Paine, Sharp, and Fuseli in almost domestic intimacy, at a time when we know that Blake was associated with at least the latter two. "Paine was an excellent mechanic," Fuseli told his biographer; "when Sharpe was about to engrave my picture of 'The Contest of Satan, Sin, and Death' [late in 1790], he employed a carpenter to construct a roller to raise or fall it at pleasure; in this, after several ineffectual attempts, he did not succeed to the expectations of Sharpe, who mentioned the circumstance in the hearing of Paine; he instantly offered his services, and set to work upon it, and soon accomplished all, and indeed more than the engraver had anticipated."[39] It is most unfortunate that Blake wrote no *Island in the Moon* for this period and kept no correspondence.

What he did write, however, leaves no question as to his familiarity with the *ideas* of the Paine set. His emphasis on the common people even when describing the debates of a royal coun-

[38] Even Flaxman, in Rome since 1787, and able in 1790 to accept "the present changes in Europe" in a Swedenborgian spirit (while sending his love to William Sharp), watched from his remoteness: "The newspapers have informed us," he wrote to his father July 22, 1794, "that our friend Mr: Sharp the Engraver has been examined on suspicion [of treason], but from what I know of him I think his character so excellent that I cannot believe anything will be found against him." Flaxman Papers (B.M. 39780), quoted in Bentley, *Studies in Bibliography*, XII (1959), 166.

[38a] Malkin's name appears in Godwin's diary Dec. 1, 1796, Dec. 24, 1797, and May 17, 1800, the latter occasion being a dinner at Fuseli's Milton Gallery. See below, p. 438.

[39] Knowles, I, 375–376; cf. 172–176. Fuseli also pictures Joseph Johnson as an active friend of Paine, helping him move in 1792.

cil, his condemnation of La Fayette rather than the Jacobins when the two come into conflict, and his insistence, in *Visions of the Daughters of Albion,* on the indivisibility of human freedom, suggest a stronger affinity for the artisan radicalism of the Constitutional and Corresponding Societies than for the more Whiggish radicalism of such younger men as Wordsworth and Coleridge.[40] In his ideas, if not perhaps in his apparel, Blake displayed a warmth of republican enthusiasm more enduring and more satisfactory to the needs of his poetic genius than the winter's gown of innocence.

In the following chapters his detailed interest in the first five years of the French Revolution will occupy us, and then in Part Four we shall pick up the thread of English history.

2

. . . Depart, O clouds of night, and no more
Return; be withdrawn cloudy war . . .
— The Abbé Sieyès (*F.R.*238–239)

The events covered by Blake's *French Revolution* (E282–290/ K134–148) may be summarized briefly. The three Estates convened May 4, 1789, at Versailles and met separately for five weeks while the deputies of the commons tried to induce the other orders to sit with them. Emboldened by increasing popular agitation, and having been joined by some of the liberal clergy and nobles, the commons declared themselves a "National Assembly" on June 17. On the 19th Louis assembled his ministers, who made several ineffectual attempts to regain the initiative, but the commons on the 20th swore not to separate before they had given France a constitution. On the 23rd they defied a royal

[40] Yet the Whig Charles Fox was considered the leader of political rebellion by artist if not by artisan radicals. Cumberland, Barry, Wordsworth, Hayley, Opie, and Hoare all address dedications to Fox. For that matter, Sharp joined the Friends of the People as well as the S.C.I. *Trial of Hardy,* III, 389.

In *American Notes & Queries,* VI (1967), 35–38, Nancy Bogen notes that Blake gives the Foxite (Washingtonian) colors buff and blue to the patriot pilgrim in the first Preludium page of *E.* (in at least two of the colored copies). Yet Blake distinguishes this youthful pilgrim from Fox himself; at the bottom of the page Fox is wrapped in (his own?) shady woe, while the youth is manacled externally.

rebuke, and they were imitated a few days later by some French Guards who declared themselves "the Soldiers of the Nation" and refused to fire on a crowd who were breaking the windows of the Archbishop's palace.[41]

On the 27th the King capitulated, ordering the nobles and clergy to join the commons. At the same time, however, he surrounded Paris and Versailles with foreign mercenaries. Feelings ran high, aggravated by increasing unemployment and a grain crisis, and on July 8 the Assembly passed a motion by Mirabeau asking the King to return the mercenaries to the districts they had come from. Abbé Sieyès declared that in Brittany troops were not permitted nearer than ten leagues to the meeting of the provincial Estates, and Target cited a similar stipulation in his *cahier*. Louis replied vaguely, and in response to a second request he stated that the troops were needed to restore order at Paris and Versailles and that if "his" Estates did not like it they themselves could move. In addition he severed a link of compromise by dismissing the cabinet liberals and exiling Necker, the finance minister who had become a symbol of the popular will.[42] On the 13th the Paris bourgeois threw up barricades and decided to establish a National Guard. Various arsenals were raided for arms by a crowd which, on the 14th, turned to the ancient fortress of the Bastille for a further supply. The commons' demands for a removal of the army were reiterated on the 13th and 14th, and on the 15th Louis again appeared to give in. On the same day the Paris committee named La Fayette *colonel-général de la milice bourgeoisie*. The King came to Paris shortly to "confirm" the nomination, and La Fayette put the King's color, white, between the red and blue of Paris to form the tricolor cockade of the new order. While the unemployed were put to work demolishing the walls of the Bastille, the National Assembly began taking apart the legal structure of the old regime.

The first and only extant book of Blake's *French Revolution*

[41] Historical details in this chapter are from *Le Moniteur Universel*, the London *Times*, the *Procès-verbal des séances de la chambre de la noblesse*, and Lefebvre, *Coming of the French Revolution*.

[42] This symbol "was embodied only temporarily in Necker, whose role was assumed, as occasion required, by various successors." C. B. Rogers, *The Spirit of Revolution in 1789*, Princeton, 1949, p. 97. It is remarkable how closely Blake's analysis is paralleled by that of the modern psychological historian.

begins approximately with the Council of State of June 19–21 and ends with the removal of troops July 15, but considerable liberties are taken with the sequence and relationship of events. The fall of the Bastille, foreshadowed by a thirty-six-line account of the "howlings" and despair of its governor and the laughter of its prisoners, is not described here but is saved evidently for full treatment in Book Two. Blake also disregards, perhaps from ignorance, the difference between the bourgeois militia and the royal army. His "Fayette" as "the General of the Nation" carries out the Assembly's "command," not request, "that Fayette should order the army to remove ten miles from Paris" (262–269). The effect is to present the Assembly as a more decisive and powerful body than it was at this stage of the revolution and as the effective voice and agent of the common people, carrying through the mandates of the *cahiers*. Blake's manipulation of episodes emphasizes the primary demand for peace by making it appear that tyranny's "war-breathing army" (253) must be removed before the forms of oppression symbolized by the towers of the Bastille can be demolished and before further social demands can be taken up.

Blake's stroke of simplification, or error, in making the scene Paris rather than Versailles has the effect of allowing "the city of Paris, their wives and children" to "look up to the morning Senate" from their "pensive streets," and of making the grey towers of the Bastille literally cast a shadow over the commons as they "convene in the Hall of the Nation" (54–58). But one foresees difficulties for a later chapter that must deal with the October march of wives and militia to Versailles and their compelling the Royal Family and Assembly to move to Paris.[43]

Politically *The French Revolution,* though written when constitutional monarchy was still the most probable eventuality for France, is thoroughly republican in its emphasis on the fraternity of citizens and its prophecy that the scepter is "no more to be swayed by visible hand." The treatment of La Fayette as a sort of George Washington shielding women and children from the armies of despotism may be considered as transitional between the Champion or Deliverer of *Poetical Sketches* and the subordination in *America* of historical figures such as Washington and Paine to

[43] Blake also has the King in the Louvre rather than the Tuileries, his actual Paris residence.

the theomorphic spirit of revolution, Orc. Yet Blake is already giving cosmic significance to specific historical figures and events. The old "heavens" passing away are dukes and archbishops, a "starry harvest" reaped by the judgment of the people (90). The "loud voice of France" which announces the morning and the unloosening of "the triple forg'd fetters of times" (15, 62) is analogous to the "great voice out of heaven," in the 21st chapter of Revelation, which announces the new Jerusalem. All the revolutionary events of June and July are treated as a single Day of Judgment or Morning of Resurrection during which the dark night of oppression lingers and fades in the marble hall of the Old Order while the Sun of democracy rises above the city streets and the people's Assembly. Blake's *French Revolution* has unique importance as the only one of his visions or prophecies in which the historical particulars are clear and explicit, and it must be observed that scholars who neglect even to consider this work among Blake's "prophetic writings" are neglecting the most available key to the historical symbolism of such later books as *Europe* and *The Four Zoas*.[43a]

As the scene opens, the King, sick on his couch and unable to wield his scepter, calls his minister:

. . . Rise, Necker: the ancient dawn calls us
To awake from slumbers of five thousand years. I awake,
 but my soul is in dreams (7–8)

The ancient dawn is Eden, the paradise that is on the horizon again after ages of oppression. Both king and people have been asleep during the dark night of feudalism. The people are now really awake, but the king imagines that his scepter still has power.

"Troubled, leaning on Necker" (a politically apt expression), Louis descends "to his chamber of council" where "forty men: each conversing with woes in the infinite shadows of his soul . . . walk, gathering round the King." Blake had to make up the details of Louis' council meetings pretty much from whole cloth, the newspapers supplying only the general information that the nobles "were in agonies of despair," that the Archbishop of Paris was attempting to keep the clergy in line, and that "council after council was held in the king's palace" without reaching agreement "in

43a The neglect has been considerably repaired by William F. Halloran's essay in *Blake's Visionary Forms Dramatic,* cited above, p. 27, n. 9.

anything."[44] Blake made the most of the Archbishop as a suitable Accuser, and for the liberal side he had several famous names to choose from, but for the representatives of the reactionary nobles he was hard pressed. He invented a Duke of Burgundy, "the ancientest Peer," and then used his name again, in French, for an "Earl of Bourgogne." Equally fictitious are his "Duke of Bretagne" and "Bourbon's strong Duke."[45] As Berger observes:

"All these men are symbols: the Duke of Burgundy is the Nobility hostile to the People, Sieyès, the People itself; the Archbishop of Paris represents the privileged Clergy; the Duke of Orleans, the liberal party among the Nobles; La Fayette the Nation in arms. Thus considered they are even historically true in their chief features, and it is mere justice to recognize that Blake has given them the characters which they had in the popular imagination and which they have kept in history."[46]

Like the "infernal forms art-bound" of *America,* the King and dukes are "bound down as with marble" while "the loud voice of France cries to the morning," a "light walks round the dark towers" of the Bastille, and the city of Paris looks hopefully to the convening commons. The nobles "fold round the King" like Gwin's chief warriors, but now "Kings are sick throughout all the earth," and Louis advises precipitate retreat. In his fear he imagines all the kings of history, with anguish on their "brazen war foreheads," looking into their graves and being advised by their wise men: "We are not numbered among the living . . . Let us hide; let us hide in the dust; and plague and wrath and tempest shall cease" (61–78). The historical Louis, in his message to the nobles advising them to save their lives and join the commons, added that if there were any noble who felt himself bound "to remain in the chamber," he would "go and sit by him, and die with him if it be necessary" (as one not numbered among the living).[47]

Blake's King is especially afraid of the people who have begun direct acts of liberation, and he identifies himself with the ghosts of the dead who cry: "Our bands and our prisoners shout in the open

[44] Newspapers quoted in the *Annual Register.*
[45] The last Duke of Burgundy died in 1714; "Bourbon's strong Duke" seems to bear no relation to the actual Prince of Bourbon-Condé.
[46] P. Berger, *William Blake, Poet and Mystic,* New York, 1915, p. 333.
[47] Louis' message of June 27.

field . . . The prisoners have burst their dens. Let us hide."[48] The
Louis of history was confronted with the fact that, three days after
his advice of capitulation, a crowd of citizens and royal dragoons
released from prison a number of French Guards who had been
arrested for deserting their barracks and vying "with the populace
in their democratic exclamations [shouting in the open field?] and
other excesses."[49] Unfortunately the King did not listen to his
ghostly conscience. To replace the guards who had chosen to ally
themselves with the living, he had begun to order up troops of the
regular army, especially Swiss and German regiments, and Blake
pictures him regaining his composure as he looks out his palace
window again (we are drifting into the first week of July) and scans
his vast mercenary armies "spread over the hills, Breathing red fires
from man to man, and from horse to horse" (80–82).

The King can now sit down, let his nobles take "their ancient
seats," and listen to the counterrevolutionary advice of "the an-
cientest Peer," from whose garments arises "an odor of war, like
a ripe vineyard" while "around him croud, weeping in his burning
robe, A bright cloud of infant souls."[50]

The bloody Burgundy, whose "words fall like purple autumn on
the sheaves," resists the passing away of the first heaven and the
first earth even while he reveals how ripe for apocalyptic harvest
is the old order he represents. His complaint is that "mowers From
the Atlantic mountains" are preparing to transform "this marble
built heaven" into "a clay cottage" and "mow down all this great
starry harvest of six thousand years."[51] The people threaten to re-
duce "the ancient forests of chivalry" to firewood and burn "the
joys of the combat . . . for fuel." "This to prevent," he declares, un-
folding the aristocratic conspiracy as of the second week of July,
"thy Nobles have gather'd thy starry hosts round this rebellious
city" in order that "the ancient forests of Europe" (note Blake's
term for the feudal aristocracy) may once more have the pleasure
of hearing "the trumpet and war shout." The "lean earth" is crav-

[48] *F.R.*74–78: E286/K137. I have corrected *bonds* to *bands,* the usual
term for troops. The text is an uncorrected letterpress proof and contains
several typographical errors.

[49] Bisset, II, 256.

[50] *F.R.*87–88. "A ghastly parody of the Sistine Madonna," notes Frye,
p. 203.

[51] *F.R.*89–90; cf. the hut-to-castle speech of Chandos in *Edward the Third*
iii: 195–203: E423/K25–26.

ing to be enriched with fresh blood, maintains Burgundy, and in language that echoes the *Prologue to King John* he urges the King to "stretch the hand" that will signal an attack (93–102).

The King is emboldened by Burgundy's speech and by the sight of "his armies . . . tinging morning with beams of blood" (an echo of *Edward the Third*). This is the point (July 11) at which Louis ceased temporizing, dismissed the liberals from his cabinet, and sent Necker into exile. "Necker rise, leave the kingdom." In the manner of a stage villain's aside to the audience the King says he is choosing war instead of peace because "dark mists roll round me and blot the writing of God Written in my bosom."[52] He points to the peasant insurrections and municipal revolutions throughout France as evidence that "the tempest must fall." Necker departs in silence, pausing a moment "like thunder on the just man's burial day."[53]

In the King's caucus the Archbishop of Paris now rises in "sulphurous smoke." Having been warned in a dream of the awful fate of the Church if the State is leveled, the Archbishop brings divine sanction to the use of armed force, as did the Bishop in *Edward the Third*. It is the "command of Heaven," he announces, "to shut up this Assembly":

Let thy soldiers possess this city of rebels, that threaten
 to bathe their feet
In the blood of Nobility; trampling the heart and the head;
 let the Bastile devour
These rebellious seditious; seal them up, O Anointed, in
 everlasting chains.[54]

In the bishop's dream democratic equality appears as a nightmare of leveling. The God of law, without his ancient props, the nobles and clergy, will go out like "a lamp Without oil." The "godless"

[52] Compare *Edward the Third* vi:39–41: E429/K32.

[53] *F.R.*105–117: E287–288/K139. Five lines that belong *after* King Louis' speech of dismissal ("He ceas'd cover'd with clouds") are out of order in the proof; i.e. they were printed as lines 105–109 instead of 120–124. Thanks to William F. Halloran's detection of this error (see *BNYPL*, LXXII [1968], 3–18), the third printing of E has the corrected sequence. Present reference is to the new numbering.

[54] *F.R.*127, 153–157: E288–289/K141. On the heart and head of the state, see *King Edward's Bishop*, ii:84: E418/K21.

people will "drop at the plow and faint at the harrow, unredeem'd, unconfess'd, unpardon'd." It is not the oppressive labor that troubles him but the lack of outward ceremony. And he shudders at the unmitigated equality of the grave: the priest rotting "in his surplice by the lawless lover," the king "frowning in purple, beside the grey plowman, and their worms embrac[ing] together." Here's fine revolution, as Hamlet said in the graveyard. The "bars of Chaos are burst."[55]

Word now comes that a spokesman, Sieyès, is coming from the Assembly, whereat the "awful" Duke of Bourbon throws his drawn sword "on the Earth," and the nobles pace the chamber "like thunder-clouds ready to burst." They will unleash civil war rather than face the indignity of equality—and of having their noble "shoulders" plowed "with furrows of poverty" (168–174).

Blake reinforces his theme of peace-against-war by introducing "a dark shadowy man in the form of King Henry the Fourth," who walks before Sieyès and makes "strong soldiers tremble." When he confronts the "Princes and Generals of France" in the palace, they accuse him of threatening to damp all their warlike fires. In the Assembly's final draft of a message for the King (July 15) it was charged that the troops around Paris were impeding the grain supply, and Mirabeau proposed adding the ironic observation that Henry IV even when besieging Paris had secretly sent it grain while Louis XVI in the name of peace was reducing the city to famine. And Blake must have been familiar with the legend frequently cited, as in Paine's *Rights of Man,* that Henry had planned to abolish war in Europe by forming a republic of nations. "Great Henry's soul," meeting among the dukes little but cold disdain and souls covered "with snows eternal," shudders and departs "indignant" (164–201).

Under the auspices of Henry's presence, however, one of the nobles does speak for peace—the royal Duke of Orleans, described in a current handbill as an "august shoot from the stock of HENRY IV."[56] He is a bit out of place here, since he joined the

[55] *F.R.*131–150. Blake's handling of the Revolution affords a contrast to Carlyle's. Blake has the people seek peace, the aristocrats fear Chaos. Carlyle has the people seize arms and rush into Chaos.

[56] London *Times,* July 17, 1789. Louis himself was hailed as another Henry IV when he was thought of as presiding benevolently over the Revolution. See Rogers, p. 86.

commons early in June, but Blake allows him to rise up in the royal council "generous as mountains" and with one look transform the Archbishop of Paris into a hissing reptile.

The speech of Citizen Equality begins with a plea for organized innocence as a policy of peace between individuals:

> O princes of fire, whose flames are for growth,
> not consuming,
> Fear not dreams, fear not visions . . .
> Can the fires of Nobility ever be quench'd, or the stars
> by a stormy night? (179–181)

and concludes with a direct challenge to the episcopal guardian of "holy law":

> But go, merciless man! enter into the infinite labyrinth of
> another's brain
> Ere thou measure the circle that he shall run. Go, thou cold
> recluse, into the fires
> Of another's high flaming rich bosom, and return unconsum'd,
> and write laws.
> If thou canst not do this, doubt thy theories, learn to consider
> all men as thy equals,
> Thy brethren, and not as thy foot or thy hand, unless thou
> first fearest to hurt them. (190–194)

Only "when the people are free," says Orleans, will the nobles be truly so. The "feet Hands, head, bosom, and parts of love" must all have liberty to "follow their high breathing joy" if the social body is to be healthy. Blake-Orleans is reversing the rhetoric with which the Archbishop justified a political hierarchy of head, heart, and servile members. Orleans fills in the analogy with names of the leaders of the revolution:

> Have you never seen Fayette's forehead, or Mirabeau's eyes,
> or the shoulders of Target,
> Or Bailly the strong foot of France, or Clermont the terrible
> voice . . . ? (184–188)

Moved by this appeal, the council agrees to hear "the voice of the people," whose first demand is that the troops of "cloudy war" be withdrawn ten miles from Paris: "let all be peace, nor a soldier

be seen!"[57] For Louis' answer that his Estates could remove themselves if they did not like the situation, Blake substitutes a more dramatic sarcasm, suggested perhaps by Macduff's Birnam Wood maneuver and designed to set the stage for the drama of July 14. Prophetic blood runs "down the ancient pillars" of the palace while Burgundy "delivers the King's command":

Seest thou yonder dark castle, that moated around, keeps this
 city of Paris in awe[?]
Go command yonder tower, saying, "Bastile, depart! . . .
Overstep the dark river, thou terrible tower, and get thee up
 into the country ten miles . . ."
. . . and if it obey and depart, then the King will disband
This war-breathing army . . . (246–253)

Blake follows history in having the Assembly receive this "unwelcome message" in silence followed by a thunderous murmur until Mirabeau arises to speak against submitting. But whereas the Assembly actually floundered in diplomatic negotiations for five days until the fall of the Bastille drove the King to order his marshal to disperse the troops, leaving the new National Guard headed by La Fayette as the only effective army in Paris by the 16th, Blake's imagination telescopes this action, with the ideal result that *no* army is left in Paris.

"Where is the General of the Nation?" cries Blake's Mirabeau, whereupon

Sudden as the bullet wrapp'd in his fire, when brazen cannons
 rage in the field,
Fayette sprung from his seat saying, Ready! then bowing
 like clouds, man toward man, the Assembly . . .
. . . murmuring divide . . . and the numbers are counted in
 silence,
While they vote the removal of War . . .[58]

[57] 240. Sieyès spoke to this effect in the Assembly July 6; he did not in fact participate in any of the delegations to the King.

[58] *F.R.*261–267. Blake makes two errors in his vision of this debate. On each of the resolutions in question the vote was unanimous, and anyway the French did not vote by "dividing" in English fashion but by voice or by standing in their places.

"Pestilence," which has been hovering in the sky, weighs anchor—or rather "weighs his red wings" to depart. La Fayette (shortened by Blake, as earlier by Barlow, to the republican Fayette) soon stands "like a flame of fire . . . before dark ranks, and before expecting captains," the "trumpets rejoice" to announce peace instead of war, and the "steely ranks move," leaving "Paris without a soldier, silent . . . and the Senate in peace . . . beneath the morning's beam" (267–306).

So ends "Book the First" with the full dawn of peace, satisfying the "first voice" of the people. But what are the social origins of their revolutionary voices? Blake indicates two interwoven strands of causation, the decay of ecclesiastical authority over men's minds, and the relaxation of monarchical authority over their bodies. When Fayette in the people's name commands the dark ranks' departure, Religion is powerless to prevent it because the guardians of superstition are now mere "spectres of religious men," easily "driven out of the abbeys . . . by the fiery cloud of Voltaire, and thund'rous rocks of Rousseau" and unable to survive "in keen open air" (274–277).

Fayette is "loud inspir'd by liberty" and by the spirits of Voltaire and Rousseau. And the speech of Orleans rings with the promise of equality. But it is chiefly fraternity, evidenced in the fraternization of troops and people, that supplies the revolutionary moral force supplanting the "soul shaking" terrors of the old regime. In the speech of Sieyès, the people's ambassador, Blake surveys the rise of this new democratic Enlightenment and the decline of feudal power.

So long have the "Heavens of France" oppressed the "meek cities" and "souls of mild France" that the very process of rearing life has become a negation; "the pale mother nourishes her child to the deadly slaughter." Recurrent wars have devastated both village and field, and the plagues that really make the people weep are "blights of the fife, and blasting of trumpets."[59] At the same time the Priest devours the labor of the plowman, enslaves the strong, and binds the honest "in the dens of superstition." He forbids "the laborious plowman And shepherd" to be educated in the use of "the saw, and the hammer, the chisel, the pencil, the pen, and the instruments Of heavenly song." Nobles and Priests

[59] F.R.204–210; cf. the blight-spreading trumpets in E.7.

are both responsible for the clouds of war and hunger. But the "dawn of our peaceful morning" has come at last because man is expanding "his eyes and his heart" and has begun to question the philosophical basis of the status quo.[60] The result is not a simple pulling down of tyrants but a movement to remodel the whole structure of society into a fraternity of brethren considered as equals. The people cry to the soldiers, "throw down thy sword and musket," the soldiers "run and embrace the meek peasant," and if this process keeps up the meek will inherit the good earth of France without a sanguinary struggle:

> . . . Her Nobles shall hear and shall weep, and put off
> The red robe of terror, the crown of oppression, the shoes of
> contempt, and unbuckle
> The girdle of war from the desolate earth . . . (220–223)

Even the Priest "Shall weep" (one hears the burden of *Ça Ira* in this repentant weeping) and shall at length come down to earth to embrace the people and put "his hand to the plow." There will be no more tithes, no more interdiction of the pursuit of happiness. The millions will have the right to "sing in the village, and shout in the harvest, and woo in pleasant gardens, Their once savage loves, now beaming with knowledge" in the new Eden of experience. No more war, pestilence, night-fear, murder, falling, stifling, hunger, cold, slander, discontent and sloth.[61] Now the happy earth shall sing in its course, "The mild peaceable nations be opened to heav'n, and men walk with their fathers in bliss." Such heaven on earth will surely come *if* the rulers hearken to the people's demand for peace (223–240).

So eloquent are these speeches of Orleans and Sieyès that we feel Blake must at some point in the early days have entertained the hope that the French King and Dukes and Archbishop might put off terror and contempt and resist the temptation to put on the

[60] *F.R.*216–233. The process of enlightenment is described in anti-Newtonian and potentially anti-rationalistic terms: "where is space! where O Sun is thy dwelling!" Man questions the limits of a mechanistic universe. Cf. *F.Z.*ix:117:1–15: E371–372/K357:1–5.

[61] Besides carrying disease, the "pestilent fogs round cities of men" signify the conditions of hunger, cold, crowded housing (stifling) and unemployment (sloth) that infest city life. Cf. the destruction that hovers "in the city's smoak" in *P.S.*

girdle of counterrevolutionary war. The people's pleas are shown to have little effect, however, on "the Princes." Their army is taken away from them and the King is frightened into a "chill cold sweat." But he and the dukes shed no repentant tear. In the final scene there is still a "faint heat" in their veins and a revival of "the cold Louvre" which bodes no good (295, 303).

8. The Eternal Hell Revives

Drive your cart and your plow over the bones of the dead.
The road of excess leads to the palace of wisdom. . . .
Exuberance is Beauty.
 —"Proverbs of Hell" (*M.H.H.*7, 10)

In *The French Revolution* we see what a deep and steady furrow
Blake has determined to plow across the graveyard of old ideas and
old allegiances. In *The Marriage of Heaven and Hell*, a collection
of manifestos and proverbs and "Memorable Fancies" in parody of
Swedenborg's "Memorable Relations," we see what a contrary and
revolutionary step Blake has persuaded himself to take from an
interest in the New Church to an enthusiasm for the new society.
We see at the same time how useful Swedenborg's theosophical
analytics are as something for Blake to transcend by contradiction,
reading black for white. "Without Contraries," he now argues,
there can be "no progression" (*M.H.H.*3: E34/K149).

Blake's progression from Wilkite patriotism in the 1770's to
humanitarian Christianity in the late 1780's to political radicalism
in the 1790's is dramatic but hardly unique. It has a shadowy but
definite parallel in the career of William Sharp, as we have seen.
And doubtless Blake was not the only recipient of new light at the
Swedenborgian General Conference of April 1789 who soon re-
ceived a much brighter light from France. In the golden dawn of
the Rights of Man many Christians felt that Christ's humanity was
perhaps more important than his divinity. Consistent with Blake's
endorsement of Fayette and Orleans and Bailly and other great
men associated with the reduction of the Bastilles of repression is
his call to those who worship Christ to love him as the greatest
man and to honor God's gifts in all men, "loving the greatest men
best . . . for there is no other God" (*M.H.H.*23).

Theological and political humanitarianism often went together—
and with them moral emancipationism. While the French com-

mons were interpreting their *cahiers,* the London theosophists were quarreling over the implications of Swedenborg's *Chaste Delights of Conjugal Love: after which follow the Pleasures of Insanity & Scortatory Love.* Some favored a doctrinal recognition of "the inborn *amor sexus*" as an irrepressible force, a question which takes on strongly political meaning for Blake and may have done so for some of the Swedenborgians. Those who went so far as to condone fornication and concubinage, however, were expelled.[1] For all their talk about the Active Life, most readers of Swedenborg recoiled from naked Energy displayed and were morally and politically passive. They enjoyed Swedenborg's *Heaven and Hell and their Wonders as heard and seen by the Author* but did not seem to hear and see the wonders taking place in the world about them. On the second anniversary of Bastille Day the Church-and-King rioters in Birmingham understandably confused the Swedenborgian Temple of Joseph Proud with the Unitarian Chapel of Joseph Priestley and would have set fire to them both. Yet Proud—who would later fail to persuade Blake to join his London community—had already chosen the path of rituals, vestments, and other Ceremonies rather than the Active Life, and his assurances that the New Church was no threat to Church or King were as genuine as the guineas with which he accompanied them.[2]

Blake continued to purchase and annotate new volumes of Swedenborg as the society issued them, for a year or so,[3] but the

[1] Strife in the Theosophical Society for Promoting the Heavenly Doctrine of the New Jerusalem Church arose over a translation of the *Chaste Delights of Conjugal* [or *Conjugial*] *Love,* but details are lost because someone tore out pages of the minute book from May 1789 to April 1790. The translator and five others were expelled but proceeded to serialize the work in a magazine of their own. One of them defined the New Doctrine as permitting bachelor members to take mistresses and permitting concubinage to members whose marriages are "disharmonious" because their wives reject the New Doctrine: such men may be "driven so strongly by the inborn *amor sexus* that they cannot contain themselves." Perhaps this dispute finds an echo in the legend recorded by Swinburne that Blake once desired to introduce a concubine into his house. C. T. Odhner, *Hindmarsh,* Philadelphia, 1895, pp. 27–30; A. C. Swinburne, *Blake,* London, 1906, p. 16.

[2] Odhner, p. 35. Proud became the London priest in 1797.

[3] Blake's fullest acquaintance with Swedenborg's work seems to come in this period of opposition to his doctrines. His annotations of *Heaven and Hell,* possibly as early as 1787, are very slight; the work suggested his *M.H.H.,* but the more recent *Divine Providence,* 1790, critically annotated, and

tone of *The Marriage* and of his extant marginalia is that of satiric and doctrinal opposition. If Swedenborg had been able to read the Bible as "celestial arcana," Blake was now in the light of history learning to read it as "infernal." He had already rounded on the pious with a declaration that active evil is better than passive good.[4] If that sounded like a proverb from Hell, he was now inspired by the French Revolution and Tom Paine to write down seventy more. "Prayers plow not! Praises reap not!" Swedenborg had conversed only "with Angels who are all religious, & conversed not with Devils who all hate religion"; his account of Hell was but hearsay (*M.H.H.22*).

Butter would not melt in the mouths of these religious Angels, but they were frightened "almost blue" by the new wisdom of Devils—and to such people all prophets seemed Devils, Isaiah and Ezekiel as well as Paine and Rousseau. One Angel is frightened terribly by his own analysis of the future yet cannot see Blake's.[5] Another is violently upset at first by the Orleanist creed of Equality and is anxious about questions of law and order, as sworn to in the society. "Has not Jesus Christ given his sanction to the law of ten commandments?" But this Angel finally accepts enlightenment, and embraces "the flames of fire" to be consumed and arise as Elijah.[6] As a Prophet or Devil he becomes Blake's "particular friend," and they "often read the Bible together in its infernal or diabolical sense which the world shall have if they behave well." It is pleasant to hear once more the confident mockery of Quid and to learn

Apocalypse Revealed (his copy not extant, but probably 1st edn. 1791), and *True Christian Religion* (available since 1784) appear to have been his current reading. *M.H.H.* satirizes also the *Chaste Delights,* 1790, not published in a version authorized by the Society until 1794.

In this period Blake may also have read in the early Neoplatonic works of Thomas Taylor—his *Hymns of Orpheus,* 1787, his *Dissertation on the Eleusinian and Bacchic Mysteries,* 1790 or 1791, and his translations of Plato's Phaedrus and Timaeus etc. in 1792 and 1793. Comparative study (see Harper's *Neoplatonism of Blake*) sheds valuable light on Blake's machinery—e.g. on his use of the Persephone and Bacchus myths—if relatively little on his own thought.

[4] Marg. to Lavater, 409: E581/K77.

[5] *M.H.H.*17–20: E40–41/K155–157. See below.

[6] *M.H.H.*23–24. Blake is probably satirizing the "Memorable Relation" of par. 477 of the Scortatory part of *Conjugal and Scortatory Love,* in which a law-abiding Angel changes the opinion of a young man who has been glorying "in the potency of his whoredoms."

that he enjoyed the company of a convert to his own corresponding society.[7]

Blake's *Marriage of Heaven and Hell* mocks those who can accept a spiritual apocalypse but are terrified at a resurrection of the body of society itself. "Energy is the only life and is from the Body," announces the Devil, and it is "Eternal Delight" though the religious may call it Evil (pl. 4). The birth and resurrection of Christ are not the equal and opposite exhalations of the theosophists but progressive stages in the life of man.[8] Blake rejects Swedenborg's "spiritual equilibrium" between good and evil for a theory of spiraling "Contraries" that will account for progress. "Attraction and Repulsion, Reason and Energy, Love and Hate, are necessary to Human existence" (pl. 3). Such *unnecessary* opposites as Bastilles and Moral Codes and the "omissions" due to poverty are merely hindrances that may be scattered abroad "to the four winds as a torn book, & none shall gather the leaves." They "spring from" the *necessary* Contraries but are not to be confused with them. Christ stamped the ten commandments to dust, and history will not return to them except perversely.

Blake is half in jest when he speaks of the "marriage" of Heaven and Hell, for Hell does not exist except as the negative way of looking at Energy, while the Heaven of things-as-they-are is really a delusion like the senile "innocence" of Har and Heva which springs from a denial of the true Heaven of progression. Blake's

[7] Some of *M.H.H.* is in the mocking tone of Fuseli's *Remarks on Rousseau*, 1767. Very much in Fuseli's vein is the remark of the devil "Isaiah" who dined with Blake and asserted that "the voice of honest indignation is the voice of God" and "cared not for consequences, but wrote" (12). Fuseli wrote from "motives" of "gratitude, humanity, indignation." "If truth is called error . . . indignation is merit" (pp. 1–2). And compare Blake's devil's catechism of how Christ mocked all the Ten Commandments (*M.H.H.*23) with this fictitious letter to the author of Fuseli's defense of Rousseau: "Has he not blasphemed man into a being naturally good? Has he not, to the abhorrence of every good schoolmaster, affirmed, that the idea of God can have no meaning for a boy of ten years; that to him Heaven is a basket of sweet-meats, and Hell—a school?" (preface, p. [ii]).

[8] To Swedenborg "the delight of the body" is definitely "not heavenly." And his ordered hierarchy of identical but opposite celestial and infernal institutions suggests an essentially static universe. The rich and poor remain rich and poor in Heaven—and presumably in Hell—and the wise Angel, as Swedenborg has been told by Angels of distinction, does not aspire above his rank. *Heaven and Hell*, pars. 35, 375–381, 537.

theory admits of a true or necessary Reason as "the bound or out-ward circumference of Energy" but leaves it no role in "life" except to be pushed about. Reason is the horizon kept constantly on the move by man's infinite desire. The moment it exerts a will of its own and attempts to restrain desire, it turns into that negative and unnecessary Reason which enforces obedience with dungeons, armies, and priestcraft and which Blake refers to as "the restrainer" which usurps the place of desire and "governs the unwilling." Tiriel was such a deity, and so is the dismal god of the Archbishop of Paris who can no longer restrain the millions from bursting the bars of Chaos. Blake will soon invent for this sterile god a comic name, Nobodaddy (old daddy Nobody), and an epic name, Urizen, signifying *your reason* (not mine) and the limiting *horizon* (Greek ὁρίζειν, to bound).[9] The poet's hostility toward this "Governor or Reason" is thoroughly republican or, to the modern mind, socialistic.

Blake's intransigence toward any marriage of convenience between Hell and Heaven appears further in an extended metaphor of conflict which he introduces with a play upon Rousseau's pronouncement that man is born free but is everywhere in chains:

"The Giants who formed this world . . . and now seem to live in it in chains are in truth, the causes of its life & the sources of all activity, but the chains are, the cunning of the weak and tame minds, which have power to resist energy, . . .

"Thus one portion of being, is the Prolific, the other, the Devouring: to the Devourer it seems as if the producer was in his chains, but it is not so, he only takes portions of existence and fancies that the whole."[10]

There is a substratum of reference here to the economic struggle of producer and exploiter or producer and consumer, not without a Mandevillean echo. This struggle is "eternal" in the sense that the producer and consumer even in the false relationships of slavery

[9] The "reason" in "Urizen" has long been accepted. First to note the "horizon" in it was F. E. Pierce, in 1931. "Nobody's daddy" for "old Nobodaddy" was suggested by John Sampson in 1905.

[10] *M.H.H.*16. A discussion of the "Argument" of *The Marriage*, proper at this point, will be found below (p. 189)—because I originally believed it to be of later vintage; I now see, from the style of lettering, that it cannot have been etched later than 1791.

and commerce are doing what must always be done to sustain life. They are doing it the cheerless way, but even in the freedom of a classless paradise there will always be work and always an audience for the artist-workman, for "the Prolific would cease to be Prolific unless the Devourer as a sea received the excess of his delights."

But Blake's more immediate focus is upon the politics of moral restraint, and he is condemning the conservatism which seeks to confine the oppressed to a passive acceptance of tyranny. "Religion is an endeavour to reconcile" the "two classes of men" who "should be enemies," i.e. to unite the lion and its prey. But "Jesus Christ did not wish to unite but to separate them, as in the Parable of sheep and goats! & he says I came not to send Peace but a Sword."[11] The illusion that energy can be quietly repressed by celestial "wisdom" is exploded by the very fact of revolution. But the fear that revolution means the cessation of all productive relations and of the very means of existence is equally illusory, as Blake proceeds to demonstrate in his fourth "Memorable Fancy."

In this parable Blake and a conservative Angel who is alarmed at his radical "career" undertake to show each other the post-revolutionary future from their respective points of view. The Angel is unwilling to plunge with Blake into the void of the coming century to see whether the Swedenborgian "providence is here also," because what he sees ahead is a "monstrous serpent" with a forehead colored "green & purple" like "a tygers" (17–18). This is what the Revolution looks like to a Tory,[12] and it is symbolic of the fear of Hell which makes him restrain desire. The monster

[11] *M.H.H.*17; cf. *An Answer to the Parson, N.*103: "Why of the sheep do you not learn peace[?] Because I don't want you to shear my fleece."

In *M.H.H.* Blake is, as he hints, turning back from Swedenborg's sweetness to the "Wrath" of Boehme, who wrote that "unless there were a *contrarium* in God, there would be . . . nothing . . . merely God . . . in a sweet meekness," and that strife "between the fierceness and the meekness" must continue, to eternity. See citations in Stephen Hobhouse, *Selected Mystical Writings of William Law,* New York, 1948, p. 370. For Blake's use of Swedenborg and Boehme in *M.H.H.* see Nurmi, *Blake's Marriage of Heaven and Hell,* pp. 25–59.

[12] A suggestion for the passage may be seen in Swedenborg's *True Christian Religion,* par. 74, in which the seer himself is the spokesman of a doctrine that alarms his auditors (they are shocked at how much his stress on "order" seems to *bind* the Omnipotent; he advises those who see a Leviathan in this to hack through it as Alexander did the Gordian knot).

that terrifies him boils up out of the nether deep beside a "cataract of blood mixed with fire" in a manner that prefigures the birth of Orc in *America* which terrifies the King of England.[13] Blake's "friend the Angel" is frightened away. But Blake stands his ground; and since he does not allow himself to be imposed upon by the Angel's "metaphysics," he finds that he ends up, not in the belly of a monster, but sitting peacefully "on a pleasant bank beside a river by moonlight hearing a harper who sung to the harp, & his theme was, The man who never alters his opinion is like standing water, & breeds reptiles of the mind."[14] The Angel is quite surprised to find that Blake has "escaped" alive. But it is only to the stagnant mind that the energy of revolution appears reptilian and sympathy with rebellion a career leading to a "hot burning dungeon . . . to all eternity" (18).

Blake then "imposes upon" the Tory in his turn, showing this Guildenstern a vision of *his* future lot, assuming the Swedenborgian Hell to be true. The Tory's clinging to the status quo means that he accepts a phantasmal eternity of cannibalistic relations between Producers and Devourers. A person who assumes that people belong in chains and who scorns the multitude as swinish has nothing to look forward to but a loathly conflict of "monkeys, baboons, & all of that species chaind by the middle." The Devourers, politician-like, grin and kiss "with seeming fondness" the body of a victim they are devouring limb by limb.[15] The implication seems to be that only those who cannot imagine progressive social

[13] The monster is sighted "in the east, distant about three degrees" or about the distance of Paris from London, as Nurmi points out.

[14] *M.H.H.*19. The harper is doubtless Welsh. In 1791 Blake was employed by Johnson to illustrate a small book by Mary Wollstonecraft. His pictures are faithful to the text with the exception of "The Welsh harper in the hut." Here the story calls for an elderly bard, but Blake has drawn an eager-faced youth.

Note the later ironic comment, in *J.*65, during the long war: ". . . this is no gentle harp . . . nor shadow of a mirtle tree."

[15] *M.H.H.*20. Blake elaborates with Dantesque literalness here Swedenborg's par. 575 on "the gnashing of teeth." He also draws heavily on par. 585 for the cavern entrance to Hell, for an allusion to "stagnant pools," and for a description of the "continual quarrels, enmities, blows, and fightings" in one of the hells. And of course Blake is making the most of Swedenborg's own definition of the fires etc. of Hell as only "appearances."

change must view the Negations as eternal and assume that human relations will be forever those of joyless slavery.

In one of the dens of Blake's Bastille there is a prisoner of the shorn Samson type, with his "feet and hands cut off, and his eyes blinded," who is the victim of a similar illusion. Like the frightened Angel he believes that Destiny is really on the side of the tyrannic forces that imprison him: "fancy gave him to see an image of despair in his den, Eternally rushing round, like a man on his hands and knees . . . without rest" (*F.R.*43–46). To minds so imposed upon by the terrors of the old order, the shining sun itself is "black."[16]

2

Fayette Fayette thourt bought & sold
And sold is thy happy morrow
Thou gavest the tears of Pity away
In exchange for the tears of sorrow.

—*Notebook* 98

Blake's rearrangement of events in Book One of *The French Revolution* presumably clears the way for a full-scale dramatization of the fall of the Bastille in Book Two. His preparatory description of the dens of the Bastille in Book One treats the seven prisoners as symbolic of types of oppression to be removed by the people in their progressive opening up of a new heaven and earth. And from his expansion of the actual garrison of eighty superannuated veterans and thirty Swiss guards to a full "thousand . . . soldiers, old veterans of France, breathing red clouds of power and dominion" (*F.R.*20) we can imagine what proportions the battle might have assumed in his account, with the whole city of Paris taking part. In his later *Song of Liberty* the cry, "France rend down thy dungeon," is prophetically associated with the cataclysm of feudal power and dominion and the "falling, rushing, ruining!" of king, counsellors, and warriors. It cannot be doubted that Blake followed the dramatic progression of Contraries in France closely

[16] *M.H.H.*18; cf. *A.*6:13. For Blake's own expression of a grimmer mood, even as early as 1790–1791, see *A Divine Image,* discussed below, p. 271.

enough to have matter for seven books by 1791 and as many more in the following two years. His extant writings abound in themes drawn from the Revolution. But his only direct and unambiguous commentary on French affairs for the crucial period of the formation of the Republic is an unfinished notebook ballad of some 71 lines (counting deletions) which begins, "Let the Brothels of Paris be opened," and is commonly titled *Fayette*. Probably written in 1793, it follows the decline and fall of the active hero of Book One and provides a valuable explicit formulation of Blake's continued sympathy with the French revolutionaries during the Jacobin period.[17]

La Fayette is treated as a willful deserter of the people's cause who, having assisted in releasing their Energy and Desire, tries at once to set a bound to Energy and to reconcile the old order and the new. Blake's judgment is harsh, but granted his point of view it is not inaccurate. La Fayette did fail as a revolutionary leader partly because he lacked the infernal wisdom that "no virtue can exist" without a breaking of all the old rules. As commander of the National Guard he attempted to establish "public order" and "legal subordination" and to restrain the citizens of Paris from hanging grain speculators and from taking down the palace as they had taken down the Bastille. To his friend George Washington (to whose formula he "stuck," according to Carlyle) he complained that the good people knew how to overthrow despotism better than they understood "how to submit to the law."[18] Though professing to "hate everything like despotism and aristocracy,"[19] La Fayette encouraged both by his repeated efforts to keep alive a staggering

[17] Blake's MS, N.98–99, is a welter of deletions and revisions, treated as two poems in E490–491, 779–780; cf. K185–186. Here, for convenience, I have arranged stanzas and lines without indicating which are scratched. None of the reworking indicates any change of theme or meaning. I suggest a late date because this poem comes in the MS at the end of a group of Songs of Experience which belong to 1793 or late 1792, at the earliest. Wright is in error in suggesting a date shortly after Aug. 19, 1792. La Fayette then crossed the border, but he was not really jailed till the second week of September, and his situation was not clear in England until the *Times* of Oct. 25 reported him in "prison at Wezel . . . sitting in sullen Majesty." He was not in Olmütz until 1794.

[18] Letter of March 1791.

[19] Letter of March 1792, also to Washington. In *Letters of Lafayette to Washington*, ed. L. Gottschalk, New York, 1944.

constitutional monarchy and to delay revolutionary solutions of the crises in bread supply and national defense. Sent to lead an army against the invading Austrians, he tried to turn it against what he considered the greater menace of the Jacobins. Finally, in despair, he fled from his "own fire side" and knocked on the door of the Austrian Empire—only to end on the "dungeon floor" of another Bastille. As Blake and other Jacobins saw it, La Fayette had betrayed equality and the wheaten loaf, the happy morrow of a republic. Why?

> Who will exchange his own fire side
> For the stone of another's door
> Who will exchange his wheaten loaf
> For the links of a dungeon floor
>
> Who will exchange his own hearts blood
> For the drops of a harlots eye

In explanation Blake accepts the charges that linked La Fayette and the Queen of France in harlotry. It was her "selfish slavish fears," Blake says, that moved Fayette to betray his original revolutionary sympathy and the tears of his aristocratic repentance. Pity for the Babylonian Whore could bring only sorrow to Fayette and to France. Edmund Burke in his *Reflections* had, in Paine's interpretation, expressed the same sort of mistaken pity for the plumage of a dying order, and Burke is never far from Blake's mind when he thinks of negative Pity as a reactionary social force. In opposition to Burke's description of Marie Antoinette as the most "delightful vision" that ever "lighted on this orb, which she hardly seemed to touch,"[20] Blake writes:

> The Queen of France just touchd this Globe
> And the Pestilence darted from her robe.

Blake seems to trace Fayette's betrayal to the day in October 1789 when he stilled the Maenads of Paris by kneeling and kissing the Queen's hand in a touching balcony pantomime:

> Fayette beheld the Queen to smile
> And wink her lovely eye
> And soon he saw the pestilence
> From street to street to fly.

[20] Burke, *Reflections*, Cambridge, 1929, p. 76.

It was in the winter of 1790–1791, however, that inflation and un-employment brought actual pestilence and starvation. The Queen, busied in counterrevolutionary schemes which stirred the King from his torpor occasionally, was said to have advised the hungry to eat cake. Blake's Queen suggests that if they cannot eat, they can at least be merry:

> Let the Brothels of Paris be opened
> With many an alluring dance
> To awake the Pestilence thro the city
> Said the beautiful Queen of France.
>
> The King awoke on his couch of gold
> As soon as he heard these tidings told
> Arise & come both fife & drum
> And the Famine shall eat both crust & crumb.

In June the King and Queen fled, leaving behind a note of abdica-tion and defiance, but when the royal truants were captured and brought back, La Fayette supported the fiction that they had been kidnapcd and he legalized with the red flag of martial law a bloody attack upon Parisians who were signing a petition against the King's reinstatement. He had given away his Pity.

In August the maturing counterrevolution was revealed to the world in a Declaration issued from Pillnitz by the Emperor of Austria and the King of Prussia. Yet in September when Louis went before the Assembly and put his royal but worthless signature to the Constitution, La Fayette breathed a sigh of relief, resigned his command, and declared that the Revolution was over, that an organized government would soon pacify the country and render absurd the "menace from its enemies."

> Fayette beside King Lewis stood
> He saw him sign his hand
> And soon he saw the famine rage
> About the fruitful land.

The royal signature did not provide bread, an unpopular clause in the Constitution put three million poor into a class of nonvoting "passive citizens," and a clause giving the King a *"veto suspensive"* was taken to mean that the King was guaranteed his right to hang (*suspendre*) whomever he chose. Accepting this popular interpreta-tion, Blake depicts the King and the God of the status quo as both delighted with the "hanging" Constitution:

Then he [Lewis] swore a great & solemn Oath
To kill the people I am loth
But If they rebel they must go to hell
They shall have a Priest & a passing bell.

Then old Nobodaddy aloft
Farted & belchd & coughd
And said I love hanging & drawing & quartering
Every bit as well as war & slaughtering
Damn praying & singing
Unless they will bring in
The blood of ten thousand by fighting or swinging.

The King did use his veto to "hang" the Constitution, but when he was not allowed the joy of swinging thousands he turned to the alternative of fighting.[21] By April 1792 Louis and the Assembly agreed to a declaration of war against Austria, Louis' purpose being obvious, the Assembly's being partly to divert attention from difficulties at home. The supreme crisis of the Revolution was approaching. Unless the Assembly shook off the dead hand of Louis' vetoes, and unless the army shook off its royalist officers as some regiments were doing, it seemed certain that the starry hosts of French *émigré* nobility, led by the Duke of Brunswick, would march into Paris at the head of Austrian and Prussian armies and restore the King's full power of hanging and drawing and quartering. Now did the radical clubs stir up the Eternal Hell and keep the tocsins ringing. Marat hoped for "some fit of civic fury" such as the storming of the Bastille had been, and one committee grimly hoisted the red flag of La Fayette's martial law, changing its meaning to the infernal sense: "Martial law of the People against the Rebellion of the Court."[22] On June 20 the "passive citizens" staged a preliminary invasion of the Tuileries and compelled Louis to don a red cap. It did not make him a republican. A few weeks later several Paris sections announced

[21] The words "ten thousand" in the last line quoted have been traced, by J. T. Boulton, to "the 'ten thousand swords' which Burke imagined 'must have leaped from their scabbards to avenge even a look which threatened her [Marie Antoinette] with insult.'"

[22] P. Kropotkin, *The Great French Revolution*, New York, 1909, I, 257, citing Chaumette. Blake did not use this symbol, but the reversal is an emblem of the revolutionary marriage of Heaven and Hell.

a deadline of August 10 as "the extreme limit of the people's patience."

During this rushing together of warlike Patriots, La Fayette wrote secretly to the Austrian ambassador proposing to restore the monarchy by marching on Paris with *his* rather than Brunswick's troops, and he wrote openly to the Assembly proposing an assault on the radical clubs and the Paris Commune to preserve the sacredness of property and hold "intact and independent" the power of the "revered King." At length he dashed into Paris, received an evasive answer from the Assembly, and rode to the Tuileries "with a tumultuous escort of blue Grenadiers, Cannoneers, even Officers of the Line, hurrahing and capering around . . . bellowing *À bas les Jacobins.*" He summoned a review to "put down the Jacobins by force"—but found he had become "a gossamer Colossus, only some thirty turning out."[23]

> Fayette beside his banner stood
> His captains false around
> Thourt bought & sold.

On August 10 the people once more stormed the Tuileries, with cannon as well as curses, drove out Monsieur and Madame Veto, and compelled the Assembly to jail them in the Temple and suspend Louis' royal power:

> Fayette beheld the King & Queen
> In curses & iron bound
> But mute Fayette wept tear for tear
> And guarded them around.

This time La Fayette was only spiritually beside their majesties, for he had returned to his battalions in the north and was trying to persuade them to march upon Paris out of pity for their rulers. Only a few "captains false" were willing, however, to exchange Liberty and Equality for chaos, for the wolf at the door. La Fayette's army refused to swear allegiance to a suspended king and to abandon France's new born wonder:

> O who would smile on the wintry seas
> & Pity the stormy roar

[23] Carlyle, *The French Revolution*, New York, 1934, p. 438.

> Or who will exchange his new born child
> For the dog at the wintry door[24]

On the 21st of August La Fayette with twenty-two false captains crossed the border and fled to the Austrians. The fact that the Emperor had him clapped into a dungeon is one of those ironic illustrations of the blindness of emperors of the Tiriel type. To Leopold, Fayette was still a dangerous equalitarian.

3

> The harvest shall flourish in wintry weather
> When two virginities meet together

> The King & the Priest must be tied in a tether
> Before two virgins can meet together

> • • •

> For on no other ground
> Can I sow my seed
> Without tearing up
> Some stinking weed
> —*Notebook* 106, 111

By the summer of 1792 it was plain that old Nobodaddy was not going to expire voluntarily. "Precisely while the Prussian batteries were playing their briskest at Longwi in the Northeast," says Carlyle, priest-benighted La Vendée in the Southwest was exploding *against* the Revolution—"a simple people, blown into flame and fury by theological and seignorial bellows!"[25] In Paris the royalists grew bolder, the people more desperate, as invading armies

[24] Damon, p. 289, glosses: "*The wintry seas:* symbolic of the uproar of materialism and cruelty preceding and during the French Revolution." But Blake is alluding here to the counterrevolution, to the cruelty of those who out of pity for the plumage of chivalry would reinstate the roar and winter of war and feudal oppression. An "Angelic" misreading persists (1969) which overlooks Blake's vision of revolution as a new born child or newly mature youth seizing a moment to sing and laugh; it is counterrevolution that roars in fear or terror—e.g. Bromion, the Prince of Albion in dragon form, and (in *M.H.H.*) Rintrah. The just man is driven ultimately to wrath, not to roaring.

[25] Carlyle, p. 481.

approached. There would be no *wise* innocence and no peace, it seemed, until both king and priest were tethered with a shorter rope than the veto-suspended Constitution. Before France could hope to sow and harvest the wheat of Liberty, every stinking weed of the old system would have to be cleared away.

This is the language of some fragmentary verses in Blake's notebook. They lack the explicit historical allusions of *Fayette*, but we know from that ballad that Blake felt he could understand such summary wielding of the destructive sword against aristocrats and royalist priests as took place in the "September Massacres":

> But the bloodthirsty people across the water
> Will not submit to the gibbet & halter[26]

In his published work of this period, Blake's allusions to counter-revolutionary threats, the people's patriot wrath, and the birth of the new republic in clouds of war are indirect, symbolic, and often blended with more direct allusions to the American Revolution. Yet a familiarity with the metaphors of *Fayette* and *The French Revolution* and the simplest reconstruction of the historical context will restore the contemporary allusions and implications. In the present chapter we shall read three short and more or less cryptic poems against the background of the coming into being of the French Republic. The lyric "Argument" of *The Marriage of Heaven and Hell*, probably written in late 1790 or early 1791, depicts in Biblical imagery the meek driven to wrath; the psalmodic *Song of Liberty*, a later appendage to *The Marriage*, is an epithalamium of the new republic; and apocalyptic in its implications is the great revolutionary lyric, *The Tyger*, written before *Fayette* in 1792 or early 1793.[27]

The spirit of *The Marriage* is one of sunny confidence, but the "Argument," bracketed in an ominous refrain, suggests the darker context of war and rumors of war:

[26] N.99: E779/K185. The "September Massacres" were precipitated by a cane-blow delivered on a citizen's skull by an angry priest, one of thirty royalist suspects being moved from one prison to another. These priests were the first victims; others were recent prisoners seized by crowds who stormed the jails. Improvised tribunals sifted out and saved as many as the intent crowd would allow. Altogether about a thousand were slain— a figure multiplied many times in reports reaching England.

[27] The relative positions of *Fayette* and *The Tyger* in *N.* make clear that *The Tyger* was earlier in composition. The "Argument" was mistakenly treated, in my first edition footnotes, as a late part of *M.H.H.*

> Rintrah roars & shakes his fires in the burdend air;
> Hungry clouds swag on the deep.

Blake had used a similar image in *Gwin:*

> The Heav'ns are shook with roaring war,
> And dust ascends the skies!

In both cases the theme is counterrevolution. The swagging (lowering) clouds are doubtless war clouds hungry for blood. The roaring and the deep suggest the stormy roar and wintry seas of counterrevolution in *Fayette*. "Rintrah" plays no further part after this roaring in the prologue and so must remain unidentified, though in later poems he will emerge as Wrath and sometimes as William Pitt, British leader of the crusade against France. Even in 1790 Pitt pushed a chance of war with Spain; in the spring of 1791 he threatened the use of force against Russian expansion and was dissuaded partly (according to Coleridge) by English popular opposition.[28]

In his *French Revolution* (55, 225 f.) Blake had imagined the commons planting "beauty in the desart craving abyss" and had hoped that the priest would "No more in deadly black" compel the millions to "howl in law blasted wastes." In the first prose page of *The Marriage* he announces "the return of Adam into Paradise." The "Argument" begins with a recapitulation of the hopeful first stage of the revolution (when, according to *F.R.*221–229, the meek peasant came out of the feudal shadow of death and was free to "woo in pleasant gardens" and plant a fair harvest):

> Once meek, and in a perilous path,
> The just man kept his course along
> The vale of death.
> [Now] Roses are planted where thorns grow,
> And on the barren heath
> Sing the honey bees.[29]

[28] Public meetings "tended to terminate the American, and to prevent a Russian war," argued Coleridge in December 1795 in his *Answer to "A Letter to Edward Long Fox, M.D.,"* Bristol.

[29] *M.H.H.*2. The soldier singing on the heath is a frequent image of war in *N*. Here "honey bees" in place of soldiers (drones) suggest life and peace.

As oppression gave way to peace, "the perilous path was planted" and man was reborn in Eden.[30] But then came the conspiracy of aristocrats and priests, as the concluding stanzas indicate. The "villain" or "sneaking serpent," i.e. the priest or any pious hypocrite opposing freedom (compare the "crawling villain" in *America,* line 128), agitated for counterrevolution and plotted to drive the righteous into the wilderness once more.

As early as the publication of Burke's *Reflections* in October 1790, the ideological issue was joined. During the next two years, as Blake worked over the revision and amplification of his "infernal" vision of history, the clouds enlarged and darkened in both France and England.

Two components of the Antijacobin spirit in the summer of 1792 are relevant. On the borders of France the army of the French Princes, mounted on English horses, was mustering under the July Manifesto of the Duke of Brunswick in which their imperial and royal majesties of Austria and Prussia threatened to exterminate "the town of Paris and all its inhabitants without distinction" unless they would submit at once to their king. "Deserts are preferable to people in revolt," the leagued kings declared.[31] In London the *émigré* priests, conspicuous in their robes as symbols of the ancient heavens, went about with increasing confidence, as English politicians anxious to secure the mark of Antijacobinism made a great show of sympathy in their support.[32]

The future had promised to be "a pleasant bank beside a river by moonlight." But now, realizing Blake's "Argument,"

> . . . the villain left the paths of ease,
> To walk in perilous paths, and drive
> The just man into barren climes.

Leaving their pre-revolutionary indolence, the priests were inciting kings to take the path of war and counterrevolution:

[30] "Red clay brought forth," i.e. Adam was reborn, a new cycle of history. See Damon, p. 316.

[31] Note Blake's image when he expresses fear that the Watch Fiends may find the citadel of Liberty in his works and "lay its Heavens & their inhabitants in blood of punishment." *J.*37[41]:20.

[32] W. L. Mathieson, *England in Transition,* London, 1920, p. 70.

Now the sneaking serpent walks
In mild humility.
And the just man rages in the wilds
Where lions roam.

While French priests were walking about London like upright serpents, the French people were "raging . . . in forests" to confront the lions of the royal armies. "The priest promotes war," Blake wrote in his notebook.[33] The threat to turn flourishing cities into deserts was compelling patriots to become warlike men.

The *Song of Liberty* at the other end of *The Marriage* celebrates the casting out of French monarchy and the rout, less than two months after his roaring manifesto, of Brunswick's starry hosts, who were forced into a dismal and muddy retreat from Valmy even as the new Republic was being announced in Paris, at the end of September. The climactic cry, *"Empire is no more!"* is applied retrospectively to America and prophetically to the Spanish and Papal empires, to the commercial imperialism of the London slave trade, and to London's god, Urizen. But the inspiring fact is that Republicanism in France, "the son of fire in his eastern cloud" born in "the American meadows," has come through fire-baptism, has braved the war clouds "written with curses" (an allusion perhaps to the manifesto),[34] and has simultaneously dethroned French monarchy and hurled back the lion of Austria and the wolf of Prussia from the wintry door. A "Chorus" admonishes royalist priests whose "accepted brethren" are tyrants to take heed and cease cursing the sons of freedom ("sons of joy"): "For every thing that lives is Holy."

The British tyrant, scarcely recovered from the military and moral reverses of the American War (recapitulated in verse 15), is most vividly reminded of those reverses by the September events in France. Glancing "his beamy eyelids over the deep," he is filled with "dark dismay" at what he sees across the Channel where "the morning plumes her golden breast." There is a prophecy of

[33] *N*.107; see 109: E719, 718/K174, 171. "God made Man happy & Rich," says Blake in his defense of Paine against the "sneaking" Bishop of Landaff (E601–602/K384–385), "but the Subtil made the innocent Poor."

[34] Cf. Wordsworth's allusion to the manifesto as written on the "dire cloud" of the armies led by Brunswick. *Prelude* x.9–20. Both the London Corresponding Society and the S.C.I. made a great clamor about the manifesto and it must have loomed large in Blake's awareness.

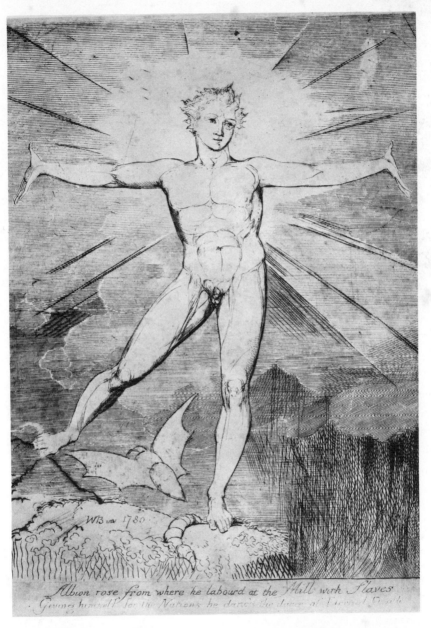

I. *Albion rose from where he labourd at the Mill with Slaves*, 1780, engraved, ca. 1800

A PINDARIC ODE. 99

" Give ample room, and verge enough
" The characters of hell to trace.
" Mark the year, and mark the night,
" When Severn shall re-echo with affright
" The shrieks of death, thro' Berkley's roofs
 " that ring,
" Shrieks of an agonizing King!
" She-wolf of France, with unrelenting fangs,
" That tear'st the bowels of thy mangled mate,
" From thee be born, who o'er thy country
 " hangs
" The scourge of Heav'n. What terrors
 " round him wait!
" Amazement in his van, with flight combin'd,
" And Sorrow's faded form, and Solitude
 " behind.

 II. 2.
" Mighty Victor, mighty Lord,
" Low on his funeral couch he lies!
 " No

II. Edward III as scourge, one of Blake's watercolor illustrations for
Gray's *Bard,* 1797

III. *Europe supported by Africa & America*, engraved Dec. 1, 1792, for Stedman's *Narrative*

IV. *The Accusers,* late version (ca. 1803) of *Our End is Come,* June 5,
1793

the demise of his own Empire in the proclamation of a Republic so close to London. Blake makes the prophecy more explicit in a declaration at the end of *America,* of which this *Song of Liberty* is a preliminary sketch (or later summary) and to which we shall come in our next chapter.

A drawing that precedes *A Song of Liberty,* worked up subsequently into a striking color print (Plate VIIb), depicts the archetypal emperor, Nebuchadnezzar of Babylon, fallen and crawling naked and woebegone in desert exile.[85] In France a king has been dethroned, and the true nature of monarchy as a "bound and outward circumference" too narrow for the infinite desires of humanity, is now revealed. Every "jealous king" who limits the horizons of others, every "Urizen" who drives the just into barren climes, does so because he understands deserts better than people and because his own vision is so limited that a correct portrait shows him on hands and knees in that pre-human state described hypothetically by Rousseau: "his long nails [are] crooked talons; . . . his whole body, like that of a bear, [is] covered with hair." If man ever lived as such an animal, Rousseau observed, "the nature and limits of his ideas" would be indicated by "the fact that he walked upon all fours, with his look . . . confined to a *horizon* of a few paces."[86]

Blake's identification of fallen Reason with Nebuchadnezzar is a striking instance of his creative and complexly ironic use of traditional material. The pictorial details, the body, the talon-nails, the impossibly hairy back and thighs, derive from his admired Mortimer's drawing of *Nebuchadnezzar recovering his Reason,* the 1781 etching of which was doubtless in Blake's print collection.[87] And the association of this bestial man with Reason is

[85] A first sketch appears in *N.*44. In *M.H.H.* a spiked crown is added. The crown is lacking in the color print of ca. 1795 entitled *Nebuchadnezzar* (Plate VIIb) but reappears in the *Visionary Head of Nebuchadnezzar,* 1819.

[86] Rousseau, "Discourse on the Origin of Inequality," *The Social Contact and Discourses,* Everyman edn., 1927, p. 177. Hereafter referred to as *Discourse.* Italics mine.

[87] Behind Blake's creeping monarch, and behind Mortimer, Jean Hagstrum (pp. 66–67) sees "the wild and powerful nude men that Hendrick Goltzius places in his caves and on his rocks." Nebuchadnezzar's further degeneration, to a state of shaggy bestiality in which his mouth crops the grass and his functionless eyes are pressed against the ground, may be seen in Blake's drawing (no. 299) for p. 27 of Night VII of Young's *Night Thoughts.* His

suggested by Mortimer's title. But Blake, shifting the subject to Nebuchadnezzar's fall, proceeds to draw the ironic emblem of Reason *losing* his reason.

The creeping Urizen is supplied with a long soliloquy in a passage in Night V of *The Four Zoas* which is worth taking up here for the light it casts back upon *The Marriage* and *A Song of Liberty*— and *The Tyger*. The fatal error of the jealous king is that his fixing of the horizon ultimately limits himself more than it does the energy of the people. Royalty can keep its crimson robes, Orleans warned, only if it stops trying to measure for each man "the circle that he shall run" (*F.R.*191). Soliloquizing as he crawls in the den or narrow circle of his own ideas, the fallen Urizen of Night V laments too late his imperial mistakes: his choice of war instead of peace, his failure to accept the opportunity to be an enlightened despot when the "mild & holy voice" of divine freedom said, "O light, spring up & shine" and "gave to me a silver scepter & crownd me with a golden crown" to "Go forth & guide" the people. "I went not forth," he laments; "I hid myself in black clouds of my wrath[;] I called the stars around my feet in the night of councils dark" (*F.Z.*v.64:21–26). Thus George assembled his council in 1774; thus Louis prepared his "starry hosts" in 1789 and let the spark of humanity in his bosom be "quench'd in clouds" by "the Nobles of France, and dark mists."[88] Each time, in the event, at Yorktown and again at Valmy, "The stars threw down their spears & fled naked away. We fell." Too late Urizen is sorry he refused the use of his "Steeds of Light" (v.64:27; 65:6).

The language of this soliloquy is doubly revealing. On the level of practice it is clear that "The stars threw down their spears" means: the armies of counterrevolution were defeated. On the level of theory it is clear that Reason, when it refuses to assist but attempts to hinder Energy, is overthrown. Denied the peaceful accommodation of the Steeds of Light, the just man seizes the Tigers

metamorphosis into the 7-headed Beast who is the Whore's mount and who eats people may be seen in Blake's 1809 water color, *The Whore of Babylon*. The hairy back and the talon-like nails are still the same, and one head still wears a crown. The variant in which several of the Beast's heads are crowned, e.g. *J.*50, suggests a confederacy of kings.

[88] *A.* pl. b: E57/K204; *F.R.*65–68, 113[108]. In *A.* the connection is specific: the "hall of counsel" of "George the third" beside the Thames is the hall "built . . . In that dread night when Urizen call'd the stars round his feet."

of Wrath. Vetoed by a stubborn monarch, the French people became, as the London *Times* of January 7, 1792, put it, "loose from all restraints, and, in many instances, more ferocious than wolves and tigers." As Blake put it in *Fayette,* the French grew bloodthirsty and would "not submit to the gibbet & halter."

If we take the tiger and horse as symbols of untamed Energy and domesticated Reason, then it is obvious which of these contraries is the more vital in days of revolution. In Hell it is proverbial that "the tygers of wrath are wiser than the horses of instruction," and the devil Isaiah assures Blake "that the voice of honest indignation is the voice of God."[39] Yet when revolt tears up one social contract, it must establish a new "free" one, based on an active marriage of Reason and Energy. The revolution "stamps the stony law to dust" as the last act of wrath against reason, but in so doing it looses "the eternal horses from the dens of night, crying *Empire is no more! and now the lion & wolf shall cease.*" This cry at the end of *A Song of Liberty* and at the climax of the Declaration of Independence as rendered in *America* is virtually a declaration that the age of reason is the true Jerusalem. Voltaire and Rousseau are still the guiding fire and cloud. The era of the beasts of prey gives way to the era of the untethered horses of intellect, who are of the order of Swift's Houyhnhnms. On this closing page of *A Song of Liberty* the text is illuminated with dashing and prancing horses. One bears a rider, but with no reins or saddle. We see no more of lion, wolf, or tiger.

Nevertheless, according to the Devil at least, the roaring of lions and the howling of wolves "are portions of eternity," even though "too great for the eye of man" and perhaps too great for the mind of man (*M.H.H.*8). Blake's famous Song of Experience, *The Tyger,* raises the cosmic question: How can the tiger of experience and the lamb of innocence be grasped as the contraries of a single "fearful symmetry"? The answer, suggested in question form, is that the very process of the creation of the tiger brings about the condition of freedom in which his enemies (his prey) become his friends, as angels become devils in *The Marriage.* The tiger in Blake's illustration of this poem is notoriously lacking in ferocity, and critics have sometimes concluded that Blake was unable to "seize the fire" required to draw a fearful tiger. He could at least have tried, but he is showing us the final tiger, who has ac-

[39] *M.H.H.*9, 12: E36, 38/K152, 153.

complished his mission, has even, perhaps, attained a state of organized innocence as have the adjacent lions and tigers of *The Little Girl Lost* and *The Little Girl Found* who demonstrate that "wolvish howl" and "lions' growl" and "tygers wild" are not to be feared.[40]

The creative blacksmith who seizes the molten stuff of terror and shapes it into living form on the cosmic anvil must employ dread power as well as daring and art, but the dread, Blake hopes, will be sufficient unto the day. The climax of the forging is a mighty hammering which drives out the impurities in a shower of sparks, like the falling stars children call angels' tears. At this point in *The Tyger* Blake employs the symbols which in his political writing signify the day of repentance when the king's "starry hosts" shall "throw down . . . sword and musket," the nobles and priests "shall weep, and put off . . . war," and the "wild raging millions, that wander in forests" shall become "mild peaceable nations" walking "in bliss" (*F.R.*220–237):

> When the stars threw down their spears
> And water'd heaven with their tears:
> Did he smile his work to see?
> Did he who made the Lamb make thee?

The creator must have smiled at Yorktown and at Valmy, not because his people were warlike, but because they seemed ready to coexist with the Lamb, the wrath of the Tiger having done its work. The question, "Did he smile his work to see?" is perhaps as rhetorical as the corresponding query of Orleans: "And can Nobles be bound when the people are free, or God weep when his children are happy?"[41]

This is not to imply that *The Tyger* is a political allegory but to point out that the fire in which the tiger is forged can be

[40] E22/K115. Blake had no difficulty drawing a fearful werewolf (see *N*.15–17) or for that matter a fearful *flea*. But his tiger is not even baring fangs. It is argued that in at least one copy the tiger looks solemn—not, on that evidence, the effect usually intended.

[41] *F.R.*186: E291/K142. Orleans' speech citing "Fayette's forehead," "Mirabeau's eyes," "the shoulders of Target," "Bailly the strong foot of France," and "Clermont the terrible voice" as parts of the Revolution which terrify only the unsympathetic beholder, anticipates the dread hand, shoulder, feet, and daring of the blacksmith who forges the tiger and clasps its "deadly terrors."

recognized as a general form of the fires that "inwrap the earthly globe" in the first year of the French Republic.[42] The tiger burning in the forests of the night is a vision in the same mind that saw in Necker a hind threatening to burn down "the ancient forests of chivalry," that saw portions of eternity wherever men were struggling to be free—"a Serpent in Canada . . . In Mexico an Eagle, and a Lion in Peru; . . . a Whale in the South-sea"—and that would see, in another year, wrathful lions and bloodthirsty tigers in "the vineyards of red France."[43]

[42] For the forest fire that destroys oppressors, see Jeremiah 21:12–14: "Deliver him that is spoiled out of the hand of the oppressor, lest my fury go out like fire . . . because of the evil of your doings. . . . But I will punish you according to the fruit of your doings, saith the Lord: and I will kindle a fire in the forest thereof, and it shall devour all things round about it."

[43] *F.R.*90–93; *A.* Preludium; *E.*15:2. Note Wordsworth's description of Jacobin Paris at night as a place "Defenceless as a wood where tigers roam." *Prelude* x.82.

Part Four
ENGLAND'S CRISIS

Thou hast a lap full of seed
And this is a fine country
Why dost thou not cast thy seed
And live in it merrily
 —*Notebook*

9. Seeking the Trump of Doom

And say unto Tyrus, O thou that art situate at the entry of the
sea, which art a merchant of the people for many isles. . . . By
thy great wisdom and by thy traffick hast thou increased thy
riches, and thine heart is lifted up because of thy riches: . . . Be-
hold, therefore I will bring strangers upon thee, the terrible of
the nations: and they shall draw their swords against the beauty
of thy wisdom, and they shall defile thy brightness. They shall
bring thee down to the pit. . . .

— Ezekiel

ON JANUARY 21, 1793, the French Convention sent Louis XVI
to the guillotine. One week later the British Parliament voted to
prepare for war, and on February 1 the Convention responded with
a formal declaration. The "English Crusade against France" had
begun.[1] Blake expected the sequel to be the triumph of revolution-
ary Energy, the collapse of the "Angels & weak men" who gov-
erned "unwilling" Britain, and the establishment of republics
throughout Europe.[2] In *America,* ready for sale by October,[3] he
presented the failure of the earlier English Crusade against the
Colonies as a prophecy for the year 1793. In it he directed at
England the "Empire is no more" chorus of *A Song of Liberty*
and foretold a consummation (in England) of the revolution be-
gun in America. In his illustrations of *America* he pictured the
judgment and execution of a ruler by a revolutionary tribunal.
In a separate picture engraved in June he portrayed the im-
minent downfall of a stout king and his henchmen. And in the
following year he traced, in *Europe,* the fatal steps of Britain's
entry into the war with France and prophesied ruin for the

[1] See below, pp. 302, 318.
[2] *A.*16:14: E56/K203; *M.H.H.*5: E34/K149.
[3] Prospectus: E670/K207.

crusaders led by Rintrah (Pitt) and Palamabron (Parliament) who had joined the counterrevolutionary lion and wolf of the Continental Armageddon.[4]

These documents, which will occupy us for a long chapter, will show us Blake's interpretation of Britain's course after 1789 in the immediate historical context. Another group of texts, the *Visions of the Daughters of Albion* and the myth-laden "Preludiums" of *America* and *Europe* and other prophecies, will point to the breadth and depth of Blake's historical interpretation. And finally certain *Songs of Experience* will give witness to the emotional pressure at the center of Empire, in the heart of the London citizen.

Insofar as *America* and *Europe* are visualizations of current history it should not surprise us to find that they draw upon graphic as well as verbal sources in contemporary journalism. Several of the scenes in *Europe* appear to have entered Blake's vision from the political cartoons of 1792–1793. And, conversely, there are indications in both *Europe* and *America* that these "prophecies" were intended, on one level at least, to have something of the immediacy of political cartoons. The next section of this chapter

Fig. 6. Gillray

[4] For this aspect of Rintrah and Palamabron see below.

will trace the cartoon sources of *Europe* as clues to its historical allegory. The present section will deal with indications of direct prophetic intent in the work of 1793 after first illustrating Blake's use of cartoon elements even in work largely divorced from temporal allusions.

The political caricaturist James Gillray in a satiric print dated January 2, 1793, opened the new year with a forecast that the English Patriots, represented by the dismal figure of Charles Fox of the Whig Opposition, were sinking so deep into the Slough of Despond that they would "never see the Promis'd Land" of "Libertas." Gillray's political pilgrim, almost neck-deep in the mire, is losing his Patriot's Staff and his diabolic Gospel of Liberty. His desire for freedom is a desire to reach the crescent moon; "The Straight Gate or the way to the Patriot's Paradise" is specious because within the Gate we see no means for climbing toward the moon but a short wooden ladder. This detail of the print is reproduced in Figure 6.[5]

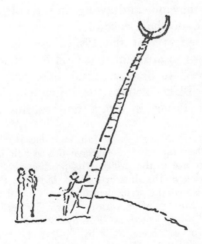

Fig. 7. Blake

[5] Gillray, *The Slough of Despond: Vide the Patriot's Progress.* Lettering over the gate, "The Straight Gate" etc., is too crowded to reproduce well and is omitted in this tracing. See my "William Blake's Debt to James Gillray," *Art Quarterly,* XII (1949), 165–170.

Blake's response to this piece of cynicism was to draw an extension to the ladder long enough to reach the moon and a youthful pilgrim energetic enough to climb to it. See Figure 7.[6] Subsequently he arranged this and other small emblem drawings accumulated in his notebook, into a series illustrating the progression of contraries, and these he etched and published from Lambeth on May 7, or earlier, as *The Gates of Paradise*. In this form, first inscribed "For Children" and many years later "For the Sexes," the drawings constitute a universal allegory of creation, growth, and death.[7] Under the ladder picture is the line, "I want! I want!"[8] But the reappearance of the pilgrim in a political guise in *Europe,* the political origin of the ladder-to-the-moon emblem, and the probability that Blake's title for his series was inspired by Gillray's "Gate to the Patriot's Paradise" suggest that some of the other emblems may have been equally political in origin. And this hypothesis is borne out by the mottoes accompanying some of these drawings in the notebook and by Blake's adaptation of some of them to political allegory in *America.*

Under one of the emblem drawings in the notebook Blake quotes Ezekiel's prophecy to the Prince of Tyre, cited at the head of this chapter, to the effect that the Prince and his rich commercial nation have grown so arrogant that God has decided to bring "the terrible of nations" to destroy proud Tyre and throw down her arrogant Prince. Blake pictures the Prince clutching his head, as might any poor Prince in 1793, and staring at some offstage

[6] Blake's drawing, in N.40, is very faint but has been exactly traced for this figure. When he proceeded to engrave this sketch he made the ladder narrower, and of course in the printing its position became reversed.

[7] Blake's numbering of the drawings in *N.* indicates that he tried several arrangements. He issued the series from his own Lambeth address coupled with Johnson's on May 7, after various tries. The series was considerably revised about 1818 when issued as "For the Sexes."

A caricature print of about 1808 by Gillray (I believe) pictures the Jacobin goal as attained by Napoleon, who pulls the moon down to his ladder with block and tackle and the weight of "Code Napoleon" etc. He strides in the crescent while six of his men climb the ladder behind him with a tricolor flag. This print I have seen only in an anonymous Dutch copy, *Na de Maan,* in the Harvard College Library.

[8] Cf. Burke's observation that when people sought economic abundance for all they were like children crying for the moon. *Works,* Boston, 1865, II, 121.

vision of his future doom.[9] Britain, in arrogating to herself the divine right to judge France, was inviting the sword of wrath from that terrible nation.

Another emblem picture of an agonizing monarch is identified by the caption, "Rest Rest perturbd spirit," as the late King of Denmark (read France).[10] And preceding this is a sketch of Milton's Satan rising "upright" with spear and shield (N.91). The inscriptions identifying these three pictures, and their order in the notebook, suggest this sequence: the eternal Devil or Patriot arises in arms (in France); the ghost of the King of Denmark (or France) is perturbed; the Prince of Tyre (or Albion) is advised by the prophet to view his own future with alarm. In *America* these two perturbed and head-clutching figures, or very similar ones, appear on Plate 4 beneath the words "The King of England looking westward trembles at the vision," and the king who fears decapitation—if we take the head-clutching literally—is of course George III. On Plate 5, a progressive cartoon to be read counterclockwise, the presumably trembling king is held aloft and judged by a tribunal of three youthful patriots who wield the flaming sword and the balances of judgment; is then flung hurtling toward the infernal flames, again clutching his head (see Fig. 8); and is finally caught in the coils of a serpent and decapitated, apparently, although here the drawing is not clear.[11]

[9] N.94 (E723). In the idiom of Blake's symbols there is a clear distinction between the pained inward look (see the Laocoön) and the look of alarm (see Bromion in the *V.D.A.* tailpiece). Most explicit is the Bromion-like dismay on the face of Belshazzar staring at the handwriting on the wall in Blake's engraving on p. 33 of his edition of Young's *Night Thoughts* (drawing no. 60).

[10] Or possibly Sweden: Gustavus was assassinated in March 1792. The use of analogical glosses, as here or in the B.M. copy of *E.*, does not signify full identification of person or theme in Blake's text with person or theme in lines quoted; it simply calls attention to a specific point or points in common. Thus both the ghost of Hamlet and the ghost of Louis are *perturbed* by events, but they are not perturbed by similar events, nor are they equally pitiable in Blake's eyes.

[11] Wright, I, 65, interprets the king as three different persons and guesses them to be Generals Clinton, Burgoyne, and Cornwallis. But on the other hand H. M. Margoliouth, *William Blake*, Oxford, 1951, p. 85, while recognizing these three as "the same figure," quite mistakes the nature of the youthful tribunal and the portion of the text (*A*.35–36, not 30) that is being illustrated: "This is the punishment which sends to hell instead of

Fig. 8

Another version of the head-clutching king, this time identified by a spiked crown, appears in Blake's engraved print published June 5, 1793, over the caption *Our End is Come*.[12] The hysterical king, flanked by two chief warriors who grip sword and spear, stands inside a threshold enveloped in flames.[12a] In theme, *Our End* is a companion picture to *Albion rose* ("Glad Day"), for when Patriots rise, rulers stand in the door of Hell. Blake had described similar moments of history in *Gwin* and *The French Revolution*. When the people rose to pull down tyrant Gwin, his chiefs stood round him like "reared stones around a *grave*" and "each seiz'd his spear." When King Louis stood in similar alarm, his nobles folded round him and their stern visages and strong limbs were "bound in astonishment" "as with marble" "in flames

redeeming, for these flames are not the flames of Orc." But it is precisely "in this terrific form" (see *A*.54–58) as "Orc, who, serpent form'd Stands . . . to devour," that the revolutionary spirit appears "to Angels eyes."

[12] The original drawing is on a sheet with two other sketches evidently made at the same time. *Pencil Drawings by William Blake,* ed. Geoffrey Keynes, London, 1927, pl. 10. Since the latter were drawn for plates 6 and 8 of *E.,* an illustration of the famine and sacking of villages foreseen as consequences of Britain's crusade, the whole group must have been drawn shortly after the outbreak of war, and Blake must have been at work on *E.* before the publication of *Our End,* i.e. before June 1793.

[12a] The flames actually first appear in the third state of the plate (see below); in the intermediate color print the background is filled with smoke and fire; in the earlier states what we see (in the eyes of the alarmed trio) is some offstage conflagration such as alarms Bromion in the *V.D.A.* tailpiece. The faces in the final version (*The Accusers*) show less alarm at anything offstage, and the flames are almost a symbolic garment of Selfhood.

of red wrath" (*F.R.*65–67). One copy of *Our End*, used as a frontispiece for *The Marriage of Heaven and Hell* and *A Song of Liberty*, serves to represent the trio of jealous king, grey browed counsellor, and thunderous warrior whose deep dismay is the subject of *A Song*.

In *Our End is Come* Blake approaches the manner of political caricature, and the print was apparently popular. He reissued it in several forms with various captions elaborating—or concealing—his meaning. In a second issue, still dated 1793, he replaced the original caption with the lines from his *Prologue for Edward the Fourth* that speak of the soul "driven to Madness."[13] The king in the picture is quite evidently mad: his eyes are popping and his mouth is distorted as in Blake's later painting of a king biting the ground.[14] The implication is that the King of England will go mad again if the French Patriots are as successful as the Americans were.

In a third and later version[15] (reproduced in Plate IV) Blake called the picture *A Scene in the Last Judgment. Satans' Holy Trinity, The Accuser, The Judge, & The Executioner.* The jest is bitter: those who accuse are guilty and those who judge shall be judged by the flaming sword; and the executioner shall be consumed in the conflagration of his own igniting. Insofar as Blake considered these as archetypes of contemporary figures, he must have thought of the Accuser originally as Burke—who with unintentional irony had called the execution of Louis "a warning to all other tyrants, and an example to all other nations"[16]—the crowned

[13] Blake added the page number of *P.S.* as if for an owner or prospective purchaser of that volume. This application strengthens my contention as to the contemporaneity of the Prologues. For the sequential inscriptions see E660.

Keynes, in his catalogue of *Engravings by William Blake: The Separate Plates*, pp. 19–22, unhappily gets the first and second states of the plate out of order. Since he describes the two as identical "apart from the inscription" his reason is apparently the earlier date of the Edward *Prologue*. But the first inscription, "Our End is Come," prints cleanly with no trace of a previous inscription, while the *Prologue* inscription, which replaced it, is still visible behind the third inscription.

[14] *Soon a King shall bite the ground*, eighth illustration for Gray's "Fatal Sisters," ca. 1797.

[15] Probably after Blake's indictment for sedition in August 1803; the lettering of the inscription is of a style he had begun to abandon by March 1804.

[16] Burke in Parliament, Feb. 12, 1793.

Judge as George III, official signer of the declaration of war; and the Executioner as Pitt, the King's executive officer. In this third retouching Blake placed a laurel wreath on the Executioner's head, to match his Roman sword and perhaps to indicate his glorious "victories." The Accuser is clothed in armor that suggests chain mail of the age of chivalry but also the serpent scales of a priestly villain.

The king in his expression of amazement bears kinship to the kings as accusers of adultery in *Queen Emma* and *Jane Shore*. As if to strengthen this link Blake added an inscription calling the three villains "The Accusers of Theft, Adultery, Murder." Burke in speeches and pamphlets in which he raised the property question accused both French and English radicals of practicing or intending Theft ("levelling").[17] Pitt was an accuser of Murder when he urged Parliament to arm against France because of the murder of the King of France, which he called "that calamitous event . . . that dreadful outrage against every principle of religion, of justice, and of humanity."[18]

Confirmation that it is the rulers of Britain whose "end is come" in 1793 is supplied by a parallel declaration in the final page of *America* that "their end should come." After the collapse of Albion's smitten bands, i.e. the final surrender at Yorktown in 1781, "Angels & weak men . . . should govern o'er the strong" only temporarily—"twelve years," according to this prophecy— "And then their end should come, when France reciev'd the Demons light."[19]

The twelve years of restraint following Yorktown have not made the rulers really strong or the people weak,[20] nor have they erased the memory of "the Demon red." When the Guardian Prince of

[17] "Levelling," "Tyranny of democracy," and "confiscation of property" loom large in the table of contents of Burke's *Reflections*.

[18] Pitt in Parliament, Feb. 1, 1793.

[19] *A*.16:13–15. This dated prophecy for the rulers of Albion has generally been taken to mean simply that the French Revolution of 1789 was inspired by the American Revolution of the preceding decade, and Blake's "twelve years" has been taken for faulty arithmetic. But France did not receive the particular services of "the Demon red" who hurls rulers into the flames of Hell or escorts them to its threshold until 1793.

[20] The idea that the strong are governed by the weak was a commonplace of democratic propaganda; it received its classic expression in Shelley's later "Ye are many; they are few."

Albion assumes once more his Dragon form, that demon arises to resume his task of dragon-slaying. The tyrants on the "heav'nly thrones" of "France Spain & Italy" have been repressing their subjects by shutting "the five gates of their law-built heaven . . . with mildews of despair," putting bolts and hinges on what people might *hear* and *see,* blasting with mildews the food they might *taste* and *smell,* and racking their bodies (*touch*) with "fierce disease and lust." But now the twelve years are gone as if they had not been; all kings can still see the "bands of Albion" smitten by the stern Americans "and the ancient Guardians . . . smitten with their own plagues"; in their crusade against the Republic of France "They slow advance," but they are now quite "unable to stem the fires of Orc."

But [now] the five gates were consum'd, & their bolts & hinges melted
And the fierce flames burnt round the heavens, & round the abodes
 of men. (*A.*16:16–23)

The revolt of Energy against the restraining Reason of kings would open all the gates to Paradise and to the perception and creation of Eternal Delight. The dialectic of Contraries was now at work, and now was "the dominion of Edom, & the return of Adam into Paradise."[21]

2

When [Pitt] came to the helm, the storm was over, and he had nothing to interrupt his course. It required even ingenuity to be wrong, and he succeeded. A little time showed him the same sort of man as his predecessors had been. Instead of profiting by those errors which had accumulated a burden of taxes unparalleled in

[21] *M.H.H.*3. According to the English Jacobins, the Devil was the first Jacobin, and Adam and Eve were Sans Culottes; so were Moses and Aaron because they abolished the slave trade. See Daniel Isaac Eaton, *Politics for the People,* 1, no. 12, London, 1793.

Blake "marries" the prophecies of Isaiah 34, 35, and 63. "The dominion of Edom means, in Blake's terms, that the red figure coming menacingly out of France, the 'Devil' called Orc in Blake's *America* and later poems, is truly a savior, however awful he may appear to the 'Angels' of Pitt's England." Harold Bloom, in E809.

the world, he sought, I might almost say, he advertised for enemies, and provoked means to increase taxation [i.e. wars]. Aiming at something, he knew not what, he ransacked Europe and India for adventures, and abandoning the fair pretensions he began with, he became the knight-errant of modern times.

— Paine, *Rights of Man,* Part Two, February 1792

The red limb'd Angel [Pitt as Rintrah] siez'd, in horror and torment;
The Trump of the last doom; but he could not blow the iron tube!
Thrice he assay'd presumptuous to awake the dead. . . .

— Blake, *Europe, A Prophecy,* 1794[22]

The downfall of the crusading Accusers did not come at once, but it continued to seem imminent. Economic disaster swept through England in 1793, and Government pamphleteers undertook the thankless task of demonstrating that the decline of trade was *not* connected with the war.[23] From Gibraltar to the Baltic the disasters of war overwhelmed the armies of Britain and her allies throughout the following year. "It is incredebl," wrote Robert Fulton in April 1794, "with what Vigor the French meet their enemies while *Live the Republic is the Constant Song; and Liberty or death their Motto.* . . . Monarchial Governments are going out of Fashion. . . . the French will prove Sucesful and . . . the Natural Consequence will be Republicks throughout Europe, *In time.*"[24]

In *Europe, A Prophecy,* Blake enlarges on the idea that the British attempt to accuse, judge, and execute revolutionary France is

[22] *E*.13:1–3: E63/K243. Bronowski, pp. 51–52 [79–80], notes that Pitt is the man "within" the symbol Rintrah and points to Blake's clues: "although the meaning of the symbols came to change, Rintrah with the Plow in *Milton* remains the Plowman whom *The Spiritual Form of Pitt, Guiding Behemoth* orders 'to Plow up the Cities and Towers.' " In *J*.91 Behemoth is equated to "the War by Land." In *Europe* Rintrah's function is, in the historical part, that of the leader of the British government after 1783, i.e. that of William Pitt.

[23] See John Bowles, *The Real Grounds of the Present War with France,* London, 1793.

[24] Fulton had come to England to study art. He is especially quotable because he may have known Blake: he was intimate with Barlow, and in 1808 he was one of the few people who subscribed for *two* copies of Blake's Blair.

equivalent to an invitation to the universal revolution, and he devotes attention to the sequence of events that led to the blowing of the trumpet of war against France, particularly the efforts in 1792 of Britain's ruling Angels to shut the gates of the minds of "the youth of England" and to condition them for the terrors of the approaching Armageddon.

This historical portion of *Europe* is set obscurely, however, in a complicated web of myth reaching from the morning of Christ's nativity to the day of Judgment. Nowhere is Blake's symbolism more cryptic; nowhere do so many new characters appear in such fleeting contexts; nowhere is there such sly shifting from one level of discourse to another, such difficulty with ambiguities of punctuation and sudden changes of pace. Many critics looking for the historical meaning have foundered on the assumption that the "strife of blood" at the end of the poem signifies the French Revolution of 1789, not the English crusade of 1793–1794— failing to distinguish the historical narrative (the middle of plate 9 to the middle of plate 13, Enitharmon's 1800-year dream, separated typographically; and the concluding 12 lines) from its mythological envelope. Yet this narrative must be read correctly before the rest of the work will come into proper focus.[25]

The historical portion begins with a reference to the innumerable wars that divided the ruling families or "heavens" of Europe up to the catastrophic end of the American War—"Till Albions Angel, smitten with his own plagues, fled with his bands"—a catastrophe which implied a very dark future for all ancient heavens, particularly those of Albion:

> The cloud bears hard on Albions shore,
> Fill'd with immortal demons of futurity,

a cloud filled with plagues which rush down on the "council house" and bury the "smitten Angels of Albion" for one hour.[26] After the American debacle the privy council (modern cabinet) did collapse, and the ministry of Fox and North in 1783 supplied a brief interlude in the long tradition of king-dominated councils.

[25] Bronowski in 1944 was unique in recognizing in *Europe* "the war against the French Revolution." By now (1969) the historical pin-pointing of the present chapter has been generally accepted.

[26] *E*.9:6–14. It had long been recognized that in this passage Blake alludes to the climax of the American War. It had not been recognized that Blake continues the story up to England's next war.

Then began the ministry, supported by all the open and secret influence of the Crown, of young William Pitt, whom Blake presents as "Rintrah furious king" and pictures as a black knight armed cap-a-pie in chain mail and carrying a crusader's sword (see Plate VI).[27] Though such "Angels & weak men" were able to restore Tory rule, the American influence remained and they did so only with difficulty, "In troubled mists o'erclouded by the terrors of strugling times." Like Satan and his cohorts, Rintrah and his fellow angels were now fallen and living among the ruins of their bright edifice of chivalry. "In thoughts perturb'd, they rose from the bright ruins silent following The fiery King" while "Round him roll'd his clouds of war" (*E*.9:16–10:4).

Rintrah's three unsuccessful attempts to blow "the iron tube" of war may be taken as the three crises contrived by Pitt in the half decade before war with France finally came. In 1787 England made preparations to hire Hessians and send munitions in support of the Dutch Orange party and to back Prussia if she invaded Holland to forestall France; in 1790 Spain was pushed to a point just short of war over an incident in Nootka Sound (Vancouver Island); and in 1791 Pitt obtained from Parliament a vote to arm against Russia but withdrew his ultimatum when he saw the size of the opposition. In each of the last two cases the "pretext for an armament"[28] was more apparent than the purpose of it, and Pitt privately conceded that he had found he could not swing enough public support behind a military venture to risk his ministry in a war.[29] These were the adventures described (in the quotations at the head of this section) as knight-errantry by Paine and as presumptuous assays by Blake. Their miscarriage pointed to the need of a preliminary softening of the public backbone such as the Antijacobin alarms of 1792 provided.

Blake's way of describing Pitt's turning to this sort of preparatory attack on morale is to say that Rintrah led his council, in clouds of war, to Druidism—to "his ancient temple serpent-form'd That

[27] *E*.5. The features of Rintrah here are calm; those of his archetype, the Executioner of *Our End is Come,* are distorted by alarm: the two figures have some general resemblance, and they hold similar swords. A sadder Rintrah in the same scaly armor appears as a destructive angel in *The Death of the First-born,* 1805.

[28] Elliot, 1, 361.

[29] Pitt to Ewart, May 24, 1791, quoted in D. G. Barnes, *George III & William Pitt,* p. 232 n.

stretches out its shady length along the Island white" of Britain. As distinguished from the self-sacrifice of Washington and Paine, praised in *America*, Pitt's Druidism represents the aggressive sacrifice of others, according to a self-righteous creed in which "man" has become "an Angel, Heaven a mighty circle turning, God a tyrant crown'd" (10:2–23). With some distortion of his Antiquarian sources,[80] Blake imagines the original serpent temple as an edifice stretching all across the waist of England, along the Thames, the artery of modern Britannia's naval power.[81] He places the serpent's head in "golden Verulam" because Verulamium is the site of Druid ruins and also because Verulam was the baronial title of Francis Bacon, whom Blake considers the Machiavelli of British imperialism.[82]

On the brink of war with France, Pitt did look primarily to naval action and the seizure of French islands.[83] Had he been able to read the prophetic warning of Blake, he could have learned that the "southern porch" of such Druidic aggression would become "a raging whirlpool" which would draw "the dizzy enquirer to his grave."[84] But Rintrah, standing on the Druid altar or Stone of Night, looked up for comfort to Urizen with "his brazen Book That Kings & Priests had copied on Earth," and as he looked it expanded "from North to South." For the moment the distinction between Urizen and George III seems very faint. Blake illustrates the page with a vision of the bat-winged, black-robed, papal-crowned Emperor of Babylon overshadowing a Gothic church similar to the Archbishop's chapel at Lambeth. His face is something like that of the King in Gillray's caricatures, and we remember that the pope of British State Religion *is* George the Third.

[80] See Todd, *Tracks*, pp. 47 ff.

[81] Compare the similar but less cryptic description of naval preparations in *A*.c:1–6: E57/K205.

[82] See Marg. to Bacon, passim. And see the antiquarian Thomas Pennant, *Journey from Chester*, London, 1782, p. 251: "Verulamium was the capital of this country, and the residence of its princes."

[83] The day *before* the execution of Louis, Pitt told his new High Chancellor that "war was a *decided measure,* that . . . it was inevitable, and that the sooner it was begun the better. That we might possess ourselves of the French Islands. . . ." *Diaries and Correspondence of the First Earl of Malmesbury,* London, 1844, II, 501.

[84] *E*.10:24–31: E62/K242. Other layers of the complex symbolism include a genetic description of the shrinking down of the divine Man into the finite man of "hair and . . . stony roof."

Blake's camera has now drawn close to London, and we see that the stone of sacrifice is in the city's heart. It is the stone of London's blackening church and bloody palace, around which swag "the clouds & fires pale" of the religion of war:

Round Albions cliffs & Londons walls . . .
Rolling volumes of grey mist involve Churches, Palaces,
 Towers:
For Urizen unclaspd his Book! feeding his soul with pity.[35]

Now comes the public reading of a page from the cruel laws of Urizen, and since the episode that follows can be identified as the downfall of Chancellor Thurlow on June 15, 1792, first publicized in the papers and in Gillray's print of May 24, the cruel preachment referred to is evidently the famous Royal Proclamation of May 21 against "divers wicked and seditious writings."[36] Looking back from 1794, Blake treats this first official effort to befog men's minds with Antijacobinism as the first decisive step of Pitt's government toward war and an effort to prepare a war psychology. Blake gives us a composite scene in which the hypocritical Angel reads the Proclamation before an unwilling muster of youthful militia, who curse the trumpeter of their doom.

The youth of England hid in gloom curse the paind heavens;
 compell'd
Into the deadly night to see the form of Albions Angel.
Their parents brought them forth & aged ignorance preaches
 canting,
On a vast rock, percievd by those senses that are clos'd from
 thought:
Bleak, dark, abrupt, it stands & overshadows London city
They saw his boney feet on the rock, the flesh consum'd in
 flames:

[35] *E.*12:2–4: E63/K243. On the Stone of Night see Frye, pp. 224–225, and Sloss and Wallis, I, 73 n. The latter call attention to *Paradise Lost* iv.543–548, where the eastern gate of Paradise is described as a rock of alabaster. Note that in both Blake and Milton the idea of armament is associated with the stone, for the alabaster gate is the place of Gabriel's magazine or "Celestial armoury, shields, helms, and spears hung high."

[36] Gillray's cartoon of May 24, *The Fall of the Wolsey of the Woolsack*, was an early announcement of Thurlow's resignation. It had been privately demanded on the 16th, but the politically well informed Sir Gilbert Elliot was not sure of it until the 22nd. Elliot, II, 29.

They saw the Serpent temple lifted above, shadowing the Island
white:
They heard the voice of Albions Angel howling in flames of
Orc [i.e. crying out against wicked Jacobinism],
Seeking the trump of the last doom (*E*.12:5–13)

Historians agree with Blake that this Proclamation began Eng-
land's "black era of reaction and coercion."[37] Ostensibly aimed at
Paine's *Rights of Man*, the second part of which, urging England
toward a republic, had been published in February, the ban's im-
mediate political intent and effect was to split the Foxite Whigs
and weaken their organization of associations of "Friends of the
People" to support Parliamentary Reform.[38] On the more popular
Constitutional and Corresponding Societies it had if anything a
stimulating effect. But in the minds of "mortal men" the Proclama-
tion was ominously linked with concurrent military maneuvers.[39]

Pitt's budget message in January had anticipated fifteen years of
peace. But from May to August the youth of England, in regiment
after regiment, were compelled to march through London and en-
camp on the open heath west of the city for much drilling and
sham battle against imaginary enemies. Newspapers at first (May
24) assured the public that "the little encampment on Bagshot
Heath" was formed for the study of new Prussian maneuvers
recently introduced into the British army, "and not from the most
distant idea of any armament being at this time requisite on the
part of Great Britain."[40] But as the summer wore on, the papers
alternated shocking reports of democratic atrocities in France with
"evidence" of sinister French designs upon Britain.[41] It was gradu-
ally taken for granted that the supposititious enemies were French

[37] C. Grant Robertson, *England Under the Hanoverians*, London, 1930,
p. 363.

[38] Elliot, II, 11–59.

[39] In *A.* pl. c it is the King who stands "on the vast stone whose
name is Truth" before the muster of his victims, called "mortal men" in
recollection perhaps of Falstaff's "tush, tush, mortal men."

[40] *London Chronicle*, May 24, 1792. The new Prussian manual exercises
were apparently first displayed in a review before the King and Princes on
March 30. *London Chronicle*, March 31.

[41] In July a detected packet of correspondence conveying "professions of
friendship of the Jacobin Club of Thoulouse" to "the President of the
Constitutional Whig Club in London" was treated as "sensational evidence"
of French infiltration. *London Chronicle*, July 1.

Jacobins (and English ones), and before the end of July the "military evolutions" at Bagshot reached the dramatic height of supposing "that an army of enemies, amounting to 20,000 had landed at Southampton."[42] In August the British ambassador gave France an ultimatum that he would quit Paris "the moment a debate is brought on for deposing the King." Pitt, without risking a consultation of Parliament, began erecting barracks in the industrial centers—rather more evidently against English Jacobins than French. And on December 1 the Proclamation of May 21 was repeated, this time formally linked with a calling out of the militia.

Blake has placed this combined "mustering" and preachment in May, when the war games began. The youth whose bodies are brought forth for slaughter and whose minds are being closed from thought are "hid in gloom." Yet they see the flames of Orc consuming the flesh of Albion's Angel—as pictured in *Our End is Come*. And it is the rulers, not they, who are pained and howl. The war trumpet will, when someone succeeds in blowing it, bring an end to the government of Angels and weak men.

The next episode in *Europe* is presented in identifiable detail and serves to confirm the present interpretation of Blake's narrative. The episode has long since faded on the pages of history, but we can easily see how it delighted Blake's sense of irony. For Pitt's first victim following the Antijacobin ban was not Tom Paine but one of the Angels of Pitt's own cabinet, the Lord High Chancellor and Keeper of the Seal and Guardian of the King's Conscience, described by one Patriot as a man "with the Norman conquest in his eyebrow and the feudal system in every feature of his face."[43] Chancellor Thurlow often took an independent line, and for years Pitt had been seeking to rid himself of his formidable colleague. His chance came when the Chancellor ridiculed Pitt's Sinking Fund Bill as the work of "a mere reptile of a minister" and

[42] *ibid.*, July 21.—The purpose was both "to overawe the people of the metropolis," as Lauderdale charged, and "to glorify the Government, to popularize war, and hence to divert . . . the clamor for election reforms." Werkmeister, p. 103; see also pp. 134–142 for the "Insurrection" of December, invented by Government newspapers. It was Blake's later judge, the Duke of Richmond, who was in July 1792 made Field Marshal to take command of the Bagshot encampment.

[43] Thelwall, quoted in C. B. Roylance Kent, *The English Radicals*, London, 1899, p. 152.

told Parliament that no bill should attempt to bind all future governments. The grain of sedition in this remark was infinitesimal, but Pitt promptly asked the King to dismiss Lord Thurlow, counting on his own indispensability at a time when he had filled the King's mind with alarm for the constitution.[44] To Thurlow's amazement the King readily tugged off his insignia, as Gillray portrays the struggle, and at the end of the session Thurlow was compelled to relinquish the Great Seal and doff his judicial gown and wig.

The episode may have been of slight political significance, but Gillray gave it mock-epic proportions, and Blake treated it as an omen of the Day when judges should be judged and a sign that the revolutionary world crisis could singe even the high guardian of British law in Westminster Hall.[45]

Above the rest the howl was heard from Westminster louder
 & louder:
The Guardian of the secret codes forsook his ancient mansion,
Driven out by the flames of Orc; his furr'd robes & false locks
Adhered and grew one with his flesh, and nerves & veins shot
 thro' them
With dismal torment sick, hanging upon the wind: he fled
Groveling along Great George Street thro' the Park gate; all
 the soldiers
Fled from his sight: he drag'd his torments to the wilderness.[46]

Here is circumstantial detail of Thurlow's leaving the Westminster government buildings and fleeing in shame and anger down Great George Street to St. James's Park. In a similar if less vivid reconstruction Thurlow's biographer pictures his last appearance as

[44] William Thomas Laprade, *England and the French Revolution*, Baltimore, 1909, p. 62.

[45] Thurlow's most recent "feudal" action had been his stalling of the resolution against the Slave Trade in the House of Lords in April and May. Blake may also have remembered Thurlow as an accuser of adultery (not an unrelated point, as we know from *V.D.A.*), for in 1779, at about the time of Blake's paintings on that theme, Thurlow had given loud support to a bishop's bill "for the more effectual discouragement of the crime of adultery." For other aspects of Thurlow's fall, see Werkmeister, pp. 82–83.

[46] *E.*12:14–20: E63/K242. Compare the 16th "Probationary Ode" of *The Rolliad,* in which Thurlow warns "every rebel soul" to tremble as he grows "profane" with a "louder yet, and yet a louder strain."

Chancellor in proroguing Parliament, his driving to St. James's Palace to surrender the Seal, his dejection as "a solitary outcast" and his "diminished consequence" when seen "without his robes, without his great wig."[47]

"Thus was the howl thro Europe!" Blake generalizes, "For Orc rejoic'd to hear the howling shadows." Some of the shadowy rulers had considerable power left, however, both political and military:

> But Palamabron shot his lightnings trenching down his [Orc's] wide back
> And Rintrah hung with all his legions in the nether deep

Regardless of Orc's rejoicing through Europe, the result for England was that the citizens were bound "in leaden gyves" and every house became a den with "Thou shalt not" written over the doors "& over the chimneys Fear" (12:21–31). And since Blake deals with no further events of English history before the blowing of the trumpet, the cited actions of Rintrah and Palamabron can be taken to signify any single or continuing activity between May 1792 and January 1793 engaged in by Rintrah as Pitt and Palamabron as Parliament, or rather as Burke in Parliament.[48]

Rintrah's water-borne legions may be British fleets waiting the command to seize French sugar islands in the Caribbean, or to carry an invasion force to the underbelly of France in the Mediterranean—both nether deeps. On another level they may be Pitt's henchmen lurking to stifle opposition.

Palamabron's thunderbolts against Orc might signify any of Burke's Antijacobin speeches. But the illustration on the first page of the Preludium of *Europe* derives from a Gillray print of December 30, 1792, and this print points to a specific occasion: *The Dagger*

[47] John Campbell, *Lives of the Lord Chancellors* . . . , London, 1845–1847, VII, 131–133.

[48] Palamabron, on the ethical level, represents Pity, usually of the restrictive sort. Politically Palamabron is "Parliament's Bromion" or blusterer. (In *V.D.A.* Bromion [Greek: roarer] is a blusterer in a cave.) In 1792 when Rintrah chooses the clouds of war, "that which pitieth" becomes a "devouring Flame" (*E*.10:16–17). Burke, having notoriously shed the tears of Pity for the plumage of French royalty, in 1792 wields a dagger in the cave of Parliament—represented in *Europe* by the symbolic equivalent, "lightnings." Blake's Palamabron is sometimes a "horned priest." Compare Gillray's treatment of Burke as a "Jesuit."

In *Milton* Palamabron's function is Parliamentary, the calling of "a Great Solemn Assembly," but no longer Burkean.

Scene; or, the Plot Discover'd (Plate Vb). Gillray's man with a dagger is Burke, whom he often pictures as a spy or vigilant watchman defending Crown and Cross against "atheistical revolutionists." Blake's dagger-wielding assassin has the same face, and Blake's whole picture is a prophetic transformation of the Gillray satire.

Pitt had called an emergency session of Parliament in December by reissuing the May proclamation and calling out troops. In this Parliament, Burke delivered a war-inciting speech on the Alien Bill, a measure based on and calculated to intensify the suspicion that foreign agents were about. At his climax Burke suddenly produced a steel dagger and flung it on the floor. "This," he exclaimed, pointing to the dagger, "is what you are to gain with an alliance with France."[49] Gillray mocks the histrionics—the dagger, the pointing finger, the "startled" adversaries. Blake pictures Burke as an assassin lurking in the cave (of Parliament) to stab a youthful pilgrim (Plate Va). The dagger in his hand (corresponding to the thunderbolts in the text) signifies that his malice is the real "plot," his speech a waylaying of Everyman on his peaceful pilgrimage, or, more specifically, the Patriot on his progress to Paradise. For at the bottom of the page the sequel of the action is indicated: the youth is hurtling head downward with a weight manacled to his wrists, and a woeful creature, perhaps suggested by the caricature of Charles Fox as the pilgrim in Gillray's *Slough of Despond,* is mired in "shady woe."[50]

The second page of the Preludium may illustrate Rintrah's hanging in the nether deep like Milton's Satan in the "nethermost Abyss" on his way to invade the Garden of Eden. Hanging in space a wrestler (Rintrah?) clutches two opponents whom he is trying to strangle. Another, who has escaped but holds his head in pain, is climbing onto a cloud. In later pictures Blake will represent Pitt and

[49] *Parl. Hist.,* Dec. 28, 1792. The episode was universally reported and widely satirized. For details of the whole context of "simulated panic," see Werkmeister, pp. 137–157.

[50] See "Blake's Debt to Gillray," cited above. In Bunyan a giant named "Pope" lurks in a cave, but though old and weak (as "Jesuit" Burke) he has no dagger.

Burke, in displaying the "English Jacobin" dagger, was of course flourishing the *real* weapon that caricaturists had been picturing in the hands of Fox. In Blake's vision the dagger-rattling reveals the true malevolence of the Accuser himself. Mrs. Bogen (in *American Notes & Queries,* VI [1967], 37) documents the Blakean transfer of Foxite traits to Burke as "a direct rejoinder to Gillray."

Nelson as harrowing and strangling nations. Gillray uses similar wrestling scenes to represent the throttling of political opponents by Pitt and Burke. Pitt's treatment of Lord Thurlow, in the text, is a case in point; and in one of Gillray's satires of that conflict he treats the clash of Pitt and Thurlow as the clash of Death and Satan at the gates of Hell. But before we pursue that connection, let us make use of some contemporary commentary.

Either because he understood *Europe* very well, or because he was coached by Blake himself, his friend George Cumberland added explanatory glosses to a copy now in the British Museum, mostly in the form of quotations from Blake's household volume, Bysshe's anthology.[51] Verses written under the two Preludium pictures imply that both are manifestations of the same windy (Parliamentary) strife. From the "hoarse din" of "imprison'd tempests" and "clam'rous Hurricanes" raving in a "noisy cave" (compare the "shrill winds" of Blake's text) emerges a global conflict:

> This orb's wide frame with the convulsion shakes,
> Oft opens in the storm and often cracks.
> <u>Horror</u>, <u>Amazement</u>, and <u>Despair</u> appear
> In all the hideous forms that Mortals fear.

The three words were underlined to call attention to the two trapped and the one escaping victims of the strangler; they suggest that Pitt is stifling expressions of Horror and Amazement at his catastrophic policy but is unable to suppress the silent figure of Despair, which is ascending.[52]

In Blake's text the domestic repression that follows the actions of Rintrah and Palamabron is welcomed by a woman named Enitharmon. In the mythical envelope of *Europe,* to be discussed later, she is the Queen of Heaven. In the temporal world her interest in the matter may be that of the Queen of England. At

[51] Damon prints these glosses, p. 348. For the identification see Geoffrey Keynes and Edwin Wolf 2nd, *William Blake's Illuminated Books: A Census,* New York, 1953, pp. 81–82. It was Catherine Blake who had Bysshe's *Art of Poetry* "in her hand" when she and her husband tried a *sortes Bysshianae* in 1807. See Blake's Memorandum: E674/K440.

[52] Blake allegorizes abstract nouns in a similar fashion in his designs for Gray and for Milton. For example in Plate II *above,* the villagers fleeing from Edward III represent (reading from right to left as listed in the text) Flight, Amazement, Sorrow, and Solitude.

the time of the King's insanity in 1788 Queen Charlotte had been advised by physicians to keep the King "in constant Awe" of herself, on the theory that this would prevent a relapse, and she had assumed charge of the royal household "with singular Zeal."[53] She was subsequently believed to control the flow of patronage and rule the Empire through Pitt. His choice of peace in 1790 had been attributed to the Queen's influence; it was logical to assume that his later choice of war was also her doing. The May proclamation against seditious writings was issued in the King's name but from "the Queen's House." Pitt's success in ousting Thurlow was attributed to her support, and Gillray's version, in a print entitled *Sin, Death and the Devil*, June 9 (Plate VIIa), is that the Queen sheltered Pitt from the fallen Thurlow's vengeance by playing a part like that of Sin in Milton's description of the contest between Satan and Death.

Gillray's lurid caricature is an instructive link between Blake and Milton. Thurlow is a muscle-bound Satan, Pitt a gaunt and naked King Death wearing "the likeness of" the British Crown (compare Blake's calling Rintrah a "furious king"), and Queen Charlotte a hideous "snaky" Sin wearing the key to the backstairs, "the Instrument of all our Woe." Her control over the gates of Hell and her jailor's function suggest why Enitharmon is delighted to see a prison made of England:

to see (O womans triumph)
Every house a den, every man bound; the shadows are filld
With spectres, and the windows wove over with curses of iron:
Over the doors Thou shalt not; & over the chimneys Fear is
 written:
With bands of iron round their necks fasten'd into the walls
The citizens: in leaden gyves the inhabitants of suburbs
Walk heavy: soft and bent are the bones of villagers

(*E.*12:25–31)

[53] "Observe that he [Pitt] is rather the Queen's man than the King's, & that since his Majesty's illness she has been of great consequence. This depends in part on a Medical reason. To prevent the relapse of Persons who have been mad, they must be kept in constant Awe of Somebody; and it is said the physicians of the King gave the Matter in Charge of his Royal Consort who performs that, like every other Part of her Conjugal Duty, with singular Zeal of Perseverance." Gouvernour Morris to George Washington, Sept. 1790, *Diary*, 1, 604.

The suggestion that the queen of jailors is Sin and that Sin is the incestuous mother of Death recalls Blake's indictment of the perverse idea "that Woman's love is Sin," a part of the Urizenic code which makes the nation's queen a symbol of whoredom and puts the chivalrous slogans of the Antijacobin crusaders in the category of accusations of adultery. On the level of psychology and ethics Blake treats war as the perversion of sexual energy; on the level of politics, as *Europe* indicates, he considers that priest and king make war to divert desire from normal channels and that they use the slogans of chivalry to make slaves of the men of their own and other nations who assert the rights of Love. The fact that Rintrah is pictured on page 5 (our Plate VI) as championing not one queen but two should remind us that there were queens of both France and England. The crusade is undertaken, according to the text, "That Woman, lovely Woman! may have dominion," and Rintrah and Palamabron are sent forth to battle for two angelic females who, on page 11, bear scepters tipped with the fleur-de-lis commonly used in English caricature prints as a French royalist symbol.

Burke, we remember, viewed the dethronement of the Queen of France as marking the extinction of chivalry, that "nurse of manly sentiment and heroick enterprise," while Paine welcomed the departure of "the Quixotic age of chivalric nonsense" and laughed at Burke as "the trumpeter of the order" and at Pitt as its "knight-errant."[54] We have seen Blake's caricature of the Queen of France in *Fayette*; it remains to be noted that in the same ballad he depicts the Queen of England as equally vicious. One darts pestilence from her robe;[55] the other spreads it like a deadly upas tree, source of poison for war-arrows:

> But our good Queen quite grows to the ground
> There is just such a tree at Java found
> And a great many suckers grow all around.[56]

[54] Burke, *Reflections,* pp. 76–77; Paine, I, 248, 443.

[55] In *E.* pl. 11[9] in the Morgan Library copy the angelic queen on the right has a serpent coming from beneath her garment, as Pestilence darts from the robe of the Queen of France in *Fayette*. There are serpents under both angels' robes in some copies, e.g. the Fitzwilliam (Pl. 3 in Hagstrum).

[56] E491, 779/K185. The second line is a deleted reading, but it makes clear the kind of "suckers" Blake had in mind. His condemnation of the English queen has been universally neglected. Damon, p. 289, overlooking the

It is true that a decade later Blake permitted his publisher to arrange for the dedication to the Queen of his Blair illustrations and even wrote two dedicatory stanzas to the "Shepherdess of England's Fold." But at the same time he confided to his notebook that "There is no such thing in Eternity as a Female Will" and he deleted a momentary concession he had made to spectators of his *Last Judgment* permitting them to think of "good Kings & Queens of England" as representing Education.[57] Evidently the two queens in *Europe*—not Enitharmon, who is their archetype, but the briefly mentioned Leutha, "sweet smiling pestilence . . . silken queen," and "silent Elynittria," the "silver bowed queen" of Rintrah—are ideal portraits of the queens of France and England as pictured to the youth who are being sent to war that these may "have dominion" (*E*.8:4; 14:11-14).

Finally, Gillray's bestowal of serpent hair upon the Queen, who is in Milton a "Snaky Sorceress" only by virtue of being serpentine below the waist, leads us to Blake's concluding lines, in which the prophet himself arises with "his head . . . in snaky thunders clad" and calls "all his sons to the strife of blood," a strife he believes will bring the end of kings and queens and the whole restrictive code of Sin. The trumpet that Rintrah was trying to blow would announce their end because meanwhile "in the vineyards of red France" a "terrible Orc" had made his appearance "before the trumpet blew." If we understand the blowing of the trump to mean the British vote for war, then the Orc whose coming preceded it is the one who guillotined the King of France on January 21, the same "Demon red" whose light was, according to *America*, received by France twelve years after the fall of Albion's power across the Atlantic.[58]

Yet when, in *Europe*, the end does come, we are reminded that the decisive battles are fought in more strategic areas than Pitt's

poisonous nature of the upas tree, to which Blake is alluding, glosses: "Queen Charlotte, contrasted by her inactivity during times of trouble."

[57] See E552 and the textual note, E798, correcting the earlier misreading that ran together "Female Will, & Queens of England."

[58] The phrase "before the trumpet blew" appears only in early proofs of the page. See entry 74, *Catalogue,* Philadelphia Museum of Art, 1939, p. 39. Removal of this phrase revises the sequence of events (compare similar adjustments in *F.R.*) to fuse into one symbol the execution of Louis and the "furious terrors" of the ensuing year in France.

cabinet or even the nether deep. The trumpet is actually blown (a larger view discloses) by the ideological creator of the whole Antijacobin universe, "A mighty Spirit . . . Nam'd Newton." *He* "siez'd the Trump, & blow'd the enormous blast!" and the mighty Angelic hosts, helpless as "leaves of Autumn,"

Fell thro' the wintry skies seeking their graves;
Rattling their hollow bones in howling and lamentation.[59]

England's crisis was exploding into a world crisis, the crisis of an epoch.[60]

The persistence of Blake's hope and even enthusiasm in 1794 appears to arise partly from the dialectics of a period in which both the forces of repression and those of reform were mobilizing, but ultimately from the firm persuasion that the thoughts which Pitt was trying to control were truly winged. The governors *were* weak men of weak vision, and their law-built heavens could not close all the gates of the senses from thought.[60a] The jailing of English Reformers did not make England Pitt's in 1793; the publications and meetings of the Corresponding Society and similar groups *increased* after the war began, and even late in 1794 the climate was such that the jury trials of their leading spokesmen ended in acquittals.[61] Rintrah's terror did bend soft bones and make "the inhabitants of suburbs Walk heavy." Blake, since March 1791

[59] E.13:4–8: E63–64/K243. Compare F.R.73–75: E286/K137.

[60] We are witnessing the twilight of the gods that goes with a new creation. See Paul Henri Mallet, *Northern Antiquities,* translated by Thomas Percy, London, 1770, 1, 104, quoted below, p. 356, n. 8.

[60a] David Williams, an ingenious pamphleteer, made diagrams showing no constitution healthy in which the *senses* of the body politic, i.e. the common people from whom all political ideas must flow to the "head," were barred from political participation. *Lessons to a Young Prince,* London, 1791, pp. 47, 73.

[61] In 1792 the radical societies were just forming. Their strength was greatly exaggerated by alarmists then, and minimized later; but careful surveys indicate growth at least through 1795. To say that by the middle of 1792 "England belonged to Pitt" (Schorer, p. 162) is dramatic but misleading. To say that "after the September Massacres of 1792 and the declaration of war in February of 1793, for most radicals retreat become a rout" (p. 164) is even more inaccurate. The Whigs who deserted Fox and Gray can hardly classify as radicals. As a matter of fact the term *radicals* did not exist: it was made necessary by the *subsequent* activities of the Corresponding Society.

living in the suburbs, in Lambeth beneath the poplar trees, was closer than ever to Parliament and Westminster Hall and the Archbishop's Lambeth Palace, closer than ever to "Infinite London's awful spires" which "cast a dreadful cold Even on rational things beneath."[62] Yet it seemed to be the Angels, not the inhabitants, who were in panic. "Between the clouds of Urizen" Blake could see "the flames of Orc roll heavy Around the limbs of Albions Guardian" and could hear "voices of despair Arise around him in the cloudy Heavens of Albion" ($E.12:32–35$). When the full lethal implications of the Newtonian epoch had been unfolded, the party of order had chosen the chaos of war, and the very principle of calculation had proved bankrupt. Newton, the calculator, pattern of the *"mistaken* Demon of heaven,"[63] had had to blow the trump.

We have followed Blake's narrative of history into the abyss of war in which the Eighteenth Century ended. Before considering the symbolic action of the Eternals in *Europe* who sleep through this "night of Nature," it is time to turn from prophecy to vision, from promise to the grounds of promise, that is, to the economic or sociological aspects of Blake's reading of history.

[62] *A.c*:7–8; cf. *E.12:3.*
[63] *V.D.A.5:3*: E47/K192. My italics. On Newton's role see Frye, pp. 254–255. The debacle of Newton's universe of weight and measure is quite differently evaluated by Cowper, self-styled poet of the middle class Whigs: "One project indeed supplants another. The *vortices* of Descartes gave way to the gravitation of Newton, and this again is threatened by the electrical fluid of a modern. One generation blows bubbles, and the next breaks them." Cowper to Unwin, Sept. 29, 1783.

10. Visions of the Daughters

The fire, the fire, is falling!
Look up! look up! O citizen of London. enlarge thy countenance; O Jew, leave counting gold! return to thy oil and wine; O African! black African! (go. winged thought widen his forehead.)
— *A Song of Liberty*

WHEN Blake came to believe, in the decade after Waterloo, that the revolutions in America and France had been merely bourgeois revolutions, destroying colonial and monarchic restraints only to establish the irresponsible "right" to buy and sell, he concluded that nearly everything of value in those revolutions had been lost—at least as far as his own countrymen were concerned. When he declared that most Englishmen "since the French Revolution" had become "Intermeasurable One by another" like coins in a till and had reduced all values to the experiment of chance, he meant that such Englishmen had absorbed nothing of the real meaning of Republican culture, had not learned that everything that *lives* is holy and without price and that each "Line or Lineament" is *itself* and is "Not Intermeasurable with or by any Thing Else."[1]

Most of his life Blake was more or less confident that the sons and daughters of Albion would learn; would enlarge their views rather than their investments, would "look up" and open their minds to the visions in the air. For "counting gold" is not abundant living; and grasping colonies and shedding blood whether in the name of royal dignity or in the name of commerce is not living at all, but killing. When Blake urges the London merchant to turn from banking to the exchange of useful commodities (Biblical "oil and wine") he is thinking on the one hand of the need to abolish hunger; on the other hand he is thinking of the gold amassed from

[1] To Cumberland, Apr. 12, 1827: E707/K878. Blake says "Englishmen are *all*" etc., but excepts himself and his friend. On the opposition of Money to Art see Laocoön: E270/K776.

colonial plunder, traffic in slaves, and open war. The winged thought which must inspire the African slave to revolt must also inspire the British citizen to let "the British Colonies beneath the woful Princes fade" (E58/K206) and to desist from coveting the colonies of France. And it must also inspire the sexes to *love* and let *live* without possessive jealousy.

Blake sees all these matters as interrelated. War grows out of acquisitiveness and jealousy and mischanneled sexual energy, all of which grow out of the intrusion of possessiveness into human relations. "Number weight & measure" signify "a year of dearth."[2] The Rights of Man are not the rights of dealers in human flesh—warriors, slavers, and whoremongers. When Fayette was "bought & sold" in the service of the royal whore, his and other people's happy morrow was also "bought & sold." Purchase and sale only bring the old relationship of tyrant and slave out into the open market.

The economic side of Blake's myth is often expressed in images of fertility and sterility, fire and frost and seasonal growth. The soul of America who sings passionately of "lovely copulation" is a woman and also a continent longing for fruit in her fertile valleys. To say that she wants to be loved, not raped, is to say, economically, that she wants to be cultivated by free men, not slaves or slave-drivers; for joy, not for profit. The revolutionary energy which appears in history as Orcus pulling tyrants down to the pit appears in husbandry as the plower, sower, and reaper of abundant harvests, symbolized as ὄρχεις, the root of sexual growth in the womb of the earth. Orc as the spirit of living that transcends the spirit of trading is the divine seed-fire that exceeds the calculations of Urizen, god of commerce. The portrait of Urizen with golden compasses is made in the image of Newton, the mighty spirit of weighing and measuring who thought to reduce the prolific universe to an orrery of farthing balls. When Newton's trump marks the end of weight and measure, the great starry heavens prove to be as light as leaves.

In the symbolic Preludiums of *America* and subsequent poems the rich sexual-agrarian implications of Blake's economics are condensed into a cryptically ritualized myth. But some of the reasoning

[2] "Proverbs of Hell," *M.H.H.*7: cf. the motion in Commons Feb. 5, 1790, for "a return from all cities and market towns of the different weights and measures now in use."

behind this myth, or more properly the questioning behind it, is available in *Visions of the Daughters of Albion,* 1793, a dramatized treatise on the related questions of moral, economic, and sexual freedom and an indictment of the "mistaken Demon" whose code separates bodies from souls and reduces women and children, nations and lands, to possessions.

Superficially the *Visions* appears to be a debate on free love with passing allusions to the rights of man, of woman, and of beasts and to the injustices of sexual inhibition and prohibition, of life ruled by "cold floods of abstraction," and of Negro and child slavery. Yet love and slavery prove to be the two poles of the poem's axis, and the momentum of its spinning—for it does not progress—is supplied by the oratory of Oothoon, a female slave, free in spirit but physically bound; Bromion, the slave-driver who owns her and has raped her to increase her market value; and Theotormon, her jealous but inhibited lover who fails to recognize her divine humanity. As a lament over the possessiveness of love and the hypocrisy of moral legislators, the poem has been widely explored in the light of Blake's notebook poems on this theme and in the light of Mary Wollstonecraft's *Vindication of the Rights of Woman.* The other pole, equally important in the dynamics of the work, has scarcely been discovered. Yet we can understand the three symbolic persons of the myth, their triangular relationship, and their unresolved debate if we recognize them as, in part, poetic counterparts of the parliamentary and editorial debates of 1789–1793 on a bill for abolition of the British slave trade—the frustrated lover, for example, being analogous to the wavering abolitionist who cannot bring himself openly to condemn slavery although he deplores the *trade*.

Blake, in relating his discussion of freedom to the "voice of slaves beneath the sun" (*V.D.A.*2:8), was directing the light of the French Revolution upon the most vulnerable flaw in the British constitution, and in doing so he was contributing to the most widely agitated reform movement of the time. The Society for the Abolition of the Slave Trade, formed in 1787, had begun at once to gather evidence, organize town meetings, and enlist the help of artists and writers. Wedgwood produced a cameo of a suppliant Negro, widely used on snuffboxes, bracelets, hairpins. William Cowper wrote a number of street ballads such as *The Negro's Complaint* and *Sweet Meat Has Sour Sauce*. And Blake's *Little*

Black Boy coincided with the early phase of this campaign. But the Parliamentary phase began in 1789 and coincided with the revolution in France and the ensuing revolution of slaves in 1791 in French Santo Domingo. It reached its height in 1792–1793, and Wordsworth, returning to England early in 1793 after more than a year in France, was struck by the extent of the English movement: "little less in verity Than a whole Nation crying with one voice" against "the Traffickers in Negro blood."[3] The abolitionists nevertheless were "baffled." The bill was defeated in Parliament by the pressure of Antijacobin attacks from Burke and Lord Abingdon and various slave-agents, of whom Blake's thundering Bromion is a caricature.

This movement "had diffus'd some truths And more of virtuous feeling through the heart Of the English People," but its breadth was due partly to the fact that relatively few had any direct stake in the trade. Conservative as well as liberal humanitarians were not unwilling to dissociate British honor and British commerce from "this most rotten branch of human shame." Moreover, the slaves themselves made the trade a risky one, both for slave-drivers and for ship owners. Scarcely a year went by without its quota of slave ship mutinies, battles on the African coast, and insurrections in the plantations. Military statesmen complained that merchant seamen died off twice as rapidly in the slave trade as in any other, effecting a loss of manpower for the British navy. And many active abolitionists were merchants who preferred to invest in well-behaved cargoes manufactured in Manchester and Birmingham. It is Blake's view that the movement failed because of an insufficient diffusion of "truths" and a considerable misapplication of "virtuous feeling," to use Wordsworth's terms.

In *Visions of the Daughters of Albion* the true feelings which the Heart must "know" before there can be human freedom are discussed by Oothoon, Bromion, and Theotormon for the edification of the "enslav'd" Daughters of Albion—an almost silent audience or chorus, who lament upon their mountains and in their valleys and sigh "toward America," and who may be considered the Blakean equivalent of traditional personifications of the trades and industries of Great Britain: in *The Four Zoas* some of them will appear as the textile trades whose "needlework" is sold through-

[3] *The Prelude* x.202–227, here and below.

out the earth. They are of course, in the moral allegory, "oppressed womanhood," as Damon points out. They are shown that as long as possessive morality prevails, all daughters remain slaves; and that while the trafficker in Negro blood continues to stamp his signet on human flesh, none of the traffic on the golden Thames is untainted. In short, freedom is indivisible, and Oothoon's is a test case.[4]

<div align="center">2</div>

<div align="center">O African! black African!</div>

Blake's knowledge of the cruelties of slavery came to him doubtless through many sources, but one was directly graphic. In 1791 or earlier Joseph Johnson distributed to Blake and other engravers a sheaf of some eighty sketches of the flora and fauna and conditions of human servitude in the South American colony of Dutch Guiana during some early slave revolts. With more than his usual care Blake engraved at least sixteen plates, including nearly all those which illustrate slave conditions. We know he was working on them during the production of his *Visions of the Daughters of Albion* because he turned in most of the plates in batches dated December 1, 1792, and December 2, 1793.[5] The two-volume work they illustrate was finally published in 1796 as *A Narrative, of a five Years' expedition, against the Revolted Negroes of Surinam, in Guiana, on the Wild Coast of South America; from the year 1772 to 1777,* by Captain J. G. Stedman. We may assume that Blake was familiar with the narrative, available in Johnson's shop—at least with the portions explanatory of the drawings.[6]

[4] For documentation and illustration of this section and the next, see my "Blake's Vision of Slavery," *Journal of the Warburg and Courtauld Institutes,* xv (1952), 242–252.

[5] Some of the work was done before the end of 1791: see next footnote. Blake signed thirteen plates, and three others are unmistakably his. He is probably the "Blake (Mr. Wm.) London" in the list of subscribers, though this might be the William Blake of Aldersgate-street, who has been mentioned above and who contributed a guinea to the London Abolition Society in 1788. See *A List of the Society, instituted in 1787, for the Purpose of Effecting the Abolition of the Slave Trade,* London, 1788.

[6] Now a Memoir and *Journal* of Stedman's have been discovered and published by Mr. Stanbury Thompson (see above) and summarized

Blake's engravings, with a force of expression absent from the others, emphasize the dignity of Negro men and women stoical under cruel torture: the wise, reproachful look of the *Negro hung alive by the Ribs to a Gallows* (pl. 11) who lived three days un-murmuring and upbraided a flogged comrade for crying; the bitter concern in the face of the Negro executioner compelled to break the bones of a crucified rebel; the warm, self-possessed look of his victim, who jested with the crowd and offered to his sentinel "my hand that was chopped off" to eat with his piece of dry bread: for how was it "that he, a *white man,* should have no meat to eat along with it?" Though Blake signed most of the plates, he shrank from signing his engraving of this bloody document, *The Execution of "Breaking on the Rack"* (pl. 71); but the image of the courageous rebel on the cruciform rack bit into his heart, and in the Preludium of *America* he drew Orc in the same posture to represent the spirit of human freedom defiant of tyranny.

For the *finis* page Blake engraved according to Stedman's specifi-cations "an emblematical picture" of *Europe supported by Africa & America*—three comely nude women tenderly embracing each other, the Negro and the European clasping hands in sisterly equality (our Plate III). Roses bloom auspiciously on the barren ground at their feet. Yet there is a curious difference between this pictured relationship of Europe *supported* by her darker sisters, who wear slave bracelets while she wears a string of pearls, and the "ardent wish" expressed in Stedman's text, that all peoples "may henceforth and to all eternity be the props of each other" since "we only differ in colour, but are certainly all created by the same Hand." The bracelets and pearls may be said to represent the historical fact; the handclasp, the ardent wish. For one plate Blake had the ironic chore of engraving a "contented" slave—with Sted-

as to Stedman's relations with Blake by Sir Geoffrey Keynes (*TLS,* May 20, 1965, p. 400). By Sept. 1, 1790, Stedman had finished his book and, presumably, made arrangments with Johnson and the engravers. By Dec. 1, 1791, Stedman had written "to the engraver, Blake, to thank him twice for his excellent work, but never received any answer." Apparently they did not take forever to get acquainted; as Keynes puts it, "Stedman had been a soldier, but had atoned for this in Blake's eyes by being also an artist, who could draw and paint and could even attempt engraving and versification. He was also an advocate of the abolition of slavery, the horrors of which he had seen at first-hand and could communicate to Blake in all their lurid details."

man's initials, J.G.S., stamped on his flesh with a silver signet.[7] "Stampt with my signet," says Bromion ($V.D.A.1:21$).

In his *Narrative* Stedman demonstrates the dilemma, social and sexual, of the English man of sentiment entangled in the ethical code of property and propriety. A hired soldier in Guiana, Captain Stedman was apologetic about the "Fate" that caused him to be fighting bands of rebel slaves in a Dutch colony: "'Twas *yours* to fall—but *Mine* to feel the wound," we learn from the frontispiece, engraved by Bartolozzi: *Stedman with a Rebel Negro prostrate at his feet*. The fortitude of the tortured Negroes and the "commiseration" of their Negro executioners impressed Stedman and led him to conclude that Europeans were "the greater barbarians." Yet he could repeat the myth that these same dignified people were "perfectly savage" in Africa and would only be harmed by "sudden emancipation." His "ears were stunned with the clang of the whip and the dismal yells"; yet he was reassured by the consideration that the tortures were legal punishment and were not occurring in a *British* colony.[8]

To the torture of female slaves Stedman was particularly sensitive, for he was in love with a beautiful fifteen-year-old slave, Joanna, and in a quandary similar to that of Blake's Theotormon, who loves Oothoon but cannot free her. Stedman managed "a decent wedding" with Joanna, about which he is shamefaced, and a honeymoon during which they were "free like the roes in the forest." But he was unable to purchase her freedom, and when he thought Joanna was to be sold at auction, he fancied he "saw her tortured, insulted, and bowing under the weight of her chains, calling aloud, but in vain, for my assistance." Even on their honeymoon, Stedman was harrowed by his inability to prevent the sadistic flagellation of a slave on a neighboring estate. We have Blake's engraving of this *Flagellation of a Female Samboe Slave* (pl. 37). Naked and tied "by both arms to a tree," the "beautiful Samboe girl of about eighteen" had just received two hundred lashes. Stedman's interference only prompted the overseer to order the punishment repeated. "Thus I had no other remedy but to run to my boat, and leave the detestable monster, like a beast of prey, to enjoy his bloody feast." The girl's crime had been "refusing to

[7] Plate 68; see Stedman's text, I, 206.
[8] I, 109, 203, 90; II, 298.

submit to the loathsome embraces of her detestable executioner."
The captain's own Joanna, to prove the equality of her "soul" to
"that of an European," insisted on enduring the condition of slavery
until she could purchase freedom with her own labor.[9] Blake's
Oothoon invites vultures to prey upon her naked flesh for the same
reason. Her lover, Theotormon, is also unable to interfere or to
rescue her:

Why does my Theotormon sit weeping upon the threshold;
And Oothoon hovers by his side, perswading him in vain
 (*V.D.A.*2:21–22)

The persons and problems of Stedman's *Narrative* reappear, cre-
atively modified, in the text and illustrations of Blake's *Visions:*
the rape and torture of the virgin slave, her pride in the purity and
equality of her soul, and the frustrated desire of her lover and
husband. Oothoon advertised as pregnant by Bromion is the slave
on the auction block whose pregnancy enhances her price; Oothoon
chained by an ankle in plate 4 is the *Female Negro Slave, with a
Weight chained to her Ancle*[10]—or the similarly chained victim
of the infamous Captain Kimber, cited in Parliament in 1792. The
cold green wave enveloping the chained Oothoon is symbolic of the
drowning of slaves in passage from Africa; the flame-like shape of
the wave is symbolic of the liberating fires of rebellion. Her friend
beside her hears her call but covers his eyes from seeing what must
be done. In another picture Oothoon is fastened back-to-back to
Bromion; yet the most prominent chains are on *his* leg, and she
has not ceased struggling to be free.[11] Impotent beside these two
squats Theotormon, the theology-tormented man,[12] inhibited by a

[9] I, 99–106, 208, 312, 319, 325–326; II, 83, 377. Stedman had come
back to England without Joanna, but eager to tell the story. Blake, who
had caricatured his friend Flaxman as "Steelyard the Lawgiver," was forced
by his vision of the realities to see a Theotormon in his friend Stedman.
 [10] Plate 4, engraved by Bartolozzi; cf. the similar weight in *E.* pl. 1.
 [11] *V.D.A.* Plate printed variously as frontispiece or tailpiece—an emblem
of the *situation*.
 [12] The names Oothoon, Theotormon, Bromion, and Leutha have been
traced to Ossian's Oithona, Tonthormod, Brumo, and Lutha. (Damon,
p. 329.) But the oo-oo doubling may come from African words in Stedman:
apootoo, too-too, ooroocoocoo (snake). A *toremon* is a shiny black bird
whose name means "a tale-bearer, or a spy"; and the rebels "have an

moral code and a white man's God that tell him his love is impure. A caricature of paralyzed will power, he simultaneously clutches himself, buries his face in his arms, and scratches the back of his head. Despite his furtive sympathy ("secret tears") he makes no effective response to

The voice of slaves beneath the sun, and children bought with
 money,
That shiver in religious caves beneath the burning fires
Of lust, that belch incessant from the summits of the earth[13]

Stedman's anxieties shed light on the moral paralysis of Theotormon; yet we must also be aware of the analogous but more impersonal and political quandary of the Abolition Society, whose trimming announcement in February 1792 that they did not desire "the Emancipation of the Negroes in the British Colonies" but only sought to end *"the Trade* for Slaves" conflicted with their own humanitarian professions and involved an acceptance of the basic premises of the slavers: that slaves were legitimate commodities and that the rebellion of slaves was legally indefensible.[14] William Wilberforce, the Society's zealous but conservative spokesman in Parliament, became increasingly preoccupied in 1792 with clearing his reputation of the taint of republicanism in an attempt to carry water on both shoulders: to be known as a great friend of the

invincible hatred against it." 1, 367–368. If *Theo* is God, an accuser of sin might be considered God's spy, *Theo-toreman*. Unquestionably Theotormon torments and is tormented: see Sloss and Wallis, 1, 34 n.

In pl. 57, *The Vampire or Spectre of Guiana,* engraved by A. Smith, Dec. 1, 1791, we can see why Blake's Spectre has bat-like wings and is so thirsty "to devour Los's Human Perfection" (*J*.6). A further matter of interest is the information that the eyes of the "tyger-cat" of South America emit "flashes like lightning." Stedman, II, 51.

[13] *V.D.A.*2:8–10: E45/K190. Cf. *M.H.H.*18 and Swedenborg's description of the "hells [which] are everywhere, both under the mountains, hills, and rocks, and under the plains." Their openings exhale flames which correspond "to the evils of love of self." *Heaven and Hell,* pars. 584–586. See Blake's comment on par. 588 in E591/K939.

[14] *London Chronicle,* Feb. 2, 1792. Against the explanation that it was simply strategic to concentrate first on abolition of the trade, consider the fact that as soon as the Slave Trade bill was passed, in 1807, the Society dissolved. Slavery itself, and consequently the trade, continued to exist.

slaves yet as an abhorrer of "democratical principles." Also he had obtained a "Royal Proclamation against Vice and Immorality" and was promoting what became known as the Vice Society, based on the proposition that woman's love is Sin and democracy is Blasphemy.[15] Blake's deliberate emphasis on the delights of "happy copulation" could be expected to shock such angelic moralists, as if to say: you cannot free any portion of humanity from chains unless you recognize the close connection between the cat-o'-nine-tails and the moral code.[16]

The situation or story of Blake's poem is briefly this. Oothoon, a candid virgin, loves Theotormon and is not afraid to enter the experience of love. She puts a marigold between her breasts and flies over the ocean to take it to her lover; she is willing, that is, to give him the flower of her virginity. But on the way she is seized by Bromion, who rapes her despite her woeful outcries, and advertises her as a pregnant slave (harlot).[17] Her lover responds not

Fig. 9. Theotormon and Oothoon

[15] See Robert Q. Wilberforce, *Life of William Wilberforce*, London, 1839, I, 129–138; 342–344; 368–369; Mathieson, *England in Transition*, pp. 70–71.

[16] In *V.D.A.*9 (here Fig. 9), Theotormon is flaying himself with a three-thonged scourge, while Oothoon runs by unaided.

[17] See Stedman, I, 206.

by coming to her rescue but by accusing her and Bromion of adultery and secretly bemoaning his fate and hers. Oothoon and Bromion therefore remain "bound back to back" in the barren relationship of slavery, while Theotormon, failing as a lover, sits "weeping upon the threshold." The rest of the poem consists of their three-sided soliloquy. Oothoon argues that she is still pure in that she can still bring her lover flowers of joy, moments of gratified desire; but he cannot act because he accepts Bromion's definition of her as a sinner. She is ready for love, but Theotormon's stasis threatens to turn her love-call into an ironic masochism.

Interpretation of the story on this level is sometimes blurred by failure to distinguish Oothoon's offer of herself to Theotormon from her rape by Bromion. The flower-picking is mistaken for a symbol of the rape, and her later argument is mistaken for defense of an "affair" with Bromion. But in Blake's plot-source, Macpherson's *Oithona,* where the heroine is similarly raped in her lover's absence, the lover returning does what obviously Theotormon ought to do, considers her still faithful and goes to battle at once in her defense, against great odds.[18] Oothoon's argument is not that she likes Bromion or slavery but that she refuses to accept the status of a fallen woman: only if her lover lets Bromion's name-calling intimidate him will she be "a whore indeed" (6:18). She is not asking merely for toleration but for love.

The allegorical level, indicated by Oothoon's designation as "the soft soul of America" (1:3), must not be neglected. Bromion's signet brands not simply a woman but "Thy soft American plains," and Bromion is no simple rapist but the slaver whose claim to "thy north & south" is based on his possession in both North and South America of African slaves: "Stampt with my signet . . . the swarthy children of the sun" (1:20–21). When the soul of America goes "seeking flowers to comfort her" she is looking for a further blossoming of the revolutionary spirit (compare the Preludium of *America*), and when she finds a "bright Marygold" in the "dewy bed" of "the vales of Leutha," she is taking note of the Negro insurrections

[18] Were Oothoon and Theotormon married before the story begins? Critics differ. Bromion's "Now thou maist marry" suggests they were not; Theotormon's jealousy of "the adulterate pair" suggests they were. What matters is that the affair was not consummated. Oothoon welcomes the "experience" that Thel shrank from, but her lover does not.

in Santo Domingo in the Caribbean around which the debate in Parliament raged: "Bromion rent her with his thunders."[19] The first risings did not succeed, but the flower or nymph comforts "Oothoon the mild" both with her own "glow" and with the observation that the spirit of liberty is irrepressible: "Another flower shall spring, because the soul of sweet delight Can never pass away." On this level Theotormon, to whom Oothoon wings over the Atlantic in "exulting swift delight" expecting him to rejoice at the good news of another rising republic, acts like those English abolitionists who were embarrassed by the thunders of the Antijacobins.

Blake's acquaintance with the abolition debate is evident. The Bromions in Parliament cried that the Africans were "inured to the hot climate" of the plantations and therefore necessary for "labour under a vertical sun." Under Bromion's words Blake draws a picture (Fig. 10) stretching across the page, of a Negro worker smitten into desperate horizontality, wilted like the heat-blasted vegetation among which he has been working with a pickaxe, and barely able to hold his face out of the dirt. The apologists also

[19] *V.D.A.*7:4–16. In the abolition debates attention was focused on this eruption of "democratical principles" in the West Indies. The fact that London merchant firms held investments in Santo Domingo in the then large sum of £300,000 "helps to explain why the British government in [1793–1798] sacrificed more than £4,000,000 in an effort to conquer the French colony and maintain or restore Negro slavery. It helps to explain also why Wilberforce's abolitionist program suffered a momentary eclipse." C. L. Lokke, "London Merchant Interest in the St. Domingue Plantations of the Émigrés, 1793–1798," *American Historical Revue*, XLIII (1938), 795–802. Leutha's Vale appears to be Blake's place-name for the French colony, Leutha being the Queen of France. In *Fayette* the Queen is one whose smile spreads pestilence. In *Europe* Leutha is "the sweet smiling pestilence," a "silken Queen" who has "many daughters" (colonies?), and in a phrase which recalls Paine's remark she is called the "luring bird of Eden." In the "Thiralatha" fragment (E58/K206) the fading of "The British Colonies" is compared to the dying of a dream, perhaps of French colonialism, which has left "obscured traces in the Vale of Leutha." After the West Indies docks were located in the Isle of Dogs, Blake took to calling it the Isle of Leutha's Dogs. *J.*31. Leutha's Vale is "dewy" perhaps because it lies in the dewy bed of the Caribbean. In Ossian, Lutha is a place-name meaning "swift stream." In *Milton* Leutha is a repressive moral force as well as a counterrevolutionary, but I see no support for the suggestion that her name is "a feminized form of 'Luther'" for "Puritanism." Damon, p. 329.

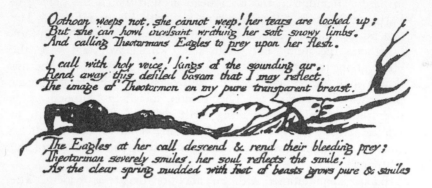

Oothoon weeps not. she cannot weep! her tears are locked up;
But she can howl incessant writhing her soft snowy limbs.
And calling Theotormons Eagles to prey upon her flesh.

I call with holy voice! kings of the sounding air.
Rend away this defiled bosom that I may reflect.
The image of Theotormon on my pure transparent breast.

The Eagles at her call descend & rend their bleeding prey;
Theotormon severely smiles. her soul reflects the smile;
As the clear spring mudded with feet of beasts grows pure & smiles

Fig. 10. Slaves beneath the sun

argued that Negroes understood only "firmness," were "contented and happy" and superstitious, and were now "habituated to the contemplation" of slavery. Bromion utters the same arguments: that "the swarthy children of the sun . . . are obedient, they resist not, they obey the scourge: Their daughters worship terrors and obey the violent."[20]

In Parliament Lord Abingdon accused the "abettors" of abolition of promoting the new philosophy of leveling: "Look at the state of the colony of St. Domingo, and see what liberty and equality, see what the rights of man have done there." They have dried up the rivers of *commerce* and replaced them with "fountains of human blood." Moreover the levelers are prophesying that "all being equal, blacks and whites, French and English [*sic*], wolves and lambs, shall all, 'merry companions every one,' promiscuously pig together; engendering . . . a new species of man as the product of this new philosophy."

It is this sort of argument that Blake's Oothoon turns right side up again. For, as Abingdon put it, "what does the abolition of the slave trade mean more or less in effect, than liberty and equality?" Wilberforce joined Burke in a committee for the relief of emigrant royalist priests partly, as he admitted, "to do away French citizenship"—for the French had misinterpreted his liberalism and named him an honorary French citizen along with Paine and Priestley! Yet this demonstration did not prevent Burke from attacking the

[20] *V.D.A.*1:21–23. See Stedman, I, 201–206, and Bisset, II, 133.

Abolition Bill as "a shred of the accursed web of Jacobinism." Blake's Theotormon is tangled in the suspicion that his own desires are part of an accursed web.

The argument of Oothoon is triplex, as she herself is. Stedman's emblematical picture treats Europe, Africa, and America as three separate women: Blake makes them into one. He can do this because Oothoon is not a person but a "soul." Pictured in chains she is the female slave, but she does not have the black skin and tight ringlets of the Africa of the emblem. Only in the picture of the exhausted worker is the Negro slave directly represented. Allowing for difference in media, Oothoon is the American Indian of the emblem, with the same loose black hair, sad mouth, and angular limbs. See especially the illustration of the title page, where she runs along the trough of a green wave pursued by the mistaken God of slavery (or compare Fig. 9 and Plate III).

Yet her skin is not the copper color of the engraved America either, but theoretically "snowy" white, according to the text. "I am pure," she cries "because the night is gone that clos'd me in its deadly black."[21] Speaking as America she means that the night of oppressive chivalry is gone with the dawn of freedom. As Africa she means that the time is gone when people's vision was limited to their five senses and they could see only her dark skin and not her inward purity.

Blake had explained this symbolism in his *Little Black Boy:*

> My mother bore me in the southern wild,
> And I am black, but O! my soul is white;
> White as an angel is the English child:
> But I am black as if bereav'd of light.

To avoid a chauvinistic interpretation Blake explained that any skin color is a cloud that cannot obscure the essential brotherhood of man in a fully enlightened society, such as Heaven. "These black bodies and this sun-burnt face," said the little black boy, are "but a cloud." If the Negro is to be free of his black cloud, the little English boy must be likewise free from his "white cloud," which is equally opaque. "When I from black and he from white

[21] *V.D.A.*2:12, 28–29. Blake usually employed brown inks in printing *V.D.A.* though sometimes he chose pink, purple, or yellow. In contrast, *E.* and *A.* are usually printed in green, blue, or black.

cloud free," I will "be like him and he will then love me." In the second illustrated page of this Song of Innocence the black boy appears as light-skinned as the English boy—or as Oothoon.[22]

Oothoon's reason for letting the vultures prey upon "her soft snowy limbs" is to let Theotormon, who is an adult version of the English child, *see* that beneath the skin her "pure transparent breast" really reflects the same human "image" as his—that her color is morally that of "the clear spring, mudded with feet of beasts," which again "grows pure & smiles" (2:12–19). As Africa she is urging the London citizen to ignore color differences. As America she is urging British law-makers to rescue her from the muddy feet of the slaver. As a woman enslaved by Marriage Act morality, she is imploring her lover to rise above accusations of adultery.

Beyond arguing her essential purity, she indicates by several analogies that there is something especially beautiful about dark skin and (she suggests both points at once) about pregnancy. Consider the dark skin of worm-ripened fruit, which is "sweetest"; or the darkness of "the soul prey'd on by woe"; or

The new wash'd lamb ting'd with the village smoke & the
 bright swan
By the red earth of our immortal river: I bathe my wings.
And I am white and pure to hover round Theotormons breast.

 (3:17–20)

It is the soul rather than the body of the slave that is "inured," in being richer in experience. The black boy already loves the English boy and is thus better prepared than he to "bear the heat" of God's presence.

And still we have not done with the complexity of Blake's symbolism, for in one illustration, on the page of the "Argument," Oothoon appears not as an American Indian but as the European woman of the emblem. Or rather in this illustration the Stedman influence is supplanted by that of a French neo-classical painter and engraver, Vien. Here the focus is on the buying and selling of woman's love, and Blake is reversing Vien's picture (based on a Roman original) of a procuress offering "loves" for sale in a

[22] Not quite true for all copies. In at least one a slight tint has been given to the black boy in heaven; but the contrast with the solid color of the first page is still pronounced.

basket: *La Marchande d'Amours*. Oothoon kneels in the same posture as that of the love-merchant, and her hair is knotted at the back of her head in a similar fashion. But whereas Vien's procuress holds one of her cupids by his wings like a captive bird, Oothoon keeps her hands to herself and lightly "kisses the joy as it flies," springing not from a basket but from the stem of a marigold.[23]

In the most general sense the soaring joys which Oothoon offers her lover are sparks of Promethean fire or winged thoughts calculated to widen his brow. In her effort to prod him to cross the threshold of indecision—"I cry arise O Theotormon for the village dog Barks at the breaking day"—Oothoon insists that the revolutionary dawn is at hand and overdue and that the corn is ripe. But this "citizen of London" does not look up. He is not at all sure "what is the night or day"; he is nearly deaf to the cries of slaves and blind to visions of a new day: he cannot arise. The springs of rebellion are as obscure to him as those of moral purity. "Tell me what is a thought," he pleads, "and upon what mountains Wave shadows of discontent? and in what houses dwell the wretched" (3:22–4:1). But he fears that the new philosophy may carry his thought to a "remote land" (America) or may bring "poison from the desart wilds" rather than "dews and honey and balm" (4:8–10). And he grows silent when Bromion shakes the cavern with rhetorical questions, just as the Abolitionists were silenced in 1793 by the clamor of Antijacobinism.

Bromion's arguments and those of the apologists of slavery are of the same order: Dare anyone question that subordination must be maintained? Has anyone even in this land of liberty and poverty yet heard of any way to maintain order without the fear of punishment? Are not war and slavery the basis of our Empire? Is not sorrow intended for the poor, joy for the rich? Is not fear of Hell necessary to keep the laborious poor from pursuing "eternal life"?[24]

[23] See illustrations in "Blake's Vision of Slavery," cited above in note 4. For a discussion and illustration of several precursors and revisions of Vien's painting, including a grotesque by Fuseli ca. 1775, see the opening pages and plates in *Transformations in Late Eighteenth Century Art*, by Robert Rosenblum—who is unaware, however, of the most striking transformation, Blake's.

[24] For a Parliamentary analogue of Bromion's speech (105–110), hear slavery's "agent for Grenada," a Mr. Baillie (*Parl. Hist.*, Apr. 2, 1793), arguing that the very Empire is based on the right to flog: "I wish to ask . . . if it is possible to maintain that subordination [in navy and army]

On the concluding page we see Oothoon, nevertheless, still daring to cry out—and wrapped in flames of the same bright rose color as the brightest band in the rainbow that arches over her on the title page.

that is absolutely necessary . . . without the fear of punishment? . . . Have we never heard of seamen being flogged from ship to ship, or of soldiers dying in the very act of punishment, under the lash . . . exposed in as shameful and ignominious a manner [as slaves]? Have we not also heard, even in this country of boasted liberty, of seamen being kidnapped and carried away . . . without being allowed the comfort of seeing their wives and families? [Nothing extraordinary in the misery of slaves.] I declare there is more wretchedness and poverty in the parish of St. Giles, in which I live, than there is in the whole of the extensive colonies."

11. The Fatness of the Earth

And the Kings . . . cried in bitterness of soul.

Shall not the King call for Famine from the heath?
Nor the Priest, for Pestilence from the fen?
To restrain! to dismay! to thin!
The inhabitants. . . .

To cut off the bread from the city,
That the remnant may learn to obey. . . .
—*The Song of Los*

THE question of slavery or freedom is one aspect, for Blake, of the general question of war or peace. Another aspect is the question of scarcity or abundance, often dramatized as the difference between starving in the wilderness and feasting in the garden. Some of Oothoon's questions in reply to Bromion and Theotormon have been traced, on the subject of sexual freedom and restraint, to Mary Wollstonecraft's *Vindication of the Rights of Woman*.[1] It is instructive to note that others reflect the agrarian economics of her earlier *Vindication of the Rights of Men*. The discovery that her Blakean axiom, "virtue can only flourish among equals," is linked to an economic proposal for the division of large estates into small farms[2] will help us understand the more elliptical economic observations of Oothoon. And these will in turn lead us to the thinking behind Blake's central myth of the origins of hunger and strife.

We know that Blake ultimately defined the whole business of man as "The Arts & All Things Common."[3] In the myth underlying the Lambeth prophecies, man in the state of innocent equality is called Urthona, the earth-owner.[4] A negation of scarcity and

[1] Schorer, p. 290; Henry H. Wasser, "Notes on the *Visions of the Daughters of Albion*," *Modern Language Quarterly*, IX (1948), 292–297.

[2] *Vindication of the Rights of Men*, London, 1790, p. 141.

[3] Laocoön: E271/K776; cf. Marg. Thornton, 3: E658/K788.

[4] Reading suggested by Damon, p. 326.

perhaps of individual possessiveness is implied, although the emphasis on ownership in the mythical name suggests that the fall of man was from peasant proprietorship of the sort advocated by Jefferson and Wollstonecraft as the proper basis of a democratic society. Blake was a city dweller and his ideal was a city republic, but the prevailing assumption that all value derives from land or from agricultural labor led him to think first of agriculture, and it has been rightly observed that Blake "regarded the peasant proprietor as the real bedrock of society and the other classes as living off him. . . ."[5]

Dimly aware of a contrast between the lost Paradise and the wretched present, Theotormon asks: "in what gardens do joys grow? . . . and upon what mountains Wave shadows of discontent?" Mary Wollstonecraft in her first *Vindication* considers the polished vices of the rich and the "tremendous mountain of woe" oppressing the poor, and concludes that economic Domination must be eliminated. England will then be a garden more inviting than Eden, with "springs of joy" murmuring on every side and every man "contented to be the friend of man" (pp. 140–149). Oothoon has similar notions. Surveying the delights of the rich and the woes of the poor, she contrasts the ideal form of human relations—in which each joy is "holy, eternal, infinite!" and no one's joy absorbs another's—with the actual relations, in which the rich, both patron ("giver of gifts") and merchant, have "delights" while the poor, both industrious citizen and husbandman, have "pains." Since it is specious to call that joy which hinders and brings tears to others, she makes the point that the "joys" of the oppressor are really "tears." In a world of hindering and hindered it is a mockery for a Bromion to speak of joy and sorrow and "one law"—as if the tyrant could understand the feelings of the patriot: "Does he who contemns poverty [i.e. who views the poor with contempt], and he who turns with abhorrence From usury: feel the same passion, or are they moved alike?" (*V.D.A.*4:22–5:13). Burke writing scornfully of "a swinish multitude," for instance, is hardly moved by the same indignation that moves Paine or Wollstonecraft to condemn monopolists and forestallers.

Oothoon comes finally to the two classes of men whose functions in the service of tyranny give them the most perverse views of

[5] W. P. Witcutt, *Blake: A Psychological Study*, London, 1946, p. 120, citing *J.*9.

human happiness, the recruiting officer and the tithing priest. The function of the priest is to supply the economic and ideological base of the whole superstructure of Empire from fortresses to marriage laws, and Oothoon outlines this process in her questions:

> With what sense does the parson claim the labour of the
> farmer?
> What are his nets & gins & traps, & how does he surround
> him
> With cold floods of abstraction, and with forests of solitude,
> To build him castles and high spires, where kings & priests
> may dwell.[6]

The same process is alluded to in *America* when Paine and other Patriots are said to shelter the grain and the "fatness of the earth" from priest and prince who wish to subvert useful labor (plow and spade) to the building of fortresses (wall and moat) and who would bring "the stubbed oak to overgrow the hills" ($A.9:5-10$) — a passage which derives from the warning by Barlow's Washington that American fields will be "to lordly manors turn'd" if the British succeed. In both passages the issue is evidently whether the land shall be used for peaceful farms or for castled "forests of solitude," an issue raised in Wollstonecraft's questions (p. 140): "Why cannot the large estates be divided into small farms? Why are huge forests still allowed to stretch out with idle pomp and all the indolence of Eastern grandeur?"

It is against such domination by "the idle" that the Patriots of *America* stand "with their foreheads reard toward the east." According to Paine, in the second part of *The Rights of Man*, "the government of the sword revolved from East to West" but a new government founded on a system of universal peace was "now revolving from West to East, by a stronger impulse . . ."[7] Blake wrote in his notebook:

> The sword sung on the barren heath
> The sickle in the fruitful field
> The sword he sung a song of death
> But could not make the sickle yield
>
> ($N.105$)

<hr />

[6] *V.D.A.*5:17–20: E47–48/K193; cf. *F.R.*225–226: E292/K144.
[7] Feb. 1792. Paine, I, 356; cf. I, 400.

This image of the sword on the heath brings us around to Oothoon's description of the man who drums to war, the other of the two agents of tyranny whose occupations make "different the world to them" and "different their eye and ear!"

How different far the fat fed hireling with hollow drum;
Who buys whole corn fields into wastes, and sings upon the
 heath! (*V.D.A.*5:14–15)

His function is like that of Sennacherib, King of Assyria, who laid waste fortified cities and dismayed the inhabitants "as grain blasted before it is grown."[8] Literally he brings the flames and trampling of battle to the fields of corn and makes his camp indifferently on field or barren heath. Cognate passages in *The Four Zoas* make the picture clear. Horses "trample the corn fields in boastful neighings" when they have been compelled to "leave the plow" and become cavalry horses. Officers of mountainous girth thrive on the ruin of peaceful husbandry:

Let us refuse the Plow & Spade, the heavy Roller & spiked
Harrow. burn all these Corn fields. throw down all these
 fences
Fattend on Human blood & drunk with wine of life is better
 far
Than all these labours of the harvest & the vintage.[9]

In short, the fat hireling is Blake's Falstaff, the eternal recruiting sergeant who leads men from the plow and musters "mortal men" for the slaughter.[10]

Modern commentators who have mistaken this Waster for "the profiteer who encloses common land"[11] have not explained how a profiteer becomes a hireling, or what he is doing with a drum on a heath. But in the 1790's profitable enclosing turned wasteland into cornfield. Blake is not talking of the fencing in of common lands or the running together of strips to make large cornfields, but of the

[8] 2 Kings 19:25–26.

[9] *F.Z.*viib.93:11–13: E397/K338:201–203; *F.Z.*i.14:8–11: E304/K274.

[10] I say "Blake's Falstaff" only to call attention to his economic function, his obesity, his larding the lean earth, and, in the line upon which Blake builds, his contempt for the lives of others: "tush, man, mortal men, mortal men."

[11] Frye, p. 239.

throwing down of fences and the destruction of grain and the mustering of armies.[12]

The imagery is, for us, puzzlingly telescoped. "Buys" is misleading, for the hireling is not buyer but bought; it is the king hiring him who "buys" cornfields into wastes, purchasing war instead of peace as well as refusing, as we have seen, to transform his forested estates into fruitful farms. Pamphleteers argued that the continental war, by interfering with imports, devastating grain areas, and requisitioning grain to feed non-productive soldiers, was causing the high price and scarcity of bread in England. There were "bread riots" in 1792 and 1793; by 1795 the worst fears were realized and England was swept by famine. Blake's *Song of Los,* published in the latter year, indicts "the King" as the villain whose policy calls "for Famine from the heath."

Blake associates the heath with famine and war not only because the heath is barren but because it is military camping ground. Throughout the summer of 1792, as noted above, the British militia were being taught Prussian "military evolutions" on Bagshot heath. London idlers went to watch. News columns were filled with accounts of the war games. And a current observation in Blake's notebook was apparently demonstrated—that "The priest promotes war & the soldier peace."[13] Before each mock battle chaplains prayed at the head of every corps, but the faces of the weary soldiers

[12] Bronowski, p. 66 [98], with Schorer after him, p. 292, recites how strip farming was wasteful and how "the dearth of corn" led to much enclosing of common land and running together of strips. It did, but the result was larger cornfields, not Blake's wastes. It was in other times that fields which could grow corn were turned into pastures for sheep or deer. In the 1790's "every patch of arable land was a gold mine" (J. L. and Barbara Hammond, *The Village Labourer,* London, 1912, p. 127); so if Blake is writing about enclosures, he is writing nonsense. Mary Wollstonecraft does not oppose enclosing but only wishes it were as easy for the poor as for the rich: "Why might not the industrious peasant be allowed to steal a farm from the heath?" So Oothoon might have asked, if she had thought upon enclosures. But her point is that the peasant is being drummed away from tillage to marching and sword-play.

Bronowski in his revised edition adds a clause arguing that Blake was making "the usual error of the town-dweller of the time"; this clarifies *his* point—but does not make it any more applicable to Blake's.

[13] N.107: E719/K174; cf. E718. The evolution of the line is interesting. Blake changed the verb from "loves" to "promotes," thus shifting attention from the priest's and soldier's feelings to the effects of their actions.

marching and countermarching with seventy-pound packs were eloquently hostile toward such "games." "We never beheld troops suffer more," wrote a *Times* correspondent on August 2; "it may be a *Camp of pleasure* to lookers on, but it is a very different affair to the poor soldiers."

The correspondent was reminded, by the spectacle of a portly citizen perspiring as he waddled after the troops, of Falstaff larding the lean earth. But to Blake the fatness of those who could look upon war as a camp of pleasure was both a symbol and an example of the evils that plagued the land. In an age when Luxury was still a sin and every fat man was a living comment on the inequitable distribution of a meager food supply, Blake echoed the popular belief that the drone or waster *was* the wolf at the door.[14]

2

With these clues from Oothoon we are ready to move on to the agrarian symbolism of the Lambeth prophecies, particularly as manifested in their Preludiums and in their illustrations.

According to the historians upon whom Blake drew for the plague imagery of *America,* it was Luxury based on plunder of France that brought Black Death and famine to Britain. And the implied modern parallel cannot be taken as merely metaphorical. Since even the scientific Priestley thought of "phlogiston" as the essence of both fire and disease, we must not suppose that Blake distinguished any more sharply than the Bible and the historians between plagues that killed people or crops directly and plagues that killed people by killing crops or that killed crops indirectly by causing people to destroy each other in battle. Most of these visitations were visible or invisible "insects" born in clouds or fire; all resulted in the destruction of both people and cornfields. Thus when the King of France says "famine shall eat both crust and crumb," he is describing the effect of the "pestilence" darting from the Queen's robe. *America* is a song of harvest reaped in the teeth of redcoats who would smite the wheat; it is also a song of praise

[14] While the hirelings of Caesar fattened on their produce, the poor could labor all their lives and never obtain "a comfortable and equal subsistence," never be able to say, "There is something in the world that is not Caesar's." Thus an anonymous pamphlet, *The Rights of the Poor,* London, 1792, p. 26.

to the industrious man who refuses to "leave his joy to the idle, to the pestilence! That mock him" (*A.*11:6–7).

Rousseau, Blake's modern source, also counted Luxury the great social evil and equated the idle and the pestilence, on the grounds that the extravagance of the rich, both in diverting honest labor to the mean employment of the luxury trades and in creating a host of servants and vagabonds, "brings oppression and ruin on the citizen and the labourer . . . like those scorching winds, which, covering the trees and plants with devouring insects, deprive useful animals of their subsistence and spread famine and death wherever they blow." Rousseau was troubled, however, by the thought that all "the liberal and mechanical arts" spring from society and luxury. "What, then, is to be done? Must societies be totally abolished? Must *meum* and *tuum* be annihilated, and must we return again to the forests to live among bears?"[15] His answer was compromise: to accept the will of God, love one's fellow citizens, and even honor those paragons of luxury, wise and good princes—while yet maintaining a "contempt for a constitution that cannot support itself without the aid of so many splendid characters."

Like most readers of Rousseau, Blake ignored such lip-service to princes. But his answer was not to go back to eating acorns—though he did urge the banker to return to oil and wine—but rather to reduce kings and their fat hirelings to that condition. It was they, after all, who seemed to like the forests of solitude. Mankind may have begun on all fours, as Rousseau suggested, but the person Blake likes to see fallen to his knees is the emperor who has tried to cut off the bread from the city. When citizens defend the ripe corn, the plague winds roll back upon the angels of tyranny. We shall understand much of Blake's symbolism if we keep in mind that every declaration of the rights of man is a declaration by hungry people that they shall have bread even if they must become warlike and mow down all the "great starry harvest of six thousand years" to deliver themselves "from clouds of war, from pestilence," and from the crawling villain who "preaches abstinence & wraps himself In fat of lambs."[16]

Thus men have fought for bread, and even reversed the pestilential effect of war to the extent that the blood of tyrants and hirelings, added to their own, has enriched the lean earth. In at

15 Rousseau, *Discourse*, p. 245.
16 *F.R.*90, 233: E286, 293/K138, 144; *A.*11:14–15: E54/K200.

least two antiquarian sources, Chatterton's Rowley poems and Percy's *Northern Antiquities* (a translation of Paul Henri Mallet's study of the mythology of the Icelandic Eddas), Blake found indications that many of man's struggles are literally preparations for harvest.[17] In Chatterton's *Aella* the "fatte blodde" of civil war feeds "the hongerde soyle." And in his *Bristowe Tragedie* the hero who stands up against Edward IV, "traytor kynge," is a patriot defending "the hungrie poore" against oppression:

> Howe oft ynne battaile have I stoode,
> Whan thousands dyed arounde;
> Whan smokynge streemes of crimson bloode
> Imbrew'd the fatten'd grounde:[18]

In Blake's *Gwin,* which leans heavily on this poem, the starving men and women whose children cry for bread feed "Earth" with their own blood and that of the tyrant and cruel nobles who "did feed upon" them, but the pleasant land is "overwhelm'd" rather than improved by the experiment.[19] Perhaps Blake had not yet

[17] For other aspects of Blake's considerable use of the Eddas see Frye, passim.

[18] Stanza 33. And in Chatterton's *Goddwyn,* when "Freedom dreste, yn blodde staynd Veste," to sing "her Warre Song," she "danced onne the Heathe"—an image that lies ironically behind Blake's use of dancing on the heath as a symbol of going to war.

[19] Chatterton's "Hee taughte mee wythe a prudent hande To feede the hungrie poor, Ne lette mye servants dryve awaie The hungrie fromme my doore" provides the frame for Blake's contrary picture: "The Nobles of the land did feed Upon the hungry Poor; They tear the poor man's lamb, and drive The needy from their door!" Blake returns to the same theme and tune when La Fayette joins the cruel Nobles: "Who will exchange his wheaten loaf For the links of a dungeon floor . . . Will the mother exchange her new born babe For the dog at the wintry door[?]" E780/K186.

In another borrowing from Chatterton a most curious inversion occurs. In *M.H.H.*6 Blake is describing his corrosive method of revealing depths of Illumination. Having hinted at the process, he concludes with an example; "he wrote the following sentence." He chooses this from the *Bristowe Tragedie:* "How dydd I know that ev'ry darte That cutte the airie waie Mighte nott fynde passage toe my harte And close myne eyes for aie?" But to illustrate his way of turning death-thoughts into life-thoughts, he writes: "How do you know but ev'ry Bird that cuts the airy way, Is an immense world of delight, clos'd by your senses five?"

For a contemporary satiric reference, see, in the 1800 *Millennium* cited

read Mallet, where he was to learn for example of a certain battle between Teutons and Romans, viewed as a contest between primitive lovers of liberty and the cohorts of Empire: "that the number of slain was incredible; that the inhabitants of Marseilles for a long time after, made inclosures for their gardens and vineyards with the bones; and that the earth thereabouts was so much fattened, that its increase of produce was prodigious."[20]

By the time he planned *America*, however, Blake was well versed in Mallet's agricultural explanation of the practice of human sacrifice. Ancient worshipers of Odin slew humans not to feed their god but to feed themselves. The sacrifice, says Mallet, was a fertility rite accompanied by prayers such as: "I devote thee for a good harvest; for the return of a fruitful season." Though the Scandinavians no longer worship Odin, Mallet states that human sacrifice is still practiced as a harvest rite by the Peruvians, the Mexicans, and multitudes in the deserts of Africa and the forests of America who "do to this day destroy each other, from the same principles and with the same blind fury."

Out of this information, politically interpreted, Blake constructed the theoretical basis of his poem on the American Revolution. Both the Revolution and the ritual sacrifices he understands as efforts of men and women to attain freedom, peace, and good harvests. If we read in combination the verbal and the graphic symbols of the Preludium of *America*, we find that the struggle for freedom in Peru and Mexico was like the sprouting of a wheat germ in dark caverns but that in the Revolution the naked multitude as one man broke through the soil (see Fig. 12) "in furrows" rent by the "lightnings" of the Enlightenment. Blake agrees with Mallet that ritual sacrifices—and most of the wars which Chatterton calls the fellfights of kin—have been blind and inarticulate efforts negating their own purpose. But the revolutionary war, with its articulate credo, is a harvest sacrifice made by people with opened eyes and an enlightened social program for cultivating the earth as a garden paradise.

below, Canto III, line 200, the line "War . . . fecundates the soil!" annotated thus: "This is a truly noble discovery of our modern philosophers . . . see the Phytalogia of Dr. Darwin, sect. xix.vii.i."

[20] Mallet, *Northern Antiquities*, I, 31–32 and, below, I, 137–140. Cf. Damon's comment (p. 319) on the second Proverb in *M.H.H.* as implying use of "the graveyard as the most fertile soil."

3

In the beginning and therefore in Eternity man properly understood the labors of the harvest and the vintage, and his festive rites were those of brotherhood, not slaughter. But something went wrong in "the Druidical age, which began to turn allegoric and mental signification into corporeal command, whereby human sacrifice would have depopulated the earth."[21] Blake's explanations of this process get increasingly involved in antiquarian and exegetical ramifications, but his economics and some of his crucial nomenclature can be traced to the hypothetical generalizations of Rousseau's *Discourse on the Origin and Foundation of the Inequality of Mankind,* just as some of the psychology of *Tiriel* can be traced to *Émile.*

Rousseau (p. 175) endeavored "to explain by what sequence of miracles the strong came to submit to serve the weak, and the people to purchase imaginary repose at the expense of real felicity." Blake wished to account for the rule of "weak men" over "the strong" or to explain why the people throughout the period of recorded time since Paradise had sold their birthright for the "allegoric riches" and "cold floods of abstraction" of king and priest. It is from Rousseau's *Discourse* that we learn how Blake's earthowning Urthona came to leave his primal garden.[22]

"Urthona was his name in Eden," and, according to Rousseau, as long as man owned all the earth and its plenty there was no ownership in private, no basis for one man's exploiting another, and nothing to fight over.[23] The earth was man's dutiful mother, wife, and daughter, providing him richly with all he desired—"food, a

[21] *D.C.*v: E533/K578. "Adam was a Druid, and Noah," and each Age and religion began in innocence—but soon perverted its wisdom into Commands.

[22] Blake's whole myth is assumed in the Lambeth books. But it is only fragmentarily alluded to in them, and its early form must be reconstructed with the help of later texts. For the explicit passages concerning human sacrifice, see H. M. Margoliouth, *Review of English Studies,* xxiv (1948), 312–316.

[23] *F.Z.*i.3:11. *Discourse,* p. 207. Rousseau's meaning is still under debate, but the question here is what Blake took him to mean.

female, and sleep" (p. 186). Blake's personification of nature in this pleasant era, when she was both Eve and the Garden, he calls Ahania, adding Aha! to Annia, the name of an Ossianic heroine. In Blake's *Book of Ahania* (v.7, 8) she recalls "the bliss of eternal valleys" when her king and husband embraced her "on the bredth of his open bosom" and she rained soft "showers of life on his harvests." But fallen and shrunken he is Urizen, the creeping and horizon-limited savage that Rousseau describes as a beast on all fours "with his horizon limited to a few paces." A lower and even subhuman state is represented by the Spectre of Urthona who squats in dishevelment at the lowest root of the tree of life, mere brute body having neither reason nor imagination, dwelling in stony "dens."[24]

The fall came when the few became tyrants and appropriated the earth privately, compelling the many to become poor and enslaved. Thus divided into tyrant and slave, Urizen and Orc, man lost his birthright to earth's bounty and became "a tyrant both over himself and over nature" (*Discourse,* p. 185). And with the *loss* of Paradise, the symbol of man's unity and communal bliss became *Los* instead of Urthona (with Blake suggesting puns on Love's Labor's Loss and *Los[s]* the *prophet*),[25] since unity was now an ideal contrary to fact. Man's divided state is also represented by division into male and female—Urizen and Ahania, who are completely divorced, or more frequently Los and Enitharmon, a quarrelsome pair representing fallen man in his unhappy dependence upon fallen nature. Since these females are not so much people as

[24] See Fig. 11. The dens are mentioned in *A Song of Liberty*.

[25] According to F.Z.viib.84:27–28, Los originated as a symbol of "Love Darkend & Lost." Damon's suggestion that Los is an anagram of *Sol* has not proved fruitful, though there are some solar associations. Los's lantern of vision is the sun's light, but he himself is "the terrible shade" (viia.82.37). The double sense of this nonce designation, however, is drummed out more directly and more insistently in the typical Blakean pun of Los as *loss*. A whole sermon on Blake's philosophy of experience and on his technique of contraries could be preached on the text: "I will sing you a song of Los, the Eternal Prophet" (*Song of Los* 3:1). It is the prophet who sees that man cannot exist without continuous loss of self. See *J*.96.

Similar puns are Luvah, the king of Love who is king of Death and also iron *lava;* Enion, who is sometimes *anyone;* the daughters in charge of the iron Reel of war who *reel* when they are drunk (*J*.56–58 and see Fig. 17); and of course Tharmas, a multiple pun on the Thames, Thammuz, Thomas, etc.

states of nature, the males must continue to stand for both mankind and womankind—a difficulty of many man-made allegories—so that Blake's hostility to "female will," for example, is not easy to evaluate.[26]

For Rousseau there is a dilemma in the fact that the growth of reason corresponds to the degeneration of the species, for reason is to Rousseau man's potential capacity for perfecting himself. To Blake, reason in its fallen state as tyrant is a false god whose "iron laws" cannot be obeyed "one moment." And there seems no hesitation in Blake's preference for the rebel, for the fire of Prometheus rather than the ice of Newton. Yet Ahania says that in Paradise the fire of Prometheus was the "generous fire" of reason.[27] What Blake insists upon is an interlocking relationship such as we can see in the emblems of the Preludium pages of *America* (Figs. 11 and 12). The Spectre at the roots (see the first page) must learn to crawl (a stage here skipped except in its effects: the stage of Nebuchadnezzar), for Urizen *exploring* his dens can at least reason upon that which he perceives and accumulate power over his own and other men's bodies. But this treadmill existence must be transcended by the rebellious energy of Orc, who breaks his chains or (see the second page and the soaring Orc of the following page) springs up out of the earth with sprouts of the wheat and the vine. Then walking free on the earth are male and female ready to be a new Adam and Eve—but their joy is incomplete without Orc's freedom (see the first page). And so they remain Enitharmon, willful queen of joyless abortions (see Milton's and Gillray's Sin), and Los, the prophet in the wilderness, whose vision of Eternity must be made actual before he can become Urthona except in spirit.

Moving up this scale we can see that Urizen on all fours is a transformed Spectre; Orc whose spirit soars is a transformed Urizen; Los walking the earth is a transformed Orc and holds the visionary power to become transformed into Urthona. He is the Poetic Genius who can see beyond the gates of sense and the

[26] For contrasting views of Blake's views on woman, see Blackstone, ch. 15, and Sloss and Wallis, I, 441–442. For an influential view see Damon's *Dictionary*, under "Will" and under "Chaucer," where he misreads Blake's contrasting of the Prioress and the Wife of Bath as disapproval of both.

[27] Urizen, when he was a function of Urthona, distributed "generous fire" and "On the human soul . . . cast The seed of eternal science." *Ahania* v.12.

horizon of the present. Because he is conscious of the loss of Eden he can guide mankind to it: "I know I am Urthona keeper of the Gates of Heaven, And that I can at will expatiate in the Gardens of bliss" (*J*.82:81–82).

"At will"—but Orc must supply the will; the prophet without the rebel is impotent, and it is not easy to reverse the whole system of gravitation or to prevent the millstone of reason from grinding humans into spectres and depopulating the earth. Blake's mythology is given life—but also complication—by the fact that each symbol is human and sometimes errs from his category, demonstrating both the human difficulties in the way of progress and the human resistance to complete retrogression. Thus Los can lose his vision and act like Urizen. In the *Book of Urizen* it is he who chains Orc in the shadow of Urizen. Yet again Los conducts an Orc-like rebellion in the *Book of Los;* whereas in *America* Orc himself fulfills all the functions of Los and the latter is not mentioned. And Urizen, even in the process of becoming a tyrant, has falsified himself while drawing the web of "woven hypocrisy" over the inhabitants of the first cities. "Like a spiders web" it is spun from his own self-pity, i.e. "from his sorrowing soul"; compare the "imposed" fantasy of "black & white spiders" in *The Marriage of Heaven and Hell* (pl. 18). As Rousseau puts it, the growth of reason and increase of inequality developed "the interest of men to appear what they really were not," and the injustices of "the new-born state of society . . . gave rise to a horrible state of war."[28]

4

The psychological analysis for which, on one level, Blake employs these splittings and joinings and shiftings of function is of a

[28] *Book of Urizen* ix.2:2; *Discourse*, pp. 218–219. Note Blake's special use of the term *hypocrisy:* a tyrant, no matter how sincerely he behaves, is a hypocrite in effect. One who advocates a military policy to secure peace is a hypocrite in effect because an armed peace is or becomes war. The result gives the lie to the argument, no matter how "honest" it was.

In *Discourse*, p. 198, the weeping of tyrants at ills they have not caused is compared to "the mournful lowings of the cattle when they enter the slaughter-house." In *Urizen* the tyrant weeps in hypocrisy when he hears the moans of "the Ox in the slaughter house." His tears do not stop his tyranny.

Preludium

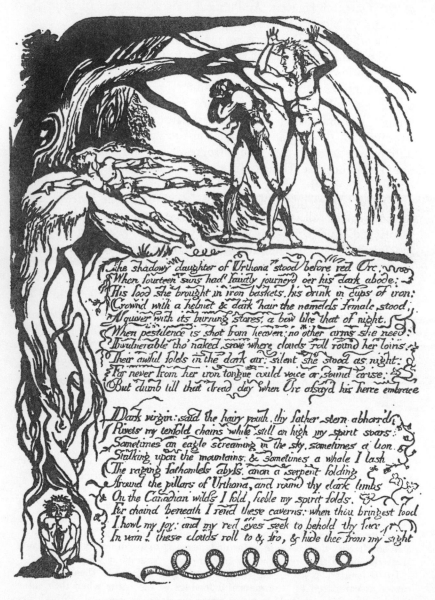

The shadowy daughter of Urthona stood before red Orc.
When fourteen suns had faintly journey'd o'er his dark abode:
His food she brought in iron baskets, his drink in cups of iron:
Crown'd with a helmet & dark hair the nameless female stood;
A quiver with its burning stores, a bow like that of night.
When pestilence is shot from heaven: no other arms she need:
Invulnerable tho' naked, save where clouds roll round her loins,
Their awful folds in the dark air: silent she stood as night:
For never from her iron tongue could voice or sound arise:
But dumb till that dread day when Orc assay'd his fierce embrace.

Dark virgin: said the hairy youth, thy father stern abhorr'd;
Rivets my tenfold chains while still on high my spirit soars;
Sometimes an eagle screaming in the sky, sometimes a lion,
Stalking upon the mountains; & sometimes a whale I lash
The raging fathomless abyss, anon a serpent folding
Around the pillars of Urthona, and round thy dark limbs,
On the Canadian wilds I fold, feeble my spirit folds.
For chain'd beneath I rend these caverns: when thou bringest food
I howl my joy: and my red eyes seek to behold thy face
In vain! these clouds roll to & fro, & hide thee from my sight

Fig. 11. *America*, Preludium, plate 1

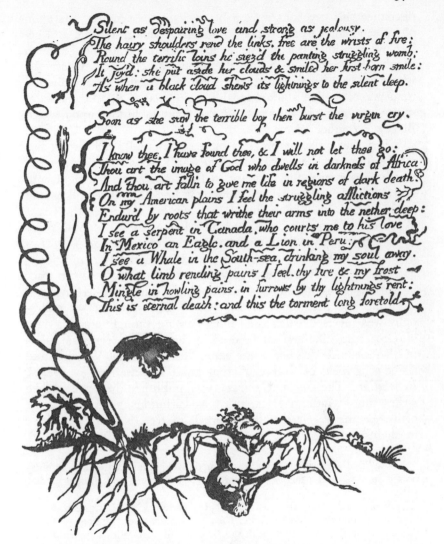

Silent as despairing love and strong as jealousy.
The hairy shoulders rend the links, free are the wrists of fire:
Round the terrific loins he siez'd the panting struggling womb:
It joy'd: she put aside her clouds & smiled her first-born smile:
As when a black cloud shews its lightnings to the silent deep.

Soon as she saw the terrible boy then burst the virgin cry.

I know thee, I have found thee, & I will not let thee go:
Thou art the image of God who dwells in darkness of Africa
And thou art fall'n to give me life in regions of dark death.
On my American plains I feel the struggling afflictions
Endur'd by roots that writhe their arms into the nether deep:
I see a serpent in Canada, who courts me to his love
In Mexico an Eagle, and a Lion in Peru;
I see a Whale in the South-sea, drinking my soul away.
O what limb rending pains I feel, thy fire & my frost
Mingle in howling pains, in furrows by thy lightnings rent:
This is eternal death: and this the torment long foretold.

Fig. 12. *America,* Preludium, plate 2

brilliance now recognized by critics who speak of Blake as having
anticipated "the whole of Freud's teaching"[29] or Jung's charting
of "psychic patterns."[30] It is not Blake but his critics, however, who

[29] Schorer, p. 256, quoting W. H. Auden.
[30] Witcutt, *Blake,* p. 8.

disconnect his psychology from his sociology. Even the separation of his economics from his politics involves some distortion, and before we continue tracing the Rousseauan motif in the Lambeth prophecies—especially in the Preludium of *America,* where the whole history of man is condensed into a metaphor to describe the tremendous change marked by the emergence of the revolutionary spirit—we ought to take note of the point in history upon which Blake's metaphor pivots.

When the apparent progress of reason actually reduces all human existence to "a horrible state of war," a contradiction appears which causes even the reasoner to think twice. In the eighteenth century this happened when "Newton & Locke" reduced all mental signification to "a Philosophy of Five Senses" and when the Great War for the Empire reduced human relations to "a Code of War" by which man hunted man into the desert wilds (*Song of Los* 3:30–4:17). The war finally exhausted its momentum in 1762,[31] and simultaneously a counter movement began, which we can trace in various allusions in the overlapping "songs" of *Africa* and *Asia* and the Preludium of *America.*[32] The direction of philosophy was reversed when the "thick-flaming thought-creating fires of Orc" rose "like a pillar of fire" in the Alps under the auspices of "Rousseau & Voltaire"—the same "fiery cloud of Voltaire, and thund'rous rocks of Rousseau" that guide Fayette in *The French Revolution.* The *Social Contract* was published in 1762; Blake writes the Preludium of *America* as variations upon the theme of its opening declaration that man, born free, is seen everywhere in chains; and in Blake's analysis it requires just "fourteen suns"

[31] The final Treaty of Paris was signed in February 1763, but fighting ceased in 1762 and peace was signed between England and France in that year.

[32] *Africa* and *Asia,* the two parts of *The Song of Los,* seem to be preludes to unwritten prophecies. *Africa* is in a sense an alternative Preludium to *America,* for it ends with the first line of text following that Preludium: "The Guardian Prince of Albion burns in his nightly tent." *Asia,* like *Africa,* reaches back to Adam and Noah, but it overlaps and carries the survey into the historical future, the millennium felt to be near at hand.

Sloss and Wallis, 1, 132 n, are uncertain whether Voltaire and Rousseau as they appear in *Africa* are still to be considered "agents of revolution." Collation of the three preludes indicates that they are equivalent to the Promethean symbol of Orc in the Alps. And Blake is still rejoicing at the sequel, the terrestrial orgasm. Only later will he turn upon Voltaire and Rousseau when he comes to question the reality of that sequel. See below.

for the new philosophy to engender the Declaration of Independence, a manifesto of warlike men standing united against Urizen's destruction of the human harvest.

During these fourteen years (1762–1776) Orc's "spirit soars" while his body, "chaind beneath," is "struggling" everywhere to be free—in Canada, Mexico, Peru, the South-sea, "the darkness of Africa," and, as the nameless female says who symbolizes fallen nature and who speaks like Oothoon, "on my American plains." This "Dark Virgin" is indeed Oothoon, in the days before the patriots of America provided her a local habitation and a name. In the illustration she appears in her American Indian form, and Orc is chained in the position of the crucified rebel African: her first words recognize "the image of God" in the Christ-like African "fall'n to give me life in regions of dark death." The slave revolts described in Stedman's *Narrative* did shortly precede the American Revolution, and so did other abortive rebellions in the lands Blake names. Blake gives them symbols of historical authenticity—a Lion in Peru, an Eagle in Mexico, a Serpent in Canada, a Whale in the South-sea, and a serpent coiled round the tree of liberty to protect it in the "serpent folding Around the pillars of Urthona"—at the same time suggesting that Orc in these struggles of self-sacrifice is groping for the right form, which will be the Human fire of the Declaration.[33]

But the central symbolism describes the pre-revolutionary period in terms of the hypothetical prehistoric gropings of Rousseau's speculation, though Blake selects only fragments of Rousseau's account and casually substitutes the primal garden of Eden for his state of nature.[34]

[33] The lion is a Peruvian symbol, the eagle a Mexican, and Blake's picture of an eagle seizing a rattlesnake (*M.H.H.*15) is a curious anticipation of the Mexican flag (adopted in 1821) based on early Toltec emblems.

[34] Also influenced by Rousseau's *Discourse* is Blake's current study of the emotions. In *The Book of Urizen* he follows Rousseau in the idea that pity, "the pure emotion of nature," is man's earliest emotion and the idea that reason gives rise to self-awareness and selfishness.

It is also curious to note in the Prelude of *The Book of Los* a revamping of material from Blake's earliest genealogy of the passions, *T.S.B.* Joy, Envy, and "Eyeless Covet" appear in both. But in the early *T.S.B.*, Desire is "pale," while in *Los* she rages furious with "living flames, Intelligent, organiz'd, arm'd with destruction and plagues." Pride, the chief negative force of the early work, is not mentioned in *Los*; new forces are Wrath and Wantonness.

5

For *Paradise* is the springing up out of the Essences in the Divine Center: which sprouteth through all Forms . . . and also through the Heaven, as a springing of a pleasant Garden; therefore *Adam,* even in this world, was in Paradise.[35]

Under the conditions of tyranny and alienation the pleasant earth became a cold moon-like "death-shadow." Los, once owner of a sunlit Paradise, became "possessor of the moon." Urizen denounced the lovely Ahania as "Sin" (see Milton and Gillray) and forced her into paths of "hard necessity." Nature became "the mother of Pestilence" and could provide only the most meager fare to the enslaved part of mankind—and that only when man struggled fiercely to embrace her, as in Peru, Africa, and America. In this sad condition man was but "a Human Illusion In darkness and deep clouds involvd," and nature was only his "shadowy Daughter."[36]

Such was life before the revolution. Nature's "iron tongue" was inarticulate—"dumb till that dread day when Orc assayd his fierce embrace"—and she had no raiment but the quiver and arrows of famine and the iron helmet of warfare. Iron brought about collective cultivation, says Rousseau, but also the divisive concept of private property. Iron, according to Blake's symbols, was the source of food—"His food she brought in iron baskets, his drink in cups of iron"—yet also of weapons, that kept man enslaved: "no other arms she need!" (*A.*1:3–10).

Los as blacksmith had performed and continued to perform both a service and a disservice. As the "father stern abhorr'd" of a *fallen* nature (the "Dark virgin"), the fallen Urthona (Los divided from Urizen and Orc, his other parts) failed to keep reason in chains as he ought but cruelly riveted "tenfold chains" upon his own energy.[37] No more beholding Eternity, the communal para-

[35] *The Works of Jacob Behmen,* London, 1764, II, 49.
[36] *Ahania* 2:4; *E.*3:7; *Ahania* 2:34; 5:2; 2:43; *Book of Los* 5:56–57; *A.*1:1.
[37] *A.* Preludium. Orc, chained by the stern parent, was yet fed by the dark virgin; "when thou bringest food I howl my joy! and my red eyes seek to behold thy face."

dise, he was driven by the jealous spirit of private possession.[38] Yet the supplying of iron cups and baskets to feed "the hairy youth" indicated a meager but positive return of vision and a willingness to build Orc's strength for his climactic Declaration of Independence.

The Orc born in 1762 is only potentially free; he is fed but in silence; his "spirit soars" but his body is chained to the rock. Yet at puberty (one connotation of "fourteen suns") he has the strength to break his chains, embrace the womb of nature, and engender a new and free-limbed Orc in 1776, theory and practice becoming both articulate and alive in the marriage of contraries:

The hairy shoulders rend the links, free are the wrists of fire;
Round the terrific loins he siez'd the panting struggling womb;
It joy'd: she put aside her clouds & smiled her first-born smile.
(A.2:2–4)

This ritual copulation reunites man and earth, and she recognizes the Christ-like seed planted for resurrection "to give me life." "I know thee," she cries, remembering the days before the fall, the pre-iron days of Eden. "I have found thee, & I will not let thee go." She feels the writhing of roots "on my American plains" wherever patriots are making love to good earth. Orc, meteorologically the sun rising above the horizon, is a spring sun thawing the frozen earth. But this is no simple return to the state of nature.

O what limb rending pains I feel. thy fire & my frost
Mingle in howling pains, in furrows by thy lightnings rent:
This is eternal death; and this the torment long foretold.
(A.2:15–17)

From now on nature has constantly to die and be reborn for man's benefit. In Eden, as she remembers in *The Book of Ahania,* she dropped fruit in his lap with no labor on his part and no pain on hers, but since the fall she has been a poor provider, often bringing war and pestilence. In the new era Patriots will doubtless seek some equitable sharing of earth-ownership, but they will also

[38] It was in a momentary lapse of vision when "No more Los beheld Eternity" that he chained Orc and cast his eye on fallen nature (Eve as Enitharmon). The moment he had become weary of chaining Urizen "his eternal life Like a dream" had been "obliterated" (*Book of Urizen* 20:2; 13:33–34).

hold on to the iron plow and harrow and spiked roller. Orc's use of lightnings to plow furrows may be an elliptical reference to man's discovering fire and thence smithery (see Rousseau).[39]

Plowing is painful for the earth; revolution involves bloodshed, as the struggling in America and France and Santo Domingo illustrates. But Blake implies that when these struggles are inspired by the spirit of prophecy they enrich the harvest and remove the arrows of pestilence from nature's quiver. If the discovery of iron and agriculture increased man's inequality and hence his misery, as Rousseau believed, then the restoration of equality could, as Wollstonecraft believed, turn the iron of spear and musket into the iron of pen and plow. The tyranny of Urizen fades as the Eternal Prophet sings the *Song of Los* with its climactic vision[40] of a new springtime when

> Forth from the dead dust . . . the shivring clay breathes
> And all flesh naked stands: Fathers & Friends;
> Mothers & Infants; Kings & Warriors.

Warriors are naked who have thrown down sword and musket. Kings are naked who have doffed the shoes of oppression. Nature is the grave of the old but the womb of the new society.

> The Grave shrieks with delight, & shakes
> Her hollow womb, & clasps the solid stem:

—simultaneously seizing the grapevine, the wheat stem, and Orc, the divine energy which sprouteth through all forms—

[39] *Discourse,* p. 208. See Frye, p. 253. Rousseau is of course not the only component of Blake's myth. Orc's "red eyes" come from the typical Ossianic hero. And the Edda supplied materials transmitted by Gray. The "virgins . . . in speechless woe" of his *Descent of Odin* suggest the sad silent virgin of the Preludium and the daughters of *V.D.A.* The unnamed "Prophet maid" awakened by Gray's Odin in "realms of night" and recognized as "mother of the giant-brood" suggests the nameless virgin mothering a "vig'rous progeny of fires" in *E*. Behind Orc, whose "fierce embrace" in western "caves" conceives "the terrible boy" who is to slay Empire, is Gray's Odin, whose "fierce embrace" in "caverns of the west" is to conceive the "wond'rous boy" who is fated to slay Odin's Cain-like son. Orc's rending his "tenfold chains" recalls the prophecy of the world's end when "Lok has burst his tenfold chain." For other Gray echoes, thematic, structural, tonal, and verbal, see Schorer, p. 405 n.

[40] *Song of Los* 7:31–40: E68/K248.

Her bosom swells with wild desire:
And her milk & blood & glandous wine
In rivers rush & shout & dance,
On mountain, dale and plain.

The dance of eternal death ends as a dance of eternal harvest. Nature has found her voice and her true love.

In place of a mere "finis" on this last page of this last of the four continentally titled Prophecies comprising a new earth—*America, Europe,* "Africa," and "Asia"—there is a settling of celestial priorities within the human breast as well:

The SONG of LOS is Ended.
Urizen Wept.[41]

Implied here are a quiet pun on the successful universal annihilation of negation, of loss; a rest from labor for the creative bard—who must surely smile his work to see—; and a proper subjugation of those war-breathing Nobles and Priests whom the People commanded, in the First Book of *The French Revolution,* to "weep," i.e. to put off contempt and to put their hands to the plow.

[41] For clues to the ironic implications of this utterance, look into John Donne's Sermon on John 11:35, "Iesus Wept," preached at White-hall, the first Friday in Lent (1622/3).

12. The Secret Child

Ah mother Enitharmon!
Stamp not with solid form this vig'rous progeny of fires.
— *Europe* 2:7–8

THE PRELUDIUM of *Europe* continues the nature myth of the Preludium of *America* and links it, by means of a vision enclosing the historical narrative, to the strife of Judgment Day that shakes "all nature to the utmost pole."[1] The Preludium begins at a point toward the end of the wintry period after the harvest season of the American Revolution. Nature is still nameless and still shadowy. She is in the embrace of Orc but is still somewhat pestiferous because Orc has not fulfilled his dragon-slaying, harvest-saving mission. Her "snaky hair" reminds us of Gillray's redrawing of Fuseli's picture of Milton's Sin (Plate VIIa) and her complaint that she has been giving birth to "all-devouring fiery kings" just as rapidly as to infant revolutions reminds us of Sin's perpetual pregnancy and hourly travail. Yet in her desire and soft spirit she is Oothoon still, and she is the spirit of earth folding "the sheety waters as a mantle" round her limbs.

She asks the midwife of historical events, "mother Enitharmon,"[2] how many times Orc and his destroyers must be born before the true millennium:

I bring forth from my teeming bosom myriads of flames.
And thou dost stamp them with a signet, then they roam abroad
And leave me void as death:
Ah! I am drown'd in shady woe, and visionary joy.

[1] *E*.15:10: E65/K245. The 24-line Preface that appears in two extant copies of *E*. is a lyric afterthought of later years and in it Blake says nothing about *E*. except that it was "dictated" to the author by a Fairy who lived in "a streak'd Tulip." A deliberate Quiddism.

[2] Named from the Greek ἐναρίθμιος, "numbered." See Frye, p. 440, and Damon, p. 336. In the personal allegory Enitharmon sometimes represents Catherine Blake. See Margoliouth, *Blake*, p. 16; also Damon's *Dictionary*.

How eternally must eternal hell revive and heaven dampen it? How many flaming Fayettes, Mirabeaus, or Orleans must be bought and sold and stamped with the signet of Bromion—or be compelled to roam abroad? On the whole, giving birth to the Orc of 1793, she appears reassured:

> [For] who shall bind the infinite with an eternal band?
> To compass it with swaddling bands? and who shall cherish it
> With milk and honey?
> I see it smile & I roll inward & my voice is past.

Seeing the infinite smile as He may have smiled who made the tiger, she has a premonition that the new Orc is no weak infant to be swaddled and milk fed.[3]

Rightly understood the Preludium is an oracle of the second coming of Christ and of the Armageddon of 1793 which must end in the final doom of the kings of the earth and their armies. Orc-Christ is coming as tiger, not as lamb, and the time is past of nature's sunless shadowy existence and of the dull round of devouring and devoured.[4] The whole prophetic framework of the poem, in which modern history is treated as an early morning dream of the malevolent Queen of Heaven, revolves upon a fatal mistake in her calculations.[5] For despite her mastery of such orderly arrangements as the astronomical heavens, and despite her power over bound citizens, Enitharmon herself fails to take note of the catastrophic difference between Christ's birth as an infant and his mature second coming eighteen centuries later.

The "Prophecy" begins with a description of the first coming in a passage which contains a hidden key like the cryptic allusion to Rousseau in America.

[3] "In the latest prophetic writings 'to feed with milk' is to establish the feminine delusions of morality and sense experience." Sloss and Wallis, I, 69 n.

[4] For portents of the nearness of the second coming in 1794, see Joseph Priestley, The Present State of Europe Compared with Ancient Prophecies; A Sermon, preached . . . February 28, 1794, London, J. Johnson, 1794.

[5] The 1800-year "moment" of her dream of history, marked by the breaks after 9:5 and 13:8, has been treated above (chapter 9, section 2). The framework of preceding and following lines begins with the dawn of eternal day, which seems like (because it breaks so suddenly into) a deep winter night. Los mistakes the light as stellar and meteoric (Urizen's) and suitable for his moon and glow-worms. In the concluding lines (pl. 15) the historical and eternal dawnings converge (in France in 1794).

> The deep of winter came;
> What time the secret child,
> Descended thro' the orient gates of the eternal day.
> War ceas'd, & all the troops like shadows fled to their abodes.

Orc's nativity brings peace, but night and winter resume almost at once.

> Then Enitharmon saw her sons & daughters rise around.
> Like pearly clouds they meet together in the crystal house:
> And Los, possessor of the moon, joy'd in the peaceful night:
> Thus speaking while his num'rous sons shook their bright fiery wings

> Again the night is come
> That strong Urthona takes his rest,
> And Urizen unloos'd from chains,
> Glows like a meteor in the distant north
> Stretch forth your hands and strike the elemental strings!
> Awake the thunders of the deep,[6]

The key is the echo of Milton's *Hymn on the Morning of Christs Nativity,* for which Blake was drawing illustrations at about this time, and to which we must turn for a fuller statement of Blake's thesis than he intends to give it himself.[7]

"Peacefull was the night," sings Milton, when "the Prince of light" was born; but it *was* night and winter, and Christ had had

[6] *E.*3:1–14: E60/K239:4:1–14. Blake used no quotation marks, and a confusing editorial tradition has grouped lines 9–14 and the following fourteen lines together as one speech by Los. As I read the passage (and continue to do after many years of critical discussion) the speech of Los ends with line 14. The next two lines describe the effect of his call. Then the sons of Urizen speak, and then Enitharmon. Otherwise we have Los incongruously asking that "we" may drink "the wine of Los" and rejoicing to see Orc bound. Little reliance can be given the comma-like mark at the end of plate 4; an earlier version of plate 5 may have continued the passage differently; in either reading the comma is not functional here. The colon at 4:2 is. (I print the mark as a comma instead of a period only to avoid seeming to conceal evidence.)

This matter is of more than passing importance, since by attributing to Los the cruel impulses of Urizen's sons and of Enitharmon, editors have erroneously discovered "what appears to be [a great] distance between the early and later presentations of Los." Sloss and Wallis, I, 63.

[7] The vagueness of the echo has led critics (e.g. *loc.cit.*) to neglect its great usefulness. Now Michael Tolley's essay in the forthcoming volume, *Blake's Visionary Forms Dramatic,* makes very good use of Blake's use of the *Hymn.*

to forsake "the Courts of everlasting Day" to descend. This is not Milton's emphasis, but these are his words. Battles were silenced, "Kings sate still with awful eye," and the old Dragon's Kingdom began to fail. Yet this moment of peace was but a token of "a perpetual peace" to come. The "blisful rapture" of mankind almost persuaded Nature that her part was done and "all Heav'n and Earth" were to be married at once. But "This must not be so" because "The Babe lies yet in smiling Infancy." Crucifixion must come, and only after that and after the "wakefull trump of doom" will Heaven "open wide the Gates of her high Palace Hall."

In Blake's adaptation of this myth it is Enitharmon who, once certain the secret child is swaddled ("now thou art bound"), is to reign in the sunless heaven of the "night of Nature" until the trump of doom is blown. In deceptive moonlight she does not at first appear the cruel queen we soon discover her to be.[8] With clearer vision we should see that the sons and daughters who gather round her with the innocent appearance of "pearly clouds" are really the intransigent "starry hosts" of chivalry's marble heaven gathering in the queen's palace as they gathered round King Gwin and King Louis. In long history (compare Blake's early survey of imperial cities ruled by Pride) they are the kings and queens of five thousand years of darkness, only momentarily abashed by the star of Bethlehem which has quickly yielded to the sinister meteor of Urizen.[9] In a shorter span they must be the princes and prime ministers of Europe summoned by the Queen of France after the peaceful token dawn of 1789.

Los, though only moon-guided, seems aware of approaching strife. He sees the people ("strong Urthona") dangerously sleeping while Urizen is free and pestilent, and the bard calls for stirring harp music to alert the strong. The sons who respond must be such prophets as Paine, Wollstonecraft, and Blake. Or, taking Los as Blake, his bright sons must be his own illuminated writings.[10] The envying sons of Urizen, such Antijacobins as Burke and Pitt, strike back with proscription and repression:

[8] On Enitharmon as Queen of Heaven, see Frye, pp. 127, 263.

[9] Blake's illustration consists of a female comet shaking evils from her hair, importing "change to times and states" and "Pestilence and War," according to George Cumberland's gloss in the British Museum copy.

[10] Blake consistently calls his works children. Winged thoughts are thoughts put on paper. The pages (wings) are illuminated (bright) and etched with acid (fiery). Thus Blake's sons shake "their bright fiery wings."

> Sieze all the spirits of life and bind
> Their warbling joys to our loud strings
> Bind all the nourishing sweets of earth
> To give us bliss, that we may drink the sparkling wine
> of Los (*E.*4:3–6)

Since oppressors prefer wine made of blood, we may take this as a way of saying, "Crucify him!" These words of the sons of Urizen anticipate the boasting of the hirelings in *The Four Zoas* who fatten on human blood and "wine of life." Their next words echo Prince Edward's love of "the noise of war" and Dagworth's laughter.

> And let us laugh at war,
> Despising toil and care,
> Because the days and nights of joy, in lucky hours renew.
> (*E.*4:7–9)

We are listening to the Edwards and Dagworths of the modern crusade against France.

Cruel Enitharmon looks forward to an "hour of bliss" in the dark night after the token dawn. As twilight deepens she finds her "weary eyelids drawn towards the evening." But before going to sleep she summons the spirits who are to keep the code of sin in force. First she must have the "red light" of desire and rebellion, of Orc "the horrent Demon." Antijacobinism cannot operate without at least the appearance of dangerous Jacobins—preferably "forms without body" or a demon well swaddled.[11] Next she summons the ruling powers. "Lion Rintrah," the crusader or "king of fire," is to "bring Palamabron horned priest"[12] (compare Gillray's treatment of Burke as a Jesuit), and "silent Elynittria the silver bowed queen," and, if he can find her, his own bride, "the lovely jealous Ocalythron."[13] In Blake's illustrations of Milton's *Hymn* two very similar queens are worshipers of Moloch, discomfited at the springing forth of Christ out of Moloch's furnace.

Satisfied with Rintrah's confidence in his own strength, the

[11] *E.*4:15–17 and Cumberland's gloss.

[12] A priest of the horned moon of chastity would, in Blake's view, properly wear the emblem of a cuckold; his true church would be the whore of Babylon.

[13] *E.*6:3–8:12: E61/K240. She calls both Orc and Rintrah "eldest born," for as contraries they are twins; yet she recognizes that Rintrah is "second to" Orc and can have dominion only when Orc is well chained down.

cruel goddess retires for the long night of nature during which man is but a female dream and men's harps are "unstrung." She laughs "in her sleep" to see "every man bound," but when the trumpet finally wakes her she does not know that she has slept. Under the impression that the night is still just beginning, Enitharmon resumes her roll call of sons and daughters—a lengthy catalogue—and repeats her invitation to Orc, "son of my afflictions," to "smile upon my children! . . . and give our mountains joy of thy red light."

Orc's behavior, in 1793, soon disabuses her. "Eighteen hundred years" have "fled As if they had not been," and it is no longer twilight but true dawn. Morning opens the eastern gate and Enitharmon weeps. "Terrible Orc" shoots down from the heights of her shadow world into the "vineyards of red France."[14] During the long night he has grown and now has burst his chains. The "secret child" of Innocence is, on his second coming, the "just man" of Experience, ready to tread the vintage of wrath. He is the avenging Christ of Saint John's prediction: his eyes are as a flame of fire and his clothes bloody, "and out of his mouth goeth a sharp sword . . . and he treadeth the wine-press of the fierceness and wrath of Almighty God."[15]

[14] From one point of view (*A.* Preludium) Orc is a seed in the ground. From another he does not enter from the celestial zone until dawn. His function, with Los, is to make fertile the new marriage and lift mankind out of the natural world's dull round.

[15] *E.*13:9–15:2; Revelation 19:11–15.

The starry queen's mistake is similar to that of the "starry king" in *A Song of Liberty* who finds soon enough that the "falling" of the "new born fire" is nothing for kings to rejoice at. Again Blake is reversing or doubling the implications of his sources. Suggestive material for tracing the image of the "birth" of Orc to emblems of the "fall" of Icarus and Phaeton will be found in Piloo Nanavutty, "Blake and Emblem Literature," *Journal of the Warburg and Cortauld Institute,* xv (1952), 258–261.

The flame in the "Famine" illustration in *E.* is blazing on a domestic hearth under a large kettle—into which an infant, apparently dead, is to be put for food. The woman watching the pot expects, like Queen Enitharmon, joy from afflictions that make children lifeless. The woman herself is not one of the physically starving; she is plump and has a pearl necklace and can welcome pestilence. (The other woman, bent in grief, will need waking from self-pity before she can be Solomon's choice to *see* the babe.)

13. Infinite London

O Earth O Earth return!
Arise from out the dewy grass;
Night is worn,
And the morn
Rises from the slumberous mass.

—Introduction, *Songs of Experience*

THE BARD who recites the *Songs of Experience*, written in 1792–
1793,[1] is capable of seeing "Present, Past, & Future"; yet he must
chide Earth's "lapsed Soul" for the tardiness of spring thaw; and
Earth's Answer is really, like the questions of Oothoon, an un-
answered appeal for help to "Break this heavy chain, That does
freeze my bones around." "Cruel jealous selfish fear" (like Fa-
yette's) has chained Earth with winter frost; no one can plow or
sow; the buds and blossoms are retarded—for Love is held in
bondage.

The complaint is essentially that the revolutionary spring torrent,
which in 1792 seemed to be "spreading and swelling . . . to
fertilize a world, and renovate old earth" (as Holcroft exclaimed
in a prologue in March)[2] is still in England dammed and frozen
by cold abstractions and proclamations of "Thou shalt not." The

[1] All eighteen of the *Songs of Experience* in *N.*, including the *Motto to
Songs of Innocence & of Experience*, precede the draft of *Fayette*. In the
Prospectus of Oct. 10, 1793, *Songs of Innocence* and *Songs of Experience*
are advertised separately. But all extant copies of the latter have a publication
date of 1794 and appear not to have been issued except in combination
with, or to complement earlier copies of, *Songs of Innocence*.
The Bard's plea, *Introduction*, is not in *N.*, but it must have been
drafted before *Earth's Answer*, which is.

[2] Prologue to *Road to Ruin* as read March 1, 1792; quoted in *London
Chronicle* of March 3.

Bard is determined that the spring *shall* come; that Earth from sleep

> Shall arise and seek
> For her maker meek:
> And the desart wild
> Become a garden mild.

And he trusts that his own art has ritual force: "Grave the sentence deep." Yet the poem bearing these declarations was at first a Song of Innocence, moved now into the contrary group to say what it was perhaps no longer easy to write.[3]

Now, in his notebook, he wrote a song lamenting that a "heavy rain" of cruelty, disguised in the specious abstractions of "Mercy & Pity & Peace," has descended on "the new reapd grain"; the farmers are "ruind & harvest . . . ended."[4] In an earlier and crueler mood Blake had written and even etched on copper a bitter characterization of the kind of *Divine Image* which Cruelty, Jealousy, Terror, and Secrecy were giving to the nation:

> The Human Dress, is forged Iron
> The Human Form, a fiery Forge.
> The Human Face, a Furnace seal'd
> The Human Heart, its hungry Gorge.[5]

But he kept the copper without printing from it, choosing instead to stay closer to the ruined grain and farmers. With a more intellectual irony he constructed from the psychological and moral gains of "mutual fear" and "selfish loves" a song of *The Human Abstract* to sing against the *Divine Image* of Innocence.

Blake retained his sense of balance by engraving together his *Songs of Innocence and of Experience* as "contrary states of the human soul," and his sense of perspective by treating winter as a season and life as an arc of Eternity. "Without contraries is no

[3] *The Little Girl Lost:* E20–21/K112–113. This and *The Voice of the Ancient Bard,* transferred from *Songs of Innocence,* carry over into *Songs of Experience* a bardic optimism that is not explicit in the *Introduction.* But *The School Boy* (see above) must have been similarly transferred because it was too gloomy for *Innocence.*

[4] *N.*114: E468, 771/K164, "I heard an Angel singing."

[5] *A Divine Image:* E32/K221. But K misdates; the script indicates a date of ca. 1791.

progression," he still asserts. Yet the peculiar anguish of these songs (and several notebook pieces of the same vintage) derives from the fact that the historical contraries of peace and war, freedom and chains, have come to England in the wrong order. For it is only contrary states of the soul, not of society, that exist in Eternity, and Blake is still firm in the belief that the blighting Code of War & Lust is historically negatable. The earth will "in futurity" be a garden; readers "of the future age" will be shocked to learn "that in a former time, Love! sweet Love! was thought a crime."[6]

Relatively little of the considerable and increasing store of commentary on the *Songs of Experience* deals with their historical matrix; yet it would be pedantic here to spell out the application to these songs of much in the preceding chapters or to go beyond calling attention to the particular setting of some of their major themes. Though immeasurably closer than the prophecies to Blake's ideal of an art that rises above its age "perfect and eternal," these great lyrics soar up from a particular moment of history. The fused brilliance of *London* and *The Tyger*, the sharp, poignant symbolism of *The Garden of Love, Infant Sorrow*, and many another "indignant page" were forged in the heat of the Year One of Equality (September 1792 to 1793) and tempered in the "greybrow'd snows" of Antijacobin alarms and proclamations.

The fearful symmetry of the period in its cosmic implications produced Blake's boldest Oothoonian question, *The Tyger*, touched upon in an earlier chapter. The recurrent negative theme in the Songs is the mental bondage of Antijacobinism, manifest not in the windy caves of Parliament or the archetypal howlings of Albion's Guardians but in the lives of children and youth forced into harlotry and soldiery and apprentice slavery by the bonebending, mind-chaining oppressions of priest and king. In *Europe* and *America* Blake sketches a panoramic view of the youth of England and their parents walking heavy and mustering for slaughter while their minds are choked by volumes of fog which pour down from "Infinite London's awful spires" and from the palace walls and "cast a dreadful cold Even on rational things beneath." In *Songs of Experience* he takes us into the dismal streets and into schoolroom and chapel to see the effects of Empire on the human "flowers of London town." He describes, in *The Human Abstract*, the growth of the evil tree which is gallows, cross, and the abstract

[6] *A Little Girl Lost:* E29/K219.

Mystery that hides the facts of war. The roots of this oak or upas tree of perverted Druidism are watered by the selfish tears of Mercy, Pity, and Peace:

> Pity would be no more,
> If we did not make somebody Poor:
> And Mercy no more could be,
> If all were as happy as we;
>
> And mutual fear brings peace;
> Till the selfish loves increase.

This tree grows "in the Human brain," planted there by priest and king, who use the virtuousness of pity as an excuse for poverty and who define peace as an armistice of fear—and thus "promote war."[7]

It is instructive to note that ideas like these were widely propagated in the latter part of 1792 by an Association for Preserving Liberty and Property against Republicans and Levellers—expressly to persuade "the minds of ignorant men" that all causes of discontent were either inescapable or wholly imaginary, and to prepare these minds for the eventuality of England's being "dragged into a French war."[8]

These pamphleteers were in favor of the mutual fear and "military policy" that temporarily bring peace and ultimately bring war.[9] And they bluntly defended the inequality that supports pity and mercy. Both the Bible and "experience," they said, tell us that "society cannot exist without a class of poor." Consequently it is our duty to teach the poor that their sufferings are necessary and

[7] *The Human Abstract* and draft called *The Human Image* (N.107) in which the "mystery" is discussed that "The priest promotes war & the soldier peace." Cf. Marg. to Watson, iv: E601/K384. For a discussion of the relations of these poems and of the internal evidence for an early date for *A Divine Image* (confirmed now by script) see Robert F. Gleckner, "William Blake and *The Human Abstract*," *PMLA*, LXXVI (1961), 373–379.

[8] I quote from *Politics . . . Reflections on the Present State of Affairs*, by a Lover of His Country, Edinburgh, 1792. For the Association, see *London Chronicle*, Nov. 27–29, 1792.

[9] *Politics.* On the one hand, peace is "an object of desire" most effectually approached, we are told, by "a military policy" and increased armaments; on the other hand, if our "great empire is insulted by the impudent memorials of a set of plunderers" (the rulers of France) war will be "necessary and unavoidable."

natural and not to be remedied by laws or constitutional changes—
that it is in fact the object of our maligned and "most ex-
cellent Government to alleviate poverty" by "poor laws, work-houses
and hospitals."[10] Blake's suspicion that "Churches: Hospitals:
Castles: Palaces" are the "nets & gins & traps" of the "Code of
War"[11] is confirmed by these anti-levellers: "Every step . . . which
can be taken to bind man to man, order to order, the lower to the
higher, the poor to the rich, is now a more peculiar duty; and
if there are any means to prevent the spreading of dangerous and
delusive principles, they must be sought for in education. [Hence
the need for] Foundation Schools, Hospitals, Parish Schools, and
Sunday Schools."[12]

Blake's counterargument is that if there were not "so many
children poor" there would be no need for institutions and moral
code—and no ignorant men for sale to the fat fed hireling. Poverty
appalls the mind, making youth sufficiently docile to be led "to
slaughter houses" and beauty sufficiently desperate to be "bought
& sold . . . for a bit of bread" (N.107). There can be no vital bond
of man to man in such "a land of Poverty!" Starvation demon-
strates the absurdity of the anti-vice campaign, for the church
remains spiritually and physically a cold barn, to which *The Little
Vagabond* rightly prefers the warm tavern.[13] The harlot's curse
will weave Old England's winding sheet, and ultimately the raging
desire for bread will undermine the whole misery-built London of
spire and palace.

Boston's Angel asked, "What crawling villain preaches abstinence

[10] William Vincent, *A Discourse to the People,* London, 1792.
[11] *Song of Los:* E66/K246.
[12] Vincent.
[13] A curious "mark of weakness" appears in Blake's own publication. In
etching the *Vagabond,* Blake bowdlerized the fourth line, changing "makes
all go to hell" to "will never do well," thereby introducing a bad rime and
an ambiguity rather than defy the moral code of the Vice Society. The
first notebook draft (N.105) reads:

> Dear Mother Dear Mother the church is cold
> But the alehouse is healthy & pleasant & warm
> Besides I can tell where I am usd well,
> Such usage in heaven makes all go to hell.

Even as published, the "audacity" and "mood of this wild poem" dis-
turbed Coleridge in 1818. *Collected Letters,* ed. E. L. Griggs, Oxford,
1959, IV, 834–838.

& wraps himself In fat of lambs?" The chimney sweep, a "little black thing among the snow," answers that it is

> God & his Priest & King,
> Who wrap themselves up in our misery [*deleted reading*]
> And because I am happy & dance & sing
> They think they have done me no injury.[13a]

King, priest, god, and parents do not reckon the revolutionary potential in the multitude they are stripping naked. Yet even the sheep puts forth "a threatning horn" against the tithing priest (*N*.109). As for the chimney sweeper, his father and mother have turned a happy boy into a symbol of death. Once a year he still does dance and sing—on May Day, when London streets are given to the sweeps and milkmaids to perform for alms in grotesque symmetry.[14] *The Chimney Sweeper* is saying to the London citizen: you salve your conscience by handing out a few farthings on May Day, but if you really listened to this bitter cry among the snow you and your icy church would be appalled.

When we turn now to *London,* Blake's "mightiest brief poem,"[15] our minds ringing with Blakean themes, we come upon infinite curses in a little room, a world at war in a grain of London soot. On the illuminated page a child is leading a bent old man along the cobblestones and a little vagabond (Fig. 13) is warming his hands at a fire in the open street. But it is Blake who speaks.

London

> I wander thro' each charter'd street,
> Near where the charter'd Thames does flow.
> And mark in every face I meet
> Marks of weakness, marks of woe.

[13a] *N*.103: E22, 716/K180.

[14] I refer to an ancient May Day custom, illustrated by Blake in 1784 in an engraving for the *Wit's Magazine,* after Collings. The picture, *May Day,* is still used in works illustrating social customs. Milkmaids danced with pitcher-laden trays on their heads; the sweeps, with wigs to cover their grimy heads, banged their brushes and scrapers in rhythm; and a fiddler or two supplied a tune. Reproduced in *Johnson's England,* ed. A. S. Turberville, Oxford, 1933, 1, 174.

[15] Oliver Elton's phrase, I forget where.

In every cry of every Man,
In every Infants cry of fear,
In every voice; in every ban,
The mind-forg'd manacles I hear

How the Chimney-sweepers cry
Every blackning Church appalls,
And the hapless Soldiers sigh,
Runs in blood down Palace walls[16]

But most thro' midnight streets I hear
How the youthful Harlots curse
Blasts the new-born Infants tear
And blights with plagues the Marriage hearse

Fig. 13

In his first draft Blake wrote "dirty street" and "dirty Thames" as
plain statement of fact, reversing the sarcastic "golden London"
and "silver Thames" of his early parody of Thomson's *Rule
Britannia*. And the harlot's curse sounded in every "dismal" street.
The change to "charter'd" (with an intermediate "cheating")[17]
mocks Thomson's boast that "the charter of the land" keeps Britons
free, and it suggests agreement with (perhaps was even suggested
by) Paine's condemnation of "charters and corporations" in the
Second Part of *The Rights of Man,* where Paine argues that all
charters are purely negative in effect and that city charters, by an-

[16] The poem originally ended here. See *N*.109: E718–719/K170.
[17] The "cheating" variant is in *N*.113; see E464, 772/K166.

nulling the rights of the majority, cheat the inhabitants and destroy the town's prosperity—even London being "capable of bearing up against the political evils of a corporation" only from its advantageous situation on the Thames.[18] Paine's work was circulated by shopkeepers chafing under corporation rule and weary, like Blake, of the "cheating waves of charterd streams" of monopolized commerce (N.113).

In the notebook fragment just quoted Blake speaks of shrinking "at the little blasts of fear That the hireling blows into my ear," thus indicating that when he writes of the "mind-forg'd manacles" in every cry of fear and every ban he is not saying simply that people are voluntarily forging manacles in their own minds. Hireling informers or mercenaries promote the fear; Pitt's proclamations are the bans, linked with an order to dragoons "to assemble on Hounslow Heath" and "be within one hour's march of the metropolis."[19] A rejected reading, "german forged links," points to several manacles forged ostensibly in the mind of Hanoverian George: the Prussian maneuvers on the heath, the British alliance with Prussia and Austria against France, and the landing of Hessian and Hanoverian mercenaries in England allegedly en route to battlefronts in France.

Blake may have written London before this last development, but before he completed his publication there was a flurry of alarm among freeborn Englishmen at the presence of German hirelings. "Will you wait till BARRACKS are erected in every village," exclaimed a London Corresponding Society speaker in January 1794, "and till subsidized Hessians and Hanoverians are upon us?"[20] In

[18] Paine, I, 407; Nancy Bogen (*Notes and Queries*, xv, January 1968) finds Paine also calling "every chartered town . . . an aristocratic monopoly" in the First Part (1791) as well. On chartered boroughs see Cowper, *The Task* iv.671; also John Butler, *Brief Reflections*, 1791, a pamphlet reply to Burke cited in J. T. Boulton, *The Language of Politics in the Age of Wilkes and Burke*, Toronto, 1963, p. 193.

[19] *Gazette*, Dec. 1, 1792. In the note just cited, Mrs. Bogen suggests that Blake's choice, in the Thames poem, of the Ohio as the river to wash Thames stains from a Londoner "born a slave" and aspiring "to be free" was influenced by Gilbert Imlay's *Topographical Description*, London, 1792. On the Ohio Imlay found escape from "musty forms" that "lead you into labyrinths of doubt and perplexity" and freedom from priestcraft which elsewhere "seems to have forged fetters for the human mind."

[20] Address at Globe Tavern, Jan. 20, 1794 (pamphlet).

Parliament Lord Stanhope expressed the hope that honest Britons would meet this Prussian invasion "by OPPOSING FORCE BY FORCE." And the editor of *Politics for the People*, reporting that one Hessian had stabbed an Englishman in a street quarrel, cried that all were brought "to cut the throats of Englishmen." He urged citizens to arm and to fraternize with their fellow countrymen, the British common soldiers.[21]

The latter are Blake's "hapless Soldiers" whose "sigh Runs in blood down Palace walls"—and whose frequently exhibited inclination in 1792–1793 to turn from grumbling to mutiny[22] is not taken into account by those who interpret the blood as the soldier's own and who overlook the potentially forceful meaning of "sigh" in eighteenth century diction.[23] In the structure of the poem the soldier's utterance that puts blood on palace walls is parallel to the harlot's curse that blasts and blights. And Blake would have known that curses were often chalked or painted on the royal walls. In October 1792 Lady Malmesbury's Louisa saw "written upon the Privy Garden-wall, 'No coach-tax; d—— Pitt! d——n the Duke of Richmond! *no King!*'"[24]

[21] D. I. Eaton, *Politics for the People*, II, no. 7, March 15, 1794.

[22] The Royal Proclamation cited efforts to "delude the judgment of the lower classes" and "debauch the soldiery." Wilberforce feared that "the soldiers are everywhere tampered with." Gilbert Elliot in November 1792 expressed a common belief that armies and navies would prove "but brittle weapons" against the spreading French ideas. Elliot, II, 74. Through the winter and spring there were sporadic attacks of the populace on press gangs and recruiting houses. Mutiny and rumors of mutiny were reported in the *General Evening Post*, Apr. 20, July 20, Aug. 3, 7, 31, Oct. 28, 30, 1793. In Ireland the mutiny of embodied regiments broached into a small civil war. See also Werkmeister, items indexed under "Insurrection, phantom," and "Ireland."

[23] Damon, p. 283, reads it as the battlefield "death-sigh" which morally "is a stain upon the State." Joseph H. Wicksteed, *Blake's Innocence & Experience*, New York, 1928, p. 253, has it that the soldier who promotes peace is quelling the "tumult and war" of a "radically unstable" society. But Blake was not one to look upon riot-quelling as a securing of freedom and peace! Alfred Kazin, *The Portable Blake*, New York, 1946, p. 15, with a suggestion "that the Soldier's desperation runs, like his own blood, in accusation down the walls of the ruling Palace," comes closer to the spirit of indignation which Blake reflects.

[24] Elliot, II, 71. Verbally Blake's epithet may be traced back, I suppose, to "hapless Warren!", Barlow's phrase for the patriot general dying at Bunker Hill (changed to "glorious Warren" in 1793).

A number of cognate passages in which Blake mentions blood on palace walls indicate that the blood is an apocalyptic omen of mutiny and civil war involving regicide. In *The French Revolution* people and soldiers fraternize, and when their "murmur" (sigh) reaches the palace, blood runs down the ancient pillars. In *The Four Zoas,* Night I, similar "wailing" affects the people; "But most the polish'd Palaces, dark, silent, bow with dread." "But most" is a phrase straight from *London.* And in Night IX the people's sighs and cries of fear mount to "furious" rage, apocalyptic blood "pours down incessant," and "Kings in their palaces lie drown'd" in it, torn "limb from limb."[25] In the same passage the marks of weakness and woe of *London* are spelled out as "all the marks . . . of the slave's scourge & tyrant's crown." In *London* Blake is talking about what he hears in the streets, not about the moral stain of the battlefield sigh of expiring soldiers.

In Blake's notebook the lines called *An Ancient Proverb* recapitulate the *London* theme in the form of a Bastille Day recipe for freeing Old England from further plagues of tyranny:

> Remove away that blackning church
> Remove away that marriage hearse
> Remove away that ——— of blood
> Youll quite remove the ancient curse

Where he might have written "palace" he cautiously writes a dash.[26] Yet despite the occasional shrinking of Blake as citizen, Blake as prophet, from *The French Revolution* to *The Song of Los,* from 1791 to 1795, cleaved to the vision of an imminent spring thaw when the happy earth would "sing in its course" as the fire of Voltaire and Rousseau melted the Alpine or Atlantic snows. In England, nevertheless, the stubborn frost persisted and the wintry dark; and England's crisis and Earth's crisis were threatening to become permanent.

[25] *F.R.*24–246: E293/K147; *F.Z.*i:14:15–18: E304/K275; ix:119:7–8 E373; ix.119:7–8: E373/K359; ix.123:5–10: E377/K363.

[26] *N.*107: E466, 773/K176, 184. Blake's dash, an unusual mark for him, replaces an earlier "man" which replaced a still earlier "place." The "man of blood" would be the King, but Blake wanted the *place,* i.e. the Palace, and so settled for a dash.

Part Five

SYMPHONIES OF WAR

What is the price of Experience[?] do men buy it for a song[?]
Or wisdom for a dance in the street? No it is bought with
 the price
Of all that a man hath his house his wife his children
 — *The Four Zoas,* Night II

14. When Thought Is Closed

In 1795 Blake published the last of his Lambeth books and ended the Orcan phase of his prophetic career. In this year too the war changed from its Antijacobin phase to its Antigallican, to use the distinction of those who grew to hate Gaul if not Liberty. For those who could bring themselves to hate neither it was a year of mounting hope followed by slow agonies of despair sufficient to last some men their lives.

It was a year of famine and extreme social tension. Housewives and workingmen in every county took civic action ("bread riots") to bring down the prices of bread and meat. Bankrupt merchants were losing their enthusiasm for "Mr. Pitt's war." Moral politicians such as Wilberforce and Bishop Watson who had supported the crusade against "French principles" opined that war was not the best way to destroy principles. The scale of military preparations meant new taxes, "a retrenchment of the comforts of life," and a movement of many of the "middling classes" to join the multitudes who already "very ardently desired peace."[1] Lecturers and pamphleteers such as Thelwall in London and Coleridge in Bristol linked the war and the famine in earnest invective, and the number of "lectural and political" gatherings increased beyond all former periods.

Audiences of fifty thousand attended outdoor rallies of the London Corresponding Society. When Parliament assembled in October the streets were crowded "in a manner unprecedented since his majesty's accession to the throne." The King's coach "was surrounded on every side, by persons of all descriptions, demanding peace and the dismission of Mr. Pitt[2] . . . first in a melancholy,

[1] Contemporary quotations in this chapter are from Bisset, II, 423, 544–545, and from debates in Parliament.

[2] Coleridge's lectures at the Plume of Feathers, Bristol, called for peace, bread, and the resignation of Pitt. See the forthcoming volume of his *Lectures 1795 On Politics and Religion,* ed. Lewis Patton and Peter Mann, in the Collected Coleridge.

but soon after [in] a menacing tone." Some shouted "No King!" and a window of the royal coach was broken, by stones or an air gun. No one could know in 1795 that the war would last another twenty years, the monarchy longer still.

Blake's *Song of Los,* dated 1795 and evidently written in this rising tide, expresses the view that "mortal men" are at length refusing to be "mortal worms" and that patriots are at last driving kings from their "ancient woven Dens." Kings "of Asia," to be sure,[3] but the sarcasms of Los are those of the itinerant lecturers: Shall not the rulers promote famine and pestilence to restrain the inhabitants while they themselves enjoy "full-feeding prosperity"?

> Shall not the Councellor throw his curb
> Of Poverty on the laborious?
> To fix the price of labour;
> To invent allegoric riches:
>
> And the privy admonishers of men
> Call for fires in the City
> For heaps of smoking ruins,
> In the night of prosperity & wantonness

No longer, Los implies, can King and Church privily call out an incendiary Church-and-King mob such as burned out Priestley in 1791, or satisfy the laborious with pie in the sky. In his *Reflections* Burke had argued that "the body of the people" must accept the hard facts of exploitation and "must be taught their consolation in the final proportions of eternal justice" (page 249). Now the body of the people were encouraging the Foxite Whigs to challenge in Parliament the ancient right of magistrates to curb the price of labor.[4]

[3] Fires of Orc *were* reaching Asia, for that matter. The Sultan of Mysore was planting liberty trees and calling himself "Citizen," and London papers murmured of "the instability of rule in India."

[4] Bronowski misinterprets the legislative proposals of Fox and Whitbread as "a minimum wages bill" and supposes Blake to mean "that in the inflation of the French wars, a minimum wage would yield only allegoric riches" (p. 91 [128]). They sought rather to provide escapes *from* the old statutes which permitted *maximum* wage fixing without regard to inflation. While some minimum wage features were suggested, the minimums would be tied to the rising price of wheat and so not allegoric in Bronowski's sense. See *Parl. Hist.* and Hammond, *The Village Labourer,* ch. VII. Even further from the facts and from Blake's view is Mona Wilson's notion that "allegoric riches" are wages that are fixed too high.

Blake attributes the curbing of wages, the Antijacobin incendiarism, and the monopolizing of grain to a deliberate Malthusian policy[5] on the part of king and counsellor—who tremble to think they may not long continue

> To turn man from his path,
> To restrain the child from the womb,
>
> To cut off the bread from the city,
> That the remnant may learn to obey,
> That the pride of the heart may fail . . .

From the streets of London the "weak men" of the Privy Council looked weaker than they were. For months they could not silence the growing demand for peace and bread, just as the allied monarchs were unable to stifle the Republic of France. But Pitt's king and priest would continue for some time in the ancient way, and the pride of many an Englishman would fail as he learned to obey. The laborious poor were placated by minimum wages of a sort in the form of a supplementary dole, the Speenhamland system. Parliament talked for a while about peace—and then passed a series of "gagging acts" to prevent the people from doing so. One of these acts gave the legal definition of "treason" an elasticity such as "un-American" attained in the 1950's. Another defined almost any kind of meeting as seditious, forbade discussion of government policy, and further curtailed press freedom. Pitt's popularity diminished—but his power increased.[6] Subsequent popular demonstrations for peace and old prices were relatively ineffectual. The "British Inquisition" with its "Black List of English Jacobins," foreseen by Gillray in 1793,[7] was now empowered.

It is true that Pitt had grossly underestimated the military potential of the French Republic and would continue to do so. It is true that the sharp decline in textile production would continue through the bank crisis of 1797; that popular meetings against war taxes would swell by that year's end to the magnitude of a brief third wave of English Jacobinism in January 1798, with the Foxites and Coleridge (in the *Morning Post*) crying out for "Reform and Peace." But Patriots had overestimated the fluidity of

[5] Malthus had not yet published, but the ideas he made notorious were already current in public debate.

[6] Bisset, II, 552.

[7] *The Chancellor of the Inquisition* [Burke], March 19, 1793.

the situation. The desire of Burke for "a long war" was not eccentric. Ironmongers and most of the mercantile and financial interests behind Pitt enjoyed the growing war/budget. Landlords and large farmers, weathering the drought and the bread riots, plowed even the downs and sands and "prayed incessantly to Heaven to preserve Pitt and to keep up religion and prices."[8] Pitt or any successor representing these interests would continue to fight France, while on the other side the militarist Napoleon would emerge as a man of destiny for the most aggressive section of the French bourgeoisie.[9]

As the prospect darkened and the Societies grew weak it is not surprising that England's prophetic bards succumbed to moments of intense pessimism. Wordsworth in 1795 "yielded up moral questions in despair"—abandoned, that is, the effort to discern where political justice and his moral duty lay in the dubious struggle between France and England; and so abandoned London for "the open fields."[10] Blake was rooted in London, but he did "shrink from his prophetic task"—and from his republican confidence, as we learn from the following quatrain which he etched into the clean margin of one of the copper plates of *America* below the hopeful picture (Fig. 12) of Orc rising from the earth like a wheat sprout:

The stern Bard ceas'd, asham'd of his own song; enrag'd he
 swung
His harp aloft sounding, then dash'd its shining frame against
A ruin'd pillar in glittring fragments; silent he turn'd away,
And wander'd down the vales of Kent in sick & drear lamentings.

This tells us, not only that the prophet of Hercules Buildings put aside his work and took a walk down the Old Kent Road, feeling that *America* was a ruined pillar,[11] but also that his dismay lasted long enough to be recorded with aqua fortis.[12] This act itself in-

[8] Hammond, *The Village Labourer*, p. 174.

[9] See Eugene Tarlé, *Bonaparte*, New York, 1937, pp. 124, 130, 181–184, 316.

[10] *Prelude* (1805), x.901; i.59.

[11] The gesture may be chiefly against the English terror, if Blake, in traditional bardic fashion, is shattering his harp rather than play it in slavery.

[12] Yet he at once erased or masked these lines in even the earliest copies he printed. Only recently (by G. E. Bentley, Jr. in *Studies in*

volved picking up the fragments; *yet after 1795 Blake published no new work for a decade.*[13] Nor did he ever again write such precisely dated prophecies as *America* and *Europe.* When Blake had "called all his sons to the strife of blood" he had had simply no idea how that strife would sear the inlets of the soul both in France and in England.

It is quite possible that for a year or two Blake did give up writing and devote all his energy to an ambitious attempt, in a more silent art, to combine prophetic terror with pursuit of the main chance. In 1796 a bookseller with real confidence in Blake's "original conception" and "bold and masterly execution" commissioned him to prepare a set of illustrations for an "Atlas-sized quarto" edition of Young's *Night Thoughts,* the popular graveyard poetry which Quid had found in Steelyard's study. Blake designed 537 water-color sketches; specimens were exhibited at the bookseller's two shops and at "the Historic Gallery, Pall-Mall"; and Part One, with 43 of Blake's own engravings, reached the bookstalls in the autumn of 1797. But that was at the peak of the financial crisis, and the remaining three or four parts never went to press.[14]

In the artistic and commercial worlds Blake's reputation had been increasing, but with this failure he was "laid by in a corner." "Since my Young's Night Thoughts have been publish'd," he could complain, "Even Johnson & Fuseli have discarded my

Romanticism, VI [1966], 46–57) has anything like a firm chronological sequence of copies of *A.* been established—and a definitive account of the history of these four lines. Bentley shows that they were present on the plate but masked or (once) erased in the printing of the first eleven copies and allowed to appear only in the last two Blake printed—when the text cannot have mattered so much to him. (An 1820 watermark in the last copy puts it at least that late; the next to last cannot be closely dated but may be as late.)

[13] Except that he probably meant to publish *Vala* as a unique illuminated manuscript and simply failed to find a customer.

[14] See Gilchrist, p. 377, and Prospectus of "Edwards's Magnificent Edition of Young's Night Thoughts." Stothard in the following year designed a vignette and eight plates for a modest octavo edition of the poem.

Only in the late 1960's did extensive scholarly study of the Blake water colors begin, as Clarendon Press undertook to publish a multi-volume edition of the whole series (with commentary by John Grant, Michael Tolley, and Edward Rose) and Micro Methods to make them available in color transparencies.

Graver."[15] Yet bitterer than the curb of poverty was the refusal of other minds to accept the apocalyptic symbolism of these pictures: the great temple-ruining Samson of the final drawing, the fallen Nebuchadnezzar "struck by Providence" and cropping the grass with his teeth, the sinister, handsome Scarlet Whore and Great Red Beast who rule without control. Even while he had been busy drawing them the *British Critic* for September 1796 had execrated "the depraved fancy" of a man who created "imaginary beings which neither can nor ought to exist."[16]

And so the closing years of the century found William Blake in his forties a poet who had shattered his harp, a prophet whose wisdom none would buy, and an artist whose humblest breadwinning tool had been laid by. "Wisdom is sold in the desolate market where none come to buy, And in the wither'd field where the farmer plows for bread in vain" (*F.Z.*ii.35:14–15). For some, the drought of '95 was never relieved.

2

The Blakes' residence during these years (1791–1800) among the decaying pleasure gardens and "flourishing" charity schools of Lambeth almost in the shadow of the Archbishop's palace seemed, according to reminiscent passages in *Milton* and *Jerusalem,* elaborately symbolic of the shattered state of the world's hopes. What should have been "Oothoon's palace" was given to State Religion. The place that should have been "Jerusalems Inner Court, Lambeth," was Asylum Cross (see Fig. 14), "ruin'd and given To the detestable Gods . . . to Apollo: and at the Asylum Given to Hercules."[17] On the north side of the crossing were three pleasure

[15] To Cumberland, Aug. 26, 1799. The high point is perhaps marked by the entry of Feb. 19, 1796, in Farington's *Diary:* "West, Cosway, and Humphrey spoke warmly of the designs of Blake the engraver, as works of extraordinary genius and imagination."

[16] Review of Stanley's *Leonora* ("altered from . . . Bürger") with three illustrations by Blake engraved by Perry.

[17] *M.*25:48–50: E121/K511. A footnote in an essay in *The Cabinet* (Norwich, 1795, I, 206) supplies a macabre detail. "If we are to believe the public papers, a society of persons did exist at Lambeth in the year 1793, who made a trade of digging up the bodies of the dead: they made candles of the fat, extracted volatile alkali from the bones, and sold the flesh for dogs meat."

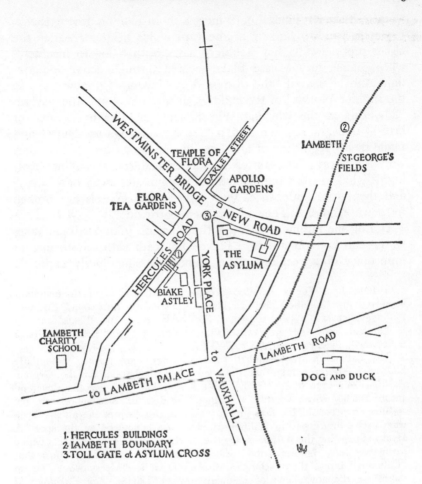

Fig. 14. Asylum Cross and Vicinity, 1791–1800

gardens of Flora and Apollo that had sprung up during the dawn of the French Revolution but were now (around 1796) falling into ruin or being suppressed as disorderly houses and the resort of "democratic shopmen . . . railing against King and Church." South of this mouldering paradise were the Royal Asylum for Female Orphans, a "house of refuge" where the Hercules Tavern once stood; the row called Hercules Buildings, where the Blakes dwelt at No. 13; and the Lambeth Charity School. Like Hercules during his slavery to Omphale, reduced to spinning among the

women, Blake felt himself once more a shorn Samson among slaves. From his window he saw in the yard of his neighbor Astley the circus proprietor "a boy hobbling along with a log to his foot," whose momentary release Blake secured through active indignation. And he shared "the distress & the labour & sorrow . . . in the Interior Worlds" of the children at the School and the Asylum "labouring at the whirling Wheel" and "in Tirzahs Looms for bread" under a regimen which "set Pleasure against Duty" and made them "regardless of any one But the poor Spectres that they work for, always, incessantly." He understood, too, their "intoxicating delight" in work that sometimes "Obliterates every other evil," and their grim endurance, that "when their Wheels are broken by scorn & malice They mend them sorrowing."[18]

During the famine year 1795 the diary of John Stedman takes us through London streets to Blake's Lambeth with the incoherent immediacy of a reel of candid camera parsimoniously exposed:

[18] M.25, J.59. For a detailed account of Blake's Lambeth neighborhood see my "Lambeth and Bethlehem in Blake's *Jerusalem,*" *Modern Philology,* XLVIII (1951), 184–192. For evidence of the Blakes' moving to Lambeth early in 1791 (rather than tradition's "1793") and details of their other residences, see Miner, *BNYPL,* LXII (1958), 535–550.

This dating of the Lambeth move brings into greater potentially Blakean interest the fact that the secretary and chaplain of the Orphan Asylum, from 1779 to 1792 (when he sailed to America) was the Reverend Jacob Duché, who "warmly welcomed" readers of Swedenborg to the Asylum chapel—and the fact that a visitor to the Asylum in January 1793 was Blake's future patron William Hayley, who composed on the spot "A Hymn, Sung by the Orphans of the Asylum." Hayley's orphans define themselves as a "helpless tribe" who see "through tears" the comfort that "Calamity" brings them: compare Blake's Devil in "Mercy would be no more" on the advantages of inequality. J. G. Davies, *The Theology of William Blake,* Oxford, 1948, p. 33; Hayley, *Memoirs,* London, 1823, I, 444–445. (For Duché, see above.)

Gardner (pp. 121–122, 126) calls attention to a different sort of chapel, possibly of the kind deplored in *The Garden of Love* built on the common or green where children used to play. "The gardens of Hercules Buildings and of the new Bond Estate built in the fields to the south led easily into the gardens of Experience, where each man nursed his jealous desires among the symbolic myrtles and rose trees. And, indeed, in 1793, a group of property developers built the South Lambeth Chapel a proprietary chapel, the cost of building being covered by an issue of sixty £50 shares. Each shareholder was entitled to four seats. The rest of the congregation of six hundred all had to be approved by the proprietors and able to pay a rent for their seats, none being free."

"June 2. Wrote Mrs. Stedman, and trip to Mr. Mrs. Blake. . . .

"June 5. . . . London disloyal, superstitious, villainous, and infamous. An earthquake prophesied by [Richard] Brothers. Many leave town. . . . Visit Loutherbourg's painting of Admiral Howe's victory. . . .

"June 9. . . . 75 guilotined at Lyons. Insurrection quell'd at Toulon. At Salisbury, Irishmen flogg'd,—a dozen. . . . Gave a blue sugar cruse to Mrs. Blake. View Drury Lane new Play-House. . . . Dined Palmer, Blake, Johnson, Rigaud, and Bartolozzi. La Vendee & Brittany in arms.

"June continued. All infantry order'd home. . . . A riot at Birmingham. . . . Saw Deslomes, who was robb'd of above 5,000 pounds sterling, Castle Street, the Apollo gardens [opposite the Asylum], Marylebone, Madagascar bat [a spectre?] as big as a duck. . . .

"June 24. On Midsummer Day receive the first volume of my book quite marr'd, oaths and sermons inserted &c. . . . How dreadful London; where a Mr. B– declared openly his lust for infants, his thirst for regicide, and believes in no God whatever. . . . Gave oil portrait to Mr. Blake. . . . Dined at Blake's . . . Riots in St. George's Fields. I was weighed,—197 lb. . . .

". . . August. . . . The King's coach insulted. D–mn Bartolozzi. He goes away. Was at Greenwich to dinner. I also was at Lambeth Gardens [Flora's?]. . . . Met 300 whores in the Strand. French prisoners come home. . . . Saw a mermaid. Meat and bread abused. Russian fleet down. Two days at Blake's. Quiberon expedition fail'd. 188 emigrants executed. . . ."

In September, when rioting for bread and peace was at an autumn peak, Stedman in bed with a broken ankle makes this unexpanded jotting:

"All knaves and fools, and cruel to the Excess. Blake was mobb'd and robb'd."[19]

Blake continued, nevertheless, to publish copies of his now considerable stock of works, from *The Marriage of Heaven and Hell* and *Songs of Innocence and of Experience* to the several books of his Bible of Hell. He continued to print off his pictorial History of England and his prophetic picture of the doom of king and

[19] *Journal,* pp. 381–391.

counselors, as well as his ardent *Song of Liberty* and the Preludium and Prophecy of *America* without the "sick & drear lamentings."[20] Some time in the 1790's he secured a liberal and steady purchaser of new pictures in Thomas Butts, chief clerk in the office of the Commission of Musters, for whom he painted such things as Elijah riding the fiery chariot or a Lazar House dominated by suicidal Despair, in which both visionary joy and shady woe seep through the conventional surface of the hagiography. But as we know from their later correspondence, Blake dared not tell Butts all his thoughts.[21] And there is little to suggest that the few purchasers of his songs and prophecies heard "the voice of the Bard" who had written them.

By 1797–1798 Coleridge and Wordsworth had responded to "these times of fear . . . when good men On every side fall off" by becoming "The most intense of Nature's worshippers" to shelter their "visionary minds" from sneers (*Prelude* II.448 ff.). Hoping that good mountains would take the place of good men and that he might still poetize "On Man, on Nature, and on Human Life, Musing in solitude," Wordsworth remained a poet but bade farewell to "the hope to fill The heroic trumpet with the Muse's breath! (*Recluse* 740 ff.). Coleridge, having in vain "wail'd [his] country with a loud lament," said (twice: in 1796 and again in

[20] See note 12, above. Bentley demonstrates that nine copies were printed before 1799, another in that year or earlier (on "1794" Whatman paper but inscribed in 1799), and an eleventh (on "1799" paper) then or later. He groups the first six copies "1793?" and the next three "1795?"—meaning only that these cannot be *earlier* than the years queried.

Extreme conclusions used to be drawn from the fact that Blake did a great deal of work on paper with a 1794 watermark; my first edition has a cautionary note, transmitted by Edwin Wolf 2nd from the present head of Whatman's, that their firm issued no dated paper before 1800 *except* the *1794 J Whatman.*

It is sobering to note that after Bentley's careful analysis of the physical evidence he is compelled to arrange copies previously given a chronological sequence from A to P in an entirely different order: G, E, F, I, K, L, C, D, H, M, B, A[*sic*], O, N, Q, P (the last three printed posthumously).

[21] There is little foundation for the legend that Butts was a Swedenborgian. See G. E. Bentley, Jr. "Thomas Butts, White Collar Mæcenas," *PMLA*, LXXI (1956), 1052–1066. Bentley deduces from their exchange of poetical epistles and Butts's ownership of at least ten of Blake's illuminated books that Butts "fully appreciated all [*sic*] the facets of Blake's many-sided genius."

1798), turning a contemptuous phrase from Gibbon upon himself, that he was snapping his "squeaking baby-trumpet of sedition" and retiring to cultivate his own bean row. Having objectivized the dereliction and dismay of the times in an imaginatively controlled nightmare *The Ancient Mariner,* he meant to turn from poetry to "abstruse research" into psychological and final causes.[22]

Blake in 1797, according to his manuscript date, once more began "the march of long resounding strong heroic Verse" in a visionary epic called at first *Vala*—because like Wordsworth but in a different sense he too wished to penetrate the *veils* of Nature—and then called *The Four Zoas*—because like Coleridge but more apocalyptically he sought to understand the "Four Mighty Ones" in the psychic alchemy of every man (*F.Z.*i.3:2–4). But Blake did not shatter, he merely hid, his heroic trumpet. He still wrote in utter condemnation of Britain's war. He still prophesied a revolutionary millennium for England. And consequently he still wrote in fear of the shadow of Pitt's Inquisition across his page; so he marched much of his resounding verse into a furious but inconclusive battle over the question whether "Secrecy" was the necessary human dress when the human form was "Terror."[23]

The verse from Ephesians which Blake inscribed in Greek across the top of his manuscript—"For we wrestle not against flesh and blood, but against principalities, against powers, against the rulers of the darkness of this world, against spiritual wickedness in high places" (to use the King James version)—does not imply a turning away from current history but rather, in Blake's sense of "wickedness in high places," a direct contention with the spiritual forms of Pitt and King George—and Napoleon. The *Night Thoughts* had suggested the form of a "Dream of Nine Nights."

[22] I quote Coleridge's letters of October 1796 and April 1798, his *Ode to the Departing Year,* 1796, *Fears in Solitude,* 1798, and *Dejection,* 1802. The extent of government espionage and suspicion of Coleridge, Wordsworth, and Thelwall, as a *foco* of English Jacobinism, is documented in the forthcoming book of studies of Blake and Wordsworth by E. P. Thompson.

[23] This is the symbolism of *A Divine Image,* ca. 1791. The *Concordance* (Ithaca, 1968) shows Blake seldom naming "Secrecy" but always interested, increasingly after 1795, in "secret" ways. It shows him comfortable early and late with "terrors" but, after 1795, triply concerned with "terror" and "the terrific," using the word "terrified" only three times before *F.Z.* but frequently therein and thereafter.

Blake's theme was, as always, a creative ascent from present strife to millennial peace, and in broad terms the climax was fairly calculable since peace and the downfall of Pitt and Napoleon must come sooner or later. But what Blake greatly miscalculated in his republican zeal was the degree to which a mere treaty of peace or the mere fall of Pitt or Napoleon would constitute any real change for the English people. In short, never was a poem so bewilderingly attached to the shifting fortunes of principalities and powers. Each stage in the transformation of Bonaparte from artilleryman of the Republic to lawgiving Emperor seems to have delivered a direct shock to the symbolic consistency and frail narrative frame of Blake's epic. And the strange Peace of Amiens would not only catch him off guard but upset the entire seventh act of his celestial drama. In *The French Revolution* and *America* and *Europe* he had dealt with *recent* events. In *The Four Zoas* he seems to have allowed his tune to be called by events unfolding as he wrote.[24] The result is as mad as the effort to play croquet in Wonderland with living mallets and balls.

One might have thought that the epic plan and the psychological emphasis of this complex drama would have freed Blake's poetic vision from the flux of current history. But "the Ancient Man" who must wake and reunite his Zoas or divided self is still the naked multitude of England who must become One Man to defeat tyranny. Night I is focused on the history of the Israelites in Egypt, a cycle one would think ancient enough to hold its shape; yet it alters as Blake describes it, because he keeps watching the current war as a guide. It may seem to the cloistered scholar that Blake "blindly alters his intellectual foci" and is inspired by "no more than chance collision with this or that circumstance, startling him to a recognition of novel considerations."[25] But the collisions which interfere with Blake's epic plan are not the merely fortuitous phenomena of his interior life. They take place in London and Paris and on the plains of Haarlem and are reported in the *Times*.

[24] We cannot be sure; an alternative explanation would be that as Blake reworked and expanded and rearranged this and that part of his manuscript, under the compulsion of the mental and allegorical travels and reverses he was creating, he disregarded chronological sequence when he drew upon current and recent memorable events for the quasi-military conflicts and negotiations of his tale. See the next notes.

[25] Sloss and Wallis, II, 124.

Consequently, to cope with *The Four Zoas* we need to make use of all we know about the dates of composition of its various parts. Fortunately certain chronological layers of text have been discriminated by Sloss and Wallis upon careful examination of the manuscript and collation of the major shifts in symbolic theme and language. My own definition of the textual layers, based on the additional evidence of historical allusions, does not conflict with theirs but goes on to mark out more precise divisions than symbolism alone can supply.[26]

I find that the early, middle, and late portions of this composite manuscript correspond to three distinct historical phases and, as it happens, to three distinct phases in Blake's personal history. When William and Catherine Blake moved from Lambeth in September 1800 to live near their new patron William Hayley beside the sea at Felpham, I believe that a first draft of *The Four Zoas* had been substantially completed. The four portions of the present manuscript that correspond (except for scattered later insertions) to this first draft are: Nights I, II, III, IV; Night V to Urizen's repentance (about line 190); Night VII*b* (early version); Night IX (beginning with line 90). This Lambeth draft, written while England and France were at war, comprises the bulk of the manuscript and will occupy us for the present.

A second or peacetime layer consists of revisions and additions made at Felpham after the autumn of 1801, when preliminaries of the Peace of Amiens were announced, and before the renewal of war in the spring of 1803. Blake sprinkled the manuscript with emendations replacing stern prophetic wrath with exuberant Christian forgiveness and rewrote the conclusion of Night V, all of

[26] Unfortunately, "all we know about the dates of composition" is rather less than it seemed when I wrote this confident paragraph and organized the following chapters with reference to a chronology more precise than the evidence of the manuscript will support. Fortunately, nevertheless, most indications are that the dates of the extant manuscript pages were later, not earlier, than I had supposed; so there is at least little probability that I have assigned apparent historical allusions to events that had not yet taken place. See G. E. Bentley, Jr.'s edition of *Vala or The Four Zoas*, Oxford, 1963; my review of it in *The Library*, xix (1964 [1968]), 112–129; and E737; also my "Dating Blake's Script: the 'g' hypothesis," *Blake Newsletter*, June 1969.

It seems best, then, to leave this part of the book as a hypothetical structure, adding notes of caution and correction along the way.

Night VI (incorporating or discarding the early draft), and all of Night VII*a* (but keeping both drafts) as well as the first eighty-nine lines of Night IX.

The latest portion of the manuscript, including the only extant draft of Night VIII, was quite evidently written after and against the mad renewal of war,[27] for Blake considered the rupture of the Peace of Amiens a cosmic betrayal, which was shortly aggravated by his having to stand trial for treasonous utterance. The Felpham sojourn was likewise ended. Now Blake added to his title a reference to "the torments" of the Ancient Man—who was coming to feel more like Job than like Adam. And he made some scattered emendations in all the Nights. But ultimately he abandoned the attempt to bring *The Four Zoas* up to date, and he never engraved the work. *Milton,* a different sort of poem (dated "1804" and first published in or after 1808, yet possibly begun at Lambeth) can hardly have been thought of as taking its place. *Jerusalem,* however, (dated "1804" but completed much later) incorporates material from the whole span of Blake's work, including *The Four Zoas,* and is evidently his final effort, during the second war period, to fuse living and ancient history into a single prophetic epic.

Approached from any direction the illuminated manuscript of *Vala or The Four Zoas* is undeniably a formidable composite. It contains some of Blake's greatest poetry and some of his boldest mental grappling. But no orderly synopsis can do justice to the real, if arguably intentional, disorder of the work itself. In the decade after 1795 Blake's universe twice reversed its laws of motion, and if we wish to understand those changes and the songs and tirades with which Blake responded to them, there is nothing for it but to retrace the record of his hopes and fears, to go through the manuscript in the apparent order of Blake's personal and historical allusions, not in the order that his scheme of Nine Nights imperfectly imposed upon it.

3

I have been commanded from Hell not to print this. . . .
— Marginalia to Watson

[27] This dating of Night VIII ca. 1804 has been accepted by all parties.

In 1795–1796 Blake was instructing congenial George Cumberland in the process of engraving plates for his *Thoughts on Outline,* which Blake justly considered a "beautiful book" when it came out.[28] Cumberland could engrave his own simple drawing of Apollo in a hammock, for Ovid's lines on the Golden Age, but Blake engraved the more complex picture of violent combat with torch and dagger, illustrating the Iron Age when "cursed steel & more accursed gold Gave mischief birth & made that mischief bold."[29] The choice of subjects was apt for the poet who was planning his own epic of man's fall from Golden to Silver to Bronze to Iron Age, into the deepest pit of which he now believed "ancient Albion" had come. Fondly Blake thought of his friend in Windsor Park as living far from the chartered streets in a "secret forest," and he believed the simple integrity of Cumberland's drawings would make manifest to the world the relation of freedom and peace to creativity: "Now you will, I hope, shew all the family of Antique Borers that Peace & Plenty & Domestic Happiness is the Source of Sublime Art, & prove to the Abstract Philosophers that Enjoyment & not Abstinence is the food of Intellect."[30]

Cumberland had to report that his society was just as spy-ridden as Blake's. He no sooner sat down in a coffee-room and "ordered my breakfast than some strange but well dressed man would seat himself on the opposite side of my box." He would *like* "to find some tranquil spot on the globe where the accursed politicks of Europe are unknown," a "lodge in some vast wilderness," to quote Cowper. But, Cumberland wrote, "I know no news, but that *Great Britain!* is hanging the Irish, hunting the Maroons [in Jamaica], feeding the Vendee [French royalist insurgents], and establishing the human-flesh trade—as to our war of Religion, virtue, and humanity; its success seems to equal its pretentions."[31] Such talk—for Cumber-

[28] Blake to Cumberland, Dec. 23, 1796. Cumberland's preface is addressed to the Whig leader Charles Fox, who, "if he should again accept the helm, is capable, under Providence, of re-conducting into harbour the mismanaged vessel of the British state, strained, indeed, but not quite ruined, shattered, but not, I hope, out of the reach of repair."

[29] See Wright, I, 76–77 and pl. 21.

[30] To Cumberland, Dec. 23 and Dec. 6, 1796.

[31] This is the final sentence in a letter of March 25, 1796, from George Cumberland to his brother Richard, in British Museum MS 36498, f. 74. Another Cumberland letter, quoted as of 1792 or 1793, expresses a pes-

land and Blake were apparently seeing a good deal of each other—takes us directly into the mood of Blake's night thoughts as they are expressed in *The Four Zoas* in his new myth of Tharmas, the god of communication, who is wretched outside Eden and whose proper food is "Enjoyment & not Abstinence."

Tharmas the tongue, whose "Gate" is the ear,[82] symbolizes communication of many kinds—verbal, sexual, and perceptual, touch being the most exacting witness of external reality, the "doubting Thomas" of the senses.[83] Much of the epic is taken up with the Tongue's plight in exile and under censorship, an aspect of Blake's own predicament after 1795. His tongue clamors to speak out; his reason seeks to enforce silence. The conflict is uneasily resolved by a compromise *which is this poem.* The tongue has its way, for Blake does write. But reason wins too, for he writes in ambiguous words and does not print. The deeper fact of censorship, however, is not that the prophet is inhibited but that the "citizens in leaden gyves" have stopped listening, their "Auricular Nerves" having become paralyzed.

As defined in the opening lines, Blake's larger theme is Man's

> fall into Division & his Resurrection to Unity:
> His fall into the Generation of Decay & Death & his
> Regeneration by the Resurrection from the dead.[84]

And the whole tangle of conflicts between prophet and writer, desire and reason, outcry and silence, is ultimately subordinated to the fact of human bondage. As a psychological god, Tharmas is the "Parent power," because sexual communication is the beginning of generation. At the same time the division which sex implies and which makes communication necessary marks a fall from perfect unity. In Rousseau's account, still relevant, the first social

simism which Blake's friend doubtless continued to feel: "It would be safer to write one's sentiments in Turkey or Venice than in this unfortunate Island—where the inhabitants are rushing blindfold to total ruin—and lick the hands just raised to shed their blood."

[82] *F.Z.*i.5:43; early readings: "the Gate of Auricular power," "the Gate of Auricular Nerves" E299, 740 (variants not shown in K267:108). Cf. *Hamlet* I.v.67: "Gates and alleys of the body."

[83] "Doubting . . . Tharmas" is mentioned in *F.Z.*iv.48:21: E325/K298. Tharmas has been identified as touch and sex and Father Thames by previous scholars, but the further suggestions below are largely my own.

[84] *F.Z.*i.4:4 and del. following: E297, 740/K264:21–23. (The deleted line was inadvertently omitted from the first two printings of E.)

cause of inequality was the application of reason leading to the discovery of iron; but behind that lay the discovery of speech, which led man to cultivate his reason in the first place. In Blake's account, the *fall* of speech (Tharmas) precipitates the fall of man from "Universal Brotherhood" into the age of iron, where he is a slave to the repressive laws of reason (Urizen).

In Pitt's England, Tharmas is the journalist or pamphleteer who utters boldly his honest alarm as the times grow worse and who is primarily concerned with immediate questions.[35] He is the father of Los, the editorial or prophetic spirit, who takes a more inclusive view. Tharmas is the commentator who must publish at once in some fashion or cease to exist. Los, concerned primarily with true vision or correct formulation, can almost resign himself to delays in publication if he can keep himself alive meanwhile by such hackwork as engraving (represented as blacksmithing). Yet his conscience (Tharmas as *vox populi*) reminds him that vision without communication is barren, and again Los and Tharmas quarrel, as they must so long as there is "the odor of War in the Valley of Vision."[36] In contemporary England if Los represents the position of Blake as a prophet who keeps his revolutionary vision in silence, Tharmas represents the position of Tom Paine, the critic of British monarchy whose voice is still published despite the jailing of his booksellers, but whose life is sustained in exile.

In Night I fallen Tharmas quarrels with his "emanation" or that portion of nature which supplies his inspiration and bears his children—his shadowy female, here called Enion. When we think of Tharmas as the writer, we may call Enion his subject-matter and also the industry (or daughter of Albion) that publishes (gives birth to) his works. In the Golden Age she was infinitely beautiful and dutifully obedient; together they produced beautiful children. Now the children are "Lost! Lost! Lost!" or "murdered" by censorship, or they have become such harlots that Tharmas is "distracted at their deeds."[37] His alternatives are to hide his ideals (the promised Jerusalem) in silence or in labyrinthine allegories that more conceal than reveal (as Blake has done), or to leave

[35] "Every honest man is a Prophet; he utters his opinion both of private and public matters. Thus: If you go on So, the result is So." Marg. to Watson, 14: E607/K392.

[36] J.22:9: E165/K645; cf. F.Z.i.4:22–28: E298/K265:41–47.

[37] F.Z.i.4:8, 38–39.

England for "a far distant Grove" (as Priestley and "Tharmas" Paine have done), or to take for mistress the world-as-it-is, Enitharmon the whore.[88]

No course is tolerable. Silence means the Tongue's "self-murder," but the temptation to publish may lead to death in another way:

> O Enion thou art thyself a root growing in hell
> Tho thus heavenly beautiful to draw me to destruction
>
> (i.4:38-39)

Unable to collaborate except "in burning anguish," Tharmas and

[88] Several layers of revision complicate the text here. See E740. A first layer can only fragmentarily be recovered.

A second version went approximately like this: Tharmas' children (called emanations in a usage later abandoned) are lost, and he fears that Enion, his wife (called his emanation in later usage) will also be taken from him; that is, the Tongue or Poetic Genius, accustomed before the fall to speak the praises of a glorious world to which he is wedded, now sees the children of that union, his poems, "Lost! Lost! Lost!" He fears that in falling he is being divorced from his wife, from ideal Nature. "I have hidden thee Enion in Jealous Despair," he says; "I will build thee a Labyrinth where we may remain for ever alone." She, too, wishes to be hidden; but they part in mutual recriminations over the loss of the children.

A change in the 10th line of this version introduces Enitharmon (i.e. Enion plus Tharmas before their separation) as the person or concept which Tharmas has tried to hide in his bosom in the fallen state; but he will build a Labyrinth for Enion "also." (Whereupon, apparently, Enion is jealous that he seems to prefer the ideal wife of Eden to his present separated wife.)

The third or final version replaces Enitharmon in *this* connotation with the new concept, Jerusalem, but retains Enitharmon as a symbol of the present night of nature in a fallen state (as in *Europe*), a personification of the condition in which nature rules man, as contrasted to the state of Eden in the past or Jerusalem in the future when man, as proper Earth-owner, rules nature. This latest symbolism permits Blake to give the writer (Tharmas) two sources of inspiration—a wife (Enion) from whom he is separated but who keeps alive for him the ideal of Eden or Jerusalem; and a mistress (Enitharmon) who compels him to follow the mischievous strife of history and thus at least keeps him from expiring in silence.

Blake's characters, however, refuse to keep to their assigned roles; the story is later complicated when Enitharmon, giving birth to Orc, becomes a changed woman, hopeful of finding Jerusalem in *her* dreams, i.e. in the womb of history. At this stage Enitharmon becomes (or supplants) Enion, functionally if not textually.

Enion separate, not to meet again until after the war: "Return O Wanderer when the Day of Clouds is oer."[39] In other words the "heroic Verse" which Blake is marshaling for the day of intellectual battle is not to go into action until the "war of swords" has departed, as Blake indicates at the end of Night IX.

The fact that we can find this same debate in the prose of Paine and Blake in 1797–1798 supports my conjecture that the spirit of Thomas Paine is one ingredient of the Tharmas symbol. Indeed the debate seems to have been touched off in Blake's mind by the words of Paine himself. In the English edition of his *Agrarian Justice* (1797) Paine announced that he "had not determined whether to publish it during the present war, or to wait till the commencement of a peace." But his indignation had been aroused by the title of a sermon "preached by Watson, Bishop of Llandaff," on "The Wisdom and Goodness of God, in having made both Rich and Poor."[40] Publication of *Agrarian Justice* would serve as Paine's refutation of the "error contained in this sermon," which he had found listed at the end of Watson's attack on him entitled *An Apology for the Bible in a Series of Letters, Addressed to Thomas Paine*. Paine added that a reply to the Bishop's *Apology* would be forthcoming.

In response to Paine's preface, evidently, Blake obtained a copy of Watson's *Apology* (in the 1797 edition) and filled its margins with material for a good blasting defense of Paine to be published, according to Blake's heading, as "Notes on the B of L's Apology for the Bible by William Blake." To defend Paine as the voice of "the Holy Ghost" against Watson as "a State trickster" with "cloven foot" would be to risk trial for seditious treason, for Blake recognized in the Bishop "an Inquisitor" of the official "State Religion." "To defend the Bible in this year 1798," he acknowledged, "would cost a man his life." Why? "The Beast & the Whore rule without control." Blake's employer Joseph Johnson was imprisoned "in this year" for publishing the works of the Rev. Gilbert Wake-

[39] *F.Z.*i.5:12 and line 3 of passage replaced by 7:1–2: E742 (i.e. K266:75; 269:181).

[40] Paine, i, 609. Paine's retort—"It is wrong to say God made *rich* and *poor;* He made only *male* and *female;* and He gave them the earth for their inheritance . . . [sic]"—was censored in London, as these dots indicate. Presumably he went on to argue the right of male and female to be earthowners—i.e. of Los and Enitharmon to unite in Urthona.

field, a milder radical than Paine—or Blake.[41] "But to him who sees this mortal pilgrimage in the light that I see it, Duty to his country [i.e. the true Patriot's kind of duty] is the first consideration & safety the last."[42]

Why then did Blake not publish? Paine, Blake, and Wordsworth were all moved to write replies to the Bishop of Llandaff; only Paine dared publish—from Paris. Blake's devils explained to him that it was bad strategy. At the end of his prefatory "Notes" he added: "I have been commanded from Hell not to print this, as it is what our Enemies wish."

One of the purposes of the notes Blake did not print, however, is the exposure of "the English Crusade against France" (p. 2) and the "wicked" notion that God ever makes one man or one nation "murder another" (p. 6). What sort of strategy can Blake's be that makes peace a prerequisite to the circulation of pleas for peace? Elsewhere (in contemporaneous notes on Bacon's *Essays*) Blake insists that intellectual war is a *means of ending* corporeal wars and is a force that "shall in the end annihilate" kings and wars. We are tempted to ask, with Bacon, whether "Good thoughts" are in themselves much better "than good dreams"? Blake's answer is evasive: "Thought is Act. Christs Acts were Nothing to Caesars if this is not so." Yet Christ did not hide his thoughts but transformed them into acts, "Cursing the Rulers before the People," and sending "His Seventy Disciples . . . Against Religion & Government" to fall "by the Sword of Justice," as Blake was wont to observe.[43] In his Watson notes Blake puts Paine in a class with Jesus as "worker of miracles," for he had been able to "overthrow all the armies of Europe with a small pamphlet (p. 13)," presumably *Common Sense*. Then why should not Blake try the effect of a small pamphlet—or seize his furious harp? The question reverberates endlessly through *The Four Zoas*.

[41] "Johnson was . . . sentenced to imprisonment in the King's bench for nine months; but his business went on as usual. He occupied the Marshal's house, was visited by sympathisers, including Blake, one supposes, and gave his weekly dinners there instead of in the queer-shaped room in St. Paul's Churchyard." Wright, 1, 89. Johnson went to prison Nov. 15, 1798. Godwin's diary confirms the continuation of Johnson's dinners but not Blake's presence at them. Godwin attended less often than once a month, however.

[42] Marg. to Watson, E601/K383.

[43] Marg. to Bacon, p. 44: E612/K400; *Everlasting Gospel*, 52–54, 69, and i.37–39: E511, 794/K752, 757; cf. *M.H.H.*23. And see Schorer, pp. 165–167.

At one point we are told that Albion lies "sickning" and refuses "to behold the Divine Image which all behold and live thereby."[44] It is not objectively true that English eyes and ears were entirely closed; Erskine's pamphlet criticizing the war was "very universally read" in 1797 and ensuing years,[45] and there was still an audience for Paine and Thelwall. But Blake's own prophecies did lie unsold "in the desolate market where none come to buy."

At another point we are advised to take comfort from the thought that no one can obey Urizen's iron laws, that censorship has been introduced in England too late to be effective. Urizen, once having permitted ideas of freedom to enter the thought-processes of his kingdom (having allowed Luvah to drive the horses of instruction), has had poor luck with his "curbs of iron & brass." Even going to war with France has not sufficiently distracted the intellectuals of Britain, by building "iron mangers To feed them with intoxication from the wine presses of Luvah." Blake may have in mind the fact that some of the best legal minds, Erskine for example, defended the London Corresponding Society leaders in the trials of 1794 and that English juries acquitted them. "They rowze thy tygers Out of the halls of justice." Urizen could keep the upper hand by building new "dens" with the gagging and jailing acts of 1795, but Englishmen were not pleased with the result: "O how unlike those sweet fields of bliss Where liberty was justice & eternal science was mercy!" (iii.39:3–11).

Such tyranny is self-defeating. It drives out pleasure (Ahania); its "thundrous throne" becomes so "petrific" as to break the "bounds of Destiny"; and once more "all comes into the power

[44] *F.Z.*i.11:10 f.; deleted passage, E745/K272.

[45] Wrote William Hayley, in his diary for Feb. 20, 1797 (*Memoirs*, I, 479): "Thinking, from the infinite popularity of Erskine's pamphlet against the war, that the mind of England may take a new and juster direction, I have thoughts of pursuing my poem on national hostility [begun after a visit to France in 1790]; as there may be now a chance of its proving of some little use to the interests of humanity. . . ." But Hayley's was the sort of "benevolent" work he could safely address "to his friend, the Bishop of Llandaff."

Yet even Erskine, though a prominent Whig, had not been immune from Rintrah's wrath. In January 1796 for protesting against the gagging acts he had been ousted from deanship of the Scottish Faculty of Advocates by Pitt's man Dundas. See the stanzas by Robert Burns.

of Tharmas" because Urizen has lost his moral if not his physical grip.[46]

Here again, however, the conclusion is inconclusive. The time is one of war-weariness (such as 1795 or 1799) but also one of utter "Confusion" (such as the years between). Since the people have "put forth Luvah" from their presence (41:17), rejecting the ideas of brotherhood and of peace with France, they have no criteria:

> Whether this is Jerusalem or Babylon we know not
> All is confusion All is tumult & we alone are escaped[47]

At such a time Tharmas the Cynic sees only one honest thing to do: to curse the rulers before the people, both the British rulers and the French rulers, for both have subverted the values on their own banners: "The all powerful curse of an honest man be upon Urizen & Luvah." Out of his love for reason (honesty) and for brotherhood (love) Tharmas must curse their simulacra. "Love & rage," he concludes, are "the same passion" since "they are the same in me" (iv.48:2; 47:18).

Yet criticism alone is chaos. The tongue's hatred of things-as-they-are is so extreme that it quarrels with the very column of air that gives it voice. Dependent upon the present world (Enion) for "Love and Hope," Tharmas dwindles to "nothing but tears . . . Substanceless, voiceless, weeping."[48] The power of his furious honesty must be transferred to the Poetic Genius, to Los as that part of fallen man that remembers the "loss" of brotherhood and can restore and rebuild Jerusalem. Observing in mother earth the "lineaments of ungratified desire," Tharmas urges Los and Enitharmon (the prophet and *his* emanation) to "Rebuild this Universe beneath my indignant power" and "Renew these ruind souls of Men." The mental war must *not* wait. "Go forth!" (iv.48:4–7).

Yet Los the son of Tharmas is like Blake the friend of Paine; he can cry "Well done Paine,"[49] but he cannot "print this." It

[46] F.Z.iii.43:25–28; iv.51:13: E322, 327/K295:123–127; 301:130.

[47] iii.42:12 ff., lines added when Blake was revising the page for use in *Jerusalem* (and thus a very late interpretation of this section). See E751.

[48] iii.46:1–5: E324/K297:200–204. On Tharmas as Chaos, see Frye, pp. 280–283.

[49] Marg. to Watson, 109: E608/K395.

is just when he is most needed that the prophet hurls down his harp. Under the illusion that he is more "powerful" as Los than as "Urthona, keeper of the gates of heaven," he tries to go on alone; yet in lonely fear and terror "at the Shapes Enslavd humanity put on" he descends to "Raging against Tharmas his God, & uttering Ambiguous words, blasphemous."[50] When a *modus vivendi* is finally arrived at, with the advice of Tharmas, it is only a recognition after all that the fallen cannot stand erect.

4

. . . only remit not, faint not. . . .

The incompatibility of Tharmas and Enion is repeated in the conflict between Los and Enitharmon, but with a difference. The honest man's curse has made it impossible to accept Pitt's England as if it were the "sweet world Built by the Architect divine"; yet the poet's inspiration (Enitharmon) while desiring to live in the sweet world of hope must somehow live in the bitter world of reality. Honest Blake may not be able "to feed five thousand men with five loaves" or like Paine to "overthrow all the armies of Europe with a small pamphlet." But he can keep himself and his good wife alive by working such miracles "as both astonish & comfort me & mine."[51] His expedient is a split personality. Among the "dislocated Limbs" of the earlier fall from paradise or division of labor that isolated the imaginative poet (Los) from the productive laborer (Urthona), the dark "Spectre of Urthona" is now recovered to perform the labors necessary to keep Los and Enitharmon in food and lodging. Unable to reunite on this side of paradise, the poet and worker can at least collaborate.[52]

[50] *F.Z.*iv.48:18–20; 53:23–25: E325, 328/K298:41–43; 302:202–204.

In issuing his biography of Milton the republican, Hayley, in a preface dated October 29, 1795, says that Gibbon and Warton both held it incompatible with the duty of a good citizen to republish "in the present times" the prose of Milton because it "might be productive of evil." But Hayley is inclined to think the worst of the Antijacobin panic now over. Hayley, *Life of Milton,* "second edition," London, 1796, pp. vii–viii. The first edition, 1794, was toned down because one of the publishers thought it too democratic. Hayley, *Memoirs,* I, 450–451.

[51] Marg. to Watson, 12–13: E606/K391.

[52] *F.Z.*iv.49:12: E326/K299:64.

Henceforth Blake the prophet must rely more heavily on Blake the engraver than he had wished. He must let his Spectre push the cuts of copper with his graver to make channels for ink (drive "his solid rocks before Upon the tide") to put a World "underneath the feet of Los" and bring a smile of hope to his "dolorous shadow" Enitharmon (iv.51:7–10). More than once the surly blacksmith has kept man and wife from "rotting upon the Rocks" and put marrow into their bones. Even journeywork can be pleasant:

Go forth said Tharmas works of joy are thine obey & live
So shall the spungy marrow issuing from thy splinterd bones
Bonify, & thou shalt have rest when this thy labour is done[53]

The political meaning is that to keep man alive the prophet must divide his energies to cope with the division of man in slavery. Putting the best possible face on his own choice, Blake treats it as a ritual choice involving a transformation of society. His decision *not* to act is defined as a determination that he *must* act. If he is commanded not to print his own death-warrant, he is also commanded to keep hope vigorous, to perfect his art, and to make ever surer (for "Thought is act") his vision of the Jerusalem that must replace Babylon:

Take thou the hammer of Urthona rebuild these furnaces . . .
Death choose or life thou strugglest in my waters, now choose
 life
And all the Elements shall serve thee . . .
. . . only remit not faint not thou my son (iv.51:32–52:5)

When Orc was a dragon-killer inspiring Paine, Washington, and Franklin, the poet's job was to some extent descriptive or journalistic, to call attention to what the "warlike men" were doing. Now he must combine the constructive ingenuity of the blacksmith and the millennial vision of unfallen Urthona.

In one sense Blake's task is to reunite Tharmas with Enion, the language with its communal meaning. Tharmas is not at all happy with his fallen role as chaos, a satirist constantly engaged in negative criticism of "the monstrous forms" that breed in the absence

[53] iv.50:24, 49:15–17. This whole section is rich in symbolic autobiography as can be seen when it is put beside the letters of 1799–1804.

of true vision. He would like to get back to the Garden of Eden. But man cannot do so by the tongue alone. "The Sea encompasses him & monsters of the deep are his companions."[54] In order to overthrow tyranny he must comprehend the motion of history and master the rhythm of its pulsations. Los must patiently forge

> under his heavy hand the hours
> The days & years, in chains of iron round the limbs of Urizen
> Linkd hour to hour & day to night & night to day & year to year
> In periods of pulsative furor. (iv.52:29–53:3)

Los (Time) is sorry to hurt Enitharmon (Space)[55] in establishing the geography of these cycles, but he enjoys chaining tryanny down to dates and places; the necessity of the operation gives him a sense of satisfaction, "fuel for his wrath And for his pity." His assistant the Spectre is a simpler fellow, who weeps when he pours "the molten iron round the limbs of Enitharmon" but laughs "hollow upon the hollow wind" when he pours it "round the bones of Urizen" (53:13–18).

Yet all Blake's bardic fortitude is not enough for the fearful symmetry of the historic cycle. When in his binding of Urizen "in chains of intellect" Los becomes what he sees and what he is "doing" (defined in later revision, lines 55:10–56:27, as reaching the Limits of Opacity and Contraction: Satan and Adam), he goes "Mad" and in his frenzied cursing lets the anvil cool and the furnaces go out.[56] When he comes in his review of history to the day when the emotion of revolt is born in space—when Orc springs from the *heart* of Enitharmon though not yet from her womb—his response is to take the babe in his hands and go "Shuddring & weeping thro the Gloom & down into the deeps."[57] Orc then reaches puberty and begins "embracing his bright mother" to conceive the historical birth of modern revolution (1776—the story is a recapitulation of the Preludium of *America*); where-upon Los, reading his own destruction in the boy's eyes, binds him

[54] See all of iv.51:17–33: E327–328/K301:134–150.

[55] See i.9:27–29: "He could controll the times & seasons . . . She could controll the spaces, regions. . . ."

[56] iv.56:19–55:16–23; v.57:1–17.

[57] v.58:17; 59:24. The time must be 1762.

to the rock of law with chains of jealousy. For "in dark prophetic fear . . . now he feard Eternal Death & uttermost Extinction" (v.60:8–30; 1–2).

Looking back from 1798, "this time Of dereliction and dismay" as Wordsworth called it, one might well wish the whole cycle had never begun. Yet almost immediately Los repents and resolves to free Orc and bring joy to the world "Even if his own death resulted, so much pity him paind." In short "Duty to his country is the first consideration & safety the last."[58] Nevertheless Los does not free Orc, for he cannot. Orc's young limbs have "strucken root into the rock." Not "all Urthonas strength nor all the power of Luvahs Bulls" can "uproot the infernal chain." Though willing to risk "his own death," the prophet alone cannot halt the process of 1798. Nor does the strength of the people or the revolutionary energy of France seem able to prevent the rulers of Britain and France from continuing their infernal war. Orc chained to the rock is not the human fire of 1776 or 1789 but an "iron hand" which, having "crushd the Tyrants head" has become "a Tyrant in his stead."[59] We need not take this as a fatalistic generalization but as a description of the period.[60]

[58] v.62:20; Marg. to Watson: E601/K383.
[59] v.62:22–32; *The Grey Monk*, N.12: E481/K431.
[60] For a suggestive brief discussion of the influence of a time of "frustrated revolutions" on the styles of Fuseli and Blake, see Antal, ch. iv.

15. The Lion & the Wolf

The Four Zoas contains two apparently unrelated myths, not to mention subsidiary related ones, and in terms of any attempt to systematize their symbolism on all levels these myths are justly considered "a loose congeries."[1] But on the historical level they are related as the subjective and objective difficulties of the historian writing of his own times. In the myth of Tharmas and Los are the inner grievances of reporter and poet; in the myth of Urizen and Luvah, often thrust into the text without transition, we can find the current history which gives rise to those grievances—the history of military and diplomatic relations between Britain (Urizen) and France (Luvah, land of Love).

The news conveyed in Night I is that peace negotiations have failed and that war continues to rage without quarter. "Ambassadors from Beulah," coming in tears to appeal to the Universal Family (or friends of Albion), describe a bellicose parley between the two powers which has broken down with the result that both Shiloh and Jerusalem, the tabernacles of French and British liberty respectively, are in ruins.[2]

The word "Ambassadors" is our clue to the ensuing dialogue,[3]

[1] Sloss and Wallis, I, 142. Blake's symbolic organization is, in a sense, anti-systematic.

[2] *F.Z.*i.21: E306/K277:469 ff. The Ambassadors kneel in "Conway's Vale," where the Bards prostrated Edward I and his army. Beulah is the moony threefold Eden, the highest realm of integration attainable during the "night of Nature" before man becomes fully unified as earth-owner and sun-viewer in fourfold Jerusalem. Shiloh, the site of the tabernacle, "dwells over France, as Jerusalem dwells over Albion." *J.*49:48.

[3] The Urizen-Luvah matter in Night I is an insertion doubtless later, physically, than I had supposed; yet it may have been, like some other "late" manuscript additions, a transfer from early but deleted or replaced parts of the MS—as for example the "Victory & . . . blood" passage of page 12. (See H. M. Margoliouth, *William Blake's Vala*, Oxford, 1956, pp. 168 and 170, but also E746.) After 157 lines of Tharmas-Los matter Blake inserted two leaves containing the Ambassadors' report (pages misnumbered 21, 22, 19, 20), and he marked a sequent four and a half

a spiritual digest of the unsuccessful peace negotiations of 1796 and 1797 between Britain's ambassador, Lord Malmesbury, and representatives of the French Directory. While Pitt, especially in the 1797 negotiation, had been willing to concede much, the public effect of the breakdown of these talks was to demonstrate the intransigence of both belligerents.[4]

The chief British demands were a return of Holland to her former status as British satellite and a cession to Britain of certain important Dutch and Spanish colonies. In return Britain would restore to France the seized Indies and India territory. The chief French demands were the restoration of some (after Fructidor, all) French, Dutch, and Spanish colonies; and unequivocal recognition of the French Republic, including a stipulation that King George must henceforth desist from the practice begun by Edward III of calling himself "King of France." Further grievances of the Directory were Jay's treaty of amity and commerce between Britain and the United States and a British Order in Council directing the seizure of ships carrying supplies to the Continent. British ships were carrying out the order, as well as applying the seizure and compensation clauses of Jay's treaty, with rigor. By 1798 there was actual naval warfare between America and France while the British talked of a lend-lease arrangement to supply British battleships to the United States.

These major points are covered in Blake's dialogue. Urizen's

sheets of Tharmas-Los matter for transfer to "Night the Second." E and K retain this matter (from MS p. 9, line 34, through p. 18) in Night I. Sloss and Wallis and the new Longmans *Annotated Blake,* ed. W. H. Stevenson and D. V. Erdman, London, 1970, make the transfer. (This chapter follows E and K.)

Even though the insertion may have been written several years later than 1796–1797, no later public negotiations occurred to supply variant accounts before the sudden announcement of peace, October 1801. The idea of "Ambassadors" may derive from that later time, when a French ambassador was in London; the basic historical drama is that of 1796–1797.

[4] On the one side George III had allowed Pitt to open negotiations on the theory that "the refusal which most probably will ensue may rouse men's minds and make them more ready to grant supplies of men and money"; on the other, the coup d'état of Sept. 4 (18th Fructidor) removed the more pacific members of the Directory and led to a stiffening of French demands. The mixture of sincere and insincere professions on both sides is still under discussion. See Barnes, *George III & William Pitt,* ch. vii; Crane Brinton, *A Decade of Revolution, 1789–1799,* New York, 1934, ch. ix; Laprade, *England and the French Revolution,* pp. 177–179.

proposition to Luvah is that if neither of them arouses the people sleeping in hill and valley each may "erect a throne" and live "in Majesty & Power." "Deep in the North I place my lot, Thou in the South." Britain wants a secure hold on the Netherlands but will recognize Napoleon's conquest of Italy and even give up most of the captured South Sea Islands. Between 1796 and 1798 the British fleet was withdrawn from the Mediterranean. Bend your "furious course Southward," suggests Urizen, perhaps not without a touch of sarcasm:

> I, remaining in porches of the brain[5]
> Will lay my scepter on Jerusalem the Emanation [of Liberty]
> On all her sons & on thy sons O Luvah & on mine
> Till dawn was wont to wake them

i.e. on the Americans, who were Britain's sons before the Revolution. Urizen has no doubt his

> strong command shall be obeyd
> For I have placd my centinels in stations each tenth man
> Is bought & sold & in dim night my Word shall be their law
> (i.21:29–35)

For England the sentinels of reaction were established by the government's "Defence of the Realm" bill of 1798, which legalized and encouraged the formation of loyal associations of armed "constitutional guardians." As for France, one of the members of the Directory, Pichegru, was known (after Fructidor) to have been in Pitt's pay. Luvah's Satanic reply stresses the question of recognition of French sovereignty and alludes to the arming of American privateers:

> Luvah replied Dictate to thy Equals. am not I
> The Prince of all the hosts of Men nor Equal know in
> Heaven
> If I arise [and go South] . . . wilt thou not rebel to my laws
> remain
> In darkness building thy strong throne & in my ancient night

[5] We are reminded that the whole drama of history is taking place inside man's skull. Here the British Isles are the head, continental Europe the body. Blackstone, p. 252, calls attention to the concept in Bacon of a "Confederacy" contracted between two faculties, Reason and Imagination, against a third, the Affections.

Daring my power wilt arm my sons against me in the Atlantic
My deep My night which thou assuming hast assumd my
 Crown.[6]

The new France, boastful of the superiority of its "hosts," scorns
negotiation and is not merely suspicious of British concessions but
no longer interested in mere Equality. Luvah, alluding apparently
to the coup of 18th Fructidor, in which the moderates were
ousted from the Directory, perhaps conflated with Napoleon's coup
of 1799, declares that he has his own methods for keeping the
people from waking:

I will remain as well as thou & here with hands of blood
Smite this dark sleeper in his tent then try my strength with
 thee[7]

After the parley Urizen silently meditates "Eternal death to
Luvah," while the latter hurls Urizen's own weapons—perhaps a
reference to the weapons of tyranny, but possibly an allusion to
French collaboration with the insurrectionists of Ireland.

Urizen's next act is to do just what he said he would not do,
withdraw his northern troops. This is inexplicable to editors seeking
mythological consistency, but it is precisely what Great Britain was
forced to do to end the ill-fated campaign into the Netherlands
in 1799. The disaster was so complete by October that when King
George was asked for "farther instructions" they proved to be "for
the immediate evacuation of Holland."[8] Here is Blake's rendition:

But Urizen with darkness overspreading all the armies
Sent round his heralds secretly commanding to depart
Into the north. Sudden with thunders sound his multitudes
Retreat from the fierce conflict all the sons of Urizen at once
Mustring together in thick clouds leaving the rage of Luvah
To pour its fury on himself & on the Eternal Man

The Ambassadors of Beulah sum up the state of affairs by de-
claring that, with one tyrant ruling the north and another the

[6] F.Z.i.22:1–8; E307/K278. Note the perversion here of Orleans' advice in
F.R.190–194.
 [7] i.22:9–10. In i.11:9 Vala's "weeping for Luvah, lost in the bloody
beams of [Enitharmon's] false morning" is apparently an allusion to the
Thermidorean reaction after the fall of Robespierre (Fuzon?).
 [8] Bisset, II, 668–669.

south, the people are left in "a fierce hungering void" and Liberty
in both England and France is in utter collapse:

> Jerusalem . . . is become a ruin
> Her little ones are slain on the top of every street
> And she herself le[d] captive & scatterd into the indefinite.

This would seem to be a proper time for Albion to arise, and the
envoys appeal to an apocalyptic Christ for action:

> Gird on thy sword O thou most mighty in glory & majesty
> Destroy these opressors of Jerusalem & those who ruin Shiloh
> <div align="right">(i.22:32–37; 19:1–5)</div>

But "The Family Divine" can only offer to shelter "the Mes-
sengers in clouds around Till the time of the End"—which will
not come till Night IX and the Last Judgment. This sheltering,
equivalent to the self-censorship of Blake and the forced retreat
of such orators of liberty as Thelwall, whose meetings were broken
up by "loyal" mobs and magistrates and who finally retired to
Wales in 1797, gives divine sanction to democracy's retreat under-
ground.[9]

This historical sanction is supplied by the fact that the dawn
of 1789 and the fiery noon of 1793–1794 have been succeeded
by the dark night of 1797–1799. We have observed how the poet
shrank from his task in moments of despair, and it has been com-
monly noted that *The Four Zoas* holds evidence of considerable
revision of values. We must not mistake Blake's description of his-
torical changes, however, for a "criticism of his own earlier
faith."[10] When Blake reports deteriorative changes in Orc-Luvah
he is criticizing not "the French Revolution" but the Bonapartism
that followed and in a sense negated it.

[9] The fact that Thelwall and other radicals sought refuge in Wales may
also have influenced Blake's choice of Conway's Vale and High Snowdon for
the retreat of his Ambassadors of Beulah. In the first draft he had put down
Biblical sites, the valley of Beth Peor and Mount Gilead. Margoliouth, in
Review of English Studies, XXIV (1948), 305, notes Blake's "inversion" of
his Biblical source, Psalm 137:8, 9.

[10] Sloss and Wallis, II, 198, suggest hesitantly that the role of Luvah in
Jerusalem contains an uncertain "allusion to France and the French Revo-
lution, which may embody Blake's criticism of his own earlier faith." Schorer,
pp. 310, 339, develops the idea but is hampered by his assumption that
the historical content of Blake's myth does not extend beyond 1789.

2

Before we go on to Blake's account of the Armageddon of 1799 it will be useful to attempt a reconstruction of Blake's view of French developments after those he described in *Europe* and the ballad on La Fayette. In Blake's symbols the link between the early Orc and the later Orc-Luvah is the transitional Fuzon (fire) who shines forth momentarily in the books of *Urizen* and *Ahania* and is quenched. To Blake the fall of Robespierre in 1794 may have seemed just such a damping down of the revolutionary fires—temporary, of course, for consider *The Song of Los*.

In *The Book of Urizen* the birth of Fuzon as fire is described in simple alchemical terms, and Fuzon acts the part of a Moses calling together "the remaining children of Urizen" and leaving "the pendulous earth" called "Egypt." But in *The Book of Ahania* he is introduced with the same fiery-chariot image that is used in *Europe* to refer to the beginning of the Terror:

> Fuzon, on a chariot iron-wing'd
> On spiked flames rose; his hot visage
> Flam'd furious! sparkles his hair & beard
> Shot down his wide bosom and shoulders.
> On clouds of smoke rages his chariot. . . .

Robespierre in June 1794 officiated at a ceremony in the Champs de Mars deposing the Goddess of Reason (a female Urizen) and establishing the Worship of the Supreme Being. There was not much distinction in the difference, as Blake later recognized,[11] but contemporary reports were confusing and Blake seems to have understood the newly legislated religion as a thorough revolt against everything represented in his own demonology by Urizen. His Fuzon launches out at once with a speech suitable for the occasion, defining Urizen as the God of Reason:

[11] In *F.Z.*viii.111:18–24, a very late text, Blake refers unmistakably to the succession of religious cults legislated by the Republic—a reference which greatly strengthens our present reading (see below, chapter 23).

> Shall we worship this Demon of smoke,
> Said Fuzon, this abstract non-entity
> This cloudy God seated on waters
> Now seen, now obscur'd; King of sorrow?[12]

And Fuzon, like Robespierre, leads a short life. The latter was executed July 27 still wearing the sky-blue coat he had worn at the Feast of the Supreme Being. Fuzon, after a castrating blow at Urizen (with a weapon that appears to be an anthropomorphic guillotine), fancies himself as God—and is suddenly destroyed by an invisible poisoned rock from Urizen's bow. Writing his iron book of war in silence, until threatened by the consequences, Urizen nails "Fuzon's corse" as a crucified Christ to the "topmost stem" of his Tree of Mystery (iii.3, 6).

A variant version of Fuzon's death is presented in the only illumination of the text of *Ahania*. Below a very prominent "FINIS" appears what may be described as a heap of the fruit of the guillotine—several bodies or parts of bodies topped by a headless trunk and a severed dripping head, drawn with a butcher-shop realism quite unusual for Blake. Doubtless one meaning is that the shedder of blood is destroyed by his own engine. But as an opponent of Urizen's mystery and war, Fuzon is a sympathetic character; and he is a guide and prophet to his people, even a martyr.

If this conjectural identification of Fuzon is correct, we have a comparison of the French Republic after 9th Thermidor to the children of Israel after the death of Moses, apt in the sense at least that they are not yet in the Promised Land. And if the "*hungry* beam" which Fuzon wields is the guillotine (compare the "blood*thirsty* people" of *Fayette*), then the statement that "the fiery beam of Fuzon Was a pillar of fire to Egypt . . . wandring" (i.9) suggests both that the guillotine was a necessary resort of the French driven into the wilderness, and that the "fury" of Robespierre was a fulfillment of the "raging" of Rousseau and Voltaire which Blake compared to "a pillar of fire above the Alps" in another prophecy of the same year.[13]

[12] *Ahania* i. 1, 2: E83/K249.
[13] *Song of Los* 7:27; cf. 4:18 (E68, 67/K248, 246). The comparison of Robespierre to Moses would naturally occur. See Paine's allusion to Joshua as "just such another Robespierrean character as Moses," in his *Examination of the Prophecies*, ca. 1802, II, 876.

3

Blake's Fuzon is followed, at a distance, by Luvah, often still called Orc, just as Robespierre was followed at a distance by Napoleon, who appeared at first to be a Joshua of the revolution. His first public act was a bloody firing of cannon into a crowd, but since the young artilleryman was putting down a royalist demonstration, republicans at a distance were not greatly disturbed. And France, though following a military hero, continued to carry a sickle against the feudal kingdoms of old Europe. Thelwall, writing in 1796, expressed a feeling not uncommon among British radicals when he declared that his fear lest the French Republic be overthrown had "long ceased to agitate my mind. The Republic stands upon a rock."[14]

How soon Blake came to realize that this new Orc was copying Urizen's book we cannot tell. Wordsworth and Coleridge announced their disillusionment upon the invasion of Switzerland in 1798. Blake seems to have been more impressed by evidence of Napoleon's aggressions against the Republic of France. *The Four Zoas,* revised perhaps quite thoroughly in the light of developments of 1799 and after, dates the complete dehumanization of Orc at the coup d'état of 18th Brumaire, and this may be the date of Blake's disillusionment. The passage I refer to, in Night VII*b* (the early version), describes the Satanic degeneration of Orc until "his human form" is "consum'd in his own fires" and only a serpent remains. It can be dated with some assurance because it comes in as a sort of special news report interrupting a series of battle dirges that relate to the stages of the British campaign of 1799 in the Netherlands.

The report of Orc's reptilization comes between a dirge on the battle of Haarlem of October 6 and a notice of the British retreat of mid-November. Between these dates occurred the famous 18th Brumaire, November 9, the day Napoleon overthrew the Directory

[14] *Rights of Nature,* London, 1796, p. 46. Of course neither Thelwall nor Blake liked the Republic of 1795 as well as the promises of 1792. "Look at their newly accepted Constitution," cried Thelwall in a speech of Oct. 26, 1795. "Have they not abandoned the glorious principle of equality?"

and had himself declared Chief Consul, in effect rending to shreds the Constitution of the French Republic—the form of her life, as Blake puts it:

No more remaind of Orc but the Serpent round the tree of
 Mystery
The form of Orc was gone he reard his serpent bulk among
The stars of Urizen in Power rending the form of life
Into a formless indefinite & strewing her on the Abyss
Like clouds upon the winter sky broken with winds & thunders
 (vii*b*.93:24–28)

Bonaparte had strewn Liberty, Equality, Fraternity upon the winds and reared his head among the dynasts in his bid for imperial Power.

But why is he here called Orc, while in the peace negotiations of Night I his name is Luvah? Possibly in an earlier draft Blake took up the name Luvah ("I was Love")[15] to signify the concept of Brotherhood, upon which he was placing an emphasis previously given to Energy (Orc). But he is also, as we shall see, interested in the concept of *lava* as fire turning to stone or Love turning to Hate, so that Luvah—although Blake's usage is rather transitional than consistent—can serve as a symbol of France as victim, while Orc can still represent the militant France, human or inhuman.[16]

The militant Orc who, as a rising "son of fire" in 1792, promised to end the empire of lion and wolf is mocked by the militant Orc who, as Napoleon in 1799, contends for imperial power, wringing from the poet a cry of dismay: "Why howl the Lion & the Wolf? why do they roam abroad? . . . they sport in enormous love, And cast their young out to the hungry wilds & sandy desarts" (i.17:8–10). Both Urizen and Luvah-as-Orc conspire to starve and poison the people; yet insofar as Napoleon is the object of Urizen's efforts to crucify his brother, he is still the divine humanity, and Albion, though drugged, rallies sufficiently on his "Couch of Death" to plead with Urizen for Orc-as-Luvah: "Thy brother Luvah hath smitten me, but pity thou his youth Tho' thou hast not pitid my Age, O Urizen" (ii.23:1–8). The war is destroying both British

[15] *F.Z.*ii.27:14. The name Luvah appears first in *Thel* (1789) where he is referred to in passing as a sun god whose steeds drink of "golden springs." See Sloss and Wallis, II, 272 n.
[16] But see below, note 35.

popular liberty, dating back a long age, and French, dating scarcely a decade.

Nevertheless Albion, "weary," hands Urizen his scepter and allows the battle to continue, despite what Schorer defines as a feeling that there is "very little to choose between Pitt's struggle to maintain his government and British privilege, and Bonaparte's struggle to win an empire" (p. 169). Schorer discovers the feeling not here but in Blake's comment on Bacon's *Essays* and assumes mistakenly that it is unique or "surely extraordinary." Actually here, in putting this sentiment into the mouth of Albion, Blake is recording it as the general sentiment. And in the notes on Bacon, which may be read as a sort of appendage to the notes on Watson and Paine, Blake raises this very question of the contradictory nature of public opinion under tyranny. How can it be that everybody (Albion) knows that Bacon's Caesarism (Bonapartism) is selfish, "& yet Every Body Says that it is Christian Philosophy"? "Every Body must be a Liar & deceiver but Every Body does not do this But The Hirelings of Kings & Courts who make themselves Every Body & Knowingly propagate Falshood." In other words the "universal" support of aggressive war in 1798 is largely a figment of the hired press, Blake believes. His reference to "the English Crusade against France," for instance, is not extraordinary; it echoes the Whig motion calling for renewed peace negotiations and condemning "a crusading confederacy against France." Indeed Blake goes on to tell us what "everybody" thinks: "Every Body hates a King" for "A Tyrant is the Worst disease, and the Cause of all others."[17]

Alas, then, why does everybody continue to serve the King? Apparently because one of the diseases caused by kings is patriotic pride or the desire to increase one's state, as Bacon advises, "upon the foreigner." Even while Blake was marginally contradicting Bacon, the ugly symptoms were spreading in England. If one cause of Albion's weary submission to sceptered power was the collapse of French republicanism, another was the chauvinism induced by news of the destruction of a French fleet in Aboukir Bay in August 1798, a dramatic British victory. Nelson's "Battle of the Nile" both halted French expansion and subdued the demand in England for peace. Bisset reports that by the end of the year support of the war

[17] Marg. to Bacon, ca. 1798, xii, 38, 67: E610, 612, 614/K397, 400, 402. Cf. *J*.52, par. 5: E199/K683.

was almost universal among "the higher classes" and had even made some headway among the workers. The "loyal associations" with their military character grew popular among the middle classes. "Discontent was silenced; the subjugation of rebellion in Ireland strengthened the power of the British government; the splendid battle of the Nile, so gratifying to the generous pride of British patriotism, encircl[ed] the whole nation with rays of glory" which lingered for more than a twelvemonth until (as dramatized in Blake's Night VII*b*) the disasters of the Netherlands campaign induced a strong revulsion.[18]

After sketching the diplomatic history of the whole period, Night I deals with the deleterious impact of the great victory. Nights III through V depict the pulsative hopes and fears of various Zoas while Urizen proceeds spasmodically toward his inevitable ruin. Night VII*a* follows the British armies in their glorious marching forth of 1799 and their inglorious retreat, synchronous with the reptilization of Orc in Paris. Night VIII exists only in a later draft, but Night IX, which prophesies the millennium following Armageddon, implies a transformation of the discontent after 1799 into an insurrection for peace, Albion's final awakening—in Britain *and* in France.

4

This is no warbling brook nor Shadow of a Myrtle tree
But blood & wounds & dismal cries & clarions of war
—*The Four Zoas* viib.93:14–15

The great Victory song of Night I, with "doubling Voices" accompanied by "loud Horns wound round sounding," is sung by Urizen's Demons of the Deep or Elemental Gods, joined by "thousand thousand spirits Over the joyful Earth & Sea."[19] And it evidently celebrates the British defeat of Napoleon in the eastern Mediterranean, possibly conflating the Battle of the Nile (August 1798)

18 Bisset, II, 638. For the growth of a militaristic or "vigillant" spirit in 1799 among the sons of the aristocracy, see *Journal of Lady Holland*, London, 1908, II, 16.

19 *F.Z.*i.13:20–14:3: E304/K274:375–382 (part of Night II in Sloss and Wallis).

and the Siege of Acre (March–May 1799), the first British victory on land.

Blake as usual transposes. The battle areas, Egypt and Palestine, are not named but symbolized: "Now Man was come to the Palm tree & to the Oak of Weeping," an oak which marks a Palestinian site named in Genesis.[20] The battle blood is described, not as coloring the waters of the Nile or of the river Kishon near Acre, but as constituting a diluvial river of blood that "swells lustful" around the "rocky knees" of Mount Ephraim, a hill of conveniently sinister connotations located roughly between Acre and the Nile.[21] And naval action, to be followed by war on land, is suggested if we take the "hosts of spirits on the wing" to be the Mediterranean fleet, and the "glittering Chariots" that "pour upon the golden shore beside the silent ocean, Rejoicing in the Victory"[22] to be an imagined disembarking of the British forces. At any rate the triumph celebrated is explicitly that of Urizen over Luvah,[23] and sad listening Enion takes the bellicose outburst to mean that "the Lion & the Wolf" are still abroad (17:8).

In the song itself Blake has blended somewhat inexpertly (we are not so far from the manner of the *Poetical Sketches* after all) a naked demonstration of the bloodthirstiness of warriors, a survey of the demoralization of the citizens of England (as in the spring of 1799) and a symbolic explanation of the predicament of the friend of freedom who sees no freedom to fight for. In the fee-fi-fo-fum cry of monstrous warriors whose "nostrils drink the lives of Men," war is grossly glorified in terms reminiscent of the first war song of the minstrel in *Edward the Third*. Then notice is taken of the discontent still smouldering in "the Villages." "Wailing runs round the Valleys" from the laborers of "Mill" and "Barn,"

[20] i.18:11: E306/K277:464. The fact that these symbols are not in Blake's general system strengthens this *ad hoc* interpretation. And weeping is appropriate when the oaken ships of England carry war to the oaks of Israel.

[21] i.14:11–12. See *J*.68:20–22, and Sloss and Wallis, 1, 576 n.

[22] i.12:32–35: E303/K273:342–346, and see textual note, E746.

[23] Damon, p. 368, is surely mistaken to call this "the Song of Revolution —in its bad aspect, as well as the good." For one thing it sings war, not revolution; for another, it is sung by the spirits not of Luvah but of Urizen and it ends with a call for more victories against Luvah. Even taking Luvah simply as a general symbol of revolution, as Damon is inclined to do and Schorer after him, p. 317, we would have to call this song against Luvah one of *counter*revolution.

and the sigh of the people is still most feared in "the polishd Palaces dark" which "bow with dread." Yet this is not 1776 or 1793. The cities are now in the camp of war, vying with one another to raise volunteers, and they "send to one another saying My sons are Mad With wine of cruelty. Let us plat [plait] a scourge O Sister City" (14:14–20).

Blake had written of children fed for slaughter in the sense that they were helpless cannon fodder. "Once the Child was fed With Milk." But now the children are "fed with blood" and brought up to *like* war.[24] Mad with cruelty "the Sons of Men muster together To desolate their cities!" If they go on so, "Man shall be no more!"[25] The ultimate prospect is "no City nor Corn-field nor Orchard!" no Sun, Moon, nor Stars, "but rugged wintry rocks Justling together in the void suspended by inward fires" (14:21–16:6).

The predicament of the visionary to whom the times supply no proper vision is symbolized partly in the war song and partly in the song's context, a Los-Enitharmon story in which it figures as the "Nuptial Song" of their *mésalliance;* for at this point we have a fallen Enitharmon and a lost Los. Is it possible that Blake observed within himself a tendency to be swayed by the wind of national pride even while he was saddened to observe its course? Outside himself, at any rate, there were many good men, once prophets, who now sneered on visionary minds as Los does under the spell of "the Clarions of war."

The story of Enitharmon and Los, wandering in "the world of Tharmas" where Albion lies as "the Fallen Man," sickening and refusing "to behold the Divine Image which all behold And live thereby," is a story of Eve and Adam, the one fallen, the other falling—with the difference that Enitharmon has tasted not forbidden fruit but human blood and the joys of combat:

> We hear the warlike clarions we view the turning spheres
> Yet Thou in indolence reposest, holding me in bonds.[26]

[24] Coleridge makes a similar point in *Fears in Solitude,* April 1798.

[25] In this context when Blake says "The Horse is of more value than the Man" (i.15:1) he is not referring to industrial horsepower, as Bronowski would have it, p. 64 [96], but to the high premium on war horses, which Britain supplied to her allies. See the condemnation of the man "who shall train the Horse to War" in *Auguries of Innocence,* 41: E482/K432.

[26] i.9:34; 10:10; 11:10 (and deletions ff.—see E745); 10:7–8.

And unlike Adam, Los refuses to taste what the woman offers; instead he smites her "with indignation hid in smiles" and accuses her, mother of events, of having blinded the Fallen Man. But to strike another *is* to taste human blood. The blow of Los is equated to the Battle of the Nile in that the Demons' Victory Song celebrates both.[27] Refusing to be Adam he has become Cain. Yet his attempt to mend matters ("he threw his arms around her loins To heal the wound of his smiting") leads him to embrace Whoredom and Victory and Blood.[28]

Los at first believes he is resisting history's "Song of Death." He points out that the people, though confused by Enitharmon's betrayal of the revolution (which *she* now calls a "false morning"), are still seeking to win or "comfort" the good earth, Vala, now further *veiled* from them.[29] Even if Orc's (Luvah's) rising was a false dawn, Los professes to be able to see the "futurity" that must follow the crucifixion of Luvah, and so he will not join the crucifying. You, he declares to cruel Enitharmon, will not survive the *next* conflict: "neer shalt leave this cold expanse where watry Tharmas mourns."[30] But to say "if" is to doubt. The prophet's faith has really gone out with his acceptance of Enitharmon's view of history, symbolized in the song by Urizen's pulling down the sun "with noise of war." One cannot really believe in the true resurrection of a false savior. Gloating over what has happened and will happen in France, Enitharmon (still in a way the Queen of France) is able to assure Los that there is no future for the Human Form of Peace and Love. The leaders of France, once "free Spirits" (first reading) or "rebellious Spirits" (second reading),[31] will not

[27] Note the sequence of 12:35 through 43. E303.

[28] i.12:42–43; cf. 11:24.

[29] i.11:5–10 and 10:21. *Vala,* Blake's first title, derives from the theme of a veil or successive veils separating man from woman or Man from Nature or Nature from her true garden state, Eden-Jerusalem. Blake finally has named his "nameless shadowy female" of the earlier books; but all the females in *Vala* are, in some sense, veiled forms of nature: Enion, Enitharmon, Eno the earth-mother, Nature, and Vala herself. The Nine Nights are one long night of nature, climaxing in a final Day of Judgment in which the veils are rent asunder with nuptial feasting. See Frye, pp. 314–315.

[30] 11:18. Tyrian Maids "their wounded Thamuz mourn" in Milton's Nativity *Hymn;* the whole passage echoes *Europe,* where we have noted the influence of this poem. Blake's Tharmas may be influenced by Jacob Bryant's spelling, Thammas.

[31] 11:24. Compare the erasure of "triumphant" in 91:21 (see below).

remain human and peace-loving but will do acts of "War & Prince-dom & Victory & Blood"; and "The Human Nature shall no more remain."

She predicts, in short, the coup of Brumaire. The metamorphosis of the human Orc into the serpent Napoleon completes the tempta-tion of Adam through Eve. Having lost faith in the vision of Luvah and Vala, who stand "forsaken" "in the bloody sky" (13:5), Los accepts what appears to be the only course, and, with sudden pity that reminds us of Fayette's disastrous tears for the Queen of France, yields himself to Queen Enitharmon.

Drawn thus into the vortex of her algolagnia, Los suffers what Swedenborg called the pleasures of insanity; bride and groom sit at the wedding feast "in discontent & scorn," craving the feast of blood, drawing bliss from "the turning wheels of heaven & the chariots of the Slain." Even on the day of victory, however, cruelty's is not the only voice to be heard. Far in the distance, while this "golden feast" goes on, Enion laments "upon the desolate wind," asking the old unanswerable questions of Oothoon: "Why howl the Lion & the Wolf? . . . Why is the Sheep given to the knife?"[32]

5

The song dies away; the fable shifts from eastern shores to in-dustrial England, from war to war production. Having demon-strated the heady effects of victory, Los and Enitharmon move on to other roles, and when we find them again listening to songs of war, in Night VII*b*, both of them are sober and full of futurity. Enitharmon is no longer the arrogant queen who grants the space of all history to Empire; now she is the mother of Orc, conscious of her responsibility for the future, yet in most desperate plight because her child is assuming the Napoleonic form. Los is the "watchman" who must shelter her in "a tower upon a rock," to prepare the light for a new day even in the darkness of a ruined one; he is, again, Blake writing *The Four Zoas*.[33]

Los and Enitharmon no longer fight each other; yet the lurid conflict strains the humanity of both. He, no longer the scornful

[32] i.13:19; 16:18–20; 17:1, 8; 18:1: E304–306/K274–276.
[33] F.Z.viib.96:19–98:6: E393–394/K334 f.:40–97.

spectator of Night I, has submitted to the will of candid Tharmas and become a prophetic war correspondent. "Night or day Los follows War"—and he begins in the "mighty stature" of a deliverer:

> . . . on Earth stood his feet. Above
> The moon his furious forehead circled with black bursting
> thunders
> His naked limbs glittring upon the dark blue sky his knees
> Bathed in bloody clouds, his loins in fires of war where spears
> And swords rage where the Eagles cry . . .
>
> <div align="right">(viib.96:19–23)</div>

Enitharmon trusts him—not Orc, whose "glittering scales" confound her (97:28–30). Yet Tharmas as "God of waters" is dissolving and destroying the cement of the old order, and Los finds himself so totally involved as to be, in effect, making war himself—the flames of which reach Enitharmon by reflection in the "dismal moon" and make her cry "upon her terrible Earthy bed."[34] Los, inclined to regard Chaos as preferable to Empire, takes a sort of anarchistic pleasure in the "night of Carnage" when he hears Eagles (Napoleonic?) and Vultures rejoicing like the two corbies at an opportunity to have "the flesh of Kings & Princes Pamperd in palaces for our food, the blood of Captains nurturd With lust & murder for our drink."

All this is quite in the spirit of the violent autumn of 1799, season of defeats and, for the first time, long *English* casualty lists, a swift reversal of the golden military glory sung in Night I. Now again "Every Body hates a King." Tharmas, laughing "furious among the Banners," predicts a speedy disintegration of the proud armies of Pitt's Second Coalition: "As I will I rend the Nations

[34] Nowhere else in *F.Z.* is Los described as a combatant, except in domestic strife, and I read "Los warrd upon the South" (97:22—a passage I overlooked in my first edition) as metaphorical. His standard activity is hammering, but as Orc reptilizes, Los Satanizes (or so the Miltonic echoes suggest). Anticipations are the "workman" in *Gwin* who "throws his hammer down To heave the bloody bill" and Jefferson, the "builder of Virginia," whom we do not follow after he "throws his hammer down in fear" (*A.* 14:16).

The Tongue, in effect, is a king-maker, and Tharmas by defining himself as God confers royal power over enemies upon his son Los: and this is what, at the dark winter time, comes of king-hating.

all asunder rending The People, vain their combinations I will
scatter them" (vii*b*.96:28–30).

Boasting and warlike confidence, followed by blood and wounds
and inglorious retreat: this is the pattern of 1799 and the pattern
of Blake's seventh Night. "They go out to war with Strong
Shouts & loud Clarions O Pity They return with lamentations"
(93:30–31). More chronologically than systematically the poem fol-
lows three concurrent but geographically separate developments of
the autumn of 1799: the British campaign in Holland, a meeting
of Parliament, and Napoleon's sudden coup in Paris.

The mood of confidence at the beginning of the campaign is
that of the victory song of Night I. Bisset (II, 698) gives us the
general background:

"In Britain, the energy of 1798 had continued through a con-
siderable part of 1799; the battle of the Nile reanimating Europe,
had encouraged the imperial powers to hostilities . . . attended
in the first part of the campaign with signal success. . . . The
retreat of Bonaparte from the siege of a fortress [Acre], which
Englishmen undertook to defend, being his first failure in any
military attempt, added to the national exultation. . . . The for-
midable armament prepared against Holland added to the general
hopes. It was confidently expected that such a force, co-operating
with the multitudes reported and supposed to be inimical to French
supremacy [the "People" of Tharmas' prophecy?], would recover
the united Netherlands, and even co-operate with the archduke in
regaining Belgium. The failure of this expedition was a gloomy
disappointment."

In Night VII*b* the Elemental Gods who sang in Night I and
whom we may now identify as the imperial powers (Austria, Prus-
sia, Russia, Turkey—Pitt's allies) welcome the British army enter-
ing the Continental war at last and chant a "war song round red
Orc in his fury," i.e. around Napoleonic France:[35]

[35] This Orc is introduced by a swift recapitulation of his rising (vii*b*.
91:1–21) in terms echoing the Preludium of *A*. The passage is a sort of
Preludium for 1799, reminding us that Orc was originally a human fire.
Indeed, as he wrote Blake gave Orc "triumphant fury" (91:21), later erasing
"triumphant" without replacing the word. Four pages further on (95:23)
he depicted Urizen boasting of being a tyrant God, a "Conqueror in tri-
umphant glory [*sic*]." Was it Blake's original intent to set the rebel's

Sound the shrill fife serpents of war. I hear the northern drum
Awake, I hear the flappings of the folding banners

The dragons of the North put on their armour
Upon the Eastern sea direct they take their course
The glittring of their horses trapping stains the vault of night[36]

The Eastern sea is the Strait of Dover, across which the Duke of
York's cavalry (dragoons or "dragons of the North") sailed in
August.

In the ensuing lines the "glorious king" is of course France, still
viewed by the imperial gods as a militant king of love. The British
(and subsidized Russians) have now landed and are winning initial
costly victories. (A "black bow" is a gun of black metal. It shoots
"darts of hail" or "arrows black" and is a "cloudy bow" when it
smokes.)

Stop we the rising of the glorious King. spur spur your clouds
Of death O northern drum awake O hand of iron sound
The northern drum. Now give the charge! bravely obscurd!
With darts of wintry hail. Again the black bow draw . . .
The arrows flew from cloudy bow all day. till blood
From east to west flowd . . . upon the plains of death . . .
Now sound the clarions of Victory now strip the slain

(vii*b*.91:30–92:9)

These battle scenes may be understood to characterize the cam-
paign which climaxed in the Pyrrhic victories of Bergen and Lim-
nen, October 2 and 4.

fury against the tyrant's glory? (Compare the *Spiritual Form of Nelson*.)
How much later was it he decided to tarnish the Orc portrait?—Perhaps
when he marked the "glory" lines to be moved to the beginning of the
chapter, thus putting Urizen's boast first, Orc's fury later.

If, as now seems likely, these pages were written out (as fair copies of
earlier drafts) at Felpham during the Peace, we may suppose Blake tidying
the survey of the 1796–1801 negotiations and war, to permit both Orc and
Urizen triumph in the Peace. Upon renewal of the war, he would go
back to his manuscript to erase Orc's triumph; Blake came to suppose
that what went wrong in 1799 was that the Napoleon who returned from
Egypt was an impostor. (See below.)

[36] vii*b*.91:25–29: E395/K336. Compare the war song of *Edward the Third*:
"Morning Shall be prevented by their swords gleaming, And Evening hear
their song of victory!" E429/K33.

Without transition except the fading-out of battle imagery, Blake shifts to the brief session of Parliament (September 24 to October 12) which at the same time was voting the crucifixion of Luvah at home and abroad: an extension of the "voluntary" militia, an increase of military supplies to meet unforeseen expenses of the Holland expedition, a renewal of the suspension of the habeas corpus, some credit relief to West India merchants, and Wilberforce's bill against labor combinations.

They sound the clarions strong they chain the howling captives
They give the Oath of blood They cast the lots into the helmet,
They vote the death of Luvah & they naild him to the tree
They piercd him with a spear & laid him in a sepulcher. . . .[37]

The rest of the passage, concerning the sorrow of the militia volunteers who must leave "the plow & harrow, the loom," etc., and the "sorrowful drudgery" of labor chained to the cogwheels of war, will occupy us in a later chapter.

Before the end of the session the news from Holland was more of death than glory. After the day-long battle of Haarlem, October 6, a few skirmishes and some "indecisive naval successes" in the Zuyder Zee ended the British campaign. The dragons of the North had spurred their clouds with no effect but the reduction of their numbers from 36,000 to 20,000. The gazettes of thousands slain and wounded so close to home shocked the British public from their relative complacency about a war previously fought on distant fronts and largely with other nations' troops. The next song by Blake's demons appears to reflect this new closeness to the actual horrors of war. A new realism of detail supplants the rhetorical generalities of "golden chariots raging" and "bloody tide." With grim sarcasm the demons call the bard's attention[38] to the difference between the real thing and the products of the harp:

[37] vii*b*.92:11–14. A shift from first to third person after 92:10 marks the end of the song. A second song begins at 92:34, "Now, now the Battle rages." A potential third song, which I have referred to as a dirge, is indirectly reported in 93:29–31.

[38] Indirectly. The lines are actually addressed to Vala, as the harlot of Urizen. If deluded nature, when prostituting herself to serve tyranny, thought that war was a beautiful pageant of "mighty hosts Marching to battle," she was sadly mistaken. "O Melancholy Magdalen!" the demons taunt her: "Wilt thou now smile among the slain when the wounded groan in the field?" 92:37–93:8: E393–397/K337–338.

Now now the Battle rages . . .
Is not the wound of the sword Sweet & the broken bone
 delightful. . . .
Remember all thy feigned terrors on the secret Couch
When the sun rose in glowing morn with arms of mighty hosts
Marching to battle. . . .
How ragd the golden horses of Urizen bound to the chariot of Love
Compelld . . .
To trample the corn fields in boastful neighings.

The reality is no such pageant:

 . . . this is no gentle harp
This is no warbling brook nor Shadow of a Myrtle tree
But blood & wounds & dismal cries & clarions of war
And hearts laid open to the light by the broad grizly sword
And bowels hidden in hammerd steel rippd forth upon the
 Ground[39]

After this song, of the climactic "victory" of Haarlem, comes the
report of Orc's Eighteenth Brumaire (November 9). And the next
lines cover the ignominious retreat of the British dragons and their
return home in November:

 The Warriors mournd disappointed
They go out to war with Strong Shouts & loud Clarions. O Pity
They return with lamentations mourning & weeping

"Loud were the murmurs at home," says the historian. It was
difficult to understand how "so very powerful, gallant, and well
officered an army," "supported by such a fleet," could sail home
after a few battles in Holland with nothing to show but a loss of
16,000 men.[40]

[39] vii*b*.93:13–17. The demons seem to be mocking the Blake of *M.H.H.*
who fancied that a "firm perswasion" was sufficient to change the future
from a bloody conflict into an idyl of "sitting on a pleasant bank beside
a river by moonlight, hearing a harper."

[40] Bisset, II, 699–702; Charles Knight, *Popular History of England,* Lon-
don, n.d.

16. Under the Great Work Master

First Trades & Commerce ships & armed vessels [Urizen] builded
 laborious
To swim the deep & on the Land children are sold to trades
Of dire necessity still laboring day & night till all
Their life extinct they took the spectre form in dark despair
And slaves in myriads in ship loads burden the hoarse sounding
 deep:
Rattling with clanking chains the Universal Empire groans.
 —*The Four Zoas* vii*b*.95:25–30

IF MILITARY GLORY was one side of the false coin of Empire, the
other side was the lure of commercial prosperity. Thelwall's as-
sertion that Commerce was a "monopolizing fiend" that bred Nile
monsters of inhumanity at home and sent abroad the brazen voice
of war "to bellow hideous discord through the World,"[1] made sense
to Blake, who had his own bitter acquaintance with the "Fiends
of Commerce."[2] The great trade expansion which was part of
the industrial revolution appeared to Blake in the guise of pro-
duction for war and for the markets opened by military crusades.
His way of saying so in cosmic hyperbole was to declare that the
whole creation was built by slave labor under "the great Work
master," Urizen.[3]

The shape of Blake's myth, it is true, implies neither an ultimate
rejection of industry nor a rejection of Urizen; in the new Jerusa-
lem each will have a glorious function. But to talk of glory and
prosperity in the Babylonian England of 1799 was a mock. In-
creased production of "hammerd steel," more and more ingeniously
"intricate wheels invented," meant only more children "laboring
day & night," more sons of Los "Kept ignorant of the use" of what

[1] *The Peripatetic*, 1793.
[2] E471/K557.
[3] *F.Z.*ii.24:5: E309/K280:22. This epithet was applied by Bacon and
Milton to their God, who was of course Urizen. See Blackstone, p. 220 n.

they forged, for they were forging their own "clanking chains."[4]
In both Nights I and VII*b* the songs of War and Victory are set
against a background of joyless, dehumanizing labor.[5]

War has now perverted all the arts of peace, and the old sword-
sickle contrast is no longer adequate. Urban industry has begun to
overshadow agriculture: the loom and the furnace now dominate
Blake's world, and he sees the Empire that exploits and extends
their commercial power as slaying Jerusalem universally. In his
poetry now, "war and industry are never far apart and are often
identified," as Schorer observes (p. 198). If the ancient legend is
true that the races of mankind all originally dispersed from an
Atlantic island of which the British Isles are remnants, then Blake
views a modern parallel as all too true, that British commerce
accompanied by the British sword is spreading Druid slaughter,
even Albion's own "loud death groan," among all peoples and
nations and bringing Jerusalem "down in a dire ruin over all the
Earth." Behind the battlefields and the "dismal cries & clarions of
war" is the harsh toil of Albion's daughters at their needlework
and of his sons at their smithery.

In *The Four Zoas* Blake first fully demonstrates his awareness of
the implications of history in the industrial epoch. In moving from
the *Songs of Experience* to this Epic of Experience he has shifted his
attention from the dirty streets and blackening church to the
"smoky dungeons" of labor, from the cries in the street to the din
and misery of the workshops. His casting himself in the role of a
blacksmith wielding "the hammer of Urthona" is an apt heroic
symbol of his own position among the skilled trades, for an en-
graver is, in literal fact, a worker in metal.[6] Bacon, who contemned

[4] vii*b*.93:17; 92:26; 95:27; 92:30; 95:30.

[5] Interpretation of Nights I and II is complicated by the insertion of later
material which appears to contradict the descriptions of industrial slavery
and to suggest that the result of work can be "infinitely beautiful" even
when the labor is "bondage night & day." These insertions were made after
the Peace of Amiens and signify that production for peace is an altogether
different human condition, e.g. ii.33:10–18. If peace did not in reality trans-
form the conditions of labor, it did in Blake's view utterly transform the
goal of labor.

[6] A deal of smithery was required in the preparation of copper engraver's
plates, which Blake used both for conventional engraving and for the etch-
ing of his prophecies. Cakes of copper from the smelters were remelted in
the copper mills and rolled into rude sheets or plates. In London these

"within-door Arts and delicate Manufactures," could hardly call forging "unmanly."[7] There is also in the symbol an emotional identification with the actual man of energy rather than with the more isolated professional worker, and a vision of the working class as the class capable of building the future.[8]

Such vision contradicted immediate fact. When Los took over "the Ruind Furnaces of Urizen" he would need "terrible hands" and a daring like His who made the tiger. And his task would be "Enormous work" requiring not one but many furnaces, a whole intellectual movement. Yet though in fancy Blake could equip his blacksmith with a thousand sons working with him as he rolled "furious his thunderous wheels from furnace to furnace, tending diligent," in reality he could not find the "brethren" to whom he appealed (iv.52:15–26). Possibly he knew something of the militancy of the London iron workers in 1789; but in 1799 it was they who supplied the sinews of Urizen's "iron power" (ii.25:43), while Blake, secretly condemning war's enormities, permitted his smith-like labors to be bought and sold to engrave designs for a war monument, as we shall see. Hence at the climax of the fiendish Victory Song of Night I the spectral Los is melting the very "bones of Luvah" in his furnaces. And the tragic burden of the industrial visions of Nights II and VII*b* is the tyrannous

plates were cut to size and prepared in small open forges notorious for their din. The plates were scraped with steel tools, *hammered on an anvil*, ground with a kind of hard blue stone wetted with water (the process perhaps referred to when the Spectre of Urthona, in the form of "a shadow blue, obscure & dismal" hovers over watery Tharmas "rotting upon the Rocks," *F.Z.*iv.50:23–24), and finally polished with fine charcoal. Blake often speaks of laboring on the rock, i.e. the copper.

But the process which Blake commonly identifies with smithing is the work of engraving and etching: hammering and burning. While he frequently exploits the analogy of plowing to the making of "furrows" in the copper to receive the ink, or in the "ground" to receive the acid, his industrial labor under Urizen is more like the cutting of "the dreadful furrows" to receive molten metal from the furnaces: ii.25:38. See my essay on "The Historical Approach," *English Institute Essays, 1950*, ed. A. S. Downer, New York, 1951.

[7] Marg. to Bacon, 144: E619/K407. "Bacon calls Intellectual Arts Unmanly Poetry Painting Music are in his opinion Useless so they are for Kings & Wars & shall in the End Annihilate them."

[8] Compare Frye, p. 291.

separation of labor from love, specter from man, production from perfection—in short, the division of labor and the division of the laborer.

Blake spells out the sinister relationship of war and commerce point by point in two highly significant analyses of the leading industries of Britain—analyses sufficiently cryptic to have been overlooked although they are scarcely baffling. Readers familiar with the neoclassical diction of such poets as Erasmus Darwin should have no difficulty recognizing the textile trades as "the daughters of Albion" and their workshops as "the dungeons of Babylon." Blake calls sheep "mild demons of the hills" and their wool "Jerusalems curtains." Instead of saying that the British textile industry strips wool from sheep, binds children to factory labor, and leads imperial armies as far as China in search of markets, he says the "Daughters of Albion" with their "Needlework" strip "Jerusalems curtains from mild demons of the hills," bind "Jeru-salems Children in the dungeons of Babylon," and "play before the Armies, before the hounds of Nimrod," in lightning voyages (i.e. like flying shuttles) "Across Europe & Asia to China & Japan."[9]

Such locutions are not simply periphrastic, of course. Mention in the same passage of "Albion on his rocky couch" is more than a quaint description of cliff-bound England; in it is a suggestion that the people are sleeping while Empire and slavery increase. King George's armies Blake calls Nimrod's hounds not merely to escape the censor or to be ornate. In alluding to Nimrod, first imperial monarch and builder of the ill-fated tower of Babel, the poet is suggesting a fate of discord and collapse for an unrepentant British empire. In a related passage in *Jerusalem* we learn that while Albion is asleep his sons submit to serve in Nimrod's armies only because they are "carried away" by press gangs and "compelld to fight under the iron whips" of their officers (*J*.65). The fighting man is but the slave in extremity.

[9] *F.Z.*ii.25:25–32: E310/K281:57–65. China and Japan are apt symbols. During the Napoleonic wars the British navy did move belligerently in Far Eastern waters—in unsuccessful attempts to break the Dutch monopoly of Japanese trade and in a show of naval and military force against Portugal's China port of Macao, forestalled by the Peace of Amiens. The British were not desperate for markets, but opportunity seemed to beckon.

2

O Lord wilt thou not look upon our sore afflictions
Among these flames incessant labouring, our hard masters laugh
At all our sorrow.
 —*The Four Zoas* ii.31:4–6

On one level the subject of Night II[10] is the creation of the
universe or, in a definition inserted in late revisions, "the Mundane
Shell." On another it is a description of industry and commerce as
based on the inequality of mankind and the increase of a state
"at the expense of foreigners." A description of the steel industry,
from mining the ore to tempering the wrought pigs, stretches over
seventy-eight lines, in which the process itself symbolizes the rela-
tion of man and nature when war is work master. The iron ore
(Luvah—love, lava)[11] stands for the brotherhood of labor, and the
charcoal or coal (Vala) used in smelting stands for that part of na-
ture which has to be destroyed to make the steel: the steel of guns
being thus destructive in a double sense—of natural resources in its
birth and of human lives in its use.

This passage not only complements the Needlework passage in
defining Nimrod's economic motive, but it also reveals his political
motive—the need to stave off the evil day of his downfall when
the brotherhood of labor will free itself and come into a non-
destructive relation with nature as in Eden.

Luvah was cast into the Furnaces of affliction & sealed
And Vala fed in cruel delight, the furnaces with fire
Stern Urizen beheld urg'd by necessity to keep
The evil day afar, & if perchance with iron power

10 The second part of Night II as arranged by Sloss and Wallis.
11 Blake found his Luvah symbol very convenient here for one of his
creative puns. Erasmus Darwin in his *Botanic Garden* (for which Blake
engraved an illustration after Fuseli) suggests that the central mass of the
earth is composed of iron lava (1.151) and also points to the "sublime
allegory" of ancient mythology that at the creation of the universe "when
the Egg of Night [Blake's Mundane Shell], on Chaos hurl'd, Burst and
disclosed the cradle of the world," the first to spring from the shell was
"Immortal Love" (1.28–29)—a moment which Mrs. Cosway (Mrs. Jacko?)
had "chosen for her very beautiful painting."

He might avert his own despair; in woe & fear he saw
Vala incircle round the furnaces where Luvah was clos'd

But he need not fear that they will overthrow him by their em-
brace, as in the Preludium of *America*. For now in joy Vala listens
to the victim, having forgotten "he was her Luvah With whom she
walkd in bliss, in times of innocence & youth."[12] And he in turn,
trapped in the furnace, regards her as Beast and Whore in one,
"a Dragon winged bright & poisonous," pictured in the margin as
a winged mermaid with web feet, a triple tail, and three breasts.[13]

The ore "in mountainous masses" ready for smelting is "plung'd
in furnaces" where it is "shut & seald" for a certain apocalyptic
"time & times" until at length it is molten (Luvah is "quite
melted with woe") and the coke (Vala) fades and falls "a heap
of Ashes Beneath the furnaces a woful heap in living death." Then
the furnaces are "unseald with spades & pickaxes" and the "roar-
ing . . . molten metal" is let out to run "in channels Cut by the
plow" where it will cool into pigs.[14]

The "Children of Man" are as much terrified at the sight of
"these visions in the air" as they were in *America* at the sight of
angelic armies mustering around their Prince to oppose the Demon
of futurity; and for much the same reason. They see in either

[12] F.Z.ii.25:40–26:3. Luvah in this industrial Night does not seem to stand
for France except insofar as France is a symbol of Fraternity.

[13] A series of drawings in MS p. 26 illustrate a recital by Luvah of the
evolutionary stages of nature in relation to man.

[14] ii.25:34–28:9. What men like Paracelsus and Boehme did with the
symbols of the alchemical process, Blake is doing with the processes of
modern production. Yet Blake evidently never saw a blast furnace (in
which furnace and oven are one) for he confuses it with a pottery- or
brick-kiln (in which oven and furnace are separate). Only in the latter
are there any ashes to fall in a heap. What falls in the blast furnace is
molten metal (with molten slag on top). Compare Richard Warner's account
of the Walker cannon-works in 1801: The ore ("iron-stone") and coke are
"thrown mingled together into the furnace, with common limestone. . . .
A strong blast is then applied to the furnace, and as the iron melts, it
falls down into the bottom of the furnace, . . . the mouth walled up with
bricks and clay. When it is ready for casting, a hole is made with an
iron crow, and the molten metal suffered to run into the proper mould
along channels of sand." *A Tour Through the Northern Counties of England
and the Borders of Scotland,* Bath and London, 1802, I, 192–193.
Like Tennyson's mistake of rails for grooves, Blake's error is convenient
for his symbolism, though the mingling and burning together of coke and
ore could have suggested another sort of irony.

case a total war program, spiritual wickedness in high places directed to the making of steel "swords & muskets." They see the melting of brotherhood (ii.28:11–13).

Now some cry out to one another in alarm: "What are we terrors to one another. Come O brethren wherefore Was this wide Earth spread all abroad. not for wild beasts to roam." But others behave like the "mortal men" of *America* who refuse to see futurity in the red air and close their senses, standing "silent & busied in their families," declaring: "We see no Visions in the darksom air."[15] These London citizens seek the main chance whatever it involves, accept Pitt's view of commerce, and will follow Nimrod's hounds to any spot beneath the sun where customers can be found and trading stations can be established under the British flag:

Measure the course of that sulphur orb that lights the darksom
 day
Set stations on this breeding Earth & let us buy and sell

So, under the thunderous foremanship of Urizen, "Commanding all the work with care & power & severity," the pig iron is heated and hammered into "pyramids" and tempered to form "awful stations." "Heated red hot they hizzing rend their way down" till they stand "Casting their sparkles dire abroad into the dismal deep" (28:18–30).

Thus, according to Blake's analysis which rather inverts the actual chronology, the stations or factories of the East India Company and the Hudson Bay Company were founded on iron pyramids forged in the manufactories of Birmingham. As for the Needlework which was the staple of this commerce, Blake in placing the weaving as well as the spinning in the caverns of manufactory expresses what was still an ideal to the Strutts and Owens: "in Caverns shut, the golden Looms erected First spun, then wove the Atmospheres." As if in recognition of the ideal nature of his factory, Blake sees in it not children but silkworms and spiders, who ply

the wingd shuttle piping shrill thro' all the list'ning threads
Beneath the Caverns roll the weights of lead & spindles of iron
The enormous warp & woof rage direful in the affrighted deep

[15] ii.28:14–17: E312/K283:124–127; cf. *A.*c:20–23: E58/K205. Note that the air has changed from *red* to *darksom*.

And the woven draperies are freighted not by ships but by "strong wing'd Eagles" in "venturous flight." Finally the idea of weaving brings Blake around to his favorite theme, the spinning and twisting by the weak of the "gins & traps" of Church and State propaganda in which "many a Spirit" is caught. Musical instruments too are fabricated under the foremanship of Urizen, "many a soothing flute . . . & many a corded lyre" to "trap the listeners, & in cruel delight Bind them" (29:3–30:5).

Then rise the Builders, "Multitudes without number," who use "mortar mingled with the ashes of Vala" to build the Golden Hall of Urizen, a twelve-roomed Pandemonium in which tyranny may rule twelve months a year. Within the hall on an altar of brass produced by the "labour of ten thousand Slaves," victims are sacrificed to the code of charity and poverty to keep Urizen's lady happy "in the absence of her Lord." This "Shadowy Feminine Semblance" also requires a Golden Altar to appease her jealous sexual fears and to keep her limbs glowing "in his absence" (30:8–39).

In the construction of the brass altar "One thousand Men of wondrous power spent their lives." Yet after all this costly slave-driving, the tyrant and his pleasure-shadow cannot agree. When he returns "from his immense labours & travels," he is not satisfied with her "caresses & her tears." "To him his Labour was but Sorrow & his Kingdom was Repentence" (30:40–50).

There is a curious parallel to this vignette of the traveling warrior and his harlot in a chapter of current history in which Blake played a slave to Urizen and sacrificed his art on the altar of hero-worship by collaborating in the construction of such an altar. In 1799 a committee of admirals and chiefs of state was formed for raising a public "Monument to Perpetuate the Glorious Victories of the British Navy." Blake had scarcely had time to inscribe in his copy of Bacon, "What do these Knaves mean by Virtue? Do they mean War & its horrors & its Heroic Villains?"[16] before he was commissioned by his friend Flaxman to engrave a Prospectus of Flaxman's designs, to be submitted to this committee, for a huge allegoric "Naval Pillar or Monument" including a statue of Britannia Triumphant with figures of Nelson and other heroic villains

16 E612, punctuation added as in K400.

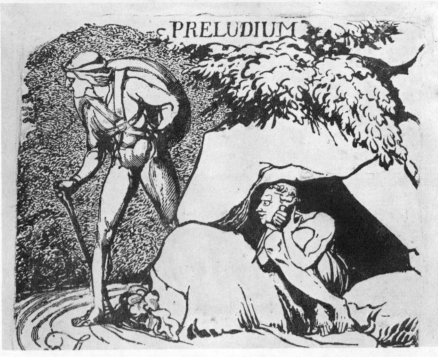

V. (a) *Europe,* Preludium, plate 1, detail, 1794
 (b) James Gillray, *The Dagger Scene,* detail, Dec. 30, 1792

VI. Rintrah and Queens, *Europe,* plate 5, 1794

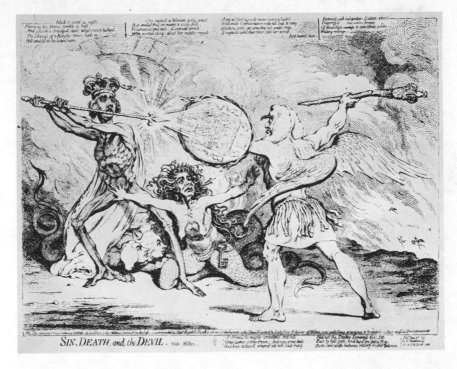

VII. (a) James Gillray, *Sin, Death, and the Devil* (i.e. the Queen, Pitt, and
Thurlow), June 9, 1792
(b) *Nebuchadnezzar*, color-printed drawing, 1795

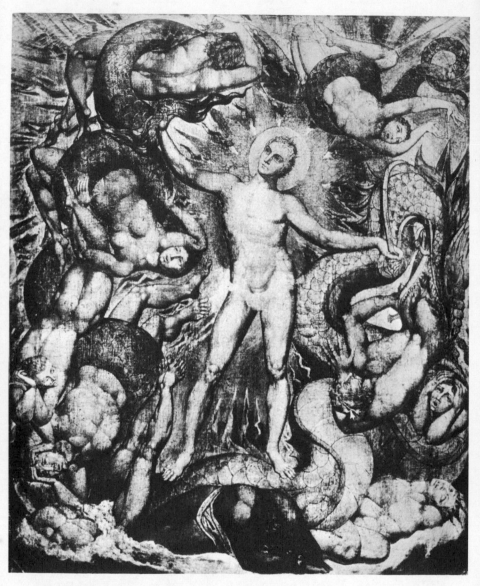

VIII. *The Spiritual form of Nelson guiding Leviathan, in whose wreathings are infolded the Nations of the Earth, 1809*

on the pedestal.[17] Urizen's golden and brass altars for the sacrifice of war victims may be taken as visionary projections of Flaxman's designs. And Blake's description of the golden altar—"with Art Celestial formd Foursquare sculpturd & sweetly Engravd"—may reflect the fact that Blake did engrave a picture of what Flaxman hoped to sculpture, a four-sided obelisk to the naval heroes and their king.[18]

An amusing and probably intentional coincidence resides in the fact that heroic Nelson, like heroic Urizen, had a shadowy feminine semblance, the erstwhile artists' model and attitudinizer Emma "Lady" Hamilton, whose caresses and tears on Nelson's departure and return from his naval labors and travels were notorious. In November 1800, Hayley, already Blake's patron, was in London introducing Flaxman to Nelson as "the sculptor who ought to make your monument."[19] In February 1801 Romney's painting of Lady Emma sighing while her hero's ship sails away was parodied by Gillray as *Dido in Despair*.[20] Should we take the passage in *The Four Zoas* as another parody, deepened by the theme that "Men of wondrous power" are sacrificed in the sculpturing and sweet engraving of altars to War and Lust? In 1804 Blake spent some time trying to find Lady Hamilton's address for Hayley.[20a] A few years later he offered to the nation his own ambiguous memorial of *The Spiritual Form of Nelson* as a nude heroic infolder of nations (and women).

[17] Published as a quarto pamphlet: *A Letter to the Committee for Raising the Naval Pillar or Monument,* by John Flaxman, Sculptor, London, 1799. Three plates are engraved by Blake: *A Colossal Statue 230 Feet High; Obelisk, Column . . . Temple;* and *A View of Greenwich Hospital with the Statue of Britannia on the Hill.* In 1801 a model of the Colossal Statue was exhibited at the Academy (see W. G. Constable, *Flaxman,* London, 1927, pp. 59–60) and James Barry introduced an extravagant Pillar-Lighthouse fantasy into the Thames section of his great mural (see below), but the project got no further.

[18] Or the engraving may refer to Opie's proposal, discussed below.

[19] Wright, I, 110.

[20] F. C. Klingender, *Hogarth and English Satire,* London and New York, 1944, pl. 34.

[20a] Letters of Jan. 27 and Feb. 23. Blake had known Romney in the days when Emma was his model and Protégée. The whole passage, in the margins of the MS, can have been added at any time.

3

Different far are the sorrows of the poorest laborers, the brick-makers compelled to labor night and day among flames and smoke, laughed at by harsh Babylonian masters:

. . . We are made to turn the wheel for water
To carry the heavy basket on our scorched shoulders, to sift
The sand & ashes, & to mix the clay with tears & repentance.
 (F.Z.ii.31:6–8)

The smoking rows of brick kilns on the outskirts of London in Blake's day supplied the nearest thing to a modern industrial atmosphere.[21] Most scorned, perhaps, were the women workers. Vala endlessly laboring "among the Brick kilns" represents the addition of moral bondage to physical suffering. Washington's *America* prediction is coming true. The people of two nations, England and France, having forgotten brotherhood are working each other's destruction and suffering mutual scorn:

The times are now returnd upon us, we have given ourselves
To scorn and now are scorned by the slaves of our enemies.[22]

This kind of labor, we are told in Night VII*b,* makes all nature Urizen's harlot, building for him a temple of "secret lust." For his workers are not allowed to know the secret purposes of the fabrics they erect and the immense machines they build and operate. Their masters have transformed "all the arts of life . . . into the arts of death" and have jealously rejected even the tools of peace, such as the hand loom and water wheel.

And in their stead intricate wheels invented Wheel without wheel
To perplex youth in their outgoings & to bind to labours

[21] Blackstone, p. 3, notes the frequent appearance in Blake's imagery of the brick kilns as an early effect of the industrial revolution, and quotes Jonas Hanway's protest of 1767 at the "chain of brick-kilns that surrounds us," rendering the environs of London "displeasing both to sight and to smell."

[22] ii.31:11–12. Compare: "When France got free Europe 'twixt Fools & Knaves Were Savage first to France, & after; Slaves." Marg. to Reynolds, ciii: E630/K451.

Of day & night the myriads of Eternity that they might file
And polish brass & iron hour after hour laborious workmanship
Kept ignorant of the use that they might spend the days of wisdom
In sorrowful drudgery to obtain a scanty pittance of bread
(vii*b*.92:21–31)

Thus far Blake has accused Empire of promoting war, intensifying exploitation, and stultifying the lives of its slaves. He now adds the charge of divisive malice. Imperialism, he says, substitutes the intricate division of labor for the simpler tools of agriculture and handicraft not only for greater exploitation but *because* these tools suggest an agrarian, communal society, free of exploitation:

The hour glass contemnd because its simple workmanship
Was as the workmanship of the plowman & the water wheel
That raises water into Cisterns broken & burnd in fire
Because its workmanship was like the workmanship of the Shepherd
(92:22–25)

In short, industrial tyranny can only be maintained by keeping the people ignorant of their heritage.

Blake drew a picture of Ezekiel's "wheel within a wheel" as a symbolic contrast to the "wheel without wheel" of factory cogwheels which transmit power mechanically and blindly. His drawing shows the arc of a large spoked wheel whose hub is God and whose cogs are eyes, transmitting power through vision and in knowledge of the use.[23]

The work master *as Urizen* is so blind to anything outside his cogs that he fancies he can even outlast the "time of Prophecy" and walk "in power & majesty" eternally,

A God & not a Man a Conqueror in triumphant glory
And all the Sons of Everlasting shall bow down at my feet
(95:23–24)

[23] Large wheels were wooden, of course. The sort of factory Blake knew in London can be seen in a contemporary print of the interior of what had once been John Bunyan's meetinghouse and which lay on Blake's path from Lambeth to the city when he went by way of London Bridge. The room is a forest of large cogwheels and beams, employed in finishing some brass and iron cylinders that look like cannon barrels. Cf. *J*.22 illustration.

To see the large smelting operations described in *F.Z*.ii Blake would have had to visit the mines, but he was content with the brick kiln as archetype.

He does not boast that the sun never sets on his Empire; rather he orders his foremen to chain the Sun and, "with immense machines down rolling," to fasten it inside his temple "To light the War by day to hide his secret beams by night . . . The day for war the night for secret religion," for orgies in which he makes nature his "nightly harlot." But a God who is not a Man is, for man, nobody's daddy at all. Urizen the Conqueror is making the same mistake Orc did when he shed the human form. The vast program that was inaugurated to save Urizen from "the verge of Non Existence" has now by its own rotation reached that verge.[24]

[24] vii*b*.96:10–18: E393/K333–334:30–38; ii.24:4: E309/K280:21.

17. In the Tents of Prosperity

It is an easy thing to rejoice in the tents of prosperity
Thus could I sing & thus rejoice, but it is not so with me!
— *The Four Zoas* ii.36: 12–13

BLAKE must have intended from the beginning to conclude his epic of the Nights of Empire with a vision of the Great Day which would dispel them. The largeness of his ninefold plan called for a vast apocalypse and extensive preparations. Tyranny, emerging angry but still triumphant from the strife of the seventh Night (VII*b*) is given another long Night in which to demonstrate that Universal Empire amounts to Universal Confusion, before Tharmas is allowed to blow his trump and wake the Ancient Man.[1] When Albion does at last listen to the truth and arise, in *Night the Ninth being The Last Judgment,* we are not surprised to see him turn upon the villains who have governed and scourged him. Yet we have learned how much the execution of Blake's plans depended upon the details supplied by current history. "I see Every thing I paint In This World," he said at a time when he was well along in the writing of the Lambeth draft of his epic.[2] As he neared the

[1] Extant Night VIII is late, and the first draft may have been as different from it as Night VII*a* is from Night VII*b;* but some final Urizenic demonstration seems indicated—if only on the theory that the nearer Satan "is to his judgment the more he rageth," for Blake is clearly working in the "decay of nature" tradition. See Ernest Lee Tuveson, *Millennium and Utopia,* Berkeley, 1949, pp. 43 and 50, quoting a Puritan sermon of 1594.

[2] To Trusler, Aug. 23, 1799. I now concede that a "Lambeth draft" may be more hypothetical than I had supposed; yet even if the extant physical MS may have been, except for pp. 1, 3–18, 23–42, largely inscribed in 1802–1808 instead of 1796–1804 (as one interpretation of the evidence suggests), there must have existed a complete draft written before the renewal of the war, since only Night VIII is found to reflect that later historical era. For one thing, the ambience of the rest of the text is, except for brief revisions and additions, that of the time before the Peace. For another, if *Vala* was Blake's work in progress at Felpham, when did he begin *Milton?* Only Night VIII overlaps *Milton* in distinctive vocabulary and symbolism.

climax of his work at the end of the century, possibly by intention, he must have been particularly alert to portents of an end and a beginning.[3] Night IX is the most explicitly democratic and revolutionary of all Blake's prophecies. That is so partly, I suspect, because at the century's close there *was* a movement of the people which could be described in Blakean hyperbole as a rising, challenging, and judging of kings and warriors—so that Blake did not have to rely on his unaided imagination and could achieve, in poetry at least, a vigorous resolution of his prophetic fears and doubts.

The lamentation of Enion in Night II which provides an emphatic counterpoint to the Victory Song of Night I is a comment on plentiful but hoarded harvests—and actually the Nile victory was accompanied by a fruitful autumn—calculated to prepare the reader for subsequent economic as well as military reverses. England's brief commercial prosperity of 1798–1799 rested precariously on a fluctuation of bad and good harvests and an intensification of economic inequality. Farmers and grain speculators were reaping gold, but the wages even of farm laborers had not gone up, while war and famine had raised the price of bread to a level that meant wretched subsistence for many even in a good year. Enion as one of Blake's muses may speak particularly for the engraver when she cries, "it is not so with me!"[4] For the prospering farmer "It is an easy thing to triumph in the summers sun And

[3] For a satiric survey of fin de siècle feelings see the anonymous *Millennium; a Poem in Three Cantos*, London, 1800. For an instructive analogue of Blake's prophetic mood and method at this time, note the following page of Holcroft's diary for Feb. 20, 1799: "Called on [William] Sharp, and paid him for his print of *The Sortie of Gibraltar;* which he said . . . was the last on such a subject, meaning the destruction of war, that would ever be published. . . . The wisdom of the Creator had occasioned all our miseries: but the tongue of wisdom was now subdued, meaning Egypt, which was not only a slip of land resembling a tongue, but the place in which the learning of the world originated. Thus, by the help of a pun and a metaphor, he had double proof. . . . Syria, Palestine, and all these countries are soon to be revolutionized; and those who do not take up arms against their fellow men, are to meet at the Grand Millenium. . . ." *Life of Holcroft,* ed. Elbridge Colby, London, 1925, II, 246.

[4] War, by cutting off the export trade in prints, had reduced the Arts to "an abject and almost expiring state" even by 1796 according to Abraham Raimbach, an engraver who later replaced Blake in Hayley's employ. Raimbach, *Memoirs,* p. 22.

in the vintage & to sing on the waggon loaded with corn." And for the rich factor or the fat John Bull of the caricature prints, swilling his port and gulping his mutton and asking only to "buy & sell," it is easy to listen to the cry of the hungry "in wintry season When the red blood is filld with wine & with the marrow of lambs" (ii.35:16–36:2).

Such greedy prosperity cannot last. It is based on indifference to misery and on a chauvinistic sense of humor that can "laugh at wrathful elements," enjoy Continental epidemics, and thank "a god" for "the thunder storm that destroys our enemies house." And it induces a forgetfulness of the cause of liberty, as we are reminded in the images of Blake's Declaration of Independence: "the groan & the dolor are quite forgotten & the slave grinding at the mill And the captive in chains & the poor in the prison, & the soldier in the field." So the hoarders' prosperity is doomed in the eyes of anyone who hates injustice and feels such kinship with "the afflicted," "the houseless wanderer," and even "our enemies," as does Enion, who is that sort of "anyone" or "everybody" who hates a king (35:18–36:10).

Her view is that of the few radical pamphleteers who continued in the aftermath of '95. Thelwall, for instance, writing after the good harvest of the following year, observed that the drug of "prosperity" and the loss of faith in the good cause were making people the prey of organized grain monopolists, government contractors, and those merchants and planters who chose to immolate "the flower of British youth, for the perpetuity of the African slave trade." The people's acquiescence in the crusade against France had left them open to "the profligate crusade of the powerful and the wealthy . . . against the oppressed." The friends of liberty, "unassociated, and unendeared to each other" (compare Blake's "What! are we terrors to one another. Come O brethren") were forgetting their common interests. But the people must recover from their Antijacobin panic, their friends must suspend "jealousy and envy"; and "then shall the golden visions of corruption fade away, and the dark mists of hovering despotism flee before the rising sun of British freedom."[5]

Thelwall was driven out of England, but so were the "vain prosperity" and the "acquiescence" he had criticized. In 1799 came

[5] *Rights of Nature*, London, 1796, pp. 1–16.

a "wet, late, and unproductive harvest," and then came famine. Of what value to the artificer and peasant was the rise of textile production in that year or the increase of commerce and construction in the next, when there was no bread?

Without making what would be a groundless attempt to imagine the contents of a missing draft of Night VIII leading from the disasters of the Netherlands campaign to Judgment Day, we may follow in actual history the developing confusion in Britain which Blake takes up again in Night IX. Lamentations after the return of the decimated armies were increased by subsequent developments. "Accounts also arriving in the close of the year of the failure of the Russians in Switzerland and their retreat into Germany, despondency again began to prevail, the people revived their wishes for peace, because they again conceived that no purpose could be answered by continuing the war."[6] Bad harvests and mounting prices intensified the discontent. Tension increased as Parliament, meeting in February 1800, failed to respond. It declined to investigate the Netherlands fiasco, and it returned a harsh answer to a suspect yet reasonably worded peace proposal from Napoleon, while its reaction to the food crisis was to discuss bread substitutes and ways to diminish consumption. In May, King George was shot at by an ex-soldier, a "madman" whose bullets came very close to the royal head. For the Royal Academy Exhibition this month Blake's contribution was a painting of *The Loaves and Fishes*.

More than against the King, however, popular wrath intensified against profiteers in grain who were guilty of the sins of forestalling and "regrating" (monopolizing and hoarding) with what Blake calls "the merchants thin Sinewy deception" (ix.123:2). Some were brought to trial and fined; more were taken in hand by the people, who rose throughout the country as in '95 and compelled, sometimes by fairly violent methods, a lowering of prices. In August and September many provincial markets were in the hands of the populace. By September 14 this determination of the people to exercise their sovereignty reached London, where bread was up to 1s.9d. the quartern loaf (Thelwall had thought 9d. outrageous). The inhabitants were stirred to shake off their leaden gyves by the following placard:

[6] Bisset, II, 699.

Bread will be sixpence the Quartern if the People will assemble at the Corn Market on Monday.

FELLOW COUNTRYMEN,

How long will ye quietly and cowardly suffer yourselves to be imposed upon, and half starved by a set of mercenary slaves and Government hirelings? Can you still suffer them to proceed in their extensive monopolies, while your children are crying for bread? No! let them exist not a day longer. We are the sovereignty; rise then from your lethargy. Be at the Corn Market on Monday.[7]

That Monday the people of London did rise and storm the Corn Market—and the price of wheat went down. On Tuesday they brought a sinewy butcher to trial and obtained his conviction for forestalling. For six days the multitudes seethed beneath the spires and towers of Infinite London.

On Thursday of the same week, the Blakes departed from Lambeth to begin their new life in a seashore cottage sixty miles away at Felpham. Arriving, Blake reported at once to his London friends that "Felpham is a sweet place for Study, because it is more Spiritual than London"—part of its spirituality consisting in the fact that "Meat is cheaper than in London."[8] Both the city-country economics and the city-country spiritual values enter Blake's Last Judgment for 1800.

All England was astir, coupling demands for bread with a cry for peace. In June there had been a "serious riot" when army officers were stoned out of a Nottingham theater for trying to make the audience sing "God Save the King."[9] In September the weavers

[7] In John Ashton, *Dawn of the 19th Century in England*, London, 1906, p. 19.

[8] To Flaxman, Sept. 21; to Butts, Sept. 23. The text of Night IX cannot be dated closely enough to tell whether Blake had begun it before he moved from Lambeth, but its clearest historical context is the 1800 famine year with mounting discontent and delayed prospects of peace. No particular signs of Felpham appear (such as the seaside atmosphere Margoliouth detects in Night VIII); yet country experiences may have assisted the country-city contrasts of this Judgment harvest vision.

A quite different peacetime context is implied in the first 88 lines, a later addition to the MS (see below).

[9] *The Times*, June 30, 1800.

of Nottingham and Mansfield, in a buyers' strike against high prices, won a signed agreement from the farmers. The "artificers" of the Portsmouth dockyard, to mention an act near Blake's new residence, put their names to a resolution to "abstain from making use of any butter, cream, milk, and potatoes" until the prices came down. In several communities gunfire between people and dragoons brought casualties.

In October the London Common Hall burst into wrath against King George. The King had refused to receive on the throne a petition from his London subjects, deigning only to let it be handed to him at a Levee. To petition the King on the throne was an ancient right, and the shopkeepers were indignant. Besides, they protested, royal arrogance was out of place when the poor were starving. England was nearer to famine than it had been since the fourteenth century.

In November handbills were circulated in London pubs and "eat shops" calling on "Tradesmen, Artizans, Journeymen, Labourers, &c. to meet on Kennington Common" the day before the opening of Parliament, to petition King and Parliament "to reduce the price of provisions, or advance the price of labour" (a legally treasonous phrase as we know from *The Song of Los*) "or to afford them the means to emigrate to some other country to avoid a famine" (a note of grim despair).[10] The Privy Council ordered a turnout of every police officer and volunteer regiment available, and this meeting was not permitted. King and Parliament continued to do nothing to secure bread or peace.

2

In Night IX Blake's Albion rises like the artisans and laborers of 1800, not to be judged but to judge. Weary of the futile war, he lifts his "faded head" and begins to look about:

O weakness & O weariness O war within my members
My sons, exiled from my breast, pass to & fro before me
My birds are silent . . . & the sweet sounds of my harp.

[10] *ibid.*, Nov. 10.

His corn is "turned to thistles" and his golden harvests are scorched by heat and ruined by "driving rain." Joys have turned to "bitter groans," sad "voices of children," and "cries of helpless infants." All are "exiled from the face of light & shine of morning." "When shall the Man of future times become as in days of old[?]"[11]

The man who slept in his chambers or busied himself in his family has at last learned to "scorn the war." His heart is still weak, his "head faint," but his eyes are open and his righteous indignation develops swiftly at the sight of men drunk with each other's blood and not with nourishing wine. With "awful voice" he at once demands that the King (Urizen, Prince of Light) do something about "all this wracking furious confusion": "Shake off thy cold repose, Schoolmaster of souls great opposer of change arise[!]" But Urizen is workmaster not schoolmaster. "Answer none" is returned to Albion's call (120:9–26).

Having humbly petitioned the King and received no answer, the people now in wrath directly give orders to the royal navy, the King in his Dragon form as Leviathan "of the Deeps," to cease operations against France. The threatened alternative is an English rebellion ending in a republic:

Let Luvah rage in the dark deep even to Consummation
For if thou feedest not his rage it will subside in peace[12]
But if thou darest obstinate refuse my stern behest
Thy crown & scepter I will sieze . . . I will steel my heart
Against thee to Eternity & never recieve thee more.

(120:28–39)

Luvah will assume a form more creative than Napoleonism if permitted to exist in peace. Britain is consistently regarded by Blake as the aggressor both against France and against honest vision:

My anger against thee is greater than against this Luvah
For war is energy Enslavd but thy religion

[11] ix.119:32–120:2: E374/K359–360.
[12] Coleridge was writing editorials with the same theme: "Now for the first time [French] ambition has been checked; and Jacobinism, if not mortally wounded, yet requires all the aids of a war against France, to its resuscitation." *Morning Post*, Jan. 4, 1800, as also Jan. 3 and 6.

The first author of this war & the distracting of honest minds
Into confused perturbation & strife & honour & pride[13]
Is a deceit so detestable that I will cast thee out
If thou repentest not . . .Wake thou dragon of the Deeps

(41-51)

3

Before proceeding to the final harvest of the Zoas, let us look
at some drawings made by Blake during his residence at Lambeth,
his water-color illustrations of Thomas Gray's poems, in which his
visionary eye discovered many bards and kings including his favorite
villains.[14]

For times of famine Gray's *Ode to Adversity* supplies suitable
dramatis personae in Poverty wielding a triple scourge in each
hand, Disease pouring plagues from her urn, Despair clutching two
daggers for suicide, and finally a king chained in his own Bastille
where the "Purple tyrant vainly groans."[15] Even the *Elegy in a
Country Churchyard* is interpreted in the spirit of a famine year.
The plowman and his horse, both bent with toil, look wretchedly
"weary." The harvester cuts the heads of wheat with tender care.
And the "Village Hampden" who withstands the little tyrant of
his fields is an irate tenant with his spade defying a cruel landlord.

Gray's prophecy in *Fatal Sisters* that "Soon a King shall bite
the ground" is literally and almost exultantly interpreted. And four-
teen spirited illustrations for *The Bard* emphasize the cruelty of
kings and the vigorous indignation of poets. The power of the
bardic harp is manifest in harp-strings as thick as cables. And it is
in one of these drawings that Edward III, the heroic villain of
Blake's early play, is shown as the "scourge of France" soaring like
Urizen above the peaceful villagers (Plate II).

More auspicious of peace is the picture, illustrating *A Long*

[13] Remember the preaching of Druidism in 1792 to the youth of England,
in *Europe*.

[14] Blake's 116 *Designs for Gray's Poems* were first published in 1922,
with a preface by H. J. C. Grierson, who dated them ca. September 1800.
Hence the reference at this point, but the date of the drawings is now
known to be 1797—closer to the famine year 1795–96.

[15] Here Blake has concentrated Gray's plural "tyrants" into one.

Story, of flying hod-carriers and fairy sculptors at work on a cathedral arch. After his move to Felpham and the cathedral city of Chichester Blake would put Los and his Spectre to work to build the City of Art as a refuge in times of trouble. Finally, in illustration of Gray's *Progress of Poesy,* Blake shows the power of bardic song as capable even of taming the Eagle of War that is perched on Jove's scepter.

Some idea of the intellectual peace Blake expected to find in his new association with William Hayley may be gathered from Hayley's newly published *Essay on Sculpture in a series of Epistles to John Flaxman,* London, 1800. Flaxman and Butts may separately[16] have wanted to temper Blake's bardic politics (see below) but it was Hayley that he was going to work with. And Hayley, while still "not yet a Republican" (remember his letter to Barlow), was evidently "spiritually adjoined to us."[17] His first Epistle concludes auspiciously:

> Angels of light! who deeds of blood abhor,
> Enchain that homicidal maniac, War!
> All hell's dire agents in one form combin'd
> To fire the globe, and demonize mankind![18]
> Let Arts, that render men divinely brave
> To Peace's temple turn Destruction's cave;
> And form, to counteract infernal strife,
> New bonds of friendship, and new charms of life!

[16] As Bentley points out, Blake's letter of Jan. 10, 1802, seems to indicate that Butts was not familiar with Flaxman.

[17] I adapt a phrase from Blake's letter of April 7, 1804—not his usual view of Hayley, yet one that emerged after much tribulation.

[18] Cf. Barlow on War (above) and *F.Z.*viii.102:19–20; 104:19–24: E360, 363/K334, 347.

18. A Wondrous Harvest

They took [the Sheaves] into the wide barns with loud re-
joicings & triumph
Of flute & harp & drum & trumpet horn & clarion.
— *The Four Zoas* ix.132:8–9

BLAKE was like most latter-day British prophets in expecting the
royal head to save itself by a last minute repentance which would
make gallows or guillotine unnecessary. Byron, writing his *Vision
of Judgment* twenty years after Blake's, allows King George to slip
into heaven after he has been laughed down to human size. In all
Blake's prophecies it is implicit that princes are capable of putting
off the Dragon form or the Angel form and resuming the Human,
of stepping into the flames to discover that democracy can be a
thing of joy. The very structure of *The Four Zoas* calls at the end
for a repentant Urizen accepted into the Brotherhood of Man, of
Nations, and of man's psychic faculties harmonized.

The big question is whether the tyrant or his slaves must take
the initiative in his repentance. After the Peace of Amiens Blake
believed for a time (as we know from his letters and from revised
Night VII*a*) that rulers might voluntarily "unbuckle the girdle of
war." But earlier—and later—he represented the people's waking
as the deciding factor. In Night IX it is Albion's call, and no mere
change of Urizen's heart, that forces the cruel work master to
repent; moreover, his repentance must be implemented by a
thorough harrowing of the empire.

The *ideas* that Urizen must repent of are, first, that commercial
advantage justifies war, and second, that slavery is essential to
commerce. This intellectual repentance seems at first a relatively
simple matter. Urizen weeps into the dark deep, is anxious to leave
his scaly form and "reassume the human," and apologizes for ever
having "cast my view into the past" to darken the present with
war and with the building of "arches high & cities turrets &
towers & domes Whose smoke destroyd the pleasant gardens &

whose running Kennels Chokd the bright rivers."[1] This has been
Cain's city or Nimrod's, built with murder and called Confusion;[2]
but Nimrod now professes to see the folly of his imperial venery,
his fleecing of innocent lambs and his running after the daughters
of Needlework from Surinam to China,

> burdning with my Ships the angry deep
> Thro Chaos seeking for delight & in spaces remote
> Seeking the Eternal which is always present to the wise
> Seeking for pleasure which unsought falls round the infants
> path
> And on the fleeces of mild flocks who neither care nor labour
> (ix.121:8–12)

It is unclear whether the "mild demons of the hills" are never
to be stripped of their fleeces at all, or only never for greedy profit
or at the wrong season. Urizen now classifies himself in a more
sympathetic category than that of work master. He says he is simply
a worker whose energies have been misdirected: "the labourer of
ages," whose hands are deformed "with the sword & with the
spear," but who takes no joy in his destructive and divisive labors.
Recognizing the folly of his ways, he casts "dark remembrance"[3]
from his brain and removes the political and press censorship:
henceforth all power to Man:

> Let Orc consume let Tharmas rage let dark Urthona give
> All strength to Los & Enitharmon & let Los self cursd.
> Rend down this fabric as a wall ruind & family extinct
> (121:23–25)

The ancient regime, which Los has been reconstructing to expose
as error, has now been exposed and must be torn down. The king
himself joins the revolution; "Rage, Orc! Rage, Tharmas! Urizen
no longer curbs your rage."[4] At these magic words, which Orleans

[1] *F.Z.*ix.121:1–8, first reading. In revision, "into the past" becomes "into
futurity." See note 3.
[2] See *T.S.B.*1:10–11: E437/K41. A merging of Cain and Tubal-cain is
involved.
[3] ix.121:19, first reading. Again, "remembrance" is changed to "futurity."
Urizen in trying to hold onto the past had been trying to rule futurity.
See E761; cf. *F.R.*120.
[4] Punctuation added.

had sought in vain from Louis of France, the Dragon Prince of Albion shakes off not only his dragon but his old-man form:

> . . . Then glorious bright Exulting in his joy
> He sounding rose into the heavens in naked majesty
> In radiant Youth. (121:30–32)

All very well. Yet a royal repentance or intellectual about-face, crucial as it is, does not automatically transform society. Rejoicing at this point is premature.[5] The turrets and towers still stand, echoing the chimney sweeper's cry. The streets of London are still "running Kennels." The once "bright" Thames is still "chokd." The "angry deep" is still "burdened" with slave ships. Both humans and civilization will have to be regenerated by "a New Spiritual birth." Babylon will have to be destroyed to make way for "Jerusalem Which now descendeth out of heaven a City yet a Woman Mother of myriads." The errors of the long reign of tyranny remain to be purged: "I have Erred," cries Urizen, "& my Error remains with me" (121:5–8; 122:17–20).

The process of purgation is a lengthy one, and Judgment Day is a misnomer: it is really Judgment Week, the seven days of Genesis enacted in reverse. Moreover before the first day there is a dramatic curtain-raiser in which the whole groaning Universe bursts its chains and explodes, releasing all the oppressed—and bringing them face to face with their former oppressors. "All spirits deceasd let loose from reptile prisons . . . Flock to the trumpet":

Fathers & friends Mothers & Infants Kings & Warriors
Priests & chaind Captives met together in a horrible fear
And every one of the dead appears as he had livd before
And all the marks remain of the slaves scourge & tyrants Crown
And of the Priests oergorged Abdomen & of the merchants thin
Sinewy deception & of the warriors outbraving & thoughtlessness
In lineaments too extended & in bones too strait & long[6]

It is plain to see whose end is come. And now is unchained the terrible democracy of Blake's apocalypse against Kings, Warriors,

[5] "Ahania rose in joy Excess of Joy is worse than grief—her heart beat high her blood Burst its bright Vessels She fell down dead . . . they buried her . . ." (35–38).

[6] ix.122:31–123:4: E377/K363:235–249.

Priests, and Merchants. Unlike the traditional visions of Judgment, in which the sinned against stand meekly on one side clothed in sheets while the sinners are judged from the throne and torn away to hell by demons, Blake's Judgment gives the oppressed their opportunity for vengeance, a brief but violent dictatorship not only of the child-bearers (proletariat) but of the children themselves, the child laborers of street and mill who had been compelled to take the spectre form in despair. Christ, appearing himself as a "Cold babe . . . furious," authorizes the vengeance, for this is Blake's grim version of "Suffer the little children to come unto me":

> They shew their wounds they accuse they sieze the opressor
> howlings began
> On the golden palace Songs & joy on the desart

Here culminate Blake's images of palace and heath.

> the Cold babe
> Stands in the furious air he cries the children of six thousand
> years
> Who died in infancy rage furious a mighty multitude rage
> furious
> Naked & pale standing on the expecting air to be deliverd,
> Rend limb from limb the Warrior & the tyrant . . .
> (123:5–10)

The "furious wind" reunites "in pain" around them: it is the oppressed, the captives and divided families, who reunite, through the painful process of tearing their oppressors limb from limb. In earlier visions Blake had prophesied a fraternization of people and warriors, with the latter throwing down sword and musket. By 1800 he knew that firm persuasion would not transform the stubborn realities of militarism into a warbling brook. British troops returning from the bloody battles in Holland had grumbled, but few had thrown away their arms. "They beg, they intreat in vain now; they Listend not to intreaty." Blake's judgment is primarily upon the "Kings & Councellors & Giant Warriors" rather than the rank and file, however, as we discover further on (123:12; 134:7).

Judges, too, are ripe for judgment. We recall Orc's howl of delight in *Europe* at the fall of the Chancellor. Now, "trembling, the Judge springs from his throne Hiding his face in the dust"

(123:23–24). It is the prisoner's turn to deliver sentence, not yet to forgive:

> The Prisoner answers you scourgd my father to death before
> my face
> While I stood bound with cords & heavy chains. your
> hipocrisy
> Shall now avail you nought. So speaking he dashd him with
> his foot (123:30–32)

Compare Tharmas' explanation of his hatred: "My little daughters were made captives & I saw them beaten" (viib.97:6). Though it has scriptural antecedents, this spirit of vengeance is not unfaithful to the spirit of the English housewives and journeymen who directed their anger against press gangs, grain monopolists, and judges who used their courts as recruiting offices for the navy or for apprentice slavery.

The Seven Days now begin, described in the apocalyptic imagery of harvest and vintage which can be felt achingly by those who have lived with hunger or who have sworn to "abstain from making use of any butter, cream, milk, and potatoes" because, perforce, they cannot afford the price. The rest of Night IX (577 lines) is an extended song of harvest, a prophecy of the delights of peace and plenty in a new world free of monopolists, slave drivers—and cannon factories.

The horses leave the battlefield; the wild bulls, tygers, and lions depart from the waste lands and "throw away The spear the bow the gun the mortar"; and the "noise of rural work" resounds.[7] Observe that the new garden of Eden is attained not through the abandonment of mills and furnaces for some primitive pastoral simplicity but through a transformation of modern industry along peaceful lines. The guns and mortars and other "iron engines of destruction" are reduced to scrap (beaten "into wedges") and given to the ringing hammers of the blacksmith Urthona and his sons to forge "instruments of harmony," i.e. "the spade the

[7] If this throwing down (away) is compared to that in *The Tyger*, we may deduce either (a) that times have changed and it is now the once justly wrathful who are aggressors and must "weep"; or (b) that we are to see tygers and stars as one and the same, both having been warriors, now becoming human. Is it possible to read *The Tyger* in the latter sense: lamb-child becomes burning tiger becomes piercing star who repents, to lie down with (and as) lamb? Confrontations are contrary states of soul?

mattock & the ax The heavy roller to break the clods to pass over the nations" (124:14–22). War and empire have actually sabotaged useful production; the plow has never been fully used, and now the sons of Urizen must polish it "from rust of ages."

The nation-breaking of Empire only extended slavery, but the revolutionary harrowing of nations is a process of international fraternization. All men, as "Urthonas sons," plow and harvest together without distinction of mine and thine. Urizen guides the plow over the entire Universe; then sows the seed of souls, making certain that the "Kings & Princes of the Earth" fall on "unproducing sands & on the hardend rocks." He does not execute the oppressors, but he removes their economic base. While the Trump of Tharmas sounds, the seed is harrowed in to "ravishing melody of flutes & harps & softest voice," and the flames of Orc heat the black mould to incubate the future. As in *America,* harvest symbolism suggests that revolution engenders and fructifies a world of plenty (125).

Now the time has come for the proper relationship of Nature to Man. Gone are Vala's quiver of plagues and her Diana-like refusal of man's embraces. The painful partnership of coke and ore in the smelting furnace, in which Vala was burned to ash in the process of preparing the steel of hate, gives way to the genial relationship of earth and rain in the growing of crops:

Luvah & Vala henceforth you are Servants obey & live
You shall forget your former state return O Love in peace
Into your place the place of seed not in the brain or heart
(126:6–8)

Thus "cooperating in the bliss of Man," all the powers obey man's will. Luvah is still fertile blood or glandous wine, but not now the shed blood of humans. Starting as simple rain he becomes red in the grape; the eating of the grape symbolizes the drinking of the blood of a fertility god; and thus the agrarian Eden is restored, "their ancient golden age." Luvah as rain and Vala as the womb of earth dance symbolically through the rest of the drama, observed in dreams by "the sleepers who rested from their harvest work" (126:17, 29; 131:20).

Enion and Tharmas are at last united, appearing in Eden as innocent boy and girl "in Eternal Childhood," he the rivers and seas, she the moon that woos them—both children in the house of

Vala or Valhalla.[8] And Urizen, in the world of nature, is now the provider of sunshine while his children are the stars. Their kind light evaporates the torrent of floods and exhales[9] "the spirits of Luvah & Vala thro the atmosphere." The clouds of war "dissipate or sink into the Seas of Tharmas" (131:25–36). Luvah must go through one more Shelleyan cycle from cloud back to cloud, and then the human harvest will be ripe, the people having grown new bodies undeformed by the armor's iron brace.

Urizen combines drying and cutting operations, and the winnowing is done by Tharmas as Tongue, making the honest man's ultimate separation of wheat from chaff, exulting over the final downfall of the great Whore and all her "Kings & Councellors & Giant Warriors":

O Mystery Fierce Tharmas cries Behold thy end is come . . .
Lo darkness covers the long pomp of banners on the wind
And black horses & armed men & miserable bound captives

This is the end so long foretold, and now Tharmas recites the beginning foretold in *America*, repeating Blake's paraphrase of the second and third demands of the Declaration of Independence,[10] Life having already been attained. The slaves and prisoners attaining Liberty are urged to pursue their Happiness as earth-owners, free of religion's tithes: "The good of all the Land is before you for Mystery is no more" (134:1–29).

Milton's Adam and Eve had "the world" all before them: Blake's "the Land" suggests an agrarian emphasis. Yet it would be a mistake to neglect the fact that Urthona remains a blacksmith. A parallel to the economics of Tharmas may be found in those of Thomas Paine, the London edition of whose *Agrarian Justice* Blake appears to have read. Neither wished to return to a state of nature or to reject "those advantages which flow from agriculture, arts, science and manufacturers."[11] Both wanted to eliminate

[8] Blake knew from reading Mallet that Valhalla was the name of Odin's palace "where that god received all such as died in a violent manner, from the beginning to the end of the world—that is, to the time of that universal desolation of nature, to be followed by a new creation and the twilight of the gods." *Northern Antiquities*, I, 104.

[9] Compare 131:34–35 and *Thel* iii.8.

[10] "Let the slave grinding at the mill run out into the field . . . & laugh in the bright air . . . & believe it is a dream" (134:18–24; cf. *A*.6:6–12).

[11] Paine, I, 610.

poverty and restore the good of all the land to all people. Paine, like Tharmas, was especially wrathful at Mystery's attempt to perpetuate inequality and dismiss man's right to the land: "It is wrong to say God made *rich* and *poor;* He made only *male* and *female;* and He gave them the earth for their inheritance." In the context of Night IX it is highly fitting that Tharmas is the one who recites the Declaration of Independence.

Nothing reveals Blake's thoroughgoing democracy more characteristically, however, than his choice of a song for the great harvest feast. On occasion Blake could see "an Innumerable company of the Heavenly host" when the sun rose.[12] But to celebrate the sunrise of equality he chose "a New Song . . . Composed by an African Black" not to be sung by hosts of choiring angels but by "All the Slaves from every Earth in the wide Universe" (134: 30–34).

The making of bread and wine for the Golden Feast is painful because it recapitulates the long tale of tyranny and mystery, though it is supervised by Luvah as a happy "prince of Love" who has discarded his "crown of thorns." The wine-press symbolizes all the machinery of oppression, "the Screws and Racks & Saws & cords & fires & floods." And the new wine of freedom is too raw at first. "Drownd in the wine is many a youth & maiden." Even the immortals rise from the feast a bit tipsy, "satiated with Mirth & Joy"; Urthona, "limping," leans on Tharmas. The milling of the wheat reenacts the "terrible distress" of the famine years. The mental suffering of those waiting for the bread to come from the ovens suggests the condition of Blake as he wrote his bitter prophecy out of his own and others' suffering:

> . . . Nature in darkness groans
> And Men are bound to sullen contemplations in the night
> Restless they turn on beds of sorrow. in their inmost brain
> Feeling the crushing Wheels they rise they write the bitter words
> Of Stern Philosophy & knead the bread of knowledge with tears & groans.[13]

But now, no longer to plow in vain, "Man walks forth from midst of the fires the evil is all consumd." These lines echo and

[12] *V.L.J.*.95: E555/K617.

[13] *F.Z.*ix.135:12–138:15: E388–391/K376–379:700–820; cf. ii.35:11–14: E318/K290:397–401.

fulfill the prophecy of *America*.[14] The bread now is baked, the wine stored. The origins of the inequality of mankind have been eradicated, all divisions of men and families and nations. "One Earth one sea beneath," and "one Sun Each morning . . . Calling the Plowman to his Labour & the Shepherd to his rest." The hammer of Urthona still sounds in the mines and furnaces, but in the evening he can "sport upon the plains," and his limbs are renewed.

And what of Los, the Eternal Prophet? Since all things are changed better than his fondest dreams, the hidden and solitary prophet is reborn in the complete man of creative thought and act:

Urthona is arisen in his strength no longer now
Divided from Enitharmon no longer the Spectre Los
Where is the Spectre of Prophecy where the delusive Phantom
Departed & Urthona rises from the ruinous walls
In all his ancient strength to form the golden armour of
 science
For intellectual War The war of swords departed now
The dark Religions are departed & sweet Science reigns.

End of The Dream

On October 1, 1801, preliminaries of peace between Great Britain and France were signed. By the 15th the price of wheat had fallen ten to fourteen shillings a quarter. A publican at Lambeth, who had vowed that whenever peace was made he would give away all the beer in his cellar, opened his barrels on the 13th.[15] William Blake, who had no quarrel with the devil or the barrel and probably knew the Lambeth pubs, was not there to collect. But when the Great News reached Felpham, he was sure that the last trumpet had blown and the feast of the Eternal Man was spread. To his friend Flaxman he wrote on October 19th:

"Peace opens the way. . . . The Kingdoms of this World are now become the Kingdoms of God & his Christ, & we shall reign with him for ever & ever. The Reign of Literature & the Arts Commences. Blessed are those who are found studious of Literature

[14] ix.138:20 to the end; cf. *A*.8.
[15] Ashton, *Dawn of the 19th Century*, p. 44.

& Humane & polite accomplishments. Such have their lamps
burning & such shall shine as the stars. . . .

"Now I hope to see the Great Works of Art, as they are so near to
Felpham, Paris being scarce further off than London. But I hope
that France & England will henceforth be as One Country and
their Arts One, & that you will ere long be erecting Monuments
In Paris—Emblems of Peace [i.e. no more pillars to war's vil-
lains].

"My wife joins with me in love. . . ."

This time the prophet had lived to see his prophecy come true—
or so it seemed.

Part Six

PEACE?

Kill not the Moth nor Butterfly
For the Last Judgment draweth nigh
　　　　　—*Auguries of Innocence*

19. I Take the World with Me

THE Peace of Amiens, signed finally in March 1802 only to be abandoned by both Britain and France a year later, was called by King George "an Experimental Peace" and was looked upon by his statesmen as nothing more than "purchasing a short interval of repose" in order to consolidate the home front and knit up raveled alliances.[1] Peace would give war-weary troops a chance to return to their families. It would enable quartermasters to suspend the diversion of scarce grain and meat from civilian markets. Without the hope of military support from France the people of Ireland might adjust quietly to the new Act of Union which deprived them of their separate Parliament. London merchants who had been grumbling for peaceful trade would have an opportunity to see just how readily the merchants of Paris would reopen the markets of the Continent.

For Blake the ending of the war of swords would mean a time for open intellectual combat. First of all it would mean a chance to travel on the Continent and see "the Great Works of Art." This thought occurred at the first rumor of negotiations, and in 1802 Fuseli and many other artists did flock to Paris. But before Blake's chance came the peace was over, and in the soliloquies of *Jerusalem* the claustrophobia of an enforced insularity is a poignant theme.

As early as the summer of 1800 Blake's letters show a readiness to believe that the time had arrived when Men should "again converse in Heaven & walk with Angels." While editors spoke of peace, the Blakes moved from the shadow of London's spires to the sunny banks of the ocean. As Blake understood the arrangement with his new patron William Hayley, the chance had finally come to escape as an artist from the drudgery of hackwork. There was even a rumor that King George and his ministers were turning, not simply from war but toward Art, true source of national greatness.

[1] Lord Grenville. For a careful reexamination of the politics of this peace see D. G. Barnes, *George III & William Pitt*, ch. ix. See also Carola Oman, *Britain against Napoleon*, London, 1942, p. 121.

The proposal for a National Art Gallery, which had not moved forward since the days of Wilkes, was now being urged by several artists including Blake's friend George Cumberland and was meeting with some encouragement in high places: "I hear that it is now in the hands of Ministers," wrote Blake to Cumberland, "That the King shews it great Countenance & Encouragement, that it will soon be up before Parliament & that it *must* be extended & enlarged to take in Originals both of Painting & Sculpture. . . . such must be the plan if England wishes to continue at all worth notice."[2]

An ingenious feature of the new proposal drawn up by a Royal Academy committee, of which Flaxman and Opie were members, was to use the idea of a Naval Monument as an opening wedge and convert a war memorial into a gallery for the arts of peace. Instead of or in addition to a Naval Pillar, the plan called for a huge "Dome or Gallery of National Honour, consisting of various apartments fitted to contain pictures representing our achievements by sea and land, Navigation, Commerce, Colonisation . . . with portraits and statues of the most celebrated worthies."[3] The "Golden Hall of Urizen," in the passage of Night II which seems to allude to the Naval Pillar, may be considered Blake's contribution to the plan. He will have not one but "three Central Domes," each with four halls or apartments opening from it, and "Every hall surrounded by bright Paradises of Delight," that is to say, galleries of statues and paintings depicting "towns & Cities Nations Seas Mountains & Rivers."[4] Thus will King Urizen subsidize a "thousand Men of wondrous power," from Flaxman to Blake.

In reality such national encouragement of art was even further off than peace, but these warm thoughts helped Blake "begin to Emerge from a Deep pit of Melancholy," as he told Cumberland. And he was further cheered when the "few friends I have dared to

[2] To Cumberland, July 2, 1800.

[3] In John Evan Hodgson and Fred A. Eaton, *The Royal Academy and Its Members, 1768–1830*, London, 1905, p. 141. The details were suggested by the painter John Opie in a letter to the *True Briton* in the spring of 1800. Opie, *Lectures*, London, 1809, pp. 167–178.

[4] F.Z.ii.30:15–40 (E313/K284 f.:173–198), MS addition. Cf. *J.*16. For James Barry's elaboration of the idea by adding a "Pillar, Mausoleum, Observatory, Light-house . . . united in the same structure" to the Thames section of his mural, see *Transactions of the [Royal] Society of Arts*, XIX (1801), xlix–lxi.

visit in my stupid Melancholy" pointed to the cultural growth of London "in so few years from a City of meer Necessaries" to "a City of Elegance in some degree." The approach of peace reminded Blake and his wife of the time of peace following the American War when they had launched the shop of Parker & Blake although a print shop had then been "a rare bird in London." Now "an immense flood of Grecian light & glory" seemed to be "coming on Europe," and in modern London there were "as many Booksellers as there are Butchers & as many Printshops as of any other trade."[5] *Bell's Weekly Messenger,* speaking for trading dealers, put the matter more crassly. Before the "sudden and severe check . . . of War," English engraving had begun to exploit a rich "source of wealth" in export trade and had "attained a reputation which surpassed the pretentions of every other Country in the World." Now the *Messenger* was "glad to perceive a revival of similar speculations," in particular a print of Washington, engraved by Heath for the American trade, and print of Bonaparte, engraved by J. R. Smith for the French.[6]

These would prove idle "speculations," for the peace negotiations of 1800 would come to naught. But Blake for a while was "full of the Business of Settling the sticks & feathers of my nest" at the cottage at Felpham, and full of ambition to begin "a New Life, because another Covering of Earth is shaken off." With "Meat cheap, Music for nothing, a command of the Sea, and brotherly affection fluttering around," as Butts, replying from London, summed up Blake's hopeful report from the seashore, it was in the nature of things that the poet should believe that the Universal Brotherhood was approaching.[7] But by the end of the year it was plain that the dove of peace had not alighted. Meat was not universally cheap. Pitt's answer to the cry for bread had been a Brown Bread Bill requiring bakers to discourage consumption by making a less palatable loaf. And the manning of warships continued despite the resignation of Pitt in February 1801 and the renewed insanity of the King. The new Addington ministry, though it did ultimately arrange the Amiens truce, proceeded first with two military adventures—Nelson's destruction of the neutral Danish

[5] To Cumberland, July 2, 1800.
[6] *Bell's Weekly Messenger,* Feb. 23, 1800.
[7] Blake to Butts, Oct. 2; Butts to Blake, Sept., in facsimile *Letters from Blake to Butts,* ed. Keynes, London, 1926; Blake to Flaxman, Sept. 21, 1800.

fleet in Copenhagen in April and the expulsion of the French from
Egypt in August.[8] Blake's vision of this grim continuation of the
war, after the fall of Pitt and the King's derangement, appears in
passages in Nights V, VI, and VII*a* in the form of Urizen's stub-
born determination to perpetuate his rule despite madness and
blindness.

When in October the peace "Preliminaries" did officially arrive,
however, Blake responded with unqualified delight, as we have
seen. He had waited so long that he simply must now believe that
France and England would hate no more but "henceforth be as
One Country and their Arts One." He was no more ingenuous
than many of his contemporaries in accepting the Peace of Amiens
in good faith. Though the politicians intended a mere truce, even
canny Robert Bisset, finishing his *History* with "the Termination of
the Late War," rejoiced at that termination as a lasting one.[9]
Blake's own renewed life in Art was itself auspicious of Divine
Mercy.[9a]

In the spirit of such rejoicing and with an almost Christian for-
giveness of tyrants, Blake began, perhaps at this time but perhaps
only when peace actually came, to revise *The Four Zoas*—to write
a meeker introduction to night IX (see below); to replace VII*b*
with a new version (VII*a*), which meant putting aside the war
songs of the Netherlands expedition of 1799 and the picture of a
groaning Empire. Yet the version containing these was not de-
stroyed,[10] and it may be that before Blake could make up his
mind to reject the darker version altogether, he saw the war clouds
gathering again. Or it may be that he was never *entirely* certain of
the peace.

Willing as he may have been to put aside some of his harsh

[8] In the first edition I mistakenly placed at this date Blake's interest in
the *Lines Written on hearing the Surrender of Copenhagen* which refer
actually to the bombardment of Copenhagen in 1807 (see below, p. 452).

[9] Bisset, note in second edition, II, 750. Cf. Thelwall's Ode V "To Peace.
1801," *Trident of Albion*, Liverpool, 1805, pp. 89–93.

[9a] Blake's hopefulness assumed a republican France; perhaps only later
revelations of Napoleonic tyranny led him to the "imposter" theory noted
below, p. 493.

[10] Some argue that one Seventh Night was not meant to replace the
other, that they represent sequential rather than alternate approaches to the
dark night of VIII, and the point is certainly debatable. Blake cannot have
intended *ten* Nights, however.

pictures of war and empire, Blake did not forget the official callousness and stubbornness of the winter and spring of 1800–1801 which had climaxed in the fall of Pitt. Certain passages in the middle of the epic are quite as bitter as Night VII*b*. The King's insanity adds a Lear motif to the conclusion of Night V and to Night VI. The philosophy of the Brown Bread Bill, with which Night VII*a* opens, only shifts emphasis from the groans of the oppressed to the stratagems of the oppressors. We must not of course suppose that Blake's responses to the rapidly alternating tides of peace and war can be chronologically extricated from their absorption into his mythical narrative. But the contrast of the two historical phases, reflected now in grim satire on government and now in thanksgiving for peace, will be clear if we put aside the passages on peace for a separate chapter and take up first the sections of Night V–VII*a* that deal with a changed Urizen.

Our bearings can be taken from the "Crust of Bread" passage in Night VII*a* and from a letter to Butts of September 11, 1801, alluding to Pitt's Malthusian view of "Distress." The letter shows how Blake viewed his own relation to the world at this time. He sought to take the part of patient resignation but found it hard:

". . . I labour incessantly & accomplish not one half of what I intend. because my Abstract folly hurries me often away while I am at work, carrying me over Mountains & Valleys which are not Real in a Land of Abstraction where Spectres of the Dead wander. This I endeavour to prevent & with my whole might Chain my feet to the world of Duty & Reality. but in vain! the faster I bind the better is the Ballast for I so far from being bound down take the world with me in my flights & often it seems lighter than a ball of wool rolled by the wind Bacon & Newton would prescribe ways of making the world heavier to me & Pitt would prescribe distress for a medicinal potion. but as none on Earth can give me Mental Distress, & I know that all Distress inflicted by Heaven is a Mercy. a Fig for all Corporeal Such Distress is My mock & scorn."

It was well for Thomas Butts, a good patron but a "Friend of Religion and Order," to have the impression that Blake's Zoas were specters of the dead and that his mountains and valleys were merely islands in the moon of abstract folly. The good Thomas was not to hear the Quiddian mockery in Blake's words, but the mockery is there. He had just finished toiling at a miniature of Butts and was

working "daily" by Hayley's side "on the intended decorations" for a *Life of Cowper*.[11] Blake's letter practically says, a fig for all this business of drudging for money: I have been taking time off to work on my epic.

The letter also tells us that the world which Blake took with him into the land of the Zoas included Bacon, Newton—and Pitt. William Pitt's prescription as Lord of the Treasury was made in a speech in Parliament November 11, 1800, on the royal message advising lords and gentlemen to direct their attention to the difficulties of "the poorer classes" and to "economy and frugality in the consumption of corn." Two radical members, political descendants of Wilkes, had blamed ministers for prolonging the war and thereby intensifying the scarcity and had urged price control and action against food monopolists. Pitt dismissed the war as a factor and branded control proposals as "wild projects, struck out from temporary distress, the offspring, not of argument, but of fear [and] inflamed prejudice." To lay a hand on grain monopolists "to redress any supposed mischief" they might occasion would be "to strike at the freedom of trade."

Pitt urged "becoming firmness" in applying the more abstemious "remedy for the distress" which he himself advised: a firm abstention "from all rash experiment in the established course of trade," a firm resistance to any temptation to lower prices—which would be "risking that increase of consumption which ought so much . . . to be avoided"—and a firm endeavor "to diminish the consumption." The "only way to prove a sincere and enlightened regard to the interests and well-being of the poor" was to guard them from "false and dangerous expectations" of enough to eat. "Parliament cannot by any charm convert scarcity into plenty. . . . Let us act with proper temper, firmness and sobriety."[12]

"Listen to the Words of Wisdom!" cries the bard of *The Four Zoas* (through the mask of Urizen) in introducing a visionary parody of this royal and ministerial message. "So shall [ye] govern over all let Moral Duty tune your tongue But be your hearts harder than the nether millstone." Urizen reads the Pittian prescription from "his book of brass in sounding tones":

[11] Wright, I, 113.
[12] *Parl. Hist.*, Nov. 11, 1800.

Compell the poor to live upon a Crust of bread by soft mild arts
Smile when they frown frown when they smile & when a man
 looks pale
With labour & abstinence say he looks healthy & happy
And when his children sicken let them die there are enough
Born even too many & our Earth will be overrun
Without these arts If you would make the poor live with temper[18]
With pomp give every crust of bread you give with gracious cunning
Magnify small gifts reduce the man to want a gift & then give
 with pomp.
Say he smiles if you hear him sigh If pale say he is ruddy
Preach temperance say he is overgorgd & drowns his wit
In strong drink tho you know that bread & water are all
He can afford Flatter his wife pity his children till we can
Reduce all to our will as spaniels are taught with art[14]

To "reduce all to our will" is the familiar obsessive power motif
of Urizen, who is still in some degree the King of England. It was
some three months after the Bread Bill debate that King George
lost his mind, but Blake for his own purposes puts this Crust of
Bread oration at the climax rather than at the threshold of his new
version of Urizen's mad wandering. It will now serve our purposes
to turn back to its beginning, in Night V.

[18] Keynes changes this word to *temperance*. But Blake is using *temper*
in a sense close to Pitt's. Pitt was asking the rich to act with "temper" by
compelling the poor to live with temper.

[14] *F.Z.*viia.80:1–21. Cf. Crabbe, *The Village*, 168–171. The thesis that
"Our earth will be overrun without these arts" was stated most sensationally
by T. R. Malthus in his anonymous *Essay on Population*, London, 1798, a
work Blake may or may not have known. Malthus did not add the idea of
"moral restraint" until his 1803 edition, however. Since Blake had repre-
sented villainous rulers as "preaching abstinence" as early as 1793, in the
words of Boston's Angel in *America,* he needed no help from Malthus to
write this passage. For a comparison of this passage to Malthus, see Schorer,
p. 325. But Blake in his letter refers not to Malthus but to Pitt, and the
only question is the shape his views take in *F.Z.*

20. Mad Again

Outstretchd upon the stones of ice the ruins of his throne
Urizen shuddring heard his trembling limbs shook the strong caves
— *The Four Zoas* v.63:22–23

On the thirteenth of February 1801, in the fortieth year of his reign, George III rose suddenly to his feet in the midst of church services and alarmed the congregation by booming out a verse from the ninety-fifth Psalm that struck him with a mad aptness: "Forty years long was I grieved with this generation, and I said, 'It is a people that do err in their hearts; for they have not known my ways.'"[1] Afterward he knelt in silent prayer till the cold stone and winter air had chilled him to the bone. All spring the King was ill; official reports used the word "fever," but the callous Prince of Wales and Duke of Clarence regaled the world with tales of their father's lunacy.

When we come upon Urizen in the new matter at the end of Night V he lies where the prophecies of Los have chained him, shuddering upon "stones of ice" like the King on the church floor and trembling at the distant voice of Orc like "the king of England" in *America* trembling at his first vision of the rebel spirit. Just as King George (and London gossip) blamed his returning nervousness on the recent resignation of Pitt (who took four leading cabinet members with him),[2] so Urizen links his dementia to the departure of his wise men:

Ah how shall Urizen the King submit to this dark mansion . . . !
Once how I walked from my palace in gardens of delight . . .
But now my land is darkend & my wise men are departed
(v.63:24; 64:1, 8)

Urizen, repentant, blames himself for having repressed the spirit of brotherhood and for having built his empire on war instead of

[1] Guttmacher, *America's Last King*, p. 282. Note the King's Urizenic identification of himself with Jehovah.
[2] D. G. Barnes, *George III & William Pitt*, pp. 381–382.

peace, and he recognizes the "cries of Lamentation Heard on my Mountains & deep sighs [compare *London*] under my palace roofs" as the result of his long neglect of mercy. Instead of opening his palaces to the public as national galleries of art, he has tried to hoard and hide the "holy workmanship" of the divine imagination and the public treasure:

> O did I close my treasuries with roofs of solid stone
> And darken all my Palace walls with envyings & hate
> O Fool to think that I could hide from his all piercing eyes
> . . . his holy workmanship (64:15–18)

In Lambeth imagery the king confesses that he was ill advised to undertake the American War: "We fell."[3] George III was wont to lament thus when mad. But Blake now has the king go further to confess that his subsequent attack on France was a wanton act of desperation ("falling I siezd thee beauteous Luvah") which led to the ruin of freedom "now . . . bound down . . . even to the gates of hell" (64:29, 65:4).

These words seem full of penitence, and when Urizen concludes that he must seek for Love even in the dens into which his rule has driven it—for "When Thought is closd in Caves, Then Love shall shew its root in deepest Hell"—we suppose that his intention is benevolent. Yet when he starts off "leaning on his Spear," we realize not only that he is quite mad but that he is still committed to a war policy. Tiriel is come again.[4]

Exploring in Night VI the Hell of his own kingdom, Urizen encounters "three terrific women," whose similarity to the weird sisters in *Macbeth* suggests the theme of inordinate ambition, and whose unkind treatment of the king, who turns out to be their father, suggests the ingratitude of Lear's daughters. Urizen, like

[3] Lines 25–28 echo *America* and the war summary of *Europe*.

[4] *F.Z.*v.65:12; vi.17:1: E337–338/K311. Night VI, particularly in the opening passage, is "strongly reminiscent of *Tiriel*" (Sloss and Wallis, I, 225). Parts of Urizen's story derive from the *Book of Urizen*, viii, but there the madness and all current allusions are lacking. Sloss and Wallis put the composition of Night VI with the late version of VII (easily later than 1801) since the two dovetail. Since the repentance speech at the end of V also dovetails with VI, I consider it a similarly late addition.

(All this in respect to time of composition; the lettering of the chapter title of Night VI, however, seems to indicate that the extant fair copy is as late as 1803.)

Lear and like Tiriel, curses his children for behavior which is largely his own fault. Allegorically these women are the arts of Britain. Once they were the envy of France and the eternals: "The daughters of Luvah Envied At their exceeding brightness, & the sons of eternity sent them gifts." A peace-loving unfallen Urizen "taught them songs of sweet delight." But now British policy is a curse destroying the peaceful arts, exchanging "blackness" for the "colours of loveliness" and "for crowns wreathd Serpents for sweet odors stinking corruptibility."[5]

In place of "labourd fatherly care & sweet instruction," the tyrant supplies "Chains of dark ignorance & cords of twisted self conceit And whips of stern repentance & food of stubborn obstinacy." As the great opposer of change he attempts to drive his rebellious children into ignorance of their own Paines and Blakes: "That they may curse Tharmas their God & Los his adopted son." Urizen prefers that they learn to "curse & worship the obscure Demon of destruction"—to reject the possibility of constructive change, to believe that the only alternative to oppression is anarchy, and thus to submit to his despotism forever.[6] He ends with a wish that his accursed sons and daughters "may worship terrors & obey the violent" like ideal slaves.[7]

As Urizen looks upon the "ruind spirits" that were once the liberty-loving citizens of Britain and France ("once his children & the children of Luvah") he sees his curse already fulfilled. The binding of citizens described in *London* and *Europe* has reached the nadir of individual isolation. The slaves, locked in self-interest and frightened out of all fraternity, "wander Moping" on a wintry earth and do not know for whom the bell tolls nor even hear the bell any more:

Beyond the bounds of their own self their senses cannot penetrate
. . . none knows his dark compeer
Tho he partakes of his dire woes & mutual returns the pang
The throb the dolor the convulsion in soul sickening woes

(vi.70:6–17)

[5] vi.67:5; 68:11–18. In Gillray's cartoons the Crown in Pitt's possession is a wreath of spitting snakes (see e.g. Plate VIIa).

[6] Cf. Shelley's *Address to the People on the Death of Princess Charlotte*, pars. 9 and 10.

[7] 68:26. Cf. *V.D.A.*1:23: E45/K190.

As the king explores his empire, he is appalled at his vision of its industrial future. The women at the brick kilns he sees as "women marching oer burning wastes Of Sand in bands of hundreds & of fifties & of thousands strucken with Lightnings"; mill workers as "myriads moping in the stifling vapours" of smoke; miners as multitudes "shut Up in the solid mountains & in rocks which heaved with their torments." In "fiery cities & castles built of burning steel" his sons and daughters are transformed by the slavish labor of war production into beasts and automatons, "dishumanizd men" in "the forms of tygers & of Lions . . . And scaled monsters or armd in iron shell or shell of brass Or gold" (21–36).

The horror of this industrial inferno is, to Urizen, that the very process of making men into slaves has made them in a sense no longer subject to his power. "His voice to them was but an inarticulate thunder for their Ears Were heavy & dull & their eyes & nostrils closed up." Blake had already prophesied this outcome in *The French Revolution* in the nightmare of the Archbishop of Paris. Ruling-class paranoia sets in when the "godless" masses appear, like an unreasoning beast, to be taking on a movement independent of the direction of the lash. Urizen agonizes for several pages and goes through one death and resurrection after another but to no avail. While he has "time enough to repent of his rashly threatend curse" and appears to do so, the difficulty is not simply that "He could not take their fetters off for they grew from the soul Nor could he quench the fires for they flamd out from the heart," but that his only real desire is to draw his children back into subjugation, not into free brotherhood. If he wants to remove their fetters, he wants also to quench their fires. In short he wants docile free labor. He wants to reach the people with his commands, but his curses deafen their ears.[8]

Like King Lear wandering in the storm, he is lost and piteous, desolate in a "poor ruind world" once glorious but "now like me partaking desolate thy masters lot." Yet all a king can think of is more regimentation, a stronger grip on his subjects, "another world better suited to obey His will where none should dare oppose his will himself being King Of All." Somewhat belatedly the author explains that the king's apparent repentance is but the "selfish

[8] vi.70:38–40, 46; 71:11–12: E340–341/K315:123 ff.

lamentation" of one "obstinately resolvd" in "aged venerableness."
The new order is not peace, but a bigger sword (72:35–73:30).

Consequently when Urizen finally wanders "into the Abhorred
world of Dark Urthona," he cannot see the humanity of his
regimented slaves but finds them all arrayed against his law. The
raising of "fifty-two armies" from his fifty-two counties for the
American War is reenacted in language repeated from *America,*
with one crucial difference—that now instead of "mustering around
their Prince" they "rise glowing around the Spectre" of Urthona,[9]
a monster in the king's eyes representing the consolidated hostility
of all the youth nourished for slaughter, the women laboring in the
kilns, and the children driven to harlotry and the labor of despair.
This "spectre Vast" is a kind of modern Talus, iron-shod and
iron-clad, with "iron spikes instead Of hair," and when he
speaks "with Voice of Thunder" he is encouraged "in stern de-
fiance" by Tharmas, the terrible iconoclast.[10]

Only by the stratagem of retiring like a spider "into his dire
Web" of Religion can the king prolong his power, for the de-
humanized warriors are still subject to the spell of Mystery, and
Urizen can still rule by astrology. The "dismal squadrons of Ur-
thona" are successfully overwhelmed by the web of superstition
woven by the comets as they roll in their "vast excentric paths
Compulsive" at Urizen's "dread command." Prospero is still able
to terrify Caliban with his magic. The Spectre and Tharmas flee
and hide.

Urizen, still filled with "horrible fear of the future," now ap-
proaches Orc himself, though not quite daring to beard him in his
den (we are now in Night VIIa).[11] Frankly amazed at Love's
power of survival in Hell, Urizen itemizes the torments of fire
and flood that beat on the chained Promethean, the salt rubbed
into his bleeding wounds, the weight of rocks that ought to bear
him "down beneath the waves in stifling despair." (The imagery
recalls the Slough of Despond and the illustration of the Preludium

[9] Lines 75:19–21 are repeated exactly from *A.*c:14–16: E58/K205. A
fourth line embodies the change indicated. Also "the four cliffs of Albion"
have become "the four Cliffs of Urthona"—a change chiefly in symbols, for
the land is essentially Great Britain still.

[10] Mortimer painted a *Sir Artegall and the Iron Man,* which was exhibited
in 1778.

[11] vii*a.*79:16: E347/K322:86.

of *Europe*.) Yet Orc's pulse still beats, his winged thoughts ("swift wingd daughters") still "sweep across the vast black ocean," and he can "laugh at all these tortures & this horrible place."[12]

The king recognizes that somehow the revolutionary is sustained by "visions of sweet bliss far other than this burning clime" and by the fraternal moral support of "others."

> Sure thou art bathd in rivers of delight on verdant fields
> Walking in joy in bright Expanses sleeping on bright clouds
> With visions of delight so lovely that they urge thy rage
> Tenfold with fierce desire to rend thy chain & howl in fury
> And dim oblivion of all woe & desperate repose
> Or is thy joy founded on torment which others bear for thee[13]

Urizen claims to have been moved by "Pity" to come and "reveal myself before thee in a form of wisdom," but Orc rejects his overtures with a curse: "Thy Pity I contemn Scatter thy snows elsewhere . . . I well remember how I stole thy light & it became fire Consuming" (78:43; 80:39–40).

Orc is not merely surviving but learning, like Shelley's Prometheus. However much he still looks like a dangerous Jacobin to Urizen, under the torture of the post-revolutionary epoch he *is* changing, both as British radicalism and as French radicalism (to express a dichotomy implied in the text). As British radicalism Orc is forced to look on, hungering, while the daughters knead "accursed dough" for his bread and while the tyrant reads his Pittian treatise on bread-as-a-weapon. The crusts are doled out with such "gracious cunning" that he is weakened and "divided" and becomes a worm. As French radicalism, however, appearing in a form in which Urizen recognizes him as Luvah, Orc becomes the Napoleonic serpent—strong but as full of pride and deceit as Urizen himself.

Urizen has discovered that the spirit of rebellion can be subverted but never destroyed, but he does not really foresee the ultimate "dread result." For he supposes that by compelling Orc to "stretch out & up" the poison tree of Mystery he can simply draw "all human forms Into submission to his will." Actually he is

[12] viia.77:26; 78:29–32. Is the black sea *ink*, meaning that radical pamphlets still circulate on the commercial ocean?

[13] 78:35–41. The situation is epitomized in Shelley's *To a Skylark*, st. 15.

preparing the tree's destruction.[14] "Blake now sees that the powers of tyranny may subvert revolutionary enthusiasm to their own extension," observe Sloss and Wallis, making the somewhat Urizenic suggestion that "the history of the years following the first successes of the Revolution in France is the likeliest cause of [Blake's] modified view."[15] This suggestion is helpful only if we neglect neither side of Blake's dialectic. The history in question must be the interlocking history of France and Britain. In it Blake sees the subversion of revolutionary force, as in Luvah's being driven to choose the serpent form and being taught "how to War" by the sons of Urizen (79:21). In it he also sees the survival of Promethean energy and "visions of delight" even in the pit of Hell, and the increase of Urizen's madness and despair, his cry of amazement: Whence art thou? How dost thou laugh at all these torments?

Nevertheless, since both France and Britain have resorted to pride and deceit, Blake now looks for peace not as the product of titanic insurrection but as an almost unaccountable gift of "Mercy & Love Divine" delivered by "the Divine hand" of a Providence not previously included in his epic machinery.[16]

[14] 81:3-6: E349/K334:163-166; see Sloss and Wallis, I, 248 n.
[15] ibid., 243 n.
[16] "Providence," "Mercy," "Merciful," and the hand Divine make a late appearance in F.Z., especially in VI, VIIa, and VIII, but it is difficult to give any date. I here assume a time before the Peace of Amiens, but other likely times are during that peace, and even after the resumption of war, i.e. in the Milton-Jerusalem period. To assume so late a date, however, we would be forced to suppose that at Felpham Blake suffered the tension of a poet still writing of revolutionary wrath in a milieu of bland Christian forgiveness. Against that view is the evidence of the Felpham letters, which confirm the emergence of Forgiveness as a dominant sentiment, at the time, in Blake's mind. It remains possible that these terms were physically inserted in the F.Z. ms. tardily. See the next chapter.

21. Soft Repentant Moan

In the long shift of Blake's thought and symbolism described by Sloss and Wallis (I, 143) as "the poet's progress from the anarchic revolutionary doctrine of the Lambeth books to a not less revolutionary Christianity" in *Jerusalem* and *The Everlasting Gospel,* the Felpham period is properly recognized as crucial. What scholars have neglected is the peculiarly *un*revolutionary quality of this brief transitional period, and its relation to the peace and rumors of peace that hovered over Blake's seashore cottage. In the Peace of Amiens Blake saw, for a time at least, a providential resolution of the impasse between the impotent rage of Orc and the obstinate cruelty of Urizen. The people of Britain and France *might* have risen in godlike wrath or Christian embracing to halt the bloodshed, but the only "existing beings"[1] in 1801 who did act with such divinity were rulers who repented and embraced each other. That George III and Napoleon should enter a state of mutual forgiveness seemed a different sort of miracle from those accomplished by the pamphlets of Tom Paine.

In 1803 Blake would discover that the mutual forgiveness had been feigned and he would turn again to the Everlasting Gospel of popular revolt, though more cautiously than ever and with more anxiety about considerations of timing. Meanwhile, during the halcyon period of life at Felpham under the Peace of Amiens, revisions of *The Four Zoas* were given a providential and even predestinarian emphasis.[2]

If in a consistently Blakean view the appearance of an external or intervening providence is really a projection or an illusion, here

[1] "God only Acts & Is, in existing beings or Men." *M.H.H.*16; restated *J*.91.

[2] See Sloss and Wallis, II, 184. Night VIII seems to be the only considerable portion composed *after* this period. The approximate date of Night VII*a* and related bits of new matter in other Nights is confirmed by parallel passages in letters of the winter and spring of 1803. See preceding chapter, final note.

the poet writes strongly under the influence of such an illusion. He now describes "the Saviour mild & gentle" as a *deus ex machina,* a "Finger of God" who sets the limits beyond which tyranny (Satan) cannot go and man (Adam) cannot be further enslaved (*F.Z.*iv.56:17–26). In this view, the French Revolution appears to have been a predestinated pageant rather than a drama of human conflict. "Even Jesus who is the Divine Vision Permitted all lest Man should fall into Eternal Death." Christ formed a part of the French Terror and "himself put on the robes of blood" to preserve France and Fraternity from extinction—"Lest the state calld Luvah should cease" (ii.33:11–14). The coming of peace demonstrates that Christ lives; the war must have been "permitted" in order to make that demonstration.

To some degree Blake has come round to the view which he so roundly rejected as "Predestination" when he read Swedenborg's *Divine Providence* a decade earlier. As Blake then exclaimed, "What could Calvin say more than this?" Blake would not usually agree with Swedenborg that the infernal "plans and preparations" of the generals of armies were sanctioned by divine "permission" or that it was a just God who permitted "kings and commanders" to proceed with the "murders, depredations, violence, and cruelties" incident to "the greater wars." There was more to be said for the last clause of Swedenborg's thesis, that Providence, though declining to interfere in the beginning or progress of great wars, did step in "at the close, when the power of one or the other has become so reduced that he is in danger of destruction."[3] In *America* Blake had seen such divinity, if not Providence, in the rushing together of warlike citizens to save their portion of eternity. And he might even now have argued that the peace, however long delayed, between England and France was an ultimate justification of the struggle of the French Republic. But he now no longer pictures that struggle as a mass crucifixion leading directly to a new heaven and earth. He treats the new peace not as a consequence of human struggle but as a sort of divine cease-fire order contravening it. Also in these revisions the economic sig-

[3] Par. 251. One of the reasons revealed to Swedenborg for the permitting of great wars is "that all wars, howevermuch they may belong to civil affairs, represent in heaven the states of the church, and are correspondences." Compare Blake's definition of "War on Earth" as "the Printing-Press Of Los." *M.*27:8: E123/K513.

nificance of Los as mankind in the state of lost equality fades before the significance of Los as mankind in the state of "Love Darken'd & Lost" (vii*a*.84:27). The emphasis, at least, becomes less social and more personal.

The extremity of the new doctrine is the thesis that "thou . . . of thyself Art nothing being Created Continually by Mercy & Love divine." These words, which express neither revolutionary anarchism nor revolutionary Christianity, "astound" Blake-Los with "irresistible conviction" and cause him to "tremble at myself & at all my former life." "I feel I am not one of those Who when convincd can still persist," says he, but not at all cheerfully. We need not question the sincerity of the conviction. We find Blake using similar language in the prose of his Felpham correspondence. Yet in both prose and poetry there are strong indications that this meek resignation to God as fate goes against the grain and is not likely to endure. In Night VII*a* the new wisdom of submission is preached by the "Spectre horrible," of all people. And while he is said to be "inspird" and to be the voice of Reason in no sinister sense, the proposition he leads the prophet to accept is tantamount to an agreement to deny Blake the poet and set up Blake the engraver and painter as supreme.[4] In fact the Felpham letters in which the pious note is most abject testify to precisely such an agreement. "The Lord our father will do for us & with us according to his Divine will for our Good," writes Blake to Flaxman, September 21, 1800. And in a letter of January 10, 1802, in which Blake speaks of himself as "a Soldier of Christ," he seems to rely on an inscrutable providence to determine when his paintings shall be accepted by the English public: "Patience! . . . if it was fit for me, I doubt not that I should be Employd in Greater things & when it is proper my Talents shall be properly exercised in Public as I hope they are now in private."

Blake's energy and ambition quickly plunge him beyond such fatalism, however. In the same breath he speaks of leaving "no stone unturnd & no path unexplord." Even in the matter of trusting God to give us good health, he qualifies: "It is a part of our duty to God & man to take due care of his Gifts & tho we ought not think *more* highly of ourselves, yet we ought to think

[4] *F.Z.*vii*a*.86:2–6; 87:52. Sloss and Wallis, 1, 255 n, observe that this concept of the Spectre as inspired and as the "real self" does not occur elsewhere.

As highly of ourselves as immortals ought to think." We should not be surprised to find, then, that even in his most passive definition of the new dawn of peace Blake suggests a direct stride through "the Gates of Wrath" as the way to reach soft repentance. The poem called *Morning,* a kind of variation upon the fifth stanza of *The Tyger,* celebrates the departure of the war of swords. "Western path," indicating the compass point of the American Revolution, signifies the way to Atlantis or the new Eden:

> To find the Western path
> Right thro the Gates of Wrath
> I urge my way
> Sweet Mercy leads me on
> With soft repentant moan
> I see the break of day
>
> The war of swords & spears
> Melted by dewy tears
> Exhales on high
> The Sun is freed from fears
> And with soft grateful tears
> Ascends the sky (*N*.8[12])

Nevertheless the revisions of *The Four Zoas* made in this spirit seem virtually to remove the central theme of struggle from the plan of the epic. They suggest that no kind of social or psychological revolution is necessary but submission, albeit submission must be to "the Divine Vision."[5] It is this tentative removal of the social dynamic that causes Blake to founder, as Frye puts it, on the approaches to the apocalypse. The new introduction to "The Last Judgment" (the first 88 lines of Night IX) seems to deny Albion any effective role. The collapse of tyranny follows a mere questioning of its validity, symbolized by the prophet's reaching up to pull down sun and moon. The people, though not responsible for this upset, do take active advantage of it. Not previously awakened, yet now awaking to the harvest, the poor "smite their opressors" who have "lost their robes & crowns." Freed slaves pursue the trembling "naked warriors" who had oppressed them. Blood drowns "Kings in their palaces" and floods all the "High spires & Castles"

[5] iv.55:10–56:10; vii*a*.86.

"till all Mysterys tyrants are cut off & not one left on Earth."[6]
Yet an impression lingers that all this apparent activity may be
only the preordained choreography of a cosmic puppet show.

In this context the poet-prophet's function, it should be noticed,
becomes unreal or miraculous in the specious sense that Blake had
rejected in his notes on Watson and Paine. With the people in-
active, the poet has either everything to do or nothing. Wishing
"to think *As* highly of ourselves as immortals ought to think," he
is inclined to ascribe magic power to his own words, to confuse
the conception with the communication of ideas, and to entertain
the notion that a change in his own mind is equivalent to, if not
the cause of, a change in international relations. The people are
"sunk down into a deadly sleep," says the prophet, in a tentative
addition to Night I,

But we immortal in our own strength survive by stern debate
Till we have drawn the Lamb of God into a mortal form
And that he must be born is certain for One must be All
And comprehend within himself all things both small and great[7]

For all his immortal strength the prophet-artist deems it advisable
now to turn aside from the building of Jerusalem, which would
directly awake Albion with the vision of a new society, to the
building of a City of Art as a shelter for the once-revolutionary
Orc, whose fires need henceforth be only mental.

Coleridge snapping his trumpet had similarly adverted to a
Christian mercy embracing all things both great and small and had
attempted the building of a dome of pleasure which should demon-
strate to the world the poet's magic power.[8]

Now the task of Los is not directly to expose and chain down
tyranny but to give eternal life to "those piteous victims of battle"
who need a "shady refuge from furious war" in the soft "bosom
translucent" of Enitharmon, i.e. in the inner folds of Blake's al-
legory's matrix. She, his willing partner now, observes that the
piteous forms they thus rescue "shall be ransoms for our Souls
that we may live." Now personal salvation, even a sort of spiritual
opportunism, is the theme, and the emphasis becomes strongly

[6] ix.118:18–119:13: E372–373/K358–359:44–79.
[7] A deleted marginal passage after i.11:11: E745/K272.
[8] See Coleridge's letter to his brother George, April 1798.

domestic, pointing to the happy collaboration of William and Catherine Blake, he engraving and etching, she tinting:

And first he drew a line upon the walls of shining heaven
And Enitharmon tincturd it with beams of blushing love
It remaind permanent a lovely form inspird divinely human
(viia.90:5–37)

Hayley observed that the Blakes, though married almost twenty years, were as happy as if still on their honeymoon: "she draws, she engraves, and sings delightfully." "He and his excellent wife (a true helpmate!) pass the plates through a rolling press in their own cottage together."[9]

Los is not now the furious prophet but the happy harvester, the binder of the sheaves who "follows The reaper." And the very act of gathering sheaves from the press or drawing lines on copper seems, fetish-like, to end the war between Britain and France. With "the strength of Art" he draws the dehumanized forms "From out the ranks of Urizens war & from the fiery lake Of Orc," vanquishing their roaring flames and bending their iron points. "First Rintrah & then Palamabron" are "drawn from out the ranks of war" in this fashion and restored to "infant innocence."[10] Not mentioned by Blake since 1795, these two as historical symbols are still Pitt and Parliament, taking on a sudden lamblike quality as they leave war for Art.[11] Remember the optimism of Blake's letter to Cumberland, and compare the words of the Speaker of the House to King George at the dissolution of Parliament in June 1802: "We now indulge the flattering hope that we may cultivate the arts of peace."

The peace terms announced in March "startled" many and may well have surprised Blake with their embodiment of a mercy and forgiveness that were, if genuine, divine: "Ministers did not think it necessary to insist on retaining all the acquisitions of our valour: we did not fight to subdue the possessions of others, but to secure

[9] Hayley to Lady Hesketh, June 10 and July 15, 1802. H. N. Fairchild, *Studies in Philology*, xxv (1928), 4–6. Note importance of the "heavy roller" among Blake's agrarian symbols.

[10] viia.90:30–45: E356/K332.

[11] This is their only appearance in *F.Z.* before Night VIII, where their roles seem to derive from *M*. Possibly their historical reference has already faded from Blake's intentions.

ourselves. We agreed to restore all our acquisitions, except the island of Trinidad and the Dutch possessions in the island of Ceylon. The Cape of Good Hope was to be opened to both parties: and the island of Malta was to be evacuated by Britain, but to be placed on such a footing as to render it totally independent of France."[12] With the opening of the Mediterranean and south Atlantic to French ships, "Orc was comforted in the deeps." With his "soul revivd in them" he could become "a father to his brethren" and have joy "in the dark lake," the Mediterranean, though still bound with chains of Britain's Jealousy and his own serpentine "scales of iron & brass." Now even Urizen was drawn "from out the ranks of war," although "his Spectrous form" could not be drawn away but had to be abandoned like a dismounted cannon, an allusion possibly to the King's insanity. Similarly every warrior was divided from his power to do harm, and "Thiriel became Palamabron"—meaning perhaps that Parliament became as harmless as a breeze.[13] The prophet was amazed to find "his Enemy Urizen now In his hands. he wonderd that he felt love & not hate"; and "he trembled within himself," as well he might.[14]

2

It appears from Blake's letters that his faith clung longer to the Peace of Amiens than it did to the corollary belief that Felpham was "the sweetest spot on Earth" and Hayley "a Prince" to work for.[15] He was aware from the first that his friends in getting him off to the seashore hoped to divert him from nervous preoccupation with the news of revolutions and war. And his adopting a respectful tone toward Angels, in his letters to his conservative friends Flaxman and Butts, deliberately marked, as Bronowski has observed, "his acquiescence in the new outlook which was planned

[12] Bisset, II, 750.
[13] viia.90:46–62: E356–357/K332:478–494. Thiriel (ethereal) is one of the four elements and not to be confused with Tiriel.
[14] 90:64–67. Blake *may* have written these lines after the renewal of hostilities, with ironic intent.
[15] To Butts, May 10, 1801.

for him."[16] But the move from Babylon to the City of Art, which
Blake calls Golgonooza and the details of which are derived
from the cathedral city of Chichester near Felpham,[17] could be
justified only if it increased the poet's power or opportunity to
transform Babylon into Jerusalem. He made what he could of the
coincidence of his own retreat with the general withdrawal from
war; yet there was an ambivalence in the very coinage of the name
Golgonooza. A Golconda of golden opportunity it might be for
the artist, but for the prophet and the London radical it sug-
gested a Golgotha of self-sacrifice in the oozy wilderness.[18]

By January 1802 Blake was complaining of the dampness which
plagued "My Wife & Myself" with "Ague & Rheumatism," and he
was coming to suspect that the sacrifices incident to Hayley's
effort "to lift me out of difficulty" might constitute a betrayal
of his duty as a "Soldier of Christ" and a refusal "to do Spiritual
Acts because of Natural Fears or Natural Desires!" The Hayleyan
program was essentially to launch Blake as an elegant miniaturist
and executor of ephemeral commissions, "to turn me into a Por-
trait Painter as he did Poor Romney." Blake at first had "a great
many orders" and persuaded himself that miniature was "a God-
dess." But he soon kicked against the pricks and returned to his
firm persuasion that the symbolic or historical content of art is
all-important. "Historical Designing is one thing & Portrait Paint-
ing another & they are as Distinct as any two Arts can be. Happy
would that Man be who could unite them."[19]

[16] Bronowski, pp. 75–76 [109–110]. See especially Blake to Flaxman and
Butts to Blake, Sept. 1800. Cf. F.Z.viia.85:29–86:12: E353–354/K328 f.:
339–369. Yet Blake's first visit to Felpham was meant to be a short one, then
grew collaborative. See Bentley, Studies in Bibliography, XII (1959), 170 n.
 [17] Wright, I, 107, 152–153.
 [18] See J.12. It is the imaginative "place of the skull." When Blake re-
turned to London, Golgonooza moved too and became "the spiritual Four-
fold London" (M.6:11: E98/K485).
 [19] Letters of May 10 and Sept. 11, 1801; Jan. 10, 1802; Jan. 30, 1803.
—We now have Hayley's own stated purpose, in a letter to a friend,
May 13, 1801: "I have recently formed a new artist for this purpose
[the obtaining of a miniature of his wife] by teaching a worthy creature
(by profession an Engraver) who lives in a little cottage very near me to
paint in miniature—." Quoted in G. Keynes, "Blake's Miniatures," TLS,
January 29, 1960, p. 72.

When Butts, a patron who had given him a fairly free hand with "historical" subjects chiefly scriptural, fell in with Hayley's plans and ordered a miniature of Mrs. Butts, Blake was miserable. After writing "many letters . . . which I burnd & did not send," he finally indited an eloquent defense of "the Majesty of Colouring necessary to Historical beauty," an entreaty to excuse the faults in "the Miniature I promissd to Mrs Butts" because after all "Portrait Painting is the direct contrary to Designing & Historical Painting," and a plea to this "Employer" and "Chief of Friends" to have confidence in the merit of the historical drawings which Blake could do with "my Head & my Heart in Unison . . . because you among all men have enabled me to produce these things."[20] When Blake's Spectre, in Night VIIa, holds out the promise of much congenial work in Golgonooza if he will put the artist before the prophet and acknowledge him "as thy real Self," it is obviously the unison of historical painting that he is bargaining for; the alternative is starvation:

> If we unite in one[,] another better world will be
> Opend within your heart & loins & wondrous brain . . .
> But if thou dost refuse Another body will be prepared
> For me & thou annihilate evaporate & be no more.[21]

In writing to Butts, Blake did not mention the collaboration of the loins, but in the epic it is Enitharmon who supplies the Majesty of Colouring.

Blake's continuing to work on *The Four Zoas* and *Milton* ("I have in these three years composed an immense number of verses on One Grand Theme") may have seemed to violate the original understanding. Hence the ingenious explanation to Butts that the time taken in writing unpremeditated poetry was thereby "renderd Non Existent." And what Hayley was allowed to see of these epic verses ("he has read Part by his own desire & has looked with sufficient contempt . . .") only disturbed him: "The truth is, As a Poet he is frightened at me & as a Painter his views & mine are opposite."[22] Yet the fact had to be faced that a subsidy

[20] To Butts, Nov. 22, 1802.
[21] *F.Z.*viia.85:43–86:1: E354/K329:353–358.
[22] To butts, Apr. 25 and July 6, 1803; to James Blake, Jan. 30, 1803. Hayley's fright, not unmixed with insight, is evident in his letter to Lady

of "Divine Assistance" was going to have to come from someone if Blake's immense number of verses were ever to be "progressively Printed & Ornamented with Prints & given to the Public." He took a chance on Butts and filled his letters with broad hints. If this Dear Friend of Angels could be persuaded that the "immense Poem" was a work of Christian enthusiasm dictated by Angels, he might perhaps accept it as the unexpected but providential "Grand Reason of my being brought down here."

Once more firmly persuaded that historical painting and "Sublime Allegory" were his métier, Blake would brook no further interference with his "Just Right as an Artist & as a Man." "Nothing can withstand the fury of my Course among the Stars of God & in the Abysses of the Accuser." But he did not burn any bridges. Wisely he stayed in Felpham till he could announce his return to London "with the full approbation of Mr. Hayley" and the promise of future business assistance. The "three years Slumber" had not been unprofitable. As far as the main chance was concerned the Blakes were for once "Getting beforehand in money matters," and there was "all the appearance in the world" that man and wife would be "fully employd in Engraving" for Hayley's various projected works. As it turned out, they and their patron were fantastically mistaken as to the magic power of Hayley's "connexions & his method of managing" and the immense and certain profits to be made from independent publishing. But at first the mild success of Hayley's *Ballads* illustrated by Blake ("we have Sold all that we have had time to print") went to Blake's head, and he boasted Quid-like to his brother James: "I know that as far as Designing & Poetry are concernd I am envied in many quarters, but I will cram the dogs, for I know that the Public are my friends & love my works & will embrace them whenever they see them. My only Difficulty is to produce fast enough."

Hesketh of July 15, 1802, referring to Blake's *"dangerously acute"* sensibility, the "perilous powers" of his Imagination, and Hayley's "penetrating eye" which can discover true Genius "in all He [Blake] does, however wild or hasty."

For a fresh interpretation of "the Blake who existed in Hayley's mind, and the Hayley who existed in Blake's," see Bishop, *Blake's Hayley,* ch. 18, which is excellent except for neglect of the important considerations advanced by Bronowski, pp. 75–76 [108–109].

Blake wrote rather differently to Butts of the work through which he hoped "to speak to future generations": "I can alone carry on my visionary studies in London unannoyd . . . converse with my friends in Eternity, See Visions, Dream Dreams, & prophecy [*sic*] & speak Parables unobserv'd & at liberty from the Doubts of other Mortals [i.e. such as Hayley]."[23] Both letters show a fierce desire to close with the Public and to carry a confident Mental Fight into the heart of London. "Fear nothing because it appears to me that I am now too old & have had too much experience to be any longer imposed upon." "My heart is full of futurity . . . I rejoice & I tremble. . . . Excuse my perhaps too great Enthusiasm." It would be difficult to overestimate the critical importance of this, Blake's forty-fifth year. He had worked through a difficult period of doubt and rediscovery. With his wife's collaboration even some of "the meer drudgery" was pleasurable. He felt he was achieving a new Unison of living which could include both "Lessons of Humility" and a pride in "my own Self Will." And he seemed to "have it in my power to commence publication with many very formidable works, which I have finished & ready," including an epic comparable "to Homers Iliad or Miltons Paradise Lost."[24]

Unfortunately all Blake's "futurity" depended, to a degree he could not have anticipated, on a continuation of peace and the climate of peace. But the nations were returning to war.

He must have heard some of the war talk that began when Napoleon invaded Switzerland a second time in October 1802. King George in his November message to Parliament hinted of renewing the conflict, and an expanded budget for army and navy was voted in December. In the spring of 1803, with France coveting Egypt and Britain delaying the evacuation of Malta, the am-

[23] Letters of 1802–1803. Compare Quid eighteen years earlier: "Before ten years . . . how I will work these poor milksop devils." *I.M.* ch. 7.

[24] One of the formidable works was undoubtedly *The Four Zoas*, but Blake was perhaps only patching that MS at Felpham. The Grand Poem which he describes as the fruit of his three years was doubtless *Milton* in some form, possibly in "12 books." The extant two-book *Milton* is a late revision. The preface of *Jerusalem* also refers to "my three years slumber on the banks of the Ocean," but much of the extant *Jerusalem* is clearly of later composition.

bitions of Orc and Urizen were rapidly devouring the remaining crumbs of peace. Addington called up the militia in March; by May the British ambassador would be recalled from Paris and the French would invade King George's birthright, the duchy of Hanover. Yet in April we find Blake still setting his hopes against the coming storm, still telling himself he will find London a city of Art, not War:

"What is very pleasant, Every one who hears of my going to London again Applauds it as the only course for the interest of all concernd in My Works, Observing that I ought not to be away from the opportunities London affords of seeing fine Pictures and the various improvements in Works of Art going on in London."[25]

Even in July, when Pitt had returned to his seat in Parliament to make a loud speech for war and Addington's cabinet was busy planning the war it had declared in May, Blake could sufficiently compartmentalize his thinking to keep public works in the category of peace. Hayley's projected edition of Cowper's *Milton,* to be engraved by Blake, he saw as well-launched because "Mr Addington & Mr Pitt" were "both among the Subscribers, which are already numerous & of the first rank." Yet Rintrah and Palamabron *had* returned to the ranks of war, and so had Urizen. On August 10 the King talked with a committee of the Royal Academy for two and one-half hours on Arts, patronage, and exhibitions, but the only tangible issue was his approval of a Royal Academy subscription of £500 "in aid of those who may suffer or distinguish themselves in the present war."[26]

Two days later the finger of God elected William Blake to suffer acutely in relation to the present war, but not in a manner anticipated by the Pity of the Royal Academy. Affronted by a royal dragoon who "put himself into a Posture of Defiance," Blake "took him by the Elbows & pushed him"; and shortly found himself under indictment for assault and sedition and ordered to stand trial in Chichester in January. This charge would "hang heavy

[25] To Butts, Apr. 25.
[26] Hodgson and Eaton, *The Royal Academy,* p. 173. But differently reported in William Sandby, *History of the Royal Academy,* London, 1862, I, 261.

on my Devil" and halve his productive powers, Blake feared; nevertheless he proceeded with his plan to return to London to try once more to "laugh & sing" and make his way upon the sea of business.[27]

[27] To Butts, Aug. 16; to Hayley, Oct. 7. There is some confusion about the date of the Blakes' move. Gilchrist, p. 169, puts it "at the end of September," but Blake's Sept. 19 letter shows him already settled in London and visiting Flaxman. If the Felpham cottage lease began Sept. 15, 1800, it probably ended Sept. 15, 1803. Blake and his wife must have then moved to London, Blake returning to appear before the Grand Jury at Petworth on Oct. 4. His letter to Hayley on Oct. 7th was then written immediately on his return; hence he could report: "Arrived safe in London, [to find] my wife in very poor health. . . ."

Blake painted a *Riposo,* which he sent to Butts with a letter July 6; and his comment in this letter suggests the picture's significance for the Blake family as they ended their repose in hiding from the fiendish gods of war: "It represents the Holy Family in Egypt Guarded in their Repose from those Fiends the Egyptian Gods . . . I have given in the background a building which may be supposed the ruin of a Part of Nimrods tower which I conjecture to have spread over many Countries." Even in retreat the Poetic Genius could not altogether escape the shadow of Nimrod's imperial city of confusion. Blake's current mistake was to think it in ruins.

Part Seven

ENDLESS DESTRUCTION?

Humanity shall be no more: but war & princedom & victory!
So spoke Albion in jealous fears. . . .

Then Los grew furious raging: Why stand we here trembling
 around
Calling on God for help; and not ourselves. . . .

—Jerusalem 4, 38[43]

The Angel that presided oer my birth
Said Little creature formd of Joy & Mirth
Go love without the help of any King on Earth

—Notebook 32

22. Another England There

Another England there I saw
Another London with its Tower
Another Thames & other Hills . . .
—The Crystal Cabinet

NOT SINCE THE DAYS of the Spanish Armada and not again till 1940 has England suffered such an invasion alarm as in the autumn and winter of 1803. Napoleon was known to be assembling thousands of flat-bottomed gunboats and rafts to embark a vast army with ten thousand horses and a prodigious four hundred pieces of cannon. Along the shallow Kent and Sussex coasts tar-barrel beacons were erected and bomb-proof Martello towers. When the Blakes returned to London in September, their quiver laden with Intellectual Arrows, they entered a city of gunpower and panic. Subscriptions were on foot, not to the projected Milton and Cowper monuments that figured in Hayley's plans, but to the Patriotic Fund. Printing presses were busy, not with Sublime Allegories but with handbills rousing Britons to "Seize the Musket, grasp the Lance," and slay "the Hell-born Sons of France!"[1] Prophetic writings? To prove that Bonaparte was the genuine Apocalyptic Beast, an eater of human flesh and poisoner of the sick. Poetry? War songs. Even candy was being made in the shape of "Boney's Ribs" for children to crunch on.

The Blakes had been scarcely a month in London, lodging in South Molton Street near the old Tyburn gallows, when Church and State joined to unfurl the Web of Religion across the land in a day of General Fast, October 19. The church-goers were said to be "united as one individual soul," and some 400,000 Volunteers were in arms, or would be if ever that many muskets could be turned out. At the same time there was much subdued grumbling at Government for losing the peace. Confidential letters warned the Home

[1] See *The Warning Drum,* ed. Frank J. Klingberg and Sigurd B. Hustvedt, Berkeley, 1944, a collection of "patriotic" broadsides and pamphlets.

Office—one from the Mayor of Leicester for example—that any failure in the supply of bread might lead "a fourth of the population" to "join the French Standard if they had an opportunity."[2]

In Blake's correspondence[3] we see none of these things, but only a poor artist minding his own business—and lamenting his fate. "Art in London flourishes. Engravers in particular are wanted. . . . Yet no one brings work to me. I am content that it shall be so as long as God pleases." He is obviously *not* content; rather he is furious that boys of twenty are preferred to an experienced engraver "almost 50 Years of Age" and that he "must go a Courting . . . awkwardly" for hackwork while he knows "that many works of a lucrative nature are in want of hands." As a man under indictment for seditious utterance, he is admittedly making a conscious effort to be cheerful—"my Devil . . . terribly resents it; but I soothe him to peace"—and is evidently keeping the war out of his calculations as long as possible. The sigh, "God send better times!" does escape—at discovery that only fifteen numbers of the Hayley *Ballads* have been sold and that "no chance is left to one out of the trade" for the profitable independent publishing of which he and Hayley had dreamed. And he reports: "Everybody complains," but hastens to add: "yet all go on cheerfully and with spirit." Aware that "Sorrow . . . is utterly useless to anyone," Blake forces himself to put the war and his own "Soldier-like danger" out of his mind:

"The shops in London improve; everything is elegant, clean, and neat; the streets are widened where they were narrow; even Snow Hill is become almost level, and is a very handsome street, and the narrow part of the Strand near St. Clement's is widened and become very elegant.

"My wife continues poorly, but fancies she is better in health here than by the seaside."

In one of the lyrics of this period the fragile fiction of a happy London is exploded. In *The Crystal Cabinet*,[4] a lament like Keats's *La Belle Dame Sans Merci*, the poet "dancing merrily" is taken by

[2] J. L. and Barbara Hammond, *The Town Labourer*, London, 1925, p. 80. Some of the material in these paragraphs is from Ashton, *Dawn of the 19th Century*.

[3] To Hayley, Oct. 7 and 26, 1803.

[4] Pickering MS, transcribed late in 1803 or 1804—or, possibly, five or more years later than that; see G. E. Bentley, Jr. *Studies in Bibliography*, XIX (1966), 232–243.

a maiden to dwell in a moonlit "World" which is another London. He and the maiden come to it from "the Wild" (Felpham), but when the poet tries "to sieze the inmost Form" of this vision, which is his hope of returning to the pleasant aspect of his Lambeth days ("another pleasant Surrey Bower"), the Crystal Cabinet bursts, and he becomes "like a Weeping Babe":

> A weeping Babe upon the wild
> And Weeping Woman pale reclind
> And in the outward air again
> I filld with woes the passing Wind

The London he experiences is not the London he had hoped to find, and the lovely Maiden of his dream is a weeping woman. Here is the "other" meaning of "My wife continues poorly" and "Everybody complains," the sadness of an unemployed artist "almost 50 Years of Age."[5] But these lines scarcely hint at what the England of experience *is* in 1803. They give no indication that London is being fortified against invasion, that the Thames is filling with captured French ships, that the Tower and numerous workshops are busy turning out small arms night and day. Yet Blake did observe this daily cast of brazen cannon and hear ambassador and king call for war almost before the drying of their signatures for peace. These woes are in his prophecies.

Shock at finding London in the frenzy of pike and musket manufacture, and a determination to forge counterarms of art are recorded not only in the passing wind but in new prophecies and in Night VIII, a final late addition to *The Four Zoas. Milton,* which covers the Felpham period, ends like *Paradise Lost* with the departure from Paradise of Los and Enitharmon, here transparently William and Catherine Blake leaving Felpham. As they ride up the Surrey road past "Wimbleton," a south wind blows their dust clouds ahead of them over London. From "the Hills of Surrey" they see "soft Oothoon," spirit of Blake's republican books, weeping "in the Vales of Lambeth." And Los-Blake, with the visionary assistance of "his Cloud Over London," "listens to the Cry of the Poor Man . . . in volume terrific, low bended in anger" (*M*.42).

[5] Damon's *Dictionary* defines this poem as commemorating an illicit love affair in Surrey; there is nothing to go on but the poem itself. The evidence of parallels in the Los-Enitharmon allegory (e.g. in the closing lines of *M*.) suggests the reading above.

Seeing Jerusalem in utter ruin from Surrey to Highgate (two of the seven hills of imperial London), Blake can hardly believe that a city of liberty and peace was ever "builded here, Among these dark Satanic Mills" (*M.*1).

This sulphurous development of the mill image appears in the famous lyric of the *Milton* Preface; in historical perspective it signifies the industry of England at war. The mill at which Samson labored among slaves was a treadmill. "Felphams Old Mill" was a windmill, fit symbol for the vapid and ineffectual projects of Hayley.[6] But "dark Satanic Mills" are mills that produce dark metal, iron and steel, for diabolic purposes. At this stage in Blake's symbolism his Satan is no angel.

London was not a mill or factory city, though there was some small scale recasting and reforging of northern iron. But it was a war arsenal and the hub of the machinery of war, and Blake uses the symbol in that sense. For industrial atmosphere he harks back to an earlier age when smelting relied on the charcoal of Surrey forests. "Loud groans Thames beneath the iron Forge" and "the Surrey hills glow like the clinkers of the furnace" in Blake's vision of the forging of the "instruments" for a bloody human "Harvest" in a city lost to love.[7] There is a passage in *Jerusalem* which implies that when the Blakes "fled" to Felpham to subsist by art "Albions Children" were developing an indifference to the "gore" they lived in.[8]

Moving back to London, Los (Blake) quickly found lodgings and "hid Enitharmon from the sight of all these things Upon the Thames whose lulling harmony repos'd her soul" ("My wife . . . fancies she is better in health here").[9] But, we are told in *Milton*, the poet himself did see these things: that the youth of England were being sent again to slaughter; that these "Cherubim" were in "Soldier-like danger" even as he was; that the Blakes' new res-

[6] "Was I angry": E496/K538. Blake made a drawing of the Felpham windmill looming above Hayley's turret and the Blakes' cottage. Wright, i, pl. 36.

[7] *M.*6. Blackstone, p. 19, makes much of the fact that the first London factory to use steam power, in 1784, was named the Albion Mill. It must be noted, however, that Blake himself made nothing of the fact. He never called any mill Albion or Albion's, nor did he ever introduce the steam engine into his imagery. The Albion Mill burned to the ground in 1791 and was never restored.

[8] *J.*44–45 [30–31]. The two pages survey a decade.

[9] *M.*11:2–3; to Hayley, Oct. 26, 1803.

idence was at "Calvarys foot Where the Victims were preparing for Sacrifice their Cherubim," because just outside their door, "between South Molton Street & Stratford Place," ran Tyburn Road or Oxford Street leading to "Tyburns fatal tree," the ancient gallows, and to the reviewing ground where "Satans Druid sons" were taught to offer "Human Victims" on Albion's rocky tomb. The first Victims were the youths' parents who brought them forth (for Blake is recalling the muster of *Europe*). Reviewed by the King and taught "Druid songs," as a current war song boasted, the Cherubim were sent to make a sacrifice of "all the Earth."[10]

Seeing these things Blake recast Night VIII of *The Four Zoas*, the chapter leading to the final deluge, to make it his most sustained outcry against the betrayal of peace by leaders whose specious "repentance" had been a combination of self-deception and "dark dissimulation." The British Urizen had persuaded himself that warfare was inevitable and necessary, because instead of practicing true brotherhood he had continued to look upon the French Orc with suspicion as "a Serpent wondrous" augmenting dangerously "among the Constellations of Urizen."[11] In these years "The Serpent of Corsica" was a common epithet of bellicosity.

Thus Urizen in self deceit his warlike preparations fabricated
And when all things were finishd sudden wavd among the
 Stars
His hurtling hand gave the dire signal thunderous Clarions
 blow
And all the hollow deep rebellowd with the wonderous war[12]

Tyranny once more had stretched his purple hand and cried for blood; once more the powers and principalities were resorting to the sword. *Famine* and *War*[13] head the list of paintings done in the

[10] *M*.4, 11; *J*.82:60. Cf. *E*.10. Recruiting songs included one with the refrain: "BRITONS strike Home, revenge your Countrys Wrongs, Fight, Fight and record your selves in DRUID Songs."

[11] *F.Z.*viii.100:7–8; 101:32: E358, 359. Presumably there was an earlier draft of Night VIII. The base of the extant draft was composed after the late version of VII(*a*), and parts of it are closer in diction and symbolism to *M*. and *J*. than to the rest of *F.Z.*

[12] viii.101:26–29. The dispatch of Nelson's fleet to the Mediterranean was the first act of the war. Blake's next line specifies "the mid deep."

[13] A redrawing of *A Breach in a City* (1784) with the body of Orc added to the heap of slain. See above, p. 75.

winter of 1804–1805, and *Let Loose the Dogs of War* is the caption of an uncolored drawing of this period. But the ancient metaphors were unequal to the scale and intensity of war in the new industrial century. Plowshares were being beaten into artillery of improved design. Napoleon's gunboats were to be halted by ingenious cable traps, and London magazines described a diving boat invented by Robert Fulton which could approach an enemy vessel under water and attach to it by boring screws and hooks an explosive magazine detonated by clock-work.[14] A sixteenth-century manuscript in the Lambeth library describing armada-inspired "Contrivances for the Defence of this Island" was brought to light with a thought that inventions once extravagant might now prove feasible: particularly an "engine" variously described as "a piece of artillery" and "a moving mouth of metal" which "passeth not lineally through the army" but has the power to seek out and destroy all living creatures within a four-mile area.[15]

Blake was impressed by the spontaneity and "deceit" of these engines. He recalled also Milton's description of the second day of war in Heaven, when Satan mustered "weapons more violent": "hollow Engins . . . thick-rammd . . . Pillars laid on Wheels . . . disgorging . . . chaind Thunderbolts and Hail of Iron Globes."[16] But whereas Milton's cannon had been of "Brass, Iron, Stonie mould," British cannon were now bored out of solid cast steel; and the newest cannon balls were hollow explosive "shells" or spheres filled with small bullets, the invention of Lt. Henry Shrapnel.[17] Milton had seen "sparkles dire" around the chariot of his God; the sparks around Blake's war god were from the smithies of London and blast furnaces of Birmingham:

Sparkles of Dire affliction issud round his frozen limbs
Horrible hooks & nets he formd twisting the cords of iron
And brass & molten metals cast in hollow globes & bor'd

[14] *European Magazine,* April 1802; *Philosophical Magazine,* February 1804.

[15] *ibid.* The MS, previously published in *The Bee,* June 1, 1791, with satiric application, is a "Memoir by Lord Napier . . . the celebrated inventor of Logarithms"—a true son of Urizen.

[16] *Paradise Lost* vi.484–766.

[17] Henry Hime, *Origin of Artillery,* London, 1915, p. 182. "Shrapnel's Spherical Case" was tested in the Thames in June 1803 and approved but was first used, by Wellington, in 1808. Farrer, p. 325.

Tubes in petrific steel & rammd combustibles & wheels
And chains & pullies fabricated all round the heavens of Los . . .

And Urizen gave life & sense by his immortal power
To all his Engines of deceit that linked chains might run
Thro ranks of war spontaneous & that hooks & boring screws
Might act according to their forms by innate cruelty[18]

This is the first time Blake's list of munitions has come up beyond
the ancient sword, spear, and chariot and the medieval musket and
mortar and "brazen cannons" (*F.R.*). Deeply shocked by the
upset of golden hopes, Blake now *for the first time directly faces
the facts of modern war.*[19] Yesterday his heart was "full of
futurity"; today the London skyline ("the Heavens of Los") looms
with cranes loading ships of war, and "All futurity Seems teeming
with Endless destruction never to be repelld" (viii.101:30–31).

The peace then *has* been a hoax, Urizen "Communing with
the Serpent of Orc in dark dissimulation" planned all along "To
undermine the World of Los & tear bright Enitharmon To the
four winds hopeless of future" (32 ff.). Such collusion was fore-
shadowed in the negotiations between Urizen and Luvah in
Night I. But now the tyrannous ambition of both contestants has
merged into the extremest Selfhood, "Abominable Deadly," and
taken a form not originally "intended" by Urizen: "a Shadowy
hermaphrodite black & opake The Soldiers namd it Satan." This
fusion of British imperialism and Bonapartism is the deadly oppo-
site of the peaceful mingling which might have made England and
France "henceforth be as One Country."[20]

The ruler of France (Orc) has now become completely evil and
entangled in the tree of Religion (Deism plus Popery). But as an
Englishman Blake continues to dwell on the responsibility of his

[18] *F.Z.*viii.100:27–31; 102:14–17: E359, 360/K343, 344. "Linked chains"
are chain shot, then common.

[19] Joel Barlow, in reshaping the *Vision of Columbus* into the *Columbiad,*
also put aside his hesitation to use the terms of modern war, having
concluded that "the modern military dictionary is more copious than the
ancient, and the words at least as poetical." *Columbiad,* p. x.

[20] To Flaxman, Oct. 19, 1801. "Closing Los from Eternity in Albions
Cliffs," Satan becomes "A mighty Fiend . . . mustring to War." *M.*10:10–11:
E103/K491. While Blake presents Satan as a symbol of the war on both
sides, he frequently uses Satan for the spirit of war in France and Urizen for
the same thing in England. But in *Jerusalem* Urizen is largely replaced
by Satan as Albion's Spectre; France is represented by Luvah.

own country. He indicates that Orc's behavior is molded by pressure from the British iron industry, "the iron hearted sisters Daughters of Urizen,"[21] but stresses fear of political change as Urizen's chief motivation. To preserve his rule Urizen's "enormous Sciences" must be applied to the invention of engines of destruction, and even the arts must be perverted to martial ends:

He formed also harsh instruments of sound
To grate the soul into destruction[22] or to inflame with fury
The spirits of life to pervert all the faculties of sense
Into their own destruction if perhaps he might avert
His own despair even at the cost of every thing that breathes[23]

Hard it is for the prophet who sees rulers choosing apparently endless war. For a time "Desperate remorse swallows the present in a quenchless rage" (101:32). The scope of preparations in 1804 did not suggest a short conflict. How long would it continue? Did it end in 1815 at Waterloo? Has it ended yet? Here was the great crisis in Blake's vision of history. How would he survive sane in the bleak concentration camp whose endless corridors he now began to pace? How long could he keep his "quenchless rage" alive—or rather, how long his love: for that seemed the test, to continue to believe in brotherhood, which meant to fight for it in some way: how continue to love those who were dehumanized by Satan?

To strengthen his necessary conviction that war and oppression *can* be permanently overthrown, Blake found it necessary to give

[21] viii.101:23. Blake must have known that the current prosperity of ironmongers was based on the sale of cannon. Between 1786 and 1798 twenty-one steel furnaces were put in blast and nineteen more were building. F. C. Dietz, *An Economic History of England*, New York, 1942, p. 378.

[22] It is a nice question whether Blake's ear was grated upon by that new "harsh instrument" the bugle; or by the bagpipe, not new but perhaps newly prominent in London (Frye, p. 223); or by the fife, which Thelwall in 1804 called "ear-piercing"; or by what Thelwall called the whole "parade of military array—the excitements of Music—the doubling drum, the martial trumpet, the ear-piercing fife, the chearful cymbal." *The Trident of Albion*, p. 57.

[23] viii.102:27, 18–22: E360/K344; cf. ii.25:42–44: E310/K289:74–76. Fulton in 1800 thought of his invention of the submarine as a means of outmaneuvering the efforts of Pitt and other rulers "to brutalize the human faculties and retain mankind the slaves of their unaccountable ambition." Samuel Bernstein, "Fulton's Unpublished Memoir to Pitt," *Science and Society*, VIII (1944), 40–63.

more systematic attention to theory. He had long distinguished between states of the soul which are eternal and accidents such as poverty and murder which are not. He now worked out a distinction "between States & Individuals of those States" which made possible a theory that although a State such as tyranny (Satan) may be eternal, no individual or nation need occupy that state in a new Heaven and Earth: Satan can become a null class. "There is a State namd Satan" at present occupied by "multitudes of tyrant Men in union blasphemous Against the divine image. Congregated Assemblies of wicked men," such as the armies and war councils of Britain, France, Prussia, Russia, Austria, and Spain. Now "the State namd Satan never can be redeemd in all Eternity," but the individuals are redeemable (thus Blake uses his new doctrine of redemption) if they "put off Satan Eternally" and accept brotherhood; and so are nations. When the Republic of France became an aggressive Empire, it entered the state of Satan: "when Luvah in Orc became a Serpent he descended into That State calld Satan." Yet the people of France were not doomed, nor was France to be destroyed; rather it was to be pitied and protected in the womb of the future, for it had at least tried to fight for the future. In the city of Art a kind Enitharmon preserved "her well beloved knowing he was Orc's human remains She tenderly lovd him above all his brethren."[24] In his republican art Blake kept alive a warm sympathy for prodigal and errant France.

Nor did Blake ever accept the thesis that Britain was fighting merely in self-defense against the serpent her pressure had created. If Napoleon (Orc) now rose as "A King of wrath & fury a dark enraged horror," his opponent seemed still basically motivated by a "lust" to reign "over all." British naval imperialism was now expanding into a sea-monster "upon his belly falling Outstrechd thro the immense" and "Abominable to the eyes of mortals who explore his books." Perhaps at Amiens Urizen had been for a moment repentant, but now "in the abyss" he "forgets his wisdom" and is repentant of his repentance (106:28–33; 107:15–20).

Holding this cool view of the matter, and keeping his eye on "Urizens Dragon Form," Blake as Eternal Prophet retained the ability ("Tharmas gave his Power to Los, Urthona gave his Strength") to expose "the dark terrors" of both Orc and Urizen

[24] viii.104:29–30; 105:19; 115:23–29: E363, 364, 366/K347, 348, 351.

and to prepare the children of men for the coming "time after time" of "the Divine Lamb who died for all."[25] And he continued to view the future as the issue of a choice between freedom and oppression, putting the question as it was put to Fayette—except that now the dog at the wintry door had become a wolf pack:

Will you keep a flock of wolves & lead them will you take the
 wintry blast
For a covering to your limbs or the summer pestilence for a
 tent to abide in . . .
Will you seek pleasure from the festering wound or marry
 for a Wife
The ancient Leprosy that the King & Priest may still feast on
 your decay
And the grave mock & laugh at the plowd field . . .
 (108:9–15)

Historians who write as if England supported the war unanimously "from shop and palace, cot and hall,"[26] have neglected to listen with Blake to the almost silent Poor Man whose "faint groans shake the caves & issue thro the desolate rocks." Blake saw pitiful submission to the wintry blast—"alas that Man should come to this"—and plentiful evidence that "all upon the Earth Saw not as yet the Divine Vision"; but no popular enthusiasm for "the Caverns of the Grave."[27]

Under scrutiny the simple epistolary remark, "Everybody complains," contains a world of connotation. The quiet unemployed artist traversing London streets intent on his own business, had other thoughts in his head than his own getting on and saw other things in the streets than their new widening. He heard theater audiences intoning "God Save the King!" He saw the shops close and the churches fill on the General Fast day. But like Burns a decade earlier he refused to join the current madness: "their God I will not worship in their Churches, nor King in their Theatres," cries Los; "O Sons we live not by wrath, by mercy alone we live!"

[25] viii.111:3; 107:31–37: E371, 368/K356, 353.

[26] Knight, *Popular History of England*, VII, 429, while presenting such a picture, does also cite a cabinet meeting in which "ministers hesitated about allowing volunteer regiments" and Lord Eldon declared, "Do as you please, but if these men do not volunteer for you, they will against you."

[27] viii.108:6–7, 32–36; 109:13: E368–369/K353–354.

"Whence is this Jealousy running along the mountains?" "So Los lamented over Satan, who triumphant divided the Nations."[28]

The division was within as well as between nations, as we can see in the pending case of "Rex *v* Blake," an epitome of the larger trial of The King *v* The People.

2

The Soldier armd with Sword & Gun
Palsied strikes the Summers Sun
— *Auguries of Innocence*

In the formal indictment against him as "a Miniature Painter" residing in the coastal parish of Felpham while "War was carrying on between the persons exercising the powers of Government in France and our said Lord the King," Blake was charged in the King's name with "Wickedly and Seditiously intending to bring our said Lord the King into great Hatred Contempt and Scandal . . . and intending to withdraw the fidelity and allegiance of his said Majesty's Subjects from his said Majesty and to encourage and invite as far as in him lay the Enemies of our said Lord the King to Invade This Realm. . . ."[29]

Blake explained the charges in a letter to Butts on August 16th: "I am at Present in a Bustle to defend myself against a very unwarrantable warrant . . . which was taken out against me by a Private [John Schofield] in Captn Leathes's troop of 1st or Royal Dragoons for an assault & Seditious words. The wretched Man has terribly Perjurd himself—as has his Comrade [Trooper Cock] for as to Sedition not one Word relating to the King or Government was spoken by either him or me. His Enmity arises from my having turned him out of my Garden into which he was invited as an assistant by a Gardener at work therein, without my knowledge that he was so invited. I desired him as politely as was possible to

[28] *M*.10, 23: E103, 118/K491, 507. Mountains and valleys still have a social referent, and mountains here may mean the upper classes. Cf. *J*.44 [30].

[29] For Blake's Memorandum, see E700–702/K437–439; for Schofield's information laid on August 15, see W. R. Nicoll and T. J. Wise, *Literary Anecdotes of the Nineteenth Century*, London, 1895, I, 5–6; for full text of indictment and other legal details, see Herbert Ives, "The Trial of William Blake," *Nineteenth Century*, LXVII (1910), 849–861.

go out of the Garden, he made me an impertinent answer . . . then threatened to knock out my Eyes . . . it affronted my foolish Pride." Private Schofield continued to threaten and curse; so Blake pushed him "about fifty yards" to the Fox Inn "where he was Quarterd." Neighbors gathered, and Private Cock joined his comrade in abusive threats "against me & my wife" until the innkeeper, who was also the proprietor of the Blakes' cottage, compelled the soldiers to go indoors.

The neighbors supported Blake's story that no seditious words were uttered; the Miller's wife sensibly observed that "in the heat of their fury" neither of the Dragoons had thought to accuse Blake of having uttered sedition. But the charge was a serious one,[30] and was not to be dropped: "I have been before a Bench of Justices at Chichester this morning, but they as the Lawyer who wrote down the Accusation told me in private are compelld by the Military to suffer a prosecution to be enterd into altho they must know & it is manifest that the whole is a Fabricated Perjury. I have been forced to find Bail. M^r Hayley was kind enough to come forwards . . ."[31]

In the autumn of 1803 the Military were not to be gainsaid. But it was some comfort to feel that the villages were still mild even in the present state of invasion alarm: ". . . this Contemptible business . . . has struck a consternation thro all the Villages round. Every Man is now afraid of speaking to or looking at a Soldier, for the peaceable Villagers have always been forward in expressing their kindness for us. . . . Every one here is my Evidence for Peace & Good Neighbourhood & yet such is the present state of things this foolish accusation must be tried in Public. . . . My much terrified Wife joins me in love. . . ."

Of course Blake exaggerated the consternation in Sussex (every man was not fearful of what an informer might read in his looks), but there is no question but that his neighbors were less loyal to the code of Urizen than to its victim. When Blake came down in

[30] I mistakenly called it a hanging charge, but Bronowski has reminded me that the accusation was sedition, not treason.

[31] Hayley's ready assistance canceled for a time all Blake's ill feeling toward him. Providence may even have let Blake into this trouble "to give opportunity to those whom I doubted to clear themselves"; momentarily Blake felt a "conviction that all is come from the spiritual World for Good & not for Evil."

January to stand trial, neither jury nor onlookers acted in accord with the official hysteria. The *Sussex Advertiser* of January 16, 1804, somewhat uncomfortably had to report that "After a very long and patient hearing, he was, by the jury, acquitted; which so gratified the auditory that the court was, in defiance of all decency, thrown into an uproar by their noisy exultations."

To go back to the origin of this contemptible business, what speaking or looking had Blake done to excite the soldier? Or what had Schofield said to Blake that aroused his wrath? What led Blake to believe that "if I had not turned the Soldier out of my Garden I never should have been free from his Impertinence and Intrusion"? When we try to reconstruct the scene from Blake's letter and memorandum it is clear that he has not given us all the facts. He has witnesses—William the Gardener who "says that he was backwards and forwards in the Garden," and Mr. Cosens, owner of the Felpham windmill, who "was passing by in the Road, and saw me and the Soldier and William standing near each other"—both of whom will testify they "heard nothing" although it was "a still Day." Thus Blake and Schofield were standing together for some time, as the gardener's being "backwards and forwards" suggests, either in conversation or in silent contemplation, as Blake implies, although the trial makes clear that "heard nothing" meant "heard no such expressions" as Blake was charged with. Schofield, apparently in reference to the time they were in the garden, "acknowledged that they were talking rather high."[32] Suddenly out of this "silence" the gardener heard Blake ordering the soldier to leave. Something that had taken place then or earlier had stimulated the soldier into "saying something that I thought

[32] Blake's lawyer, Rose, attacked this question of the length of time spent in the garden as an inconsistency in Schofield's account: "the witness Scholfield came into his garden . . . there he continues for some time without any apparent reason"; "it is an unaccountable story. He was in Blake's garden talking to the ostler; he came to tell him . . . that he had but few words to say, and no time to spare, yet we find him lounging about, leaning against the garden wall. That Mr. Blake came out and without any provocation," etc. Nicoll and Wise, I, 11–17.

Samuel Rose (1767–1804) studied at the University of Glasgow, in 1786 beginning the study of law in London. He and his father William, esteemed by Dr. Johnson though a Scot and a dissenter, wrote reviews for the *Monthly Review*. See B. C. Nangle, *The Monthly Review, first series*, Oxford, 1934, p. 37.

insulting," which led Blake to request the soldier to leave. And it was something so annoying that Blake felt he would never be free of such "Intrusion" if he did not wield his mace at once.

In Schofield's deposition Blake is charged with having said: "that we (meaning the People of England) were like a Parcel of Children, that they would play with themselves till they got scalded and burnt, that the French Knew our Strength very well, and if Bonaparte should come he would be Master of Europe in an Hour's Time, that England might depend upon it, that when he set his Foot on English Ground that every Englishman would have his choice whether to have his Throat cut, or to join the French, and that he was a strong Man, and would certainly begin to cut Throats, and the strongest Man must conquer—that he damned the King of England—his country, and his subjects, that his Soldiers were all bound for Slaves, and all the Poor People in general—"

At this point the deposition brings in Mrs. Blake, whom Blake's account scarcely mentions. Deponent says that Blake's "Wife then came up, and said to him, this is nothing to you at present, but that the King of England would run himself so far into the Fire, that he might [not] get himself out again, and altho' she was but a Woman, she would fight as long as she had a drop of blood in her— to which . . . Blake said, My Dear, you would not fight against France—she replyed no, I would for Bonaparte as long as I am able—"

Here follows a clause that we shall take up later. And finally, "that his Wife then told her said Husband to turn this Informant out of the garden—that this Informant thereupon turned round to go peaceably out, when . . . Blake pushed this Deponent out of the Garden into the Road down which he followed this Informant, and twice took this Informant by the Collar, without this Informant's making any Resistance and at the same Time the said Blake damned the King, and said the Soldiers were all Slaves."

It is a common opinion that Blake is as unlikely to have said none of this as to have said all of it.[33] He certainly *thought* that the King's soldiers, whom he was not afraid of taking by the collar, were bound for slaves, as were "all the Poor People in general." He believed—nay hoped—that on its present course the King's government would run so far into the fire that a Last Judgment

[33] Gilchrist, p. 172; Bronowski, pp. 78–79 [112–113].

would be inescapable. He is not at all likely to have talked of cutting throats with Napoleon nor to have uttered treasonous oaths. The point Blake pounced on as "Perjury" was the stereotyped accusation that he had said Damn the King in front of the crowd at the inn. Here he had witnesses and no doubt a clear conscience. Yet as soon as Blake read the warrant he must have recognized that mixed with Schofield's "Fabricated Perjury" there were some strong opinions that were, however they got there, his own. How *had* they got there?

Blake himself vacillated between the theory that the soldier was a deliberate or hired informer and the theory that "the whole Charge must have been fabricated in the Stable afterwards" for revenge. For defense he naturally leaned heavily on the latter theory, and his witnesses and lawyer rested on it. But there was scope for more significant martyrdom in the first view, and in later years Blake was wont to declare, according to Gilchrist, that "the Government, or some high person knowing him to have been of the Paine set, 'sent the soldier to entrap him.'"

There was no mention of Blake's past at the trial, it is true. But Blake must have been at least as sensitive as Hayley to the manner of the presiding judge, the Duke of Richmond, who was, "for some unknown reason, bitterly against" Blake and who made what Hayley considered "some unwarrantable observations" and a hostile summary to the jury. When Hayley afterwards confronted the duke with an emphatic remark about Blake's honesty and industry, he made a sort of "no-comment" reply: "I know nothing of him."[34] This was credible, for Blake had not *published* his 1798 defense of Paine. But if we are to appreciate Blake's state of mind throughout this "Soldier-like danger" (the very phrase suggests identification with the "warlike men" of *America*), we must realize that the poet himself believed that his republican sentiments were written all over his "active physiognomy." The rimed lament of Blake's August 16 letter to Butts—

> O why was I born with a different face
> Why was I not born like the rest of my race
> When I look each one starts!

[34] Unpublished Hayley correspondence, quoted directly and indirectly in Wright, I, 138–140. See also note 37 below.

—ought to be read in the light of Gilchrist's report that Blake "down to his latest days . . . would jokingly urge in self-defence that the shape of his forehead made him a republican."[35] It was hardly *his* fault if his countenance spoke so plain. Moreover he had orders, as he had told Butts shortly before the encounter with Schofield, "to set my face like a flint . . . against their faces & my forehead against their foreheads," that is, against anyone (it had been Hayley at the time) who sought to swerve him from his prophetic course.[36]

As for Hayley, there is a piece of evidence which may signify that for one wild moment during the scuffle with Schofield Blake suspected that it might be *he* who had set a trap. Hayley's immediate and unstinting assistance must have driven the suspicion from Blake's mind. And Blake apparently accepted as well-intended the somewhat creeping defense made by Samuel Rose, the lawyer brought in by Hayley.[37] "Farewell, Sweet Rose!" he exclaimed when "my Generous Advocate" died at the end of the year.[38] But eight years afterwards, when Blake was feeling betrayed on every hand, the poison tree of suspicion sprang into full growth and in his notebook we find him cursing Hayley as "Felpham Billy" and gloating over the deaths of "Billys Lawyer & Dragoon" with an

[35] Gilchrist, p. 80. Blake adapted these verses from his MS poem *Mary* (E479/K428) which tells of a woman whose superior beauty and unblushing delight in Love and Beauty made her a victim of envy and ostracism which drove her insane. Blake implies that his own superior "Talents" and "simplicity" are "the origin of all offences committed against me." His remarks point partly to the "soldier-like danger" but more directly to the previous quarrel with Hayley, in which Blake was imposed upon when he was "silent & passive" but offended when he finally spoke out. In the case of the soldier, he implies, he offended only by his startling look.

[36] To Butts, July 6, 1803.

[37] We now know that Hayley remunerated Rose "magnificently." See G. E. Bentley, Jr., *Notes & Queries*, II (1955), 118–119. Rose, on May 5, 1804, reported to his father-in-law that "I was highly complimented by the Duke of Richmond for my Defense of Blake"—which still does not tell us what the Duke thought about the defendant himself.

[38] To Hayley, Dec. 28, 1804. Hayley, writing to Lady Hesketh, observed that Blake's "friendly rustic witnesses" were more impressive than his "eloquent" lawyer, who had a bad cold, felt his faculties "desert him before He concluded, & failed to reply (as he otherwise would have done) to the art and malevolence of the opposite counsel." Letter in Kenneth Povey, "The Case of Rex *v* Blake," *Sussex County Magazine*, III (1929), 314–317; also in Bishop, *Blake's Hayley*, pp. 297–298.

insinuation that they (Hayley, Rose, and Schofield) had conspired against him, that Hayley had "Hired a Villain to bereave my Life."[39]

The evidence I allude to is a curious statement in the dragoon's deposition, not retained in the indictment and neglected in most discussions of the case. Toward the end of his recital Schofield declares that "Blake, then addressing himself to this Informant, said, tho' you are one of the King's Subjects, I have told what I have said before greater People than you, and that this Informant was sent by his Captain or Esquire Hayley to hear what he [Blake?] had to say, and to go and tell them." I take Schofield to mean that Blake (suspicious of the drift of the soldier's impertinence and intrusion) accused him of having been sent by his captain or by Hayley to draw Blake out on something he had said before Hayley, the great man of the neighborhood, about the war or the soldiers. In a passage in *Milton* where Satan is usually taken for Hayley, saying "unkind things in kindness!" and doing "the most irritating things in the midst of tears and love," he is described as "Glorying to involve Albions Body in fires of eternal War."[40] In his notebook Blake identifies Hayley with "Pick Thank," the informer in *Pilgrim's Progress* who accuses Faithful of seditious utterance against the Prince of Vanity Fair.

Further indication of at least momentary suspicion of a trap lies in Blake's interpretation of the Landlady's report—that the soldier "called me a Military Painter"—as evidence not of ex post facto fabrication but of "his having come into the Garden with

[39] *N*.22, 35: E495, 497/K537, 544. Every so often some critic is *sure* that the notebook epigrams were written at Felpham. Thus D. Figgis, *The Paintings of Blake*, London, 1925, p. 56, and Davies, *The Theology of William Blake*, p. 156. But of course internal evidence dates them after the Cromek affair, some even after the deaths of Schiavonetti in 1810 and Cromek in 1812. The fact that the line "Hired a Villain to bereave my Life" is quoted from *P.S.* need not mean that Blake was romancing in his use of the words.

[40] *M*.12:32–33; 13:6. For Schofield's deposition, scholars have relied on a MS copy in the Trinity College Library, Hartford; Paul Miner, consulting the original in Chichester, reports that the wording "sent by his Captain to Esquire Hayley" is a mistake for "sent by his Captain or Esquire Hayley." This correction has required a change in the wording of my interpretation, but not in its tenor, now confirmed. The alternative interpretation, deduced by Povey and Bishop, which I previously cited (1954 edition, p. 381), is now ruled out altogether.

some bad Intention, or [here the suspicion flickers out] at least with a prejudiced mind."

In broad daylight the "trap" theory was not very attractive, nor did that fantastic indictment look like anything he had *said*. In his letters, in veiled allusions to his own responsibility for this "perilous adventure," Blake seems to say that it was not his tongue but something else that gave him away to the informer. He is relieved to report that his Devil (Los or Tharmas) "is a good natur'd Devil after all & certainly does not lead me into scrapes— he is not in the least to be blamed for the present scrape, as he was out of the way all the time on other employment seeking amusement in making Verses"[41]—which is to say that he was *writing* against war and religion but was not caught speaking so.

Whatever we make of the coincidence of some of the dragoon's charges with some of Blake's prophetic opinions, however, the trial was an ordeal for Blake. The peaceable villagers were with him, but his accusers were hurling "arrows of darkness"[42] at a son of fire who did not know, in actual combat, how to wield his mental sword except by sheathing it in silence or in the privacy of his manuscripts. He had, he believed, a glorious precedent: Jesus had "omitted making a defence before Pilate"; yet he knew that to do so was to "bear false witness."[43] At one point in the trial, during the accusations, Blake is reported to have called out *"False!"* in a "tone which electrified the whole court."[44] And in one of his mythical versions of the scene Blake thwarts his accusers by wielding his terrible mace. But to make a bold defense, as to print the notes on Paine, would have been to do "what our Enemies wish." Blake suffered Rose in his defense to shudder at the thought of defending any wretch who *had* uttered contempt for "the sacred person of his sovereign," to soften the jury by pointing to "the exclamation of God save the King" as "the language of every Eng-

[41] To Hayley, Oct. 7, 1803. Hayley and his friends had, of course, gossiped about Blake's views. On Jan. 27, 1804, the liberal minister Samuel Greatheed, of Newport Pagnell, wrote to Hayley, concerned at the newspaper account of Blake's having been accused of seditious language. "I knew our friend's eccentricity, and understood that, during the crisis of the French Revolution, he had been one of its earnest partisans. . . ." Quoted in G. E. Bentley, Jr., "Blake as a Private Publisher," *BNYPL*, LXI (1957), 556.

[42] To Hayley, Jan. 14, 1804.

[43] *M.H.H.*23: E42/K158.

[44] Gilchrist, p. 172, quoting Mrs. Blake.

lishman's lip . . . the effusion of every Englishman's heart" (though as Los in *Milton* he cries he will *not* "worship their king"), and to argue that Blake had no tumultuous passions in him because his heart was softened by "the tendency" of art.[45] At this Blake's republican forehead may have grown hot (he suffered the heat of seven furnaces, he said), but his tongue kept still.

In another mythical version (*J*.7) his "Spectre," that part of Blake who took the soldier by the elbows and pushed him to the inn, is aghast and indignant to see the present "Shadowy Generation" of Englishmen all involved in "webs of war & of Religion." He curses the poet "for his friendship to Albion" and suggests "murderous thoughts against Albion." "I saw it indignant, & thou art not moved!" But the poet, struggling to "abstain from wrath," maintains his love of the people. It is his "strength" that he still believes that a time of peace and freedom will come

> When all Albions injuries shall cease, and when we shall Embrace him tenfold bright, rising from his tomb in immortality.

3

It was probably in the months that followed his trial that Blake etched new inscriptions on his plate of the three terrified rulers whose End was to have Come in 1793. They were now singled out as "The Accusers of Theft Adultery Murder" or "Satans' holy Trinity The Accuser The Judge & The Executioner." In Blake's vision (see Plate IV) they are still on the verge of utter rout, standing in flames and constituting "A Scene in the Last Judgment." Yet the wounds made by the accusation and the inarticulate trial never entirely healed. The sinister names of Schofield and Cock (Kox) and of the assisting justices Brereton, Peachey, and Quantock are etched with aqua fortis into the plates of *Milton* and *Jerusalem*. Schofield and Kox, rolled into one with Kotope and Bowen (other dragoons perhaps),[46] compose a "Fourfold Won-

[45] Nicoll and Wise, I, 11–13.

[46] Ives suggests that Bowen may have been the prosecuting attorney. Blake's picture of "Schofield" in *J*.51 can hardly be a portrait; he had used the same stock figure for "Despair" in his 1795 painting *The Lazar House*, and it can be traced back at least as far as Peter Breughel.

der" epitomizing the Englishman turned "cruel Warrior." "In the deadly Night" Blake reenacts the trial "in grinding agonies in threats: stiflings: & direful strugglings." "In shame & confusion of Face" he hides even from his wife his fantasies of fighting back:

Go thou to Skofield: ask him if he is Bath or if he is Canter-
 bury[47]
Tell him to be no more dubious: demand explicit words
Tell him: I will dash him into shivers, where & at what time
I please. (J.17)

Inevitably the effect of the experience was to intensify Blake's self-censorship and the tension between man and prophet. He parades his name and address and declares his theme to be social and contemporary—"I write in South Molton Street, what I both see and hear In regions of Humanity, in Londons opening streets" (J.34[38]). Yet he seeks to prevent "Satans Watch-fiends" from entering into the *meaning* of what he writes by concealing, as he says in riddles, the "Gate" in his own head (J.35[39]). He tempts the curious with reversed writing that must be read in a mirror. Yet should some snooping Schofield try in his glass the mysterious title-page of *Milton, Book the Second*, he would read only: "How wide the Gulf & Unpassable! between Simplicity & Insipidity. Contraries are Positives. A Negation is not a Contrary." The baffled informer might wonder whether the author was simple or insipid but would hardly suspect that he himself, a Satanic Negation, was reading a prophecy of his own eternal non-existence.

In *Jerusalem* similar mirror writing calls attention to a page in which Blake cryptically declares that even his Lambeth prophecies should be inaccessible to spies because they must be read from many angles. The friendly reader who enters Blake's "translucent" "Grain of Sand" will find the inner theme to be freedom ("Oothoons palace") and a new heaven and earth ("Jerusalem & Vala . . . hid"). "But should the Watch Fiends find it, they would call it Sin And lay its Heavens & their inhabitants in blood of punishment" (J.37[41]).

In the first flush of victory over his accusers Blake went to work

[47] Is he perhaps a hireling of the Archbishop of Canterbury, whose dubious opinion of Blake was mentioned by Butts as something the Felpham experiment should change?

"briskly" on various projects, hoping "yet to make a figure in the great dance of life."[48] He painted such ecstatic pictures as *Noah and the Rainbow* and *Samson bursting his bonds*.[49] "Rouze up O Young Men of the New Age!" he exhorted in a preface for *Milton,* "set your foreheads against the ignorant Hirelings! . . . in the Camp, the Court & the University: who would if they could, for ever depress Mental & prolong Corporeal War." "After my three years slumber . . . I again display my Giant forms to the Public," he declared in a preface for *Jerusalem*. And he prepared title-pages for *Milton a Poem in 12 Books* and *Jerusalem The Emanation of The Giant Albion In XXVIII Chapters,* each dated "1804 Printed by W Blake S^th Molton S^t." Yet only two books of *Milton* were ever displayed to the public; and *Jerusalem,* reflecting in its final text the corporeal war from Trafalgar to Waterloo, was not published till 1818–1820, in four chapters.

Undoubtedly, as Blake hinted to Butts, he was held back by lack of such "Divine Assistance" as money and customers. But he was also still frightened at his own republicanism. The *Milton* preface, for all its boldness of Mental Fight, focuses attention on the non-verbal arts ("Painters! on you I call! Sculptors! Architects!") and concedes that the author is not "at leisure to Pronounce" the truths of the New Age nor to make such direct defense of "the Sublime of the Bible" as would presumably still "cost a man his life."[50] "Would to God," Blake adds, "that all the Lords people were Prophets." It would obviate much of this indirection. But "the Public" are really "Sheep" and "Goats" (he makes this division at the top of the *Jerusalem* preface) and only the latter can be expected to understand Quiddian ambiguities. Among the few purchasers of *Milton,* around 1808 and 1815, and of an occasional copy of *America* or *Europe,* there were apparently neither goats nor prophets. Before Blake finally printed *Jerusalem* he erased a reference to the "love and friendship" of those who accepted his "Giants & Fairies," and deleted *Dear* from the phrase "Dear Reader."[51] He also as a precaution against Watch-

48 To Hayley, Jan. 27, 1804.
49 See Wright, I, 142.
50 Compare *M*.2 and Marg. to Watson: E601/K383.
51 *J*.3: E143–144/K620–621, with all deletions now deciphered.

fiends scratched all the names after Richard and John from a list
of "Kings . . . to be in Time Reveald & Demolishd."[52]

The most immediate poetic record of Blake's mental suffering
in time of trial, however, is the plaintive notebook ballad partly
incorporated into the preface to the third chapter of *Jerusalem* and
partly transcribed into another manuscript as *The Grey Monk*.[53]
This story of a tortured pacifist who will not recant is associated
with Blake's trial by the fact that the Gothic courtroom of Chich-
ester was known to have been the chancel of a Grey Friars
convent church. The monk's martyrdom is that of the honest man
who has written against war and empire and whose writings have
been found out. He has been accused of sedition, jailed by "War"
personified (the fourfold Schofield?) and has been temporarily
allowed (on bail?) to visit the mother of his children (Blake's only
children being his "Giants & Fairies").

In the original manuscript we can see the poet's mind at work.
With an underthought of the bleeding wounds of Christ (stanza
4) he thinks of early Christian victims of "Grecian mocks & Roman
sword" and seeks for the name of an emperor—Constantine, Titus
—but the Gothic courtroom suggests a medieval scene: "Charle-
maine & his barons bold" torturing a monk who has refused to
bless their unholy crusades:

> Seditious Monk said Charlemaine
> The Glory of War thou condemnst in vain
> And in thy Cell thou shalt ever dwell
> Rise War & bind him in his Cell

Here, scarcely disguised, is the charge in the trial of "Rex *v*
Blake." And the intimate stanzas that follow, while hardly con-
sistent with the domestic arrangements of a monk, sound like an
almost direct outpouring of the Blakes' grief on that August day
when the poet appeared "before a Bench of Justices at Chichester"
and returned to the sick-bed of his "much terrified Wife" with the
news that he must stand trial for his life and must find bail in

[52] *J*.73. The deleted Kings were "Edward Henry Elizabeth James Charles
William George"; yet a matching line of Prophets was also deleted: "Py-
thagoras Socrates Euripedes [*sic*] Virgil Dante Milton."

[53] *J*.52; Pickering MS: E199–200; 480–481/K683, 430–431; *N*.8[12], col-
lated E732, 778.

£100. Catherine Blake was "near the gate of death" before the trial was over.[54]

> I die I die the Mother said
> My Children will die for lack of bread
> What more has the merciless Tyrant said
> The Monk sat down on her stony bed
>
> His Eye was dry no tear could flow
> A hollow groan first spoke his woe
> He trembled & shudderd upon the bed
> At length with a feeble cry he said
>
> When God commanded this hand to write
> In the studious hours of deep midnight
> He told me that All I wrote should prove
> The Bane of all that on Earth I love[55]

To write against War has nevertheless been his duty as a soldier of Christ, and he is ready to endure the tortures of "the wrack & griding chain" for the sake of his "Brother," the poor man, "starvd between two walls" (that is to say, in the street) and the poor man's children, whose cry ever "my Soul appalls."

In continuing to write, Blake does of course defy the rack and chain. Yet their marks are even upon this ballad, for he mutes "Seditious Monk" to "Thou lazy Monk" before transferring it to the public text of *Jerusalem*.

Subsequent stanzas carry us into a further range of symbolism.

[54] To Hayley, Jan. 14, 1804.
[55] *N*.8[12]; see facsimile edition or E732, 778.

23. O Voltaire! Rousseau!

> a Grecian Scoff is a wracking wheel
> The Roman pride is a sword of steel
> Glory & Victory a phallic Whip[1]

AFTER the renewal of war in 1803 Blake never quite emerged from an ambivalent view of the American and French Revolutions as having been either too warlike or not revolutionary enough. In either case he held the intellectual begetters of those revolutions responsible for their failure, and his Grey Monk utters the bitter cry that the thought-creating and rebellion-inspiring fires of the Enlightenment ought never to have been lit:

> O Voltaire! Rousseau! Gibbon! Vain
> Your Grecian Mocks & Roman Sword
> Against this image of his Lord!
>
> But vain the Sword & vain the Bow
> They never can work Wars overthrow.[2]

Yet the militancy with which the "seditious" monk "mocks" at his torturers seems to belie his thesis that *only* tears and humble submission "can free the world from fear." He does not submit, and one feels that if the multitude were dancing the carmagnole again this monk would not stay long in cloister.

The charge that Voltaire and other revolutionists are responsible for the counterrevolution and Napoleonic wars is elaborated in another notebook poem, *Mock on Mock on Voltaire Rousseau,* and in an address *To the Deists* prefacing the Grey Monk stanzas in *Jerusalem.* Here Voltaire, Rousseau, Gibbon, and Hume are accused of worshiping "the God of this World by the means of what you call Natural Religion," and as "Deists" (defined sweepingly as "those who Martyr others or who cause War") they are held

[1] N.8[12]: E733/K420.
[2] *ibid.* as in *J.*52 and Pickering MS.

responsible for "all the Destruction" that has arisen "in Christian Europe" (*J.52*). The theological language of this attack is misleading, since Blake had never accepted the Natural Religion of Deism, even when he had cried well done to Paine and Rousseau and defended Paine as a "better Christian" than Bishop Watson.[3] Blake as "a Monk or a Methodist"[4] is not very different from Blake as the friend of Paine; he employs more orthodox language at times, but he still knows of "no other Gospel than the liberty both of body & mind to exercise the Divine Arts of Imagination" (*J.77*). The Jesus of *Jerusalem* "who is the God of Fire and Lord of Love" is foreign to Deism, but not any more so than was Orc the "Human Fire" of the Lambeth books rising in the Alps with Voltaire and Rousseau.[5] It is evidently historical change rather than theology that leads Blake to shift his emphasis from Energy to Forgiveness, from warlike men to the solitary seditious monk, and to revile the heralds of peace-through-revolution as having been false prophets.

Because kings are still at large, Blake remembers that Voltaire and Rousseau while attacking religious superstition paid a good deal of lip service to royalty. France now has a pope-crowned emperor, and George and his barons bold are still threatening corporeal punishment to the religious advocate of peace. You Deists, Blake exclaims, "charge the poor Monks & Religious with being the causes of War: while you acquit & flatter the Alexanders & Caesars, the Lewis's & Fredericks: who alone are its causes & its actors" (*J.52*). The essence of the charge is that Voltaire and Rousseau— and Paine, who is included in a more gently worded passage— were diverted by their barren theological battles from sufficiently directing their fire against monarchs and militarism.[6] Blake, for instance, should not have been caught off guard by the military "Peace" of Amiens. The Enlightenment had not sufficiently weeded out king-worship and planted a hardier concept of brotherhood and human self-reliance. "I suppose," Blake wrote wearily to Hayley in May 1804, sending him a new *Life of Washington* which

[3] Marg. to Watson, 120: E609/K396. Blake would defend Voltaire in the same way in 1826. Gilchrist, p. 341.

[4] *J.52*. Of Monk and Methodist Blake says "We are Men of like passions with others" (compare Shylock).

[5] *J.3*. See Blackstone, p. 168.

[6] Paine is not named in *Jerusalem* but "Paine & Voltaire" are linked in a milder attack on the same position in *V.L.J.92–95*: E554–555/K615.

he had no time to read, "I suppose an American would tell me that Washington did all that was done before he was born, as the French now adore Buonaparte and the English our poor George; so the Americans will consider Washington as their god. This is only Grecian, or rather Trojan, worship, and perhaps will be revised[?] in an age or two."[7]

If Voltaire and Rousseau should have attacked kings instead of religion, one may ask why Blake himself is now attacking natural religion instead of kings? Partly, perhaps, because Blake in the absence of inspiring patriot action must find comfort in the educational fallacy: attitudes persistent since the days of Troy "perhaps will be revised in an age or two." Partly because Voltaire and company had been right, after all, in attacking the superstitions that hedge tyranny. They failed, and Blake marks their failure by branding them "Enemies of the Human Race"; but Blake must behead the same dragon. The Mystery they slew has reappeared in their own abstractions. Adoration of George and Louis has been replaced by adoration of Washington and Napoleon.

The religion of the *ancien régime* was officially destroyed in June 1794 at Robespierre's Feast of the Supreme Being when turpentine-soaked effigies of Atheism, Egotism, Discord, and Ambition were ignited and, while they blazed and crumbled into ashes, an effigy of Wisdom rose through a trap, her face ominously blackened by the flames. Blake at the time, in *The Book of Ahania,* i, approved Robespierre's overthrow of the worship of an "abstract non-entity" and pictured the subsequent destruction of Robespierre (Fuzon) as a crucifying of the Moses of the Revolution. Now Blake thought of Robespierre's fury as "Cold"[8] and of the whole ceremony as an attempt to destroy a phoenix by fire. According to a late passage in *The Four Zoas,* when the Convention of the French Republic met as the "Sanhedrim of Satan" and voted

[7] Keynes, in *Letters,* rightly queries "revised"; the source of this letter is Gilchrist, for the original has not been traced.

Blake clearly felt differently about George III as a person and as a state. To adore "our poor George" as a "god" is Trojan worship which must be negated; yet Hayley's "little poem on the King's recovery" is "one of the prettiest things I ever read," Blake says and hopes "the king will live to fulfil the prophecy and die in peace." The only way that poor George can die in peace is for tyrant Urizen to withdraw from war: alas, "at present, poor man, I understand he is poorly indeed, and times threaten worse than ever," i.e. more war and more royal madness.

[8] To Phillips, Oct. 14, 1807.

for the Robespierrean project, all that happened was that "Satan
divided against Satan" and "resolvd in open Sanhedrim To burn
Mystery with fire & form another from her ashes."[9]

The Ashes of Mystery began to animate they calld it Deism
And Natural Religion as of old so now anew began
Babylon again . . .[10]

Bonapartism was the natural sequel. "This Voltaire & Rousseau"
were thus initially responsible. And now instead of one Louis there
had risen an imperial beast with seven war-hungry heads, as John
"on Patmos Isle" had foreseen long ago, and an imperial Whore,
whom Blake calls "Religion hid in War" or "the State named
Rahab."[11]

The Grey Monk parable makes this point more simply, starting
from the same premises as *Gwin, King of Norway,* and written
in the same form. In both poems the "wives and children" cry
for bread. In *Gwin* the bloody answer is to "pull the tyrant
down." In the *Monk* the answer, though just as bloody for the
children's defender, is "Love & forgiveness" and "submission to
death" beneath the tyrant's feet. Perhaps this "unsays a lifetime of
hope."[12] It does show the difference between 1776 and 1803 for
an English lover of humanity. Suffering alone for his thoughts,
he is inclined to blame the civil war on agitators and to cry: Get
thee behind me, "False Tongue!" "Seat of Satan," "Paine &
Voltaire."[13]

The Monk sees revolution as a vicious circle. The "father" or
king marches threateningly "with his thousands" from the north.
The "Brother" or fraternal citizen arms to avenge the suffering

[9] I have suggested elsewhere (*The Library,* xix [1964], 126) a possible
reference to Napoleon's summoning (in October 1806, to meet in 1807)
a Sanhedrim of European Jewry, to mark Paris as the new Jerusalem,
after having induced a Pope to assist at his coronation. Conceivably
this addition to the ms was late enough. Yet then Orc, not Urizen, should
be summoning the Sanhedrim. The Synagogue of Satan comes from Revela-
tion and is required by the plot, i.e. of night leading to Judgment Day.

[10] *F.Z.*viii.111:19–24: E371/K357. On the actual unity of the successive
phases of the religion of the revolution, see Rogers, *The Spirit of Revolu-
tion in 1789,* pp. 20–21.

[11] *M.*40:12–22; 37:43; *J.*52; cf. *F.Z.*viii.111:1–5. See also Blake's 1809
painting of *The Whore of Babylon.*

[12] Bronowski, pp. 105 [146], commenting on *To the Deists.*

[13] *M.*2:10; 27:45–46.

"Children." "The hand of vengeance" crushes the tyrant, but then, lacking democratic vision, usurps "the tyrants throne & bed" and becomes "a tyrant in his stead."

> Untill the Tyrant himself relent
> The Tyrant who first the black bow bent
> Slaughter shall heap the bloody plain
> Resistance & war is the Tyrants gain[14]

King George in America first bent the black bow (fired the musket) as Satan did in Eternity,[15] and only intellectual resistance can make him relent. But how can a bard hiding from Satan's watch-fiends conduct intellectual war?

Shelley too believed that a firm persuasion would "melt the sword of steel," as Blake puts it. His *Masque of Anarchy* (1819) advises Englishmen to let the tyrants "Slash, and stab, and maim, and hew" till their rage cools and the soldiers fraternize with the many, all shaking off their chains "like dew." Yet Shelley's friendly censor, Leigh Hunt, decided not to print even such advice lest it be militantly interpreted. And Blake acted as his own censor. Politically such censorship expresses a hope fairly common among romantic radicals that the benefits of democracy might be obtained for England by sober leadership without any stirring up of the English people.

Yet Blake's bardic wrathful self would never stay convinced that "forgiveness sweet" was anything more than "the passive that obeys Reason."[16]

[14] N.8[12]: E732/K420. Perhaps it is indicative of the transitoriness of this extreme position that Blake did not use these lines either in *J.* or in the Pickering fair copy.

[15] See the fifth stanza in *J.*52.

[16] *M.H.H.*3. It is curious to note that during the invasion scare Lord Exeter made a public bonfire of works of Voltaire, Rousseau, and others. And this in a sense is what Blake does. See Elie Halévy, *A History of the English People in 1815,* Pelican edn., III, 74.

The *mockery* of Blake's Voltaire, Rousseau, and Democritus, by the way, can be traced to Lavater's *Essays on Physiognomy,* for the first volume of which, published in London in 1789, Blake made three engravings including Democritus the Laugher, after Rubens. "He is not the person whom the Philosophers represent 'as a vast and penetrating spirit, a creative genius,'" explains Lavater, but "a fatal mixture of humanity and inhumanity, of satisfaction and malice." And so his face is the archetype of "Mockery [which] contracts the eyes," "a hypocrite" with a "contemptuous grin converted into habit" (pp. 159–161).

2

In Heaven the only Art of Living
Is Forgetting & Forgiving . . .
But if you on Earth Forgive
You shall not find where to Live (*J*.81)

Blake's political ambivalence stands out sharply in his notebook jottings and marginalia of 1808–1812. "If Men were Wise, the Most arbitrary Princes could not hurt them," and Blake is "really sorry to see my Countrymen trouble themselves about Politics." Yet he cannot refrain from exclaiming that Princes and their Hirelings have hurt *him* deeply, nor from crying with Solomon: "Oppression makes the Wise Man Mad."[17]

"Houses of Commons & Houses of Lords" appear to Blake to be fools and "something Else besides Human Life" (*P.A*.18). Yet he keeps an eye on the Houses of Parliament and is delighted to see an occasional stirring of human life there. He greets the final passage of the Slave Trade Bill in 1807 (*J*.40). And in 1809 the radical Colonel Wardle, in his Parliamentary exposure of the Great Whore presiding over the sale of army commissions, impresses Blake as capable of giving the corrupt and corrupting "English Nobility & Gentry" just the medicine they need:

And I call upon Colonel Wardle
To give these Rascals a dose of Cawdle[18]

Perhaps it is only specious politics that citizens should learn to ignore, for Blake goes right on to ascribe the "wretched State of the Arts" to "the wretched State of Political Science which is the Science of Sciences" (*P.A*.20). While turning his back on the politics of "such contemptible Politicians as Louis XIV," he excludes any idea that the state of Political Science is unimportant. His question, "Are not Religion & Politics the Same Thing?" (*J*.57) cuts two ways. He urges fellow artists to stand firm against

[17] *P.A*.18: E569/K600; Marg. to Reynolds, 180: E647/K472.

[18] *N*.40: E506/K548. William Cobbett found Wardle's speech "at once concise, plain, and impressive" and praised him "for having opened the eyes of this blinded nation to the character and conduct of . . . the very worst of its foes." *Political Register*, Feb. and Apr. 1809.

the Counter Arts of royal politicians who prefer "Bloated Gods Mercury Juno Venus & the rattle traps of Mythology." And his furious language on the relatively safe subject of art quite upsets his meek advice about submitting to arbitrary princes: "If all the Princes in Europe like Louis XIV & Charles the first were to Patronize such Blockheads [as Reynolds] I William Blake a Mental Prince should decollate & Hang their Souls as Guilty of Mental High Treason" (*P.A.*19).

Blake does, to an extent, "push what were for others external problems back into the realm of mind," as Schorer observes. But what Blake wants the mind to solve is the strategy of decollating contemptible politicians. From his earliest interest in kings as accusers of adultery Blake looked upon psychology as a phase of politics and upon politics as an acting-out of mental strife. He saw revolution freeing infinite desire. He saw the code of War & Lust perverting the phallus into a "whip" of separation. But he was not so ready as his modern interpreters to compress all the politics of "liberty, fraternity, and equality . . . into their psychological equivalent . . . forgiveness."[19]

In *Milton* and *Jerusalem* politics and psychology are still distinguishable. The political relevance of *Milton* is indicated by the fact that Blake sees Milton's relation to the English Revolution as similar to that of Paine, Voltaire, and Rousseau to the American and French Revolutions. The anxious emphasis on matters of timing is political. And in a broad strategic sense Milton is charged with the same political mistake as Paine, Voltaire, Rousseau—and Blake himself (for much of his outcry is a self-castigation)—that of trusting too much to analytics and not enough to spontaneous movement.[20] For Blake believes that had the Puritan Revolution succeeded, there need have been no American Revolution, and modern England would not be still sadly awaiting the return of Jesus' feet to its pleasant pastures.

[19] Schorer, pp. 361–362.
[20] See *M.H.H.*20: E41/K157.

24. What Mov'd Milton

And Milton said, I go to Eternal Death! The Nations still
Follow after the detestable Gods of Priam; in pomp
Of warlike selfhood . . .
When will the Resurrection come . . . ?

— *Milton* 14

THE missing ten books of *Milton* seem to have constituted a vision-
ary account of the English Revolution, as in an ideal sense each
of Blake's prophetic works does, and it is instructive to study both
the remnants and the modifications of that account in the text we
have. Except for interpolations of this earlier matter, however,
the extant two books are largely taken up with a description of the
sorry shifts of law and commerce whereby mankind achieves a
modus vivendi (during the endless Napoleonic wars) while wait-
ing for the great Day, and with the tortuous accommodation of
Milton's (Blake's) social philosophy to the long darkness of patient
waiting, an adjustment dramatized as the instructing of the elder
bard by the younger in the lesson of the Grey Monk that "we must
not be tryants also!" (*M*.7:25). The reward, nevertheless, can be
instant *mental* liberation, and in that sense the poem is a trium-
phant freeing of Los—not to escape the world's problems but to
return to London to work as, and "listen to," the Poor Man
(*M*.42:34–35).

The extant text begins with a Bard's "terrible Song" of the
rise and redemption of tyranny. John Milton, duly impressed,
descends to enter into William Blake and learn the error of his
tactics in the mental fight. When he has corrected his course and
united with his Emanation, Ololon or history-as-it-should-have-
been, Milton achieves a sudden unity with Jesus the Saviour;
whereupon William Blake returns to his Vegetable Body in his
cottage at Felpham, somewhat shaken but mentally ready for the
Great Harvest.

In the early draft, represented by certain extra pages which

appear only in the last two of the four extant copies of *Milton* but
which go back in symbolism to the Lambeth period, it is probable
that the lesson for Milton was approximately that of *The Marriage
of Heaven and Hell* and *America*.[1] I think Blake must have used
the English Civil War as an object lesson, for we find King
Charles, Cromwell, and Satan joined on the same battleground, in
page 5. And though the clues are slight, it is possible that the strife
between Satan and Palamabron derives from the struggle between
Cromwell and Parliament.

If we suppose that Blake viewed the career of Cromwell as com-
parable to that of Napoleon, some plausible parallels suggest them-
selves: Satan's usurpation of Palamabron's place "under pretence
of pity and love" could be Cromwell's domination of Parliament.
Palamabron in calling "a Great Solemn Assembly" acts like Parlia-
ment; and Palamabron's prayer recalls Parliament's need of pro-
tection from Protectors:

O God, protect me from my friends, that they have not power
over me
Thou hast giv'n me power to protect myself from my bitterest
enemies. (*M*.9)

Palamabron's proper implement, the Harrow of the Almighty,
suggests the leveling function of revolutionary legislation: it is
abused in the tyrant's hands. Satan calling himself God suggests
Cromwell (Napoleon) in dictator role; Satan's Mills supply Crom-
well's artillery. Los's initial support of Satan would signify Milton's
(and Blake's) support of "the Devils party" in the execution of
Charles (and Lewis). Blake's Satan, like Milton's Satan and like
Cromwell, begins as one of the "Elect" and ends as a notorious
"Reprobate."[2]

[1] Two extant copies of *Milton* are on paper watermarked 1808. The extra
pages appear only in the other two extant copies, one on paper of 1815,
the other on unwatermarked paper but presumably of a similarly late
vintage.

[2] The London fire of 1666 seems to be alluded to in 5:40–41, where the
King "calls for fires in Golgonooza. for heaps of smoking ruins In the night
of prosperity and wantonness which he himself Created" (echoing *Song of
Los,* pl. 6). But that the King is James rather than Charles is puzzling.
Is it that James I created the prosperity and wantonness that culminated
under Charles II in the fire?

This interpretation would not conflict with our reading in the fable a pattern of Blake's relations with Hayley in which the Harrow figures as an engraving tool and the Mills as Hayley's art and epitaph factory.[8] The Mills also suggest the blighting effect of machinery (their chief connotation to many moderns), and Blake makes the parable broad enough to define the historical rise of Satanism from the first "primitive tyrannical attempts," through a labor of "a thousand years," to the mature imperial tyranny of "Rome, Babylon & Tyre" which culminates in Druid slaughter "throughout all the Earth."[4]

Here, however, Blake veers sharply from the revolutionary solution, which would have been to reap the starry harvest in warlike wrath. He does so partly in precautionary retreat before the onslaught of Albion's cruel Sons, Schofield and the rest. But he does so chiefly because he is writing not in a revolutionary time but in the second decade of a bootless military conflict which calls first of all for some minimal cease-fire agreement, some cooling of the wrath of both combatants. The trouble is, however, that Blake is not content to formulate a message for the times but must go back and reconstruct all previous history, censure all previous messages.

The positive message of *Milton,* forgiveness of "the Guilty," is conveyed with political allusiveness in two cryptic but professedly didactic visions of the judgment of the Beast, Satan, and the repentance of the Whore, here named Leutha and associated with the person of Sin in *Paradise Lost.*

Palamabron or the part of Blake's mind that debates public matters "dared not" call an assembly to discuss the guilt of Napoleonic Satan until Satan "had assum'd Rintrahs wrath." When he did so, though the rage was in Satan, the judgment "fell on Rintrah and his rage."[5] Responsibility falls on Rintrah-Pitt for the original crusade even though now, after 1803, he is "Innocent" and Satan-Napoleon is "Guilty," having assumed his rage. The moral is that Satan must be forgiven or vengeful slaughter will never end.

The point is reinforced by the story of Leutha, who offers "herself a Ransom for Satan." She and Satan together constitute "the

[8] There Blake, like Palamabron, had thought to serve "as the easier task" (*M.*8:5: E101/K488).

[4] *M.*7:5, 13; 9:51; 11:8: E99–104/K486–491.

[5] *M.*11:25; 9:10.

Spectre of Luvah" (France) and we may think of her as the spiritual form of Marie Antoinette, the modern Helen for whom rival empires grapple, permitted now to return to earth and put off the pestilent Magdalen. Still shining in "moth-like elegance" the silken Queen explains how she urged Satan on in his mad career when the Horses of Palamabron (the leaders or the Houses of Parliament?) called for rest; how she "form'd the Serpent" of Brumaire when the beast was harrowing a third part of the universe "to devour Albion and Jerusalem the Emanation of Albion."[6]

The Queen seems to be an acceptable ransom; yet insofar as she is a State she cannot really change, and as the scene closes she is giving birth once more, like Sin, to "Death" and "Rahab." We must understand that Leutha, having acted out the vision of how things ought to be, returns to her station as a symbol of how things are. Rahab and her daughter Tirzah both figure prominently henceforth as license in sex and sex suppressed, "the Female-male & the Male-female." The first is "Religion hid in War" and the second perhaps War hid in Peace or hypocritical charity: in Lambeth she is matron of hard labor at the Female Orphan Asylum.[7]

These parables are recited by the inspired Bard for Milton's instruction, and Milton with surprising ease, considering the failure of modern readers to find political meaning here, understands him to have said that the persistence of corruption and war in the world of the nineteenth century is an indictment of the revolution for which Milton bears bardic responsibility.[8] Milton for a good "hundred years" has been pacing Eternity "Unhappy tho in heav'n" because history has not gone according to his vision of it ($M.2$). He is ready to be corrected at some length and restored to the faith that with a proper dialectic Albion may yet attain Jerusalem. For our purposes it will suffice to look into the difference

[6] M.11:30–33; 12:27–29; 13:8; cf. $F.Z$.viib.93:20–27. In other words, her spirit kept France from responding to the English peace offers of 1797–1798.

[7] M.19, 13, 25. The "Asylum" mentioned in the latter passage (see Fig. 14) has been mistaken for Bethlehem Hospital, referred to in J.45 [31], but there is no connection between the two.

[8] M.14. Frye, p. 319, observes that if Milton "had not been checkmated by failure of the British nation to purify itself," his great epic might have dealt with apocalypse rather than creation and fall.

between the early and late versions of the Blakean instruction, both conveniently available in the post-Waterloo copies as if to meet the contingencies of either revolutionary or non-revolutionary times.

In the revolutionary version Milton learns that the "sufferings poverty pain & woe" of the people are very real, that they are woven of the "misery of unhappy Families" by the textile imperialism of Britain,[9] that the garment of oppression is so "inwoven" with Kings, Pestilence, and War that it must be rent by revolution ("O Orc! my only beloved!")—and yet that every revolution will turn to counterrevolution unless the guiding genius of man puts on "a Garment of Pity & Compassion like the Garment of God." In the version drafted for the time of present war, Milton is told that the English Revolution and all historical revolutions have been "premature," and Blake revises "an old Prophecy" concerning the Orc-releasing powers of Milton into a watchword in which patience is stressed and Orc is not mentioned. Nevertheless in either version the ultimate goal is revolutionary. Milton will effectively "break the Chain of Jealousy from all its roots" (*M*.23).

While there is war on the Rhine and the Danube, then, even revolutionary vision can be premature. For one thing it cannot be communicated by or to war-manacled minds. "The Wine-press on the Rhine groans loud, but all its central beams Act [even] more terrific in the central Cities of the Nations Where Human Thought is crushed beneath the iron hand of Power" (*M*.25:3–5). Overt censorship is not Blake's theme but, once more, the insidious and pervasive accommodation of vision to militarism which he hears in every voice and feels in his own mind as he struggles to break through the fears that stop his tongue and shut the ears of his fellow citizens, reducing their medium of communication to the mere surface of Blake's "designs." Under these conditions the handmaidens of the silent arts are permitted to form "secret Obscurities" which preserve "Human loves and graces" safe "from Satans Watch-Fiends" (*M*.23:39–41). And the prophet as a *recorder* of history must continue to follow the course of events. In this sense

[9] *M*.18: E110/K499. Compare the "needlework" passage in *F.Z.*ii.25. And for the garment of oppression see *F.R.*221–223.

the "Wine-press . . . call'd War on Earth . . . is the Printing-Press Of Los" (*M*.27:8–9). He may even describe the crushing of "the Opressor & the Opressed Together." But he must not express wrath, perhaps not even "the fury of Poetic Inspiration" (*M*.30:19), until the day when a manifesto of freedom will not be mistaken for an exhortation to violence.

Remember how Calvin and Luther in fury premature
Sow'd War and stern division between Papists & Protestants
Let it not be so now! O go not forth in Martyrdoms & Wars.
(*M*.23:47–49)

The "Universal Brotherhood & Mercy" have given us "powers fitted to circumscribe this dark Satanic death,"

But how this is as yet we know not, and we cannot know;
Till Albion is arisen; then patient wait a little while.
(53–54)

This argument, a blend of the Godwinian concept of historical necessity and the idea of waiting upon the Lord, is virtually against fury at any time. Voltaire and Rousseau should not have stirred up the spirit of 1776 and the Terror; Calvin and Luther should not have unsheathed their mental swords because those swords became steel in the German Peasant Wars and the English Civil War. Blake is somewhat sorry to have defended Orc in 1776 and 1793 and in the early version of *Milton*, and he implies that Milton should never have put aside poetry to write with his left hand in the service of Satan.[10] The charge seems ungrateful in one who

[10] Perhaps we hear, even in Blake's *Milton*, distant reverberations of the mocking sarcasm of Fuseli's youthful *Remarks on Rousseau*. Consider the lines just quoted as a sober acceptance of the point made ironically in Fuseli's preface that the "itch of propagating truth" is "the destroyer of peace—and the parent of revolution." And compare also Blake's advice "To the Deists" in *Jerusalem*. Fuseli argues that had it not been for Luther's "paroxysms" of truthfulness he could "have indulged himself quietly in the fat luxury of a convent—Leon's golden age of literature [to which Blake often refers] . . . had not been overrun by the armies of Fanaticism; *Charles, Philip,* and *Alba,* had not turned their red-hot furies loose on *Europe;* the bells of *Bartholomew's* night had not been rung; . . . the *Henrys* the *Louis',* the ****, would not have been stabbed—abominated—expelled; no *Holy Tribunal* would smother the howlings of humanity—nor

drew much of his prophetic wisdom from Milton's left-handed *Aeropagitica*.[11] Yet Blake is by no means advising Milton to submit to the status quo.

The throwing off of tyranny is not after all wrong; it has only so far been unsuccessful, and one reaches the conclusion that the chief prophetic consideration is timing. In other words, as William Blake reaches identity with Los, his function as the god of Time is emphasized.[12] God's wheel of fate has Seven Eyes; each of the first six fails to serve as an eye for Albion, but the seventh, Jesus, comes at the right moment and thus marks or produces the complete revolution which makes any further rotation of human misery unnecessary (*M.23*).

When fury is successful Blake does not disapprove either of parliamentary politics or of extra-parliamentary and distinctly violent resistance and rebellion. When the Slave Trade Bill was finally passed in 1807 he attributed the victory to a conjunction of the rising of "Africa" and the "well timed wrath" (a most revealing epithet) of his friends the "wrathful brethren" who "cut his strong chains, & overwhelm'd his dark Machines in fury & destruction."[13] "But Albions sleep," Blake hastens to add, "is not like

earthquakes shake a throne; Truth—the wretched victim itself—had not been torn to tatters under the hands of its defenders; . . . *Luther* had not damned *Zwingli—Calvin* had not burnt *Servet* . . . in short—we might all be of one mind—jolly fellows. . . . Curiosity . . . pierces the sanctuaries of power . . . and on your *Greves, Terreaux,* and *Tyburns* racks, burns, hangs, and smashes the bones of every government, society, and police under the moon."

[11] On Blake's debt to Milton's prose, see Frye, pp. 159–160, and Blackstone, p. 139. Crabb Robinson in 1825 understood Blake to say that Dante was "a mere politician and atheist, busied about this world's affairs—as Milton was till, in his (M's) old age, he returned back to the God he had abandoned in childhood." Symons, p. 294.

[12] *M.24*:68; 30. Blake becomes one with Los and declares, "both Time & Space obey my will" (22:17).

[13] *J.40*[45]. Damon in 1924 saw only "enslavement in Egypt and release under Moses"; in his *Dictionary,* 1965, he sees rather "the revolt of the Surinam slaves, described in J. G. Stedman's *Narrative. . . .*" Yes, but then the black Africans' friends in England are seen as acting as Moses. Blake's image dramatizes the synchronization of Africa's rising to bind down "Sun & Moon" (change the universe) with the wrath of those who "cut his strong chains" (abolished the slave trade). A correspondence is implied between the modern slave trade and the apparatus of Egyptian pyramid-building.

Africa's: and his machines are woven with his life." If Albion should rise up to cut his own chains, he would fail and the failure would "slay Jerusalem." "Nothing but mercy can save him!" Yet Blake continues to use a violent figure for what Albion must do: he must "cast his Spectre into the Lake" if only "When his Humanity awake."[14] In short, the English revolution must be timed by internal judgment. *When* the people are firmly persuaded of the divinity of Humanity, they will drown Schofield, quell the Covering Cherub, and reenter Paradise. We are assured that Time, "the swiftest of all things," is always later than we think. In an eternal view, Time and the Prophet are one.[15]

The hopeful side of Blake's message is that the marriage of

[14] The point is made in *M*.39:10–11; these words are from *J*.37 [41]: E731/K669.

[15] Compare the analogous reasoning of Godwin, who made a strong point of the danger of revolutionary failures and argued that even a threatened revolt "tends to excite a resistance which otherwise would never be consolidated"; of Coleridge, who felt that England could avoid the sanguine path of France only if "benevolent affections" replaced the idea of "retribution"; and of Shelley, whose Prometheus is freed by an exertion of strength only when Jacobin thoughts of vengeance have given way to Christian thoughts of brotherhood. See Kenneth Neill Cameron, "The Political Symbolism of 'Prometheus Unbound,'" *PMLA*, LVIII (1943), 737–738.

In all these cases the emphasis is comparable to Blake's transfer of leadership from a fiery Orc to a merciful Los. All, including Blake, assume that no great movement of change will succeed unless the young men of the New Age are sober intellectuals who have annihilated the specter of Selfhood which haunts the warlike.

Compare the advice directed to the London Corresponding Society by the anonymous author of *A Summary of the Duties of Citizenship*, London, 1795: "I love the cause so well, I tremble lest any ill-advised labourer in the vineyard of liberty, should sully, or disgrace the character of a man. Surely you can never . . . attempt to introduce peace by anarchy and war? . . . You must patiently wait till the GENERAL VOICE proclaims, in irresistible articulation, the obvious necessity of a Reform."

Yet an inactive prophet is especially inclined to look for signs of speedy fulfillment. See Francis Dobbs, *A Concise View, from History and Prophecy, of the Great Predictions in the Sacred Writings*, London, 1800, p. xxi. Dobbs, speaking in the Irish House of Commons in June 1800, was willing to submit to the Act of Union "without a murmur until it be repealed, or until the sun shall miraculously withhold its light, and announce the appearance of Christ," because he was convinced, from a Swedenborgian reading of the Bible and of historical Signs, that the sun would almost at once withhold its light and the Act "never be an operative law."

prophecy and history (Milton and Ololon) is virtually at hand. We might have known that Milton's re-education "is the Signal" (24:42) that the evil results of "Miltons Religion" have reached their nadir. Under the Circean regime of Rahab and Tirzah men have become mere animals of belly and brainless nerves, clashing by night in dubious commercial wars. Now, in Book II, two lyric symphonies of daybreak and springtime, ringing with a prophetic pun on "the Wild Thyme," demonstrate the dialectical bursting of dawn out of darkness. Each of these vernal lyrics is a "lamentation of Beulah over Ololon" or of intellectuals over the course of history—a lamentation which turns to rejoicing because the weeping of Nations that precedes the coming of Christ in history ("in the Clouds of Ololon") is actually a sign of that coming. Blake, thinking once more of how "Orc howls on the Atlantic" in "War Not Mental," knows that it is even from such war that one draws inspiration for war that *is* mental. Vain are the rammed combustibles, but mighty the intellectual tear. The prophet's vision can *see* the mighty weeping of nations that will end the war: England repenting her cruelty toward America and India, the Germanic allies repenting their persecution of "France & Italy" (*M*.31).

Alas, such visions tempt the patience even of a reformed prophet. When Milton-Blake says to Satan, "I know my power thee to annihilate And be a greater in thy place" but my purpose "is to teach Men to despise death," he is preaching passive resistance. Yet he itches to destroy every hireling writer or artist "Who creeps into State Government." The Divine Mercy has replaced the Human Wonder, but the work is still to annihilate the "destroyers of Jerusalem," and Milton laughs Satan's laws "to scorn . . . shaking down thy Synagogues as webs" almost in the same way that Orc stamped the stony law to dust.[16]

Even the prophet's sons remark his ambivalence, which is to say that it is apparent in his works: "They saw that wrath now swayd and now pity absorbd him. As it was, so it remaind & no hope of an end." During the long wait for the great Dance and Song, a gut-filling existence is necessary, for there is "the Stomach in every individual man" to be filled, as well as the Stomach of society, "namd Law by mortals," named Bowlahoola by Blake. And there

16 *M*.38:29–42; 41:11, 21.

is the nervous system to be soothed by the musical instruments of "Art & Manufacture" "to ameliorate the sorrows of slavery." These nerves are called Allamanda, Commerce. The identification is not without irony, for it was precisely in the chartered streams of Commerce that Blake's own nerves were most mortally attacked.[17]

[17] *M*.24. Blake specifies Bowlahoola as the Stomach. As for Allamanda, Sloss and Wallis and Damon call it the nerves; Frye finds it to be anything in the body that circulates, like trade in society, whether blood or nerves; Blake does not say. I suspect that Blake coined two overlapping terms, Bowlahoola from the bowels and Allamanda from the alimentary canal (see it pictured on *J*.25) and then arbitrarily assigned to them somewhat different, though complementary, functions.

25. Renew the Arts on Britains Shore

All things acted on Earth are seen in the bright Sculptures of
Los's Halls & every Age renews its powers from these Works
— *Jerusalem* 16

DESPITE occasional misgivings that "the footsteps of the fiends of
commerce" may never wear a path to his door, Blake's letters of
1804–1805 are full of the theme, "Busy, Busy, Busy I bustle along,"[1]
and this tune must have continued for the next year or so
although we have no letters in evidence. Having accepted the idea
that steady employment at engraving, which he alternately blessed
and cursed, must be the foundation of his economy, Blake cir-
culated brightly among authors, artists, and publishers, pursuing
for Hayley and others a multitude of projects and keeping on the
lookout for work to engrave.

Projects to advance his fame were brewing too. Not without
artistic reputation by this time among his fellows, Blake needed
some kind of popular success to make it secure. His poems also,
at least the lyrics, were not without private admirers. In the
summer of 1805 two publications which would put both his songs
and his pictures before the buying public and draw the notice
of reviewers were undertaken by his friends, true and false. A
true friend was the Antiquarian and schoolteacher Benjamin Heath
Malkin (known possibly since the radical '90s). His *Father's Mem-
oirs of his Child*, to be published by Longman early in 1806, would
include a frontispiece by Blake and an Introduction devoting
twenty-four pages to Blake's life and works, quoting in full two
early lyrics, three Songs of Innocence, and *The Tyger*. Malkin was
also, with Blake's assistance, prepared to contribute a prefatory ap-
preciation of Blake's illustrations intended for a "New and Elegant
Edition" of Blair's *Grave*. Blair's poem was little more than a
vehicle for a prophetic series of large "Designs Invented by William
Blake"; Malkin's "explanation of the artist's view in the designs"

[1] To Hayley, Feb. 23 and Aug. 7, 1804.

and five paragraphs of praise by Fuseli of the artist's exciting interpretation of the poet's "Moral Series" would focus attention where it was due.[2]

Unhappily Robert Hartley Cromek, an unscrupulous promoter and mediocre engraver who would earn the name "Bob Screwmuch" in Blake's Notebook, was parisitically involved in both projects. So duplicitous was Cromek's notion of how "to create and establish a reputation" for his friend Blake—and a windfall for himself—that the precise nature of his imposition has only recently been brought to light.[3] Having "so often" (as he complained to Blake in a wild letter in May 1807) heard him compare his works "to a Raphael or to a Michael Angelo," Cromek gave Blake an order for forty drawings to illustrate a Bensley edition of *The Grave* and then commissioned him to engrave twenty—or so Blake understood. Cromek lined up a testimonial by President Benjamin West and twelve other Royal Academicians as to the "excellence" of Blake's drawings and a frontispiece portrait by the newly fashionable Thomas Phillips, just elected R.A. Yet even with Blake's happy letter to Hayley (November 27, 1805) telling of the "liberality" with which Cromek "set me about the Drawings [and] has now set me to Engrave them," Cromek mailed a printed Prospectus, not shown to Blake, announcing the fashionable Louis Schiavonetti as the exclusive engraver.

Blake apparently swallowed his pride, accepted his small fee for the drawings (20 guineas), and even submitted to Cromek's decision to relieve Blake of the engraving of the frontispiece for Malkin's *Memoirs*. In June 1806 Blake even accepted the Cromekian chore of writing to request the patronage of the Queen (with helpful advice from a better friend, Ozias Humphry). Blake seems not to have lost patience until Cromek rejected and refused to pay for his design to accompany the dedication to the Queen. When *The Grave* went to press in 1808, five names had been withdrawn from the list of patrons, including those of Acade-

[2] The recent edition by S. Foster Damon is forthrightly titled *Blake's Grave: A Prophetic Book* (Providence, 1963) and dispenses with Blair's poem altogether.

[3] This account of Cromek's dealings with Blake has been revised in the light of new information, in particular the text of Cromek's Prospectus of November 1805, presented by G. E. Bentley, Jr., in "The Promotion of Blake's Grave Designs," *University of Tortonto Quarterly*, xxxi (1962), 339–353.

micians Fuseli, Northcote, and Opie.[4] Malkin's name did not accompany the analysis "Of the Designs," and he had not supplied an advertised "Critique on the Poem." Fuseli's eulogy, which it would have been no act of friendship to withdraw, remained, declaring the picturesqueness of Blake's playing "on the very Verge of legitimate Invention" and the elegance of his simplicity. There were 589 subscribers.

The reviews were unenthusiastic about the lyrics quoted by Malkin; savage about Blake's contribution to the Elegant Edition of Blair.[5] It brought the artist to his widest public, but in a form that seemed to bear witness to his unfitness to engrave his own designs and that brought him no royalties. Little wonder that he turned from the careful pursuit of his own fortune to the more urgent requirements of his prophetic program for Art. The angel who had commissioned Blake at birth to overthrow the armies of Europe kept insisting that Art was a more powerful form of international competition than War. Englishmen were told that they must defend Britain's shores from Napoleon. Blake *knew* that they could better defend Britannia's isle with works of Art and that the only chance of survival for the "King & Nobility of England" lay in their encouraging imaginative genius. "What you Fear is your true Interest. Leo X was advised not to Encourage the Arts; he was too Wise to take this Advice." "Let us teach Buonaparte & whomsoever else it may concern That it is not Arts that follow & attend upon Empire but Empire that attends upon & follows The Arts."[6]

When Blake called for "a Fair Price & Proportionate Value & a General Demand for Art," he was renewing the early demands of Barry and Wilkes. And what he especially wanted changed was the proportionate over-valuation of portraits, landscapes, and merely

[4] Also withdrawn were the names of Thomas Hope, Esq. and William Locke, Jun. Esq., friends of Malkin apparently, for they are the only patrons, besides Fuseli, that he mentions in his reference to the project in his *Memoirs*.

[5] The *Antijacobin* was attentive to the Blair designs but predictably hostile; Phillips' *Monthly Magazine* (see below) was predictably gentle, taking its cue from Fuseli's approbation of "the technic Part" as redeeming the wildness of design. For the more surprisingly hostile *Examiner* review, see below.

[6] Marg. to Reynolds, 3: E631/K452; *P.A.*66: E566/K597; cf. "Now art . . .": E471/K557.

decorative art. With a mixture of "Love to My Art & Zeal for my Country" he was pleading for public recognition of patriotic and humanistic art that had "Power . . . to Instruct," power to deflate heroic villains, and "Power . . . to Make a Man."[7]

It is not likely that many of his fellow "Historical & Poetical Artists" would have gone all the way with Blake politically. With the death of James Barry in February 1806 the last Wilkite artist was gone, a "sturdy republican" who had continued to believe in epic and prophetic art and to urge upon patriot statesmen like Charles Fox "the great ethical and political purposes" of such art.[8] There was Fuseli, whose Milton paintings Blake considered an actual "Exposure" of Satan which the King and Nobility found embarrassing because *they* were Satan.[9] But Fuseli himself was concerned more with the dignity than with the meaning of art; and so was the young Haydon, self-appointed vindicator of English history painting, whose bias was anti-republican.[10] Two gentle followers of Barry, however, John Opie and Prince Hoare, did take up the campaign for public support of patriotic art in this decade. And since Blake in his bustling about London became acquainted with this movement, a reconstruction of its history will help us to understand what he was trying to do in his own zealous if impractical way in the summer of 1809 with his one-man exhibition and his manifestos.

The chief categories of English patriotic art were the heroic poetical and the heroic historical. The poetical had flourished in the peaceful eighties, and then the war had turned more attention

[7] Marg. to Reynolds, ii: E626/K446; *P.A.66.*

[8] Whitley, *Art,* p. 100; Barry to Fox, Oct. 5, 1800, *Works,* I, 286–287. Blake was out of town when London engravers, after a successful suit against underpayment, organized in 1801–1802 a Society of Engravers to enable "each individual to act with more firmness in opposing the pretensions of . . . booksellers and publishers." Raimbach, *Memoirs,* pp. 14, 37.

[9] Or were in the State of Satan. Marg. to Reynolds, i.

[10] Fuseli befriended Haydon (as did Hoare) but did not share his John Bull outlook. " 'Be Gode,' said Fuseli, to me one day, 'it's like de smoke of de Israelites making bricks [the smoke of London].' 'It is grander,' said I, 'for it is the smoke of a people who would have made the Egyptians make bricks for them.' 'Well done, John Bull,' replied Fuseli." *Autobiography of Benjamin Robert Haydon,* Oxford, 1927, p. 51. Compare Fuseli's comment in 1804 on the "improvements" in the city of Liverpool: "but methinks I every where smell the blood of slaves." Knowles, *Fuseli,* I, 377.

to the historical. But war sharply reduced the export market for prints and forced upon England the question of public subsidy. During Blake's lifetime the greatest stimulation of poetical painting had been the Shakespeare Gallery assembled in Pall Mall by the trading dealer John Boydell with the advice of Fuseli, Romney, Hayley, and Hoole. Between 1786 and 1802 Boydell had commissioned 162 paintings and a quantity of engraved plates valued at £300,000. But when Blake looked in on him in 1804, a shadow at 85 of "what he was," Boydell had been driven into bankruptcy by the war and was arranging a public lottery of his entire stock and gallery, which Parliament had declined to purchase.[11] Only less ambitious had been Thomas Macklin's Poets' Gallery in Fleet Street, for which one hundred paintings, and corresponding engravings, had been commissioned, and Robert Bowyer's "superbly embellished" folio series of Hume's *History of England,* destined to go on the rocks after its fifth number in 1806. Macklin had also commissioned sixty pictures for an illustrated Bible.[12]

It deeply hurt Blake's pride and pocket that even in their flourishing these great projects passed him by; it also spurred him to push past the dealers to the Public. Macklin was only once his employer, in 1783. Boydell hired Fuseli to paint a long series of Shakespeare illustrations but assigned only one plate to Blake, a Juliet after Opie, published in 1803.[13] In 1790 Joseph Johnson engaged Fuseli for thirty Milton paintings, some to be engraved by Blake and Sharp; but before the project was well under way

[11] To Hayley, May 4, 1804; D.N.B. s.v. Boydell.

[12] Whitley, pp. 9–11; D.N.B. s.v. Bowyer. Blake's own project of a series of historical engravings, advertised in 1793, was not continued, and no copy is extant of his "History of England, a small book of Engravings": E671/K208. In 1788–1790 Blake engraved one Hogarth plate for Boydell. Gilchrist (p. 115) speaks of Blake's illustrations of Young as "emulating Boydell's Shakespeare and Milton."

[13] Wright, II, 150. In 1804 Blake was helping distribute "the 22 numbers of Fuseli's Shakespeare that are out." To Hayley, Feb. 23. Boydell had begun publishing these numbers or parts in 1791. James Parker, Blake's former partner, did many of the engravings—Blake none. In 1805 Fuseli was having his drawings for Wieland's *Oberon* engraved by seven engravers— not including Blake. Some did well; some wretchedly, neither capturing the Fuseli marks nor giving any of their own, as Blake would. Two of the plates were done by Cromek—who engraved one tolerably, the other badly and hastily. (These were for the 1805 edition but "published" Mar. 1, 1806.)

Boydell, having plans for a Milton of his own, compelled Johnson to withdraw.[14] Fuseli then defied the monopolizers and undertook to paint a Milton Gallery of his own. After nine years' work this was opened in May 1799 at the old Academy gallery in Pall Mall, and in 1800 Boydell and a number of Academicians gave the Gallery their blessings at a public dinner honoring Fuseli. But the showing was not a financial success, the expected assistance was not forthcoming, and Blake could justly exclaim, "O King & Nobility of England! Where have you hid Fuseli's Milton[?]"[15]

[14] Boydell's Milton was published in 1794–1797, 3 vols., with a Life by Hayley and 28 paintings by Richard Westall prepared by 10 engravers. Johnson's Milton was to have been edited by Cowper, who in 1791 understood it was "to rival, and if possible to exceed in splendor Boydell's Shakespeare." Next February Hayley saw a newspaper paragraph on the rival projects, perhaps shown to him by Joel Barlow, who was his current house guest and was in contact with Johnson; whereupon Hayley introduced himself to Cowper, persuaded him that their respective labors need not clash, and worked happily with him side by side at intervals in the next few years.

Johnson did publish several Milton editions, one by H. J. Todd in 1801, Cowper's translation of the Latin and Italian poems in 1808, and in 1810 a four-volume edition of Cowper's Milton with a reprint of the Life by Hayley. But none of these modest projects involved Fuseli or Blake, though there is a notice in *The Artist* of Aug. 1, 1807, to the effect that one Haughton was undertaking to engrave "The *Milton Gallery*, with additional designs from Shakespear and Dante." Johnson's 1808 volume has three line drawings by Flaxman engraved by A. Raimbach. See Hayley's preface for Cowper's part in the project; also Knowles, 1, 171–173; Bishop, pp. 144, 162, 174, 182. See also Chas. Lamb to Coleridge, May 1796 (*Letters*, 1, 9): ". . . Cowper is recovered from his lunacy, and is employ'd on his translation of the Italian etc. poems of Milton, for an edition where Fuseli presides as designer."

Aware of all these Miltonic labors of Cowper, Fuseli, Hayley, and a shoal of engravers from 1790 on (Barry too had "in good forwardness" in Dec. 1794 a project "to dress Milton"; in 1799 a Todd edition of *Paradise Lost* was "beautifully printed, with plates by Richter"), Blake naturally chose to write, illustrate, and "print" his own *Milton;* nor is it improbable that an early draft of *M.*, comparable in symbolism to *F.R.* and *A.*, was begun in the 1790's.

[15] Marg. to Reynolds, i: E626/K446. Note, however, that Fuseli was never really "hid" in Blake's sense—as Blake realised: having written "Fuseli Indignant hid himself," he later inserted the word "almost" and, for his own part, revised "I was hid" to "I am hid" (E625/K445–446). "The general public did not like the Milton Gallery but many intellectuals admired it and the critics treated it respectfully. Some of the pictures

With Shakespeare and Milton spoken for (though for direct sale
Blake painted some ninety different Milton illustrations, many at
this period) Blake undertook to illustrate Chaucer and Spenser
by a single "cabinet picture" devoted to each—with the hope that
orders for something "ever so large" might follow. He began a
panorama "fresco" of *The Canterbury Pilgrims* as soon as his
drawings for *The Grave* were well under way.[16] What happened
next is not certain. Coincidence may have operated, but if we
accept Blake's word, Cromek saw his Pilgrims, saw the commercial
possibilities of a sort of omnibus print, and decided to take the
idea to a more docile artist and with sufficient promotional fan-
fare to make Stothard's *Canterbury Pilgrims* a gold mine. He had
already decided that Blake's *Grave* drawings would sell better if
etched by Schiavonetti. Even before Blake knew what was hap-
pening, he had premonitions: he *seemed* to have a publisher now
for his own engravings of his own designs—but it was too good
to be true: "I expect Nothing. I was alive & in health & with
the same Talents I now have all the time of Boydell's, Macklin's,
Bowyer's, & other Great Works. I was known by them & was

were bought by Fuseli's regular patrons, who also supported him financially
during the years he was painting them. The largest buyer, who was also
the largest contributor, was Coutts." Antal, p. 90. What failed was the
engraving project, and nearly half the 47 paintings are now lost. See
Gert Schiff, *Johann Heinrich Füsslis Milton-Galerie*, Zürich, 1963.

It is striking that Blake was *not* among those present (of Godwin's
acquaintance at least) on either the day of the gallery opening or that of
the testimonial dinner. Godwin's unpublished diary, May 20, 1799: "Milton
Gallery; adv. Lawrence, Opie, Barry, (Locke,) Chandler, B. Hollis, Batley,
Chalmers, Cartwright and W[hi]t[e]"; May 17, 1800: "dine at Milton
Gallery, w. Fuseli, Opie, Northcote, Smirke, Flaxman, Nollekens, West,
Lawrence, W. Turner, Bourgeois, Shee, Westal, Banks, Smith, Heath, Reyn-
olds eng[raver], Hoare, (Angerstein, Boydel, Gilpin, Beecher), Bannister,
Johnson, Morgan, Malkin, & Dr. Simmons."

For an excellent examination of the relations between Fuseli and Blake,
including the question of friction and tension between them in this period,
see E. C. Mason, *The Mind of Henry Fuseli*, London, 1951, pp. 41–57.
But for Fuseli's financial and social support by Thomas Coutts, England's
wealthiest banker—an important strand of Fuseli's life which Blake seems
scarcely to have been aware of—see Antal, chapters 4–5.

16 The date of *The Characters of Spenser's Faerie Queen*, sold to Lord
Egremont by Blake's widow, is not known. Damon's *Dictionary* puts it ca.
1815.

look'd upon by them as Incapable of Employment in those Works, it may turn out so again, notwithstanding appearances."[17]

Even while doubting, Blake's mind ran on to new and vaster projects in the memorial branch of history painting, projects that would require the support of the English Public, the "true Encouragers of real Art" (*P.A.*24). We have seen how Blake and George Cumberland exulted prematurely in 1800 at signs of royal and Royal Academy support for expanding the projected naval monument into a Gallery of National Honor. In 1802 to encourage original historical work by British artists, and to break the Academy's exhibiting monopoly, Opie and other Academicians with Whig connections supported a gallery in Berners Street under the patronage of the Prince of Wales. But this patronage proved only nominal ("Princes appear to me to be Fools," Blake would say later) and the "British School" collapsed just at the time Blake was to have two pictures exhibited there.[18] With more vigor in 1805 the nobility and gentry organized a Royal British Institution for Promoting the Fine Arts and donated £5300 for the lease and renovation of Boydell's Shakespeare Gallery "for the express purpose of encouraging the British school of Painting," the particular British genius being defined as that of Historical Painting.[19] As Blake said of the earlier "Encouragement" society, however, "The Rich Men of England form themselves into a Society, to Sell & Not to Buy Pictures. The Artist who does not throw his Contempt on such Trading Exhibitions, does not know either his own Interest or his Duty."[20]

John Opie's vaster plan, presented by the Academy to His Majesty in 1801 as a request for an "extendable" English Gallery of History to be progressively filled with works "representing the heroes and heroic exploits of this country, as they should present

[17] To Hayley, Dec. 11, 1805. Perhaps the first blow was Cromek's re-engraving of Blake's Malkin picture, published Feb. 1, 1806. The furious exchange of letters between Blake and Cromek occurred in May 1807. See Russell, p. 124; Wright, ii, ch. xii. For a neglected, but also very improbable, account of the Cromek-Stothard affair by the engraver John Sartain see his *Reminiscences of a Very Old Man,* New York, 1900, p. 112. Sartain has Henry Richter become Stothard's pupil about two decades later (1807) than he actually did.

[18] To Butts, Aug. 16, 1803. The gallery, opened in October 1802, was up for auction 18 months later. Whitley, *Art,* p. 45.

[19] *The Times,* June 8, 1805; Whitley, *Art,* p. 106.

[20] Marg. to Reynolds, 4.

themselves in actual succession," a scheme whereby the sons of Los might regularly follow the wars, still lay on the table, though in January 1805 the Academy's foreign secretary, an artist and playwright named Prince Hoare, proposed that it be published. The committee for erecting a Naval Pillar, dismissing the Flaxman-Blake obelisk as fantastic, remained silent.[21] Blake, incidentally, incorporated an obelisk into his drawing of *Death's Door* for the climactic illustration of *The Grave*.

Then came Nelson's "glorious death" in November, and people began writing angry letters to *The Times* about the money raised by the naval committee and calling "loudly for the immediate appropriation of this fund to its destined purpose."[22] Artists of all kinds heard the knock of opportunity. Flaxman persuaded Hayley to persuade Lady Hesketh to intercede with the King to ask him to do a statue. An Academy committee obtained the King's "command" to design a monument combining the arts of architecture, sculpture, and painting. On private commission from the Nelson family Catherine Andras modeled two wax figures in Nelson's own dress uniform, one for Westminster Abbey and one for the Pall Mall gallery. Benjamin West fulfilled his promise, made two years before to Nelson, "that he would paint a picture of his death scene that should be a companion work to the well-known *Death of Wolfe*." And in the spring West showed his *Death of Nelson*, not at the Academy but at his own home. Next year the exhibitions of both Academy and Institution included designs submitted for the commanded monument. But there had been little public response to the idea of a Naval Pillar or Gallery of History. In six years' time the rich men of the naval committee had not raised the price of a marble column. After Waterloo the talk would start again, but not until 1832 would a Reform Parliament appropriate funds for building a National Gallery, and not until 1867 would England have her completed Nelson Column.[23]

John Opie, in March 1807, interrupted the third of his Academy lectures as the new Professor of Painting to gird at "the apathy of the public" and deplore the plight of English artists who must

[21] Hoare, *Academic Annals*, London, 1805, p. iii; Sandby, *History of the Royal Academy*, I, 374.

[22] *The Times*, Nov. 19 and Dec. 19, 1805; Jan. 22, 1806.

[23] Bishop, p. 314; Whitley, *Art*, pp. 98–99, 104; Lord Edward Gleichen, *London's Open-Air Statuary*, London, 1928, p. 6.

subsist "on the mere scraps, offals, and *dog's meat* of patronage, afforded by hungry speculators."

"Our halls and public buildings, instead of having their walls made the records of the virtues and heroic actions of our ancestors, and the oracles of philosophy, patriotism, and humanity, still remain barren and desolate; and our churches [look] like prisons. . . .

"It has lately, to my great surprise, been discovered, that in no age or country have the arts been so splendidly and liberally encouraged as in England . . . that no artist has wanted employment, but through his own demerits, and that all complaints and remonstrances are libels on the nation. Hear this! injured, but immortal, shades of Hogarth! Wilson! Barry! . . . Hogarth, who was compelled to dispose of works . . . by raffle or auction . . . Barry, who, scorning to prostitute his talents to portraiture or paper staining, was necessitated, after . . . more than monastic privations, to accept of charitable contribution, and at last received his death-stroke at a six-penny ordinary!"[24]

This was strong meat for the "virtuous." Flaxman, for one, was shocked and protested that Opie's lecture "had a Democratic spirit in it"[25] The lament over Barry was virtually a direct slam at the Academy, from which Barry had been expelled in 1799 because of the abusiveness with which he had made this same sort of attack on the inadequate support of philosophic art, accusing the Academicians of illegally voting themselves pensions instead of buying paintings. Opie, a rural carpenter's son and "a sort of *painting Chatterton*," was one with Barry and Blake in stressing "noble and daring conceptions," vigorous imagination, and the "extensive powers" of art.[26]

[24] *Lectures,* pp. 91–98. March 2, 1807. Barry, shortly before his death, had promised to introduce a portrait of Nelson into his Art Society mural. *Transactions of the Society,* xxiii (1805), xviii.

[25] Farington, quoted in Todd, *Tracks,* p. 61.

[26] *Lectures,* p. 11. Opie read Voltaire and Paine; he and his wife, the novelist, were for many years intimate with Holcroft and the Godwins. See Earland, *John Opie and His Circle,* passim. His lectures are innocuous, but Blake would like his stressing the inferiority of "natural objects" to "examplars of the mind, which alone gives animation, energy, and beauty to art, and causes the loves and the graces to descend and take up their habitation in the hardest marble" and his remark that exertion can mature

If Blake's "Dear Sculptor of Eternity" could have seen his marginalia on Reynolds' *Discourses* (but by 1808 Flaxman was holding "no intercourse with Mr Blake")[27] he would have encountered even stronger democracy:

"Who will Dare to Say that Polite Art is Encouraged, or Either Wished or Tolerated in a Nation where The Society for the Encouragement of Art. Sufferd Barry to Give them, his Labour for Nothing, A Society Composed of the Flower of the English Nobility & Gentry—Suffering an Artist to Starve while he Supported Really what They under Pretence of Encouraging were Endeavouring to Depress.—Barry told me that while he Did that Work—he lived on Bread & Apples. . . .

"The Enquiry in England is not whether a Man has Talents. & Genius? But whether he is Passive & Polite & a Virtuous Ass. . . ."

In his fury against "Patronage" Blake promised to write "Barry a Poem."[28]

an artist to whom the "gates of learning" and of "flogging and whipping" have been shut. Compare "Thank God I never was sent to school To be Flogd into following the Style of a Fool" (*N.42*: E502/K550).

[27] Flaxman to Hayley, March 11, 1808, in Bentley, *Studies in Bibliography*, XII (1959), 187; for the cooling of relations see preceding pages. In 1810 Flaxman made a motion in the Academy "That no comments or criticisms on the opinions and production of living artists in this country should be introduced into any of the lectures delivered in the Royal Academy." The rule is still in force. Whitley, *Art*, p. 163.

To Bentley's one bit of evidence of later personal contact between Blake and the Flaxmans, a copy of *Songs of Innocence* inscribed "Mrs Flaxman April 1817," may be added a curious pair of entries in Crabb Robinson's diary that suggest that critical opinion somehow got from Flaxman to Blake at least as late as the latter part of 1814, after the publication of Wordsworth's *Excursion*. On Dec. 19, 1814, Flaxman heard Robinson read aloud some passages out of the *Excursion* and "took umbrage at some mystical expressions . . . in which Wordsworth talks of *seeing Jehovah unalarmed*. 'If my brother had written that,' said Flaxman, 'I should say, "Burn it." ' " Flaxman and Lamb and Robinson debated the passage. Eleven years later, Dec. 10, 1825, when Robinson first met Blake, the latter, evidently primed by the earlier debate, asked about Wordsworth's Christianity and "said he had been much pained by reading the Introduction to 'The Excursion.' It brought on a fit of illness. The passage was produced and read. . . . This 'pass them unalarmed' greatly offended Blake. . . . Wordsworth was finally set down as a Pagan; but still with high praise, as the greatest poet of the age."

[28] Marg. to Reynolds: E626, 632/K446, 453; *N.60*: E790/K553. Actually this note in Reynolds can have been inscribed by Blake any time after 1798.

Shortly after Opie's democratic lecture, his ideas found a champion in a slight periodical of essays, correspondence, and notes on the state of the arts, edited by Prince Hoare. *The Artist,* issued weekly in 1807 and again, less regularly, in 1809, attempts gently to restore the English public, victim of Connoisseurs and Dabblers, to its senses in favor of an English school in which historical painting will be encouraged and rewarded. The magazine concentrates desultorily on two themes, the neglect of imaginative artists and the question of how best to exploit the sentiment for a commemoration of Trafalgar.

Living English artists and poets starve in garrets, writes the aging playwright Richard Cumberland in the tenth *Artist,* while Parliament buys a gallery for the British Museum consisting not of living art but of "the bones and skeletons of the dead arts," the dirty daubings of imported *virtu,* and the scraps and leavings of "our conoscenti-monkies." Several numbers (e.g. the third and sixth) dwell upon the "cruel neglect" of Barry and others who chose sublime and terrible subjects "of the highest order." The death of Opie, who was exhausted by the arduous preparation of his lectures, is occasion for a full issue (the seventh) in which Hoare and others eulogize him as another painter who suffered, despite his fame, from "the want of established public direction of his art."

From the first number the proposed remedy, public patronage such as advocated by Barry and Wilkes, is linked persistently with the hope that governmental and popular subsidies will be forthcoming for Nelson memorials. The proposal that a foreign sculptor be commissioned for a monument is scouted as humiliation and further neglect of the patriotic artist whose work must be "interwoven with the grandeur and policy of the state" (number 3). The painter, however, is championed as even more neglected than the sculptor. Hoare advocates a public competition for "an Historical Picture of Lord Nelson," and a correspondent argues that the historical work of the painter is by comparison both more attractive to the public and more powerful as a patriotic influence, especially if "sanctioned by a vote of the Parliament or an order of the Government" (numbers 1 and 5).

At first glance we might suppose that Hoare's attitude toward war and its heroes was diametrically opposed to Blake's. Yet each in his own way viewed paintings as "examples of heroic worth" calculated to teach the hearts of a whole people "to glow & ex-

pand," to use Hoare's words.[29] The declaration on one of his title pages, that "ours are the plans of Peace, To live like Brothers, and conjunctive all, Embellish life," is a quotation from Thomson which epitomizes Blake's view and might even have been supplied by him.

Blake was not associated with *The Artist,* but he knew Hoare and was "delighted with the Man" and "with his work."[30] Hoare had been a friend of Godwin and Holcroft in the '90s; as "foreign secretary" of the Royal Academy he conceived it part of his duty to establish ties, corresponding club fashion, with other academies of art in the interest of international peace. In 1803 Blake engraved a frontispiece after Flaxman for Hoare's *Academic Correspondence,* a volume in which solidarity with Continental artists is promoted and Opie's plan is praised. In 1804 Blake called on Hoare, obtained a copy of this work for Hayley,[31] and was evidently drawn into earnest discussion of the parlous state of art and letters, for within two months he was thick with Hoare and the progressive publisher Richard Phillips who seemed "spiritually adjoined to us" (he was from Leicester and had been jailed in 1793 for selling Paine, a matter which Blake did not quite get straight) in a project to remedy the ills of Albion with a periodical of essays and reviews to be called *A Defence of Literature.*[32]

The plan was dropped when they failed to obtain the great name of Hayley for their masthead, but some idea of what Blake might have done in this line may be gained from his vigorous attack on

[29] *Academic Annals,* p. ii.

[30] Blake does not directly say that he is delighted but that "I assure myself you will be." To Hayley, Feb. 23, 1804.

[31] The title page cited above is that of the further *Academic Annals,* 1805. In 1806 Blake engraved a plate, after Reynolds(!), for Hoare's *Inquiry into the Arts of Design in England.* See Katherine A. McDowall, *"Theory, or The Graphic Muse* Engraved by Blake after Reynolds," *Burlington Magazine,* xi (1907), 113–115.

[32] Letters of Apr. 7, May 4, 1804, and Jan. 22, 1805. For Blake's associates in this venture see my "Blake's 'Nest of Villains,'" *Keats-Shelley Journal,* ii (1953), 61–71. A later witness to Phillips' cordial reception of forlorn republicans is Samuel Bamford, who in 1819, awaiting trial after the Peterloo Massacre, found in this prosperous bookseller "a real friend . . . the only professed scholar and literary character, to whose acquaintance [he could] refer with entire satisfaction"; a source of "much useful caution and advice," while urging him "to write something in the metrical way about the Manchester affair." *Passages in the Life of a Radical* [1844], London, 1967, pp. 231–232.

the critics of Fuseli, published as a letter to the editor in Phillips' *Monthly Magazine* in 1806 (E705/K863). There Blake is out to end the critical boycott of paintings which express the poetical sublime and the "gloom of a real terror," and to persuade Englishmen "that every man ought to be a judge of pictures" and not let himself be "connoisseured out of his senses." It is idle to speculate as to what Hoare's mildness and Blake's fire might have achieved in harness; but it may be observed that *The Artist,* launched singly by Hoare (with some help from Holcroft), fatally lacks the drive and vigor Blake could have supplied, while Blake's single-handed campaign in the summer of 1809 desperately lacks the tact and geniality of Hoare.

2

Now he comes to his trial.
　　　— A Descriptive Catalogue v

Though Blake's exhibition and *Descriptive Catalogue* are highly idiosyncratic, they are yet recognizable as natural offshoots of the movement we have been tracing. Blake now, like Barry, is a man who wants Parliament to vote that he "should decorate Westminster Hall with giants."[33]

Not only does the exhibition feature "grand Apotheoses of NELSON and PITT" and other "Poetical and Historical Inventions," but Blake emphasizes the suitability of his inventions for vast public works and repeats the thesis that the Artist, "like the Hero," must combine zeal for his own fame with zeal for that of his country.[34] "England expects," says Blake, using Nelson's words that were in all mouths, "that every man should do his duty, in Arts, as well as in Arms, or in the Senate" (*D.C.*xiv). Like Hoare he declares painting "more adapted to solemn ornament than Marble can be," and lacking Hoare's tact he goes on to complain that "the Painters of England are unemployd in Public Works, while the Sculptors have continual & superabundant employment." Blake wants what Opie and Hoare have talked about, "Monuments

[33] H. Walpole, cited above, p. 40.
[34] *D.C.* passim; *P.A.*58: E563/K594. Compare *Artist* no. 3: "The Painter, like the Hero, pants for fame, and . . . like the Hero, to impart it to his country."

to the dead Painted by Historical & Poetical Artists like Barry & Mortimer." He must "forbear to name living Artists," but he announces his own readiness to adorn "Westminster Hall, or the walls of any other great Building" with portable frescos "on a scale that is suitable to the grandeur of the nation who is the parent of his heroes"—the figures to be "one hundred feet in height." Blake is afraid that sublime monuments are not "now the fashion." But "if Art is the glory of a Nation, if Genius and Inspiration are the great Origin and Bond of Society," then "my Exhibition" is called for "as the greatest of Duties to my Country."[35]

An additional and perhaps precipitating motive for Blake's exhibition was the need to seek customers for his engraved Chaucer. Cromek had forced his hand by exhibiting Stothard's *Canterbury Pilgrims* in a perfume shop in the Strand in May 1807 and thus determining Blake to complete and exhibit his own "in self-defence," if need be in his brother's hosiery shop. By December 1808 he was deeply "involved" in preparations and had "begun to print" his Catalogue.[36] Broad Street was unfortunately not the Strand, and neither James nor William Blake was a man of such commercial enterprise as Cromek. William printed his prospectus in a neighbor's shop, and James printed the *Descriptive Catalogue* at a shop around the corner—both shops lacking facility for wide publication[37]—whereas Cromek had got John Hoppner, R.A., to take Stothard's picture to Carlton House for the Prince of Wales's approval (Princes were surely Fools) and to write a splendid puff for insertion (of all unfortunate ideas) in Hoare's *Artist* (June 6, 1807).

Doubtless neither Hoare nor Hoppner had yet heard of Blake's Pilgrims.[38] But in recoiling from the apparent perfidy of Stothard

<hr/>

[35] *P.A.*23: E570/K601; Advertisement, 2: E518/K560; *D.C.*ii: E522/K566.

[36] To Cumberland, Dec. 19. I take "an account of my various Inventions in Art" to be *A Descriptive Catalogue of . . . Inventions.* See Sloss and Wallis, II, 301.

[37] The prospectus was printed by Watts & Co., Southmolton St.; the catalogue by D. N. Shury, 7, Berwick-Street, Soho, for J. Blake. An advertisement was also printed by Watts & Bridgewater, Southmolton-Street: see Gilchrist, p. 406.

[38] Cromek was trying to interest Hoare and Hoppner in "Blake's Poems" (one wonders which ones) at about this time—either to advance Blake's reputation or, if we take Blake's dim view, to obscure his (Cromek's) own trail. See letter from Hoppner to Hoare, *TLS,* Oct. 7, 1926, p. 680.

and Cromek, Blake damned all his "dear Christian Friends" so violently that "all the Virtuous" from Cosway to Flaxman would not "associate with Blake" just when he most needed their support.[39] The Broad Street exhibition was thus an even more desperate gesture than it might have been. Its catalogue, instead of appearing in *The Artist,* girds at *The Artist'*s puff by "Mr. H[oppner]."[40] And in Blake's lexicon the genial Hoare becomes "trembling Hare" who "sits on his weakly paper On which he usd to dance & sport & caper."[41]

It is customary to dwell on the lack of worldly wisdom in Blake's selection of paintings to exhibit.[42] It would be more to the point to note how his desire to promote public works overrode his need to make private sales. Patriotic grandeur and terror dominate his list: *The Spiritual Form of Nelson guiding Leviathan* (Plate VIII); *The Spiritual Form of Pitt guiding Behemoth; The Canterbury Pilgrims, from Chaucer; The Bard, from Gray; The Ancient Britons; A Subject from Shakespeare; Satan calling up his Legions, from Milton;* and a few scriptural and miscellaneous titles. Even the most salable, the four Biblical paintings, are intended as

[39] N.37, 50: E496, 498/K545, 551. There is little reason to suppose that Blake flung his angry barbs "no further than his notebook" (Figgis, *The Paintings,* p. 56). We have Cromek's shocked response to barbs that he did fling, in a letter. And Blake's notebook epigrams imply that he "cast out devils" audibly enough to impel Cosway, Hayley, Flaxman, and others to spit, fear him, and cut him. At some climax of exasperation Blake seems to have put these people out of his garden as emphatically as he did Schofield.

[40] The directness of Blake's replies may indicate that he began drafting the *D.C.* at once. Possible evidence of an immediate rift between Blake and Hoare is the fact that the August first *Artist* (no. 21) in a long list of current "Public Undertakings in the Arts of Design" contains the bare item "Designs for Blair's Poem of The Grave" with no mention of Blake although adjacent items name both designers and engravers, e.g. "Mr. West's Picture of the Death of Lord Nelson, by *Heath*" and "Mr. Stothard's Picture of the Procession of Chaucer's Pilgrims, by Bromley." A starred item informs us that the Committee of Taste has approved Flaxman's design for a Nelson monument "to be placed in St. Paul's."

[41] N.22: E495/K537. Compare Mercutio's "old hare hoar." In the context "Hare" is being compared to "Hunt," both editors of weeklies that have injured Blake. Phillips, Hoare's publisher and also culpable for admitting some very faint praise of Blake into his January 1807 *Monthly Magazine,* likewise comes in for abuse. N.34: E497/K544.

[42] See Figgis, p. 74. Gilchrist first sounded this note.

samples of what might be done "on an enlarged scale to ornament the altars of churches" and make England respected "on account of Art" (*D.C.*xiv).

In the *Catalogue* Blake hints that his heroic portraits contain "mythological and recondite meaning, where more is meant than meets the eye," and in additional unpublished notes justifying his course to someone who has objected to his attempt to "rouze the Public Indignation" against worship of "the Contemptible Idiots who have been calld Great Men of late Years" he makes his purpose very plain. "I wonder who can say Speak no Ill of the Dead when it is asserted in the Bible that the name of the Wicked shall Rot." Blake, not waiting for it to rot, intends to turn the name of the wicked "into an Ornament & an Example" which people and princes may variously interpret—"an Example to be Avoided by Some and Imitated by Others if they Please."[43] The handsome golden Nelson, "guiding Leviathan, in whose wreathings are infolded the Nations of the Earth," will be recognized for a villain—by those receptive to Blake's hatred of the "detestable Gods" of war. Pitt, floating like an innocent child in nightgown and broad-brimmed halo, above a battle in which Behemoth tramples the multitudes, is described as "that Angel who, pleased to perform the Almighty's orders, rides on the whirlwind, directing the storms of war." Some will recognize Satan in the God who directs nations to slay each other, and some may even detect a recondite echo of Addison's *Campaign*. But in many respects the irony, the political satire, is as inscrutable as that in Blake's early drama.

The general intent of the contrast between the angelic heroes and their bestial mounts has doubtless been discerned by many in later times. Some who have seen the Pitt (now badly blackened) profess to find Tom Paine in a crescent moon reaching out to rescue the nations struggling in Behemoth's jaws.[44] Edgar Wind sees in the Nelson "a powerful indictment against all attempts to honour a hero by dramatizing his earthly adventures,"[45] and Mark Schorer has penetrated its equivocal symbolism:

[43] *D.C.*ii; *P.A.*17. One might compare the defense of "symbolical or allusive painting" in *Artist,* II, no. 14, 1809.

[44] D. Conway, *Writings of Paine,* New York, 1892, III, viii. Wright, I, 47, is confused.

[45] See above, p. 37, n. 26.

"Here . . . the leviathan is not only the symbol of the sea, with which Nelson would quite properly be coupled, but also of the tyrannical state. Again, the central figure is heroic, and of a golden tint, but the coils of the monster, the 'heroic villain's' instrument, are wrapped about struggling, shrieking, and exhausted men [and women], and the hero himself stands on a pediment composed of a coil of the beast and the collapsed body of a Negro. This, after the hero's own figure, is the most prominent object in the picture, and both in position and in color is in sharpest contrast to the hero."[46]

"A History Painter Paints The Hero . . . most minutely in Particular," says Blake in defiance of Reynolds,[47] and the particulars of this painting are worth even further study. The contrast is between heroism at the top and slavery at the base of British naval power; but in 1807 the slave trade had been legally abolished, and Blake does not represent the Negro as still in the monster's coils nor as directly under the feet of Nelson but as resting in the surf of the shore (of freedom) though his hands remain manacled (to the continuing institution of slavery).[48] The enfolded nation at the top of the picture is probably France, shorn of sea-power at Trafalgar, for she is clutching the ragged ends of her hair, the rest of which Nelson holds as a trophy.[49]

But the conflict of nations and even the warfare of tyrant and slaves can be "one dull round" unless the Poetic Genius fights on the side of the oppressed. Nelson's spiritual antagonist—who has never been pointed out but is definitely in the picture, in the very jaws of the monster—is Christ, crowned with lilies but also wielding a militant sword. Nearly devoured by imperial war, Christ is still fighting War's false gods. Yet only a bit of his sword's hilt is showing, as only a bit of Blake's meaning. Only a very close observer will notice that the lines of radiance that appear to emanate from Nelson are really thunderbolts converging upon the heroic Antichrist. In Blake's preliminary drawing his purpose is less disguised: a great bolt of lightning is piercing Nelson's right

[46] Schorer, p. 174.
[47] Marg. to Reynolds, 106.
[48] Compare Orc in the broken wall in the frontispiece of *A*.
[49] She reappears, still clutching her hair, in *J*.63. See below, Fig. 16.

shoulder, his head is jerked sharply to the left, and another bolt of lightning flashes from the direction of the sword of Christ.[50]

As we grow familiar with contemporary caricatures we recognize that Blake's Christ and Nelson are respectively performing the roles of the aroused father Zeus-Phoebus and errant son Phaeton, an aspect of the son's error being the assumption that his apotheosis is at hand. Blake's autobiographical and prophetic adaptation of the Phaeton myth in *Milton* is less precisely relevant than the numerous current political applications by Gillray and others. Richard Newton's *Sola Virtus Invicta . . . To the Whig Club,* of Feb. 26, 1798 (B.M. 9177), shows Charles Fox on Phaeton's chariot, with halo/sun, and with lightning striking him from offstage. Gillray's *Destruction of the French Collossus,* Nov. 1, 1798 (B.M. 9260), lets the bolts pierce Phaeton's neck as they pierce Nelson's in the Blake drawing. A crude, unsigned *Fall of Phaeton* of November 17 (B.M. 9266) has thunderbolts shooting directly from the Phoebus face of George the Third. Here Phaeton is Charles Fox again, not in a chariot but mounted on the griffin Ambition. More immediately, to leap a decade, the function of Nelson's halo/sun as a helmet warding off the celestial artillery can have been suggested by that of Pitt's halo in Gillray's *Phaeton Alarm'd!* of March 22, 1808 (Draper Hill, pl. 106). In size it is a sun about as large as the halo of Blake's *Pitt,* and against the projectile showers of a multiple zodiac of opponents in the sky it is as effective as Nelson's; yet no defense seems possible from the flames of burning

[50] Plate 36 in Keynes, *Pencil Drawings by Blake.* Anthony Blunt (pp. 102–103) sees the thunderbolts, but patriotism compels him to see them as Jovian attributes in the hand of Nelson (where they are not) and to refuse to "believe that the lines of radiance round the central figure are really thunderbolts directed at him" (though no other thunderbolts are in the picture). Blunt chooses not to consult the pencil drawing. He also finds it "inconceivable that Blake should represent Christ in this degrading pose," forgetting what Blake says about the way "the Modern Church crucifies Christ" ("with the head downwards" *V.L.J.*). (Prefatorily Blunt declines "becoming involved in the details" of Blake's "mystical symbolism.") He rightly rejects my description of Christ's crown as of thorns; longer acquaintance with Blake's details has convinced me they are lilies. For Christ with similar profile and beard, see *The Angel Rolling Away the Stone from the Sepulchre* (1808: *Blake's Illustrations to the Bible,* no. 147; see also 134), and Christ crowned with a thorn branch in p. 34 of *Night Thoughts.*

nations ascending from below. Perhaps the hellfire beneath Nelson arises from burning ships.

For the other strand of available tradition, that of the hero-villain's ascent-descent to heaven-hell, Gillray's *Apotheosis of Hoche* of January 11, 1798 (Draper Hill, pl. 78) is sufficiently apposite. Approaching nudity, on a rainbow above burning town and smoking battlefield, the Republican general is the glorious center of a Judgment Day chorus of witnesses. His halo is edged by bands of radiation that can have suggested the placing of bolt-heads around Nelson's; they fail to protect his pretty head from a lowering noose.[51]

Proof, if needed, that Blake had not grown mellow since Trafalgar in his attitude toward the British navy's enfolding of other nations may be found in his copying into his notebook some newspaper *Lines Written on hearing the Surrender of Copenhagen*, signed "Birmingham J.," expressing outrage at Britain's pre-emptive strike against the nation of Denmark struggling to be neutral in 1807. Albion, once the champion of Liberty, has become a Tyrant hurling "The flame shaft of war oer a desolate world," and the bard of Birmingham is filled with Shame to see England driving the "Seraph of Peace" from her Northern refuge. In three September

[51] The probable relation of Blake's *Nelson* to the work of an obscure London caricaturist may be noted. In *The Three Steps to the New Imperial Diadem*, an anonymous print published in June 1804 by W. Holland, 11 Cockspur Street, Napoleon is portrayed and exposed in a way that is diagrammatically similar to Blake's mock apotheosis of Nelson. (There was, by the way, more than one satiric "Apotheosis of Napoleon"— e.g. on a gibbet, in B.M. 10058.) If France's hero is a villain, so, Blake implies, is England's. In each picture the hero is elevated at the expense of other humans (representing nations in Blake, representing the hero's means, "Hypocracy, Rapine, Murder," in the Holland print), but lightning is about to strike each hero, and hellfire awaits him below. Opposite Napoleon is the Devil; opposite Nelson is Christ.

The probability that Blake knew this print and took a clue from it is enhanced by the further probability that the caricaturist knew the work of Blake. For in a print of September 1803 published by Holland, the same artist uses the motif of the 11th emblem of *The Gates of Paradise*, "Aged Ignorance" clipping the wings of an ambitious young man, to compose a picture of *John Bull clipping the Corsican's Wings*.

These two prints, in the Harvard College Library, are not in *B.M. Satires*, but similar work issued by Holland is there tentatively ascribed to one Temple West. See vol. viii, p. xxxxix and index.

days, much of Copenhagen was burned down, over two thousand Danes were killed, and ships and naval stores were seized. Blake inscribed the poem beside an emblematic drawing (perhaps now retouched) of a lurking assassin, with background details suggesting a city in flames. He must have shared the unknown poet's indignation at the prospect of laurels and acclaim for the commanding generals and admiral.[52]

Blake's "grand Apotheoses," then, of Britain's aggressive heroes constitute an "Exposure" of Satan considerably more direct and intentional than Fuseli's Milton illustrations. The names of the wicked are named, though their wickedness is made ornamental. That the Sea Captain or "soldier by sea" such as Nelson is a negation that "only exists in certain periods," as distinguished from the Knight or "true Hero" who "stands as the guardian of man against the oppressor," we learn from Blake's comment on the third picture of the exhibition, his *Canterbury Pilgrims*. Even in 1809 Blake is not an unqualified pacifist, for he still approves of the warlike man who fights in defense of the people. But he implies that since Chaucer's England was able to live happily without naval aggression, Blake's England should be able to do so too. Chaucer's Shipman is a peaceful sailor, "a Trading Master of a Vessel, called by courtesy Captain" but not engaged in strangling other nations (*D.C.*iii). Blake's fourth picture, *The Bard*, exhibited for the second time, is pointed out as a graphic demonstration of the power of art to overturn armies.

Blake in the Advertisement of his Exhibition appeals to the Public as well as to "the Rich and those who have the direction of public Works," but he is willing to settle for "fit audience . . . tho' few."[53] If any of the Rich attended, they did not leave their

[52] The poet was James Bisset (ca. 1762–1832), a radical bookseller and artist who ran a "museum" and curiosity shop in Birmingham, occasionally contributing political anapests to London journals or magazines over variants of the signature here. From the nature of the inscription I deduce that Blake did not know the author and was copying a printed source.

For the identification of Bisset and for a corrected transcription of these *Lines* (given incorrectly in my first edition, where I read "fate bearing" as "pale burning" and "vulture &" as "ravening," etc.) see *BNYPL*, LXXII (1968), 518–521; and, for the historical details assembled by Burton Pollin, 507–517, with a correction by Geoffrey Carnall concerning Southey, LXXIII (1969), 10, answered by Pollin, 215–217.

[53] E518/K560.

impressions on record. But some of the few who came were not unfit. Charles Lamb was impressed by *The Bard* and *The Ancient Britons*, liked Blake's *Canterbury Pilgrims* "far above Stothard's," and kept the *Catalogue* for its "most spirited criticism on Chaucer."[54] But Lamb was not writing art reviews. Crabb Robinson, who was— for a German periodical—recognized in Blake a sincere combination of religion and love of art, although he did not dare describe the spiritual forms of Nelson and Pitt—possibly from uncertainty whether these angels were black, white, or gray. And Robinson's review contains a sour note: that the materiality of Blake's spirits is "offensive."[55]

Similar criticism of his Blair illustrations—that there is "an appearance of libidinousness" in the "indecent" embraces of soul and body—had been made by Robert Hunt in the *Examiner* of August 7, 1808, and now less than a fortnight before Blake's announced date of closing, "The Examiner whose very name is Hunt" pounced on the exhibition as that of "an unfortunate lunatic, whose personal inoffensiveness secures him from confinement," and laughed at the *Catalogue* as "a farrago of nonsense . . . and egregious vanity." Hunt brushed aside the allegory as "unintelligible" and at the same time jumped to the conclusion that Blake was whitewashing the war policy associated with Pitt and Nelson. He pronounced that Blake's reputation was a civic malady so "pernicious" that it had become "a duty to endeavour to arrest its progress."[56] On the face of it, to paint halos on Pitt and Nelson in the autumn of 1809 was to praise a policy that was wasting the flower of British manhood in the malarial swamps of Holland and the bleeding hills of Spain. It was to glorify a government whose organized graft in the sale of army commissions was currently being exposed in Parliament by Colonel Wardle and the Foxite Whigs whom the *Examiner* supported. Hunt could not know that Blake was secretly delighted to see them give the rascals "a dose of Cawdle" (*N.*40). Unaware of the recondite republicanism of the painter, Hunt readily agreed with the hanging committees of the Academy and Institution who, as Blake defiantly

[54] In Mona Wilson, *Blake,* p. 221.

[55] Article in the *Vaterländisches Museum,* Hamburg, 1810, translated by K. M. Esdaile, *The Library,* v (1914), 229–256.

[56] *Examiner,* Sept. 17, 1809; Wilson, pp. 224, 376.

reported in his prospectus, had said that his works were "but an unscientific and irregular Eccentricity, a Madman's Scrawls."[57]

Thus the *Examiner* ruled: "If beside the stupid and mad-brained political project of their rulers, the sane part of the people of England required fresh proof of the alarming increase of the effects of insanity, they will be too well convinced from its having lately spread into the hitherto sober region of Art." And thus the liberal weekly that was to champion Romantic poets began by stoning their spiritual forerunner, and Blake's exhibition took place in a social exile more complete than that of Byron or Shelley in Italy in the following decade.

3

Blake had re-entered London well aware that the competition among "Engravers, Painters, Statuaries, Printers, Poets" made it "a City of Assassinations" despite the streets' being "widened

[57] Advertisement, E518/K560. Critics have looked for these words in some printed review, but Blake is appealing to the Subscribers to the British Institution over the heads of their agents who have told them "that my Works are . . . a Madman's Scrawls."

Blake's insinuation that his works are excluded because they are in water color is a red herring. Neither the Academy nor the Institution excluded water colors in 1809; nor is it true that Blake's designs "in Water-colours (that is in Fresco)" had been "regularly refused to be exhibited by the *Royal Academy.*" The Academy had exhibited three of Blake's works in the previous year (1808)—one in conventional water color and two in what Blake chose to call Fresco (Gilchrist, p. 383). But these had represented orthodox scriptural subjects, not naked Britons or Nelsons. The large *Ancient Britons* (10×14 ft.) with life-size "naked forms . . . almost crimson" must have nonplussed the hanging committee. Five years earlier they had rejected James Ward's lurid *Serpent of Ceylon,* depicting a boa constrictor strangling a Negro. Now along came Blake with a naked Nelson guiding another such boa! Ward, like Blake, had withdrawn all his pictures and exhibited them privately. Whitley, *Art,* p. 71.

What gave Blake's charge some plausibility was the fact that many water-colorists now preferred to exhibit in their own galleries because of the crowding of pictures in the Academy. Blake sent his *Pitt, Nelson,* and *Canterbury Pilgrims* to the fifth and last exhibition of the Associated Artists in Water Colours in 1812, when its president was Henry Richter, brother of the London Corresponding Society man. Wright, II, 47.

where they were narrow."[58] His first response to the *Examiner*'s attack was to gird for battle, and he began crowding the pages of his notebook with rejoinders to the editorial "Nest of Villains," interspersed with satiric rimes on the level of scurrilous caricature prints. Constructively his notes indicate a plan to repeat and augment his exhibition, those headed "For the Year 1810 Additions to Blakes Catalogue of Pictures &c" showing that he intended to add to his paintings a triumphant *Vision of the Last Judgment*— "Necessary because Fools flourish."[59] Another set of notes, now editorially grouped as *Public Address,* were to be "Published" as "Anecdotes of Artists" and "Advertizements to Blakes Canterbury Pilgrims" (*N*.56) to sell prints of a large engraving of the cabinet picture, to be finished by September 1810.

We are indebted to the Anecdotes for much of our knowledge of Blake's relations with other painters and engravers, though under the circumstances he dwells unfortunately on the unpleasant side of these relations. And Blake did complete his Chaucer engraving in the promised time. But he did not try another exhibition. When a year and more had passed he endeavored to substitute Quiddian "Mirth at the Errors of a Foe" for the "Anger & Wrath" that still rent his bosom. Could he really be "angry with Macklin or Boydel or Bowyer Because they did not say O what a Beau ye are," he asked himself,

> Or angry with Flaxman or Cromek or Stothard
> Or poor Schiavonetti whom they to death botherd

He could be: he was. There was more than Quiddian bitterness in the "Mirth" with which Blake enjoyed the upset of Cromek's schemes by the death in June 1810 of Schiavonetti, the second engraver he had turned to. And it was a grim stock-taking that he recorded, after Cromek's death in March 1812, in the couplets beginning "And his legs carried it like a long fork."[60]

[58] To Hayley, May 24, 1804, and Oct. 26, 1803.

[59] *V.L.J.*70, 84: E544, 551/K604, 612. There would be a triumphant progression even in size. The most elaborate of the Blair drawings was a *Last Judgment;* then an enlarged painting was made for the Countess of Egremont, by January 1808; and in the spring Blake exhibited this or another at the Academy. He did later paint a large "fresco," now lost. See Gilchrist, pp. 229–233, 383. (The title of the "Countess" was one of courtesy.)

[60] *N*.24, 22: E494–496/K536–537.

Screwmuch (Cromek) and Assassinetti (Schiavonetti) and Jack Hemp (Flaxman) and Felpham Billy (William Hayley) and Stewhard the Friend of All (Stothard) had tried to clap Blake into their jaw; they had plotted his death three ways, through assault at Felpham by Billy's Dragoon, through Cromek's effort to starve him, and through the calumnies printed "in a Sunday paper cald the Examiner Publishd in Beaufort Buildings" (*P.A.*52). They failed to recognize, however, that "Death was in the Pot," Blake having been the original designer of *The Grave*. When "Screwmuch at Blakes soul took a long leap," he found "Twas not a Mouse twas Death in a disguise." So Death smote Billy's lawyer ("Sweet Rose" who never recovered his health after the trial) and the Dragoon (did Blake keep track of Schofield and learn of his death?) and then Assassinetti and finally Screwmuch himself. Stewhard's golden eggs were addled. As for the *Examiner* and the *Artist,*

> The Examiner whose very name is Hunt
> Calld Death a Madman trembling for the affront
> Like trembling Hare [who] sits on his weakly paper
> On which he usd to dance & sport & caper (*N.*22)

We know why Hoare trembled. The good reason for Hunt's trembling is indicated in more solemn imagery in *Jerusalem*.

There the villain's name is Hand, for reasons we shall consider in a moment. Up for trial "on the Anvils of bitter Death" (a continuation of the Death-in-the-pot sarcasm), Hand attempts a protest but trembles at sight of the poet's "Mace Whirld round from heaven to earth." "Hand sits before his furnace" (epic idiom for "sits at his writing desk" or "sits on his weakly paper") until "scorn of others & furious pride! Freeze round him to bars of steel & to iron rocks beneath His feet." Two of the three Hunt brothers were compelled to edit their paper from behind bars in 1813 and 1814—not for affronting Blake but for "scorn" of the Prince Regent. Their record as opponents of the war party might have earned them recognition among the Friends of Albion; yet because they had joined the forces of death in attacking the artist of peace, they received bardic justice (*J.*7:71–8:16).

Nevertheless Blake knew that the trembling of Hare and Hand was a projection or correspondence of his own tremor. As long as he could pour his aqua fortis on the names of the wicked, he had

little temptation to swallow it. By a combination of facing his own torment and transferring it to others he managed to keep his hand steady enough to continue his great works. But his spiritual self-portrait in adjacent lines reveals what "anguish of regeneration!" and "terrors of self annihilation" he underwent (*J.7:61*) before attaining the tranquillity that made his associates think of him in his late years as "the most practically sane, steady, frugal and industrious of men."[61]

Trembling I sit day and night, my friends are astonish'd at
 me.
Yet they forgive my wanderings, I rest not from my great
 task!
To open the Eternal Worlds . . .
O Saviour pour upon me thy Spirit of meekness & love . . .
Guide thou my hand which trembles exceedingly upon the
 rock of ages,
While I write of . . . Hand & Hyle & Coban . . .
Of the terrible sons & daughters of Albion and their Gen-
 erations. (*J.5*)

After the failure of his effort to "speak out boldly" in catalogue and exhibition, Blake somewhat recognized that his own work was destined rather for the record (to keep "the Divine Vision in time of trouble" *J.95*) than for a contemporary audience. Yet he continued in his lonely writing to declare that their mutual isolation would be fatal to himself and to Albion. The *Examiner* article that nailed shut the door of his exhibition was not simply an act of injustice to William Blake. It was an *example* of the intellectual tyranny that kept Albion chained to the wheels of war and jealousy, specifically an example of the tyranny of the press.

Consequently in *Jerusalem* the old debate as to whether to publish is pushed into the background by charges that the press has been perverted to serve death and that it has destroyed men's receptivity to the publication of "leaves of the Tree of Life" (*J.*41[46]). And of all the evil Sons of Albion who foster in the popular mind the illusion of the necessity of death, Blake gives greatest attention to the one who represents the Cerberus of the press, the triple editorial person of the *Examiner* collectively called

[61] Samuel Palmer, quoted in Wilson, p. 238.

Hand because of the accusing "indicator" or printer's fist of Leigh Hunt's editorial signature: ☞ and perhaps in the first instance because of the *Examiner's* 1808 pronouncement that the "bad drawings" of Blake were given an exterior charm by "the unrivalled graver of Schiavonetti" and his "tasteful hand."

This connection between the three editors Hunt and the chief villain of the first chapter of *Jerusalem,* with his

> . . . Three strong sinewy Necks & Three awful & terrible
> Heads
> Three Brains in contradictory council brooding incessantly
>
> (*J.* 70)

has been recognized for some time, but the implications have been neglected. The difficulty lies partly in the nature of the connection. Most of the time Blake's treatment of "Hand & Hyle & Koban: Skofeld, Kox," and the rest of the evil sons is so impersonal as to justify Frye's conclusion that "Blake shows no rancor and makes no personal allusions: he simply needed such names in his symbolism."[62] At other times, however, the link of the symbol to Blake's personal experience makes it evident that he needed for his symbolism not just any names but these names—of the particular detractors, accusers, and judges before whom he had been made to stand trial in the courts of law and reputation. Singling out individuals who had accused him and isolated him from the public, Blake held

[62] Frye, p. 377; Wright, II, 42–43. Koban (or Coban) has often been taken as Bacon, but Bacon appears in his own name in the trio "Bacon & Newton & Locke" on a different symbolic level from such contemporary rogues as Schofield, Hyle (Hayley), Hand (Hunt), and Koban. Coban suggests Caliban as in the notebook line "Prospero had One Caliban & I have Two"—the two being Flaxman and Stothard whom Blake found blind and taught how to see but who resist his magic; they are "Old Acquaintance" who now "renew" their selfish arts (*N.*24). Like "the Cromek A thing thats tied around the Examiners neck" (*N.*65) Koban may be thought of as "Flaxman or Cromek or Stothard" (*N.*23) or all three, but his function in *J.* is not clearly differentiated. John Adlard suggests, for Coban, the bookseller Henry Colburn who from 1808 paid Hayley an annuity for publication rights to his memoirs. No direct link with Blake is known, but, as Adlard points out, this would make of "Hand & Hyle & Koban" a trio of Editor, Poet, Publisher.

For the symbolic elaboration, see E. J. Rose, "Blake's Hand: Symbol and Design in *Jerusalem,*" *Texas Studies,* VI (1964), 47–58.

them up as types of the institutional "hirelings" who were confusing and isolating the people from a humane vision of the future.

Thus the charge that Blake's accusers are led by the Editors of Beaufort Buildings is transposed to: "Hand has absorbd all his Brethren in his might" (*J.*8). And Hunt's stinging word "pernicious" is flung back with: "Anytus Melitus & Lycon thought Socrates a very Pernicious Man: So Caiaphas thought Jesus."[63] (See Fig. 15.) In other words the "Editors of Newspapers" are now chiefly responsible for discrediting the prophet and for hardening the exterior of Albion's mind. "For Lo! Hand has peopled Babel & Nineveh" (*J.*7), has spread confusion and delusions of Empire.

Fig. 15 (*J.*93)

But Blake has in mind the press that supports war, and hardly the actual *Examiner,* when he describes Hand as "Building Castles . . . and strong Fortifications," forging "bars of condens'd thoughts . . . Into the sword of war: into the bow and arrow: Into the thundering cannon and into the murdering gun" (*J.*18 and 9). Only in this sense is "The Wheel of Hand, incessant turning" the emblem of an "Insane" Jerusalem, "hoarse, inarticulate" (*J.*60). And it is Hand, but hardly Hunt, who leads all the rest in taking

[63] *J.*93. Observe the direct link to *P.A.*86, where Blake warns "his Friends Anytus Melitus & Lycon . . . that they are not now in Ancient Greece" and that he can appeal to the English Public against the poison which "these Bad Men both Print & Publish [i.e. in the *Examiner*]."

The editorial trio suggests earlier trinities, e.g. that of king and henchmen originally entitled *Our End is Come* (1793). Formerly I supposed it was about 1808 that Blake retitled that engraving *The Accusers . . . Satans' Holy Trinity;* from the style of lettering I now have suggested ca. 1803 (see above).

care that Albion as common soldier, home "from the bloody field," is placed on a golden stretcher with "his back to the Divine Vision" lest he abandon the religion of war.[64] In this symbolic expansion of his own experience, Blake understands the attack on his own inventions and their "Naked Beauty displayed" as part and parcel of the total Urizenic effort to hide the human form in armor of "steel" and "helmet of gold" and surround "the beauty of Eternity" with "a Body of Death" (*J*.9).

Ultimately Blake knew only one remedy against the accusers—to publish the spiritual message of Jesus:

> Even from the depths of Hell his voice I hear,
> Within the unfathomd caverns of my Ear.
> Therefore I print; nor vain my types shall be:
> Heaven, Earth & Hell, henceforth shall live in harmony
>
> (*J*.3)

It is in the preface to *Jerusalem* that Blake announces "To the Public" this resolve to continue publication of the Bible of Hell. His theme was calling him "in sleep night after night" and getting him up "at sun-rise" every morning (*J*.4). And while he labored at the drudgery of engraving—for after all, the Virtuous had not really connived to starve him, and Flaxman for one continued to turn some business his way from time to time—his Saviour dictated ever more persuasive variations on the Everlasting Gospel.[65]

Yet even this preface was mutilated by the author's own hand, in misgiving that it would find no reader who would "love me for this energetic exertion of my talent." It was unnerving for Blake to think of himself as a writer or printer: work once set in "types" would be at the mercy of the Wheels of Hand. One must still conceal the naked theme of Liberty in "beautiful labyrinths": Oothoon must be hidden "in merciful deceit Lest Hand the terrible destroy" her (*J*.83). It was more satisfactory to think of oneself as laboring at the forge, a concept which emphasizes the poet's strength, and to think of one's work as building the golden temples of the City of Art, a concept which suggests the work's intrinsic sufficiency.

[64] *J*.46[32]:12–13; 29[33]:1—the connection of these phrases being disrupted in the variant sequence of plates.

[65] So I read the passage (*J*.55) in which "many" converse while they labor "at the furrow."

26. War on the Rhine & Danube

The Rhine was red with human blood:
The Danube rolld a purple tide:
On the Euphrates Satan stood:
And over Asia stretch'd his pride.

—*Jerusalem* 27

AFTER 1809 personal and political history contained few surprises for Blake, except for the pleasant advent after 1818 of an Indian summer of friendship and quiet recognition. *Jerusalem,* written between 1804 and 1820, is not disturbed by the demons of change that made such a shambles of *The Four Zoas;* at least the text as we have it does not indicate that Waterloo and the postwar policy of "denying the Resurrection" of France upset the poet's calculations or seemed any great change from the war policy of crucifying France. There is not so much orderliness in this "harsh" poem[1] as the division into four equal chapters might lead us to expect, but there is greater thematic unity than in the earlier epics. And the theme is still war and peace, though Los and Blake instead of closely following the war "walk up and down in Six Thousand Years" of history choosing illustrative events and geographic correspondences. From these the prophet strives to "Create a System" (*J.*10) to draw mankind out of the systems which accommodate greed and war.

The contemporary frame of reference is the latter part of the war, the years of Napoleon's decline and fall and of the triumph of British and German arms, when the problem is not simply to dissuade Albion from fighting but to oppose his making a conqueror's peace. Hence the motif of *Jerusalem* is *peace without vengeance,* and Waterloo appears not as a time of last judgment but as one more bonfire of Druid slaughter lighting up the solitary figure of the poet meditating on man's "criminal" inhumanity and

[1] "*The Four Zoas* . . . has much more of the rococo spirit, and much loveliness. *Jerusalem* is harsh [from] a grim resolve to portray experience as it is. . . ." Frye, p. 358.

division.[2] In 1801 peace seemed to promise life, because the rulers were withdrawing from war. In 1814 and 1815 when the armies of Albion were trying a brother Nation "in his own city Paris,"[3] they were demonstrating that a certain kind of peace can strangle nations as cruelly as war.[4]

In cultural terms, Albion waging war on "Humanity" in these vengeful years was living in the stone age. Having abandoned the ancient peaceful Atlantic commonwealth, he had shrunk down to the sea-girt "cliffy shores" of Britain to assert exclusive ownership of "My mountains" and "my Laws" (*J*.4), and the natural "Vegetation & Corruption" of such existence was a "Polypus of Roots of Reasoning Doubt Despair & Death, Going forth & returning from Albions Rocks" in Selfhood and Empire, keeping the stony altar bloody and the people petrified: "Devouring Jerusalem from every Nation of the Earth" (*J*.90, 69).

"Jerusalem is named Liberty among the Sons of Albion" (*J*.26), and the tale is that once the tents of Liberty "reachd from sea to sea," from London to Jerusalem, across Italy, France, Spain, Germany, Poland, Turkey, Grecia, Egypt, Lybia, Ethiopia, and America (*J*.79). Then Freedom shrank, and imperial Selfhood expanded, sending military roads radiating from London (and Rome) which are visible today as scars on the body of Albion. The Druid serpent, first insinuating its cruelty through England, quickened into an octopus "Shooting out Fibres round the Earth, thro Gaul & Italy and Greece . . . to India, China & Japan."[5] The modern

[2] *J*.44[30]–46[32]. Compare Byron in the third canto of *Childe Harold*.

[3] *J*.63:5–6. Albion (England) brings Luvah (France) "To Justice in his own City of Paris, denying the Resurrection," i.e. the Revolution. The preceding action is that "Luvah slew Tharmas the Angel of the Tongue"; the phrase "denying the Resurrection" applies as well to Luvah's negating action as to Albion's—and of course to their visions of futurity.

[4] Luvah in the text is, as a fallen Zoa, masculine; in the illustration (Fig. 16) we see his feminine counterpart. Compare the entwined figure of the nation France (as I guess) in *The Spiritual Form of Nelson*, top left (Plate VIII). Here again she is clutching her hair, and shorn locks appear at her side signifying lost strength and freedom. This time the shearing of France is done on land, and Leviathan has become a worm. In the Ellis and Yeats *Works of Blake*, 3 vols., London, 1893, the symbolism is lost, for the lithograph of *J*.63 has been retouched to give the shorn woman a luxurious head of hair. The colored copy of *J*. (formerly Stirling, now Mellon) shows that the hank of hair seen behind the left side of the waist is no longer attached to the head, from which a few loose strands dangle.

[5] *J*.67. At the foot of the page is a youth stretched in chains of torture.

parallel of this diaspora is the spread of armies "across the Rhine, along the Danube," from Albion to Tartary carrying the Ark of Druid sacrifice and weaving with their spears the "Polypus of Death."[6]

Yet if the "ravening eating Cancer" or Polypus of war has destroyed "the most Ancient" world-encircling web of Liberty, by the progression of contraries it too can be supplanted by a new web woven of the "Fibres of love from man to man."[7] And since London is at the center of all the concentric webs of life and death, Blake at his furnaces in South Molton Street beside old Tyburn Road is in a position to watch and even to forge a transformation in the whole system and counter-system. In his vision the relic of the central milestone of Roman Britain, called "London Stone," was originally the central altar of Druid sacrifice, which

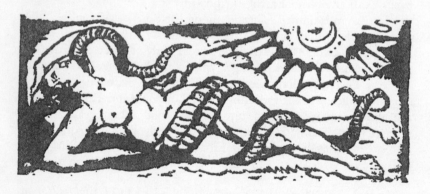

Fig. 16. France shorn again (*J*.63)

in turn was a relic of the ruins of Atlantean Jerusalem. In Blake's time it is represented by "the Stone where Soldiers are shot,"[8] in the northeast corner of Hyde Park beside the gallows known as

[6] *J*.63:40; 49:25; 67:33.

[7] *J*.69:2; 4:8. In *J*.15 the "Fibres" are of the lumber that forms the British fleet of oak, now carrying death and Empire but properly engaged in peaceful international exchanges. The axe, though formed by blacksmith Los on "his Anvil Of death," is "an Ax of gold"; the fact that his "Four Sons" collaborate in "cutting the Fibres from Albions hills" is auspicious, even though, as long as Albion sleeps "divided from the Nations," their purpose, "That Albions Sons may roll *apart over* the Nations," seems imperial and further divisive.

[8] These words appear on John Roque's map of London, 1745.

"Tyburn Tree."[9] London Stone is thus a "mighty Ruin" of old Jerusalem, of Druid Britain, of Rome, and of modern British freedom.[10]

The "mighty Ruin Where Satan the first victory won" is thus the very place

> Where Albion slept beneath the Fatal Tree
> And the Druids golden Knife
> Rioted in human gore,
> In Offerings of Human Life. (*J*.27)

To correspond to the serpent in the Garden of Eden the topography of Hyde Park supplies the Serpentine River, which Blake in his deviousness never refers to by its own name but calls "Tyburns Brook" or "The Brook of Londons River." The forbidden Tree is of course Tyburn's Fatal Tree, a Druid oak and a gallows. As the center of the Polypus of Death it has multiplying suckers like the poison upas. The naval leviathan is a limb of it, as are the serpents of divisive Good and Evil, "Riches & Poverty a Tree of Misery" (see the Laocoön engraving).

The modern equivalent of the man slain in Druid sacrifice is the hapless soldier who is mustered before his sovereign in Hyde Park (as in the review before the royal family in 1803 when, according to the newspapers, "the sons of Albion resolved to continue free, or gloriously to fall with the liberty and independence of their country")[11] and who is allowed, in effect, the choice of being shot at the stone or of taking the spectral form of Schofield to carry "all the pomp of War!" (*J*.27) to other nations and to make them "the Victims." The latter course contributes to the fall of Jerusalem

[9] Daniel Lysons, *The Environs of London*, 1795, III, 278.

[10] The relic called "London Stone" was preserved at St. Swithin's Church, but since the Tyburn stone was also on Roman Watling Street, Blake can hardly be said to have exceeded his prophetic license. Cf. the "Stone of Night" in *Europe*, which Frye, p. 224, identifies with the stone on which Jacob's ladder rested, "a stone still used, according to the legend, to crown the kings of England": the Stone of Scone.

Patrick J. Callahan notes that in William Stukeley's *Itinerarium Curiosum* (London, 1776, I, facing p. 119) the London milestone, "London-stone, the *lapis milliaris* from which distances are reckoned," is a small pyramid. Perhaps the pyramid in *A*.6 and *M.H.H*.21 marks the point of a new beginning for Albion. Actually "London Stone" was not Roman at all; see Walter George Bell, *Unknown London*, London, 1966, pp. 82–88.

[11] Oct. 26, 1803, quoted in John Ashton, *Hyde Park*, London, 1896, p. 152. Cf. *M*.4 and 11, discussed above, pp. 396–397.

"from Lambeth's Vale . . . Thro Malden & acros the Sea," and to the spread of the Satanic armies to the Roman and Napoleonic battle zones and beyond, to Asiatic reaches of the British Empire, withering up "sweet Zions Hill, From every Nation of the Earth."

Politically "our brother Albion is sick to death" because he has fallen to the level of Despair and is convinced, as his war with France demonstrates, that it is necessary and inevitable to kill *and* be killed. "He hath leagued himself with robbers!" presumably the fox and wolf of Austria, Prussia, Russia; "he hath studied the arts Of unbelief!"; and his Friends, the English Jacobins, "are his abhorrence!" (*J*.36[40]). Emblematic of his despair are his "black shoes of death" and "deaths iron gloves" (*J*.35[39]) and the report that in "the hot day of Victory" the warrior sings not of peace ("O Skofield why art thou cruel?") but of rushing "again to War," though momentarily sickened by the bloodshed (*J*.68).

The extent of the bloodshed "from Albion across Great Tartary" suggests the extension of the war in 1812 into Russia; on another page the Battle of the Nations of October 1813 seems to be alluded to;[12] and the Battle of Waterloo supplies the background for a London soliloquy on page 45[31]. Albion's twice bringing Luvah "to Justice in his own City of Paris" (*J*.63–66) probably refers to the two occupations and the two Treaties of Paris in 1814 and 1815, with Napoleon's meteoric Hundred Days in between. "For Luvah is France: the Victim," to be slain by the knife of a Druid priestess. The furious battle of page 66 and the Victory song of page 68 may then be symbolically related to Waterloo—though for detail the poet goes back some fourteen hundred years to the "last Battle of Arthur," which has the advantage of making the very "streams of Albion" run with blood.[13]

[12] *J*.68:52 *J*.38[43] refers to a battle in which "Scofeld & Kox," English soldiers, "are let loose upon my Saxons!" Everyone knew that there were Saxon regiments fighting with Napoleon at Leipzig, because they dramatically changed sides during the battle. In the context Blake is noting the extent to which the "English are scatterd over the face of the Nations" and lamenting that English man has become "the Enemy of [English] Man."

[13] See *D.C.*v.—*J*.65 and 66 seem revised or interpolated (Sloss and Wallis, 1, 566 n) possibly to meet the occasion of the Hundred Days. The first part of this interpolation contains material brought into *J*. from *F.Z.*, and the matter transferred comes from the passage on the 1799 Netherlands campaign, a proper parallel to the Belgium campaign of 1815. In each case a vote of Parliament was followed by an embarkation and war on land east of England. "They vote the death of Luvah" (65:8).

The effect of these allusions, scattered without regard for chronology, is on the one hand to extend the war over time and space and erase any sense of finality from the concept of a Victory—and on the other hand to focus attention on Albion's desire to crucify Luvah as the central issue. The trial and nailing of Luvah to Albion's Tree constitute Albion's "denying the Resurrection" (*J*.63). In a narrow sense this may signify the termination of Napoleon's Hundred Days.[14] More inclusively it means that Albion and his league of robbers deny the legitimacy of revolutionary governments, in France and elsewhere, and have set about restoring "the Lewis's & Fredericks: who alone are [war's] causes & its actors" (*J*.52). The Holy Alliance will not end but perpetuate war.

The persecution of France is of course as deadly to Albion as to his Victim, and it brutalizes Albion's fair Daughters, who lay aside their needlework to "sit naked upon the Stone of Trial" (*J*.66) and who vegetate into one "hungry Stomach & a devouring Tongue," a monstrous degeneration of the shadowy female who symbolized in *America* the relationship of nature to man before the revolution. Now "Her Hand is a Court of Justice, her Feet: *two* Armies in Battle" (my emphasis) and "in her Loins Earthquake, And Fire, & the Ruin of Cities & Nations & Families & Tongues" (*J*.64). As the knife of flint passes over France the Victim, "London feels his brain cut round: Edinburghs heart is circumscribed!" (*J*.66). Outwardly the situation could hardly be worse.

2

What were the war's roots? Where were "the tempters" who hid in the soul of Albion, persuading him to take vengeance on his friends and labor incessantly for his oppressors? Poverty, Blake realized, had done much to drive young men to war. Some were lured by harlots into taverns that turned out to be recruiting offices: "the Opressors of Albion in every City & Village . . . buy his Daughters that they may have power to sell his Sons."[15] Many were warriors only under compulsion:

[14] The 1815 Parliament voted to renew war not against France but against Napoleon personally, by a ballot in which the Opposition scored 72 votes.

[15] *J*.44[30]. Or perhaps the oppressors buy the daughters as industrial slaves to finance the war to which the sons are sold. But see Fig. 17.

We were carried away in thousands from London; & in tens
Of thousands from Westminster & Marybone in ships closd
 up:
Chaind hand & foot, compelld to fight under the iron whips
Of our captains; fearing our officers more than the enemy.[16]

But compulsion had had its effect, and these "Spectre Sons" had be-
come cruel through their function and from "imbibing the Emana-
tions" of the enemy, Napoleonic France. In the day of victory they
stood "Mocking and deriding at the writhings of their Victim."
The Sons of Albion had become Roman legionaries.

Frequently in *Jerusalem* we hear echoes of Gibbon's account of
the *Decline and Fall* of the archetypal Empire: the border wars on
the Rhine and the Danube; the theme of imperial excess leading
to imperial decline; here, applied to press-gang methods in Mary-
bone, the "inflexible maxim of Roman discipline, that a good
soldier should dread his officers far more than the enemy." Earlier,
Satan standing on the Euphrates and stretching his pride over
Asia (*J*.27) recalls Trajan (in Gibbon's first chapter) viciously
thirsting for military glory, carrying war beyond the sensible borders
of the Danube and, in "dangerous emulation" of Alexander, be-
yond the Euphrates—"against the nations of the east."[17]

But how had the citizens at home been tempted to betray the
Divine Humanity, even while "the praise of Jehovah" was chaunted
from their lips? Was it simply that these were "lips of hunger and
thirst"? When Blake looked into the dark shops and den-like
hovels in the shadow of London's spires and towers, into the "caves
of solitude & dark despair" "among Albions rocks & precipices!"
he saw that individuals, "every Minute Particular of Albion," were
"degraded & murderd" as by cruel pyramid-builders who might
"take up The articulations of a mans soul, and laughing throw it
down Into the frame, then knock it out upon the plank"—in the
way that brickmakers in the London kilns threw clay into a mould
and then knocked the moulded brick out onto a board to be

[16] *J*.65. From top to bottom of this page falls a heavy chain.

[17] All these matters are in Gibbon's first chapter, "The Extent and Mili-
tary force of the Empire," and it may be noted that first-chapter borrowings
are of the most likely sort. I cite above, however, a possible borrowing
from chapter 69; and G. E. Bentley, Jr., has traced the "Females of
Amalek" of *J*.67–68 and *F.Z.*106 to chapter 51.

baked.[18] He saw souls "bakd In bricks to build the pyramids," but he "saw not by whom." He searched in vain because he was "closd from the minutia: he walkd, difficult."

In his walk (*J*.45[31]) he conducted a Diogenes-like search with "globe of fire" through the "darkness & horrid solitude" of teeming London—a search which is the central *action* of the whole poem and is shown beginning in the frontispiece. He traveled with the sun clockwise through the eastern, southern, and western districts, and then "sat on London Stone" to meditate. At the meridian of his journey he questioned the "stones and rocks" of the new Bethlehem Hospital, "Dens of despair in the house of bread," which had been "builded" but not yet occupied: in Bedlam there might have been minds free of vengeance, "mad as a refuge."[19] But ominously "human form was none." Where he did find humans, in the crowded alleys of the poor—the location, be it noted, of "the winding places of deep contemplation intricate" of Albion's brain—he saw "every minute particular, the jewels of Albion, running down The kennels of the streets & lanes as if they were abhorrd."[20]

The Blakean reversal here is typical: oppressors talked of casting pearls before the swinish multitude; Blake "saw" that the people were the pearls and that they had been "hardend" by the contempt of those who treated them like swine and who cast forth "all the tendernesses of the soul . . . as filth & mire." Here was the core of his answer.

He could not help "looking on Albions City with many tears,"

[18] *J*.44–45[30–31]. See Margoliouth, *Blake,* p. 157. Cf. Fuseli's observation to Haydon, quoted above. It is odd even for demons to make bricks out of *articulations* rather than, say, the *stuff* of a man's soul. But Blake is probably recalling the *Anti-Jacobin's* cruel criticism of Fuseli that his "figures are meagre and poor; and the articulations of the joints so hardly marked as to appear without flesh on them." Edward Dayes, in the 1806 *Anti-Jacobin,* p. 83, reviewing Chalmers' 1805 *Shakespeare,* for which Blake had engraved two of Fuseli's illustrations.

[19] *J*.45; Marg. to Spurzheim: E652/K772. For Blake's suspicion that "the madmen outside have shut up the sane people," see Gilchrist, p. 323. The allusion to the new Bedlam gives us a date in the summer of Waterloo; but the new hospital was near, not in, Lambeth. For fuller explanation of this whole passage, see my "Lambeth and Bethlehem in Blake's *Jerusalem,*" *Modern Philology,* XLVIII (1951), 184–192.

[20] The poet was in Narrow Street, "the narrows of the Rivers side," near "where the Tower of London frownd dreadful over Jerusalem."

for the Continental war was reaching a climax and the danger was imminent that Albion would impose a conqueror's peace on Luvah and thus perpetuate the cycle of "deadly war (the fever of the human soul)" (*J*.34[38]). "O Albion, if thou takest vengeance . . . Thou art for ever lost!" (*J*.45). Los "trembled sitting on the Stone Of London" because he could hear Jerusalem lamenting Albion's unfitness to be her bridegroom and see Vala spitefully pointing to Waterloo ("the strife of Albion & Luvah . . . great in the east") as a "glorious combat" that would effectively purge man of all illusions about freedom.[21] The worst aspect of the matter was that even when the warrior did return "trembling from the bloody field" he was always kept ignorant of his true friends: "the interiors of Albions fibres & nerves were hidden From Los" and therefore from himself. Despite the bard's "shouting loud for aid Divine," there sprang from Albion's bosom a dozen spectral fiends:

> Hand, Hyle, Koban,
> Gwantok, Peachy, Brertun, Slaid, Huttn, Skofeld, Kock,
> Kotope
> Bowen: Albions Sons: they bore [for Albion] a golden couch
> into the porch
> And on the Couch reposed his limbs, (*J*.45[32])

to keep him petrified "lest any should enter his bosom & embrace His hidden heart" (*J*.34[38]).

What can Los do about these villains who have worked up Albion to such "petrific hardness" of bosom? "What shall I do!

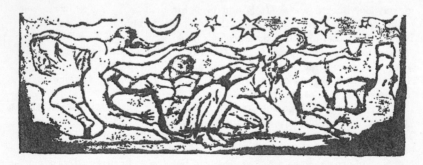

Fig. 17. (*J*.69) "But what may Woman be?" (56:3)

[21] *J*.46[32]; 45[31].

what could I do, if I could find these Criminals[?]" (*J*.45[31]). Pitt's successor Perceval was assassinated in 1812 by a man called mad; the thought of laying a hand on Satan might flit through anyone's mind. Yet "If I should dare to lay my finger on a grain of sand," the effect would be only to "punish the already punishd" and multiply revenge. So the central question in the central soliloquy of *Jerusalem* is: "What can I do to hinder the Sons of Albion from taking vengeance? or [for the question is wrongly worded] how shall I them perswade?"[22] And how cope with the Daughters, who "have had Punishment enough to make them commit Crimes," who have seized "the Druid Knife of Revenge," and whose hearts are "drunk with blood"?[23]

The creative prophet may not simply hack down the fibrous "self-devouring" Polypus, for even vegetation is better than dead stone (*M*.34). He must water instead the Tree of Life, which can penetrate the "stone walls of separation" with a "mingling of soft fibres Of tender affection" (*J*.90).

[22] The difference of wording contains "the whole difference," as Schorer observes, p. 373.
[23] *J*.69, 63, 68. See Fig. 17.

27. The Intellectual War

What are those golden Builders doing
Near mournful ever-weeping Paddington
Standing above that mighty Ruin[?]
—*Jerusalem* 27

IN POLITICAL TERMS Blake took hope as always from the thought that at the limits of empire, contraries begin. Liberty, when "witherd up" from every nation, is reborn "in a dark Land," as when the Jews began to resist Pharaoh, or the Christ child was hidden from Herod, or in modern times the Africans began their revolt against the "dark Machines" of the British Leviathan. In economic terms Blake desiderated a commerce that was not fiendish but a mutual exchange of love and labor, "Both heart in heart & hand in hand" (*J*.27). But of course Blake was never in doubt about the goal: Jerusalem must be built. He affirmed again and again his determination not to let his sword sleep in his hand. Indeed the declaration of faith in a counter-polypus, an iterated declaration that the poet and his inspiration are furiously weaving the fibers of affection from man to man to counteract the destructive work of "the Mills of Satan & Beelzeboul,"[1] runs through the whole poem and has been omitted from each paragraph of the last chapter only in the interest of brevity. But was anyone else building Jerusalem? In architectual terms the problem was to make Gothic or "Living Form" prevail over Druidic monuments of death. But where did Blake, living in the shadow of Tyburn, "that mighty Ruin" of so many systems, see any "golden Builders"?

To see anything golden he must first alter "his Spectre & every Ratio of his Reason." For the Satanic specter follows God's blueprint perversely and "reads the Voids Between the Stars" (thou readst black where I read white) to erect opaque "pillars in the

[1] See *F.Z.*viii.113:1–21 for details of the industrial competition between Los and Enitharmon and the firm of "Satan Og & Sihon."

deepest Hell To reach the heavenly arches," while Los must read "the Stars of Albion" to restore the translucent golden arches of the Eternal City. He does not directly in Samson's fashion attack the "pillars" of "the War by Sea enormous & the War By Land astounding," named "Leviathan and Behemoth" as emblematized in the paintings of Nelson and Pitt. But by revolutionizing his perception he can make the specter's pillars appear but "dust on the flys wing: & his starry Heavens; a moth of gold & silver mocking his anxious grasp" (*J*.91). Only by thinking of the stars as dead and fixed could Satan build to reach them.

True vision does not fondly construct a fictitious City but works through the sensually perceived "minutia" of the city of experience. Blake's objection to "Bacon & Newton & Locke" was that they imagined a universe which they could not *see*. Blake builds *Jerusalem* on historical minutiae that come into his ken as an inhabitant of the northwest regions of London in the second decade of the nineteenth century. For us to examine these particulars may be to take a spectral interest in the dust on the fly's wing, but without such contrariness there can be no progression into Blake's meaning.

In Edenic times, and in Blake's childhood when he lived in Broad Street, Golden Square, most of the area north of Tyburn Road or Oxford Street was meadowland open to the sun and dotted with pleasant inns; it was a paradise "from Islington to . . . Saint Johns Wood" builded over with Jerusalem's "pillars of gold" and overrun with "Her Little-ones" and boys and cows. Most of the places enumerated tenderly in Blake's four opening stanzas (*J*.27) may be found in Rocque's London survey of 1745. The Green Man was on the New Road from Paddington to Islington; a little further, down Love Lane, was Jew's Harp House. Pancras could be reached by wandering past Paradise Row and through the pastures called Lambs Conduit Fields, east of the Green Man. The outer "pillars"—Islington, Kentish-town, Primrose Hill, and St. John's Wood—were all within a two and a half mile radius of Golden Square.

When Blake moved to South Molton Street on old Tyburn, he was just keeping up with the receding "meadows green." Cary's *New Plan of London* shows that by 1811 residences had been built another half mile into the northern fields. The tile kiln directly above Tyburn, on Rocque's map, had been overtaken by its own

labors. But the Jew's Harp and other inns were still in open coun-
try. The ponds by Willan's farm would survive for Dickens' Sam
Weller to explore. And there is the pleasant, immediately con-
temporary note that on a May day in 1812 Crabb Robinson read
Blake's Songs aloud to Wordsworth while walking through the
fields north of Oxford Road.[2]

Blake's song is not to be mistaken for a lament over the depart-
ing countryside, for much of the new home-building was under-
taken during a boom of construction at the time of the Peace of
Amiens, and it represented the arts of peace overshadowing the
gallows of war. Blake's next question, about "those golden Build-
ers . . . Near mournful ever-weeping Paddington," is a question
full of hope prompted by the further expansion of home building in
1811. In that year on the Paddington side of old Watling Street
some excavation for new houses was made just north of the ancient
gallows, and the workers dug up a cartload of Tyburn bones and
parts of apparel.[3] It was recalled that after the Restoration the
bodies of Cromwell, Ireton, and Bradshaw had been disinterred,
hanged and beheaded, and then reburied here—another denial of
the Resurrection. Presumably Paddington had been weeping this
posthumous torture of the Friends of Albion ever since, so that
Tyburn also symbolized the ruin of the Commonwealth. As a village
of poverty-stricken Irish laborers, Paddington was sufficiently
mournful in any case.[4]

A more elaborate version of Blake's question (*J*.12) makes it
quite clear that he is delighted at evidence that fabrics of peace
are replacing gibbet and halter, that the builders are transforming
the place of "Calvary and Golgotha" into "a building of pity and

[2] For contemporary water-color drawings of Willan's farm, with cows,
and also of the Green-Man Pye-House and the Jew's Harp Tea Garden in
Marylebone Fields, with boys watching ducks in an adjacent pond, see
Miner, *BNYPL*, LXII (1958), 535 ff.

[3] John Timbs, *Curiosities of London*, 1867, p. 809. The site of Tyburn
Tree "was frequently changed, so that both Marylebone and Paddington
can claim the dreadful association." Sir Walter Besant, *London North of the
Thames*, London, 1911, p. 344.

[4] In 1812 Paddington "had an evil reputation." Its "extensive waste
. . . was occupied with the most wretched huts, filled with squatters of the
lowest of the community." Charles Knight, in George, *London Life in
the 18th Century*, p. 115.

compassion." The work is golden because it establishes human habitations even on the "most ancient promontory" of sacrifice. Blake dwells on homely details: the "mortar & cement," the nails, "screws & iron braces"; the furniture and curtains, from the "pitying looms" of Lambeth. But his illustration suggests that the building is global, and "Lo! The stones are pity, and the bricks, well wrought affections: Enameld with love & kindness."

2

They wept into the deeps a little space at length was heard
The voice of Bath, faint as the voice of the Dead in the
 House of Death —*Jerusalem* 39[44]

The larger architectural problem for Britain as a whole was to restore the great cathedrals now given to Trojan or Druid worship. York, for example, and St. Albans (Verulam) had been successively Druid, Roman, and Christian. In anticipation of their reconversion from State Religion to true Christianity, Blake introduces twenty-four of them as "Friends of Albion," and another four, "Verulam, London, York, Edinburgh, mourning one towards another," as including all the rest (*J*.36–41[40–46]).

Signs of any actual work on this great project of restoration are meager. Blake points to his own work in Lambeth, where he has hidden "Oothoons palace" in a grain of sand in the very shadow of the palace of the Archbishop. And he cites the self-sacrifice of "Selsey, true friend!" who gave his life for Chichester—in the eleventh century.[5] In more modern times London, speaking as a City and a "father of multitudes," is still an "immortal Guardian" willing to give himself for Albion, as London and Bristol gave themselves for the nations in 1780; and his very "Houses are

[5] Selsey, the ancient seat of the bishopric, was eroded by the ocean and "submitted to be devourd by the waves of Despair" while its emanation "was nam'd Chichester" (*J*.36[40]). See Sloss and Wallis, I, 517 n. Damon, in his *Dictionary,* unhappily misreads the Chichester-Selsey passage. See my criticism of this and other *Dictionary* identifications of the "Cathedral Cities" in *Journal of English and Germanic Philology,* LXV (1966), 606–612.

Thoughts." Edinburgh, too, keeps alive in prophetic memory (through "the Gate of Los") the first victims of Antijacobin "Justice," the leaders of the British Convention of Reformers who were tried in Scottish courts in 1793 and 1794:

> Edinburgh, cloth'd
> With fortitude as with a garment of immortal texture
> Woven in looms of Eden, in spiritual deaths of mighty men
> Who give themselves, in Golgotha, Victims to Justice. . . .

But even these particulars have become past history.[6] The most recent architect of peace is introduced as "benevolent Bath," "Bath, healing City! whose wisdom, in midst of Poetic Fervor: mild spoke thro' the Western Porch, in soft gentle tears" (*J*.36[40], 40[45]).

Bath is a cathedral town only by virtue of its place in the title of the Bishop of Bath and Wells. But Bath did have a "voice," however "faint," the voice of a poet and preacher who did "engage himself openly & publicly before all the World in some Mental pursuit for the Building up of Jerusalem," as Blake was urging "every Christian" to do (*J*.77). His name was Richard Warner, he was the minister of St. James's parish, a "rigorous whig," and "the best known man of letters in Bath."[7] His enemies charged that he preached "foul DEMOCRACY,"[8] and as for Blake's statement that Bath "first assimilated with Luvah in Albions mountains," which I take to mean that he was one of the first British intellectuals to preach peace with France in the present period, Warner in 1804 startled Bath and London with the publication of a sermon, preached on the day of National Fast in support of the renewed war, declaring *War Inconsistent with Christianity* and urging Englishmen to refuse to bear arms even in case of an invasion by

[6] *J*.34[38]. At the third of these notorious trials Judge Braxfield rebuked Gerrald, one of the "victims," who had said that all great men had been reformers, "even our Saviour himself," with: "Muckle he made o' that: he was hanget." Sentenced to transportation, Gerrald did not survive the first year of Botany Bay; Muir and Palmer died returning home; for two of the victims see *A Narrative of the Sufferings of T. F. Palmer and W. Skirving*, London, 1797; in 1844 Edinburgh erected an "immortal" obelisk, "The Martyrs' Monument."

[7] D.N.B. This identification of Bath is discussed in my essay on "The Historical Approach."

[8] Warner, *Bath Characters*, 2nd edn., London, 1808.

Napoleon.[9] (Warner too, as a boy, had known the joys of Willan's farm.)[10]

"Stripped of its Oriental dress," says Warner in this sermon, "the declaration of CHRIST may fairly be taken as a direct and unequivocal reprehension of hostile violence, both in individuals and states." "However brilliant the successes are with which their arms shall be crowned; whatever acquisitions of territory conquest may unite to their ancient empire, . . . WAR is the GREATEST CURSE with which a nation can be afflicted, and . . . all its imaginary present advantages, or future contingent benefits, are but as 'dust in the balance,' and as 'chaff before the wind'" (pages 26–27). Blake quotes "Bath" at some length in an appeal to Albion which amounts to an anti-war sermon ("leaves from the Tree of Life") urging mercy and inveighing against imperial self-hood or British national pride in almost Warner's terms: "however high Our palaces and cities, and however fruitful are our fields In Selfhood, we are nothing" (J.40[45]).

Again in 1808 Warner published in Bath and London *A Letter to the People of England; on Petitioning the Throne for the Restoration of Peace,* in which the author's alarm that the national spirit "is graduating into a spirit of lawless ambition, and aggressive violence" parallels Bath's concern lest Albion should "slay

[9] Title suggested by Robert Hall's *Christianity Consistent with a Love of Freedom,* London, 1791. Warner quotes from Hall's *Reflections on War.* Blake's interest in Warner suggests that a study of other published sermons, especially those in the Price-Priestley-Hall tradition, might be fruitful. Other anti-war sermons by Warner, all published in Bath, include: *Practical Discourses,* 2 vols., 1804; *National Blessings Reasons for Religious Gratitude,* 1806, with a severe character of Pitt; *The Overflowings of Ungodliness: a Sermon on the Times,* 1806; *The Wisdom from Above,* 1808. There are numerous expanded editions of *War Inconsistent.*

[10] From Warner's *Literary Recollections,* London, 1830, I, 20, we learn that from his 5th to 13th years (during Blake's 11th to 19th) Warner lived in the very region of Blake's boyhood Eden—i.e. on the edge of "Wellan's farm" in the meadows of Marylebone, "where the kite had wont to fly, the cowslip to be gathered, and . . . the bowl of milk to be quaffed, pure, warm, and foaming from the udder." Warner had two sisters. He was, by 1793, a Fellow of the Society of Antiquaries and a friend of Thomas Astle of Battersea Rise (I, 283) (see above).

Evidence of Warner's "Poetic Fervor" includes his *Bath Characters* and *Rebellion in Bath, an Heroico-Odico-Tragico-Comico Poem* [*with*] *a vindication of the Glorious Revolution in 1688,* London, 1808.

Jerusalem in his fearful jealousy." And the warning, "Be *expeditious* . . . lest the concluding scene of the war be performed upon your own shores; lest [Britain's] peaceful plains exhibit those horrors which the nations of the continent have so long and so largely experienced," suggests the tenor of Bath's urgency: "his [Albion's] death is coming apace! . . . for alas we none can know How soon his lot [the lot of Jesus or of Luvah-France] may be our own."[11]

Bath, singled out thus particularly in *Jerusalem* as the one contemporary Friend of Albion engaged "openly and publicly" in the mental building of the new City, yet receives oddly qualified or ambivalent praise from Blake. Before Bath's speech, the poet indicates, the situation had become desperate. The "Friends of Albion" had watched the sickening effect on the people of the "horrible falsehoods" and "sown errors" of war propaganda (*J*.36[40]). They had seen Albion turn against them and egg on the dragoons of "Hand & Hyle" to "sieze the abhorred friend" (Jesus or Los) to "Bring him to justice before heaven here upon London stone."[12] Against such misdirected effort the people's friends had raged in private ("in the forests of affliction") "like wild beasts," but publicly they had curbed "their Spectres as with iron curbs." Publicly they had managed but a "low, scarcely articulate" inquiry "after Jerusalem" (*J*.42). The account would seem to be satiric or at least critical, and the friends are represented as having called on God yet declined to take action, on the grounds that to act was to enter into corruption. They had reasoned, in a circle similar to Theotormon's, that "If we are wrathful Albion

[11] *J*.40[45]. Bath alludes to the abolition of the Slave Trade, 1807[45], as does Warner in a note.

[12] *J*.42. Here "London stone" signifies the whole ground of London—"Between Blackheath & Hounslow, between Norwood & Finchley." Blake may have known of some of the attacks on Warner, such as that in the *Gentleman's Magazine*, 1804, p. 1135, quoting a pamphlet by Thomas Falconer dedicated to the "commanders of the Bath Volunteers and Members of that Patriotic Association." It may be the coexistence in Bath of such opposite spirits as the war-loving associators and the peace-loving preacher that Blake alludes to in speaking of "Bath who is Legions" as "the physician and The poisoner: the best and worst in Heaven and Hell" (*J*.37[41]). And he seems to have had a suspicion that Schofield was from Bath. See *J*.17. A reference may also be intended to David Hartley, the famous "physician and philosopher of Bath." For other reviews of Warner see Emanuel Green, *Bibliotheca Somersetensis*, Bath, 1902.

will destroy Jerusalem with rooty Groves If we are merciful, our-
selves must suffer destruction on his Oaks!" (*J.*38[43])—at which
point Los had burst out "furious raging":

> Why stand we here trembling around
> Calling on God for help; and not ourselves in whom God dwells
> Stretching a hand to save the falling Man: . . .
> I will not endure this thing! I alone withstand to death,
> This outrage! Ah me! how sick & pale you all stand round me!

"Only Los (only Blake), with his piercing insight through the
surfaces of fact," Schorer reads, "is capable of the true revolutionary
protest" (p. 374). But it turns out that Los had been mistaken.
Blake is once more exhibiting the impasse of mercy and wrath as
the pattern of the times. In the first place Albion's "Friends &
Brothers" and "beloved Companions" had not lost their love of
him nor even their willingness at the proper moment "with kindest
violence [and well-timed wrath?] to bear him back Against his
will thro Los's Gate to Eden" (as Blake had escorted Schofield
out of his Eden). Their objection was (and here the debate shifts
ground) that "the Will must not be bended but in the day of
Divine Power." In the meantime Los (who had after all been
just as silent as they) had been "delegated" to keep alive "the
Spirit of Prophecy" (*J.*39[44]). In the second place, then, there
are times when "the true revolutionary protest" has no objective
existence except as the impotent "raging" of a poet letting off
steam.

In this context the speech of Bath, which comes in to illustrate
the willingness of the Friends of Albion to respond to the call
of Los, illustrates *also* the futility of speaking out. At the end of
the whole performance "Albion turnd away refusing comfort"—
at which the poor "immortal Bard" of Oxford, Bath's eloquent
friend who had introduced him, "fainted in the arms" of his more
silent brethren.[13] Bath's speech was heard by "those whose Western

[13] *J.*41[46]. Blake in a letter to Hayley, Jan. 27, 1804, speaks of "Edward,
the bard of Oxford," whom Gilchrist has identified as "a certain young
Mr. Edward Marsh, of Wadham College" (see Sloss and Wallis, I, 529 n),
but I have been unable to connect him with Warner or with Bath in any
way. David Hartley the younger [ca. 1730–1813], an Oxford man, was a
friend of Warner; he may have written poetry.

Damon's *Dictionary* puts forward the attractive—but quite indefensible—
identification of the Bard of Oxford as Shelley. (See my review, cited

Gates were open, as they stood weeping Around Albion: but Albion heard him not" (*J*.40[45]). Under the circumstances "deep dissimulation is the only defence an honest man has left" (*J*.49).

This conclusion is scarcely inescapable. Warner did not dissimulate; he called "openly and publicly" for a petition to the King for peace; his pamphlets were reviewed widely and heatedly, and his Fast Day sermon went into four editions within a few months and continued to be reissued throughout the war period. Apparently there were many "whose Western Gates were open" and to whom Blake too might have spoken if his own desperate case had not led him by now to erect his own loneliness into an awful barrier between Albion and the Friends of Albion and thus even between the latter and himself. He said at the beginning of *Jerusalem* that he was willing to go to any lengths to keep his own despair "invisible" to his "own Children" (*J*.10), but he went to such lengths as to confirm and solidify that despair, though we may accept it now as the mere integument of his vision. In the third chapter of *Jerusalem* he pictures himself as shouting and weeping and "rearing his hands to heaven for aid," yet not daring to speak to Albion "lest Albion should turn his Back" (*J*.71). It is the war, the veil woven "With the iron shuttle of War among the rooted Oaks of Albion," that unnerves him and his honest works:

Weeping & shouting to the Lord day & night; and his Children [Weeping] round him as a flock silent Seven Days of Eternity

Yet for all that, he is resolved to stay with the people and not use his visionary power as a means of private escape:

above, note 5.) Damon makes the more plausible, though difficult, identification of Ely, Scribe of Los, as Milton, and suggests in passing the possible identification of Winchester as Hayley. Most of the cathedral cities are merely listed by name. "Hereford, ancient Guardian of Wales," however, who is addressed in *J*.41[46] just after "Bath," is another that is somewhat particularized: his "hands Builded the mountain palaces of Eden, stupendous works!" Damon suggests Inigo Jones, who built palaces—but no Eden. Ruthven Todd, in correspondence, makes a suggestion that can be brought close to Blake's associations in 1806. Thomas Johnes, the man to whom Malkin addressed his biographical and critical remarks on Blake (and of whom Malkin must have given Blake a glowing account), qualifies as "Hereford" because he built himself an Eden at Hafod which included the "new mountain-farms" which Malkin visited in 1805 and describes in his *Memoirs,* a "magic creation in the wilds of Cardiganshire."

> I know I am Urthona keeper of the Gates of Heaven,
> And that I can at will expatiate in the Gardens of bliss;
> But pangs of love draw me down to my loins which are
> Become a fountain of veiny pipes: O Albion! my brother!
>
> (*J*.82)

And again,

> Go, on, builders in hope: tho Jerusalem wanders far away,
> Without the gate of Los: among the dark Satanic wheels.
>
> (*J*.12)

Even such silent building as Blake's or such scarcely articulate endeavor as Bath's is hopeful, although all Albion's friends realize that there can be no great progress in constructing the "spiritual fourfold London" until Albion himself awakes.

But is not something more than that implied in the Friends' advice to wait for "the day of Divine Power," the day when "Jesus shall appear" (*J*.39[44])? Is this a Delphic utterance like the prophecy in *Milton* that Albion will arise when the Sun of Salah is quenched in the indefinite sea?[14] Does it mean that some historical ripening of events beyond the prophet's control, some development more apocalyptic in its effect on Albion than a mere treaty of peace, may be at hand? The introduction of a new historical symbol at this point suggests that it does, for the new symbol is Ireland, weaving a rainbow of power over the wheels of Albion. And we are told, after the failure of Bath's speech and the concomitant "death" of Albion, that the hopes of "the grievously afflicted Friends of Albion" now "Concenter in one Female form an Aged pensive Woman" named Erin (*J*.48).

3

> I see a Feminine Form arise from the Four terrible Zoas
> Beautiful but terrible struggling to take a form of beauty
> Rooted in Shechem: this is Dinah, the youthful form of Erin
> — *Jerusalem* 74

[14] See *M*.23:60 where the time of the Last Vintage is indicated by a piece of obscurantism possibly suggested by the business in *Henry V* I.ii.11–64 where the interpretation of "the law Salique" depends on where one locates "the river of Sala." In Genesis, Salah is the father of Eber, founder of the Hebrew race.

"Erin replaces America in the Jerusalem symbols," says Damon (p. 440), "since America was now definitely not a part of England." "Ireland is 'Erin's Continent,'" explain Sloss and Wallis, "the western land, and like America, the place of liberty and Imagination. Here the Giants dwelt before the floods of abstraction overwhelmed them, and here are laid the foundations of Jerusalem" (1, 553). But America had stopped being a part of England long before Blake had begun writing prophecies, while his statement that Albion's Friends "saw America clos'd out by the Oaks of the western shore: And Tharmas dash'd on the Rocks of the Altars of Victims in Mexico" (J.38[43]) was not made till the second decade of the nineteenth century. And it is simply not true that Erin replaces America. Erin is a new symbol of hope, but America is still spoken of as a good hiding place for Jerusalem —and this in a speech by Erin.[15] On page 11 the text describes Los's joyful discovery and embrace of Erin and the illustration contains a resplendent American Indian. America remains a symbol of freedom, or there would be no point in the lament, which runs all through *Jerusalem*, about its being closed out by wilful act of Albion and his oaken navies. The history of the decade in which Blake was writing *Jerusalem* affords a more direct and simple explanation.

The Sacrifice of Tharmas in Mexico can be accounted for by the execution in 1811 and 1813 of Hidalgo and Morelos and other Mexican insurgents by Spanish firing squads. The closing out of America by Oaks or Druidic warships can be understood in reference to the various efforts of France and Britain to exclude each other from the American trade, efforts which took the form of Napoleonic Decrees and British Orders in Council and culminated in the naval War of 1812. And the new prominence of Ireland in Blake's symbolism can be explained by the renewal of the struggle for Ireland's independence.

Erin was of course "an Aged pensive Woman" centuries older than the "soft soul of America." But Blake is not wide of the mark in declaring that the hopes of Friends of the People at this time tended to "Concenter in" the new Irish movement. Catholic Emancipation was the immediate issue, but national freedom was the goal. "We would fain excite a national and Irish party capable of annihilating any foreign oppressor whatsoever," announced

[15] *J*.49. And in another by Los, *J*.83.

Daniel O'Connell in 1810 as leader of the movement.[16] Ten years of the Act of Union of England and Ireland had proved a sad experience, and Byron was expressing a common sentiment when he called it "a Union of the shark with its prey." That was in Byron's second speech in Parliament, in 1812, and students of literature are familiar with the fact that Shelley two months earlier[17] addressed a meeting in Dublin and distributed his own pamphlets to the Irish people expressing the hope that Ireland would be the starting-point of a universal liberation of the human spirit. *Jerusalem* gives evidence that Blake was filled with the same hope and similarly responsive to the stir of sympathy in England.

Here was something of so opposite a tendency to Albion's pre-occupation with strangling other nations that it offered the friends of liberty a "space" for hope, just as the American Revolution had done earlier. Erin is first introduced just a page before Blake's question about the golden builders near "weeping Paddington," and perhaps there is an allusion to the fact that this was a neighborhood of Irish laborers with whose republicanism Blake may have been acquainted through Barry.[18] The second and third chapters of *Jerusalem* both conclude with the appearance of a rainbow in Erin's land. At the end of the second chapter "Erin's lovely Bow" brings to the Daughters of Beulah a promise that the Lamb will come to "take away the remembrance of Sin" (*J*.50). And at the end of chapter three Blake sees "the youthful form of Erin" arising, "a Feminine Form . . . Beautiful but terrible struggling to take a form of beauty" (*J*.74); it would be another century before Blake's son Yeats saw the terrible beauty born.

Apparently Blake, like Shelley, rejoiced in the new struggling of

16 D. E. Halévy, *History of the English People in 1815*, III, 106. In 1800 Francis Dobbs had read "the signs of the times" as heralding a new order in which Ireland was "to have the glorious pre-eminence of being the first kingdom that will receive" the Messiah. *A Concise View*, p. vi. Dobbs, however, had expected the Second Coming before the Act of Union could go into effect.

17 My mistake in putting Shelley's address "in the same week" was called to my attention by Charles E. Robinson.

18 *J*.11–12. For Barry's association with Irish radicals see Whitley, *Art*, p. 102. Evidence of his earlier association, in the critical year 1796, is supplied by Godwin's unpublished diary, Mar. 6 and 11, Apr. 9, May 23: Barry meets with Arthur O'Connor of the United Irishmen and the English radical Sir Francis Burdett.

Erin as in the renewed progress of intellectual war, a "Striving with Systems to deliver Individuals from those Systems." "For the Soldier who fights for Truth, calls his enemy his brother: They fight & contend for life, & not for eternal death!" Shelley expected the new stir of liberal thought to free the Irish people not only from subservience to England but from the superstitions of their own religion. In Blake's last chapter, just before Albion's final waking, Erin is the one who sits in the "Immortal Tomb" of Los's furnaces "to watch them unceasing night and day."[19] These strategically placed references to Ireland provide a strong note of contemporaneity.

4

> Albion mov'd
> Upon the Rock, he opend his eyelids in pain; in pain he mov'd
> His stony members, he saw England. Ah! shall the Dead live
> again — *Jerusalem* 95

The finale of *Jerusalem* is simple but effective. Unlike the conclusion of *The Four Zoas* it is neither insurrectionary nor elaborately paradisaical but is a hymn to the spiritual regeneration of man and nature.

The "Signal of the Morning which was told us in the Beginning" is the appearance of Antichrist or ultimate Druidism. Materially this is the extreme form of the Polypus of War. Intellectually it is "Bacon, Newton, Locke," the complete denial of Vision.[20] The limits of modern Caesarism are indicated in an allusion to Albion's effort to tax the nations. The efforts of Augustus Caesar to tax the ancient nations had brought Joseph and Mary to Bethlehem, where the destruction of selfish love and war and taxes was born.[21] Now England's Selfhood had so extended itself that "the Body of Albion was closed apart from all

[19] *J*.11:5; 38[43]: 41 f.; 94:12 f.

[20] *J*.95:2 f.; 93:26, 21. Cf. Matthew 24:3–15.

[21] "Blake is thinking also of (1) the taxes leading to the American revolution, (2) the taxes leading to the French revolution, (3) the taxes in England during and after the Napoleonic wars." Margoliouth, *Review of English Studies*, XXIV (1948), 312.

Nations." Obviously "Time was Finished!" (*J*.94). Britannia must stop her trident-shaking and put down her shining spear, must abandon "A pretence of Art, to destroy Art: a pretence of Liberty To destroy Liberty, a pretence of Religion to destroy Religion" (*J*.43:35–36).

In Blake's final "Visions of Heaven & Earth" (*J*.96) he sees a revolutionized Britannia reversing the original Temptation by leading Albion *into* Paradise. She put down her Druid Knife, the story goes; put aside her role of "the Jealous Wife" terrorizing the "Nations of the Earth"; and stood forth as "England who is Brittannia," awake at last from her dream of Death and Chastity and Moral Law. Her waking exclamations reanimated the "stony members" of Albion-Adam, who, when "he saw England," rose up first in anger, full of "the wrath of God" and speaking "in direful Revolutions of Action & Passion." But these revolutions swiftly compelled his dislocated Zoas to resume their proper places as "Sons of Eden." Whereupon "England who is Brittannia enterd Albions bosom rejoicing, Rejoicing in his indignation! adoring his wrathful rebuke" (*J*.94–95).

After this visionary preview, the rest is easy. Blake knows that the prophetic wrath he has had such difficulty trying to control will be fully vindicated when Albion learns to express it adequately and generously in Action and Passion. *Vox populi, vox dei.* The wrath in his bosom has really come from the Divine Humanity in his bosom, as he now discovers when Jesus appears, ready to converse "as Man with Man, in Ages of Eternity And the Divine Appearance [is] the likeness & similitude of Los." Albion is quickly given to understand that the angry prophet has been his true friend all along, dying for him continually—for "every kindness to another is a little Death In the Divine Image nor can Man exist but by Brotherhood" (*J*.96).

Now for a moment it is Albion who views with alarm the condition of the world, which Hand has hidden from him:

> Do I sleep amidst danger to Friends! O my Cities & Counties
> Do you sleep! rouze up. rouze up. Eternal Death is abroad

But this act in itself accomplishes the revolution, demonstrating as it does that Albion has begun to think "not for himself but for his Friend." Now from all the Earth, unchained from desolation, poverty, or oath of allegiance to tyranny, the triumphant cry arises:

Where is the Covenant of Priam, the Moral Virtues of the Heathen
Where is the Tree of Good & Evil that rooted beneath the cruel
heel
Of Albions Spectre the Patriarch Druid! where are all his Human
Sacrifices
For Sin in War & in the Druid Temples of the Accuser of Sin! . . .
Where are the Kingdoms of the World & all their glory that
grew on Desolation
The Fruit of Albions Poverty tree when the Triple Headed Gog-
Magog Giant
Of Albion Taxed the Nations into Desolation & then gave the
Spectrous Oath (*J*.98)

Without Good and Evil will the new Jerusalem be a tame
society? Far from it. This may be "incomprehensible by Mortal
Man," but there will be "A Sun of blood red wrath . . . Glorious"
and occupying no mere spot in the sky but "surrounding heaven,
on all sides around." And under the illumination of this furious
sky, man with man will converse together like the four Zoas "in
Visionary forms dramatic . . . bright Redound[ing] from their
Tongues in thunderous majesty, in Visions In new Expanses."
"Bacon & Newton & Locke, & Milton & Shakespear & Chaucer"
will join in the discussion, for once the Druid Spectre is "An-
nihilate" there will be a fine "clangor of the Arrows of Intellect"
without any bloodshed. In William Blake's Paradise the intellectual
lions and lambs will not exactly lie down together but will roar
and bleat at each other in an energetic comradeship ranging over
all topics which the Human Imagination can conceive.

On the 99th page we see Man and God embracing as Man
with Man—or, for Blake depicts both embraces in one picture,
Woman with Man. For now Albion and Jerusalem are one, one
sex, one Form, and one Nation; Jerusalem is become truly the
Liberty she is called "among the Children of Albion" (*J*.54). And
now God, truly Man, can embrace the one human Nation, his
true place and people. This means *living*, not departing; for "all
Human Forms" and their Emanations it means "living going forth
& returning"—into the "Planetary lives of Years Months Days &
Hours" and back "into his Bosom in the Life of Immortality"
(*J*.99). On the 100th page we see Los, Urthona, and Jerusalem,
poised in their curtain call yet ever ready for "going forth." Los

is shouldering the sun, Jerusalem (or Enitharmon) is spinning the atmospheres, and Urthona, with the hammer and tongs which he has used throughout the times of trouble, is scowling his forgiveness at the audience. The serpent temple stretches white—amid flourishing vegetation—across the backdrop.

EPILOGUE

In Equivocal Worlds

In Equivocal Worlds

BLAKE lived twelve years after Waterloo, and labored mightily and found contentment, but no sign of an end to times of trouble. He lived to see the system he had called Religion-hid-in-War step forth unashamed as a religion of profit in pounds and shillings, a religion whose "God Creates nothing but what can be Touchd & Weighed & Taxed & Measured."[1] Blake in his sixties, still in corporeal poverty, looked out on the accelerating "cogs tyrannic" of industrial capitalism and summed up his feelings in a curse: "Money!"

"Where any view of Money exists Art cannot be carried on," and Blake saw his countrymen dwelling in no green and pleasant England but in hell and those "Equivocal Worlds" described by Dante which are built by "Money, which is The Great Satan or Reason," not by "The Imagination, that is, God himself." The new Englishmen, as "Politicians," were "fond of The Indefinite, which they Measure by Newtons Doctrine of the Fluxions of an Atom. A Thing that does not Exist." As moneylenders and tax collectors they were fond of the "uncontrolably powerful" and they worshiped the will of a God who was "just such a Tyrant as Augustus Caesar" and whose power they measured by the fluxions of a guinea, a thing which did not exist in Blake's vision—nor in his pocket. "But since the French Revolution Englishmen are all Intermeasurable One by Another Certainly a happy state of Agreement to which I for One do not Agree." Naturally those whose god was "only an Allegory of Kings" thought that Republican art was inimical to their atom. It was inimical to their guinea too. "God keep me," Blake wrote to his old friend Cumberland, "from

[1] Quotations in this and the following paragraphs are from Blake's Marginalia to Thornton, 1827, his commentary on the Laocoön engraving, ca. 1820, his letter to Cumberland, Apr. 12, 1827, and his notes on illustrations to Dante, 1825–1827. (E657 ff.; 270 ff.; 707; 667 ff./K786 ff.; 775 ff.; 878; 785.)

the Divinity of Yes & No too—The Yea Nay Creeping Jesus from supposing Up & Down to be the same Thing. . . ."[2]

In a new translation of the Lord's Prayer by Dr. Thornton, Blake encountered the mad extreme of the new Caesar worship. Certain that "The whole Business of Man Is The Arts & All Things Common," he was incensed at the idea of begging one's daily bread from any god.[3] Thornton's "Grant unto *me, and the whole world* . . . an abundant supply of *spiritual* and *corporeal* Food" made Blake explode:

"Lawful Bread Bought with Lawful Money & a Lawful Heaven seen thro a Lawful Telescope by means of Lawful Window Light The Holy Ghost & whatever cannot be Taxed is Unlawful & Witchcraft

"Spirits are Lawful but not Ghosts especially Royal Gin is Lawful Spirit No Smuggling real British Spirit & Truth"

This was the time when Cobbett cried out every week against paper money and "the Waterloo taxes" levied "to pay the score due for *Anti-Jacobin* wars": malt tax, beer tax, gin tax, license tax, house tax, window tax, candle tax, coal tax, sugar tax, leather tax, "and taxes besides without number."[4] But Blake pushed aside the whole system of property and taxes. His own prayer—or demand—was: "Give us the Bread that is our due & Right by taking away Money or a Price or Tax upon what is Common to all in thy Kingdom."[5]

Blake had by now rather completely identified himself with the

[2] Cumberland's *Thoughts on Outline* thirty-one years before had ridiculed artists whose outlines were "thick and thin alternately" as "forgetting what our penetrating Bard, Shakespeare, says, that, 'Aye and no too, can be no good divinity.'"

[3] Laocoön; cf. "I rose up at the dawn of day." *N*.89: E472/K558.

[4] *Political Register*, April 1825, and passim.

[5] Still close to the literature of popular protest, Blake is reversing the traditional irony of the genre—an example of which may be quoted from a handbill of December 1797: "A Creed for all GOOD and LOYAL SUBJECTS. . . . I believe in God as by *Law established*—in BILLY PITT, *Heaven Born* Chancellor of the Exchequer . . . and in Secretary HARRY DUNDAS, the only beloved of BILLY PITT. . . . And I believe in *Paper-Money* and *National Bankruptcy* as the outward and *visible* Signs of the Nation's prosperity, and I look not for a Remission of Taxes, no, not till the *Resurrection* of the *Dead*, and I look for a *better* Government in the World to come. Amen."

lantern-bearing Los who could "at will expatiate in the Gardens of bliss" (*J*.82:82). From this center of wisdom he spoke with prophetic geniality to fellow laborers who were astray—to "Lord Byron in the Wilderness," to whom he addressed a corrected version of *Cain* ("Were it not better to believe Vision with all our might & strength?");[6] to Wordsworth, whose intimations of immortality delighted him but whose talk of how exquisitely the "external World is fitted to the Mind" struck Blake as a complacent acceptance of the night of nature and the slave status of divided and suffering Humanity;[7] and to his new friends among younger artists, John Linnell and the astrologer John Varley, for whom he drew rapid sketches of the spiritual faces of his acquaintance in Eternity —residual images, chiefly, of his earlier drawings.

"Varley believed in the reality of Blake's visions more than even Blake himself," said Linnell, and the report of these possibly Quiddian sessions comes to us through the distorting journalism of Alan Cunningham and Jane Porter. Yet it is evident that Blake, in talking about the historic personages he was drawing, characterized them forcefully as friends of liberty or as Satanic kings and accusers. The face of William Wallace was "noble, and heroic, that of Edward stern and bloody. The first had the front of a god, the latter the aspect of a demon." Another visitor was "a scoundrel indeed! The very individual task-master whom Moses slew in Egypt." Wat Tyler and a Welsh Bard were, of course, true heroes. When drawing "the Devil," Blake apparently alluded to some of his recent avatars, for Varley passed along a hint that the Devil resembled "two men who shall be nameless: one is a great lawyer, and the other—I wish I durst name him—is a suborner of false witnesses." And the head of Herod: "How like an eminent officer in the army!"[8] Wellington, one may guess.

As for Napoleon, Blake had been told by an eminent politician —and how well his story fits the career of Orc who became Luvah!—"that the Bonaparte of Italy was killed, and that another was somehow substituted . . . who was the Bonaparte of the

[6] *Ghost of Abel*, 1822: E268–270/K779–780.

[7] Marg. to Wordsworth, E656/K783.

[8] Mona Wilson, *Blake*, pp. 271–274. The Blake-Varley sketchbook has now been discovered, and its publication in facsimile, with an introduction by Martin Butlin, has been announced for 1969.

Empire! He referred to the different physiognomies (as he thought) in the earlier and later portraits."[9] When he of the Empire escaped in 1822 from St. Helena to Eternity, Blake painted *The Spiritual form of Napoleon* as a "fresco" to match his Pitt and Nelson. In this picture, which has disappeared but was described in 1876, Napoleon is flanked by "inexplicable" angels and stands forth as a "strong energetic figure grasping at the sun and moon with his hands, yet chained to earth by one foot, and with a pavement of dead bodies before him in the foreground."[10] The slave to war could not achieve a revolution of the heavens.[11]

Pleasant labors occupied Blake's final years—the printing and illumination of *Jerusalem* in two or three black and white copies and as many more colored ones; the recollection of the rural delights of Felpham in a series of woodcuts for a Virgilian Eclogue;[12] the organization of the Book of Job into an emblematic epic; the illustrations of *Paradise Regained* and of *The Divine Comedy*— though Blake found in Dante vanity and hate—and of Genesis and of the apocryphal and apocalyptic Book of Enoch, not finished at his death. During his last two years Blake had the pleasure of a worshipful following among the younger painters Palmer, Calvert, Richmond, Walter, and Finch. These disciples took Blake into the countryside and learned from him to see *through* the eye, to see the pastures and cottages of Sussex and Kent as corners of Paradise. A modern critic speaks of the momentary "state of communal ecstasy" in which these enthusiasts worked, "heedless alike of sales or celebrity." At Shoreham some twenty miles southeast of London they issued forth at night "into the moonlit cornfields and there released their spirit in songs and declamations that continued sometimes until sunrise."[13] To them Blake was "The Interpreter," and the spiritual form of these rejoicings had been revealed in his Virgil woodcuts and in the final plate of his *Job*.

That he had reached these young men of the new age was to Blake an augury of a great audience to come. On his deathbed

[9] Gilchrist, p. 327, quoting an unnamed late friend of Blake's.

[10] H. H. Stathom, in *McMillan's Magazine*, XXXIV (1876), 60.

[11] He had slain "Tharmas the Angel of the Tongue" (*J*.63:5).

[12] The milestone in one of the designs, reading "LXII Miles London," indicates that the locale is Felpham. Palmer spoke of the series as "visions of little dells, and nooks, and corners of Paradise." Gilchrist, p. xii.

[13] Robin Ironside, "The Followers of William Blake," *Magazine of Art*, XL (1947), 309–314.

he felt the warmth of their affection "and He burst out Singing of the things he Saw in Heaven," they told each other.[14] When near the gates of death he had been ready, he said, to "get into Freedom from all Law of the Members into The Mind in which every one is King & Priest in his own House."[15] Such a republic had not come on Earth, but he prayed that God would "Send it so." William Blake was never willing to give up hope for the ancient man—or for the modern man—nor to resign this pleasant world to the Accuser:

"All is not Sin that Satan calls so all the Loves & Graces of Eternity."

"Solomon says Vanity of Vanities all is Vanity & What can be Foolisher than this"

> Truly My Satan thou art but a Dunce
> And dost not know the Garment from the Man[16]

[14] Richmond to Palmer; Gilchrist, p. 353.
[15] To Cumberland, Apr. 12, 1827.
[16] Note on Laocoön, note on a late print of *Mirth and Her Companions*, and lines from the Epilogue of *The Gates of Paradise*.

Chronology

1757 Nov. 28, born in London, at 28 Broad St.
1763 End of Great War for the Empire.
1768 Enters Pars's Drawing School, Strand.
1772 Aug. 4, apprenticed to James Basire, engraver.
1775 American War begins.
1779 Ends apprenticeship. Oct. 8, enters R.A. schools. Paints *Ordeal of Queen Emma, Penance of Jane Shore,* etc. Engraves for booksellers, including Joseph Johnson.
1780 Exhibits *Death of Earl Goodwin* at R.A. "Involuntary" participant in June riots. Draws picture later called *Albion rose.*
1781 British surrender at Yorktown.
1782 Aug. 18, marries Catherine Boucher; they live at 23 Green St. till 1784. Engraves for *Novelist's Magazine,* etc.
1783 Peace treaties. *Poetical Sketches* printed.
1784 Engraves for *Wit's Magazine.* Exhibits *War unchained* and *Breach in a City* at R.A. Print shop of Parker & Blake opened at 27 Broad St., ca. Oct. Writes *An Island* (MS), ca. Dec.
1785 Exhibits *The Bard* and three *Josephs* at R.A. Late in the year, partnership with Parker dissolved. Blakes move to 28 Poland St.
1787 Feb., death of brother Robert. Fuseli "given to me."
1788 *No Natural Religion* booklets.
1789 *Songs of Innocence. Thel.* Apr., Blakes attend Swedenborgian conference. Annotates Lavater's *Aphorisms* and Swedenborg's *Divine Love.* July, fall of Bastille.
1790 *Tiriel* (MS). Begins *Marriage of Heaven and Hell.* Annotates Swedenborg's *Divine Providence.*
1791 Illustrates two Wollstonecraft books. *The French Revolution* set in type. Blakes move, in 2nd quarter, to 13 Hercules Buildings, Lambeth. Probably begins early version of *Amer-*

ica. In Dec. is praised by Stedman for illustrations. Perhaps revises *Thel.*

1792 July, Duke of Brunswick's Manifesto. Sept. 20, battle of Valmy halts invasion of France; Sept. 21, France proclaimed a Republic. Concludes *M.H.H.* with *A Song of Liberty.* Finishes engraving for Stedman's *Narrative.*

1793 Jan. 21, execution of Louis XVI. Feb. 1, war with France. May 7, *Gates of Paradise.* June 5, *Our End.* Oct. 10, Prospectus advertises *America, Visions, Thel, M.H.H., Innocence, Experience, Gates,* engraved *History of England* (lost).

1794 Publishes combined *Songs of Innocence and of Experience, Europe, Book of Urizen.* July, fall of Robespierre. Nov., trials of Hardy and Tooke. Flaxman returns from Italy.

1795 Famine year. *Book of Los, Book of Ahania, Song of Los.*
1796 Sept. *British Critic* attacks *Leonora* illustrations.

1797 Bank crisis. Illustrated *Night Thoughts* a failure. Begins *Vala,* much later titled *The Four Zoas* (MS). Illustrates poems of Gray.

1798 Annotates Bishop Watson on Paine. Aug., Battle of Nile. Begins annotation of Reynolds, resumed as late as 1808.

1799 Exhibits *The Last Supper* at R.A. Netherlands campaign disastrous. Napoleon's coup of 18th Brumaire (Nov. 9).

1800 Famine year. Exhibits *The Loaves and Fishes* at R.A. Sept. 18, Blakes move to Felpham.

1801 Feb., resignation of Pitt, insanity of King George. Oct. 19, rejoices at peace. Engraves for Hayley's *Cowper* and *Ballads.*

1802 March 27, Peace of Amiens signed.

1803 May 10, renewal of war. Aug. 12, encounter with Schofield and Cock. Sept., Blakes move to 17 South Molton St. *Gray Monk* stanzas in notebook. Other "Pickering MS" poems probably begun. Re-titles *Our End: The Accusers.*

1804 Jan. 11–12, tried at Chichester, acquitted. Paints *Samson bursting bonds, Noah and Rainbow;* also *Famine, War.* Designs title pages of *Milton* and *Jerusalem.* Discusses *Defence of Literature.* Visits Truchsessian Gallery.

1805 "Pickering MS" copied? Oct., prepares to engrave Blair's *Grave* for Cromek; Cromek engages Schiavonetti.

1806 Cromek gives Blake's *Canterbury Pilgrims* idea to Stothard.

Feb., Malkin introduces Blake and his lyrics in *A Father's Memoirs.*

1807 Passage of bill abolishing Slave Trade. Sept., bombardment of Copenhagen.

1808 *Grave* published. Exhibits *Christ in the Sepulchre, Jacob's Dream, Last Judgment* at R.A.

1809 May-Sept., own exhibition at 28 Broad St. *Nelson, Pitt, Canterbury Pilgrims,* etc. *Descriptive Catalogue.* Attacked by *Examiner,* Sept. 17. Writes *Public Address* (MS). Begins final engraving of *Milton,* probably finished 1810.

1812 Exhibits *Nelson,* etc., at Associated Artists. America "closed out" by war. Rejoices in death of "Screwmuch" et al.

1815 Waterloo ends war. Depression. Blake, poor, engraves designs for Wedgwood's chinaware catalogues, 1815–18. Visits R.A. to draw the Laocoön.

1816 Illustrates *L'Allegro* and *Il Penseroso.*

1818 Begins printing *Jerusalem. The Everlasting Gospel* (MS). Meets Linnell. Begins *Job* water colors for Butts.

1819 Draws "visionary heads" for Varley.

1820 Begins woodcuts for Thornton's *Virgil.* Notes *On Homer's Poetry, On Virgil,* on the Laocoön, about this time. First complete copy of *Jerusalem.*

1821 Sells print collection. Blakes move to 3 Fountain Court, Strand.

1822 *Ghost of Abel. Spiritual form of Napoleon.* Receives donation of £25 from R.A.

1823 Agrees to engrave *Job* designs for Linnell.

1824 Illustrates *Pilgrim's Progress.*

1825 March, completes *Job.* Begins Dante drawings. Dec. 10, Crabb Robinson's first visit.

1826 *Illustrations of the Book of Job.*

1827 Begins Dante engravings; dies Aug. 12 at 69.

1831 Catherine Blake dies at 69.

Index

Both text and footnotes are indexed. Asterisks here (*) indicate pages where symbols are identified or particularly discussed. Works cited, except Blake's and anonymous or periodical publications, will be found under the author's name.

130–32, 142, 146, 176, 289; his view modified by developments, 313, 322, 375–76, 378, 422; beginnings, 130–32, 149–50, 162–63; fall of Bastille, 130, 150, 164–66, 182, 209 (see also Bastille); bread riots, 150, 184; National Assembly, 150, 162, 186; Convention, 155; first Constitution, 185–89, 195 (see also La Fayette); veto suspensif, 185–86, 188; September Massacres, 189, 192; Republic of France, 183, 189, 192, 310, 315, 401, 418, underestimated, 285. See also France

French Revolution, The, 21, 130, 153, 156, 175, 182, 189, 196–97, 206, 223, 249, 258, 279, 294, 351, 373, 426; commentary, 164–74; events covered, 162–64; failure to publish, 151–53; textual errors, 166–67; useful as key to later symbolism, 164, 263

fresco, 455

Freud, Sigmund, 257

"Friend of Religion & Order," 367

Friends: of America, 22; of Freedom, 160; of Liberty, 154; unassociated, 343. See also Albion: his friends

Friends of the People, etc., see societies

Froissart, Jean, 65

Fructidor, 18th, 310–11

Frye, Northrop, xviii, 5, 33, 64, 117, 119, 135, 145, 167, 225, 246, 264, 380, 400, 426, 432, 459, 462, 465, and passim

Fuller, Thomas, Worthies of England, 120

Fulton, Robert, 159, 210; memoir to Pitt, 400

furnaces: blast, 333–34, 396, 398, confused with kiln, 334*; image dominant, 26–27, 271, 330, 354, 358; as means to build Jerusalem,

306, 457, 484. See also blacksmiths, smelting

furrows, 23, 169, 175, 261–62, 331*, 461

Fuseli, Henry, 37, 124, 156, 157, 159, 161, 287, 308, 363, 434, 437–39, 469; Darwin illustrations 333; influence on Blake, 42–43, 140–41; Lavater translation, 139, 140–41; his Milton, 436, 438–39, 451; portrait of Priestley, 105; his Shakespeare, 439; The Nightmare, 90; Remarks on Rousseau, 43, 129, 177, 178, 428; Satan, Sin, and Death, 161

futurity, 322, 351*, 387–88, 399; demons of, 89, 334

Fuzon, 314*–15, 418

"gagging acts," 285, 303

Gainsborough, Thomas, 42, 49

gallery, see national gallery

Galt, John, 37, 45

Garden of Love, The, 272, 290

gardens: of the Kings, 370; of Flora and Apollo, 289

Gardner, Stanley, xi, xviii, 4, 94, 96–97, 136, 290

garments: of blood, 378; of chastity, 62–63; of fortitude, 476; of innocence, 115–16; of oppression, 427; of pestilence, 184, 223; of pity, 27–28, 426–27; of war, 72, 166, 172–73, 194, 271–72, 350

Garnett, Richard, 68

Gartenberg, Max, 23

gates, 84; of Heaven, 209, 255, 305; of Los, 479, 481; of meaning, 412; of the tongue, 298*; of wrath, 272–74

Gates of Paradise, The, 204, 453, 495

Gaul, 463

Gazette, 15, 277

Gazetteer, 94

General Evening Post, 278

generation, 298–99

Genesis, 320, 494

Paradox

" I am not allowed to complain about anything.
If T, then I am complaining _so_ _F_.
sd F,
If F, then T. _